THE
WORLD OF
TELECOMMUNICATION

THE WORLD OF TELECOMMUNICATION

Introduction to Broadcasting, Cable, and New Technologies

Phillip O. Keirstead
Florida A&M University
Sonia-Kay Keirstead

Focal Press
Boston London

Focal Press is an imprint of Butterworth Publishers.

Library of Congress Cataloging-in-Publication Data

Keirstead, Phillip O.
 The world of telecommunication : introduction
to broadcasting, cable, and new technologies /
Phillip O. Keirstead, Sonia-Kay Keirstead.
 p. cm.
 Bibliography: p.
 Includes index.
 ISBN 0-240-80014-1
 1. Broadcasting—Vocational guidance.
I. Keirstead, Sonia-Kay. II. Title.
HE8689.6.K45 1990
384.55′4′02373—dc19 88-30651

British Library Cataloguing in Publication Data

Keirstead, Phillip O.
 The world of telecommunication : introduction to
broadcasting, cable, and new technologies.
 1. United States. Broadcasting services I. Title
II. Keirstead, Sonia-Kay
384.54′0973

 ISBN 0-240-80014-1

Butterworth Publishers
80 Montvale Avenue
Stoneham, MA 02180

10 9 8 7 6 5 4 3 2 1

Printed in the United States of America

CONTENTS

PREFACE ix

ACKNOWLEDGMENTS x

1 TELECOMMUNICATION TODAY—AN INTRODUCTION 1
What Do We Mean by
 Telecommunication? 1
Specialized Mass Media 2
Forms of Telecommunication 2
The Legal Environment 5
The Significance and Impact of
 Telecommunication in the
 United States 6
Issues Facing the
 Telecommunication Industry 7
The Major Part of
 Telecommunication—
 Broadcasting 9
Summary 12
Glossary 12

2 TELECOMMUNICATION YESTERDAY—A HISTORY 14
Why Wire Communication Wasn't
 Enough—The Telegraph 14
From Telegraph to Telephone 14
Radio and Big Business 17
The 1927 Radio Act 22
The Growth of the Networks 23
The Communications Act of 1934 24
The Press–Radio War 24
A New Technology—FM Radio 25
The Beginning of Television 26
Broadcasting and World War II 26
Growth in Television: 1946–48 27
The "Dark Ages" 29
The Sixth Report and Order 30
The Change in Radio 31

The Importance of Newton Minow 34
Television Comes of Age 35
Summary 39
Glossary 40

3 LAW, REGULATION, AND ETHICS 42
The Source of Communication Law 42
Key Ideas in the Radio Act of 1927 44
Precedent-Setting Cases 45
The Communications Act of 1934 46
Regulations in Broadcasting 52
Other Sources of Broadcasting Law
 and Regulation 62
Ethics 66
Summary 67
Glossary 69

4 BROADCAST RADIO 72
Where Radio Is Today 72
Radio Is a Local Medium 74
AM Radio 74
AM Stereo 77
FM Radio 77
Radio Programming and Formats 79
Cable Radio 83
How a Typical Radio Station
 Operates 84
Buying Your Own Station 92
Public Radio 95
Radio's Competition 96
Summary 96
Glossary 97

5 BROADCAST TELEVISION 100
Television Networks 100
Independent Stations 102
A Fourth Network? 103
Television Allocation Developments 103

How a Typical Television Station
 Operates 104
Public Television 116
Structure of the Commercial
 Networks 119
Issues in Television 127
Outlook for the Future 128
Summary 129
Glossary 129

6 CABLE AND OTHER MEDIA 133

Cable 133
Videotex 146
Teletext 147
Multipoint Distribution System 148
Direct Broadcast Satellites 148
Subscription Television 149
Videocassette Recorders 150
Stereo Television 151
High Definition Television 151
HDTV and the Rest of the World 155
The Big Question for HDTV 156
Computers 156
Cellular Telephone 157
Summary 157
Glossary 158

7 PROGRAMMING 160

Radio Programming 160
Television Programming 175
Programming Consultants 184
Summary 184
Glossary 185

8 THE AUDIENCE AND RESEARCH 187

How Is Advertising Sold? 187
How Do We Find Out Who Is
 Listening and Watching? 187
Sweeps—Another Name for
 Ratings 187
Arbitron for Radio 189
RADAR 189
Audiences—Why Sample Them? 189
Ratings and Some of the Terms 191
Rating Ploys 197
Electronic Media Rating Council 197
Paying for Ratings 197

Market Research 197
Research as Part of Programs 199
Research as a Tool of Government
 Policy 199
Listening and Viewing Habits 200
Qualitative Research 200
Summary 201
Glossary 202

9 ADVERTISING—THE ART OF MAKING MONEY 204

Advertising and Broadcasting 204
Advertising—How It Is Done in
 the Communication Media 207
Self-Regulation—The NAB's Role 207
Why Advertise? 207
Media Mixes 208
Selling Advertising 208
Creating Ads 210
A TV Commercial Created 212
Networks—How They Sell
 Advertising 216
Competitors All 216
Public Service Advertising 216
Summary 217
Glossary 218

10 TELECOMMUNICATION AROUND THE WORLD 220

Broadcasting, Culture, and Politics 220
How the World Systems Are Tied
 Together 221
Broadcasting in Britain 222
Broadcasting in the Third World 228
The Soviet Union 233
American Programming Around the
 World 234
Technology Around the World 238
Summary 242
Glossary 242

11 TELECOMMUNICATION AND SOCIETY 244

Telecommunication—
 The Gatekeeper 244
Entertainment 244
New Channels—New Programming
 Needed 245
Media Criticism 246

Danger Signals in Media Images 247
The Media and Public Taste 249
Violence 251
Children's Programming and
 Violence 252
Sex 254
Social Problems in the Open—
 The Docudrama 254
Power of the Media 254
Summary 255
Glossary 255

**12 CAREERS IN
 TELECOMMUNICATION 257**
The Business and Getting a Job
 in It 257
Job Categories 259
How Much Will I Be Paid? 266
Vocational Preparation vs.
 Educational Preparation 266
Marketing Yourself 266
Your Resume 267
Audition Material 271

Cover Letters for Applications 272
Preparing Yourself for the
 Interview 273
Some Early Career Considerations 273
Organizations That Can Help You 274
Glossary 275

APPENDIXES 277
A: Amendment of Communications
 Act of 1934; Title VI—Cable
 Communications 277
B: Radio-Television News Directors
 Association Code of Broadcast
 News Ethics 295
C: The Society of Professional
 Journalists, Sigma Delta Chi,
 Code of Ethics 296

BIBLIOGRAPHY AND
 REFERENCE LIST 297

INDEX 301

PREFACE

The occupational field known as broadcasting is made up of a variety of technologies, including cable, microwave, direct broadcast by satellite, AM and FM radio, television, Low-Power Television, and short-wave.

One of our objectives has been to try to make this text read like the broadcast field it talks about. Each chapter has a glossary of terms. The italicized parts of the text call attention to important points and names.

At the end of the book we have included an extensive section on employment in the telecommunication field. We have found that many of the most successful students have been those who began to plan early for their entry into the work force. We have witnessed too much frustration, too many dashed dreams for those who have waited until the last minute before dealing with one of the most important steps they would take in their adult lives, getting their first professional job. Students and instructors both benefit when students know what to expect at the end of their professional education.

This book was written by two people who love the telecommunication field. We have infrequently regretted our decision (and then only for short intervals) because the telecommunication business has meant excitement, involvement in some of the major events of this century, travel, friendships, and creative and intellectual stimulation.

ACKNOWLEDGMENTS

Thanks to the literally hundreds of people within and outside the telecommunication industry who at one time or another have made their contribution to this book. It is an exciting occupation, shared with interesting people who make every conversation an education.

Particular thanks to staff members of the Federal Communications Commission, the National Association of Broadcasters, and the dozens of other associations and industry groups who contributed a great deal of background information. And an appreciative word for the public relations practitioners who gave freely of their time and knowledge to provide pictures and data essential to a project of this sort.

Deepest thanks to Ralph Keirstead, who showed that writing and teaching about an area can be as rewarding as working in that specialty.

Thanks to the students who "came back later" to see their professor when he was home working at the computer keyboard. Special thanks to Gloria Woody, the skilled librarian who oversees the fine Resources Center in the Division of Journalism of the School of Journalism, Media and Graphic Arts at Florida A&M University. Also, special thanks to Greg Toole, reference librarian and computer search whiz at Strozier Library at Florida State University.

Thanks also to supportive administrators and colleagues and to Mrs. Maryann Travis and Mrs. Gertrude Taylor who provided essential support services and fended off intrusions when quiet and concentration were needed.

To Karen Speerstra, Editor, at Focal Press—thanks for her patience and guidance.

Phillip O. Keirstead
Sonia-Kay Keirstead

Tallahassee, Florida
May 1989

TELECOMMUNICATION TODAY—AN INTRODUCTION

1

You are about to begin an adventure. Communication is a trip through one of the most fascinating aspects of modern life. It is also a study of how people deliver messages to other people. Our route will take us on a survey of telecommunication, which is the use of the sound and visual media to convey messages. We will limit our exploration to the telecommunication media, which distribute messages to many people at one time. We will make only passing reference to telecommunication media, which generally convey messages between two or among a few people, using devices such as telephones, telex, and data links.

We have tried to keep our language plain and straightforward. Sometimes we will communicate with you in the same way as an announcer who reads a script in a conversational style. At times we will repeat themes and ideas to emphasize essential information.

Despite our best efforts to keep the language plain, there will be new words and terms. For instance, within this chapter there are new terms such as: *AM* (amplitude modulation, which describes the way a radio signal is transmitted); *FM* (frequency modulation, another way to transmit a radio signal); *cable* (television pictures/sound distributed through an insulated bundle of wires); *satellite* (a device suspended in space which gets its power from the sun and retransmits video, audio, and data signals back to earth from space); *DBS* (direct broadcasting by satellite); *microwave* (a form of radio transmission which distributes audio and video in a horizontal plane); and *multipoint distribution* (using microwave to distribute programs to homes instead of using a cable).

To make learning terms easier, there is a glossary at the end of each chapter.

When you have finished the journey, we hope you will want to know more about the telecommunication media. We would be pleased if you make the telecommunication media your career choice, but even if you become a more informed consumer and perceptive critic, you will benefit from reading this text.

WHAT DO WE MEAN BY TELECOMMUNICATION?

In this book we will concentrate on what used to be called the broadcast media. We will change the term to the telecommunication media because this description more accurately reflects the state of today's electronic media.

At any given moment the telecommunication media are reaching anywhere from a few hundred to many millions of people, often across national boundaries. For example, the Live Aid concert in 1985 for the starving people in Africa reached millions of people around the world with a live broadcast from London and Philadelphia, which included live inserts from the Soviet Union and Europe.

Mass Media—What Is a Mass?

Mass in our terms means a number of people. It can be a very large number like all the people who watch the Olympic Games on television or it can be a small number like the professionals who subscribe to and watch a cable channel which programs only medical news and information. We also use the term *mass media* to describe the means we use to reach groups of people. People get the same message through a distribution system accessible to many and whose message or information is not individualized for each consumer.

Mass Media can refer to a medium that is read, heard, or seen. It can be read on paper or video screen. It can be heard through the air or through earphones. It can be seen on a television set, movie screen, or computer monitor. We will be dealing with mass media transmitted by electronic devices, hence the term telecommunication. Radio stations, radio networks, television stations, television networks, cable systems, cable networks, microwave distribution systems, and direct broadcasts from satellites (DBS) are among the telecommunication mass media we will discover and explore in this book.

Figure 1–1
SBS satellite transmitting high frequency signals for reception within the area of the U.S. covered by the solid white patterns, on antennas (dishes) measuring about 16 feet across. Courtesy of Hughes Aircraft Co.

A radio station serving a community of 15,000 people with general interest programming is a mass medium. So, too, is a television network which may attract millions of viewers during its prime time evening programming.

SPECIALIZED MASS MEDIA

Educational microwave, teletext, subscription television, and pay-per-view cable channels are examples of mass media that attempt to reach a specialized or targeted audience even though the audience may be made up of large numbers of people. The difference is that the target audience

has specific desired characteristics, which sometimes include the willingness to pay extra to gain access to the programming. It may consist, for example, of home gardeners, housewives, or young executives.

Mass media consumers may be reached individually, such as the person who listens to radio on earphones, but the medium, in this case an FM rock station, is targeting not just one listener but a large number of people whether they listen in groups or alone. The specialized mass medium defines its target audience by using a number of devices to encourage consumption by certain people. These methods include charging for use of the medium as Home Box Office (HBO) does with cable viewers, requiring a decoding device to receive a signal, or designing the programming to suit only certain listeners or viewers, as is done by cable services which want to reach only certain groups of professionals. Specialized mass media grew in the 1980s as cable companies laid more wire and more satellites became available to carry specialized programming. The ultimate example of a targeted mass medium is direct mail in which advertising is mailed to addresses preselected according to economic models and previous buying patterns. Cable shopping channels select their audiences by offering only certain kinds of goods as defined by price, style, and quality.

FORMS OF TELECOMMUNICATION

Television

Television has become the telecommunication medium with which most Americans are familiar. More than 98 percent of American homes are equipped with a television receiver. That's approximately 88.6 million households according to 1988 estimated figures compiled by Nielsen Media Research. Yet television as an effective MASS medium is less than 40 years old.

For now we will define *television* as what is transmitted over the air by broadcast facilities transmitting on two bands, VHF channels 2 to 13 or UHF channels 14 to 64, with power in excess of 1,000 watts. Our definition sounds odd, but we are trying to indicate the difference between broadcast television and other systems, which use different frequencies (microwave), lower power (LPTV), wires (cable), or satellite transmissions (DBS). The television station

broadcasts or transmits its signal *through the air*. UHF and VHF refer to the kind of transmission. At the end of 1987 there were over 1,300 television stations on the air. (This does not include 272 Low-Power TV stations, which we will address later.) More than 1,000 of these stations are "commercial" facilities, which solicit advertising to make a profit for their owners. The remainder are noncommercial "public" stations, religious stations, or other noncommercial facilities.

Television is now so important to our lives that it is considered the primary mass medium when advertisers or politicians are making plans to reach large numbers of people. Some of the issues we will discuss in detail include the government's plan to "drop-in" TV stations in certain areas, the growth of the UHF band, the emergence of "independent" TV stations, subscription TV, Low-Power TV, teletext, and telecommunication media, which impact on traditional television broadcasting.

Television Networks

Most of the commercial, and many of the noncommercial TV stations, are tied together by some form of network, which provides high-quality programming from a central source. High-quality programming refers to both the quality of the signal sent out and the description of the content. Networks are groups of telecommunication outlets banded together for a common purpose. The Armed Forces Network is made up of military radio and television stations located on U.S. military bases around the world. The NBC Television Network was comprised in 1988 of 208 member stations, which receive payment from NBC for carrying the commercials within NBC's programs. A network can consist of outlets interconnected by cable (wire), a combination of cable and microwave, or signals from satellites.

Radio

Many Americans don't realize it, but radio is just as pervasive as television. It is difficult to get completely out of range of broadcast radio signals unless you hike into extremely remote, rough terrain. Even then, you would probably pick up a radio signal at night.

At the end of 1987 there were more than 10,244 radio stations on the air in the United

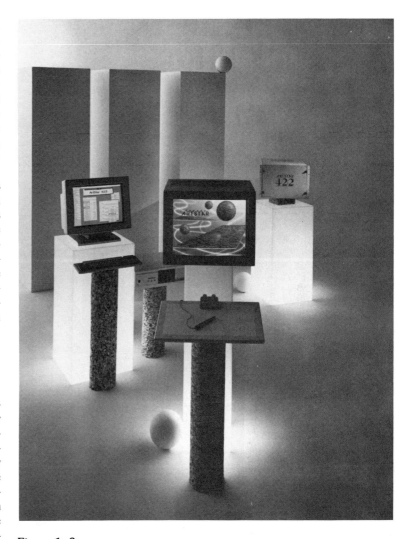

Figure 1–2
Television and computer tecchnology combine to permit a graphic artist to draw on the palette at center front, creating a picture on the screen in the center, which then can be saved and reused thousands of times. Courtesy of Colorgraphics Systems, Inc.

States. Of these, more than 8,843 were commercial stations seeking advertising or subscription support and more than 1,300 were noncommercial or public stations.

Radio broadcasting in the United States is split into two bands: the AM band (540 to 1,600 khz) and the FM band (88 to 108 mhz). One of the historical peculiarities of broadcasting in the United States is the development of two distinct bands for both radio and TV.

In the United States, the broadcast regulatory agency is the Federal Communications Commission (FCC). It must decide whether to authorize

Figure 1–3
Radio reporters and producers are switching from conventional audio cassette recorders to new digital audio portable tape recorders in an effort to raise the quality of a station's sound. Courtesy of Panasonic Industrial Co.

more stations in the already crowded AM and FM bands. Another interesting development is the gradual increase in the number of radio signals carried by cable systems. These are in addition to audio channels, which the cable system may offer from sources other than radio stations.

Radio is primarily a local medium, meeting the peculiar needs of the area served by the radio station, while, in general, television is more of a national medium, which has a heavy dependence on programming originating from distant production centers such as New York or Los Angeles. As a result of its local orientation and the large number of radio stations on the air, radio has become a targeted or specialized mass medium, aiming its programming at a specific segment of the available local listening audience.

Cable

Cable is a shortcut title for a system of transmission, which delivers a number of audio and video signals to homes via a cable or bundle of wires, extensions of which run into the residence, much the same as a telephone wire. Cable originally functioned just to bring on-air TV station signals into areas where TV reception was poor. Later, cable systems acquired the ability to receive signals from satellites locked in orbit 22,300

miles above the earth, thus changing cable from a retransmitter of TV signals to an alternative medium, which could bring nonbroadcast audio and video programming into the home.

Some cable systems originate local programming and others are linked in regional networks, which carry special programming to certain geographic areas.

There are experiments underway to find ways of using two-way cable signals, which come into and depart from the subscriber's residence. One major area being tested involves providing written material on the screen in addition to the usual selection of visual programs.

Another new area is the use of cable systems as a substitute for telephone lines to transmit data from one computer to another.

Multipoint Distribution

Multipoint distribution uses a form of radio transmission (microwave) to transmit programs to receivers mounted on roofs. The programs received are similar to the offerings of cable systems. Multipoint distribution provides a less expensive means to relay signals in areas where reception of microwave signals is easily accomplished because the microwave company does not have to run cables all over town. Instead, a small "dish" antenna is installed on the roof of the subscriber's residence. Another use of microwave is to distribute programming for school systems.

Direct Broadcasting by Satellite

One of the newest entrants into the world of telecommunication is direct broadcasting by satellite (DBS). Programming is beamed up to a satellite, which is "parked" in orbit 22,300 miles above the earth and then is beamed down directly at the viewer's home via a satellite dish receiver without passing through a television station transmitter or a cable system. DBS companies hope to convince enough people to buy special home satellite receivers to make their businesses viable.

Satellites

Satellites are retransmission devices which are playing a major role in reshaping the nature of the telecommunication media. The satellite has provided an economic and flexible alternative

to metallic telephone cable as a means of distributing data, audio and video. By replacing telephone company circuits with satellite transmissions, many of the technical limitations which gave the television networks dominance over local broadcasters have disappeared, making local broadcasting flexible and dynamic. The satellite has caused a massive reshaping of the telecommunication media. This reshaping is not over because telephone companies are now offering an inexpensive land and sea transmission medium called "fiber optic cable." Fiber optic cable uses strands of glass to transmit information-carrying beams of light. The cable is small, weatherproof, and inexpensive to install by burying it in a trench dug by a trenching machine.

THE LEGAL ENVIRONMENT
The United States Is Different

Broadcasting in the United States is unique in relation to the rest of the world for three reasons. *First,* the United States belongs to a minority of nations, which support a major part of their broadcasting system through the sale of advertising time. *Second,* the government does not have direct access to the broadcasting system to influence the populace, except: (1) in times of extreme emergency or (2) as a courtesy to the president when he wishes to broadcast a statement of national importance. *Third,* because the government does not program broadcast stations or networks, broadcast outlets devote more time to entertainment than outlets in many nations. The government does, however, influence broadcasting. Early in the history of American broadcasting, the theory developed that the government should act as the assignor of space in the "frequency spectrum," that invisible inventory of electronic signal space.

The FCC

Under rules established in the Communications Act of 1934, the Federal Communications Commission is responsible for allocating "slots" within the frequency spectrum, based on its own rules, after holding public hearings. The FCC is discussed in more detail in Chapter 3. At various times the FCC has had a direct influence on broadcast programming and operations because of its power to give and take away the right to use the spectrum. In recent years the govern-

Figure 1–4
This is what the SBS satellite looked like in November 1980, before it was launched from Cape Canaveral, Florida. The powerful satellite had two concentric cylindrical solar panels, which telescoped in space from 9 feet to nearly 22 feet high, significantly increasing the satellite's solar power generating capacity. Courtesy of Hughes Aircraft Co.

ment has advocated a lessening of government interference in private business and the FCC followed suit, reducing its direct influence over broadcasting, although its power to grant frequencies remains.

The FCC grants business firms or nonprofit groups a limited right to broadcast on an assigned frequency at a defined power in a certain location for a stated period of time. The broadcast license functions in much the same way a driver's license does, giving certain rights but holding the individual licensee to certain rules and regulations. Before the license period ex-

pires the broadcaster must reapply to continue using the assigned frequency. The FCC also regulates the types of equipment used to transmit a signal and sets standards for the operation and maintenance of the equipment. It also requires broadcasters to file a variety of reports, which are used to verify that the broadcaster is operating within government guidelines. At times these reports have been used as a means to direct certain activities of broadcasters such as the hiring of women and minorities.

The FCC is responsible for defining the role of new technologies within the existing scheme of telecommunication. For many years the FCC was an instrument for the preservation of existing services against competition from new services. This approach has undergone an evolution, and more recently, the FCC has tended to favor letting the marketplace decide whether or not a new technology will survive.

Broadcast Regulations

The regulation of broadcasting creates a problem for broadcast journalists. The U.S. Constitution has been interpreted to provide wide latitude to all media to report/write/show whatever is deemed necessary without fear of government censorship. Although the U.S. Supreme Court has said that freedom of the press applies to broadcasting, the fact that broadcasting is regulated provides some restraints on broadcast journalists.

The U.S. government has the responsibility to provide broad protections to all of the populace. This is referred to as the government's regulatory function. When the government regulates an activity such as nuclear power generation or broadcasting, its role as a rule maker becomes significant. For instance, broadcasters must be aware of copyright laws because most material used has been copyrighted. Telecommunicators have to abide by government job safety rules, equal opportunity (hiring) laws, consumer safety laws, and, if the company is a publicly owned corporation, it must obey the rules of the Securities and Exchange Commission.

Anyone involved in the telecommunication industry must be aware of the regulatory atmosphere in which they work. As a result, we will make frequent reference to laws, regulations, and agencies. Chapter 3 deals specifically with laws, rules, and regulations, and it is important to learn how they will impact on you as a telecommunication professional or as one who is involved with the media.

THE SIGNIFICANCE AND IMPACT OF TELECOMMUNICATION IN THE UNITED STATES

The United States is the most telecommunication-intensive nation in the world. The telephone is so universal we expect to find telephone instruments in most buildings and homes. Television blankets the country and occupies people's attention for several hours each day. Radio offers programming choices in all but a few areas. Cable is widespread. Computers and microcomputers are commonly used in business communication and are becoming popular as household communication instruments.

Businesspeople carry pagers or respond to messages on two-way radios and mobile telephones. Public safety agencies use personal, portable communication transceivers. When the U.S. president travels, he has immediate access to a communications system, which puts him in touch with his key military and civilian aides.

Portable Communication

The U.S. people are a nation of portables. We jog while listening with stereo headsets to portable FM receivers; we go to the beach and watch a ballgame on battery-powered TV sets, and the vast majority of our cars are equipped with radio receivers. Many motor vehicles have two-way radios operating on the citizens' band frequencies, or cellular telephones. Some cars even have TV sets in the backseat.

Newer Technology

Telecommunication companies are spending millions of dollars on new media technology including microwave distribution, direct distribution of programs and data from satellites, high-definition (wide screen, high-quality) TV, cable TV, fiber optic cables, videotape cassettes, and solid-state recording media.

Because the U.S. is a telecommunication-intensive nation, we tend to take for granted our ability to communicate widely and rapidly. The high level of technology available in the U.S. is shared only by the citizens of Canada, Western Europe, Japan, and some of the major urban centers in less advanced nations. During a visit to Jordan in 1983 the authors discovered that

the Jordanian government was proud to have been able to assure each village in the country a minimum of one telephone and one telegraph connection. However, Jordanians who live in the capital city of Amman have many of the telecommunication amenities enjoyed in the United States as well as the ability to watch TV transmissions from three or four other countries.

ISSUES FACING THE TELECOMMUNICATION INDUSTRY

Competition

Competition has been a factor in the U.S. media ever since radio became a regularly programmed service. At first radio competed with newspapers, which had been the dominant medium. Later, TV came along to compete with radio and newspapers. The competitive environment remained static during the 1960s and the earlier part of the 1970s. The three major media—newspapers, radio, and television—found their own niches and, for the most part, they prospered. Then other media began to enter the mix.

Cable TV introduced television signals into communities previously served by one to perhaps four TV stations. The signals were not only competitive, they were often of better quality than the broadcast signal. After a while, cable introduced cable audio, a potential diluent to local radio audiences.

Satellite technology turned cable into an aggressive supplier of programs. Instead of just bringing in existing stations with better signal quality, cable systems began to carry programming designed specifically for them. For some time cable made possible more on-air competition by making independent TV stations economically viable. The satellite also made possible direct delivery of programming to the home without intervention by either the local TV station or the local cable system. Consumers erected their own satellite receivers in backyards to pick up programming normally available only to cable systems and TV stations. Then the cable services began to scramble their signals as a way of enforcing fee payment.

Other consumers bought videocassette recorders (VCRs) and began to "time-shift," that is, recording programs and playing them at another time, thus covering the scheduled program they might have viewed at that time. The popularity of the home VCR has caused the rapid growth of a cassette rental business in which the viewer bypasses both the TV station and the cable system signal.

Various services now provide information to home television sets and home computers in visually transmitted written form. When the home viewer is using this sort of service, he or she is not viewing the on-air or cable TV service.

Daily newspapers have undergone a difficult period of retrenchment and the print media have become increasingly competitive with the introduction of suburban papers, so-called "shoppers," carrying only advertising, specialized papers, and a raft of targeted magazines. All of this material competes for the consumer's time, thus diminishing the amount of time we spend on aural or visual media.

Response to Competition

Despite the competition faced by the media today, there is little to indicate the disappearance of any of the traditional big three—newspapers, radio, and TV. What has happened is that each medium has responded to competition by improving its product, lowering operating costs, raising advertising charges, and doing more intensive research to define its audience. The level of profits common in earlier years may be smaller, but the various forms of mass media continue and coexist.

Part of the reason for this survival is that we have become multimedia consumers. We may glance at a newspaper over breakfast; watch TV as we dress for work or school; listen to the radio while driving to school or job; read a specialized publication during the day (the school paper or our favorite magazine); call up information from a data bank on a personal computer; and then rent a movie to view on our VCR as we return home at the end of the day. Thus the mass media may be less massive than in former years, but the audiences for each of these media can be counted in anything from thousands to millions of people.

Pressure Groups

Because telecommunication is a powerful force in U.S. society, many groups try to exert pressure on broadcasters and other telecommunicators in an effort to curb or mold their programming. A leading example is program-

ming oriented toward children. A number of groups have tried to influence the creative and advertising content of children's programming, especially the programs shown on Saturday mornings by the major networks. One group, Action for Children's Television (ACT), has developed into a highly sophisticated lobbying organization, which has frequent dealings with the FCC, the Federal Trade Commission (FTC), and members of congress.

Pressure is usually applied to the media by using the media. The pressure group will call a series of news conferences usually well attended by reporters from the media the group wishes to curb. (The U.S. media is in the unique position of fostering a free flow of ideas even when some of those ideas may involve curbs on the media itself.) The pressure group will then try to gain support from members of congress and other political leaders. Eventually, the group may try to gain public acceptance of its ideas in the hope that individuals will write letters to editors and speak out against whatever practices are being criticized.

There is no harm in this process. It is a natural outgrowth of the U.S. theory of democracy. Pressure groups make the business environment more challenging for the investors and managers who are responsible for financing and running telecommunication businesses.

Political Pressure

The U.S. political parties work hard to influence the telecommunication industry. The parties use federal regulations governing political broadcasts and political advertising to their best advantage. When the president makes a nationwide appearance on radio, television, and cable, the major opposing party usually jumps right in and demands an equivalent amount and quality of airtime. The final decision usually depends on the networks' interpretation of the FCC's political broadcasting rules and their fortitude in the face of strong and persuasive political pressure.

U.S. presidential administrations have tried on many occasions to reshape the news coverage of the networks and individual broadcast outlets. Richard Nixon's vice-president, Spiro Agnew, created a stir when he attacked broadcast journalists. In a 1970 speech Agnew referred to the news media as the "nattering nabobs of negativism." Over the years several network newspersons have accused their management of buckling under to pressure from Washington.

Conservative and Religious Pressure

More recently, several conservative religious spokespersons tried to accuse the news media of favoring liberal causes and personalities. This became a hot issue during the 1980 U.S. presidential campaign. Within two years the conservatives seemed to lose some of their clout. Four years later conservatives (religious and otherwise) tried a new approach, by attempting to "take over" the U.S. media through stock purchases. One conservative group tried to gain control of CBS Inc.

Deregulation

The FCC grew to be a strict regulator of the broadcast industry in the years after World War II. The theory of strict government regulation of broadcasting began to be modified during the Carter administration (1976–1980). With the arrival of President Ronald Reagan in 1981, the government began a gradual move in the direction of reduced government involvement in the activities of regulated businesses. Limitations were removed on the broadcast, telephone, trucking, and airline industries.

At the same time, the FCC began to study many of the rules it had promulgated since 1934. Outmoded or unnecessarily restrictive rules were deleted and others were restructured to give broadcasters more latitude in how they conducted their businesses.

Deregulation has had several important effects on the industry. Changes in the rules requiring licensing of engineers and technicians have eliminated a number of jobs and lessened the pay scales of other technical employees. This has meant financial savings for management, but it has caused great concern among engineers and union leaders. Many of the record keeping rules of the FCC have been modified, eliminating considerable expensive clerical work. The FCC lightened its pressure on broadcasters to employ women and minorities. The effects were not as dramatic in this area, but personnel specialists have noticed a diminished drive to hire by Equal Opportunity categories. In 1989, the FCC began to reapply equal employment pressure on broadcast and cable companies.

Another major reform was a move to permit multiple-facility owners to own more stations. Regulations that limited a single company (or individual) to owning no more than 7 AM, 7 FM, and 7 TV stations were lifted. A single

company now can own a combination of as many as 36 radio and TV stations.

THE MAJOR PART OF TELECOMMUNICATION— BROADCASTING

Broadcasting, for our purposes, means transmitting intelligence via radio waves traveling through the air, for reception by electronic receivers (either radio or TV). The electronic receivers when activated (turned on) convert the electronic signal to sound and pictures with the intent of having the signal received by anyone who has the appropriate reception equipment and wishes to monitor it. Broadcasting is divided into radio and TV. Radio in the United States is subdivided into short-wave, AM, and FM. TV is subdivided into VHF, UHF, and Low-Power.

Radio

AM Radio

The name of the medium wave band, AM (amplitude modulation), indicates the modification of electric signal strength. This oscillation of an electrical current is varied to encode information on the radio signal. The radio signal is transmitted on a carrier wave. In the United States AM stations are found between 540 kilohertz (khz) and 1600 khz on the radio dial (1 khz equals 1,000 hertz; a hertz is a frequency of 1 cycle per second). AM radio was the first form of broadcast radio invented. Two main characteristics of AM are its propensity to have static (especially during electrical storms) and its lack of fidelity (the range of sound that can be transmitted). AM radio was firmly established before better methods of transmission were discovered, and the basic means of broadcasting in the United States remained AM radio until late in the 1970s.

FM Radio

FM radio was developed from experiments started in 1924 by Edwin H. Armstrong. FM (frequency modulation) signifies varying the frequency of the carrier signal. Armstrong was anxious to eliminate the static, which accompanied AM radio reception. His work resulted in a system that is almost static-free and that has a frequency range comparable to the stereo disc played on a hi-fi (but not as good as a compact disc). FM

Figure 1–5
Standard (AM) band extends from 535 khz to 1605 khz. AM stations are assigned within this band in 10 khz steps, beginning at 540 khz.

A

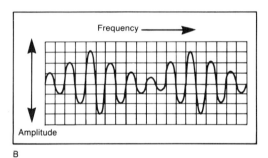

B

Figure 1–6
Modulation means using an audio-frequency signal—music or voice, for example—to change (or *modulate*) the radio-frequency (RF) signal produced by the transmitter. (A) An unmodulated RF signal is called the *carrier*. (B) AM, or amplitude modulated, carrier. The frequency remains constant, and the amplitude changes.

stations are found between 88.1 mhz and 107.9 mhz (millions of cycles per second) on receiver dials. Incidentally, in the United States the FM band is squeezed between TV channels 6 and 7 in the frequency spectrum. *Frequency spectrum* is a term used to designate different groups of radio frequencies. Low frequencies such as AM radio have longer radio waves than higher frequencies such as TV.

Short-Wave Radio

Short-wave broadcasting is a method of radio transmission used when it is desirable to send

Figure 1–7
The FM band extends from 88.1 mhz to 107.9 mhz. The first channel is 88.1, and stations can be assigned from this point onward each odd decimal number, 88.3, 88.5, etc.

A

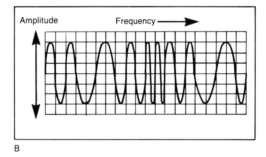

B

Figure 1–8
(A) An unmodulated FM (frequency modulation) carrier. (B) When an FM carrier is modulated, the amplitude is constant and the frequency changes.

intelligence over great distances using high-frequency signals. It relies on a phenomenon in which certain radio waves reflect back to the earth when they strike the ionosphere layer of the earth's atmosphere. Short- or high-frequency waves have the property of reflecting back to the earth over long distances. Short-wave radio comes between AM radio and TV in the frequency spectrum (3 to 30 mhz). Short-wave is used primarily for international broadcasting. The U.S. government transmits international programs prepared by the Voice of America over short-wave transmitters placed around the United States and in overseas locations. Short-wave signals tend to be better for voice than music and are affected by the nature of the earth's atmo-

sphere at the time of transmission. Thus, most international short-wave stations broadcast on a number of different frequencies, depending on the time of day of the transmission and the area of the globe to which the broadcast is aimed.

There are commercial and nonprofit short-wave radio stations based in the United States. Their objective, however, is to reach overseas audiences. If they had desired to reach domestic U.S. audiences, they would have elected to use AM or FM transmission systems. The Voice of America is, by law, prohibited from targeting its programming to U.S. audiences because it is a government propaganda medium. However, in the United States you can listen to VOA's overseas broadcasts on a short-wave receiver, as well as dozens of signals aimed at the United States by nations around the world.

You might wonder why so many countries aim short-wave signals at the United States when so few Americans listen to short-wave. Some countries do it because they want to reach Americans who have come to the United States from their country and who are still interested in events in their native land. Others, such as the Soviet Union, have almost no other choices if they want to reach anyone in the United States with a propaganda message.

Television

Television is, in engineering terms, a form of "radio" transmission. To transmit a television picture with all of its allied information, a wider section of the frequency spectrum (6 mhz) had to be set aside for each television transmission. The need for more room on each transmission frequency caused regulators and engineers to choose a higher frequency range, which had not been fully developed, as the location of the TV frequencies. This was named the Very High Frequency Band (VHF). As television transmission engineering reached new levels of technical sophistication, another band was set aside, the Ultra High Frequently Band (UHF). The VHF and UHF bands are separated from each other on the imaginary line called the frequency spectrum.

Television in the United States is thus divided into two categories, the VHF and UHF bands. VHF broadcasting came first on channels 2 through 13. The word channel represents a specific frequency (just as a radio station would be on a frequency of 1450 or 93.7), but it became easier to designate the TV frequencies by chan-

Figure 1–9
This computer-enhanced TV weather map was created from a black and white National Weather Service picture, taken by a GOES weather satellite. Satellite transmissions take place at extremely high frequencies, which are measured in *gigahertz,* or billions of hertz. Courtesy of Colorgraphics Systems, Inc.

nel numbers. For example, channel 4 takes up 6 mhz of frequency space from 66 mhz to 72 mhz. There was a channel 1 in the earliest days of television, but it proved unsatisfactory for television transmissions and was dropped. The VHF band is interesting because it is really two bands. The lower part contains channels 2 through 6, then a section of the spectrum is set aside for FM radio, and further up the spectrum the VHF band resumes with channels 7 through 13.

Engineering refinements opened up the UHF band, which is designated as channels 14 through 83. Although the band goes up to channel 83, broadcasters are currently using only channels 14 through 69. There is a big jump in frequency between VHF channel 13 and UHF channel 14 even though the number are adjacent. This is because the space in between is assigned to other types of transmissions.

In 1980 the FCC authorized a new television service, called Low-Power TV. Low-Power TV stations can be assigned to any VHF or UHF channel not in use in the area as long as they don't cause interference to nearby TV stations. Some industry leaders are using the phrase *Com-*

Figure 1–10
Setting the slab section for a 2000-foot high tower for KTVE-TV in El Dorado, Arkansas. Photograph by S.G. Communications; courtesy of Stainless, Inc.

munity TV to get away from the image of weakness implied by the word *low-power*. Low-Power TV (LPTV) stations operate with only a minute fraction of the power employed by regular TV stations. LPTV stations operate at either 10 watts on a VHF channel or 1,000 watts on a UHF channel. Regular VHF TV stations transmit at power maximums of 100,000 to 316,000 watts (depending on the channel number) and normal power UHF stations can employ up to 5 million watts in their transmissions.

and business challenges to accompany each telecommunication innovation.

During your working lifetime many fields of employment will change dramatically. Automation is having a significant impact on manufacturing. Service industries are replacing the "smokestack" industries as major employers. Jobs and professions grow and then decline.

However, the need for improved communication continues to grow, as does the desire for entertainment and information. The context or setting of your work may change, the technology will change, but the ability to translate ideas into images will be in demand.

SUMMARY

The telecommunication industry today is vastly different from what it was in the mid-1970s and different, too, from what it will be in the 21st Century. Cable has become a major force as an independent program source. Many nonnetwork affiliated TV stations are financially viable, and the U.S. government has introduced a new type of TV station, LPTV. In addition, the FCC is "shoehorning" in new AM, FM, and TV stations, providing more competition in local markets.

The networks, which once overwhelmingly dominated TV, are finding that they have to compete with cable networks and independent station networks for the prime time audience. Network radio, which nearly died in the late 1940s and early 1950s, after television began to grow, has returned, and today there are many more networks available than there were during the pre-World War II heyday of the radio networks.

The pervasive quality of U.S. telecommunication facilities creates opportunities for mass persuasion by private individuals and businesses, which are not available in other countries. Conversely, in the U.S. we have access to information via the media that would be unavailable in many countries. The pervasiveness of the American media raises questions of responsibility, restraint, and concern over who controls the media.

We probably have not seen the end of the technologic changes fragmenting the telecommunication audience. Ingenious people will discover other ways to use electromechanical energy to reach into people's homes and automobiles. The changing nature of the telecommunication business makes the future exciting. New job opportunities will be created, there will be creative

GLOSSARY

ACT (Action for Children's Television) An organization which seeks to improve the quality of children's TV programs and the advertisements within these programs.

AM (Amplitude Modulation) Putting information on a vibrating electrical current (carrier wave) by changing the amplitude or amount of energy imposed on the carrier.

Carriers The vibrating electrical wave carrying the information, which becomes a radio or television transmission. A broadcast transmitter emits a carrier wave when it is turned on, even if no information is imposed on the signal.

DBS (Direct Broadcast by Satellite) A satellite suspended 22,300 miles in space retransmits a signal to the earth for reception directly by the consumer.

Equal opportunity The U.S. governmental policy of making employment available equally to people regardless of gender, race, religion, creed, or handicap.

FCC (Federal Communications Commission) U.S. government agency charged with regulation of broadcasting and other areas of telecommunication.

Fidelity The degree to which an electronic device accurately reproduces its effect.

FM (Frequency Modulation) Changing the frequency rather than the amplitude of the carrier wave.

Frequency Where stations or allocations may be found on the broadcast band. Also, the number of waves (vibrations) per second produced by an electromagnetic emission.

Frequency spectrum The range of frequencies; usually illustrated by a horizontal straight line, with low frequencies on the left and high frequencies on the right.

Hertz One cycle per second. The location of a type of emission along with frequency spectrum is described in terms of hertz. Named after early radio theory scientist, Heinrich Hertz.

Independent A broadcast facility not affiliated with a network.

Ionosphere Atmospheric belt around the earth, which reflects AM radio signals at night when the belt cools and settles nearer to the earth's surface.

Low-Power TV (LPTV) VHF TV stations transmitting with no more than 10 watts and UHF TV stations transmitting with no more than 1,000 watts, designed to serve small areas. This class of stations is less heavily regulated than full-power stations. Also called **community TV.**

Microwave A short electromagnetic wave used to transmit data, audio, and video.

Multipoint Reaching many targets.

Network An interconnected service with the majority of its programming originating from one location, which provides programming at precise times to a number of stations, called *affiliates.* The affiliates may be paid in cash or with programming provided at no cost by the network. Syndicated networks charge the affiliates for their service.

Satellite Retransmission device, which is launched from the earth and travels in an orbit 22,300 miles above the equator to receive and return signals from and to the earth.

Short-wave High-frequency radio transmission system noted for coverage over great distances.

Solid state Electronic device that uses solid materials in the transmission of a signal.

Teletext Method for transmitting alphanumeric (written) material within an existing television signal. Textual information encoded in a broadcast TV signal (and some cable signals), which once decoded can be read as "pages" of text on TV screen.

Time shift Receiving and storing programming for playback at another time.

UHF (Ultra High Frequency) A transmission on the high end of the television band designated by the channels 14 to 83. UHF bands are also allocated to two-way radio communication.

VCR (videocassette recorder) Usually a consumer level videotape record/playback unit.

VHF (Very High Frequency) Used to designate TV signals on channels 2 to 6 and 7 to 13.

Videotex Text service, usually two-way, fed by cable. It has greater flexibility and capacity than broadcast teletext.

TELECOMMUNICATION YESTERDAY— A HISTORY

2

Broadcasting wasn't around when Og, the cave-man, slipped out of his cave in search of a mastodon sandwich. Broadcasting as we know it came into being between World War I and World War II. It evolved from early experiments with electricity. The telegraph, the telephone, and finally, the wireless telegraph all were precursors of radio, television, cable, and satellite broadcasting.

WHY WIRE COMMUNICATION WASN'T ENOUGH—THE TELEGRAPH

Electrical communication by wire, using the telegraph, appeared in England in the 1820s. It sent meaningful communication over wires by using combinations of short and long bursts of electrical energy to represent letters of the alphabet. The electrical energy was read by the human ear as short and long bursts of sound. The message was encoded using a telegraph key at the sending point and was decoded by a trained operator who listened to a sound producing device at the receiving point.

However, it was an American, Samuel F.B. Morse, who turned this invention into a commercially viable system. Morse conducted developmental experiments in the 1830s. By 1844 he demonstrated the commercially viable telegraph by sending messages between Baltimore and Washington, D.C.

The telegraph caught on rather quickly, although it was far from a common man's device. It was necessary to take a tightly worded message (to save cost) to a telegraph office where it would be laboriously spelled out, letter by letter in Morse code. On the receiving end, a telegraph operator had to decode the message, write it out, and then have it delivered. Telegrams were not inexpensive forms of communication, although they significantly lowered the time involved in sending messages. Telegraph service

was highly vulnerable to disruption due to weather or having lines cut.

The telegraph could only transmit messages to places where lines had been strung. This meant that many areas were still without means of rapid communication.

The desire for improved means of communication coincided with the Industrial Revolution in Europe and America in the first half of the 1800s. With the increase in productivity brought on by the Industrial Revolution, manufacturers had to find new markets for their goods. The need for efficient communication increased as sales representatives set up office in distant cities. They needed to communicate orders and shipping information quickly.

There were many other demands for faster communication. The United States was growing as the great migration to the West began. Up until then, people had been willing to rely on sending written messages by mail or courier. Imagine how long it took letters to reach some distant points, such as California, when a ship leaving New York had to sail around South America to reach the West Coast.

The far-thinkers of the mid- and late 1800s envisioned a means of communication which would allow people to talk with each other over long distances without wires.

FROM TELEGRAPH TO TELEPHONE

While Morse and others were giving us telegraphic communication, Alexander Graham Bell was about to make a revolutionary change in the world's communication system. Bell was working on a device which would transmit the human voice!

Consider the difference between sending a written message you have edited to its minimum length to reduce cost, and being able to have a two-way telephone conversation with someone! Bell demonstrated his telephone at the Phila-

delphia Centennial Exposition in 1876. Bell not only showed that a human voice could be transmitted by wire but that conversations could be carried on. Bell also invented the microphone, which is an integral part of any broadcasting system. By the third quarter of the 1800s we already had two significant parts of an electronic communication system in place, the telegraph and the telephone.

Maxwell's Electromagnetic Waves

In 1864 a Scotsman, James Clerk Maxwell, developed a theory of electromagnetism. In 1873 he published a paper, which theorized the existence of electromagnetic waves. Remember this because it is one of the reasons that we have MTV today.

Hertz

In Germany Heinrich Hertz, in an 1887 experiment, applied Maxwell's theory, thereby proving that Maxwell's electromagnetic waves did exist. He did this by actually generating the waves. Formally, people call radio waves "Hertzian Waves." The symbol Hz for hertz is used to designate a frequency. A hertz is 1 cycle per second, and it is used around the world to describe the frequency of radio waves. In Chapter 1 we found out that we can use prefixes in front of hertz to represent thousands (kilohertz), millions (megahertz), and billions (gigahertz). When we talk about where to find a radio or television station on the dial we are really talking about its frequency. New York's WBLS is on 107.5 mhz, Chicago's WLUP is on 97.9 mhz, Houston's KKHT is on 96.5 mhz, and Los Angeles' KPWR is on 105.9 mhz. The expression *on a frequency* refers to the frequency used to broadcast the electrical signal.

Marconi

Maxwell provided the theory, Hertz proved the theory correct, and Guglielmo Marconi produced the first wireless telegraph or radio. Marconi was more of an inventor than a scientist. Growing up in a wealthy Italian family, Marconi experimented with ways to transmit and capture Hertzian Waves. In 1895 he demonstrated to friends and family members that he could send a telegraph signal without wire through or over

a hill. A key element of Marconi's device was his antenna.

The Italian Ministry of Post and Telegraph turned down an opportunity to try Marconi's device, so Marconi went to Britain. In 1897 Marconi received a British patent for his "wireless." A group of English investors backed Marconi, forming the Wireless Telegraph and Signal Company.

By 1899 Marconi had demonstrated the effectiveness of his wireless over longer distances, including sending a signal across the English Channel.

Some of the experiments involved transmissions from ship to shore. These experiments aroused the interest of the British Royal Navy, which needed a better means of communication between its ships as well as between the fleet and the Admiralty Headquarters.

In 1901 Marconi astounded people by transmitting the Morse Code letter "S" from Cornwall in England to a receiving antenna held aloft by a kite in the Canadian province of Newfoundland. The distance covered by that transmission was in excess of 3,000 miles.

Other Early Names

Other people were also trying to unlock the secret of wireless transmission. *Adolphus Slaby* in Germany worked on developments, which led to the founding of the famed Telefunken Company, a major name in professional and consumer electronics. In Russia *Alexander Popov* experimented with the elements of radio transmission.

A number of early experimenters exceeded Marconi in their progress, but fate prevented their work from attaining fame. *Dr. Mahlon Loomis* sent what he called intelligible signals between two Virginia mountains as early as 1866, and he received a telegraph related patent in 1872. Professor *Amos Dolbear* of Tufts College in Massachusetts patented a wireless telegraphy device in 1886. *Nathan B. Stubblefield* was said to have broadcast voice transmissions over short distances as early as 1892, but he ended up fighting a number of court battles over his invention and died of starvation in a Kentucky shack in 1928.

Fessenden

One of the major contributors to early radio development in North America was *Reginald A.*

Fessenden. He was a Canadian who had worked with Thomas Edison and the Westinghouse Company in Pittsburgh before becoming a professor of electrical engineering at today's University of Pittsburgh.

Fessenden had a theory that radio waves should be sent out as continuous waves with the voice superimposed. Marconi had sent them as interrupted waves much like the telegraph signals. Fessenden applied his theory using his own devices in 1901 and 1902. Later Fessenden went into business with two partners, called the firm the National Electric Signaling Company, and moved his laboratory to Brant Rock, Massachusetts.

Fessenden commissioned the General Electric Company to build an alternating-current generator. The man assigned to the project, *Ernst F.W. Alexanderson,* had studied radio theory under Slaby in Germany. Alexanderson's name was given to the AC generator, which became known as the Alexanderson Alternator. In 1906 Fessenden succeeded in transmitting voice to listening ships' radio operators. It's said one of his later broadcasts that year was heard by ships sailing the West Indies. The United Fruit Company became interested in Fessenden's transmissions and soon outfitted its ships plying Caribbean waters with Fessenden radio equipment. While Fessenden was working to transmit voice messages, Marconi's company was rapidly installing its wireless telegraph equipment on ships. Marconi was more interested in achieving great distances with his radio/telegraph signal than he was in voice transmission.

de Forest

Another of the early participants in the race toward developing voice radio was *Lee de Forest.* In 1899 de Forest received his PhD from Yale, experimented with voice transmission, and became part of a radio development firm, the de Forest Wireless Telegraph Company in New York. De Forest equipment was tested and sold to ship owners. He improved on the design of the vacuum tube, which he called the "Audion" and successfully demonstrated it in 1907.

De Forest lost his investment to a stock manipulator but retained his valuable patents. Further experimentation led him to demonstrate his transmission equipment in New York City in 1910 by broadcasting a performance of the Metropolitan Opera. Reception of the broadcast was impaired by interference from other transmitters operating on the same frequency. Interference by transmitters operating on one frequency soon became a major problem.

1934 *1942* *1951* *1959* *1967* *1975* *1985*

Figure 2–1
The "shrinking" of the early radio tube into today's micro-chip. Courtesy of Schott Electronics, Inc.

Herrold

By 1909 *Charles D. "Doc" Herrold* had started a College of Engineering, which had an experimental radio station in San Jose, California. Some people regard Herrold as the nation's first newscaster because he used to fill time by reading the newspaper over the air. His early experimental station eventually became KCBS, the CBS owned and operated radio station in San Francisco.

The *Titanic* and Sarnoff

On her maiden voyage in 1912, the supposedly unsinkable ocean liner *Titanic* struck an iceberg and sank in the North Atlantic. The ship's wireless operator kept transmitting a call for help. These transmissions were heard at great distances. The *Carpathia* responded and succeeded in saving some of the women and children who had been set adrift in the liner's lifeboats. *David Sarnoff,* a young Marconi wireless operator assigned to the Wanamaker store in New York, first received a wireless report of the tragedy, established contact with the S.S. *Olympic,* which was approximately 1,400 miles away from New York, and relayed the *Olympic*'s reports of the *Titanic* tragedy to members of the New York press. President Taft ordered all other radio stations in the United States off the air so that the Wanamaker station could communicate with the *Olympic.* Sarnoff stayed at his post for 72 hours relaying the information to anxious New Yorkers who gathered at the Wanamaker store. He then went to another telegraph station, Sea Gate, where he communicated with the *Carpathia,* obtaining the names of survivors. The *Titanic* tragedy pointed out the importance of the wireless, and the Marconi company became a leading force in the wireless telegraph business. Sarnoff later rose to the top post at RCA, which owned NBC.

One story told about Sarnoff is that in 1916 while he worked at Marconi he wrote a letter to the president of American Marconi, suggesting that radio could become a "household utility" by placing a "Radio Music Box" in the family's living room or parlor. His superior rejected Sarnoff's rash proposal.

Crystal Sets

By the time World War I arrived, the airwaves were filled with experimental and amateur transmissions, often received on rudimentary "crys-

Figure 2–2
David Sarnoff, telecommunication pioneer and, later, head of RCA.

tal" receivers by curious youths. A crystal receiver could be made by winding a coil of wire around a stiff round Quaker Oats hot cereal box. A piece of galena, silicon, or iron pyrite, called a 'crystal," was used to pull the signal out of the air. The listener would move a thin wire over the crystal until a radio signal was detected in a pair of earphones that were connected to the rudimentary receiver. The crystal receiver was crude, but it was cheap, and so many people began to make a hobby of building receivers and listening to those early radio transmissions.

RADIO AND BIG BUSINESS

The American division of the Marconi Company grew increasingly powerful, while companies started by Lee de Forest, Fessenden, and others fell by the wayside.

Marconi's challenger turned out to be American Telephone and Telegraph (AT&T), which had already become a wealthy and powerful firm. AT&T eventually surpassed its original competitor, Western Union (the telegraph company), and for a time owned Western Union until the government forced AT&T to divest itself of the telegraph company.

An incident during World War I brought two new competitors on the scene. General Electric

and Westinghouse, manufacturers of light bulbs, were asked to make vacuum tubes and radios for the armed services. The vacuum tube experience aroused the companies' interest in radio.

During the war major technical steps were made, such as development of relatively small "trench radios" and construction of a 200,000-watt transmitter for the Navy at New Brunswick, New Jersey, which was used to broadcast President Wilson's "Fourteen Points" call for peace. The 200,000-watt transmitter, built by Alexanderson, was powerful enough for its signal to be heard all over Europe.

RCA

Powerful industrial interests who had become involved in radio during World War I entered the competition as radio emerged from its experimental stage following the war.

In 1919 *Owen D. Young* created the Radio Corporation of America (RCA). Young had been the General Counsel for the General Electric Company (GE). By the time the war was over, Young was in a position of great influence within GE. He saw the potential of broadcasting as a business when the parent firm is a large electrical manufacturing company. Young forced American Marconi to transfer its assets to RCA because Young was able to suggest that the Navy would not return facilities it had seized during the war to a British-owned company. Using his government contacts and Marconi's facilities, Young created an instant monopoly for RCA in radio telegraphy. Young became the chairman of RCA.

An Industrial Alliance

The next step was an alliance consisting of American Telephone and Telegraph, General Electric, and the Radio Corporation of America. They agreed to share patents they owned, making it possible for them to manufacture various pieces of radio equipment. The companies also agreed that each would have special areas of interest. GE and AT&T also bought stock in RCA.

While the giants of industry were making arrangements to control the manufacture of radio equipment and stake a major claim in the transmission of radio signals, thousands of amateurs were experimenting with transmitters and receivers. Many of these amateurs were inventors who contributed to the development of radio. Some worked for major electrical manufacturing

firms and others were acquiring skills they would put to use as the owners of broadcast stations. Soon serious work was begun by researchers working for universities and manufacturing companies on voice and music transmission by radio.

University of Wisconsin

Scientists at the University of Wisconsin began regular broadcasts of weather bulletins in 1921. Detroit News publisher William E. Scripps set up a radio transmitter in a file room at the newspaper in 1919, and his staff experimented with radio programming and measured audience reaction.

Westinghouse

The Westinghouse Electric and Manufacturing Company acquired key patents, including Edwin H. Armstrong's superheterodyne circuit, which was needed for amplification. Westinghouse had developed the capability to manufacture radio equipment during World War I and wanted to put the investment to use in the civilian population once the demand for military products subsided.

While the top echelon at Westinghouse was wrestling with corporate problems dealing with moving into the civilian marketplace, a Westinghouse employee named Frank Conrad succeeded in assembling broadcasting equipment in his garage in Wilkinsburg, Pennsylvania, where he was broadcasting regularly, using the experimental call letters 8XK. Several Westinghouse employees pitched in to help with his experiments aimed at testing the point-to-point capabilities of radio. After a while, a Pittsburgh department store ran a newspaper ad offering to sell receivers to be used to listen to the Conrad broadcasts. At this point Conrad's superior at Westinghouse suddenly had the thought: instead of concentrating on transmission equipment, why not sell receivers? It was decided to put the station on a regular schedule, and advertise the broadcasts in the paper so people would know when to listen. What would they listen on? Westinghouse receivers, of course! November 2, 1920, election day, was chosen for the kickoff of the new service.

KDKA

The U.S. Department of Commerce assigned the call letters KDKA to the new station.

After its much-publicized success reporting the Harding-Cox election, Westinghouse shipped transmitters to its factories in Newark, New Jersey; Chicago, Illinois; and East Springfield, Massachusetts and broadcasts were begun from those locations. Soon the demand for receivers became apparent and department stores established radio departments to sell the new receivers.

At this point Westinghouse was invited into the consortium with GE, AT&T, and RCA thereby gaining the right to use the pool's patents. The other electrical equipment firms recognized Westinghouse's early success in establishing a broadcast station and its control of some key patents on components. None of the manufacturers could successfully stand alone because they needed access to components for which the other firms had patents. GE and Westinghouse became the largest shareholders in RCA with AT&T and the United Fruit Company holding somewhat smaller lots.

General Electric

Receivers and parts were to be made by GE and Westinghouse, marketing of the receivers would be done by RCA, and AT&T would sell transmitters and would have sole involvement in telephony, either by radio or wire. They left one loophole: none of the companies limited sales to amateurs and many of their patent agreements with inventors did not provide for restrictions on amateurs. Soon the amateurs began to assemble receivers and build transmission stations.

Westinghouse's success caused leaders of the other three firms to rethink their business strategy, and each began to look at broadcasting as a possible investment. During the same period Westinghouse people were running another "experimental" station, WJZ, from their factory in Newark, New Jersey. It began to attract actors and singers, thus performers got their introduction to radio, which was to eventually revolutionize the performing world.

Radio Stations

By 1922 broadcasting stations were popping up all over the country. The Bamberger Department Store put on WOR in Newark, New Jersey; *The Detroit News* operated WWJ; Westinghouse put on KYW in Chicago. The airwaves were becoming crowded with competing signals. The matter of choosing a frequency was complicated by weak regulation from the U.S. Department of Commerce plus an unusual arrangement under which the government reserved 485 meters (in those days frequencies were expresses in meters, rather than kilohertz or megahertz) for weather and government reports. Stations would switch to 485 to give the weather, and then return to another frequency. Listeners ended up chasing their favorite stations around the dial. Listeners were further confused by agreements between stations which permitted time-sharing on the same frequency.

During the 1920s broadcasting was operating under the Radio Act of 1912, a weak regulatory statute. Newly appointed Secretary of Commerce Herbert Hoover became concerned about the interference issue and called together leaders of the young industry and representatives of the government and congress. The meeting is referred to as the first Washington Radio Conference because it was to become the first of several radio conferences.

Early Radio Advertising

During this period there was no clear-cut movement to have advertising on radio; there was in fact much opposition to it. The situation was further complicated when AT&T decided to enter the radio business. The telephone company

Figure 2–3
1924 antenna of WCAL (previously 9YAJ) at St. Olaf College in Northfield, Minnesota, the nation's first listener-supported station. Courtesy of WCAL, St. Olaf College, Northfield, Minnesota.

planned to build transmitting stations around the country and then charge people who wished to buy blocks of time to broadcast over them. The concept was called "toll broadcasting." It was designed to be similar to renting a telephone line or making a long distance call. The program producer was paying the telephone company rent on the facilities for a period of time. Today in the United States the commercial broadcasting concept calls for the broadcaster, in most cases, to control the programming and the facilities and sell advertising insertions within and between programs. The development of this type of advertising, called spot advertising, has left the program content and production in the hands of the station or network. Today the broadcast industry frowns on leasing periods of time to outside people or companies which take total responsibility for both the program content and advertising content during a certain period of time. There are exceptions, however. Some stations which program in foreign languages, some religious format stations, and many public broadcasting stations essentially relinquish everything except final oversight when they sell or lease periods of time to certain groups, which then program the segment and sell the advertising running in the program. Public stations carry no advertising but may identify a program's "sponsors."

Ironically, the telephone company made trouble for itself because its Western Electric division manufactured radio transmitters. Early broadcasters were buying Western Electric transmitters, while the AT&T branch was telling them it would be better to rent time on the existing transmitters of AT&T.

Another irony of the telephone company venture was that its radio station, WEAF in New York City, was attracting customers who bought blocks of time to advertise.

The AT&T stations broadcast sports events directly from the stadiums and opera concerts from opera halls using telephone lines. While the telephone company was using its lines to do these out-of-studio or *remote* broadcasts, it was systematically rejecting requests for remote lines placed by other broadcasters. This restricted the possibility of building networks.

Herbert Hoover

Amidst the increasing chaos caused by technical experimentation, more stations broadcasting, and monopolization by the giants, Herbert Hoover called his second Washington Radio Conference

in March 1923. Although Hoover's series of conferences individually yielded little substance, they set the groundwork for the Radio Act of 1927, which was to be the first strong law regulating broadcasting.

Radio Programming

What were people listening to in the early and mid-1920s? Mostly music, drama, and soap operas. Much of the music was performed live. There was a great deal of classical music, but broadcasts by popular performers including black musicians were also part of the fare. The black performers brought blues and jazz with them, and radio popularized their art form.

Some radio stations played recordings, but the quality of records in those days was poor; consequently, recorded music was not much used. If you have ever listened to an old 78 record on a wind-up Victrola, you will understand why live music was preferred to recordings. Many performers were willing to sing or play free just for the publicity. Some companies provided musical and dramatic programming free to radio stations just for the mentions they received during the program. One of the early programs was the Eveready Hour, sponsored by a battery company.

This informal programming, which depended on artists dropping in, was not to continue. Soon the performers, their agents, and the musicians' union began to realize that broadcasters were getting something for nothing.

By 1924 the American Federation of Musicians had become involved in the matter of broadcast performances. The union began to demand that its members be paid for appearing on radio. This idea was not popular, because many radio stations were still being subsidized by their owners. Broadcast station managers began to look at alternatives. Fortunately, an alternative had been developing parallel to the use of live musicians. The alternative was drama. There were instances of plays being broadcast from theaters, but because this meant possible lost revenue to the theaters if people stayed home and listened to the radio, this approach to programming never took off. Some stations were experimenting with studio drama, using both paid and unpaid talent.

News

There was some news on radio during the 1920s. The news consisted of information taken from

the news agency Teletype reports, newspapers, and magazines. In addition, a small number of "commentators" were beginning to be heard. These "commentators" frequently worked for newspapers and presented a mixture of news and discussion about the day's events, hence the term "commentator." The commentators' broadcasts served a function similar to the editorials which appear in a newspaper.

Kaltenborn

One of the famous news broadcasters of the 1920s through the 1940s was H.V. Kaltenborn, who was an editor at the *Brooklyn* (New York) *Daily Eagle*. He began broadcasting in 1921 over WEAF in New York. Kaltenborn was put off the air by AT&T's management after he criticized the U.S. Secretary of State, causing many agonizing moments for telephone company executives who were responsible for WEAF. He soon returned to the air, broadcasting first over WAHG in Brooklyn and later over WOR, Newark. During World War II many people relied on Kaltenborn to explain the war to them.

Linking

Radio in the mid-1920s lacked the smooth precision of today's broadcasting. Stations would sign off the air when the volunteer performers failed to appear. Dramas were not presented on a regular schedule, and news commentators were subject to removal if they angered important people. A solution to the problem of creating sufficient programming at reasonable cost was in the works. It involved linking several stations together and producing a top quality program in one location which the stations could share at considerably reduced cost. The system was called "networking," and it was done by linking the stations by telephone lines.

Sports

Sports programming had great appeal, and soon broadcasters were covering sports events direct from stadiums. In the fall of 1922 the World Series was networked over WGY in Schenectady, New York, and WJZ in Newark, New Jersey. In early 1923 WEAF in New York was linked by phone line with WNAC in Boston. Later that year the owner of WMAF in South Dartmouth, Massachusetts, contracted with AT&T to have a telephone line installed so he

Figure 2–4
The early days of radio—WGAR radio welcoming competitor WJW radio to Cleveland. Note the Western Union clock on the wall, the standard broadcast clock for decades!

could rebroadcast the programming of WEAF. Later WJAR in Providence, Rhode Island, was added to the circuit. By late 1923 AT&T had linked seven stations into a network to broadcast a presidential speech.

AT&T's "Network"

All of these ventures had involved direct participation by a station owned by the telephone company. However, AT&T would not lease its lines to other broadcasters. RCA and GE experimented with networking via Western Union telegraph lines, which were designed to carry

Figure 2–5
Making sound effects at the studios of WGY radio in Schenectady, New York.
Courtesy of General Electric Co.

dots and dashes, not the human voice, and the signal was not satisfactory.

During 1923 and 1924 AT&T was renting its transmitting facilities under the toll broadcasting concept. The telephone company began to make money from broadcasting in 1924. Businesses were leasing time on the AT&T stations to present programs which only related to their products or services in a general way. Sometimes all a business would get would be a mention of its name in conjunction with the content of the program. Direct selling was thought to be in bad taste.

Advertising

By 1925 non-AT&T stations were beginning to actively sell commercial time. The difference from AT&T's concept of broadcasting was that these other stations kept control of the facilities and sold either single commercials or sponsorship of programs they produced. During the same period AT&T developed a new concept in networking, in which the network kept revenue from sponsorships in exchange for providing free programming to affiliates. This is the way some U.S. radio networks are run today. However, AT&T was facing a major problem. In 1925 the Federal Trade Commission (FTC) was becoming interested in the relationship of RCA, GE,

Westinghouse, and AT&T, which gave the appearance of possible restraint of trade by these large electronic firms. The threat of government action led the companies to a long series of meetings during which they further subdivided the telecommunication business in the United States.

Leasing Telephone Lines

AT&T took the right to market radio receivers and parts. Oddly, AT&T did not enter the consumer electronics market then but waited until the 1980s when it began to sell computers. AT&T agreed to lease its circuits to other broadcast firms. This change came about after David Sarnoff, now a top executive at RCA, pointed out that AT&T would make far more money leasing lines than it did leasing broadcast time. At the time it was thought AT&T was going to just lease its lines to RCA; thus, the idea of leasing circuits to other firms did not seem that important. Sarnoff gained a significant victory because circuit leasing made possible the creation of radio networks and these networks became the backbone of broadcasting in the United States.

Throughout this period broadcast radio was limited to the AM band. Research on both FM radio and television was underway, but their introduction as broadcast bands was still many years away.

The Creation of NBC

A realignment of the major powers in American broadcasting occurred in July of 1926. A new firm, the National Broadcasting Company (NBC), was created. It was owned jointly by RCA, GE, and Westinghouse. The deal included the purchase of WEAF in New York from AT&T. The AT&T station in Washington went off the air, and WRC, owned by RCA, took over its assigned time (during that period stations were told by the government how many and which hours they could use to transmit each day).

THE 1927 RADIO ACT

During the period when NBC was being formed, another important event occurred. A U.S. District Court in Illinois decided the Secretary of Commerce did not have as much authority as he had been using to control broadcasting. The decision left broadcasting virtually without government regulation. When it became apparent the

powers of the Secretary of Commerce were inadequate under the 1912 law, Congress acted quickly, passing the Radio Act of 1927. The new law set up the Federal Radio Commission (FRC) to administer the law. The 1927 Act was strongly regulatory and was destined to bring order to the chaos of broadcasting. A more complete description of the Radio Act of 1927 is found in Chapter 3.

The 1927 Act didn't specifically address advertising because advertising was not an important part of broadcasting when the law was being drafted. However, soon after the law was enacted, radio advertising became important as others saw NBC's success in getting paid sponsorship of its programs. Some of the early broadcast stations which sold advertising were owned by newspapers. Their management was familiar with advertiser-supported media and saw advertising as a natural way to support their business ventures. Many people thought broadcasting should be advertising-free or should be restricted in the amount and type of advertising it could carry.

Figure 2–6
1920's transmitting equipment for pioneer General Electric radio station WGY, Schenectady, New York. Courtesy of General Electric Co.

THE GROWTH OF THE NETWORKS

Erik Barnouw, in his book, *A Tower in Babel,* reported that there were 732 licensed broadcasting stations on the air as the Federal Radio Commission was being formed in the spring of 1927. Of these, more than 600 were not affiliated with a network, but this was about to change.

NBC inaugurated network broadcasting in November 1926. In January 1927 NBC added a second network. They were known as the "Red" and "Blue" networks, after the color of the connecting lines drawn on network maps. The **Red** network was fed from WEAF, which had been the AT&T station, and the **Blue** network was fed from RCA's WJZ. NBC continued to operate two separate and very successful radio networks until 1943, when the government forced NBC to get rid of the Blue network under terms of an antitrust action. The Blue network had several owners and eventually became the ABC Radio Network.

Another Network Formed—CBS

NBC enjoyed almost instant success with its networks, and so a competitive group of businessmen formed United Independent Broadcasters.

Before United transmitted a program its name was changed to the Columbia Phonograph Broadcasting System, denoting a large infusion of funds from the phonograph company. The Columbia Phonograph Broadcasting System transmitted its first network program on September 18, 1927. Columbia Phonograph soon became disenchanted with the network when sponsors spurned it for NBC. A group of Philadelphia investors then bought a controlling interest, renaming the network the Columbia Broadcasting System. A frantic search for a new network head ended when the investors selected William S. Paley, the 26-year-old son of the owner of one of the network's sponsor companies, the Congress Cigar Company. Paley soon talked film magnate Adolph Zukor into becoming a 49 percent partner in the network, which became known as CBS and eventually changed its corporate name to CBS, Inc.

William Paley of CBS and David Sarnoff of NBC were to become the leaders of American broadcasting, using the enormous wealth and clout their respective networks generated.

And Soon There Were More

The third major network of the early period was the Mutual Broadcasting System, which was

formed by the association of four powerful independent stations, WGN, Chicago; WLW, Cincinnati; WXYZ, Detroit; and WOR, New York. Mutual was started in 1934.

Two major regional networks of the period were the Don Lee Network on the West Coast and the Yankee Network in New England.

Monopolies

The Department of Justice continued to pressure RCA, GE, and Westinghouse over what still appeared to be a near-monopoly over most aspects of broadcasting. Another series of meetings resulted, which ended with GE and Westinghouse yielding their facilities and stake in RCA to NBC. RCA would continue to be a manufacturing firm and GE and Westinghouse could compete with RCA, after taking a two and a half year break from manufacturing. NBC became a wholly owned subsidiary of RCA, and in a peculiar arrangement, Westinghouse and GE kept their broadcasting stations but handed the management of the stations over to NBC. The Department of Justice accepted the plan. RCA finally had its own identity. It owned a majority of the clear-channel radio stations (powerful stations whose frequencies were not used by other stations at night) in the country, two networks, manufacturing facilities, and major international and ship-to-shore communication facilities.

THE COMMUNICATIONS ACT OF 1934

The 1927 Radio Act was superceded by passage of the Communications Act of 1934, which is the law under which we still operate. It was created out of President Franklin Roosevelt's desire to bring broadcasting and telephone service under one regulatory agency. Up to that time the Interstate Commerce Commission had watched over telephone regulation.

The Communications Act created a Federal Communications Commission (FCC) to oversee broadcasting. Chapter 3 contains a detailed description of the Communications Act of 1934. It gave the government strong regulatory control over broadcasting and this control by the FCC became stricter over the next 30-plus years until the late 1970s when the FCC began moving toward a theory that broadcasting should be competition-based and governed as much as possible by marketplace controls.

THE PRESS–RADIO WAR

While the networks were being formed and programming was becoming more formalized, a battle was underway between the printed press and the early broadcast news organizations. It is now referred to as the "Press–Radio War."

To understand the Press–Radio War we have to transport ourselves back to the 1920s and 1930s. The dominant source of news was the newspaper. Most major metropolitan papers published several editions a day, so one was seldom without a paper containing fresh news. There were many daily papers in most cities, so the offerings were easily available and varied. The newspaper business had made a number of people wealthy. Names like Hearst, Scripps, and McCormack represented immense wealth and power.

Then, as now, newspapers and broadcast stations received a great deal of their news from wire services. There were three news agencies, the Associated Press (AP), a nonprofit cooperative owned by newspaper companies; United Press (UP), owned by the E. W. Scripps Co., and the International News Service (INS), owned by the Hearst Corporation. They each had reporters and free-lancers stationed all over the country and the world. The news agencies collected the stories generated by member papers and combined them with the reports gathered and written by their staffs. They transmitted thousands of words daily.

Many papers reprinted the wire service stories in the form in which they arrived on the Teletype machine. Their reporting efforts were mainly concentrated on local coverage in their circulation area. Broadcasters took the newspaper copy off the wire and rewrote it in a form that was easier to hear and understand.

The Importance of the Wire Services

To have a wire service affiliation was crucial to the success of any news organization, whether it was a newspaper, a broadcast station, or a network. The key issue during the Press–Radio War was whether or not the press agencies would sell their services to broadcasters. Without the wire services, broadcasters would be virtually unable to present state, national, and world news.

This is just what many of the newspaper publishers wanted. They realized that radio was a powerful medium, capable of collecting millions of listeners in front of receivers during major

broadcasts. The publishers didn't want to lose their readers to radio, because they feared they would lose advertising revenue to the new medium.

The publishers decided to try to stamp out news competition from radio. Their ace in the hole was their ownership of the press agencies. The AP was a nonprofit organization founded by a group of newspapers and was open to affiliation by other papers. UP and the INS were for-profit businesses owned by newspaper companies.

Election News

The publishers became upset because of the success of a series of national news broadcasts over radio. For example, a Chicago station broadcast the famed Scopes "Monkey" (creationism) Trial live in 1925. In 1928 broadcasters gave results of the Smith–Hoover presidential election, and in 1932 returns from the Franklin D. Roosevelt–Herbert Hoover election were carried on radio. The public loved these special events. Besides, the radio stations were able to give much more up-to-date election returns. Most voting was done by writing on paper ballots, which had to be individually counted, a slow process; no one was predicting the winner at 8:30 P.M. as is done today. Radio stations continued to update the returns late into the night and during the morning after the election, while the papers had to stop at some point and print and distribute their product, which meant the election results in the paper were far behind what people were hearing on the radio.

The hostilities came to a head after the 1932 election. In April 1933 the AP board of directors canceled all service to radio networks. The only radio service permitted was to stations owned by AP member newspapers. UP and INS joined the boycott.

Broadcasting's Response

Bill Paley of CBS showed some of the resilience which was to make him a giant in the industry. He formed the Columbia News Service, which used a combination of domestic and foreign news from bureaus staffed by CBS reporters and copy from several minor wire services which did not join the boycott. NBC made similar arrangements, thus putting two already strong business organizations in direct competition with the wire services and newspapers.

In December 1933 representatives of the publishers and the radio broadcasters met in New York City for a summit conference. A Press–Radio bureau was formed in exchange for the networks giving up *domestic* news collection. The networks were provided with a limited amount of news copy designed to supply two daily news broadcasts, which would occur after the newspapers had hit the street. Notice that we said the networks would give up "domestic news collection." They wisely decided to keep their overseas bureaus. It was this skeletal news organization, which CBS developed successfully as the backbone of its famed World War II coverage, led by Edward R. Murrow in London. Murrow not only became the voice of CBS's European War coverage, he returned to New York after the war to play a key role in the building of CBS News and the production of the first news documentaries on TV.

The newspaper publishers also failed to take into account the nonnetwork-affiliated broadcasters, called *independents*. The independents believed they were not obligated to go along with the New York agreement. In 1934 they formed TransRadio Press, which reworded dispatches from several smaller wire services and used information compiled by the station members to create a successful wire service. The real contribution of TransRadio Press was its decision to send copy out in radio script form, ready to be read by an announcer. This was the forerunner of the broadcast wires that the AP and UPI wire services now sell to broadcasters.

UP and INS

UP and INS could not withstand the pressure of ignoring potential income from broadcast members because they were for-profit wires services, and in 1935 they gave in and began to sell to radio broadcasters. The AP, a nonprofit consortium, held out until 1940. TransRadio Press faded away after the leading wire services began signing up broadcast subscribers.

A NEW TECHNOLOGY—FM RADIO

During the 1930s two other broadcasting developments took place which were to become important after World War II. One was the development of FM (frequency modulation) radio and the other was television.

Edwin Armstrong is credited with being a key

figure in the development of FM. In 1933 he conducted laboratory tests in a facility owned by RCA and in 1934 he demonstrated FM transmission from the Empire State Building in New York. In 1936 he went before the Institute of Radio Engineers to demonstrate his invention. The technical staff at the FCC took little interest in FM and denied Armstrong a permit to build an experimental FM station. This was one time the FCC failed to properly judge the impact of a new technology.

Armstrong was persistent, and in 1936 he succeeded in getting the FCC to allow him to build an experimental FM station. In 1938 he started construction of a 50 kw station at Alpine, New Jersey. Armstrong picked up a powerful ally in John Shepard III, who was President of the Yankee Network. Shepard began construction of a 50 kw FM station at Princeton, Massachusetts.

In July 1939 Armstrong's FM transmission system was heard for the first time over the Yankee Network, which then applied to build another 50 kw FM station in New York City. Soon the FCC had 150 applications on file seeking FM frequencies.

Commercial FM

The FCC finally authorized commercial development of FM in 1940. Initially, the FCC assigned 35 channels to FM in the 43 to 58 mhz band. It was estimated that between 1,500 and 2,000 FM stations could utilize the band.

In 1945 the FM band was shifted from the 43 to 58 mhz range to the 88 to 108 mhz range, adding 60 more channels to the FM band, and relegating the 500,000 FM receivers manufactured up to that point to the trash heap.

THE BEGINNING OF TELEVISION

Television traces its technical heritage to Germany and *Paul Nipkow's* 1884 invention of the scanning disk. It consisted of a spinning metal disk with a ring of holes. The holes permitted a little light reflected from the scene to hit a phototube, where a current was generated that varied in proportion to the amount of light falling on it. These electrical currents were sent by wire to another spinning disk equipped with a glow lamp, which if viewed at eye level, would reproduce the image. In the early 1900s French scientists experimented with television, and by the

1920s experiments were underway in the United States. In 1925 an American, *C.F. Jenkins,* transmitted motion pictures by way of radio waves.

The significant invention which impacted on TV was *Vladimir Zworykin's* development of the iconoscope camera tube in 1923, followed in 1926 by his development of a receiving tube called a kinescope. Between 1926 and 1928 American inventor *Philo Farmsworth* submitted applications for three patents relating to key components of the television system, including an electronic scanning system he called "image dissection." RCA licensed several of Farnsworth's discoveries.

RCA's David Sarnoff took a great interest in television, sensing it would be the medium of the future for NBC.

John Baird demonstrated an actual live TV picture in England in 1926 and in 1929 Baird was broadcasting TV pictures. The British Broadcasting Corporation (BBC) began regular transmission of television programs in 1936.

On September 7, 1927, the first successful transmission of a TV signal in the United States took place in New York City, sponsored by AT&T.

The 1939 World's Fair and TV

The U.S. public got its first chance to see television at the 1939 New York World's Fair. TV soon followed the example of the early days of radio and broadcast the returns of the November 1940 presidential election. The results were carried by the Dumont and NBC stations in New York as an experiment. The transmissions were largely tests because there were few private receivers.

BROADCASTING AND WORLD WAR II

In 1940 the FCC ordered a halt to the development of TV because some of the materials used in the manufacture of TV equipment were needed for the war effort.

World War II had two major effects on United States broadcasting. First, it gave both the industry and the FCC some breathing space to try to cope with a rapidly growing medium undergoing major changes brought about by advances in technology. The FCC at the time was being pressed hard to move ahead with both FM radio

and television, even as it became apparent that both systems would undergo further technical development. Second, the war firmly established news as an important ingredient in broadcasting.

The War and Broadcast News

Many of the individuals who molded broadcast journalism after World War II got their first taste of broadcast newsgathering under fire during the war. Among the personalities who emerged from the war were *Edward R. Murrow, Walter Cronkite, Richard C. Hottelet,* and *Charles Collingwood.* All of them broadcast radio news during the war and went on to become the news headliners of the new medium, television. Each of these news people was already a skilled writer and reporter for either a newspaper or wire service when they moved to broadcasting. News every hour became the standard for radio broadcasting during the war. The tradition of news at least once every hour continued on radio until the 1980s.

On-Scene Reporting

On-scene reporting took place on a regular basis, with two of the best known efforts being Edward R. Murrow's dramatic reports live from the roofs of London buildings as the Germans dropped incendiary bombs and launched V-2 rockets against the city and the live broadcast of Japan's surrender aboard the battleship *Missouri,* which was anchored in Tokyo Bay. There had been infrequent on-scene reports before the war, and these were usually reserved for elections or presidential addresses.

Portable Recording

The first "portable" recording equipment was used to record the sounds of the war. The use here of the word "portable" may be overstated. The most often used recording machine was a very heavy wire recorder, which recorded sound on spools of wire.

Fireside Chats

During World War II President Franklin D. Roosevelt reassured the nation by broadcasting his "fireside chats" on radio. He had started his radio talks in the 1930s during the depths of the depression. He used these informal broadcasts to influence the American people and congressional policy. Calvin Coolidge was actually the first president to make extensive use of radio, beginning with his broadcast of a message to Congress over a seven-station network in 1923. Coolidge received generous praise for that broadcast; he subsequently permitted several journalists to interview him on radio, and he made other radio addresses. FDR is credited with establishing the tradition of broadcasting presidential addresses to the nation, perhaps because his broadcasts dealt with topics of great public concern such as recovery from the depression and victory in World War II. In the 1980s after many years of presidents using television to reach a national audience, Ronald Reagan returned to the FDR tradition by recording a short weekly talk, which was fed by several of the radio networks.

GROWTH IN TELEVISION: 1946–48

By the end of World War II, Americans had created a demand for consumer goods they couldn't obtain during the War. Similarly, the people and companies which had invested in broadcasting had accumulated an agenda of enterprises they wished to launch. Topping the agenda was television development.

As World War II ended RCA promised it would market TV sets by 1946. The FCC began granting broadcast station licenses. Then RCA made an even more bold declaration, promising television sets that would be able to be seen in color or black and white. Late in 1946 while already marketing black and white receivers, RCA actually demonstrated a crude version of its color system.

The years 1946 and 1947 brought a series of television special events including the broadcast of a championship prize fight, the opening of Congress, and an operation in a hospital. Television was able to develop faster than radio because the delivery system was in place. There were established broadcasting companies, which had technical and programming expertise. The licensing of parts for manufacture and the assembly of TV equipment and sets was a spin-off from years of experience producing and marketing radio sets. Most of all, the radio networks were earning a great deal of money, which was being used to promote the growth of TV.

Allocation of Channels

The growth of television was irregular. By 1948 there were over 100 stations on the air, but only 24 cities had two or more stations. Storm clouds were gathering over the TV industry. The FCC had taken a totally different approach in allocating TV channels. For radio an applicant conducted an engineering survey and then proposed a location, power, and frequency to the FCC; for TV the FCC decided to publish its own table of allocations, assigning specific channels to certain cities.

There was a great deal of dissatisfaction with this approach because many cities were left out of the allocation table. Further complicating matters for the FCC was the development during World War II of the Ultra High Frequency TV band (UHF) extending from channels 14 to 83, the existence of two color TV systems which were competitive and incompatible, and strong pressure to reserve some TV channels for educational broadcasters.

TV Freeze

The FCC's response in September 1948 was to order a freeze on new TV station allocations. The freeze, which was expected to be of short duration, lasted nearly four years. One reason given for the length of the freeze was the Korean War. The war did affect production of TV receivers and transmission equipment, just as World War II had because some of the materials used in television manufacture were also used in military equipment.

Color

The type of color transmission system to be adopted created a major conflict. RCA had developed an electronic system, which was compatible with black and white television. By compatible, we mean that if all you had was a black and white receiver, you could still receive a picture, transmitted in color, which would be black and white (monochrome) on your TV set.

Meanwhile, CBS was holding back, unsure of the pace at which television would develop and planning its entry into color using a different color transmission system which employed a rotating wheel. What CBS was pushing was an updated version of Nipkow's scanning disk. It created an excellent color picture but its output was incapable of reception on a black and white

receiver. The eventual winner of this tug of war was RCA.

UHF

It had become apparent to the FCC and industry experts that the 12 VHF channels then allocated did not provide enough TV stations to cover all the markets that would want TV. The VHF allocation did not allow for sufficient competitive channels to support more than two national TV networks. As a result, one of the other issues the FCC had to consider during the freeze was the future of UHF television. At that time the UHF spectrum consisted of channels 14 through 83, which could provide flexibility in coverage and competition. There were problems, however. The TV sets in use at the time did not have UHF band tuners; thus, the only way one could receive a UHF signal was by using a converter box attached to the TV antenna, which redirected UHF channels through unused VHF channels on the receiver.

There were also technical problems with UHF. It required much greater power (and electricity consumption) to cover an area equivalent to the coverage of a VHF station, and picture reception, even in the best of cases, tended to be less clear than that of VHF signals unless viewers bought expensive UHF antennas.

Then there was the question of what to do with the existing VHF stations. Some experts suggested moving all TV stations to the UHF band and reallocating the VHF band to other services. This would have made every TV set sold up to that time obsolete. It would have cost VHF station owners tens of thousands of dollars for new transmission equipment, and it would have destroyed the economic dominance enjoyed by the VHF stations. Of course, the FCC had done just this earlier with FM when it made several thousand FM receivers obsolete by moving the FM band. The difference was that FM was not an established, profitable medium when the FCC made the change, while VHF TV was already profitable and well established.

One proposal that was discussed for several years was deintermixture. This would have involved selecting certain markets (cities and the area around them) which had both UHF and VHF stations and making them UHF-only markets.

An example of the complexity of the deintermixture issue and its political and business implications occurred in the Hartford–New Haven,

Connecticut, market, where competitive well-financed broadcast companies owned respectively one VHF network affiliate in Hartford and another VHF affiliate in New Haven, about 40 miles away. The remaining stations in the market consisted of a UHF network affiliate at New Britain, near Hartford, and independent UHF stations in Hartford and Waterbury (about halfway between Hartford and New Haven).

The issue in the Hartford–New Haven market was further complicated because CBS owned the Hartford UHF station and NBC owned the New Britain UHF. Deintermixture might have stood a chance in that market if the networks had not decided to sell off their unprofitable UHF stations. This left the combatants lined up with three poorly financed UHFs facing two well financed VHFs: one owned by a major insurance company and the other by a major media chain. The two VHF owners were prepared to spend large sums and slog through years of court hearings to protect their franchises. They were also able to exert pressure on the state's congressional delegation, which, in turn, could pressure the FCC if desired. The end result was that no changes were made and the Hartford–New Haven market remains UHF–VHF mixed today.

Industry Competition During the "Freeze"

During the prohibition on licensing new TV stations, important behind-the-scenes activities were taking place. William Paley of CBS was hiring away key talent from NBC. Paley later said he chose popular radio stars who he thought would successfully make the transition to television. NBC chose not to compete with Paley when the CBS leader offered high salaries to snag the stars. Later, NBC regretted its lack of foresight in the programming area, although RCA and NBC were competitive in fighting CBS over technological decisions. RCA's color TV system was finally adopted in 1953 after a series of FCC decisions and subsequent court battles. Each company was entering the TV age fighting from its strength: RCA/NBC with its technical and manufacturing expertise and CBS with its flair for programming. Over the next three decades the two firms continued to battle.

During the freeze on new TV stations many investors realized the potential of TV as a business, and applications were being prepared in expectation of the FCC increasing the number of channels which would be available. The FCC was faced by a deluge of new applications when it dissolved the freeze.

The networks were losing no time, even as they fought each other over technology and programming. Facilities were being improved and network lines (leased from AT&T) were being readied for rapid expansion once they could own more stations or sell their programming through networking.

THE "DARK AGES"

The TV freeze period was also known as the "dark ages" of American broadcasting. It was the period during which national hysteria, fueled by Senator Joseph McCarthy, arose over the perceived threat of communism invading the entertainment and broadcast industries.

Lists were circulated of people who at one time either had belonged to the Communist Party of the United States of America or had in some way consorted with known Communists. These lists were known as *blacklists*. They were used to force the firing of writers, producers, directors, and performers, as well as to keep independent creative people from having their works used on the air. Investigations into some of the accusations revealed that many of the accused had belonged to the Party briefly during the political turmoil of the depression years or had attended meetings or written documents viewed as sympathetic to communism.

"See It Now"

The influence of the "witch hunters" was pervasive after U.S. Senator Joseph McCarthy, a Republican from Wisconsin, began his vitriolic attacks on suspected Communists. The blacklist period lasted into the mid-1950s when Edward R. Murrow and Fred Friendly produced one of their "See It Now" documentaries in 1954, which exposed the bullying tactics McCarthy used in his congressional hearings. The broadcast began a change in political and public opinion which accelerated when McCarthy's hearings attacking the U.S. Army were broadcast live for 36 days. McCarthy lost his investigating subcommittee chairmanship after the 1954 elections and was subsequently condemned by the Senate for "conduct contrary to Senate traditions." The McCarthy period was over, but it took at least another decade for some of the victims to restore their professional careers—some never did.

Looking to the End of the Freeze

The TV freeze did not end until 1952, but the FCC offered its first revised allocation plan in 1951. It included a mix of VHF and UHF channels and a major increase in the number of allocations available. The plan also included a controversial proposal to reserve 10 percent of the channels for educational broadcasting. Loud protests were heard from industry sources, which had fought educational allocations since the 1930s. In the early days educational radio broadcasters occupied AM frequencies that could be used for commercial broadcasting. As a result, some were forced off the air and others were bought out by commercial interests. Seeing the way channels available to educational broadcasters were eroding, a movement began to convince the FCC to reserve frequencies for educational broadcasters in any new bands which might be created.

ABC—A Third Network

The Foundation was laid for a third TV network when ABC put its first TV station, WJZ (now WABC-TV), on the air in New York City in 1948. Shortly afterward, the network began lining up TV affiliates. The major problem facing ABC was a lack of money. The Blue network, which became ABC, had been the weaker of NBC's two radio networks; consequently, ABC did not have the wealth of CBS and NBC. During 1951 ABC began merger talks with United Paramount Theaters and merged in 1953.

Dumont and the Fourth Network

The Dumont Company, which manufactured receivers, started a fourth TV network in 1948, using as a base its TV stations in New York, Washington, D.C., and Pittsburgh. Dumont struggled for years, finally giving up in 1955, defeated by the lack of strong affiliates and insufficient advertising revenue. During the same period ABC was reporting losses as it fought to be competitive with CBS and NBC.

THE SIXTH REPORT AND ORDER

The FCC document broadcasters and investors had been awaiting was published on April 14, 1952 as the FCC Sixth Report and Order. It ended the TV freeze, providing for 2,053 channel assignments in 1,291 communities. Of these, 617 assignments were for VHF channels and 1,436 were for UHF channels. Two hundred forty-two channels were reserved for educational stations including 80 in the VHF band. When the Sixth Report and Order was released there were only 108 TV stations operating. Within several months over 700 applications were received and 90 allocations were made before the year was out.

The color battle had been resolved, with RCA the winner and the television business was set to take off. The nation's TV system would be based on electronic color cameras and a transmission system which would allow black and white TV sets to receive all TV transmissions, whether they were in color or monochrome. Tremendous consumer demand had been created by the freeze, and there were plenty of investors waiting to satisfy that demand by building stations, creating programming, and manufacturing TV sets.

Coaxial Cable

A major technology breakthrough which helped the growth of television was the *coaxial cable,* a telephone cable system capable of relaying high-quality TV pictures over long distances. Early experiments in networking had taken place in

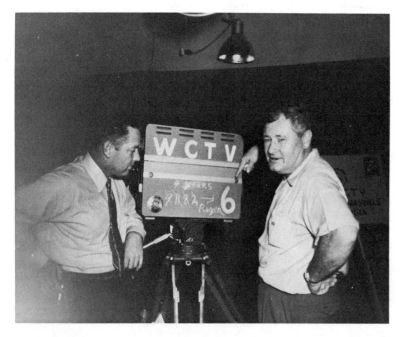

Figure 2–7
General Manager and Owner of WCTV, Thomasville, Georgia–Tallahassee, Florida, posing next to a studio camera when the station went on the air on September 15, 1955. Courtesy of John H. Phipps, Inc., WCTV.

1946 in four East Coast cities. In 1948 the cable linked New York and Washington, D.C. Later in the year when voting in the Truman–Dewey election took place, the cable reached fourteen stations in 13 states. During 1948 the cable extended to the Midwest and regular network service was begun. In 1951 the networks began coast-to-coast broadcasting while they waited for the freeze to be lifted.

Newsfilm

If you had been watching television in 1953 you would have seen some of the first newsfilm, incorporated into NBC's "Camel News Caravan" with *John Cameron Swayze* or the "CBS-TV Television News" with *Douglas Edwards*. Both programs ran 15 minutes. The use of film to show news events was not new. Movie theaters had regularly shown newsreels between the features, but these were films of events which had occurred several weeks earlier. The major obstacle for TV was to increase the speed of processing the film so events could be shown closer to the time when they occurred. TV also needed to make the film equipment smaller and more portable. Delivering film from the location where it was shot to the network studios in New York consumed both money and energy in the early days of TV news.

VTR

The videotape recorder (VTR) was introduced to broadcasters by Ampex in 1956. This bulky machine, which recorded video images and sound on 2 inch wide tape, was to revolutionize the TV business. Both CBS and NBC immediately placed large orders for the machines, planning to use them to delay the transmission of programs to the West Coast by three hours. Up until the invention of the VTR, the only device available to record a live television program was the kinescope, which filmed the image projected on a video tube. Kinescope pictures were far less satisfactory than viewing the live production, while videotape very nearly duplicated the appearance of a "live" broadcast when it was replayed.

One of the great ironies of television is that TV stations had videotape available since the late 1950s for recording programs and commercials in the studios but had to rely on adapted Hollywood film technology to record news events for the evening news broadcasts. Portable video-

Figure 2–8
Reporter and film cameraman from WFMY-TV, Greensboro–High Point–Winston–Salem, North Carolina, covering civil rights dispute in mid-1960s. In the picture the cameraman is wearing earphones to monitor the sound. He is also shooting from a shoulder brace, an uncomfortable way to try to keep a heavy 16mm sound camera stable, but necessary in volatile situations.

tape of broadcast quality acceptable for news coverage did not become commonly available until well into the 1970s. In the meantime news stories were photographed using silent 16mm film cameras or adapted Hollywood 16mm sound cameras and special reversal film, which allowed speedy processing of newsfilm. Despite many improvements in film equipment, most TV newscasts were not able to add any new film material during the two to three hours preceding the broadcast because time had to be set aside to develop and edit the film to be shown.

The television industry grew quickly in the late 1950s, developing the TV "specials," live coverage of important events, and counterprogramming. (Counterprogramming was a technique used by ABC to improve its flagging ratings. ABC would program an adventure western against comedies on the other networks.) The industry also withstood a major scandal when it was discovered that some of the guests on quiz programs knew the answers before the questions were asked.

THE CHANGE IN RADIO

The mid-1950s saw network radio on the decline as its major stars moved to TV and the television

audience became large enough to weaken night-time radio. The disk jockey format, which had first appeared prior to World War II, became stronger. Radio chain broadcasters *Gordon McLendon* in Dallas, Texas, and *Todd Storz* in Omaha, Nebraska, developed the idea of playing only the top 40 or so hit records into a successful and money-making format. McLendon also created two other popular formats, all-news radio, and beautiful music radio.

The orientation of radio was changing. Between the 1920s and the 1960s the majority of radio stations rebroadcast programs produced by the networks in their studios in New York. Many radio stations did little of local nature, depending on the strength of network programming and relying on the sale of station break time for their income. Tremendous growth had taken place in radio. In 1940 there were a total of 882 radio stations in the United States including experimental FM stations. By 1948 there were 1,621 commercial AM and 458 commercial FM stations broadcasting. The next year the numbers jumped to 1,912 AM and 700 FM stations. By 1953 the growth of radio was so fast that at the beginning of the year there were 2,391 AM stations on the air and by the end of the year the number of AM stations had risen to 2,521. Meanwhile, during 1953 the number of FM stations operating dropped from 600 to 560.

Figure 2–10
Gordon McLendon, pictured here at a Liberty Network microphone, was the prime mover in creating three of the most important post-World War II radio formats: Top-40, All-News, and Beautiful Music. Courtesy of the Southwest Collection, Texas Tech University.

In the 1950s radio became a locally oriented medium. The adoption of disk jockey formats meant selling aggressively to local merchants to fill up the sudden increase in commercial positions which were available. Soon radio station owners realized that there was a great similarity in disk jockey formats, but they could make their product distinctive through development of local personalities, by presenting local news, and by becoming more involved in the community through the station's public affairs activities.

Changing Times

Two developments that were to have significant impact on radio were the slow growth of FM and the vast improvement of the quality of recording disks.

The Growth of FM Radio

The FM Switch

In June 1945 the FCC shifted the FM service from the 50 mhz band to the 100 mhz band, between TV channels 6 and 7. A decision was made to limit the maximum power of FM transmissions in certain urban areas to make room for more stations. This effectively eliminated FM as a major source of regional signals in some parts of the country. This decision, which affected the urban areas in the northeast, hindered the plans of many broadcasters to use FM as a means of providing radio network service.

Figure 2–9
The transmitter room of WCAL's first FM station, which was a commercial classical station that began broadcasting in 1949 and ended transmissions in 1952. WCAL-FM returned to the air in 1968. Courtesy of WCAL, St. Olaf College, Northfield, Minnesota.

Had higher power and taller transmission towers been authorized in the FM band, a number of networks could have been created simply by picking up the signal of an adjacent FM station and rebroadcasting it. Even though the signals of two adjacent FM stations might overlap, if they were allowed to broadcast over sufficiently large distances, the stations would not have considered themselves to be competing for the same geographic audience. An air-to-air network is created when each station receives *clearly* the signal of a station on one side of its coverage area and rebroadcasts that station's signal, which is then picked up by the station adjacent on the opposite side of the coverage area and rebroadcast. If the overlaps are close enough for good signal reception, it is possible to create an air-to-air network, thus bypassing the expensive facilities of AT&T.

The Yankee Network in New England was interested in FM to FM relays for its affiliates. Air-to-air relays were actually used by the QXR network, which broadcast classical music programming originated by WQXR-FM in New York City. A similar classical music network was created by the Concert Network in Boston, tying together company-owned and affiliated stations. The lack of strong enough signals and efficient signal processing equipment helped both of these early FM networking ventures to fail. Absence of enough advertiser support was another cause.

Figure 2–11
Student announcer doing air shift in 1950. WCAL at St. Olaf College in Northfield, Minnesota, was staffed mostly by students from 1918 until the mid-1970s. Courtesy of WCAL, St. Olaf College, Northfield, Minnesota.

Dual Ownership

In 1945 the FCC authorized AM stations to own FM stations, limiting the ownership of FM properties to a total of seven per owner. Effectively, this made FM the servant of AM. The FCC's premise was that the profitable AM service could support FM until it became profitable. In reality, the decision left the concentration of ownership with the permittees of AM stations, clearly marking FM as a secondary service used to retransmit AM programming, rather than allowing FM stations to develop alternative programming which might have competed with the AM stations.

AM Drop-Ins

During the early years of FM the FCC continued to allow AM stations to be "dropped-in" (dropping-in an AM station means adding a facility by carefully selecting a frequency and designing the coverage pattern of the station so that it

doesn't conflict with other stations on the same frequency). This is done through skillful design of the station's signal pattern, curbing it in the direction of signals with which it might interfere, and expanding it in areas where there is no conflict. If you pass by a radio station's transmission building and see anywhere from two to seven towers arranged nearby, you are looking at a directional antenna created to permit a station to be dropped in among stations on the same or adjacent frequencies.

FM Stereo

FM radio languished during the growth years of TV, but in 1961 FM received help when the FCC approved a system for stereophonic broadcasting, which allowed listeners to get the same effect from an FM radio equipped with two speakers as they had been getting from their stereo records. (Stereo creates the same effect as if you were listening to a live performance where each of your ears hears more of some parts of the music than other parts.) Stereo gave FM a unique

Figure 2–12
The director and the video controller sat here in this early 1960's photo taken in the control room of WCTV, Thomasville, Georgia–Tallahassee, Florida. Courtesy John H. Phipps, Inc., WCTV.

Figure 2–13
Picture taken off the screen during live NBC coverage of President Richard Nixon's visit to the People's Republic of China, February 29, 1972. Norelco provided color cameras for the coverage. Courtesy of Norelco/Philips Broadcast Equipment, Co.

programming dimension and provided encouragement to FM broadcasters.

FM Grows because of Car Radios

While TV was enjoying its "boom" years FM radio was given a boost in 1971 when automobile manufacturers began to regularly include the FM band on their best car radios. During the mid 1970s FM grew quickly as the FCC's nonduplication rule began to be felt. The rule had gone into effect in 1964, eliminating all AM–FM simulcasting of programming in the larger markets and limiting duplication to 50 percent of the broadcast day in the largest markets. What happened was that a separate FM audience was gradually created during the nonduplicated hours. Many stations ran different programming on AM and FM at night, and some FM stations programmed to people who preferred not to watch TV.

A number of FM stations had adopted what they called "underground music" formats in the 1960s; these were music formats designed to appeal primarily to the college-age 1960s protest generation. The stations played antiestablishment artists, ran longer music cuts from albums, and avoided the intensity and repetition common to top 40 radio. As the underground radio audience grew older, the stations adapted, and by the mid-1970s they were in the mainstream of radio broadcasting appealing to people who now took for granted the existence of an FM band on their stereo hi-fi tuners and car radios.

THE IMPORTANCE OF NEWTON MINOW

Educational broadcasting and TV news were given a major shot in the arm in 1961 by *Newton Minow*, a 35-year-old reformer appointed chairman of the FCC by President John F. Kennedy. Minow had been in office only two months when he delivered a memorable address to delegates at the National Association of Broadcasters convention. He told the delegates they should replace the "vast wasteland" of television with better programming. Coming from the man who oversaw license renewals, the words had dramatic impact. Broadcasters listened when Minow said, "There is nothing permanent or sacred about a broadcast license." Minow made it clear he wanted to see more and better programming for children and better support for educational broadcasting.

Public Broadcasting Begins

In 1962 Congress took the Minow challenge and voted $32 million for educational television stations (providing they raised matching funds). The Ford Foundation added an $8.5 million grant. These two actions provided the base for today's public broadcasting system, which continues to be supported jointly by government funds and private grants. Public (or educational) radio and TV are discussed in more detail in Chapters 4 and 5.

The Corporation for Public Broadcasting was created under the Public Broadcasting Act of 1967. The initiative started by Newton Minow had come to fruition with the urging of President Lyndon Johnson.

TELEVISION COMES OF AGE

Satellites

Intercontinental live television broadcasting became reality with the first live television relay from space, which occurred on July 10, 1962 when AT&T's Telestar I communication satellite relayed programs to and from the United States, England, and France. Telestar I marked the opening of a new era for program transmission. Telestar II was launched in 1963. The two communication satellites provided vastly improved means to relay telephone and Teletype messages, data, and radio and television programming between Europe and the United States. Their launching marked the beginning of a new era in communication, which has in two decades opened up most of the world to the reception and transmission of live programming and has permitted the creation of dozens of new program sources that are utilized by broadcasters, cablecasters, and other telecommunicators.

UHF Reception

In 1962 Congress passed a law which required all TV sets manufactured after April 30, 1964 to be equipped to receive both the VHF and UHF bands. This was to be a major boost to UHF stations, which were doing poorly. The other major development that helped UHF occurred during the 1970s, the growth of cable television, which put UHF and VHF stations on an equal footing in the eyes of cable viewers.

Figure 2–14
TV camera (right) and film camera (left) shooting launch of Apollo 11 at Cape Canaveral. Courtesy of Norelco/Philips Broadcast Equipment Co.

Color TV

In November 1966 NBC achieved a benchmark by broadcasting its entire schedule in color. CBS has nearly reached that point, while ABC was lagging behind, largely due to its inability to afford the costly conversion to color. It took many more years before color TV receivers became the sets of choice in American homes.

Color Worldwide

Color television reached high levels of consumer and broadcaster acceptance in the United States long before it did in other countries. Some countries did not move into color broadcasting until the 1980s. India first transmitted regular color service in the fall of 1982 in time for the Asean Games (an Asian version of the Olympics).

Cable

During the late 1960s cable TV increasingly received the attention of the FCC and Congress.

Figure 2–16
Discovery astronaut Jeffrey A. Hoffman attaching tools to the space vehicle's remote manipulator system prior to attempting to recover the troubled Syncom IV communications satellite from space. Courtesy of NASA.

Figure 2–15
The live return of the Apollo 13 astronauts on April 17, 1970, shot from aboard a helicopter used by CBS News. Courtesy of Norelco/Philips Broadcast Equipment Co.

In 1968 the U.S. Supreme Court ruled that cable systems did not have to pay copyright fees if they carried programs they picked off the air from broadcast stations. Congressional legislation aimed at dealing with the copyright question was immediately proposed, but the issue became mired in debate. In 1969 cable interests suffered a defeat when the FCC ordered all larger systems to originate programming by January 1, 1971. Up to that time the majority of cable systems were simply retransmitting off-air broadcast signals without inserting either commercials or locally originated programming (other than a display showing the current weather conditions.) The FCC softened the blow, however, by permitting cable systems to carry advertising, which they sold and originated. (More information about cable TV is given in Chapter 6.)

Cigarette Ads

In 1969 Congress passed a bill that banned cigarette advertising on radio and television effective January 1, 1971. The ban was a major economic blow to the broadcasting industry. In 1986 Congress passed a ban on so-called "smokeless tobacco" product advertising (snuff and chewing tobacco) on radio and TV. When similar proposals were introduced regarding the advertising of alcoholic beverages in the mid-1980s, the industry quickly let it be known it would cooperate with groups which wished to limit alcoholic beverage advertising and the consumption of alcoholic beverages during dramatic programs. This was to forestall Congress from legislating against alcoholic beverage advertising.

Prime Time Access

As the television industry grew, it became the target of regulatory efforts by people who at-

Figure 2–17
Television viewers watched as Discovery astronauts used a special arm which extended from their spaceship to remove the troubled Syncom IV communications satellite from space so that it could be repaired. Courtesy of NASA.

Figure 2–18
Reporter using Basys newsroom computer during 1984 Democratic National Convention in San Francisco. This terminal, in a hotel room, allowed reporters to access the latest news and receive messages. This is believed to be the first presidential election year in which broadcast newsroom computers were used for convention coverage. Courtesy of Basys, Inc.

tempted to impose what they saw as socially desirable limits on the medium. One area of attack was the prime evening viewing hours monopolized by the three national TV networks who required that affiliated stations take their programs. In 1970 the FCC implemented the Prime Time Access Rule, which prohibited affiliates in the top 50 markets from accepting more than 3 hours of programming from a network between 7 P.M. and 11 P.M. This move effectively returned 1 hour a night (7 P.M. to 8 P.M.) to local stations. The backers of the prime time rule had hoped that local stations would originate more local programming during the access time. The results were mixed. Eventually, some major market stations used some of the time to accommodate expanded local newscasts. Others inserted some local programming on specific nights. Many simply bought old programs the networks had already run to fill the hour. The prime time rule did encourage the establishment of Group W's *PM Magazine,* in which a station would employ a local staff to produce a limited number of features that were combined with features prepared by other stations and supplied by Group W (Westinghouse Broadcasting Corporation) to create a weeknight "magazine" show. It was a cost-effective way to add local programming during the prime time access period.

New Videotape Recorders

In the 1960s the Japanese introduced consumer-quality videotape recorders, which used narrower tape than broadcast industry machines and were somewhat portable. The networks were interested in the new machines and experimented with them. However, the new consumer technology was not adaptable to broadcasting because the picture produced by the so-called "small format" videotape recorders was not then up to standards demanded by the FCC for broadcast transmission.

Time Base Corrector

Early in the 1970s a device called the time base corrector was invented. It could be used to upgrade small format videotape to broadcast standard and it also provided reference points to be used in editing videotape.

Electronic Newsgathering

The networks experimented with portable videotape and other lightweight equipment in conjunction with their coverage of the national

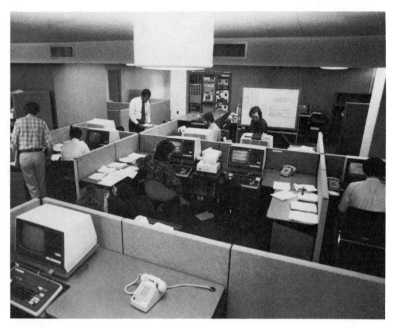

Figure 2–19
October 1984 inaugural picture of the first fully computerized network newsroom in the U.S., built for the Associated Press Broadcast Services. Staffers worked at individual computer terminals to put together scripts for the AP Radio Network and copy for the AP Radio Wire. Courtesy of Associated Press Broadcast Service.

political conventions in the late 1960s and early 1970s. The experiments led to the development of smaller cameras (with smaller tubes), lightweight cables, better battery supplies, improved and smaller microphones, and wireless microphones and headsets. All of these devices pushed broadcast news toward its ultimate goal of creating an "electronic pencil," a camera and microphone which would be lightweight and unobtrusive when used for news coverage.

KMOX and ENG

One of the first major experiments with this new technique, electronic newsgathering (ENG), was undertaken by the CBS owned and operated station, KMOX-TV, St. Louis, in 1974. The station made a major commitment to ENG by buying several portable videotape units and began to shoot most of its news on tape. Later KMOX developed one of the first electronic newsgathering coordination centers, remodeling the newsroom so that it would provide efficient communications facilities and work space for news staff members who supervised and processed incoming material from the station's live micro-

wave trucks (which were some of the first of their kind, too). Soon other broadcasters followed, and in less than five years TV news made a nearly total conversion from shooting film to using portable videotape and microwave equipment installed in small trucks or automobiles for news coverage. A similar revolution took place among program and commercial producers, who called their technique *electronic field production* (EFP).

Family Viewing

In the years since Newton Minow made his "vast wasteland" speech, TV had been under attack over the violent content of some of its programming. The issue came to a head in 1975 when, at the urging of CBS President *Arthur Taylor,* the National Association of Broadcasters Television Code Board and later the NAB at large adopted a plan to have a family viewing period from 7 P.M. to 9 P.M. (eastern time) during which program content would be designed for viewing by a wide range of family members. The action of the NAB was overturned in a federal court decision in 1976 on the premise that the NAB Television Code Board was acting as a national board of censors for television.

The Now Generation

The 1980 broadcasting decade began with a new emphasis on technology. Comsat filed an application for a $700 million direct broadcast by satellite system and other companies followed suit. Five years later one DBS company had failed and another major applicant was using its capabilities in a variety of other ways, including supporting a nationwide news exchange for local TV stations. DBS as a supplier of consumer television had not taken off.

Cable had changed from a repeater to an originator, and the networks and local stations were beginning to feel the impact in terms of lower households using television (HUT) figures reported on surveys.

Ted Turner inaugurated the Cable News Network (CNN) in June 1980. Many experts expected Turner to fail, faced with the sophisticated and well-financed competition of the big news departments at ABC, CBS, and NBC. Five years later CNN had become two TV news networks (CNN and Headline News), it added an all-news radio network, and it bought out its cable com-

petitor, Satellite News Channels. Another cable network predicted by many to fail, the Entertainment and Sports Programming Network (ESPN), also survived. The skies were full of TV and radio programming beamed by satellite to cable systems, which were offering (in some cases) three or four dozen channels of programming.

Low-Power TV (LPTV) has come from a tentative rulemaking proposed by the FCC in 1980 to a small and slowly growing part of the telecommunication environment. LPTV stations serve a 10 to 15 mile circle around their tower and operate with only 10 watts on VHF channels or 1,000 watts on UHF channels, compared to the 100,000 watts or more of transmission power employed by most TV stations.

Figure 2–20
Millions of TV viewers held their breath as the Space Shuttle Orbiter Discovery landed at Kennedy Space Center on April 19, 1985. Americans across the country shared the six day adventure with the crew via television and radio. Courtesy of NASA.

SUMMARY

By 1976, 97 percent of the nation's families owned TV sets. That was a tremendous growth for an industry which really didn't get started until 1952.

FM radio had supplanted AM as the most-listened-to form of radio. AM broadcasters had begun to install stereo transmission equipment in an effort to recapture some of the music audience that had moved to FM, but disagreements over which system of stereo would be used held up widespread conversion of stations to AM stereo. AM programming increasingly concentrated on talk and specialized interests while FM stations took over the mass audiences who listened to various forms of music programming.

Multipoint, multichannel distribution systems (MMDS) which use microwave to distribute satellite programming, much the same as cable systems, were authorized and the FCC was making grants of MMDS channels.

A great upheaval took place in the ownership of broadcast properties as Wall Street investors discovered potential profits from quick purchase and resale of broadcast properties, using borrowed money. The networks, which had resisted mergers with other companies, came under pressure. ABC merged with Capital Cities Communications and General Electric absorbed RCA and its subsidiary, NBC. International communication financier Rupert Murdoch became an American citizen, purchased the television stations owned by Metromedia, and set up the Fox Network. Throughout the industry there was great turmoil as sales, resales, mergers, divestments, and takeovers proliferated, while the sell-

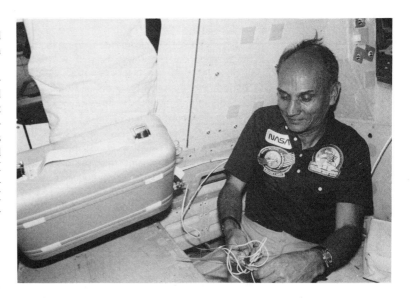

Figure 2–21
Via space-to-earth transmissions, television viewers watched U.S. Senator E.J. (Jake) Garn plug in a food warmer on the Earth-orbiting space shuttle Discovery. Courtesy of NASA.

ing prices of broadcast and some cable facilities rose to unprecedented levels.

All of this growth, realignment of ownership, and redefining of the role of various services occurred against the background of a government regulatory policy, which had swung sharply from fairly strict regulation to one of deregulation, letting the marketplace settle issues such as how much news stations broadcast.

GLOSSARY

Broadcast wires News agency stories written in verbal style for direct broadcast delivery. A direct result of the work done by the defunct TransRadio Wire service.

Cable Originally and more correctly known as community antenna television (CATV). The signal is picked up out of the air through the use of antennas or satellite dishes and is then sent to subscriber TV sets by a cable wired into their homes.

Coaxial cable A telephone cable capable of carrying high quality picture and sound communication over long distances. It made possible television network transmission from coast to coast.

Commentators The early news presenters on radio who infused the news with their viewpoints.

Communications Act of 1934 This act brought all broadcasting and telephone communication (more specifically common carrier) under the purview of one regulatory agency. The act created the Federal Communications Commission. (A common carrier transmits, but does not alter, a communication.)

Counterprogramming A technique in which one network or station plans a contrasting type of programming in the same time period for the specific purpose of stealing audience from another network or station. Originally used by ABC-TV to boost its audience, it is now a normal programming ploy.

Crystal receivers The simple, cheap receivers that people fashioned from "crystals" (rock), an oatmeal box, a coil of wire, and a "cats hair" used to tune the receiver.

Dark Ages A historical term used to describe a period of religious persecution in Europe. In our context, it describes the anticommunist hysteria which swept the entertainment industries during the "McCarthy period" when Senator McCarthy and others questioned the activities of many performers, writers, and producers.

DBS (direct broadcast by satellite) A satellite suspended 22,300 miles in space retransmits a signal to earth for reception directly by the consumer.

Dropping in The practice of finding a space for an AM, FM, or TV station by planning the signal coverage so that it will not impinge on other stations strong enough to complain. This is a practice that has led to directional patterns, as well as to high engineering and antenna costs.

Electromagnetism The theory that governs the way radio waves move and carry voice.

Electronic newsgathering The use of the newest technology tools to collect the news of the day. Specifically, the term refers to the newest generations of videotape cameras and microwave transmission used to bring news to the public at the moment of happening.

First Washington Radio Conference The conference called by Herbert Hoover in an attempt to untangle conflicts over frequency switching by broadcasters. The first conference led to a series of other similar meetings, at which the principles were developed that were written into the Radio Act of 1927.

Frequency Where stations or allocations may be found on the broadcast band. Also, the number of waves (vibrations) per second produced by an electromagnetic emission.

Hertz One cycle per second. The location of a type of emission along the frequency spectrum is described in terms of hertz. (Prefix *kilo* means thousands, prefix *mega* means millions and prefix *giga* means billions of hertz.) Named after early radio theory scientist Heinrich Hertz.

Iconoscope camera tube The earliest type of pickup tube used by television studio cameras.

Kinescope A receiving tube for the image generated by the iconoscope camera.

Microphone A device which converts the pressure waves created by speech or sound into electrical impulses.

Microwave trucks Vehicles equipped for mobile transmission of microwave signals. Used for TV electronic newsgathering.

Network An interconnected service with the majority of its programming originating from one location, which provides programming at precise times to a number of stations, called "affiliates." The affiliates may be paid in cash or with programming provided at no cost by the network. Syndicated networks charge the affiliates for their service.

News agencies Organizations which gather news, write it up, and transmit it to subscribers. The Associated Press (AP), United Press International (UPI), and Reuters are examples of news agencies.

Newsreels News that was shown in motion picture theaters between movies, usually at least two weeks old. Newsreels paved the way for the videotaped news reports seen currently on TV news.

Press–Radio War This "war" occurred in the

1930s when newspaper barons who controlled the press agencies became worried that radio was getting too popular as a place to get news.

Prime Time Access Rule This rule was implemented by the FCC in 1970 and states that only three hours of network programming can be accepted by stations in the top 50 markets between 7 P.M. and 11 P.M. This has led to a big market in syndicated programming but little local programming.

Radio It comes in two major varieties: AM and FM. AM preceded FM and was the dominant source for the first 40 years of radio. FM became dominant once technology was able to take advantage of its unique transmission patterns.

Radio Act of 1927 First strong regulatory law for broadcasting. It gave the government the power to deny licenses for broadcast stations.

Radio Act of 1912 First law to regulate radio broadcasting. It was weak because it failed to address government power to prescribe frequencies and deny licenses. The regulatory agency was the Department of Commerce.

"Red" and "Blue" networks Two radio networks developed by NBC. The Blue network eventually became ABC when NBC was forced to divest due to antimonopoly proceedings.

Remotes A broadcast trade term for an away-from-studio broadcast. It is sometimes called "nemo" by old-timers.

Satellite Retransmission device which is launched from the earth and travels in an orbit 22,300 miles above the equator to receive and return signals from and to earth over great distances.

Scanning disk A spinning metal disk with a ring of holes, which allowed reflected light to hit a phototube, where electrical current was generated. The electrical current was sent by wire to another spinning disk, equipped with a glow lamp, which reproduced the image.

Second Washington Radio Conference This conference was called by Herbert Hoover in March 1923 to try to deal with the chaos and monopolization of radio.

Sixth Report and Order The document that ended the TV freeze and provided for UHF and VHF stations, as well as reserving 242 channels for educational stations.

Superheterodyne A circuit that amplifies the electronic signal. Developed and patented by Edwin H. Armstrong who sold the patent to Westinghouse in 1920. This was a key ingredient in Westinghouse's plan to use manufacturing capacity left idle after World War I to manufacture radio equipment.

Telegraph A system of communication over wires which uses short and long electrical impulses arranged in various orders to represent alphabet letters. It predates the telephone. The major name in telegraphy is Samuel F. B. Morse.

Telephone A communication system that allows voice transmission via electrical wires or cables which have receiver/transmitters at each end. Alexander Graham Bell is the person to remember for his work with the telephone and for inventing the microphone.

Teletype Used by press agencies to transmit their information to subscribers (now generally replaced by a dot-matrix printer). Electrical signals sent over wires or radio transmitter trigger the equivalent of an electric typewriter that prints out the message.

Television (TV) A system of transmitting pictures and voice by radio waves.

Time base corrector An electronic device that brings videotape and other video signals into conformance with standards prescribed for broadcast technology.

Toll broadcasting An early concept that called for individuals to buy chunks of transmission time on the airwaves from AT&T.

TV freeze It began in September 1948 and lasted nearly four years. The freeze allowed the FCC to develop rules and new allocation patterns for television.

UHF (Ultra High Frequency) A transmission on the high end of the television band designated by the channels 14 to 83. UHF bands are also allocated to two-way radio communication.

Vacuum tube Key part in early radio equipment; fine wires encased in a glass enclosure that had its air expelled, similar to a light bulb. If the air were allowed to remain, the heated wires in the tube would have set off an explosion of the oxygen in the air.

Videotape recorder (VTR) A machine that records images and sound on tape made of metallic dust bound between two bands of plastic. Originally, it was bulky but clearer in picture than film, and now it can be reduced to miniature size.

Wire service Another way of describing a news agency.

Wire recorder An early audio recording device that imprinted its information (sound) on a spool of wire.

Wireless telegraph A system of sending a coded electrical message through the airwaves rather than by wire. Guglielmo Marconi developed the system and patented it.

LAW, REGULATION, AND ETHICS

3

This chapter discusses the many laws, regulations, and rules governing telecommunication. Governments all over the world regulate telecommunication. The reason for regulation is simple. There is limited room available in the frequency spectrum, which is shared by such services as radio, TV, short-wave, telephone communications, military communications, space agency communications, data transmission, two-way radio, and TV electronic newsgathering equipment.

Some laws are called acts because they are Acts of Congress such as the **Communications Act of 1934.** Some are called acts because they come from international treaties to which the United States is a signatory. Governments of various countries have made agreements about spectrum space and transmissions in the form of treaties. Without these agreements there would be utter chaos, much worse than what occurred in the early days of radio.

Rules, laws, and acts serve the purpose of regulating what is done in broadcasting and other telecommunication technologies; these rules, laws, and acts are not constant and firm. They change through interpretation by the bureaus administering them and by amendment of the legislators who promulgate them. Anyone involved in broadcasting is responsible for knowing the rules, laws, and acts as well as their application to the job that is being performed.

Ethics are "self-imposed laws" used to guide people working within a profession. Ethics in the broadcasting sense means acceptance of the idea that one is using airwaves that belong to everyone and that one must accept the role of caretaker for the public trust. Ethics consists of being honest and truthful in representing yourself and your employer to others. Acceptance of ethical guidelines or rules by people in a field such as telecommunication cuts down on the number of government rules, regulations, and laws.

Although laws and ethics govern the running of the telecommunication industry, court rulings are needed to resolve indistinct or conflicting areas. The rulings become **precedents,** which are, in effect, laws or rules to follow.

THE SOURCE OF COMMUNICATION LAW

The Constitution

The Constitution gives Congress the right to make laws pertaining to interstate commerce (Article 1, Section 8). Congress can thus regulate business which is carried on across state lines. The U.S. Supreme Court has ruled that the term "commerce" applies to electrical communication. Radio wave communication is electrical communication, and because state lines cannot limit its movement, it is interstate, and therefore a matter for federal regulation. The Supreme Court reasoned that even though a station may be licensed at low power in the middle of a big state, nothing really keeps the signal within state lines. In addition, it could potentially interfere with a signal received from another state. (You can occasionally pick up signal "skips" of low power stations at considerable distances.) What the Supreme Court originally ruled about **radio** transmission has been extended to cover all electrical or electronic telecommunication.

The Acts and What Led to Them

Wireless Ship Act of 1910

The first regulation of broadcasting in the United States was established by the Congress in the Wireless Ship Act of 1910, which decreed that all U.S. passenger ships must be equipped with radios as part of their safety equipment. These radios transmitted Morse Code rather than voice. The reason Congress passed this act was that by 1910 the wireless had already played an important role in the rescue of crews from a number of ships, including many people aboard the S.S. *Republic,* which had sunk off New York in 1909.

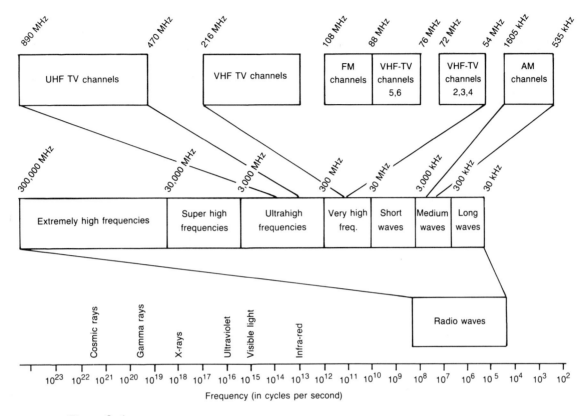

Figure 3–1
The electromagnetic spectrum, which includes the telecommunication frequency spectrum.

The number of large freighters and passenger-carrying ocean liners was on the increase, creating a need for wireless communication.

In 1910 Congress also amended the Interstate Commerce Act to give the federal government regulatory powers over interstate wireless and wire communication.

Radio Act of 1912

Pressure brought by military and maritime interests caused passage of the Radio Act of 1912. This act required that all radio transmitters and radio operators be licensed by the federal government. Management of radio communication was given to the Secretary of Commerce who was designated to set specific wavelengths for use by different groups, such as the military and civilian broadcasters. The Secretary could also determine the time periods during which stations could broadcast. What the Secretary of Commerce could *not* do was decide whether or not an applicant should have a license. Anyone who applied could secure a license.

The weakness of the 1912 law soon became apparent as more licenses were handed out. Radio was an exciting new medium and curious people soon found out they could assemble radio transmitters at home. Interest by amateurs in building radio transmitters led to a situation in which several people would want to transmit at the same time, with no provision in force to keep signals from interfering with one another. Unlike today's broadcast band, which has much greater capacity, only a few frequencies were set aside for broadcasting; so a great deal of sharing had to take place.

Zenith Ruling

Herbert Hoover was Secretary of Commerce when the airwave crowding became intolerable. In 1923 Hoover decided to do something about radio interference. He claimed the 1912 law gave him the power to refuse to grant a license, and refuse he did. A federal court reversed Hoover's action saying he had no discretion and his duty to issue a license was "mandatory" (*United States v. Zenith Radio Corporation et al.*, 1926). After the "Zenith" ruling people who were

> **Section 8.** (Powers of Congress) The Congress shall have power
>
> To lay and collect taxes, duties, imposts and excises, to pay the debts and provide for the common defense and general welfare of the United States; but all duties, imposts, and excises shall be uniform throughout the United States;
>
> To borrow money on the credit of the United States;
>
> *To regulate commerce with foreign nations, and among the several States, and with the Indian tribes;*
>
> To establish an uniform rule of naturalization, and uniform laws on the subject of bankruptcies throughout the United States;
>
> To coin money, regulate the value thereof, and of foreign coin, and fix the standard of weights and measures;
>
> To provide for the punishment of counterfeiting the securities and current coin of the United States;
>
> To establish post offices and post roads;
>
> To promote the progress of science and useful arts by securing for limited times to authors and inventors the exclusive rights to their respective writings and discoveries;

Figure 3–2
Congress gets its authority to regulate broadcasting from the *commerce clause,* Article 1, Section 8, of the U.S. Constitution.

broadcasting began to do whatever they desired, switching frequencies and adjusting power output at will. Hoover then took a different approach. He had been calling yearly meetings to discuss problems in broadcasting. He used some of the information he gained in these meetings to propose legislation, which failed in Congress.

Airwaves for Public Benefit

Hoover used his Fourth Radio Conference in 1925 to set forth a theory concerning the regulation of broadcasting. He said the airwaves were *a public medium which must be used for the public benefit.* Hoover once again tried unilaterally to regulate broadcasting, and he was soundly defeated in the courts. Despite the court defeat his theory that "public airwaves be used for public benefit" persisted, and it was embodied in both the Radio Act of 1927 and the Communications Act of 1934.

The problems of interference and failure to abide by government instructions finally became so severe that Congress thought they had to do something about broadcast regulation. Members of Congress got a great deal of support from broadcasters, who were now *asking for government regulation to end the chaos on the airwaves.*

Radio Act of 1927

The 1927 Act set the basic philosophic tone for American telecommunication regulation. Many of the concepts introduced in the 1927 Act remain a part of today's telecommunication law. Hoover's idea of the airwaves being a public resource, something like water, was written into the 1927 law. Hoover's concept set the tone for the "scarcity theory" which states the radio spectrum is a scarce resource which must be wisely used for public benefit by franchisees who can lose this privilege if they abuse it. Also the phrase, *"public interest, convenience and necessity"* in the 1927 law became a basic standard for judging administrative actions.

Most important, the 1927 law created an independent regulatory body, the five-member Federal Radio Commission (FRC), to oversee broadcasting. The FRC was given the job of deciding who would receive a limited time license to use the public airwaves. The FRC was empowered to regulate all forms of radio transmission, but it focused on broadcasting because this is where the greatest problems were. The FRC worked to clear up the interference problem by making broadcasters abide by frequency, power, and time restrictions.

KEY IDEAS IN THE RADIO ACT OF 1927

1. The application of the "public interest, convenience and necessity" standard.
2. Freedom of speech under the First Amendment applied to broadcasting, but political candidates had to be treated in such a way that no one was shown favoritism.

3. Monopoly would not be tolerated in broadcasting.
4. The FRC had the power to regulate programming, licensing, and renewal of broadcast facilities. Regulation of programming, however, did not mean censorship.
5. The Scarcity Theory was implemented saying the airwaves and frequencies are limited and finite and therefore must be regulated and held in the public trust.
6. The key to the power to influence programming lies in two items, licensing and renewal.

The 1927 Act also contained provisions for the inspection of broadcast facilities and for the suspension of operator licences for violation of regulations. Both are powerful threats. The inspection could result in a fine or loss of license for the licensee. Engineers, or operators, had to secure licenses from the FCC.

The FRC Goes to Work

The FRC did not wave a magic wand and instantly clear the airwaves of interference. It set about classifying frequencies, moving some stations, putting others off the air, and refusing to renew the licenses of others.

The FRC went through a series of drawn out court fights in defense of the 1927 Act, which led to precedent-setting decisions. Many of the provisions contained in the 1927 Act were carried over to the 1934 Act, so that the precedents held and made federal regulation of broadcasting stronger.

PRECEDENT-SETTING CASES

Dr. Brinkley

One of the leading cases involved *Dr. John Brinkley,* who claimed to be a physician. He owned station KFKB in Milford, Kansas. "Doc" Brinkley broadcast a heavy schedule of promotions for his "goat gland" operations and a line of patent medicines. Finally, he drew enough criticism that the FRC refused to renew his license. "Doc" went to court, claiming the FRC was interfering with his First Amendment Rights and was censoring him. In 1931 a federal appellate court said the FRC acted properly and that it was not interfering with an applicant's First Amendment Rights when it used his prior record as a broadcaster as rationale for not renewing a license. (Cases from the FRC were referred immediately to the Federal Appeals Court rather than originating in a Federal Circuit Court.)

Reverend Schuler

A 1932 case centered on a station in Los Angeles, California. *The Reverend Bob Schuler* of the Trinity Methodist Church South broadcast over his station, KGEF. Schuler strayed from the text and devoted a great deal of time to defaming various groups, including the Los Angeles Police Department and almost anyone who took issue with his ideas. Again, the FRC refused renewal. Schuler claimed both the First and the Fifth Amendments in challenging the FRC, but the appellate court said the FRC had not censored, nor had it confiscated his property, so Schuler lost (*Trinity Methodist Church, South v. Federal Radio Commission,* 1932).

Nelson Brothers

A case referred to as the *Nelson Brothers case* set an important precedent. *The precedent said the FRC had the right to choose between two "mutually exclusive" applicants.* In the Nelson case one applicant wished to serve the city of Gary, Indiana, while the Nelson brothers wished to serve metropolitan Chicago (which isn't far from Gary). The FRC decided Gary was underserved and granted the license to the Gary applicant. The court upheld the FRC's right to make such a choice. *The simple concept of choosing the applicant who best serves the audience has been the foundation of a great percentage of the regulatory decisions by the FRC and later the FCC.*

Figure 3–3
Cases involving disputes with FRC decisions move directly to the Court of Appeals, bypassing the Federal District Court. The final decision rests with the U.S. Supreme Court, provided a Constitutional issue can be demonstrated.

THE COMMUNICATIONS ACT OF 1934

The Rationale for the Communications Act of 1934

From the previous discussion, it is hard to see why Congress did away with the Federal Radio Act of 1927 and passed the Communications Act of 1934. One reason the new law was passed was that President Franklin Roosevelt felt that a broader law was needed to regulate other aspects of telecommunication.

Common carriers such as telephone companies and satellite transmission firms transmit communications from point to point, without altering their content. Prior to the 1934 Communications Act, the Interstate Commerce Commission regulated common carriers sharing some of the regulation with the FRC, the White House, the Post Office, and state agencies. President Roosevelt decided that national communication policy needed to be controlled by one entity. He proposed a bill to Congress, which eventually passed as the Communications Act of 1934.

The Communications Act vested the responsibility for regulating broadcasting and the other telecommunication services in the *Federal Communications Commission (FCC)*.

The Substance of the Act

If you wished to find and read the Communications Act of 1934, as amended, you would seek out Title 47 of the United States Code. The United States Code is the name given to the laws which govern the country as a whole.

The Communications Act of 1934 has six primary sections. The first section, Title I, gives the purpose of the Act and deals with the powers, organization, and duties of the Federal Communications Commission. Title II deals with common carriers such as a telephone company or Western Union (a telegraph company). Title III is a four-part title devoted to radio. (Even though the Act was amended to include references to television and other media, the word radio is the operative broadcast word in the name of Title III.) Its subparts cover the following: (1) radio licensing and regulation, (2) shipboard radio, (3) radio on ships which carry passengers for hire, and (4) noncommercial educational broadcasting. Title IV describes procedural and administrative procedures. Title V sets penalties for violation of FCC rules, and Title VI outlaws the unauthorized interception of certain communications and gives the Presi-

Code of federal regulations

Telecommunication

47

PARTS 70 TO 79
Revised as of October 1, 1987

CONTAINING
A CODIFICATION OF DOCUMENTS
OF GENERAL APPLICABILITY
AND FUTURE EFFECT

AS OF OCTOBER 1, 1987

With Ancillaries

Published by
the Office of the Federal Register
National Archives and Records
Administration

as a Special Edition of
the Federal Register

Figure 3–4
Among standard books which could be on any telecommunication manager's desk are Parts 0–19 and 70–79 of Title 47 of the Code of Federal Regulations, published by the Office of the Federal Register. The Communications Act and the FCC Rules and Regulations can be ordered from the Superintendent of Documents in Washington, D.C.

dent emergency powers to invoke in case of war or other national emergency.

In writing the 1934 law Congress affirmed the existing structure of broadcasting in the United States as *a privately owned broadcasting system which uses publicly owned spectrum space.*

Wide Powers of the Act

The Communications Act of 1934 is a comprehensive measure that gave the newly created Federal Communications Commission wide powers. The FCC was given authority to regulate interstate and international radio communication as well as interstate and international wire communication. *The act defines radio communication as, "transmission by means of radio of writing,*

signs, signals, pictures, and sounds of all kinds, including all instrumentalities, facilities, apparatus, and services (among other things, the receipt, forwarding, and delivery of communications) incidental to such transmission." (Title I, Section 3b). Wire communication is defined in Title I, Section 3a.

The Communications Act of 1934 retained some of the basic philosophical ideas of the 1927 Act. It called for a broadcasting system which would be privately owned but publicly regulated by a bipartisan commission, which would use *"the public interest, necessity and convenience"* as its measure of performance. As a regulatory agency, the FCC was instructed to promulgate rules that carried out the intent of the 1934 Act. Using the *"checks and balances theory,"* Congress wrote into the law that the president would appoint the commissioners and the federal courts would resolve FCC decisions which were contested.

A regulatory agency is given authority to make rules that carry out the legislative *intent* set forth in the enabling legislation creating the agency. The federal courts, particularly the U.S. Supreme Court, are frequently called upon to rule whether or not the concepts in the 1934 law are properly interpreted in the *FCC Rules and Regulations*.

Some Provisions of the 1934 Act

No censorship. All broadcasters are protected by the First Amendment to the U.S. Constitution. The Communications Act included wording which made the First Amendment apply to broadcasting and forbade the FCC (in Section 326) from censoring broadcasts. The First Amendment to the U.S. Constitution specifically says Congress shall make no law infringing on "freedom of the press" and "freedom of speech." The U.S. Supreme Court was asked if this wording included broadcasting, and the court replied affirmatively.

No person has ownership of frequencies. Although free competition for audience and revenue is permitted, the Act clearly points out that broadcasters do not own their frequencies and can use them for only a limited time subject to renewal by the FCC.

The Federal Communications Commission

The FCC's real power came from the authority the 1934 Act gave it to classify broadcast sta-

United States of America
FEDERAL COMMUNICATIONS COMMISSION
NON-COMMERCIAL EDUCATIONAL

FM BROADCAST STATION LICENSE

File No. BLED-840911BY
Call Sign: WAMF

Subject to the provisions of the Communications Act of 1934, as amended, treaties, and Commission Rules, and further subject to conditions set forth in this license, the LICENSEE

FLORIDA A AND M UNIVERSITY

is hereby authorized to use and operate the radio transmitting apparatus hereinafter described for the purpose of broadcasting for the term ending 3 a.m. Local Time: FEBRUARY 1, 1989

The licensee shall use and operate said apparatus only in accordance with the following terms:

1. Frequency (MHz): 90.5
2. Transmitter output power: 0.100 kw
3. Effective radiated power: 0.160 kw (H)
4. Antenna height above average terrain (feet): 137 feet (42 meters) (H)
5. Hours of operation: Unlimited
6. Station location:
7. Main studio location: Tallahassee, Florida
 Tucker Hall, Room 317, Florida A & M University
 Tallahassee, Florida
8. Remote Control point: --
9. Antenna & supporting structure: North Latitude: 30° 25' 38"
 West Longitude: 84° 17' 16"
 CCA FMH-E-2 two section horizontally polarized antenna, pole-mounted at the 63 foot (19 meters) level (C/R-AGL) atop Tucker Hall. OVERALL HEIGHT ABOVE GROUND: 69 feet (21 meters) (without obstruction lighting)
10. Transmitter location: Tucker Hall- Room 317, Florida A & M University
 Tallahassee, Florida
11. Transmitter(s) (See Sections 73.1660, 73.1665 and 73.1670 of Commission's Rules): Type Accepted
12. Obstruction markings specifications in accordance with the following paragraphs of FCC Form 715: NONE REQUIRED
13. Conditions: __

The Commission reserves the right during said license period of terminating this license or making effective any changes or modification of this license which may be necessary to comply with any decision of the Commission rendered as a result of any hearing held under the rules of the Commission prior to the commencement of this license period or any decision rendered as a result of any such hearing which has been designated but not held, prior to the commencement of this license period.

This license is issued on the licensee's representation that the statements contained in licensee's application are true and that the undertakings therein contained so far as they are consistent herewith, will be carried out in good faith. The licensee shall, during the term of this license, render such broadcasting service as will serve public interest, convenience, or necessity to the full extent of the privileges herein conferred.

This license shall not vest in the licensee any right to operate the station nor any right in the use of the frequency designated in the license beyond the term hereof, nor in any other manner than authorized herein. Neither the license nor the right granted hereunder shall be assigned or otherwise transferred in violation of the Communications Act of 1934. This license is subject to the right of use or control by the Government of the United States conferred by section 606 of the Communications Act of 1934.

This license consists of this page and pages

Dated: November 13, 1984
dac

FEDERAL
COMMUNICATIONS
COMMISSION

FCC Form 352-A
January 1980

Figure 3–5
This is the FCC Broadcast License for radio station WAMF at Florida A&M University. The original license must be posted near the station's transmitter. Note that the license lists very specific details about the station's power, tower height above average terrain, and precise tower location.

tions, indicate the nature of their service, grant frequencies, establish coverage areas, assign power and location of transmitters, and take actions to prevent interference. Because the FCC must renew licenses periodically, licensees have to be continually prepared to satisfy the mandates of the FCC.

The Commission—How Many Members?

The FCC consists of five members. Originally it was seven members, but in 1982 Congress reduced the size of the Commission during an

economy move. The President appoints members of the commission, with the consent of the Senate. Appointees serve seven-year terms. No more than three members can be from the same party, with the President having the power to appoint the commission chair. Generally, the combination of the long terms and the mandatory party split deemphasize the Commission as a political arm of the White House. However, the statements and policies put forth for consideration by the chairman often reflect the thinking of the administration in power, but the Commission members do not always go along with the desires of the chairman.

The FCC is organized into four bureaus and eight offices.

The Bureaus of the FCC

1. Mass Media Bureau. This department handles broadcasting and cable. If you were applying for a new station, modifying an existing station, or applying for renewal of a station license, your paperwork would go through the Mass Media Bureau. The few FCC cable regulations are administered by this Bureau. The Mass Media Bureau also deals with matters relating to Low-Power TV, subscription TV, and direct broadcasting by satellite (DBS).

2. Common Carrier Bureau. This bureau determines rates charged by interstate or international common carriers based in the United States. The Bureau licenses common carriers and sets and adjusts rates charged for services. When AT&T is seeking a "tariff increase," (higher rates) you know the matter will be handled by the Common Carrier Bureau.

3. Field Operations Bureau. This bureau issues licenses to radiotelephone and other classes of radio operators. The FCC requires the broadcast station's primary technical person and many people who perform maintenance on transmission equipment to have an FCC General License. Engineers have to pass a government test to qualify for the license. The FCC also issues Operator Permits, which are needed by staff members who take transmitter readings (which usually means air personalities and some newspeople). The bureau is also responsible for on-site inspections of new and existing telecommunication facilities, and can issue citations for violations. It can begin legal proceedings if severe violations are found.

4. Private Radio Bureau. This bureau oversees such services as citizens band radio, amateur radio, paging systems, cellular telephone, and various two-way radio systems, such as those used in emergency vehicles, business vehicles, and taxis.

The Offices of the FCC

1. Office of the Managing Director. This office provides managerial leadership to the FCC staff and carries out the directives of the Commission. The Office of the Secretary, housed in the Office of the Managing Director, is responsible for issuing call letters. These are the four-letter "names" given to stations. There are a few older stations, which have three-letter designations because they had them before the four-letter rule went into effect. All stations east of the Mississippi River begin their call signs with the letter W, those west of the Mississippi River begin their call signs with the letter K. There are a few exception, "grandfathered" stations, which had the opposite designation for a long time, such as KDKA in Pittsburgh, Pennsylvania, and WSUI in Iowa City, Iowa. The FCC consults its records to make sure the call is available, or if not, if one of the alternate sets of call letters proposed is available. Many stations try to spell something with the call sign, such as WARE in Ware, Massachusetts, WCBS in New York (owned by CBS), or WTAL in Tallahassee, Florida.

Bureaus:	Mass Media Bureau
	Common Carrier Bureau
	Field Operations Bureau
	Private Radio Bureau
Offices:	Office of the Managing Director
	Office of Engineering and Technology
	Office of General Counsel
	Office of Plans and Policy
	Office of Administrative Law Judges
	Office of Public Affairs
	Office of Legislative Affairs
	Review Board

Figure 3–6
The FCC is organized into four *bureaus* and eight *offices.*

2. Office of Engineering and Technology. This office evaluates technologies, cooperates with international allocation bodies, conducts scientific and technical studies, advises the Commission on technical matters, and maintains liaison with other government agencies.

3. Office of General Counsel. This is the legal office serving the FCC.

4. Office of Plans and Policy. This office is the FCC's "think tank" in which technologies and policies are evaluated and analyzed. Staff members review all proposed FCC actions for policy implications.

5. Office of Administrative Law Judges. This office conducts all adjudicatory cases within the FCC structure. It recommends solutions to disputes including contested applications or licenses.

6. Office of Public Affairs. This office attends to consumer and media inquiries and releases news to the media.

7. Office of Legislative Affairs. This office maintains liaison with Congress over pending legislation.

8. Review Board. This board is comprised of Commission employees who review all actions of the Administrative Law Judges, unless the Commission directs otherwise. Some disputes are resolved at the Review Board level, although appeal to the Commission is available.

What the FCC Does

The FCC interprets laws passed by Congress and treaties that the United States is party to, and then makes regulations based on these laws. The regulations are enforced by the FCC; even the first appeals and objections are heard by the FCC.

FCC and Administrative Law

The important thing to remember about regulatory agencies is that they are given the power to make rules that have the force of law. This is known as *administrative law*.

The FCC is a quasi-judicial organization in that it enforces and amends administrative law. Federal employees called *Administrative Law Judges* conduct inquiries for the FCC. Appeals are heard by the actual Commission. Only after an issue has been through all the administrative

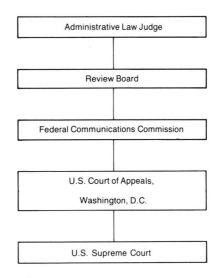

Figure 3–7
The route of a complaint from Administrative Law Judge to the Supreme Court.

steps within the FCC is it eligible for consideration by the federal courts. A case taken to the federal courts automatically goes to the U.S. Court of Appeals because the FCC has already conducted a hearing similar to one which would be conducted in the U.S. District Court. The Appellate Court considers the case on the basis of the factual record that was developed during FCC hearings. If a dissatisfied petitioner can find a cause for consideration of a constitutional issue, the decision of the appellate court can be reviewed by the U.S. Supreme Court.

The FCC Can Impose Penalties

The Commission has the power to impose fines, issue "cease and desist" orders, shorten license periods, or deny licenses. Fines and short licenses have been used to deal with nonconforming situations. Relatively few stations have had their licenses revoked.

If the FCC desires, it may use several strong measures to force a broadcast station into line. They include:

Revocation or nonrenewal of the license. This is the most severe penalty. It is seldom used and almost automatically involves the Commission in a long court fight because the licensee being disciplined stands to lose a valuable business franchise.

Short-term renewal. The idea is to tell the licensee to change the way the station is being

run in a relatively short period of time or lose the license.

Fines up to $20,000. Fines have been fairly common. They can be small and almost routine for minor violations of rules, especially technical violations found during on-site inspections, or major fines for serious violations, which are usually discovered after a complaint has been lodged against the broadcaster.

A cease and desist order. This is legal language for "stop the practice now or severe action will be taken."

A letter of reprimand. The threat here is that the letter, if combined with other detrimental information in the station's file, could be used as a basis for nonrenewal of the licensee.

Why Penalties are Imposed

Obscenity. Federal law under Title 18, Section 1464 of the U.S. (criminal) Code, prohibits broadcasting of obscenity, but it is not clear what is obscene. The Supreme Court uses what it calls a "community standard" to measure obscenity, which means what is not acceptable in Pittsburg, Kansas, might be perfectly acceptable in San Francisco. The FCC did win one important case when the U.S. Supreme Court ruled that radio station WBAI-FM in New York City (a noncommercial radio station owned by the Pacifica Foundation) *did* broadcast obscenity when it aired a George Carlin record. Although the announcer warned listeners about the possible offensive nature of the content of the recording, it was broadcast in the afternoon when children might be listening. The FCC received one complaint from a parent who said his child heard the "seven dirty words" uttered by Carlin and the Commission acted on the complaint applying its rule against obscene broadcasts, which can bring to bear a heavy fine and a prison sentence. The Supreme Court, in ruling in favor of the FCC, noted that the record was broadcast during a time when a child could have easily heard the broadcast. Although the WBAI case supported the FCC's power to deal with obscenity, the court's decision was so worded as to raise the question whether it would rule for the FCC in another but slightly different set of circumstances (*FCC v. Pacifica Foundation* 1978).

How obscenity is defined at the FCC. The FCC continues to prohibit the broadcast of "obscene" material at any time. The Commission's defini-

tion of obscenity is based on the obscenity test in *Miller v. California*, 413 U.S. 15 (1973). The three parts to the Miller test are:

1. An average person, applying contemporary community standards, must find that the material, as a whole, appeals to prurient interest.
2. The material must describe, in a patently offensive way, sexual conduct specifically definend by the applicable state law.
3. The material, taken as a whole, must lack serious literary, artistic, political, or scientific value.

Frankness and obscenity. The trend to deliberate frankness on some TV talk shows and many radio call-in programs has caused a great deal of concern for station owners and managers who must protect their licenses. Radio stations customarily use a delay device so that about seven seconds elapse between the time a caller speaks and the time the words are heard on the air. This is designed to permit the host or producer enough time to cut the caller off it necessary. Some TV talk shows use the same device when they accept telephone calls from viewers.

Indecency complaints. The FCC was called upon in 1985 to decide what to do about station KTTL in Dodge City, Kansas. The licensee permitted anti-Semitic and racist comments to be broadcast periodically over a two-year period. A request was filed asking the FCC to revoke the station's license, and in April 1985 the commission said: *all broadcast speech is protected under the First Amendment, no matter how offensive it may be to listeners.* The FCC essentially said: if you don't like it don't listen, or create enough pressure locally to stop the practice.

The FCC shook up the industry in April 1987 when it reminded broadcasters it had the authority to regulate "indecent" material. Up until that moment, the Commission had been using comedian George Carlin's so-called seven dirty words, taken from the WBAI case, as the standard to judge what speech was indecent.

In 1987 the FCC threatened action against three licensees, one a commercial radio station, another a student-run radio station, and the third a Pacifica noncommercial "public" radio station. The agency defined indecency as "Language or material that depicts or describes, in terms patently offensive as measured by contemporary community standards for the broadcast medium, sexual or excretory activities or organs." The FCC also said material meeting that description

would be actionable if there was a reasonable risk that children might be in the audience. The Commission did not define *children,* but legal authorities suggest the term might include anyone younger than 18 years of age. In 1988 Congress ordered the FCC to enforce the restrictions of 18 USC §1464 saying that obscenity laws must be in force 24 hours per day.

The FCC action hit the radio industry hard because a programming trend was sweeping the country in which air personalities "talked dirty."

In 1988 the Commission issued an order penalizing an independent TV station in Kansas City for showing the film *Private Lessons* during prime time. The FCC indecency action was expected to be appealed to the federal courts.

Other Criminal Law Implications for Broadcasters

Federal Criminal Laws are incorporated into Title 18 of the U.S. Code. There are four areas that have criminal law implications for broadcasters. They are obscenity, lotteries, double-billing, and payola.

Section 1464, U.S. Code Title 18, empowers the FCC to revoke the license of a broadcaster who broadcasts obscene or indecent material. Violation of the statute carries a fine of not more than $10,000 or a prison term of up to two years.

Lotteries

If we move to Section 1304 of the Criminal Code we find that broadcasters may not broadcast lotteries or information about lotteries. The penalty is a fine of $1,000 and/or one year's imprisonment for each day the offense occurs.

Broadcasters do not have to worry about broadcasting advertising or information about lotteries run by their state or adjacent states because these public lotteries were exempted by the law.

What broadcaster *do* worry about is stepping over the fine line that exists between a contest and a lottery. Broadcasters have potential problems every time they air a promotional announcement for the station or a public service agency, or a commercial for an advertiser which involves a contest. Any contest is potential trouble for a broadcaster if it contains all *three of the legal elements for a lottery: prize, chance, and consideration.* A prize is something of value, chance means choosing the winner by lot, and consideration means any expenditure such as

going to a store and buying something. You will notice many contests have a disclaimer, "no purchase necessary." Some contests you enter by submitting an entry blank indicate that you do not have to use the official entry blank (which you can only get by buying the newspaper or taking it off a display in a store).

The basic lottery rule is: Never put anything on the air which even vaguely sounds as though it incorporates the elements of prize, chance, and consideration *until you have consulted with your management or legal counsel.* Lotteries of this sort are a constant problem because program promotions, public service announcements, and commercials are frequently built around contests by people who are unfamiliar with the lottery law, and their lack of knowledge can lead to serious trouble.

Double-Billing

Double-billing is a practice which can result from the use of cooperative (or co-op) advertising. In a co-op advertising situation, a national or regional manufacturer or supplier will pay part of the cost of commercials if dealers or distributors will pay the remainder. Double-billing occurs when the station and the local sponsor conspire to report a higher advertising charge than actually occurred. The manufacturer gets stung for a big bill, while the local sponsor either advertises free or splits a cash gain with the station. The FCC strictly prohibits double-billing and will take punitive action against a station if it discovers double-billing has taken place.

Payola

Violation of Section 508 of the Communications Act, which deals with "payola" practices, can result in a $10,000 fine and/or one year in jail. There was a major "payola" scandal in the broadcast industry years ago when it was discovered that record companies were making cash payments to big-name disk jockeys to get their artists' records played. A similar practice, called "plugola" occurs when the air talent takes money (or anything of value) for mentioning a business without the station reporting the payment as a commercial. Stations can get into trouble if they don't clearly identify their financial stake in events or issues they support through on-air mentions.

Other Illegal Practices

There are other business practices that are illegal. Falsification of records indicating commercials

have been aired when they haven't can lead to legal problems. Another practice which will draw FCC attention is "clipping" a network program. Clipping occurs when a station cuts out of a network program early to squeeze in additional commercial time. Clipping can also occur when a station covers a network commercial with one of its own without permission.

REGULATIONS IN BROADCASTING

The Fairness Doctrine

The early literature of broadcast regulation makes reference to "fairness" and "balance." The concept was introduced in the 1927 Radio Act, and a 1929 ruling by the Federal Radio Commission (Great Lakes Broadcasting Inc.) required broadcasters to air *contrasting views on public issues.* The 1934 Communications Act required broadcasters to serve the *"public interest."*

The Doctrine was developed in the aftermath of a 1941 FCC ruling *(in re: Mayflower Broadcasting Corp.,* WAAB, 1941). Radio Station WAAB in Boston had editorialized in favor of a political candidate, triggering a petition to the FCC that resulted in the "Mayflower Decision." The Commission ruled that *"broadcasters shall not advocate." This was a direct prohibition on editorializing by broadcasters.*

The Mayflower Decision was vigorously protested by broadcasters, and after years of discussion, the FCC in 1949 issued a report entitled "In the Matter of Editorializing by Broadcast Licensees." The report said that broadcasters had an affirmative responsibility to provide a reasonable amount of airtime for the discussion of public issues. The report also required broadcasters who aired controversial topics to give opponents a reasonable opportunity to present contrasting views.

This report and later FCC actions combined to create the *Fairness Doctrine,* which established rigid and sometimes complicated requirements for meeting the controversial issues standard.

Two closely spaced federal court decisions ruled that the Fairness Doctrine was constitutional. Attorney John Banzhaf, III, in 1967 complained to the FCC that WCBS-TV in New York City would not give time for antismoking announcements. In 1969 the U.S. Court of Appeals in Washington, D.C., agreed with the FCC that stations which carried cigarette commercials had

to carry free public service announcements warning of the dangers of smoking. Later Congress passed a law that banned all cigarette advertisements from the broadcast media.

In 1969 the U.S. Supreme Court ruled that the Fairness Doctrine and the Personal Attack Rule (requiring notification to people who were "attacked" on the air) were constitutional *(Red Lion Broadcasting v. FCC)* and told a right-wing radio evangelist, Billy James Hargis, that he had to provide free time to an opponent of his views.

The Supreme Court in 1973 said broadcasters could reject all opinion advertisements individuals or groups desired to air, saying there is no private right to purchase airtime *(CBS v. Democratic National Party).* In 1975 the Supreme Court forced WHAR in Clarksburg, West Virginia, to cover a "controversial issue of public importance." The issue was strip mining. In another case *(CBS v. FCC,* 1981), the high court ruled that candidates for public office had privileged access to the air waves during campaign season.

During the 1980s some organizations began to question why broadcasters were limited by the legal and bureaucratic boundaries of the Fairness Doctrine, while newspapers and magazines could express and repeat opinions without having any legal concerns. Up to this point, the scarcity theory had been cited as the rationale for government regulation of broadcasters' treatment of controversial public issues. Opponents of the Doctrine pointed to the large number of broadcast stations on the air in the early 1980s, saying that although the total number of available frequencies was limited, there were plenty of "voices" (stations) broadcasting and the sheer number of stations would stimulate wide and varied discussion of public issues.

In 1983 the Commission asked Congress to repeal the doctrine. Congress did not act; so, in August 1985 the FCC said the Fairness Doctrine no longer served the public interest, but the Commission would continue to enforce it. In its report the FCC mentioned Congress' "intense interest" in preserving the Doctrine, as one reason for its decision to continue enforcement. The FCC had maintained that a dramatic rise in the number of radio, television, and cable outlets since 1949 had eliminated the need for requiring every broadcaster to present balanced editorial views.

A landmark in the fight over the Fairness Doctrine was the Meredith Corporation case. In 1984 the FCC said a TV station in Syracuse, New York, owned by the Meredith Corporation, had violated the Fairness Doctrine by running

commercials endorsing a nuclear power plant while failing to air contrasting viewpoints.

In January 1987 the Court of Appeals remanded the Meredith case to the FCC, saying the Commission had to consider alternatives to the Fairness Doctrine and report to Congress by September 30, 1987. Essentially, the court said that federal officials take an oath to uphold the U.S. Constitution, and if they think a policy such as the Fairness Doctrine is unconstitutional, then to not do something about the Doctrine would violate their oath.

While Meredith was working its way through the courts, Congress, in the Appropriations Act of 1986, also directed the FCC to give Congress a report on alternatives to the Fairness Doctrine by September 30, 1987. One issue being debated was whether or not the Fairness Doctrine was included in the Communications Act of 1934 or was a creation of the FCC.

In December 1986 the Court of Appeals ruled that the Fairness Doctrine was *not* codified by Congress, and could be changed or abolished by the FCC. In February 1987 the FCC asked for comments on alternatives to the Fairness Doctrine.

Some members of Congress who thought the Fairness Doctrine offered legitimate protections to minority or unpopular views became alarmed that the Doctrine might be eliminated. In June 1987 Congress passed a law making the Fairness Doctrine law, but later that month President Ronald Reagan vetoed the legislation, saying the Doctrine did not serve the public and had a chilling effect on broadcasters by discouraging editorializing and the airing of controversial topics. Congress was unable to repass the bill over the President's veto.

The FCC reported to Congress in August 1987, saying none of the possible alternatives to the Fairness Doctrine would solve problems having to do with government regulation of the content of broadcasting. Separately, in replying to the Meredith case order, the FCC abolished the Fairness Doctrine, saying it violated the First Amendment rights of broadcasters.

As the Bush Presidency began, Fairness Doctrine supporters in Congress were preparing for another attempt to write the Doctrine into law.

Section 315: Broadcasting and Politics

The key provisions of the 1934 Act pertaining to political broadcasting are contained in *Section 315.* Congress wanted to be sure the owners of broadcast stations could not influence elections, especially by excluding some candidates from using their facilities while opening their microphones to other candidates. Section 315 states:

> If any licensee shall permit any person who is a *legally qualified candidate* for any public office to *use* a broadcasting station, he shall afford *equal opportunities* to all other such *candidates* for that office in the use of such broadcasting station: Provided, that such licensee shall have *no power of censorship* over the material broadcast under the provisions of this section. No obligation is imposed under this subsection upon any licensee to allow the use of its station by any such candidate.

This is an excerpt from the opening language of Section 315. You should read the whole Section to fully understand its impact. The political broadcasting rules derived from Section 315 are important to many areas of broadcast station's activities including news, public affairs, programming, advertising sales, community affairs, and the editorial department.

Because a broadcaster may not censor a political broadcast, the broadcaster cannot be held liable for what is said during the political broadcast. The candidate, however, can be sued for libel or slander.

Section 315 and the Legally Qualified Candidate

Even though the legal language is difficult to read, you can easily spot a key phrase in Section 315. It is *"legally qualified candidate."* What if you were the manager of a radio station and someone who was totally unknown to you came in and said she was a "legally qualified candidate" and wanted to buy political airtime on the station? Some of the qualities needed to be a legally qualified candidate include the following:

1. *A public announcement of the person's candidacy.*

2. *The person must have met state requirements which make it possible for people to vote for them.*

3. *The person must be eligible to serve if elected.*

The public announcement test is important because many people assume an incumbent is planning to run again or a person may say he or she is "thinking" about running. The test is the *actual public announcement* that one is a candidate.

Qualification rules differ somewhat from state to state especially for write-in candidates. Thus, the candidate must meet the state standards for qualification.

A person could be ineligible to serve if elected if he or she were too young, not a citizen of the United States (for offices which demand citizenship), or a convicted felon whose civil rights have not been restored.

Equal Opportunity Provision of Section 315

A common misunderstanding that surfaces during almost every political campaign is that broadcasters owe "equal time" to all candidates. This is not true. The most the law demands is that all candidates for the same office be given *an equal opportunity*.

A broadcaster may choose to ignore elections and neither sell nor give time to candidates as long as they are *not candidates for a federal office*. However, if a broadcaster gives or sells time to one candidate, then any other bona fide candidate *for that office* must be given an equivalent opportunity to buy time or appear.

Spokespersons under Section 315

There is a distinction between the *candidate* and *people speaking for the candidate*. A political ad which does not show the candidate, have the candidate's voice incorporated into it, or is voiced by a "spokesman" for the candidate is not covered under Section 315.

"Zapple Doctrine"

Supporters of the candidate are covered by the *Zapple Doctrine*, which complements Section 315, saying that if a broadcaster permits supporters of one candidate to have air time, the broadcaster must make "comparable time" available to supporters of opposing candidates. The 1970 FCC policy gets its name from a former Senate aide, Nicholas Zapple, who wrote to the FCC asking for clarification of the status of supporters. The Zapple Doctrine was restated in a 1972 FCC policy report on political broadcasting.

Use and Section 315

The word "use" contained in Section 315 causes severe problems. If the president gives a foreign policy speech while he is running for reelection, is this a "use" under Section 315? The answer is not simple. The networks have dealt with this problem by measuring the circumstances. When there is an obvious foreign policy crisis, then it is clear the president may have to make a public statement. Otherwise the speech might be use

of the office and its inherent access to the media to further the president's campaign. When this appears to be the case the networks routinely offer the opposition party time for a reply.

Although the political broadcasting regulations contained in Section 315 are strict and are of great concern to the sales and program departments, they have little effect on the staff in the newsroom.

Impact of Section 315 on News

You might think that a news director would have to be extremely concerned about which politicians appeared on the news during a campaign, but there are some protections in the law which allow news reporters to cover political campaigns without fearing Section 315.

The Four "Bona Fides"

There are four exclusions relating to Section 315, which allow the news staff greater flexibility than other departments within the station.

The news department does not have to grant an equal or equivalent opportunity to opponents when the appearance of the candidate was part of:

A Bona Fide news story. A mayor who is running for reelection does and says many things which relate directly to his or her official responsibilities. For instance, anything he or she says while presiding over the City Council meeting is bona fide news.

A Bona Fide news interview. If you invite the mayor/candidate to appear on a long-running, regularly scheduled news interview program, this is fine. You have a problem, though, if you have just introduced a new interview show or if you fail to *invite* all the candidates when you plan to broadcast a *special* election interview program.

A Bona Fide news event. The mayor participates in the dedication of the new urban plaza at the downtown urban renewal site. He or she is doing something mayors do, even though they get publicity as a result of the public appearance.

A Bona Fide news documentary. The mayor is interviewed as part of a documentary on public housing. You need to get the "official" view of the city administration, and this logically comes from the mayor.

All of the "bona fide" exceptions resulted from a 1959 amendment to the 1934 Act.

Public Affairs and Section 315

One area which causes a great deal of uneasiness for station management is public affairs program appearances by candidates. Stations which set aside time for interview programs on which the candidates appear have to be careful to invite each candidate in writing and follow up on any candidates who do not respond so that management can document that everyone was given an equal opportunity to appear.

Free Commercials Included in Section 315?

The way Section 315 reads, if the broadcaster gives free time to one candidate for a specific office, then all other candidates for that office are entitled to free time. If a broadcaster sells time to a candidate, an equal opportunity to buy a similar value of commercials must be available to any other candidate for the office. Nothing says the broadcaster has to give away time if the opposing candidate cannot afford to buy air time. Section 315 does not apply to ballot issues such as referenda or annexation votes.

Section 312

Members of Congress realized they could have difficulty getting airtime in some communities, especially if there were only one or two broadcast stations; so, they amended Section 312 of the Communications Act in 1972 to permit the commission to revoke a license if a licensee refused to permit reasonable access or purchase of a reasonable amount of time by a legally qualified candidate for a federal office. This means a broadcaster could choose to ignore the election for county clerk, but he or she must permit candidates for Congress or the presidency and vice-presidency to buy time.

Political Commercials

A broadcaster is free to sell advertising time to a legally qualified candidate. At one time broadcasters charged politicians premium rates based on the short period during which they would advertise. Some broadcasters were simply applying the old adage of charging "what the traffic could bear." This practice was expensive, and possibly exclusionary to candidates with meager budgets, particularly women and minorities.

Lowest Unit Charge

In 1971 Congress amended Section 312 and said that broadcasters could charge political candidates only the *"lowest unit charge"* they charge advertisers who buy the highest and most frequent volume of commercials. (This rule holds only for specific time periods preceding the election.) The rule applies even if the candidate does not buy the minimum number of spots required to earn the lowest rate.

The FCC Grants Licenses

A primary duty of the FCC is to grant and renew broadcast licenses. The Commission established a list of criteria, which is used to help it determine which applicant is best qualified to receive a license. This list was first compiled by the FCC in 1965 and includes the following:

1. Diversification. Does the applicant own other media outlets in the area? The Commission's general policy is to promote diversification, so it will favor the applicant who does not own media outlets in the area, but it does permit ownership of more than one type of facility in one geographic area in limited situations.

2. Participation by owners. The Commission looks more favorably on owners who will participate in running the station on a day-to-day basis.

3. Programming for the community. The greater the amount of time the applicant proposes to devote to public affairs, information, or educational programs, as opposed to entertainment, the better the Commission likes the proposal. This requirement has been deemphasized under the deregulatory concept.

4. Prior Record. Does the applicant have either a very good or very bad record as a broadcaster/owner?

5. Spectrum Use. Is the proposed station an efficient use of the spectrum? (Would putting a station in location A cause interference or deny eventual service in location B? Another spectrum issue is, would the granting of a new station overburden the market's ability to support commercial broadcast facilities?)

6. Character. A test of the applicant's character. Has he or she been convicted of a serious criminal offense?

7. Other. A catch-all category. This might include questions relating to the foreign nationality of the applicant's minority stockholders.

(The majority stockholders must be U.S. citizens.)

In addition to these general guidelines, applicants must meet specific legal, financial, and technical requirements. These requirements are specific but have been undergoing reevaluation and are best studied by referring directly to the FCC Rules and Regulations.

Because of the technical nature of the application process, licensee-seekers usually employ an attorney and an engineering consultant familiar with FCC procedures to assist with technical details.

Applicants for AM stations actually have to conduct a study to see if it is possible to put a station on the air on a specific frequency in the location of their choice. Applicants for FM and TV licenses have to select from channels the FCC has already allocated, which have not yet been licensed. The application is actually for a Construction Permit (CP) for a station. The license is not issued until all FCC specifications are met and the facility is inspected by an FCC representative.

Applicants are required to post notices in local newspapers when they file applications, and the FCC permits other parties to then file competing applications.

Recently, the FCC has adopted a "lottery" approach for issuing licenses for some high-demand locations. Once the applicants are screened for basic eligibility and adjustments are made to give a slight advantage to female- or minority-owned applicants, a drawing is held for the actual CP.

The Next Steps

If there are problems or contested applications, the FCC may refer the application to a hearing before an Administrative Law Judge (ALJ). *Comparative hearings* can be held when there is more than one applicant for a frequency. Comparative hearings can also be held when a renewal is contested.

After the ALJ issues a finding, the matter can go to the Commission, its Review Board, or the courts, depending on the outcome.

Station Construction Rules

Construction must be completed in 12 months for AM, FM, translator, and ITFS educational microwave stations. (Translators are low-power repeaters, which extend the coverage of a radio or TV station.) Construction must be completed in 18 months for a TV station. Extensions can be sought for completion of construction of a broadcast station but they are not freely given. The licensee can begin equipment tests once construction is completed and the FCC is notified. An FCC inspector then visits the site to certify that all requirements have been met. Then the CP holder applies for the actual license. Program tests may begin as soon as the application for test authority is approved. The FCC forwards a license if all specifications are met.

Sale of a Broadcast Property

Broadcast properties may be sold with the approval of the FCC. A sale involves two separate entities: the license and the physical plant of the station. The buyer is buying the license because without the license the physical plant is virtually worthless. Two stations in different service areas with exactly the same frequency and power can be sold for widely differing prices. For instance, a network-affiliated TV station on channel 2 in Casper, Wyoming, would have a much smaller selling price than the CBS-owned-and-operated channel 2 TV station in New York City. The difference is in the size of the actual and potential audience or how much money the buyer can make.

To consummate a sale the buyer must apply to the FCC, providing information similar to that provided by a construction permit applicant, except that most of the engineering data is omitted because an existing facility is being sold.

Construction permits can also be sold. This frequently occurs when (1) the original applicant runs out of money to get the facility on the air or (2) the original applicant decides the facility won't become profitable in a reasonable period of time. Some buyers prefer to purchase CPs because some of the time-consuming and difficult steps in securing an initial license are skipped when a CP is transferred.

Renewal of Broadcast Licenses

Radio stations must seek renewal of their licenses every seven years, TV stations every five years. If the paperwork is done correctly and no one challenges the station's renewal application, the process is usually automatic, requiring only that the station send in a post card form. Prior to 1981 broadcasters had to apply for renewal of their licenses every three years. In 1981 after extensive lobbying by the broadcast industry Congress changed the term. Broadcasters ob-

jected to the uncertainty of the short license period and pointed out that it was difficult to get bank financing when a company was only assured of operating a station for three years. Media critics often point out that the public was better served by the shorter license period because it made station management more responsive to community needs.

The FCC has the right to make a thorough examination of a renewal applicant's qualifications, but the sheer volume of the Commission's work usually prevents this sort of inquiry unless someone objects to the renewal. In 1966 the U.S. Supreme Court ruled that a citizens' group could have legal standing to contest a license renewal.

Over the past 20 years this decision *(United Church of Christ v. FCC)* has allowed a number of license challenges by groups wishing to alter the make-up of broadcast industry employment and ownership. A series of license challenges supported by the United Church and other reform organizations forced industry adherence to government equal opportunity hiring regulations and created additional educational, job, and promotion opportunities for minorities. Some major license challenges were based on issues such as alleged racism (WLBT-TV, Jackson, Mississippi); discrimination (Alabama ETV stations); and misconduct by the corporation which owned the broadcast licensee (RKO Stations).

Other Regulations of the FCC

Identification

The FCC requires station identifications at stated intervals. It requires that sponsorship of programs and commercial announcements (including political ads) be clearly announced.

Format Changes

There have been several attempts to get the FCC to force stations to abandon format changes. One of the long-running battles had to do with an attempt to change the format of radio station WNCN in New York City from classical to popular music. The fight to prevent the change, led by a group of listeners, ended up before the U.S. Supreme Court, which in 1981 declined to reverse the FCC's policy of letting local market conditions determine station formats. The FCC is not prohibited from denying format changes; it simply has chosen not to force the issue.

Record Keeping

Broadcast stations must keep logs or lists of certain activities. Both radio and TV stations must keep engineering logs which list readings of transmitter functions. These meter readings must be taken by a licensed radiotelephone operator at intervals prescribed by the FCC.

Until relatively recently stations were required to keep program logs, which listed each program, commercial announcement, public service announcement, and promotion announcement, in other words, a minute-by-minute list of everything that went out over the air. As a result of deregulation, radio stations no longer have to keep extensive program logs. TV stations are still required to keep detailed program logs.

Technical Standards

The FCC sets technical standards for the different broadcast services. The Commission prescribes minimum quality limits which are acceptable for each service. It also sets limits of interference between adjacent and distant signals. The equipment used in a broadcast station must be "type accepted," meaning that it meets certain specifications. This is one reason why few consumer-type electronic devices can be used by a broadcast station.

The Commission also requires stations to keep engineering logs, which tell the Commission inspectors if the station's equipment is operating as it should.

Many radio stations are automated, which means that the meters needed to take transmitter readings are located in the control room. This is one reason that most on-air employees of radio stations secure an FCC "restricted permit" which authorizes them to take the readings. Generally, technicians or engineers take meter readings at TV stations.

Personal Attack Rule

If a broadcast attack is made "upon the honesty, character, integrity or like personal qualities of an identified person or group, the licensee shall, within a reasonable time and in no event later than one week after the attack, transmit to the person or group attacked (1) notification of the date, time and identification of the broadcast; (2) a script or tape (or an accurate summary if a script or tape is not available) of the attack; and (3) an offer of a reasonable opportunity to

respond over the licensee's facilities" (47 CFR 73.1920).

These rules do not apply to: (1) attacks on foreign groups or foreign public figures, (2) personal attacks made by "legally qualified candidates, their authorized spokesmen, or those associated with them in the campaign, or other such candidates, their authorized spokesmen, or persons associated with the candidates in the campaign and (3) to bona fide newscasts, bona fide news interviews, and on-the-spot coverage of a bona fide news event."

The response rules also apply to political editorials. The time permitted for notification is only 24 hours, and if the broadcast is planned within 72 hours of the election day, the broadcaster must notify the affected parties enough in advance for them to be able to prepare responses.

Ascertainment

Between 1973 and 1981 the FCC used a requirement called *ascertainment* to encourage certain types and amounts of programming. In 1981 ascertainment was dropped for radio but not for TV.

Ascertainment required stations to conduct a survey of people living in the service area and to interview community leaders in an effort to define a list of "community issues," which the station would then address through its programming. The FCC required stations annually to list 10 community issues, and it published a 19-item list, suggesting areas in which the station might be interested.

Once the ascertainment process was in place, the commission simply compared *promise vs. performance*. Unfortunately, ascertainment created a mountain of paperwork for stations, and was a particular burden to smaller stations. Very small stations were relieved of some of the paperwork because they did not have to do community surveys and report on interviews with community leaders. The assumption was that the operators of a small station in a small community would know the nature of the community's problems and concerns.

In 1984 the FCC loosened TV ascertainment rules by requiring only the submission of quarterly lists of issues and programs that addressed these issues. The lists consisted of five to ten local issues along with a description of how these lists were compiled.

THE 19 MAJOR COMMUNITY GROUPS

Agriculture

Business

Charities

Civic, neighborhood, and fraternal organizations

Consumer services

Culture

Education

Environment

Government

Labor

Military

Minority and ethnic groups

Organizations of and for women

Organizations of and for children, youths, and students

Organizations of and for the elderly

Professions

Public safety, health, and welfare

Recreation

Religion

Figure 3–8
The 19 major community groups once used by the FCC as a part of ascertainment. Attorneys still refer station management to this list when it is time to prepare the required Issues/Program List.

Public File

Broadcasters are required to keep a "public file" accessible to members of the public during business hours. The records which must be kept on file include the following:

Copies of all applications submitted to the FCC.

Certification of Renewal Notice. (Indicates the station made the legally-required announcements before filing its license renewal application.)

Ownership Reports and Contracts.

A copy of every written agreement with citizens' groups.

A description of any petition to deny a license filed against the station.

Network affiliation contracts.

Required records concerning broadcasts by political candidates.

Annual employment reports.

An FCC manual titled, *The Public and Broadcasting, a Procedure Manual.*

Station ownership reports.

Letters from members of the public.

A copy of the licensee's *Model EEO Program* and a list of any discrimination complaints filed against the licensee.

In addition, radio and TV stations must keep annual listings of five to 10 community issues that the station's programming has addressed. The station must also document how the lists were compiled.

Procedural rules regarding public files call for the material to be kept for up to seven years, depending on the specific category. Access must be available to the public during regular business hours, and copies of material must be provided on personal request, although a small fee may be charged for reproduction services. A person wishing to inspect a public file is required only to give his or her name and address. The public file is one of the first items checked when an FCC inspector visits a station.

Sometimes the clout used against broadcasters is a threat.

Exit Polling

Folowing the 1984 presidential election, the networks faced severe government pressure designed to stop them from a practice called *exit polling.* For several years the network news departments had commissioned the use of a survey technique, which involved interviewing people as they left the polling place and asking them for whom they voted. This was used as a measure of the likelihood of a candidate winning. Critics said network prediction of probable winners based on East Coast or Midwest polling was influencing voters on the West Coast, whose polling places stayed open long after the networks began to report results from the closed eastern polling places.

Congressional action was threatened for several months after the 1984 election, but the issue was set aside after the three major networks wrote to members of Congress promising to limit the use of exit polling results until after the West Coast polling places had closed. Several states passed laws prohibiting exit polling. Lower courts subsequently overturned some states' anti-exit polling statutes.

Equal Opportunity Employment

The FCC brought about a significant influx of women and minorities to the broadcasting and cable industries by requiring stations to report in detail on their minority employment procedures and their actual hiring at each license renewal time.

Later those EEO rules were revised to push broadcast facility owners to include women and minorities in management positions.

Females and minorities are also given preference in comparative license proceedings and in lotteries for initial licenses.

The EEO rules apply to all commercial and noncommercial radio and television broadcast stations. Licensees are required to afford equal employment opportunity to all "qualified persons" without regard to "race, color, religion, national origin or sex."

The Communications Act as the Century Ends

Since strict regulation of the airwaves began in 1927 at the request of broadcasters, the role of the regulatory agency had been to control the allocation of spectrum space in the best interest of the people. The number of stations and variety of services increased after time, and some people began to see competition as the force that would protect the people's interests just as well as a government agency. It was thought that station operators who did not serve **the public interest** would be driven out of business by competitors who would better serve the public's needs. This is the *marketplace theory,* which is a viewpoint of the deregulatory movement.

Deregulation

The communications deregulatory movement started in 1976 when California Congressman Lionel Van Deerlin was Chairman of the Communications Subcommittee of the House Com-

merce Committee. Van Deerlin announced his desire to undertake a total revision of the Communications Act.

Van Deerlin's Proposals

Van Deerlin was joined by Representative Lou Frey of Florida in 1978 in sponsoring H.R. 13015, which was a draft of the revised Communications Act.

Some of the proposals which were considered included having licensees pay a license fee to support two proposed agencies, the Communications Regulatory Commission and the Public Telecommunication Programming Endowment (PTPE). These agencies would have replaced the FCC and the Corporation for Public Broadcasting (CPB).

Van Deerlin and Frey thought the government was overregulating; and so they proposed agencies with much diminished regulatory powers.

Although Van Deerlin's rewrite of the Communications Act did not take place because he lost in the next election, significant changes in telecommunication regulation have taken place because of it. President Ronald Reagan appointed Mark Fowler Chairman of the FCC in 1980, and under his direction, and later under Dennis Patrick's, the Commission methodically went through the *FCC Rules and Regulations,* altering some and discarding others until by 1989 the regulatory atmosphere surrounding the broadcasting industry had become far less restrictive.

Some of the 1980s Changes

One of the major steps taken by the Commission was elimination of the *7-7-7 Rule.* Under this rule no one ownership could have more than seven AM, seven FM, and seven TV stations (two of the TV stations had to be UHF stations). Under the revised rules of July 1984, the numbers are 12-12-12. (Even these numbers can be increased if a licensee agrees to be a minor partner in a licensee owned by a racial minority.)

Other adjustments made in the early 1980s by the FCC include the following:

Removing time limits on commercials for radio and TV.

Eliminating rules requiring stations to keep program logs for public inspection.

Removing minimum requirements for news and public affairs broadcasts.

Eliminating a policy statement that sets guidelines for children's programming on TV. (In 1988 the Commission reinstated some rules regarding children's programming.)

In June 1984 the FCC began the process of deregulating TV by eliminating nonentertainment programming guidelines, commercial policies, and ascertainment and program log filing requirements.

FCC Regulation of Other Telecommunication Services

The FCC regulates other telecommunication services including telephone service; all forms of common carriers, such as microwave; cellular mobile telephone service; citizens band radio; two-way radio; paging systems; police and other emergency service radio; shortwave radio; some data transmission; teletext; and satellite services. For example, when several firms decided to develop direct broadcasting by satellite (DBS), the FCC became involved because the Commission had the authority to decide who would get the franchise for DBS. In 1982 the FCC authorized DBS operations for seven companies, although there have been nowhere near that many companies active in the new technology.

In recent years the FCC has been involved in a number of major projects that represent either alterations or advances to the traditional telecommunication pattern. The FCC has had to rule on matters relating to satellites, cable systems, DBS, LPTV, expansion of the AM, FM, and TV bands, reallocation of some UHF frequencies for mobile services, and questions relating to technical standards for AM stereo, TV stereo, and high definition television (HDTV). The FCC goes through months and sometimes years of staff studies, hearings, and discussion before it rules on fundamental changes in the use of the spectrum.

Regulation of Cable

Cable system operators have had to answer to two and sometimes three masters. The FCC regulates cable. Some states regulate cable, and localities regulate cable through their power to grant franchises.

The FCC began regulating cable in 1962, even though cable (or *community antenna television* as it was known at the time) dates to the late 1940s. At first the Commission only regulated

cable systems which transmitted signals via microwave as well as cable, but after a favorable U.S. Supreme Court ruling in 1968, the FCC began to regulate all of the cable industry. The regulation included adherence to the Fairness Doctrine, equal time, and sponsor identification rules. Then the Commission told cable operators that if they served more than 3,500 subscribers they would have to originate local programming. The cable industry objected, but the Supreme Court ruled in favor of the FCC in a 1972 decision. Shortly after winning that court battle, the Commission issued "The Third Report and Order on Cable Television Service."

Eventually, the Commission overstepped its legal bounds by ordering all but the smallest cable systems to expand to 20 channels by 1986 and demanding they provide facilities for *access* programming. This time the Supreme Court ruled against the Commission, saying in 1978 that the FCC was turning cable into a common carrier, which cable was not.

That defeat, plus a swing toward the theory of deregulation by the Commission brought about some significant changes in 1980. The Commission removed a limit on the number of distant signals a system could import. Up until then the Commission had been protecting broadcasters in the communities served by cable systems by limiting the number of distant signals that could be imported. Distant signals are defined as those originating more than 35 miles from a large market system or more than 55 miles from a smaller market system. The other major change the FCC made was to eliminate a rule which had prohibited cable systems from carrying a program from a distant station if it were being broadcast by a local station.

In 1982 and 1983 pressure began to build in Congress to have the FCC take a stronger role in cable regulation and at the same time limit the power of municipalities over cable systems. The 1984 Cable Communications Policy Act was the result of this pressure.

The 1984 Cable Law did the following:

- It authorized local government to regulate cable systems but established federal standards for awarding franchises. Cable systems are prohibited from omitting service to low income areas.
- The FCC is prohibited from setting franchise fees and local government may set franchise fees up to five percent of the gross operating revenue of the system.

- After 1986 rates for basic cable service were deregulated except in a very few cases and cable systems were allowed to raise rates up to five percent a year to account for inflation without seeking local government approval. State and local governments challenged the FCC rule, which limited regulation of rates for basic cable service, but in March 1988 the U.S. Supreme Court refused to hear the challenge, effectively supporting the Cable Act's provision.
- Local franchising authorities may set facility, equipment, and channel capacity requirements, but cable companies can seek modifications of these requirements if either the local franchising unit or a court determines the requirements are commercially impractical. (In 1983 and 1984 a number of cable companies tried to renegotiate their franchise agreements in major markets when they realized they had overstepped their financial capabilities.)
- Cable operators are required to sell or lease lock boxes, which parents can use to prevent children from watching programming they deem undesirable.
- Forced transfers or sales of cable systems must be done at *fair market value.*
- The law makes it difficult for a city or county to not renew a franchise unless there are major deficiencies.
- Franchising authorities may require channels to be set aside for public, educational, and governmental use.
- The law requires cable systems to offer a certain percentage of their channel capacity for commercial use by parties not affiliated with the cable company. (In some cases broadcasters had tried to lease channels and were denied access by the cable operator.)
- Local TV stations may not own local cable systems but newspapers can.
- Local telephone systems may not own cable systems in the same community except in rural areas.
- The FCC can waive the prohibition on ownership of cable systems by telephone companies in certain circumstances, and state and local franchising authorities may own systems but may not control the editorial content.
- The law creates a national standard for privacy protection for cable subscribers.
- Local authorities may enforce customer service requirements and constructions-related requirements.
- The law allows local franchising authorities to

prohibit obscene material or material not protected by the U.S. Constitution (primarily First Amendment protection).

- The law sets civil and criminal penalties for theft of cable service.
- The law requires cable companies to certify annually that the cable system or its headquarters operation is in compliance with government equal employment opportunity standards. (A more detailed discussion is included in Chapter 6.)

Cable and Obscenity

Cable operators have to watch the obscenity problem because they frequently relay services and programs that might be considered obscene by some parties. Because municipal, county, and state governments are involved in the regulation of cable, the problem of community tastes has been a thorn in the side of cable system owners for a long time. Many have found that "blue" movies get good audiences, even in conservative communities where certain groups are trying to prevent the cable system from showing explicit programming. There have been numerous attempts to legislate obscenity on cable, but few of these efforts have withstood the threat of Supreme Court consideration. There have been occasions where cable systems have been coerced by local authorities into dropping the more explicit channels.

OTHER SOURCES OF BROADCASTING LAW AND REGULATION

Copyright

The federal copyright laws apply to many broadcast activities, but they have been a particular concern to cable system owners and LPTV station owners. The problems hinge on the act of retransmission of a program. Each new transmission, in the view of some copyright attorneys, constitutes a new use and triggers a new copyright payment. Historically, cable systems did not pay royalties on broadcast programs they relayed. It is relatively simple for a network or a syndicator to keep track of retransmission of a program, but it becomes far more complicated when we're dealing with cable systems with three dozen or more services.

A solution was found in the Copyright Act of 1976 under which cable systems must secure blanket copyright licenses. The Copyright Tribunal collects copyright fees from cable systems and distributes the money to the copyright holders.

The Federal Trade Commission

The FTC regulates the way business is done in the United States. It is on the lookout for unfair practices and conduct that adversely affect consumers. The FTC has been particularly involved in questions relating to commercials advertising products during children's viewing hours. It has caused major changes in the way some advertising is presented. For instance, a few years back the FTC banned nondoctors from appearing in over-the-counter medical products ads wearing white coats. The FCC is denied the right to act on advertising, so the FTC has become an important agency in the eyes of sponsors, ad agencies, and the telecommunication media.

U.S. Department of Justice

The Department of Justice investigates criminal and fraudulent practices. It has become interested in the telecommunication field from time to time, such as the time years ago when it was found that record companies were paying disk jockeys "payola" to play certain records. More recently the Department of Justice has investigated factories that have been producing bootleg records, records copied from popular disks, which do not pay copyright fees. The FCC occasionally asks the Department of Justice to look into selected obscenity complaints.

Federal Aviation Administration

The Federal Aviation Administration (FAA) becomes involved with broadcasting when a broadcast licensee wishes to erect a tall transmission tower. The FAA has to approve towers that might interfere with the flight path of aircraft.

Environmental Protection Agency

The Environmental Protection Agency (EPA) can demand an environmental impact report from a broadcaster who contemplates putting up new antennas. From time to time, the EPA has also been asked to study radiation emissions from transmission towers.

Department of Labor

The Department of Labor sets wage and hour standards and other conditions that affect all employers. These rules particularly affect telecommunication employees who work overtime. When you visit a telecommunication company you will probably see one bulletin board dedicated to notices having to do with wages, hours, and conditions of employment. Many of these are issued by the Department of Labor.

Occupational Safety and Health Administration (OSHA)

The federal government keeps close tabs on industries which have potential for placing workers in hazardous situations. The telecommunication industry is included because some employees work with electricity, and others have to climb towers or operate mechanical equipment. OSHA issues regulations having to do with workplace safety and can perform inspections of the workplace.

Equal Employment Opportunities Commission

This commission deals with discrimination in the workplace. The FCC for many years incorporated government EEO objectives into its annual reporting process and renewal forms, thus putting intense pressure on the telecommunication industry to hire, train, and promote women and minorities. Telecommunication managers must continue to be aware of and comply with EEO rules.

Securities and Exchange Commission

The Securities and Exchange Commission (SEC) regulates the sale of stock and a wide variety of transactions having to do with the sale, transfer, and acquisition of controlling interests in companies.

The flurry of mergers and leveraged buyouts that hit the broadcast and cable industries from 1984 onward brought into sharp focus the important regulatory role of the SEC, as companies filed literally tons of documents needed to comply with the many regulations that apply to stockholder companies.

Civil Law

Defamation

Defamation is the legal term for libel and slander. Defamation is holding someone up to hatred, ridicule, or contempt, lowering the person in the esteem of his fellows, or causing him to be shunned in his business or calling. We often substitute the words *libel* (printed) or *slander* (spoken) in referring to defamation. The definition is based on how one's peers perceive a person. A person's calling could be his or her profession. In the case of a minister who is defamed and loses the respect of his or her congregation, we are dealing with a person's reputation.

There are certain basic ingredients you have to have to make a case for a defamation suit. First, there has to have been actual damage. If a person gets fired, run out of town, or loses income, this constitutes actual damage. The suit must be filed by the person who is defamed. This means family members cannot file on the behalf of a deceased relative. The injury to a person's reputation must be apparent to a significant and respectable minority in the community. The term *minority* refers to the people with whom one associates at work, school, church, or other places. The term *respectable* means it is hard to damage the reputation of a criminal. There is little likelihood the court would entertain a defamation action involving two inmates of the local prison farm.

The Station and a Suit

If someone said they wanted to file a slander (spoken defamation) suit against your broadcast station, your attorney would want to jot down four items on his or her yellow lined pad. The attorney would want to determine that a broadcast occurred. This would be done by looking at the station's program log (record) and checking a tape recording of the day's broadcasts (if one exists). This also means that the slanderous statement was said by one person and heard by a third person who understood. (The second person is the person who was slandered, the plaintiff.) The reason that *understood* is included in this definition is to eliminate witnesses (infants, foreign-speakers) who would not understand the remarks. The attorney would want to be sure that what was said is truly defamatory. Is calling someone a "wimp" or a "nerd" defamatory? Probably not, but suggesting that someone is a thief or a cheat could be actionable. Context

affects words as does the way in which the listener(s) took them.

Publication. In legal terms *publication* means dissemination of the offending material. A third person must receive and understand the message. The courts have said that the act of broadcasting something *is* publication.

Identification. The attorney would want to make certain the plaintiff was identified so that it is clear who was slandered. Identification does not necessarily mean using a person's name. It could mean showing a picture, or hinting so clearly that everyone knows who is being talked about.

False statement. The libelous statement must be false and must cause injury to the plaintiff's reputation.

Actual damage. The libelous statement must cause actual damage to the plaintiff's reputation.

Fault. The plaintiff has to prove the broadcaster's lack of care or fault in disseminating the libel. The *elements of neglect* and *careless disregard of the truth* have to be present. Some simple errors may be forgiven by the court. Careless disregard also implies that one did not consider or care about harming someone, like reporting as truth a rumor of a minister doing some despicable act. Truth is the best defense in this situation and facts should be checked several ways before broadcasts are made that could in any way show someone in a bad or harmful way. However, even truth is subject to interpretation by a jury.

Defamation or slander suits are a major concern to broadcasters even though it is difficult for a plaintiff to win a defamation suit. All on-air people should be briefed on the law of defamation and should be monitored to prevent situations that lead to defamation. This includes carefully monitoring people who call in to talk shows. News staffers particularly need to be aware of the law of defamation because they run into many situations which have the potential for a defamation suit.

Privacy

Now we turn to a less clear part of civil law, the law of privacy. The basic idea is that a person's own life, conduct, and image are private and should not be used or abused. There are four basic types of privacy invasions:

Intrusion. This refers to invading a person's privacy or private area. You can reasonably expect to be sued if you sneak into a rich person's estate and take photographs that cause that person discomfort. This is one reason that news videographers are often told to be sure to shoot their pictures from a public street or public sidewalk. Generally, the courts have not reprimanded videographers who follow police or fire officials onto private property, but there is a potential danger in doing so. One U.S. Supreme Court decision said reporters should not be treated differently from anyone else who trespasses on private property. The case involved reporters who followed protestors onto private property.

Appropriation. Appropriation refers to taking someone's image for commercial purpose. Let's suppose the morning show staff go out and shoot tape of a prominent local banker feeding her dog at the weekend dog show. Somewhat later an overeager salesperson at the station dubs off part of the news tape and edits the banker feeding her dog in such a way that it appears to be an endorsement for Gruffo dog food. This is appropriation.

False light. Holding a person in false light is presenting the person in a manner that does not truly represent the circumstances. Let's say the news department does a feature on holiday shopping and gets a clear picture of Mrs. Green window shopping at a lingerie store. Later another staff member is working on a documentary on housewife prostitution and pulls the tape of Mrs. Green to accompany a script, which talks about housewives "turning tricks." Mrs. Green stands a good chance of considerably enhancing her net worth by suing the station.

Private (embarrassing) facts. Release of personal, private information can get you sued. It's fairly safe to criticize the mayor's public policies, but not the mayor's private life. Do not use any material not of legitimate concern to the public nor something that would be highly offensive to a reasonable person. Some states have laws that make the publication of a rape victim's name an invasion of privacy.

As in most legal areas, a degree of common sense needs to be applied. Any time you think you are doing something which might be improper, you can pretty well judge an invasion of privacy. If you think what you're doing is an invasion, get legal advice, or don't do it.

Open Records Laws

Open records laws to one degree or another declare that all but a small portion of government's paperwork is available to the public to look at. Some of the documents that cannot be read under open records laws include secret documents of the federal government, some employee personnel records, and some court records, particularly those relating to juveniles.

The number and type of records that are available to persons to look at vary considerably. The federal government has a rather cumbersome Freedom of Information (FOI) law, which requires a person seeking records to fill out an application form, describe the records, and pay for having copies made. The government in turn must promptly produce the records or provide an acceptable excuse for not doing so. Every year the nation's media organizations battle with interests (such as the CIA and the Department of Justice), which seek to limit access to government documents. The state of Florida has what some call the nation's strictest public records laws. Letters on officials' desks, interoffice memos, information in file cabinets, and applications for major jobs are all open records which may be viewed by the public and the press.

Free Press—Fair Trial

One of the major areas of conflict over the rights of the press centers on a defendant's right to a fair trial versus the public's right to know how the courts are dispensing justice.

Lawyers will argue that the press ought to be excluded from pre-trial hearings and similar proceedings because by the nature of these hearings, the media reports the accusations against the defendant while little is available to be said about her or his defense.

The press replies that if the courts are closed, there is no way to know whether justice is being dispensed fairly and equitably. Both sides are right; it's just that the *rightness* overlaps and this overlap has caused a great deal of conflict over the years.

Gag Order

The U.S. Supreme Court has ruled that judges may not exclude the press from trials or order the press not to report what takes place. This is called a *gag order,* and gag orders have been overruled by the Supreme Court. However, judges still occasionally try to gag the press.

Those judges usually lose a quick appeal at the next level.

Right to Cover Trials

Regarding the press' right to cover trials, one Supreme Court case (*Gannett v. DePasquale,* 1979) brought a ruling that the press could be excluded from pre-trial hearings, and a later decision (*Richmond Newspapers,* 1980) said the press definitely had the right to cover the actual trial. By 1986 in *Press-Enterprise v. Riverside Superior Court,* the Supreme Court said there was a presumption that pretrial hearings will be open unless the defendant or the state shows that *a substantial probability* of prejudice would be caused by an open hearing.

Confidential Sources

The greatest point of tension between the press and the courts comes from information reporters obtain from sources who do not wish to have their names revealed. Reporters frequently pledge to keep sources anonymous to protect sources' lives, reputations, and jobs.

Prosecutors who are unable to get adequate information will try to subpoena reporters to testify about their sources. The general theory is that a court will not even consider this sort of request if it can be reasonably demonstrated that the prosecutor could have found the information from some other source. In most states the prosecutor has to make a telling argument to get a judge to rule that a journalist must reveal his or her sources. There have been famous cases in which reporters went to jail instead of revealing sources. Some states have passed what are called "shield laws," which protect reporters from having to testify in these cases. If the reporter is not protected by a shield law which allows him to keep his sources confidential, he could be held in contempt of court.

Privacy Protection Act

Reporters and news organizations are now protected by the Federal Privacy Protection Act of 1980. It prevents local, state, and federal authorities from making an immediate search of a newsroom to secure notes or tape. Instead of obtaining a search warrant, which permits an immediate, unannounced search, authorities must get a subpoena. Under the Privacy Protection Act, both parties have to go into court and argue before a judge who rules on granting the sub-

poena, thus giving the media outlet warning of the search.

Secrecy Stamps

One major area of concern is secrecy in the name of national security. Many documents are stamped secret by the federal government (states are prohibited from doing this).

sometimes these documents are stamped secret only because someone does not want them read, not because they would reveal strategic information to potential enemies. It is hard to use the federal Freedom of Information Act against such secrecy labels.

Cameras in the Courtroom

The majority of states now permit, either experimentally or permanently, the use of sound and picture equipment in at least some courtrooms. The federal government does not permit any sound or picture recording equipment in courtrooms, except for very specific situations such as naturalization hearings.

Usually the rules for using sound or video equipment in courtrooms are set by the highest administrative level of a state court system. In the most liberal situations, audio, video, and still photography are permitted in all adult criminal courtrooms, with the defendant having little power to keep the media out. In some less liberal states, defendants can petition to exclude the media. Usually the court system establishes the type and amount of equipment and conditions for its use. Typically, the sound will be taken directly from the courtroom's internal amplification system. Often only one television camera is permitted, with its output being pooled (recorded and excerpted) by media representatives located in another room. There are rules for court decorum (behavior) so that the media presence will not be disruptive.

ETHICS
News and Public Affairs

There are certain practices related to newsgathering which have come under ethical scrutiny. They include staging, free materials, paid interviews, accepting gifts, advertising-related coverage, advocacy journalism, and selective editing.

Staging

Staging customarily refers to planning or rehearsing an event before news coverage is recorded. Disturbances can be created that did not exist, picketing can be made to appear more intense than it was. The greatest hazard is falling into a trap by covering an event that has been blatantly *staged* for the benefit of the media. Unfortunately, this does happen. If TV cameras are present, the vigor of pickets or protestors tends to increase.

Appropriate Coverage

Two international hostage-taking incidents involving Americans, the first by radical students in the U.S. Embassy in Tehran, Iran and by Muslims from Beirut, Lebanon brought the issue of staged news into focus, as both media executives and critics questioned how much and what type of coverage should be given in hostage situations where it is apparent the hijackers are seeking publicity.

Following the hijacking of a TWA jetliner with Americans aboard to Beirut, Lebanon, NBC News in July 1985 issued a special set of standards for dealing with terrorist coverage. The memo from then NBC News President Lawrence Grossman said information could be withheld for reasons of taste or sound journalistic practice. (During the TWA incident NBC and other news agencies concealed the fact that some of the hostages were U.S. Navy men after the hijackers killed one of the Navy men whom they identified.) Grossman told NBC news personnel not to become involved in the story, maintain a low profile if possible, and remind listeners of the context of the situation. He called for taping and editing interviews which emerge from terrorist/hostage situations rather than letting the terrorists appear live to say whatever they like. He also set down interview guidelines designed to keep NBC News from becoming a tool of the terrorists.

Free Materials

Literally hundreds of organizations make free materials available for use by radio and TV news people. The general principle is that it's okay to use "supplied" material if you clearly label it. The problem with free materials, as journalists see it, is that the reporter has no control over the questions which are asked or the pictures which are shown. The public relations aspect of

this activity is not particularly harmful. The ethical problems arise when broadcasters fail to inform their audience they are using packaged material over which they have had no editorial control.

Pay for Interviews

From time to time, a debate arises over decisions to pay individuals being interviewed in a news or public affairs context. There was much controversy after Richard Nixon resigned the presidency and then agreed to be interviewed by British talk show host David Frost upon payment of a rather hefty fee.

Gifts and Bribes

In the early days of journalism there were few internal rules about accepting gifts from potential news sources. As the profession matured it became apparent that there needed to be clear guidelines about what gifts can or cannot be accepted. The fear is, that by accepting a gift, a reporter compromises objectivity toward the person or organization that proffered the gift. Policies vary from organization to organization. In some newsrooms you cannot accept anything, including a paid lunch. In others it is acceptable to receive a gift of minor monetary value (a ball point pen) or a lunch appropriate to business you are conducting. (A five dollar lunch would be okay but a $100 lunch is suspect). The point is that no one should be able to "buy" news coverage.

More frequently what we have to watch out for is subtle attempts to influence broadcasters (particularly reporters). Broadcasters need to be suspicious of anyone who makes accomplishing a difficult transaction easy. Examples would include easy-to-obtain loans, unreasonable discounts on merchandise, offers of employment for a spouse, or extraordinarily low prices on vacation packages. Some broadcast companies require employees to fill out a form which describes the employment and affiliations of close relatives on the theory that the organization should know if even the slightest potential exists for influence being exerted on its programming, advertising, or news content.

Advertising and News

Advertising-related news coverage can be a problem. Salespeople, no matter how strictly they are restrained by management, want to assure their clients of the maximum exposure for their dollars. Most major broadcasting firms have rules that prohibit assuring clients of news coverage.

Editing

Selective editing occurs when an editor, reporter, or producer consciously chooses scenes to distort a story. It could be an effort to make someone look bad, or selection of crowd scenes to make a demonstration look larger, or exposing the face of someone whose identity is supposed to be kept confidential such as a rape victim. (It is not unusual for reporters to know such information even though it is confidential and cameras are sometimes present when a sexual assault victim or undercover police officer appears at the courthouse.) Selective editing is something that must be controlled by each news person's personal ethical standards, with careful supervision from editors, producers, and management.

Ethical Codes

Both the Society of Professional Journalists, Sigma Delta Chi, and the Radio-Television News Directors Association have ethics or professional conduct codes to which their members must pledge allegiance and adhere. These codes spell out in simple direct statements the issues that we have just brought to your attention. The Code of Broadcast News Ethics of RTNDA is Appendix C.

Management

The management of a telecommunication company can reasonably be expected to observe ethical business practices. Typically, telecommunication firms are leading citizens in their communities and provide a platform for discussion of community issues.

SUMMARY

Everyone who is seriously interested in a career in broadcasting should read Volume III, Parts 73 and 74 of the *FCC Rules and Regulations*. The rules which apply to political broadcasting affect such a wide range of people including sales-people, programmers, and news personnel, that everyone should be aware of the basics.

If you will be required to sign a document, such as a transmitter log, you should read the regulations and find out how to sign it and how to make corrections. Air personnel should pay close attention to requirements regarding accepting gifts or bribes or giving unreimbursed *plugs* to individuals and businesses. Business office and sales personnel need to know about *double billing,* FCC financial reports, and all forms of legal constraints on what is said in advertising. Engineering personnel have to become familiar with FCC standards and have to know what to do if a transmitter or other major piece of equipment fails to perform correctly. All operating personnel and many others need to know what would be required of them in case of an emergency situation such as a tornado or hurricane striking their community. In short, rules and regulations don't provide "fun" reading, but

Figure 3–9
Communication law and federal regulations change rapidly, requiring broadcasters to attend frequent seminars in order to keep current. Attorney Matthew L. Leibowitz, who heads a communication law firm with offices in Miami, New York, and Washington, D.C., is shown briefing broadcasters at a National Radio Broadcasters meeting. Courtesy of Leibowitz & Spencer.

they are absolutely required reading for professional broadcasters and cablecasters.

Once you are working, plan to attend law and ethics in-service training sessions. Don't be intimidated by the legal and ethical demands of the telecommunication field. They are similar to those of a great many regulated industries, such as utilities, insurance companies, and airlines. Remember, you are in a sense a public servant.

The White House exerts major influence on telecommunication. Most recent presidents have had close advisors who were familiar with telecommunication matters. The National Telecommunication and Information Administration (NTIA) serves as a research and policy shaping agency of the White House. The president can directly affect telecommunication policy through choice of the chairman of the FCC, appointment of commissioners, and by the appointment (as needed) of federal judges who deal with telecommunication matters. The president also appoints the head of the Equal Opportunity Commission, members of the board of the Corporation for Public Broadcasting, and the head of the U.S. Information Agency, which controls the Voice of America.

Congress plays a big role. The FCC is an arm of Congress even though the president recommends appointment of the chairman and commissioners. The House Subcommittee on Telecommunications, Consumer Protection and Finance of the Committee on Energy and Commerce drafts legislation that impacts directly on telecommunication. The Senate has a parallel subcommittee. Historically, the chairpersons of these communities have been outspoken and influential in matters of telecommunication policy, although the subcommittees failed in the late 1970s to secure a total rewrite of the Communications Act of 1934. The courts also play a major role. The Court of Appeals in Washington, D.C., often has the final say on interpretations of both law and FCC administrative actions. On a broader scale, the U.S. Supreme Court defines telecommunication policy when the issue is purely constitutional.

We must not forget the organizations which spend so much time and money trying to influence government policy. Broadcasters themselves often try to limit government regulation through their private actions. For instance, during World War II the broadcast industry agreed to a voluntary Censorship Code to avoid having censorship imposed by the government as an emergency war power.

A number of organizations including trade or-

ganizations, professional societies, and unions have rules or codes which apply to their membership.

The largest organization representing broadcasting is the National Association of Broadcasters, which has its headquarters in Washington, D.C. The NAB lobbies for the industry; develops programs designed to prevent further regulation; carries out industry public affairs programs such as its efforts to curtail drinking and driving; conducts training for broadcasters; publishes books and pamphlets of interest to the industry; conducts research; and holds an annual international convention and exhibition with special programs for engineering, radio and television interests, plus the world's largest exhibit of broadcast technology.

GLOSSARY

Administrative law The rules of government regulatory agencies, which have the force and effect of law.

Ascertainment policy An FCC policy that said broadcasters had to document through surveys and interviews the controversial issues that would be covered in their news and public affairs programming. The station was then judged at renewal time on the basis of promise and performance. This policy was lightened considerably in the 1980s.

Cable Communications Policy Act of 1984 This act authorized local government to regulate cable systems, established federal standards for franchises, prohibited cable companies from omitting service to low income areas, and required cable operators to sell or lease lockboxes to prevent unauthorized viewing. This law also weakened power of local government to control cable subscription rates.

Call letters Four (or in case of very old licenses, three) letter combinations which identify a broadcast station. In the United States the letter "W" precedes calls east of the Mississippi River and "K" is the first letter of calls west of the Mississippi.

Careless disregard In a defamation situation this implies that one did not consider or care about the truth or facts.

Cease and desist An order to stop and not repeat an action, issued by the FCC in regard to an action by a licensee.

Checks and balances A theory which says responsibilities and authority should be spread out in such a way that no one part of government can dominate the others.

Clipping This occurs when a station cuts out of a network program early and inserts its own commercials. It is also known as clipping when a station covers a network commercial with its own commercial without the network's permission.

Common carriers They transmit communication from point to point without altering the content. Examples are telephone companies and satellite transmission firms.

Community standard A legal concept that what is acceptable to a community becomes their standard. This is used in regard to obscenity charges.

Comparative hearing FCC hearing at which comparisons are made between or among applicants for the same facility.

Constitution This refers in this text to the U.S. Constitution and its amendments.

Construction permit (CP) Document issued by the FCC that permits an applicant to construct a broadcast facility.

Defamation Holding someone up to hatred, ridicule, or contempt, lowering the person in the esteem of his fellows, or causing him to be shunned in his business or calling. The words *libel* (printed) or *slander* (spoken) are often substituted.

Double-billing Illegal process in which hidden discounts are given advertisers.

Equal opportunity laws Employers must hire according to a quota system various ethnic, racial, and gender groups. The station license would be in jeopardy if the quotas were not met.

Equal time A policy of the FCC derived from the law that provides that all candidates for the same office be given an equal *opportunity*. A broadcaster may ignore a political race, but if the broadcaster sells or gives time to one candidate in a particular race, then the same opportunity must be extended to all candidates for that office. If the office is a federal one, the broadcaster cannot refuse to sell time to a candidate without the risk of license loss.

Ethics "Self-imposed laws" used to guide people in the honorable, honest pursuit of their profession.

Exit polling A survey technique that involves interviewing people leaving polling places as to how they voted, and then predicting the winner based on the poll and statistical projections. The projections are only as accurate as the honest participation of the voter.

Fairness Doctrine It required broadcasters who aired controversial topics to give opponents a reasonable opportunity to present contrasting views. The doctrine was abolished in 1987 by the FCC saying that it violated First Amendment rights.

FCC—Federal Communications Commission U.S. government agency charged with the regulation of broadcasting and other areas of telecommunication.

Federal Privacy Protection Act of 1980 It prevents local, state, and federal authorities from making an immediate search of a newsroom to secure notes or tape. A subpoena must be obtained after a court hearing.

Federal Radio Commission (FRC) A five-member board created by the 1927 Radio Act to oversee broadcasting. It could determine who would or would not get three-year radio broadcast licenses.

Freedom of Information (FOI) Law A federal law that gives the public (and press) legal access to most nonsecurity documents of the federal government's administrative departments. In practice, the FOI law's rules and application make obtaining information cumbersome enough that many people give up.

Gag order This order occurs when a judge rules that the press does not have the right to report what it witnessed in a courtroom. It is usually promptly appealed and overturned, based on a U.S. Supreme Court decision (*Nebraska Press Association v. Stuart,* 1976).

Interference More than one person transmitting on a given frequency in an overlapping area where the signals interfere with one another, and the listener receives either noise or parts of several signals, which usually results in gibberish.

Legally qualified candidate This person must have publicly announced candidacy, must have met the state requirements for candidacy, and must be eligible to serve if elected.

Log A daily list of a station's program activities, second by second. It details names, times, and lengths of programs, program elements, commercials, and other announcements of broadcast station. Also, a list of transmitter readings or maintenance actions by the engineering staff.

Lowest unit charge The rate charged advertisers who buy the highest and most frequent volume of commercials. Also, the rate defined by a 1971 amendment to Section 312 of the Communications Act of 1934 that broadcasters must adhere to when charging for political candidate commercials. It is in effect for a specific time before elections.

Marketplace theory Theory that the marketplace (people watching or listening) will influence what is broadcast and that government regulation of programming in terms of required amounts of time devoted to specific types of programming is unnecessary.

Open records laws These laws to one degree or another declare that all but a small portion of government's paperwork is available to the public to review. Some of the documents which cannot be read under open records laws include secret documents of the federal government, some employee personnel records, and some court records, particularly those relating to juveniles.

Payola The illegal paying of disk jockeys or other station personnel to insure playing of certain songs, recordings, or compact disks.

Plugola Bribes paid to have free commercial mentions included in a program.

Pooled Information comes to a group of news people from one physical source, but they are free to use it as they see fit. Used when physical conditions are cramped, as in courtrooms, or in extraordinary security situations, such as a public address by the President.

Precedents Rules having the weight of law stemming from prior court decisions that have been made to resolve an indistinct or conflicting part of the rules and laws governing broadcasting.

Promise versus performance This was the way the FCC created accountability. When a station license was to be issued, the applicant had to tell the FCC what the station would do in the way of programming, hiring, and maintaining facilities. At renewal time the original statements were reviewed for compliance. Noncompliance could mean anything from a reprimand to a denial of license.

Public airwaves be used for public benefit A concept that Herbert Hoover promulgated at the Fourth Radio Conference in 1925. This idea was embedded in the 1927 Radio Act saying the airwaves are not owned by individuals but rather are a public trust which must be used in such a way as to benefit the most people. (Also known as the trustee or fiduciary concept.)

Public file The FCC-required file kept in every broadcast station for public inspection during business hours.

Public interest, convenience, and necessity The standard that administrative actions regarding broadcasting are judged by.

Publication In regard to defamation, it means dissemination of the offending material. A third person must receive and understand the message. Any broadcast is defined by precedent as publication.

Regulated industry An industry that must comply with governmental rules and regulations to be allowed to operate.

Regulatory agency It has the authority to make rules governing business activities as long as those rules follow the standards and intent of the laws they represent.

Seven Dirty Words Words without any redeeming social value uttered in a broadcast of a record by comedian George Carlin. The words caused the FCC to issue a large fine against radio station WBAI. The Supreme Court upheld the fine.

Shield laws Some states have passed laws that protect reporters from divulging their confidential sources. In some states these laws only pertain to the written press.

Skips Radio signals heard well beyond their normal range because of atmospheric conditions.

Staging It customarily refers to planning or rehearsing an event before news coverage is recorded. Disturbances can be created that did not exist; picketing can be made to appear more intense that it was.

Tariff Rate schedule usually applied to telephone and other common carrier rates.

United States Code The name given to that group of laws which govern the country at the national level.

Window Thirty-day period during which FCC accepts certain types of applications.

Wireless Ship Act of 1910 First U.S. regulation of broadcasting, which said that all U.S. passenger ships must be equipped with radios as part of their safety equipment. These radios used Morse Code rather than voice transmission.

Zapple Doctrine This doctrine states that if a broadcaster permits supporters of a candidate to have air time, then that broadcaster must make comparable time available to supporters of opposing candidates.

BROADCAST RADIO

Radio today bears little resemblance to radio as it was before World War II. In those days radio networks provided most of the programming. Stations in smaller markets could maintain relatively small staffs because they relied on the network for most programming. However, major metropolitan stations often had large staffs to cover extensive schedules of live programming. In the early days news was not a major factor in radio broadcasting. News became a factor in the 1950s, growing in importance in the 1970s due to various regulatory requirements. In the deregulatory period of the 1980s news was eliminated or cut back as a cost saving device by many radio stations.

After World War II vast improvements in the quality of recordings (45s and long-playing 33⅓ RPM albums) plus increased consumer interest in popular music helped radio to develop new programming. During the same period many of the comedy, drama, and quiz programs from radio migrated to television.

Radio underwent another major transition in the 1960s becoming a local medium with *disk jockeys* who became local celebrities. This was a counterprogramming concept used to try to win back audiences that had been lost to television. In reality what happened was that radio began to cater to a different type of audience with the heavy listening periods being daytime while television continued to dominate the evening airwaves. Network programming was reduced to only a small portion of the typical station's schedule if it belonged to a network at all.

The *Radio Advertising Bureau,* a major fact-gathering organization serving the industry, in 1987 reported that there were 505 million radios in use, with radio sales up by 30 percent since 1980.

WHERE RADIO IS TODAY

Today's radio station has not come full circle, but there is a trend back to greater use of some forms of network programming. Stations are mixing three hour weekend network record reviews with local programming; they are carrying popular music concerts from networks; stations are carrying network sports; and they are taking an increased amount of news, public affairs, and talk programming from networks. Radio today is dominated by derivatives of the disk jockey format plus a heavy mix of spoken programming in the form of news, talk, and sports. Some stations even receive the greater part of their programming from satellite syndication services that transmit disk jockey shows nationwide.

The radio industry is a locally oriented business. Radio stations tailor their product to the local markets they serve and sell most of their advertising to local merchants.

Who Listens?

A 1987 survey done for the Radio Advertising Bureau (RAB) by R.H. Bruskin Associates found that radio was named as the first source of news when people got up in the morning by 49 percent of the respondents. TV came in second with 29 percent and newspapers were named by only 15 percent.

Radio news was named as a first morning news service most strongly by people 18 to 54 years of age and by high income respondents earning over $50,000 per year who preferred radio three to one over TV from 6 to 10 A.M.

Fifty percent of the people surveyed said they would turn to radio first for up-to-the-minute news in a time of emergency.

Other surveys have indicated that the majority of Americans get the greater part of their overall daily news supply from television, but their predominant TV news viewing is done in the evening. Generally, this means that radio is a major source of news in the morning with TV being the major source in the early evening.

Where Are the Sets?

The RAB said 99 percent of all American households have a radio, with the average being 5.4 sets per household. It says 67 percent of living rooms, 58.4 percent of bedrooms, 49.8 percent of kitchens, 21.9 percent of dens and family rooms, 9.3 percent of dining rooms, and 7.2 percent of bathrooms had radios.

The Bureau said radio reaches 85 percent of Americans at home every week, plus 21 million people with walk-along or run-along sets. The RAB says 95 percent of all automobiles have radios (they don't report on pick-up trucks!) The RAB says that three of four adults are reached weekly by a radio in a car.

Segmenting the Audience

Competition is intense and will become more fierce as stations are added to both the AM and FM bands. As a result, more stations are moving from providing programming aimed at a mass music audience; the trend is to pick a segment of the available listeners and address programming to the tastes of that specific group. As you move through the AM and FM dials, you will detect wide differences in what you hear. Most likely you will hear several stations playing contemporary hit tunes, aiming their programming at the young, money-spending population. Others will play more vigorous rock music, aiming at the 13 to 20s age-group. Still others will play background or easy listening music, designed to attract an older, more affluent audience. Some stations will aim their music at people in the mature and senior citizen age group who like nostalgia music. Others will specialize in listeners who seek information, an opportunity to talk about their ideas, or coverage of sports events.

The targeted nature of these radio formats and the large number of stations on the air create intense competition. Both these factors hold down the amount stations can spend to staff or supply programming. As a result, many stations are automated, meaning that part or all of their programming originates from tapes produced by outside organizations called *syndicators*. In some cases the tapes include an announcer's voice, and in other cases, the subscribing station employs an announcer and only the music is from tape.

Figure 4–1
AP Radio Network newscaster anchoring an hourly newscast. Note that the newscaster "runs his own board," that is, does his own technical work, during the newscast. Courtesy of Associated Press Broadcast Services.

Simple Radio Automation

Usually these taped programs are played on automation systems, which consist of audio tape recorders hooked to a computer, which starts and stops the music, commercials, and other announcements according to a predetermined plan.

Within the past few years some stations have switched to receiving music formats, with the announcer's voice included, by satellite feed. This allows for insertion of current commentary and some news. It also eliminates the problems inherent in shipping the syndicator's audio tapes from one station to another.

Size and Character of Radio Stations

Radio stations on the AM dial vary in size from low powered and usually physically small 250-watt daytime facilities to blockbuster 50,000-watt stations. On the FM dial the smaller stations broadcast with 1,000 to 3,000 watts and the biggest FMs send out 100,000 watt signals from tall towers. As a result you can find everything from

a true "mom and pop" station run by only two people to large operations with up to 100 employees. The almost universal similarity among radio stations is that they will serve a community or area. Many (and probably the most successful) will have specific local identities, matching the character of their voices, music, news, and format to the area they serve. A rather large portion will sound like a copycat version of stations in other areas of the country. This is because the industry relies heavily on taped or satellite music services that provide a standard music and promotion package heard on each of the participating stations.

FM radio has grown from a feeble late starter, simulcast with AM to a highly successful medium, which now dominates the radio spectrum in most markets. This is because radio's most popular product is music, and the FM transmission system permits a station to nearly duplicate the sound quality of a home stereo system. Also, radio has always been a "take-along" or background medium, providing us with music and information as we go about our daily tasks.

The shift of major audience segments to sta-

At AM stereo station KDAY, Los Angeles, staff member labels a digital cartridge disk. The station uses a digital cartridge disk recorder/editor in its production studio. Radio stations are having to stay on the "cutting edge" of audio technology to keep up with the high quality receiving equipment owned by many listeners. Broadcasters have to be willing to learn how to use new technological devices. Courtesy of Compusonics.

tions on the FM band has created serious problems for AM stations, hindered by poor frequency response and static. Many stations have responded by relying heavily on the human voice, in the form of increased news programming, talk, call-in programs, and sports broadcasts.

RADIO IS A LOCAL MEDIUM

There is heavy reliance on advertising placed by local firms, with most stations trying to promote local events and organizations. Radio places less reliance on commercials for nationally sold products. If the station has a news department, it will concentrate on local news, since national and world news is readily available from a number of excellent news organizations. Local sports coverage is one of the ways that radio shines. The majority of stations participate in local activities, by being members of the chamber of commerce, by promoting various civic efforts and organizations, and by focusing their on-air material on local interests. In one southern city a local station's morning talk segment almost always features college football on fall Fridays because the station is located in a university town where football dominates weekend activities.

There is a general feeling among radio programmers that the more local service information you can provide, the better you will be able to market your station. Radio is a portable medium, bouncing along on the heads of joggers and entertaining us from the consoles of our automobiles, so it has the unique opportunity to tell us about weather conditions, traffic tie-ups, civic and entertainment events, news, sports scores, and even give us hints about movies, health, finances, and hobbies.

AM RADIO

As we have indicated the United States has a mixed system of radio transmission. The first radio band to be developed for domestic civilian use was the AM band (540 to 1600 khz).

Four Classes of AM Stations

AM allocations were based on existing market size. There are four classes of station allocations based on service area and population. Class I stations are *clear channels* (having no stations on the same frequency at night and no one nearby

on the same frequency during the day) designed to serve an extended area with from 10 to 50 kw of power. These are the powerhouse stations we hear when driving at night. The clear channel stations were necessary when AM radio was the only broadcast medium, but as more stations came on the air and FM and TV were added, the clear channel stations changed their focus and have become more important as regional or metropolitan facilities. Some examples include WBZ, Boston; WCBS and WINS, New York; WLS, New Orleans; WBBM, Chicago; WWVA, Wheeling, West Virginia; KMOX, St. Louis; KSL, Salt Lake City; KNX, Los Angeles; and KCBS, San Francisco.

Class II-A stations are similar to Class I with most operating at 50 kw during the day but no more than 10 kw at night. Class II-B stations can use high power on clear channels during daytime but must sharply cut back nighttime power, and some must operate at significantly lower power during the day to protect other clear channel stations.

Class III-A stations serve a region (there is no

Figure 4–2
85 KOA Radio crew doing remote broadcast live from outside Mile High Stadium in Denver while waiting for the Broncos football team to return to practice following a National Football League strike. Courtesy KOA Radio, Denver.

One of ten studios at WTIC-AM and FM in Hartford, Connecticut. This is a 12 foot by 14 foot AM production studio which looks into the AM-FM Narrative Production facility and on into the WTIC-FM production studio. The video screen over the producer's head is connected to an AP wire machine so that all staff members can monitor incoming news. The screen can be switched in order to show readings for automated AM and FM transmitters. Courtesy of Ten Eighty Corporation (WTIC), Hartford, Connecticut.

definition of a region, but it should be both a good sized city and the suburban and rural areas around it) and operate from 1 to 5 kw. Class III-B stations are also regional stations, but they must drop their power to 500 watts at night.

A Class IV station serves a local area. Originally, these were 100 or 250 watt stations, but revisions in the FCC rules have raised the daytime power for most Class IV stations to 1,000 watts. Try experimenting with finding AM stations on the dial, you will find that certain frequencies are reserved for certain classes of stations. For instance, 1010 is a clear channel (Class I), 1270 is a regional channel (Class III), and 1450 is a local channel (Class IV). You can find a table that tells you the classifications of the frequencies in *Broadcasting/Cablecasting Yearbook.*

Wattage and Direction

One of the complications of AM broadcasting is the differences in the amount of power permitted by day and by night. Many stations have to reduce power at night. The matter is further complicated by another characteristic of AM radio. During the day the signal is radiated from both the tower and wires buried in the ground beneath the tower radiating outward from the tower base for a considerable number of feet. The wave from the tower, the *skywave,* goes out into the atmosphere and disappears. At night the *groundwave* continues to perform as during daytime, its performance being determined by the conductivity of the soil in which it is buried, with wet soil being better. The skywave runs into the ionosphere, which has descended as the

earth has cooled, and part of the skywave is reflected off the ionosphere and back to earth, creating *skips*. This explains why you can sometimes hear distant radio stations when driving in the country at night.

To squeeze more AM stations into the spectrum, stations have moved from using nondirectional signals to using directional signals. A nondirectional signal radiates about equally in a circle from the transmission tower. A directional signal can be created by using two or more towers in such a way as to shape the pattern of the signal to make it go further in some directions than others. This technique is used when a station must avoid interfering with another station on the same frequency. The directional antenna curbs the signal so it doesn't clash with the other station. In some cases directionality actually improves a station's coverage. There was, however, one Boston station which received permission to operate on high power, but because it had to protect another station, most of the signal had to be pushed out over Boston harbor to the east, rather than toward the growing suburbs to the west. You could hear the station fine 50 miles out to sea.

Operating Hours

Many regional and local AM stations were licensed to operate during the daytime only to protect high power stations on the same channel. These *daytimers* or *daylighters* were allowed to transmit from sunrise to sunset only, according to a uniform definition of sunrise and sunset established for each month by the FCC. The daytime stations were at a serious disadvantage in markets where they competed with full-time

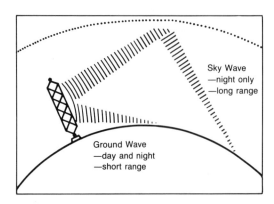

Figure 4–3
Sky wave and ground wave transmitted by an AM station.

Figure 4–4
Signal patterns of nondirectional (A) and directional (B) AM station transmissions.

stations because they lost their profitable early morning and late afternoon broadcast times in November and December, just when there was a heavy demand for advertising time for pre-Christmas commercials. In recent years some of these stations have received permission to operate with reduced power prior to sunrise and after sunset. From the owners' viewpoint, this was only a partial victory because the pre-sunrise and post-sunset power is frequently not sufficient to cover the daytime listening area.

AM STEREO

There has been a recent effort by AM station owners to establish a system for transmitting AM stereo signals to compete with FM stereo. A broadcast AM stereo transmission sends out a two-part signal, which gives the effect of dividing the sound at the receiver end to a right and left side if two speakers are used. The idea is to have the signals coming from the radio station sound much the same as if you were listening to a record on your home stereo set. AM stereo is at a disadvantage because it is limited by AM radio's restricted frequency response and problems of static, as well as a lack of AM stereo receivers.

The AM Stereo Standards Problem

The conversion to AM stereo has been slowed by a coincidence of technology. Five usable systems for transmitting AM stereo were introduced at about the same time, and the FCC refused to specify which system it preferred, saying the standard should be set "in the marketplace." Unfortunately, the five systems were not compatible, so a listener would have had to buy up to five receivers to listen to the different types of transmissions. Eventually, some manufacturers dropped out, but at least two firms continue to offer noncompatible AM stereo systems. Some manufacturers have come up with reasonably priced receivers which can switch from one type of transmission to another; so a few stations have installed stereo transmission equipment. AM stereo still has not come of age and certainly has not been the savior of AM radio it was predicted to be.

NRSC Standard

At the urging of the National Association of Broadcasters, the National Radio Systems Committee (NRSC) AM Quality Voluntary Standard went into effect on January 10, 1987. The three-part standard affects three technical areas of AM transmission: transmission preemphasis, receiver deemphasis, and a 10 khz AM system bandwidth. The Committee was sponsored by the NAB and the Electronics Industries Association (EIA), which represents receiver manufacturers.

Transmission preemphasis boosts high frequencies prior to their arriving at the transmitter; it is similar to increasing the treble on a home stereo. The standard deemphasis curve in the receiver means an engineer can set preemphasis at the transmitter, knowing how an average receiver will handle the signal. The bandwidth adjustment improves reception of new NRSC Standard receivers and some hi-fi receivers.

In April 1989, the FCC adopted another standard designed to improve AM radio reception, called NRSC-2. The standard sets limits on AM radio station signal emissions.

FM RADIO

The FM band consists of the portion of the frequency spectrum between 88.1 mhz (megacycles per second) and 107.9 mhz, 100 channels of 200 kilocycles per second each. The Commission divided the country into three zones. Zone I is most of the United States. Zone I-A consists of Puerto Rico, the Virgin Islands, and California south of the 40th parallel. Zone II consists of Alaska, Hawaii, and the part of the United States not in Zone I. (The descriptions are based on map coordinates and are listed in Par 73, section 205 of Volume III of the *FCC Rules and Regulations*.) The maximum operating power of an FM station is determined by the zone in which it is located. For instance, the maximum power that any FM station could operate at is 100,000 watts, but in New England that maximum is 20,000 watts because most of New England is in Zone II.

FM Broadcast Channels

One of the significant differences between AM and FM radio allocations is that the FCC decided to assign specific FM channels (and operating power limits) to communities throughout the country. Most applicants seek a specific channel based on the availability of an FM frequency in the community where they wish to operate. Oc-

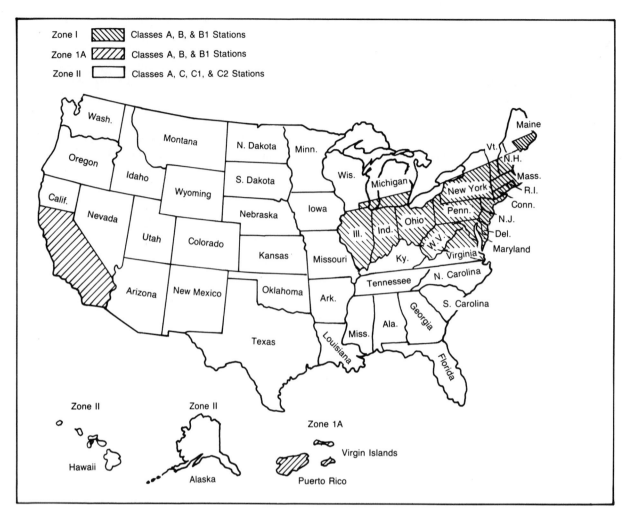

Figure 4–5
Map of the United States illustrating the FM zones and the types of stations operating in each zone, as mandated by the FCC.

casionally, an applicant will suggest moving a frequency assigned to a nearby town to another location, but until the early 1980s the FCC strictly adhered to its "Table of Allocations." In 1985 the Commission approved *Docket 80-90* and began dropping 689 additional stations into the FM band. This squeezing in of stations provided some frequencies in locations not currently served. It caused some existing FM stations to seek authority to transmit with full power; otherwise, their output power could be restricted permanently and new stations could be dropped in.

The FCC uses two ways to designate an FM channel. One is the frequency and the other is the channel number. Thus, a station on 90.5 mhz operates on channel 213. To further complicate matters, the frequencies from 87.9 mhz to 91.9

mhz are reserved for educational noncommercial radio stations.

Power Levels

FM stations have defined power levels at which they can operate, just like AM stations. The commission assigns a power maximum to each channel by saying that stations of certain classes can operate only on certain channels. Class A stations usually serve a small community or limited area and have a maximum power of 3,000 watts. Class B stations operate with no more than 50,000 watts. The rules for Class B stations become complicated because maximum power is determined not only by channel but by zone (see

73.206, Volume III, *FCC Rules and Regulations*). Class C stations have a power limit of 100,000 watts.

In 1989 the FCC added another class of FM station. Class C-3 applies only in Zone II (which covers most of the country, except the Northeastern states and most of California.) C-3 stations can have a maximum effective radiated power of up to 25,000 watts and a tower no higher than 328 feet above average terrain. Some Class A station assignments were upgraded to C-3, recognizing that 3,000 watts can be insufficient to cover a rapidly-expanding community.

These power limits take into consideration the height of the transmission tower, so it would not be possible to put up an antenna radiating 50,000 watts on an antenna 2,000 feet above ground for a Class B FM station. This would exceed the maximum power to height ratio. The ratio for 50,000 watts on a Class B station is based on a tower height of 500 feet above average terrain. The reason tower height is an important consideration is that the FM signal travels in a straight line from the top of the tower. In an effort to keep the coverage areas of stations in a specific class comparable, the FCC requires that there be a balance between transmitter output and tower height. If you put your FM antenna on top of a mountain, you might get by with a short tower, but on the prairies tall towers are needed to cover the area allowed by the FCC rules.

As an example, 94.3 mhz is a Class A channel numbered 232. Remember Class A stations can have no more than 3,000 watts of power. So flipping through the Table of Assignments in section 73.202 of the *FCC Rules and Regulations* our eye falls on Aitkin, Minnesota, and there's an assignment for channel 232. According to 1980 U.S. census figures, Aitkin had a population of just over 13,000 people. So you see, small community = local service = Class A channel = channel 232 reserved for class A stations = 94.3 mhz, which is the frequency reserved for a 3,000 watt (or less) FM station in Aitkin, Minnesota.

FM Advantages

FM radio has two major advantages over AM. It provides *a relatively noise-free signal* with a *good frequency response range,* which approximates a new recording played on a high-quality home sound reproduction system. The FM signal can be transmitted in stereo. The full impact of stereo reception is available in a smaller area than that

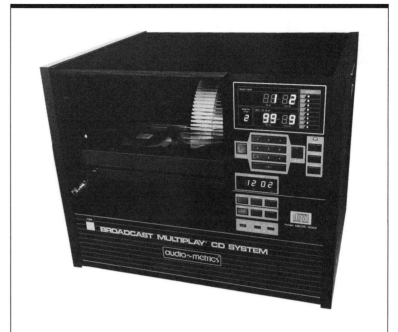

Playback unit for several compact disks. This new technology device interfaces with various radio automation systems. FM is better able to take advantage of the higher quality sound achievable with such new technology. Courtesy of Allied Broadcast Equipment Co.

covered by the main station signal because the second (or stereo) channel is transmitted at only a fraction of the power of the main channel. Thus, as you move away from the FM transmitter you will detect a loss of the stereo signal long before you lose the main station signal.

RADIO PROGRAMMING AND FORMATS

Format Diversification

In the early days of radio, there was a great similarity in the programming of radio stations, just as there is today in TV. Most stations were network affiliates and took the majority of their programming from a network, inserting only local station breaks and selected local programs. The first break-off occurred when the radio industry grew to the point that there were more stations in a community than there were networks available with which they could affiliate. These independent stations began counterprogramming the network affiliates. One of the most

common approaches used by independent stations was to play recorded music.

During the decline of network radio in the early 1950s when TV was taking over as the source of drama, comedy, quiz, and live music programs, the majority of radio stations converted to formats that revolved around the use of music hosts *(disk jockeys)* who talked between recorded selections. These "disk jockey" formats became popular, especially with younger people who were beginning to listen to radio in cars.

Segmenting

Soon radio programmers learned a new competitive twist; they discovered that certain types of music tended to appeal to certain age groups. At first these divisions were rather crude. Stations would program to young people, adults, and older adults. Programmers began to target their audiences to establish a "niche" in their market. By "niche" we mean the station would aim its programming at a defined segment of the local population and then attempt to sell advertising to retailers who served this segment. The competition intensified and the definitions of audience segments narrowed. Today we find station formats being described by such terms as contemporary hit radio (CHR), adult oriented rock (AOR), country, talk, news/talk, all-news, religious, black, Hispanic, adult contemporary, urban contemporary, middle-of-the-road, or "Music of Your Life" (a format created by radio programmer Al Hamm consisting of selected old, favorite recordings to get the age 45 plus listener.) Programmers whose stations run contemporary hit radio or adult contemporary formats are still trying to dominate their markets by securing the loyalty of the largest chunk of the available audience, people 13 to 34 years of age who tend to favor the current trends in popular music. Stations have also been successful programming a mix of news, talk, and sports to affluent males.

Syndicators

The need to create a variety of programming to accommodate different radio formats has given energy to syndicators. These are the companies that prepare programs at one location and sell them to as many stations as they can enlist. Syndicators play an important role in the economics of today's specialized radio formats.

Two common approaches to combat increased competition are to cut the size of station staff and substitute automated programming or a satellite service. *Automated programming* consists of audiotapes that are played according to instructions from a computer. The company or syndicator which provides the tapes can supply them with or without an announcer's voice. Industry sources indicate it is possible for some radio stations to purchase a complete schedule of automated and announced music programming for the approximate monthly cost of one announcer's salary.

Networks as Syndicators

Some networks are providing specialty music programming consisting of major pop music concerts recorded and replayed as specials; others provide top-hit countdown programs which play the top 40 (or any other number) hits of the week, according to a record rating system. Others provide live talk programs in which callers may reach the host or hostess by calling a toll-free telephone number. It is hard to pin down the number of networks currently serving radio stations because they regularly start up, exist for a while, and go out of business. There are at least 20 radio networks available to local broadcasters.

Some other types of syndicated programming are short features such as programs on hunting, fishing, skiing, finance, child care, taxation, sports, and health. Some programs are produced by companies which wish to tie advertising to the program. A fishing tackle company provides a program on fishing. Time–Life produced a program based on the contents of the current *Time* magazine. Programs of this type are informative and are often supplied free to the station.

Networks for News

One thing which survived the reorganization of radio networks when television took over entertainment programming was the hourly newscast. The tradition of supplying at least one newscast an hour began during World War II when people were hungry for news about the war. In the early days the key networks, CBS, Mutual, and NBC, tried to assemble a strong line up of the most powerful stations in as many markets as possible. Originally, they sought to affiliate with the large, powerful AM stations. By the late 1970s the major radio networks were seeking affiliation

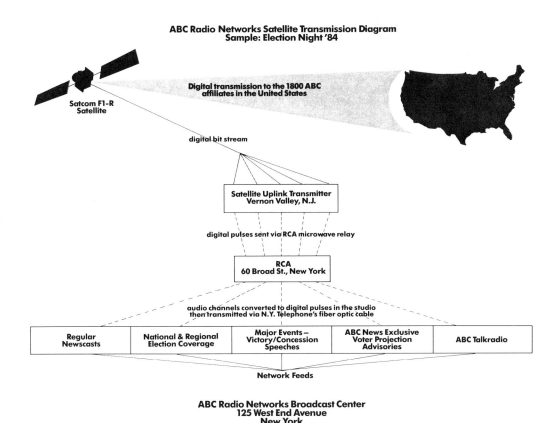

ABC Radio Networks Satellite Transmission Diagram
Sample: Election Night '84

Digital transmission to the 1800 ABC
affiliates in the United States

Satcom F1-R
Satellite

digital bit stream

Satellite Uplink Transmitter
Vernon Valley, N.J.

digital pulses sent via RCA microwave relay

RCA
60 Broad St., New York

audio channels converted to digital pulses in the studio
then transmitted via N.Y. Telephone's fiber optic cable

| Regular Newscasts | National & Regional Election Coverage | Major Events— Victory/Concession Speeches | ABC News Exclusive Voter Projection Advisories | ABC Talkradio |

Network Feeds

ABC Radio Networks Broadcast Center
125 West End Avenue
New York

Figure 4–6
Illustration of how ABC Radio feeds its multiple networks to affiliates across the country. This example specifically illustrates how election coverage could be done on three channels while regular programming went out on two. Stations could opt in and out of special election feeds. Courtesy of ABC Radio Networks.

with FM stations. The big-three radio networks (ABC, CBS, and Westwood One, which includes NBC) each now program two or more separate networks. Each network tailors its program and news presentation to a radio station format or a specific listener demographic. The news collection and news editing is centralized in the network's main radio newsroom for economy of scale while each subnetwork has its own writers and correspondents who are selected because they can write and present according to the style desired.

ABC Becomes Four Networks

The revitalization of radio networking got a big boost in 1968 when ABC executives realized that they were paying for expensive telephone network lines while they were utilizing those lines for as little as 15 minutes out of some hours even though they leased 60 minutes of line time. The

solution was to create four radio networks, each targeted to a specific audience, thus using the leased telephone circuits more efficiently. With only modest increases in personnel, ABC was able to offer affiliates four distinctly different approaches to presenting national and world news. It took a while for ABC to make the transition from being one large radio network to being four smaller networks. As stations underwent format changes, the total number of affiliates multiplied significantly until ABC's total number of affiliates was much higher than before the creation of the four networks.

As the 1990s begin ABC radio programs six individual networks (Direction Network, Entertainment Network, Information Network, Contemporary Network, FM Network, and Rock Radio Network). In addition, ABC feeds ABC TALKRADIO by satellite as a live syndicated program service. ABC Radio in 1985 was feeding more than 1,800 newscasts, business reports,

ABC Radio Networks Broadcast Center
125 West End Avenue
New York, N.Y.

TECHNICAL OPERATIONS CENTER

BROADCAST FACILITIES

OFFICES

COMMON AREA

OFFICES

"FLOATING" STUDIOS

COMMON AREA

STUDIOS

SPORTS

OFFICES

COMMON AREA

STUDIO

NEWSROOM

EDITING ROOMS

BROADCAST FACILITIES

NEWS STUDIOS

NEWS STUDIOS

BROADCAST FACILITIES

RECEPTION

Technical Operations Center
News Facilities
Common
Offices
Sports Facilities
Broadcast Facilities
Editing Rooms
Studios

RADIO abc

Figure 4–7
Floor plan of ABC Radio Networks Center in New York City. Note that the largest areas are taken up by technical operations and newsrooms.

minidocumentaries, and public affairs specials per week, serving 1,800 affiliates. By 1988 that figure had grown to 2,240 affiliates.

Other Multiple Networks

The idea of having multiple networks which would program to a variety of audiences caught on. NBC added The Source, a network aimed at a younger upwardly mobile audience. Later NBC added a lineup of talk programs that were transmitted by satellite. RKO, a long-time group owner, reentered the network business (RKO had owned The Yankee Network in New England in the early days of radio). RKO set up two full-time networks and one special program service. In 1985 the RKO radio networks were sold to United Stations, which continued to build on the same concept.

Mutual tried a different approach, creating the Mutual Black Network and the Mutual Spanish Network. These efforts did not fare well as businesses and were later sold, but they continue to exist and make a moderate profit. However, Mutual continued to offer two distinct types of news programming, which can be carried as separate networks, plus some live sports and an overnight talk show. Mutual is now a subsidiary of Westwood One, as is the NBC Radio network.

CBS added a second, youth-oriented network called Radio, Radio. It also added sports and concerts to its program schedule.

Technology has played a significant role in the revitalization of radio networks. When domestic satellite time became available at reasonable rates, it was possible to set up a radio network at very low cost. Even more important, satellites made it possible to program music with quality acceptable to FM stations.

Satellite Network Radio

The flexibility and reduced cost offered by satellite transmission opened up new vistas for radio. Regional sports networks were created; state news networks, which had faltered using telephone lines, became financially viable. The Dow-Jones Company, which publishes the *Wall Street Journal*, created a network to provide hourly business news reports. Some networks offered extended live coverage of presidential news conferences, space shuttle launches, and congressional hearings on an auxiliary channel while providing only brief newscasts on their main channel. This means that if a radio station desires, it can carry a whole presidential news conference live or it can stick with hourly summaries of the event.

Other developments in networking include the creation of CNN Radio News, which began as a virtual rebroadcast of the audio of the cable TV network, CNN Headline News. In mid-1985 the then three-year-old network stopped repeating the hourly news reports on the half hour and went to two original news summaries per hour, 24 hours a day. CNN Radio added hourly sports

and business reports throughout the day and began *closed-circuit* news and feature story feeds for use by affiliate stations. Some weekend 30-minute programs were still being taken off the audio of CNN's two cable video networks. Today CNN Radio functions as an all-news radio network, something that had been unsuccessfully tried between 1975 and 1977 by NBC.

The sky is full of network signals. There are farm networks, sports networks, business networks, program services, classical music networks, regional and state news networks, and many other uses of the satellite radio spectrum.

Specialty Networks

A survey conducted for the Radio-Television News Directors Association in 1984 indicated that industry observers expected to see a continued growth of specialty networks into the 1990s. The survey respondents said the topics most likely to be favored by specialty networks include sports, business and financial news and information, news, entertainment, life-style, health, and medical information. The same survey indicated there would be more job growth in radio news/sports/feature at the outside supplier level, rather than within radio stations.

Networks and Money

There are so many radio networks because advertiser support has returned to radio networks. Advertisers can hit specific target audiences at reasonable cost with radio. In addition, advertisers reach radio listeners in automobiles, on the job, jogging, and even in the shower. Not all networks make money, but network radio has become a strong enough medium that millions of dollars are being invested by broadcasters hoping to make their networks profitable.

Not all networks exist by selling advertising. Both major domestic wire services, the AP and UPI, run audio services and provide hourly news, sports, and feature broadcasts. They receive payment from member stations for these services. National Public Radio is supported by government funds and donations.

You might think radio broadcasters would want to give up their network affiliations and recapture the time and commercial availabilities. Two of the reasons they don't is that (1) it is difficult for a local station to do a satisfactory job of presenting world and national news and sports

Figure 4–8
AP Radio Network correspondents co-anchoring a special election night report. Note they are broadcasting from a standing position, which some stations demand. The theory is you have better voice control if you are standing than if you are hunched over in a chair. Courtesy of Associated Press Broadcast Services.

and (2) most radio stations have an adequate inventory of unsold advertising time to allow for the highly discounted network spots running on their air. In many cases the network pays each station a fee for carrying its sponsored programs.

CABLE RADIO

Cable radio is a not widely known aspect of the telecommunication business. There are three types of cable radio: retransmission of on-air radio signals, origination of cable-only radio, and satellite-supplied cable-only audio channels. In the early days of cable TV a few brave entrepreneurs tried to run radio stations using only the cable system as a means of distribution. They ran into a multitude of problems: (1) cable wasn't portable, so people couldn't take the cable system with them in the car or out to the beach; (2) the cable connection in the average home terminates at one or two TV sets, which meant that the radio used to receive the cable station usually had to be near the TV set; (3) most cable systems did not serve the majority of the homes in their community; and (4) advertisers were

unsure about spending money in this new medium. Most of the early cable radio stations died for one or more of these reasons.

In recent years a new trend has developed in the cable business. It is the rebroadcast of existing radio signals on the cable. The cable system usually charges a small additional fee to connect the cable to a home hi-fi set or other radio receiver.

You might ask, why would anyone bother to subscribe to cable radio? The answer is for much the same reason people subscribe to cable TV, to get more and better signals. If you lived in a small town served by a cable system, you might not be able to listen to the type of music you preferred, especially in the evening. One particularly successful cable service has been the satellite transmission of the signal from WFMT, a classical music station in Chicago. As a result of WFMT's success, KKGO, an all-jazz station in Los Angeles, and fine arts station WQXR in New York became available on cable. There are many towns and cities that do not have classical music stations. If a cable subscriber likes classical music, it may be worth a small extra fee to have WFMT piped into his or her stereo system. In communities where one or more daytime radio stations have to shut down at night, they can continue to feed their programming via the cable system, thus keeping at least a segment of their loyal audience for the next morning while earning a little more income. Some national program syndicators now feed cable radio as a supplement to their regular business of feeding programming to radio stations. Satellite Syndicated Systems offers a package of seven audio feeds and Studioline Cable Stereo offers nine audio channels. There are special reading services for the blind and channels that program in Italian and Greek.

Research in 1985 by Satellite Syndicated Systems showed that the commercial success of satellite-delivered cable audio services is greater in smaller markets with fewer over-the-air radio stations. When asked why they liked cable audio, men tended to be more attracted to the quality of reception while women placed more emphasis on program variety.

Some small college radio stations feed a cable system as an economic way of extending their signal.

HOW A TYPICAL RADIO STATION OPERATES

Perhaps the easiest way to understand the inner workings of a radio station would be to pretend

we are going to put our own station on the air. Let's say we want to apply for a 3,000 watt FM radio station in Tallahassee, Florida.

Application for a Frequency

First we apply for the frequency, which we have selected from the FCC's table of available frequencies. Let's say we find that 93.5 has been assigned to Tallahassee. (This is a Class A frequency, but it is not really assigned to Tallahassee.) This information is found in Subpart B of Volume III (October 1987), Part 73—Radio Broadcast Services at 73.202, *FCC Rules and Regulations.* The rules themselves can be purchased by anyone who writes to the Superintendent of Documents, U.S. Government Printing Office, Washington, D.C. 20402.

We have to undertake two parallel sets of activity: (1) we have to develop a business plan, and (2) we have to begin the legal process leading to the granting of the FM channel.

Business Plan

Our business plan is a detailed description of our financial assets, personal and personnel resources to run the business, plan for achieving a successful market position, and an analysis or projection of future expenses and income. This information will help when we prepare our application, but its main purpose is to persuade bankers or other sources of financing to give us the loans we need to start our radio station. Very few applicants have enough cash to put a station on the air and sustain its operation until the income exceeds the expenses of running the facility. We can sell partnerships to local people who are looking for investments (doctors and lawyers frequently invest in this sort of venture), or we can persuade a venture capital firm to give us backing in return for a share of the business (which we may buy back later). We can borrow money from a bank if we have a strong business plan and good credit or we can get a loan from an investment source, which loans money to broadcasters. As in any new business venture, if the cost of starting up is relatively high, people usually borrow start-up money hoping they will generate enough revenue to pay off the debt.

Experienced observers would expect us to spend $100,000 to $200,000 to get our station on the air. We have to buy or lease clear, high land for the transmitter and tower, build or renovate studios and offices, equip and furnish our facil-

ity, and be able to meet operating expenses for a while after we start.

Once we are fairly certain we have the financial ability to go into business, we consult with an experienced communications attorney. The majority of these specialists are located in Washington, D.C. However there are a few in other parts of the country. The attorney double checks to make sure we can apply for the channel and then suggests we contact a consulting engineer.

Business Environment

While we are looking into the legal and engineering sides of our venture, we must simultaneously complete our analysis of the business environment in Tallahassee. We must study the current market in terms of the amount of advertising dollars it generates, growth potential, the number of radio signals that can be received in the community, the nature of competitive media, and their impact on the advertising market and we must determine a programming approach which offers us the chance for commercial success.

Programming Survey

We must decide what kind of station we are and who we are trying to reach. The first step is to analyze the market. Here is the current lineup:

AM station # 1, black, urban contemporary, 10,000 watt daytimer

AM station # 2, country music, heavy news, and sports, 5,000 watt fulltime

AM station # 3, religious, 5,000 watt daytime

AM station # 4, rock hits of last 20 years, 5,000 watt daytimer

AM station # 5, Music of your Life, 1000 watts days, 250 watts night

FM station # 1, beautiful music, 50,000 watts

FM station # 2, contemporary hits, 100,000 watts

FM station # 3, contemporary hits, 100,000 watts

FM station # 4, contemporary rock, 3,000 watts

Other stations in market:

FM educational, jazz, gospel, 100 watts

FM educational, traditional National Public Radio format, 50,000 watts

Figure 4–9
Employees in a new or small radio station may have a great deal of responsibility. A news anchor in an all-news radio station may run his own board, load and run his own commercials and news tapes, and write most of his own copy.

In addition, a 100,000 watt FM country music station 100 miles away gets a few rating points in surveys.

Other signals entering the market include a powerful AM 30 miles northwest, a powerful FM contemporary 100 miles west, and another powerful FM contemporary 30 miles northwest plus an FM programming country by day and black-oriented format by night 20 miles to the west.

Ratings

That is a lot of radio signals for a relatively small market. So how do we find our niche? Well, the next thing to do is look at the ratings. Say the ratings lined up like this:

Number 1 shared by AM #1 and FM # 3, one a black format and the other contemporary. Both stations are owned by same company. The black format station gets crossover audience while the contemporary pulls college and young working people who make up the largest segment of the local population.

Number 2 FM # 4, a 3,000-watt rock station, which demonstrates a lower-power station can make it in the market.

Number 3 FM # 2, the other powerful contemporary station. The median age in this

community is 27 years, which explains the success of stations playing contemporary hit music.

Number 4 AM # 2, a regional station which programs country music, news, and sports. It has been slipping, but market experts say most of the slippage is caused by the young listeners' switching to the FM band. The market has traditionally been strong for country music and country usually leads in other area cities.

Number 5 FM # 1, a beautiful music station.

Number 6 AM # 5, which programs the successful old hits format, "Music of your Life," which appeals to mature listeners.

Number 7, a 100,000-watt FM country music station in a city 100 miles away.

The two remaining AMs, one religious and the other rock hits, are unrated, but the religious station reportedly makes a good income from its low-cost, specialized programming.

Programming Decision

Where do we go from here? It's obvious we can't break into the contemporary or contemporary rock markets, and with only 20 percent of the area population being black, we had better not try to overtake the established black format station. If we look carefully at the ratings, we notice there is a lack of a local, FM country music format, and that's our best bet.

Next, we have to decide the strength of our proposed programming. We soon discover that the two country music stations available to listeners in our market talk a great deal, so we decide we will deemphasize announcer talk and promote a "more music" concept. This also makes sense from a business viewpoint during the first few months because we will have fewer sponsors than we plan to have later, so we need fewer commercial interruptions. This approach also helps us to keep down personnel costs because we do not have to pay a premium for disk jockeys with established followings or proven ratings.

We will have to make other decisions. Will we carry local news? None for now because it is a high cost item beyond the budget of a start-up station. In a few months we will sign up with a national network to get news on the hour, and if our business plan works out, we will hire one newsperson to start a local news department late in the second year of operation.

What public affairs programs will we schedule? Will we bid for live coverage of local high school or college sports?

After giving programming a great deal to thought, we have decided to program modern country music, we will limit news to a network service for national and world coverage and have our air personalities read copy from the wire service for state and area coverage. We have made preliminary contacts at the two universities and other major civic organizations so that we can develop a small number of our own public affairs programs or features and also use some material they have prepared, and we have decided not to attempt to bid for sports rights for the time being. The rights to the local high school and college sports would be too expensive, and because most games are carried on our local country music competitor, we would be in a better position by programming music when the games are on.

Figure 4–10
Radio stations undertake many promotional activities in order to boost their popularity and ratings. A good example is remote broadcasts from locations in the radio's market area. Here, an 85 KOA radio talk host at a remote broadcast interviews the mayor of Denver, Colorado. Courtesy of KOA Radio, Denver.

Engineering Consultant

The technical requirements for a radio station application are complicated enough that most applicants decide to employ an engineering consultant. The consultant uses computer software

to determine if we might have any problems with interference from co-channel stations (stations on the same frequency in adjacent areas). The new station has to make adjustments to prevent interference with stations which are currently on the air.

The engineering consultant recommends the tower height, power (these can be adjusted within limits), and other specifications we need and tells us whether or not we should proceed with our application. Fortunately, the application side works out fine and the consultants tell us we can go ahead and apply for the frequency.

Competing Applications

Our application is posted by the FCC, and it appears among other places in *Broadcasting* and *Electronic Media,* weekly trade magazines read by the majority of people in the broadcasting industry.

Another group of people from outside Tallahassee has decided they would like to go into the broadcasting business in Tallahassee. They prepare their business plan, and make application to the FCC for the same frequency. This is a perfectly legal procedure and happens with most broadcast station applications.

What is going to give us an advantage over our competitors? Currently, showing that a significant percentage of our ownership consists of minorities and/or women will give us a decided advantage. If we are local residents who know the community and have solid financial backing, we will be in an advantageous position. If some of our participants have broadcasting experience, this will help. If our competitors have had an application turned down previously or have had legal or engineering problems with a station they own, they may be at a disadvantage.

At this stage, then, we have to do some detective work. We will have to prepare comparative information for use by the FCC to determine who gets the allocation for 93.5, so it is to our advantage to find out as much about the competitors as possible.

Dealing with Competitive Applications

Sometimes two or more competitive applicants are so strong some sort of compromise has to be struck. One way to get out of the dilemma is to merge with the competing firm, and this happens frequently. Another approach is to offer to buy out the competitor. Legally, you may only pay the competitor's expenses in filing and pursuing the application, but if the competitor has a weak case, this may be the economic way to quickly resolve the competitive issue and get on the air.

If you have to compete directly with another applicant, the process of getting the channel may drag on for years. It will probably end up being heard by an FCC Administrative Law Judge who makes a recommendation to the FCC staff, which in turn passes its recommendation to the appointed FCC commissioners who must make the final decision. Even the FCC's decision can be appealed in federal court if the expense involved is justified.

We have wisely developed a strong, well-financed business plan, we've included minorities and women among our partners, several of us have prior broadcasting experience, and all are local residents. Chances are we have a strong application. Probably the most efficient way to get on with the process is to have our attorney approach the attorney for the competing group and point out the futility of their application. They will probably agree to be bought out for expenses, just so they won't have wasted any money. This raises the cost of obtaining a license, but it accomplishes two important purposes: (1) it reduces the cost of litigation, and (2) we get on the air sooner.

The Construction Permit

One spring day, we receive a notice from the FCC granting a construction permit (CP) to begin the process of getting the station on the air. As soon as possible, we will want to erect the tower, construct the transmitter building, build or renovate studios, and start buying equipment. If we have been wise, we already have an option on an acceptable piece of land on which we will erect our tower and transmitter building. This is an important decision because the placement of the tower is critical to business success. It must be on terrain that assures good coverage and must be located in such a way to cover current and future markets. In addition, the land cannot be too expensive, or it will eat into the capital budget.

Let's say that we did get an option on a satisfactory piece of land. Should we build the studios at the transmitter site, or should we have the studios at some other location? There are several approaches. Many broadcasters prefer to

lease a studio location closer to the economic and business center of the market so they will have visibility and will be able to reach clients easily. Other broadcasters, especially those who set up business in less populous areas, will build studios at the transmitter site to cut transmission costs between the studios and transmitter and to keep from paying rent. (We can get a mortgage on a building if we build our own studios. Having a mortgage may give us some tax advantages.) A good many small radio stations have started out in modular homes towed to or erected at the transmitter site. Later as the station became more prosperous, a larger, custom-built facility was erected.

Location

Tallahassee is a market of 210,000 people spread out over a 40-mile diameter circle, so we decide to rent studio space near downtown and use a microwave link to send our signal out to the transmitter, located on a piece of farmland just north of the newest residential part of town.

The problem of locating a tower can be complicated. The FAA frequently becomes involved because it wants to keep broadcast towers out of aircraft flight paths. In other instances, a station has to prepare an environmental impact study to show it won't damage the environment. Also, the tower has to be located in such a way it won't fall on nearby homes if a big storm should hit.

While our station is being built and equipped, we have a number of other tasks. We must finalize our programming, hire a staff, begin our sales effort, and prepare a promotion campaign to announce our entry into the market.

Staffing

The next set of decisions we have to make concern staffing. How many people can we afford to hire and what will they do for us? The key here is whether we choose to totally automate the station, semi-automate, or do live announcing and play records. We hesitate to go to total automation because two other stations in town use automation, and they have been hurt by their lack of local personality and the mechanical glitches which have occurred in the automation equipment. Our best alternative is to use live announcers, but to purchase a tape service so we have well thought out music sequences that include all the latest hits. This type of programming can be done better and cheaper by a syndicator. Besides, we don't have to consume valuable staff time contacting record companies, cataloging and sorting records, and working out record rotations.

We know that we need a minimum number of announcers to cover the time we're on the air, which will be from 5:30 A.M. to 1 A.M. We will not stay on overnight, for now, to hold down personnel and electricity costs. We must sign on early, however, because a great many people in our market get up early: to commute to work, to arrive at 7 A.M. for construction work, to get children ready for school, which opens as early as 7:30, or to get to jobs in state offices that open at 7:30 or 8 A.M. We want to stay on until 1 A.M. to catch the youth audience listening in cars or trucks.

Our announcers will be competent but not spectacular. We will be able to hire full-timers from nearby smaller markets, and we can fill out the staff with part-timers who attend one of the three local colleges. Our air shifts will be relatively long, about 6 hours per person, so we will be able to get by with three full-time employees on weekdays and one part-timer for late nights. The full-timers will pull one weekend shift each

Figure 4–11
Announcers sometimes do a good deal more for the station and the market than just announce. As an example, KOA Radio's afternoon personality crawled over 11 miles up and down Denver's 16th Street Mall to increase public awareness of the March of Dimes fight to prevent birth defects. The promotion raised $94,000 in pledges. Courtesy of KOA Radio, Denver.

and will be augmented by part-timers. One full-time person will also be the operations manager in charge of programming, contests, promotions, and public affairs. This person will carry a reduced shift. Because we are buying a syndication service to provide our music, we do not need a full-time program director or music director.

We will need a general manager, a sales manager, and three salespeople. Some of our department heads will be part owners of the station, so they will probably take reduced salaries at first until the business gets on its feet. The salespeople don't cost the station a great deal because they receive only a small guarantee, which is recaptured from their commissions. They make most of their money from commissions on their sales.

The Unheard Staff

We will probably need two office workers, a receptionist–traffic person to run the front desk and prepare the daily operating schedule (log), and a business manager to handle billing, payroll, and paying our bills.

We can use an outside accountant, attorney, and consulting engineer on an hourly fee basis to keep down the overhead. We pay for these people only when we need their services. That does not seem like many people, perhaps nine full-time people and three part-timers, but that's typical of many radio stations.

Earning Money

Now we turn to selling advertising, which is the reason we are in business. We have a number of tasks to accomplish: set a rate card (prices for our commercial time); list all potential advertisers; assign potential advertisers to our sales people; prepare printed literature, stationery, etc., to accompany our sales presentations; determine whether or not we can afford to belong to the Radio Advertising Bureau, the Florida Association of Broadcasters, and the National Association of Broadcasters; train our sales staff; begin contacting potential advertisers to book ads at our special pre-start-up price; and investigate possible cooperative advertising tie-ins local sponsors can use in conjunction with products such as food items and lawn mowers.

Rate Cards

Our *rate card*, which is a list of the prices we charge for various lengths and quantities of com-

Figure 4–12
Advertising presentations are frequently inserted in folders with covers like this one, which gives the reader an immediate idea of the station's format. Courtesy of WRTN, New Rochelle, New York.

mercials, is an important document. We must set the prices so that they reflect what the market will pay for a station without ratings. At the same time, we will try not to underprice ourselves so that we don't have to spend too long getting our rates up to a satisfactory level as our audience grows. Our research consists of obtaining rate cards from other stations, which is usually done through third parties who let us copy the information from cards that have been left with them.

The sales effort is and will continue to be the most time-consuming part of our business activity. You can only sell advertisers whom you visit (and revisit). Once you have sold advertising time there is a great deal of paperwork and record keeping which must be done to make certain the commercials are created, run when they are supposed to, are billed accurately, and the payments are collected.

We will pay the salespeople a modest "guarantee" to sustain them until they start to earn commissions. Usually part of the guarantee is recaptured from the commissions, and then the

The "Swells'" WKTU.
The other hottest
station.
RETURN☆RADIO
93.5 FM
WRTN

Our sponsors
get results.

So will you.
Old smoothie!

RETURN☆RADIO
93.5 FM
WRTN

Music for
the folks who
live on the hill.
RETURN☆RADIO
93.5 FM
WRTN

FM Stereo. Just past 95.
Next to good, old WPAT.

FM Stereo. Just past 93. Next to good, old WPAT.

We'll always
give you a pretty
song. RETURN☆RADIO
93.5 FM
WRTN

You never know
when you might
need a pretty song.

RETURN☆RADIO
93.5 FM
WRTN

Figure 4–13
The sales and promotion departments work together to create a graphic "image" used in promoting the station. Courtesy of WRTN, New Rochelle, New York.

sales people get to keep 15 or 20 percent of their net collected billing. We said *collected* because many stations do not pay commissions until the advertising has run and has been paid for. It is possible for a salesperson to earn quite a lot of money, but it usually takes some time to establish a big enough base or *list* of steady advertisers to make the saleperson's hard work pay off. We will probably contract with a national "rep" or *representative organization,* which will solicit national and regional advertising for us.

Internal Organization

While the contractors are finishing the studios, the transmitter building, and the tower, the consulting engineer is supervising the installation of our equipment. We have to spend some time on setting up our organization. We have to train our limited office staff, buy supplies, furnish the offices, install telephones, get a copying machine, and set up a business office.

We will join several local civic organizations to raise our visibility in the business community. We're almost certain to join the Chamber of Commerce, and individuals on our staff will probably belong to the Junior Chamber of Commerce (Jaycees), Rotary, Kiwanis, Lions Club, and similar organizations.

Promotion

We will need an economical but effective *promotion* campaign to let the community know we're on the air. It is probably best if we hire a local advertising agency to help us develop a campaign and prepare the ads. The agency will contract for newspaper space (which, oddly enough, is one of the most common ways of announcing the arrival of a new station in town) and design our logo or trademark to use on stationary, T-shirts, and other promotion pieces.

We'll probably have a few give-away items made, such as ball point pens, so we can give little reminder gifts to the people we contact about advertising. We may even decide to run some contests and give away T-shirts or baseball caps to winning listeners.

We will have to plan a year's worth of on-air promotions, including deciding what we will call ourselves so that our trademark will stick (something like "Modern Country 93").

We will plan our promotions so that they intensify before and during the annual rating period when we must make certain people remember our name (call letters or dial position). There are certain rules we must follow during these prerating period promotions. The rating services frown on promotions which begin and end precisely at the same time as the dates when ratings are being taken. Therefore, contests and promotions have to begin well before the rating period.

FCC Rules

Speaking of rules, our general manager, operations director, and engineering consultant have to make certain that appropriate staff members are familiar with the *FCC Rules and Regulations,* other regulations and laws we must follow, and the rules on political broadcasting.

Figure 4–14
Radio stations make effective use of bumper stickers to drive home call letters (WVOX) and dial position (1460 AM). Courtesy of WVOX, New Rochelle, New York.

Figure 4–15
Another promotion sticker. This one gives a very clear idea what type of music the station plays. Courtesy of WRTN, New Rochelle, New York.

Three deck cartridge recorder/playback. One of the pieces of equipment you would have to learn to use if you operated the controls in a radio station. Courtesy of Fidelipac.

Permits

We must make certain all our announcers post their FCC operator's permits because they will have to sign legal documents relating to the transmitter control equipment. The chief engineer will post his or her license near the transmitter control panel. We must obtain the necessary local business permits and we must set up the *public file* required by the FCC.

Getting Ready for the Big Day

Once all the equipment is installed, the consulting engineer performs a series of tests and then certifies to the FCC that we have met the required engineering standards. Shortly thereafter, the FCC sends us a telegram authorizing us to conduct program tests. This means we may transmit programming, but we may not yet carry

One of the newest audio devices installed in some radio stations, a digital audio studio tape recorder/player. Courtesy of Panasonic Professional Audio Systems.

An audio production control board which combines signal processing, storage, mixing, and editing functions into a single compact system. This is the direction radio is going, toward increased audio excellence. Courtesy of Solid State Logic.

commercials. Usually within a few days permission is received to begin regular programming.

Before we go on the air, we assemble our on-air staff and make certain each person understands our format and how the station should sound. We will tape record some dry runs so we can work out any bugs in the style of our presentation (called the format). We want to sound organized and highly professional when we go on the air.

The Big Day

Finally, four months after we got our construction permit, we are ready to begin regular broadcasting. The ads are in the newspaper, selected billboards are up around town, a few commercials have been swapped (or traded) with a local TV station (we will carry ads for the station during its rating period), and we have talked the daily paper and two weeklies into doing short articles on our new station.

The sales staff has booked a light schedule of advertising and we have selected some local public service announcements to fill some of the open time.

The music tapes have arrived, the equipment has been tested, the on-air jingles and promotions are ready, the staff is rehearsed; and now it is time to start broadcasting.

Summary

As you have read through this example, you have learned a little bit about how a radio station is put together. Very small stations have to omit some of the people and activities we described and very large stations have many more employees and specialists on their staffs. A large station would have a large news department, a public service director, a marketing expert to assist the sales staff, an in-house promotion department, and staff engineers.

BUYING YOUR OWN STATION

The "Great American Dream" for many broadcasters is to own their own station. In most cases this means owning a radio station because it usually costs less than a TV station and can be run by the owners if it is small enough.

How do we go about buying a radio station?

The National Association of Broadcasters suggests asking these questions:

Am I prepared to put in long hours?

Am I tenacious?

Am I the kind of person who inspires confidence in other people?

Am I willing to listen and learn?

Am I a communicator?

Do I have enough money?

How to Go About It

Most people who set out to buy a radio station make some sort of market or geographic choice. If we are investing in a "mom and pop" small-town station, we need to pick a place where we will enjoy being a part of the community. However, some business people set up a model for the type of property they want to buy and go wherever they find that station. One of the old standbys in looking for a property is to find one that is underpriced and undermanaged, a station that is cheap in comparison with similar stations and one that has been poorly managed. We can increase its income simply by being more efficient and doing a better job of programming. It would be nice to buy a big moneymaker from Group W (if they would sell), but we might pay a very high price and then find the station was returning just about all the income it could earn. (That's because Group W owns top properties and manages them well.)

Brokers

One way to learn about pricing and terms is to call a few brokers (people who represent either buyers or sellers, and who usually advertise in the pages following the classified ads in *Broadcasting* magazine) and discuss our objectives in general terms. Most brokers will be brutally frank with us if they think we are dreaming or impractical. We should have access to a communications attorney and talk extensively with the attorney before we do much of anything else.

Business Plan

Our business plan is the first thing a banker or potential investor will ask to see. It is a written explanation of what we are trying to do to make money. In order to write a business plan we have to do research. We have to figure out how much money we will need to buy and sustain the new business, what amount of income we need and where it will come from, what it will cost to run our business, and whether or not we can generate enough income to pay both expenses of running the station and the principle and interest on bank loans. We will have to study the market to be familiar with our competition, understand the advertising environment, and know what services we can offer to the potential audience.

We can do a good part of this research ourselves working with the Chamber of Commerce, the Real Estate Board, and other fact-gathering groups including local colleges and universities. We may decided to seek professional help in some areas, such as asking a consultant to survey the market and suggest a programming niche that is not currently being filled. Our business plan must contain forecasts of revenues and expenses. Don't try to fool the bankers and don't be underprepared because bankers and investment advisers will catch you. (And if they don't you'll probably end up in bankruptcy court anyway.)

When we get to the point we are seriously considering buying a specific property, we should get an engineering opinion from a qualified consulting engineer. We need to know exactly where the station's signal goes, where it doesn't go, why it does or does not cover the market, the condition of the station's physical plant, and any expenses we can plan on incurring to bring the equipment up to par.

As individuals we should have a personal attorney. We will need advice as to whether to set up a sole proprietorship, a partnership, or a corporation. No matter which choice we make, we will need legal guidance to get through the paperwork required to set up a business. We may need a financial consultant if we want to put together a deal which involves more than borrowing money from the bank. Most station buys involve some kind of partnership in which individuals or investment companies put their money into the business in the expectation that they will make more money than as if they put it in a savings account or speculated in the stock market.

One of the best financial advisors anyone can have is a good certified public accountant who prepares your tax returns and tries to shield your income from taxes. We will need accounting and bookkeeping services for our new station. We may decide to employ a different accountant for

the business, just to keep our personal and business affairs separate.

Once we've gotten laryngitis from talking to all these experts and consultants, we can go to a bank or financing source and get an initial commitment for financing.

Station Search

Now the search for our station begins. We will need to talk with several brokers. Most brokers demand exclusive listings because theirs is an expensive business. This means that broker A is not likely to have the same listings as broker B. You will notice when you read the back pages of *Broadcasting* magazine that certain brokers tell you what geographic areas they cover, the type of station they handle, or the price range of their properties. This information will help us weed out brokers we don't need to talk to. We can, if we wish, employ a consulting broker to help find a station. It's not a bad idea, but hiring consultants costs money, so we have to figure out what we can afford. We can make up for the lack of consultants by doing a lot of telephoning and hard work ourselves, but we need to call in the consultants when we get down to specifics, such as making the final decision to buy and seeking the actual financing.

Consultants are selling expertise, most are scrupulously honest, but that doesn't mean they are less likely to tell you information detrimental to closing the deal. A number of first-time buyers have been stung by failing to do their homework by asking the difficult and searching questions.

Zeroing In

Some steps we can take include calling people we know in the business who might be familiar with the market we're looking at, or with the people who own the station. We can find out how the station has been managed. We can find out if there are any stories going around suggesting tricky or even illegal dealings.

When we inspect the property, we should read its public file, get accurate up-to-date copies of its financial reports, and have an expert study them. We should take a consulting engineer with us to inspect the facility and we should *listen* to the station for several days. We can learn a lot by listening to the station and by observing who around town listens to the station. We should quietly make inquiries about the station by talk-ing to merchants and, if possible, competitors, and even contact former employees. We should use any system we can to learn as much about the property we are looking at.

Too many first-time buyers have ended up with a station, which was falling apart, technically and structurally, where all the employees were dissatisfied, the advertisers unhappy and behind in paying their bills, and the programming in shambles. There have been exceptions where buyers have turned around weak properties and made a good profit, but these instances tend to be exceptions.

One common mistake made in buying a station is failing to find out how the owner is handling the accounting. We may find the owner's car is the property of the station, personal expenses have been taken out of station income, or a spouse is on the payroll but not active.

Pricing

There are all kinds of fancy formulas used to price stations. One is multiples, which means you pay so many times the gross revenue. A reasonable multiple in one market is unreasonable in another. In other words, you can pay more for a radio station in a growth market and still get a decent return than you can for a radio station in a stable low-growth market. Real estate sometimes gets tossed into the figuring. Remember, the real estate under the tower or the studio building is unusable for anything else, so we can't be taken in by someone who suggests looking at the value of the 14 acres that comes with the station. If we can't sell off or expand on the land, it means little to us in terms of added value.

The Buy

Finally, we find our station. It turns out to be a 3,000-watt FM station in a small but growing community with only one competitor on both the AM and FM bands. The studios need a little fixing up and we will need to make selected equipment purchases, but the physical plant is adequate and the transmitter and tower are in fine shape. The station was put on the air four years ago by a man who owned an AM/FM combination in an adjacent state who expected his son to take over the station we're buying. The son tried radio for a while and then decided to open a computer store instead. The father has

found the station too difficult to supervise from a distance and decided he was better off disposing of it. He was willing to dispose of it at a fair price to get out from under the responsibility of coming to check on the station every week. From all appearances we can significantly improve its revenue picture because we will be on the scene, making acquaintances in the business community and aggressively programming, promoting, and selling our station. The younger people in the community are not being well served by the music currently being played, so we can cultivate a portion of the market, which, thanks to new industry, is continuing to grow. We can reasonably project at least a break-even the first year, a modest profit the second year, and then continued healthy profits in following years if we work hard and put energy into our enterprise.

A first-time buyer who thinks he or she is going to turn around a station may get a surprise. Unless the property is poorly managed, it may take more expertise than the first-time buyer has acquired. It is smarter to buy a good solid property in a growth area from someone who wants to leave the business for good reasons (retirement, estate planning, other business interests, settlement of an estate) and work hard to make it do better.

Two very wise Washington communication lawyers, Erwin Krasnow and Julian Shepard, remind us of three of Murphy's laws:

1. It something can go wrong, it will.
2. Nothing is as easy as it looks.
3. It always takes longer than you think.

Despite all these dire warnings, we can become the owners of a radio station at a relatively young age if we work hard enough. Right now, we should begin by reading every book we can find on broadcast management, broadcast sales, and programming. We need to become careful readers of the trade magazines and then we should contact the National Association of Broadcasters in Washington and buy some of their booklets on various aspects of station buying and ownership. In the meantime, we can get experience by getting involved in the business by working in programming and sales.

PUBLIC RADIO

Noncommercial public radio started out being called *educational radio* because in the early days of radio many of the noncommercial stations were run by colleges and universities. Usually, they combined educational programs with selected music (frequently classical music because it was offered less frequently on commercial radio). One example is WSUI at the University of Iowa, which was run for many years as part of the extension service and provided educational opportunities and information to people who could not come to the university campus. In the late 1950s WBUR (FM) at Boston University was part of the School of Public Relations and Communication and a training ground for broadcasting students while it provided programming not heard on most commercial stations, such as live jazz, discussion programs, university sports (other than football), folk music, and some classical music. In nearby Cambridge, Massachusetts, noncommercial WGBH (FM), which was owned by a nonprofit community corporation, featured classical music, live concerts by the Boston Symphony Orchestra and the Boston Pops, and other cultural fare. Other colleges in Greater Boston had their own radio stations and each was programmed to suit local tastes and needs.

National Public Radio

With the development of *National Public Radio* (NPR) in 1970, public radio has taken on a new dimension. NPR has made it possible to improve program quality and reduce the financial and production burden on local stations by the creation of a network that supplies news and programming to over 325 affiliates. NPR estimated in 1987 that it reached over ten million people a week via its member stations.

The stations contribute to the cost of running NPR with the balance of its budget coming from The Corporation for Public Broadcasting, grants, and contracts to produce programs.

NPR has made great strides in improving the quality of programs heard on local public broadcasting stations. The network has reduced the number of hours of programming that have to be created locally. It has also created a "sameness," which marks much public broadcasting today. The existence of a public network and the rules it imposes tend to create uniformity among stations, which were once noted for their individuality.

A factor in the sameness of public stations has been a government scheme, which during the 1960s and 1970s plowed a great deal of money into building powerful noncommercial FM and

TV stations which could affiliate with the public networks. Because the stations were funded by the government and established specifically to affiliate with NPR (and PBS, the TV public network), they were essentially the same. Independent public or nonprofit stations continue to exist, primarily on college campuses.

Ten-Watt Stations

For many years colleges and some high schools took advantage of a liberal government policy, which permitted them to put on 10-watt FM stations in the educational band. These facilities were inexpensive to build and were relatively free of restrictive regulations, such as FCC requirements that a licensed engineer be on duty at all times. Then the Commission decided to phase out the 10-watt stations as a poor use of spectrum space. The stations had to either turn in their licenses or increase their power. This policy has caused many college stations to seek minimal power increases while a few have become major independent facilities.

A few schools operate profit-making stations in the commercial bands. Dartmouth College in New Hampshire operates a commercial radio station (WDCR), as does Yale University in New Haven, Connecticut, (WYBC-FM) and the University of Florida in Gainesville (WRUF-AM-FM).

Educational or public radio stations are not the only nonprofit radio stations on the air. There are listener-supported stations that exist for specialized reasons. Some religious groups operate nonprofit radio stations, which are supported by listener and church contributions. A few municipalities still operate radio stations, although many of these stations have been sold in recent years. Some are nonprofit and others are designed to make a profit.

Noncommercial broadcasting has a definite role, the public stations have achieved great financial and programming strength, and some even garner significant audiences in their communities. Even though the federal government is reducing its financial contributions to public radio, grants, contributions, and state and local public funds have kept the system going.

RADIO'S COMPETITION

Radio's number one competitor for advertising dollars is the local daily newspaper; next comes television. In recent years radio has had to face increased competition from new radio stations, added TV stations, and new technologies.

Cable companies are selling spot advertising for insertion in both their satellite network and locally originated programs, and frequently the rates the cable systems charge are similar to the cost of advertising on radio. LPTV is new and has not yet made serious inroads in many markets. However, the thinking is that many LPTV stations will perform local functions similar to those of radio and at similar prices, making them competitors for radio dollars. Multipoint Microwave Distribution Systems and DBS are seen less as competitors to radio than to TV and cable. However, home VCRs could cut into radio revenues a little simply by further diluting the already weak nighttime audience for radio. All in all, the new technologies are still less of a threat than the local newspaper and existing TV stations.

Other Income Sources in Radio

One type of revenue producer that has become more important to radio in recent years are the subcarrier services. Portions of either an AM or an FM signal can be used to transmit additional signals. Frequently, these signals are scrambled so they can be received only on special receivers. A number of services can be offered, such as Muzak, a franchised background-music service for offices and factories; specialized networks for news, sports, farm information, etc.; paging services; programming for the blind; weather services; or business reports.

SUMMARY

The FCC is undertaking two parallel projects that affect radio. The Commission has negotiated new treaties with Canada and Mexico, which permit more U.S. stations to broadcast with increased power before dawn and after dusk. In some instances the treaties permit night broadcasting for the first time by selected U.S. stations. The FCC has also been eroding the exclusivity of the clear channel AM stations, adding a limited number of new stations to the clear channel frequencies.

In FM actions the Commission has been permitting drop-ins, or closely spaced allocations that were not on the original table of assignments. This puts additional stations on the air and could provide signal interference for FM stations already on the air. In 1985 the FCC

posted a list of 100 unused allocations, which stimulated more applications.

Of greater concern is Docket 80-90. This proposal would add 689 (if all allocations are used) new FM stations nationwide. The new frequencies were "found" by reducing the protective circle around existing stations and by telling existing stations they must reach their maximum authorized power soon or a drop-in will be permitted. Docket 80-90 has set off a scramble by existing stations to increase their power. This is an expensive process, both to buy new transmission equipment and to pay the power bill once the station is on the air. The other scramble is to obtain the new channels. Responding to pressure from political sources and women's and minority groups, the FCC has indicated that it will look favorably on applications from groups which show strong minority and/or female participation. The Commission also made special provisions to favor 80-90 FM allocations from daytime only radio station owners. The application process began in 1985, and it is expected that the allocation of these new channels will take some time due to the number of applicants and the many competing applications. Docket 80-90 adds stations in nonserved and underserved areas. The result may be that some of these new stations will fail simply because the underserved or nonserved areas couldn't support a radio station. Others will survive because the new areas have grown since the original FM table was drawn up. This will be particularly true in the sun belt where many thousands of people have moved in the past decade.

One of the greatest business hazards for radio broadcasters today is that so many stations are on the air in most markets that the local audience has become fragmented. Radio station managers and owners respond by doing more research about their audiences so they can make strong arguments to sponsors about being able to deliver the listeners the sponsor desires. There is a diminished tendency to try to sell advertising by quoting ratings in favor of a solid, well-researched approach which features the station's audience and their buying patterns.

These are desperate times for many local AM stations (Class IV, 1,000/250 watts) and daytimers. They are having to compete with FM and with few weapons in their arsenal. The Class IV station often finds that its community has grown outward into the suburbs and beyond the station's coverage area. A few daytimers have been able to present solid engineering arguments and have been permitted to add nighttime signals. Another group, located adjacent to the Mexican

Figure 4–16
A visual that was part of a massive advertising campaign designed to highlight the important role of radio in American life, thereby increasing the public's appreciation of the medium and boosting radio's share of media advertising dollars. As part of the campaign, on May 26, 1989, commercial radio stations and networks went dead for thirty seconds to dramatize radio's importance. Sponsored by the National Association of Broadcasters and the Radio Advertising Bureau, the campaign was based on the theme, "Radio: what would life be without it." Courtesy of NAB and RAB.

and Canadian borders, have benefited from new treaties with these countries, which permit U.S. daytimers to operate during some night hours.

Anyone who predicts the demise of radio is ill advised. Radio has proven its vitality by surviving two major upheavals, the advent of television and the growth of the FM band into a primary radio service.

Radio is a business that is capable of flexibility. Formats can be changed, new ideas tried, and new technology explored at relatively low cost.

But the real strength of radio is that it is personal. The person on the radio speaks to you and me as individuals. Radio goes along as a friend, even as we do something else.

GLOSSARY

Arbitron A service which collects listenership and viewership data and publishes radio and TV station audience ratings.

Adult Oriented Rock (AOR) A format and type of programming that appeals to a certain segment of the potential audience, usually 19 to 45 years of age.

Automation In radio its most simple form consists of tape recorders hooked to a computer, which starts and stops the music, commercials, and other announcements according to a predetermined plan.

Broker A person or firm assisting in the sale or purchase of a broadcast property for a fee.

Cable radio It comes into the home on the same wire as cable TV. There are three kinds of cable radio: retransmission of on air signals, origination of cable only radio, and satellite supplied cable only radio.

Clear channel Having no stations on the same AM frequency at night and no one nearby on the same frequency during the day. They are designed to serve an extended area and range from 10 to 50 kw of power.

Closed circuit feeds Any intelligence that is fed to a network's affiliates to be used later or as information. It is not broadcast as it comes in.

Contemporary Hit Radio (CHR) A format or type of programming, aimed at the 19 to 34 year old age group, using best-selling popular music.

Construction permit (CP) Document issued by the FCC which permits an applicant to construct a broadcast facility.

Daytimer (daylighter) AM radio station authorized to operate only during daylight hours unless special operating time extension has been granted.

Directional pattern A radio signal can be extended and curbed in such a way to favor transmissions in certain directions and reduce transmissions in other directions.

Disk jockey A person who plays music and announces on radio. This also has come to mean anyone who plays music and announces.

Docket 80-90 FCC action causing the addition of a great many radio stations to the FM band.

Format An outline of a program or in radio, the type of music played, and the style of the presentation.

Frequency response The range in cycles of sound generated by a recording medium and reproduced by a radio transmitter.

Full-timer Opposite of daytimer, AM radio station authorized to operate day and night.

Groundwave Radiation of AM radio signal from base of tower through copper wires buried in ground.

Guarantee Base salary paid to salesperson before commissions on salaries are calculated.

Ionosphere Atmospheric belt around the earth which reflects AM radio signals at night when it cools and settles nearer to the earth's surface.

Kilohertz (khz) One thousand cycles per second.

List The advertisers or potential advertisers that a particular sales executive has developed or is assigned to service.

Megahertz (mhz) One million cycles per second.

National Public Radio (NPR) It was established in 1970 and is a quasi-governmental network that provides programming to noncommercial stations.

Noncommercial radio, educational radio, public radio All names for that segment of the FM band from 87.9 to 91.9, which is set aside for noncommercial broadcasting. It was called educational in the early days because most of these stations were run by colleges or school districts and carried a great deal of educational programming.

Network An interconnected service with the majority of its programming originating from one location which provides programming at precise times to a number of radio stations, called "affiliates." The affiliates may be paid in cash or with programming provided at no cost by the network. Syndicated networks charge the affiliates for their service.

Option A preliminary contract or binder on land purchase, which guarantees price to buyer if sale is concluded within the agreed upon time; used to tie up land for new station antenna because contract can be abrogated if applicant fails to win license.

Promotion, promotion manager The department and person that sells the station to the community. The objective of promotion is to increase a station's audience through public relations and advertising techniques, which enhance image.

Public file It contains documents relating to the station license and must be kept available for inspection by any member of the public during normal working hours.

RADAR Name given to rating service which estimates network radio audiences.

Rep, representative organization Firm hired by a station, operating at national and regional level, to get advertisers to place their commercials on the station. The rep gets a per-

centage of the advertising billed as its commission.

Radio Advertising Bureau (RAB) A major fact gathering, marketing, and sales training organization which serves radio. Supported by member stations.

Rate card A price list for time sold on a radio station. It breaks the day up into best times (highest priced) and least best. Time is generally sold in 10-, 30-, and 60-second chunks according to rated audience.

Skips Radio signals heard way beyond their normal range because of atmospheric conditions.

Skywave Portion of AM signal that is radiated through sky from antenna.

Stereo AM or FM transmission split into left and right sound similar to hearing pattern of person's ears. AM stereo is a manipulation of a two-part signal so that it will sound similar to FM stereo.

Subcarrier A subpart of an AM or FM carrier signal, which can carry subsidiary communications not normally heard on the main carrier.

Syndication Program sold individually to a number of outlets, broadcast and cable; often used to refer to present or former network series (off-network) available for sale to other parties; can also refer to special made-for-syndication programming.

BROADCAST TELEVISION

Sooner or later you are going to hear someone say, "TV? Aw, that's just radio with pictures!" At one time that statement was true. The first TV shows were derived directly from popular network radio programs. In some cases little more was done to create a TV show than to wheel TV cameras into a radio studio and add some lighting. In the 1950s many of the popular radio dramas moved to TV with only simple adaptations. Popular entertainer and variety show host Arthur Godfrey, who had been a big radio star, had U.S. network programs running concurrently on radio and TV networks. Soap operas were daytime mainstays on radio in the 1930s, 1940s, and 1950s just as they are today on TV. It was relatively easy for TV producers to *visualize* the soap operas by adding sets, costumes, and lights, but in some cases actors had to be replaced because they did not look the part. TV actor William Conrad, a man of expansive girth, played "Marshal Dillon" in the radio version of the popular U.S. western, "Gunsmoke". He was replaced by a tall, muscular actor named James Arness in the TV series of the same name. William Conrad went on to play other parts such as in "Jake and the Fat Man," where he could take advantage of his size.

There are some fundamental differences between radio and TV. First, radio requires more imagination from its listeners. If you are listening to news, drama, or other programs on radio you have to create visuals in your own mind. TV presents it all in "living color" leaving virtually nothing to your imagination.

Most U.S. commercial and noncommercial TV stations depend heavily on a network for the major portion of their programming. Capital Cities/ABC, CBS, NBC, and PBS have developed strong programs in almost every portion of the day, so that the amount of time devoted to local programming by a network-affiliated TV station is relatively small. In some cases local programming consists only of local news and syndicated entertainment shows, many of which originally ran on the network, and which now air during

times when the network is not feeding. Local news, weather, and sports are often the only truly locally produced programming.

TELEVISION NETWORKS

In the early days of television the TV network emerged as an extension of the radio network. The moguls of radio saw owning television networks and having affiliates as a way to both make money and control the TV airwaves. In those early days after World War II the major TV networks were NBC and CBS, the same two companies which dominated the radio network business.

Television Network Dependence

The television industry's long-time dependence on the New York networks has changed in the last few years. The reason is the availability of alternative programming, including programs made specifically for first run (first use) programming by TV stations, programs fed via satellite, and programs which involve both local production and use of program segments produced by other stations. These program sources allow a station program manager to pick and choose rather than just taking the network feed. Although that choice exists, the degree to which it is exercised differs radically from market to market and station to station.

The big three networks are not happy about the availability of high-quality programming from nonnetwork sources. They frown on stations which fail to clear most of their schedules (take most of the network programming offered). The networks have traditionally been able to keep nonnetwork programming from replacing network shows, except for one-time-only programs, by reminding stations that their network affiliation is too valuable to dare to delete major portions of the network schedule, thereby putting their affiliation in jeopardy.

This strategy worked well for many years for two reasons: (1) for a long time ABC affiliates did not benefit as much from their affiliation because ABC fed less programming and garnered significantly lower ratings and advertising revenue; therefore, it was easy for CBS or NBC to suggest to one of their affiliates that if it didn't clear most of the network schedule it might be dropped, causing it to have to affiliate with ABC. (2) Many station owners and managers feared changing "brands" (affiliations), thinking that being identified as the CBS or NBC channel was advantageous.

The networks began to lose their clout as far as threatening to pull affiliations was concerned when: (1) ABC finally became a strong competitor, and (2) networks began to raid each other's stations in order to have stronger affiliates. ABC is credited with starting the raiding trend in the mid-1960s. ABC approached desirable stations and pointed out that it was delivering a younger audience. At that time youth was the fastest growing demographic and the one most desired by advertisers. ABC was able to add several strong affiliates, making itself more competitive for ratings and national advertising.

The growth of local news ratings in the 1970s showed station owners that they could make a lot of revenue without the aid of the network. In the mid and late 1970s affiliates turned back several attempts by the networks to extend the evening news to one hour, because a one hour network news program would have cut into the money-making local news block.

Concurrently, other sources of news content became available for use in stations' local news, making it even more attractive to expand the local news rather than accept the longer network early evening news. Some of these news sources included high-quality syndicated features such as programs on consumer topics, health, and finance. News feature companies began to distribute quality topical news features and hard news stories by satellite. During the late 1970s and early 1980s many group owners established their own bureaus in Washington, D.C. In the 1980s stations formed national and regional news cooperatives to share stories they produced with other stations by using daily satellite feeds.

The level of syndicated programming also improved in the 1970s, and once satellite time became available at reasonable cost, a number of

Figure 5–1
News studio at CBS affiliate KSL-TV in Salt Lake City, Utah. Photograph by Alan Seko; courtesy of KSL-TV, Salt Lake City.

syndicated shows were distributed live, which made them much more timely. "The Phil Donohue Show" (a guest interview/audience participation program) and "Entertainment Tonight" (a topical news/feature program about entertainment and entertainment personalities) demonstrated to TV stations that they could gain access to high-quality, highly profitable programming from sources other than the network.

Network Viewership Drop

According to statistics compiled by the National Association of Broadcasters, in a February 1988 report network affiliates nationwide experienced a six percent drop in viewers in 1986–87 compared to the 1982–83 season. Independent TV stations gained two percent during the same period; public television's viewership was about the same; cable-originated programming gained five percent since 1982; the so-called superstations on cable were unchanged; and pay cable remained unchanged since 1982.

The NAB also reported that in 1986–87 there were 47.5 million U.S. homes which received only off-air broadcast signals. Projections by Browne, Bortz & Coddington, Denver media consultants, predicted the broadcast-only audience would fall to 35.5 million by the 1992–93 season. The NAB also reported that in 1987 cable passed 87 percent of all U.S. TV households.

In January 1988 the *Wall Street Journal* reported that the amount of time spent watching TV had declined by one half hour per week between the 1985–86 and 1986–87 TV seasons, based on estimates by A.C. Nielsen and Company. The biggest drop was in the evening prime time. In April 1988 the *Wall Street Journal* reported that the three broadcast networks lost nine percent of their average audience in 1988 prime time, compared to 1987. That amounts to almost 6½ million fewer viewers watching network programming on any given night.

This is one type of studio camera you might operate if you worked at a television station. The device in the center with the 360 degree handle is called the "pedestal." The handle comes out from the "tilt-pan head" on which the actual camera is mounted. The lens is manufactured separately from the camera. This particular lens is a "zoom" lens which permits smooth transitions from long to close shots while maintaining focus. Courtesy of Ikegami Electronics, Inc.

INDEPENDENT STATIONS

Independent stations existed even in the early days of television but generally they were the station in the market which could not get a network affiliation. Since some independent station owners found they could make money without a network affiliation, the number of independents has grown steadily.

There have been strong independent stations in most of the top 10 markets for years, but the 1980s saw a rapid increase in the number of independent TV stations, many of which were new UHF facilities. Some were stations that were programming specialized formats such as *subscription TV*.

One reason for the growth of UHF independents was cable. If the independent UHF station were a local *must-carry* station, it had to be included on area cable systems, along with the network affiliates giving it equal coverage in cable homes. The FCC must-carry rule required cable systems to carry the signals of all nearby TV stations. However, in July 1985 a federal court struck down the must-carry rule and a revised version was struck down by the U.S. Court of Appeals in December 1987. This caused the on-air broadcast industry serious concern because both the independents and the affiliated stations were faced with the possibility of having to pay a fee to gain space on cable systems.

As more independent TV stations came on the air, the movement to share programming grew stronger. Ideas discussed included creation of a fourth network and financing joint ventures. Independent stations could get world and national news from a news network, either the Independent News Network or the Cable News Network (CNN). Temporary networks were created to air sports events and other one-time-only programs. Independent stations found that the fact that they were not tied to someone else's schedule proved advantageous to programming in local markets.

Some syndicated programming is supplied via satellite, giving the independent station the advantage of airing a current show rather than one which has been "bicycling" from station to station for the past three weeks.

A FOURTH NETWORK?

Writers in trade magazines have been predicting the establishment of a *fourth network* for years. One problem which held back formation of a fourth network was a lack of program materials. Other than inventories of old movies and network reruns, there was a deficit in the type of new (first-run) color high-quality programming a fourth network would need to compete against Capital Cities/ABC, CBS, and NBC. Several large station group owners who invested heavily in buying independent stations worked on joint programming projects. They shared the cost of acquisition or production, and then tried to sell their product to other stations, which had not participated in producing or acquiring the program.

Another problem faced by anyone who wished to establish a fourth network was lining up powerful stations with good audience acceptance in the nation's top markets. Some major market independents were satisfied with the programming they had in place. In other markets there were only three VHF stations available, so a fourth network might very well have to affiliate with a UHF station, having a smaller coverage area and audience.

The FCC's loosening of station ownership rules allowing a single company to own 12 and participate in management of two more TV stations with minority owners opened the way to creation of a fourth network based on common ownership in 12 or 14 major cities.

International media mogul Rupert Murdoch moved into U.S. broadcasting in the mid-1980s

This is the type of camera mount used in the production of network television programs. Note that tracks are laid to permit smooth movement when a camera is "trucked" or moved across a floor or terrain. Courtesy of Vinton Equipment, Inc.

after years of successful media ownership in Australia and Great Britain. He became a U.S. citizen and promptly put together the nation's largest chain of independent stations, Fox, built around a core of powerful independents acquired from Metromedia. Murdoch then created the Fox Network, with the Fox Television stations as its backbone. The network began cautiously, feeding a limited schedule of programming on selected nights. Much of the programming was created for the Fox Network. The Fox Network continues to grow steadily.

TELEVISION ALLOCATION DEVELOPMENTS

Two allocation developments in television are *VHF drop-ins* and *Low-Power TV*. The FCC is

Cameras are frequently mounted on a tripod for program, commercial, or news photography and videography. The tripod and case together weigh only 14.5 pounds and can support cameras weighing 8 to 18 pounds.

call *community TV* because it is designed primarily to serve communities, either small towns or sections of larger cities. A licensee can put a 10-watt VHF or 1,000-watt UHF station on the air for $200,000 to $500,000, compared to a start-up cost of $1 million to $5 million for a full-power TV station. The LPTV station does not have the coverage of a VHF TV station with from 100 to 316 kw or an UHF station with up to 5,000 kw of power. Although start-up costs are low, community TV stations face serious problems as far as being able to buy quality programming and sell advertising in competition with existing radio and TV stations.

Other than getting on a cable system, if possible, it appears that the best bet for an LPTV station is to program in an area isolated from strong TV signals. There have been instances where LPTV stations in isolated markets have managed to provide a unique local service and program on a budget which permits advertising to be sold at rates comparable to those charged by radio stations.

In March 1988 the research firm of Kompas, Biel & Associates reported 333 licensed LPTV stations operating in the United States and 1,290 construction permits outstanding. By far the greatest number of LPTV stations had been built in Alaska.

HOW A TYPICAL TELEVISION STATION OPERATES

Let's pretend your long lost uncle hit it rich prospecting for gold in Alaska and has given you money to buy a TV station.

First, count the money. We're talking about millions of dollars, anywhere from 5 million to 500 million, so make sure your uncle's check is good!

You shop around and lo and behold you can buy a UHF independent in the nation's 17th market (Tampa, Florida) for a mere 44 million dollars. It's a good thing that uncle found a mountain of gold!

Assume that the FCC has no problems with the sale and all the paperwork is done.

The Facility—More Money

What is the facility? Well, the studios are already in existence, but the equipment is limited and the station has to upgrade to produce local news,

permitting a few VHF stations to be added to the allocation table. As you might expect, there have been some major battles to obtain these valuable licenses. Each allocation has been the object of multiple applications.

Low-Power TV

A new development in the early 1980s in the U.S. was LPTV, which some people prefer to

programs, and commercials. The station is not operating at full power, so you decide to apply to the FCC for a power increase. As soon as you get permission and install the necessary transmission equipment, expect your electric bill to take a jump. You really don't have any choice because a UHF TV station has to pour on the power to get coverage similar to the more fortunate VHF stations in the market.

Budget $1 million for the power increase and modifications to the building and equipment, which will need to be done to accommodate the change. Add another $1 million for production equipment so that you can have the capability of doing sophisticated programs, commercials, and perhaps news programs.

The Programming—More Money

You found that the station has been owned by some well-intended businessmen who didn't have the capital to do much with the facility. They bought a few very old movies, some equally old syndicated programs, and ran a heavy schedule of religious programming. It sounds as if you're going to have to spend some more of uncle's gold to improve programming.

What kind of programs are you going to run? The first thing you do is list the competition and see what's left. The competition is:

Channel 3, the local public broadcasting station

Channel 8, the NBC affiliate

Channel 10, the ABC affiliate

Channel 13, the CBS affiliate

Channel 16, a university-run PBS station

Channel 21, your station

Channel 40, an independent on the south edge of the market

Channel 44, a strong, well-financed independent in the market.

You have to list all programming by all on-air stations, which can be seen by viewers in the market. Then list cable programming because so many people watch TV solely on cable systems. A wall chart is helpful because it makes it easier for everyone who uses the information to visualize the competitive situation. Once the programming is listed on a chart, the ratings of each program should be inserted, based on the most recent rating book. If the rating book is not available through the station you have pur-

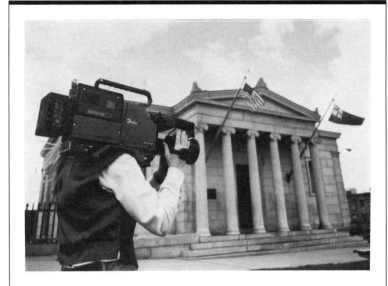

A videographer from WNEV-TV News in Boston shooting with a Sony Betacam SP combined camera/recorder. Lightweight equipment such as this permits videographers to move around freely, without having to worry about cords or assistants. Courtesy of Sony Corp.

Television videographers have to learn how to operate new cameras and recorders, such as this Panasonic color video camera. It weighs just over seven pounds and uses solid computer "chips" to process images instead of glass cathode ray tubes, giving it, among other features, greater ruggedness than earlier model "tube" field cameras. Courtesy of Panasonic Broadcast Systems.

Another modern video camera which uses computer-type chips instead of cathode ray tubes to record images. These new cameras are based on Charge Coupled Device (CCD) technology. They are popular for news production and field work not only because of their ruggedness but also because they work well under very low light levels. Courtesy of Sony Corp.

chased, you can usually get the information you need from someone at an advertising agency.

For the most part your competition will be the commercial stations. There are only a very few programs shown on the Public Broadcasting Service which get large enough audiences to impact significantly on commercial TV programming.

You have to accept as a given that there will be significant audiences for most network programming on channels 8, 10, and 13. You find that Channel 40 relies on less costly syndicated programs and older films. Channel 44 also uses syndicated programs and old films, but its management spends more and therefore gets better quality recent off-network programs and more recent movies. In addition Channel 44 does a local evening newscast adjacent to the world and national news program provided by INN, The Independent News Network. Channel 44 also carries some live sports.

Your best bet is to go head-to-head with Channel 44 by buying good quality programs and then *counterprogramming*. Counterprogramming means placing different types of programs up against the competition in each time period. An example of counterprogramming would be to run your news at 8:00 P.M. against the network

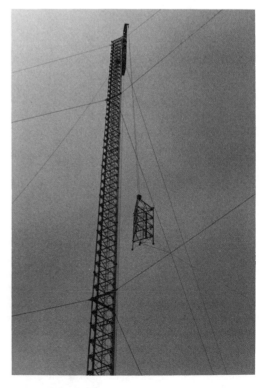

Figure 5–2
New and sometimes older television stations need new transmission facilities. *(Above)* A crane is being used to lift a section into place for a 1,929-foot television tower at KARD-TV in West Monroe, Louisiana. *(Right)* The tower section is being hoisted into place. After the tower sections were erected, an elevator was installed to assist with maintenance and warning light servicing. Courtesy of Kline Iron & Steel, Inc.

entertainment shows and the syndicated reruns on the independents. You are aiming at the audience which gets home from work late or which prefers to eat dinner later and watch the news during the dinner hour.

You decide you cannot afford to leave the local news out of your schedule if you are going to establish Channel 21 as the most important independent station in the market. You decide to build your own news staff and run your news at 8 P.M.

Organizational Structure

Let's talk a little about the structure of your organization. The station had been run with a bare-bones staff by the former owners. The general manager shared a secretary with the sales manager. The sales manager was responsible for directing all the activities of the sales department, including national, regional, and local sales; marketing, research, and traffic; and keeping track of the commercials and making sure they get on the day's schedule. The general manager devoted about 20 hours a week to direct selling in addition to being the administrative head of the station and its spokesperson in the community. The program manager supervised production in addition to buying and scheduling the station's programs. The chief engineer performed maintenance on equipment in addition to scheduling the technical staff, purchasing equipment, and assuring compliance with FCC technical regulations. There was no *promotion manager,* just a promotion clerk and the station had no news department. Everyone doubled up on jobs to keep the cost of running the station low. The only problem was that although costs were kept low, there was not sufficient staff to effectively create growth through development of new programming, cultivation of sales opportunities, or promotion to enlarge the audience.

The Departments

What departments will you need to run the station properly? Here is a typical list:

Administration

The *general manager* who runs the station and his or her assistants and clerical staff. You will probably decide you need a general manager, a *station manager,* and one executive secretary to serve both offices. The front reception desk and switchboard will also be under this department,

This is what videotape cassettes look like. These cassettes are designed to be used with 3/4-inch machines, a common videotape recorder in the broadcast and cable industries. Videotape also may be stored on open reels or on cartridges (also referred to as "carts"), which are enclosed plastic containers similar to cassettes. Courtesy of Ampex Corp.

Today's telecasters must understand and be able to use several different videotape "formats," distinguished by sizes, such as 3/4-inch and 1/2-inch, and electronic configurations, such as Betacam and VHS. The videotape containers depicted hold one of the newer formats, 1/2-inch videotape, for use with Sony and Ampex Betacam recorders. Courtesy of Ampex Corp.

This is a modern 3/4-inch videotape recorder/player of the type you might use on the job at a TV station. Twenty-five years ago you would have had to load the standard recorder/player on a two-ton truck to carry it. This model is obviously a good deal easier to manage. It even can be put in a case and shipped as airfreight. Courtesy of Sony Corp.

as well as the security staff and the maintenance personnel.

Managing a TV station is an extremely complex operation. A TV station general manager does some selling, but more time is spent on community relations, promoting the good image of the station, dealing with national advertisers, developing long-term plans for the business, dealing with the financial community, and just plain running the complex organization, which can have from 50 to 300 employees. That is why we suggest having a station manager, who can take some of the routine management tasks off the hands of the general manager. The station manager (1) can oversee the preparation and filing of regular reports to the FCC and other taxing and regulatory organizations, (2) can act as the station's representative at civic meetings and events, (3) can deal with routine coordination of activities between departments, and (4) can deal with some personnel matters and conduct preliminary discussions with labor unions (if there are any). The station manager can also

perform a major service by coordinating planning for the future in terms of budgets, facilities, growth, and any aspect of planning which involves coordinating the work of the individual departments.

The station's *public file* is kept in the executive secretary's office and he or she is responsible for its maintenance and for keeping a record of who requests to see its contents.

Most TV stations have to spend more on maintenance and security than cable or radio communicators. TV stations take up a lot of space, so the exterior of the facility has to look neat and attractive. The interior needs to be clean and well maintained, not only because of the large number of people who work there but also because people like to tour TV stations, and no one wants to have a messy business place when tours are going through.

TV stations attract people, including some people who they would rather not attract. This could be an unbalanced person who wants to get a message on the air or someone bent on stealing the expensive equipment. As a result, most TV stations either have their own security personnel or hire a security service.

Sales

This department is headed by the *general sales manager,* who is assisted by a *regional sales manager,* a *local sales manager,* a *marketing manager,* a *research specialist,* and a *cooperative advertising specialist.* There will be six *account executives* (salespeople), plus a two-person clerical staff, and two sales *traffic* specialists who keep track of the commercial orders and contracts.

The big difference between owning a network-affiliated TV station and owning an independent is in your sources of income. The network affiliates get a significant amount of money from the network in the form of payment for carrying network commercials. At the same time, the affiliates get popular programs, which yield big audiences and permit the affiliate to charge high rates for its local commercial *availabilities,* the time that is available for sale in or adjacent to network programs.

The independent station is able to sell the commercials that run in almost every program it carries unless the independent arranges to carry a network program *preempted* by the local affiliate. In contrast, the network affiliate gets to sell only the *breaks* between network programs during much of the day. An exception for the independent station would be football, baseball,

basketball, or hockey in which a regional network might sell the commercial availabilities and pay the stations that carry the games for their time.

Independent stations are far more dependent on regional and local advertisers than affiliated stations. Independents do have national *representatives* called "reps" who sell to national sponsors, but this is not as big a part of most independents' income as it is for affiliates.

Channel 21 should have more sales people on staff simply so they can call on more clients. There are three sales executives included in the plan. The general sales manager supervises the whole sales operation and maintains relations with national accounts. The regional sales manager concentrates on regional accounts, which might include such products as milk, beer, jewelry stores, department stores, gasoline, groceries, farm implements, hardware, cattle feed, seed for farmers, and almost any product or service which is regional in nature.

The local sales manager concentrates on developing sponsors in the station's coverage area. This requires expert selling, some price concessions, and sometimes requires that the station produce the client's commercials. It is in this area that production and sales work closely.

You will notice some differences in clients when you compare network affiliates and independents in large metropolitan areas. The used car dealer who feels he or she cannot afford the cost of advertising on the number one affiliate in town may spend money to advertise on an independent station. Another type of commercial seen on many independent stations is the *per inquiry* (PI) spot. You usually see these late at night or early Sunday morning. Typically, you get a reverse thread widget, a set of screwdrivers, and a plastic hole gauge, all for just $19.95 when you "call right now" to a toll-free number or send your check to a post office box. This sort of advertiser makes a deal with the station to run spots in unsold time and pays the station only for valid orders from customers in the station's coverage area. If the product and packaging are appealing, a station could do well. Usually, these PI commercials are simply an effort by a station to get some revenue from its unsold *spot inventory*.

Some stations and station groups will not accept PIs because they feel the low rate damages efforts to sell other advertisers at published rates. Also, some stations contend advertising is a matter of impressions received by viewers and cannot be tied directly to sales to specific people.

This is a computer work station used to make recordings, update a station's data bases, down load logs from traffic, kill expired spots, edit play lists, print "As Run" logs, and preview videotape carts. Technicians generally operate devices like this, which usually are also part of automated video cassette or cart playback systems. Courtesy of Odetics Corp.

Marketing

You'll notice the staffing plan calls for hiring a marketing manager. This member of the sales staff helps sponsors get their products into stores and provides any assistance a sponsor needs beyond the normal spot sales agreement. This person will try to get stores to put up special displays or give the product prime exposure. The marketing manager may help account executives pre-

An automated videotape record/playback system. Tapes prepared on the equipment in the preceding figure are played by this rather complicated device. The computer in the foreground programs the entire system, which can coordinate and play material from a number of cassettes or carts. Courtesy of Odetics Corp.

Technician checking an automated videotape cassette playback unit. Many TV stations load all announcements and even programs into automated playback units, thus cutting down significantly on the number of people needed to tend control room equipment. Courtesy of Sony Corp.

pare their sales presentations, which frequently involve sophisticated reports, graphs, or audio-visual items.

The research specialist is trained in market research and works with ratings and other data to creatively demonstrate how a station can best serve advertisers.

The cooperative advertising specialist works with dealers to take advantage of advertising allowances offered by manufacturers. For instance, a lawn mower company might prepare its own top-flight commercial and then try to get local dealers to pay a small part of the advertising cost in return for short dealer identifications (called *tags*) at the end of the spot. The cooperative advertising specialist tries to get both parties, manufacturer and dealer, together and helps dealers get their dealer tags produced for the spots. *Rotations* are worked out so each dealer gets a fair share of the exposure, and a schedule is planned which targets the advertising to programs viewed by males over 25 who might be in the market for lawn equipment.

Hiring the Sales Staff

The sales managers will most likely be hired from other stations because experience and contacts in the business are a necessity at this level. Account executives are frequently hired from the junior staff of other local stations or from local radio stations. There is no prohibition on hiring an experienced salesperson from out of town except that it will take this person longer to learn the market, and this could slow down effectiveness in generating new business. You must look for salespeople who work well with retail clients because they make up a major portion of an independent's *client list*. The sort of person you are looking for is self-motivated, confident, instills trust among clients, and is willing to do everything that is needed to get the client on the air on time, including writing the commercials if necessary. Our ideal salesperson is well organized, strong on follow-up, and creative in helping advertisers with small budgets expand their potential through use of cooperative ads or by forming dealer groups. Automobile dealers use the group approach effectively. Some of these people may be on the staff currently.

The *sales traffic* specialists should include at least one experienced person who knows how to keep track of sales commitments, available time slots, rates, and the myriad of details involved in getting the client's schedule on the air. To-

day's traffic specialist must know how to use a computer because most stations employ computers and computer software to keep track of clients and availabilities and to prepare proposed schedules for new clients. Most account executives will use computers to help them plan their sales presentations for clients, so any experience using a computer proves valuable in a TV sales department.

A marketing manager can be found working at a consumer goods firm or perhaps at a smaller station. Here again, you need an experienced person in a market of Tampa's size, preferably a person who may have been dealing with local merchants and wholesalers.

Research specialists are frequently graduates of marketing or communications research programs at universities. Previous experience with a station, advertiser, or agency is helpful.

Business

This department is headed by a *business manager*. The business department keeps track of the station's income, expenses, personnel, and profit. It prepares the books, helps with reports to the stockholders, pays the staff, assists in hiring employees, manages the employee benefit program, and provides audit controls on other departments. The business department also plays a key role in the preparation of budgets and then tries to make sure that department heads don't overspend their budgets.

There will be a bookkeeper, a personnel specialist, and two account clerks. This department relies heavily on computers and has a contract with a computer firm for assistance with the system. The business department is responsible for the mailroom and the station courier. The business department depends on an outside accounting firm for accounting and auditing functions. Legal assistance is secured as needed from a local law firm. Occasionally, a collection agency is called in to help collect seriously overdue bills.

The business manager should be attracted from another TV station due to the specialized nature of the work and the experience needed in working in a regulated media industry. There is an association of broadcast financial experts, which can help identify candidates for this position. Other business office employees can be recruited through classified ads and other normal recruiting procedures. Each employee, however, has to bring to the job a certain set of skills, such as bookkeeping or personnel management. Good sources for business office employees are the

This videotape recorder operates on a digital D-2 format, which offers superior sound and picture quality. Digital formats were introduced to broadcasters in the late 1980s. Courtesy of Sony Corp.

If you work in news or production at a TV station or cable system, you might have to learn how to use this Sony video editor. As the name implies, a video editor is used to assemble a coherent program from the many shots taken during production. Courtesy of Sony Corp.

A videotape editing system for news or small production jobs. This system can control material from four videotape machines, two audio channels, three auxiliary sources, and three graphics devices. Courtesy of Ampex Corp.

A type of headphone often worn by camera operators and other TV studio crew members. Courtesy of R-Columbia Products Co.

business programs at local community colleges and universities.

Programming

The *program manager* is the program department head and is assisted by a *production director* and an *operations manager*. The program manager creates the station's regular program schedule and plans special programs. It is a strategic planning position, involving creation of a unified program strategy which assures the maximum audience for all programs against the competition, taking into account the long-term audience and sales objectives developed by the station management. A great deal of this job involves knowing what syndicated programs are available, selecting the programs that appear to be most effective for the station's programming strategy, and then negotiating to buy, lease, or *barter* the needed programs. The program manager also has important responsibilities in assuring compliance with a long list of FCC regulations, such as the political programming rules and logging requirements.

The *production director* directly supervises the technicians who prepare all nonlocal programs for air. Their work includes editing and timing movies and syndicated shows, preparation of commercials shipped in from outside sources, supplying program materials to the control room staff, and receiving and shipping syndicated programming that arrives by mail, express, or freight.

The production director also oversees the directors and production staff, which produces and directs local programs, commercials, and public service and promotional announcements.

The *operations manager* uses a computer system to schedule every aspect of the station's operation from sign-on to sign-off. The production director and operations manager are assisted by a secretary, two operations clerks, a staff

artist, two full-time and one part-time director, and several production assistants who run cameras, erect and take down scenery, run prompters, adjust lights, and do related studio tasks. All non-news air talent is supervised by this department.

What Goes on the Air?

Programming an independent TV station is a challenge because you seldom have the money available to buy programs comparable to what the affiliates get for nothing from the networks. Most independents rely heavily on old movies, old off-network reruns, and sports.

Your main advantage in programming Channel 21 is that your uncle left you enough money to buy much higher quality programming than what was scheduled by the old ownership. To some extent there is a relationship between money spent on programming and audience yield, if you don't make mistakes with your scheduling strategy. There can also be a relationship between audience size and sales if you sell aggressively.

One strategy is to strike a deal with one or more networks to air their programs when they are preempted by the local affiliate. This can work well in a market where an affiliate originates football or baseball for a regional network.

Another approach would be to go in and bid against the affiliates to get the rights to games of major sports organizations. Many of the regional baseball networks originate from independent stations, which can more easily program around the team's schedule. The station may set up the network and sell the advertising. The revenue from the advertising, which is higher than usual because other stations join the ad hoc network, can be a big boost to an independent.

Sometimes an independent can obtain a top quality program through barter. An organization that syndicates programs will undertake to sell spots in the program, leaving a few open availabilities for the local station. No cash changes hands. The national sponsor gets lower cost per exposure and the station gets a good program at no cash cost and the opportunity to sell a few spots. This is a common way of placing syndicated programs. The result can be lower income for the station, but barter removes the high cost of buying syndicated programming so the net income to the station may be satisfactory.

The thing independent stations do best is counterprogram. If all the network affiliates in town are running news, the independent will run

Crew on a "production shoot" frequently wear FM wireless intercom microphone/headphone combinations like this to avoid getting tangled up in headphone cords. Courtesy R-Columbia Products Co.

an entertainment program, knowing that some people will choose entertainment over the seriousness of the news. Inversely, many independents run their news sometime between 8 and 10 P.M. The 8 and 9 P.M. newscasts are popular in areas where commuters get home late from their jobs in the city. The 10 P.M. news has been successful in areas where a lot of people have to be at work by 7 A.M. the next morning, as they tend to go to bed early.

Some independents produce their own entertainment programs. However, production is expensive so most of the production effort is likely to be devoted to doing news, sports, and commercials for local sponsors.

The independent station has to be prepared to go an extra mile for a sponsor. This may

Computers are more and more a critical part of a television station's operations, particularly the news. A reporter from KRON-TV, San Francisco, was in instant touch by computer with his newsroom while covering the 1984 Democratic National Convention. Courtesy of Basys, Inc.

include writing the commercial, doing the visuals, hiring the talent, and producing it. A few independent TV stations have been so successful in the production area they have set up separate operating divisions just to do TV production assignments for sponsors, ad agencies, and programmers.

The program manager must be found among existing program managers or assistant program managers working at medium to large market independents. This position calls for hiring an expert. The production director should be experienced and can probably be attracted from a smaller station within the state. The operations manager will also have to be experienced, although two to three years experience may be suitable for a qualified person who has done operations work before and who is familiar with a program traffic computer system.

The directors will have to have had experience, although it may have been in smaller markets or as assistant or associate directors in larger stations. The production crew can come from among recent graduates of the state's universities and community colleges. Try to train some of the more talented crew members as assistant directors so they can cover the directors' vacations or can be promoted if a director quits.

The two staff announcers must be qualified professionals, preferably with on-camera TV experience, but you may be able to train a talented radio announcer for one of the positions.

The News Department

This department is headed by a *news director,* who is assisted by an *executive producer,* an *assignment editor,* and an *operations supervisor.* The department has one secretary, two *anchorpeople,* six *reporters,* four *videographer/editors,* two remote unit *technicians,* two *sportscaster/* reporters, and one *meteorologist.*

The news director is the department's manager. It is recommended that this *not* be a *talent* position. Good management of a major market news department demands the full time attention of its executive. The executive producer will be in charge of producing the 8 P.M. weeknight news and will have general supervision over all news producers and news programs on a daily basis. The basic format for the news is determined by the news director, executive producer, and assignment editor in conjunction with top station management. The assignment editor is in charge of the reporters while they are covering their stories. After they have finished gathering information their supervision is shared by the producers and the executive producer as each newscast is prepared. The assignment editor plots out the department's immediate and long-term news coverage plans in conjunction with the executive producer and the news director. The operations supervisor is responsible for the scheduling of technical staff and the smooth running of all technical support, which includes videographers who shoot the news stories, editors who edit the news tape, and technicians who run the electronic newsgathering equipment. This position demands close liaison with the executive producer and the assignment editor.

News programming is complex for an independent station. An independent must try to do as much or more with fewer people and less equipment. Some independent stations have been successful by aiming their news at a particular audience or by taking a certain approach. There was a time when a New York City independent carried a lot of crime, fire, and disaster news, a "blood and guts" format. The theory was based on the fact that the largest circulation newspaper in the country at the time was the *New York Daily News,* which featured large pictures, bold type, and many crime and action stories. The TV station copied the newspaper's style because

it found that its audience and the readers of the newspaper had much in common.

Other independents have relied on having a number of specialists on their staff, such as a theater reviewer and outspoken editorialists. Other have tried hard to do "people" stories, news items that center on what affects people in their area. There is no question the news department of an independent station faces major challenges if it is to gain acceptable ratings in competition with the network affiliates.

Because one of the other independent stations in your market already airs world and national news from the Independent News Network, you should consider making a deal with Ted Turner to carry segments of his CNN Headline News before or after your local news. The Turner Broadcasting organization has sold its service to many on-air stations.

The small size of your news department will require that both anchor people also do some reporting. It will be necessary to hire experienced anchors who have demonstrated credentials as reporters and writers. You should first attempt to hire at least one anchor locally to benefit from people's familiarity with the person. If both anchors can be hired locally, even better. Be careful, though, in selecting anchors already in the market to pick people with potential for growth who are proven audience winners.

A mix of moderately and lightly experienced personnel can be hired as reporters and videographers. You must be cautious in hiring entry level reporters or videographers because their inexperience may be detrimental to your product at a time when you will be struggling to establish the professional image of your news department in the eyes of the audience.

One way you might supplement your staff and at the same time possibly discover highly talented entry level employees would be to establish an internship program. This can be done in other areas of the station, too, but an internship program will be most helpful and beneficial in programming and news. You should consult with your legal counsel if you plan to have interns perform any work you would ordinarily have a staff employee do. The rule of thumb, under federal regulations, is that people doing the productive work others could be hired to do should receive pay. One suggestion is to budget a small amount for the purpose of hiring one or two interns year-round rather than taxing the small news staff by asking them to supervise a large number of unpaid interns.

The four top news positions—news director, executive producer, assignment editor, and operations supervisor—will require hiring experienced personnel. Look at young up-and-comers in smaller markets or bright assistant news directors, producers, night or weekend assignment editors, and assistant operations supervisors in large markets.

Promotion Department

Promotion will be a small department headed by a *promotion manager* who is assisted by a secretary and a promotion specialist. The promotion manager should be experienced in the same position in a smaller market or as an assistant promotion manager in a large market. The promotion specialist could be a recent graduate from a telecommunication program at a university or community college.

Your small promotion department will play a major role in the station's business strategy. You must aggressively promote Channel 21 because its programming is not as well known as that of the network affiliates, which is promoted by the networks, featured in the TV guides, and gets frequent mentions in newspaper and magazine columns.

You will rent selected billboards near high-traffic areas so that your theme and channel number will be seen by a large number of people driving to and from work or to the shopping centers. Your newspaper ads won't be too large because they are costly, so you have to make them stand out.

You have to come up with an advertising budget that will permit the station to buy newspaper ads and billboards. In the Tampa market you will have to place periodic ads in at least the *Tampa Tribune,* the *St. Petersburg Times,* and the *Clearwater Sun.* There are several other papers, including weekly newspapers and shoppers (free papers), which might also be used from time to time. You could easily use a dozen billboards spread around the area, but you may find it more effective to buy ads on four or five "super" billboards adjacent to the high-traffic highways.

Channel 21 must have a promotional slogan or *logo* so the promotional advertising will always have a recognizable theme and look. You should hire an advertising agency to assist with the print ads. It's likely you can get a little radio exposure by trading ads with some radio stations. They will carry your commercials and you will run a few of their ads in unsold time slots. No money changes hands. These are known as *trade*

deals when time or merchandise is swapped for time. Occasionally, a station will swap a service or merchandise for commercial time rather than paying cash.

The promotion manager should be extremely careful to meet deadlines to get your programs listed in the various TV guides and newspaper TV columns. You don't want to get left out because many of the viewers attracted will be people who have decided they don't like what's on the networks that night and pick up a TV listing to find an alternative program.

There are other ways to gain visibility. The promotion manager should arrange personal appearances for air personnel. Although the news anchors should not appear at commercial functions (it would affect their credibility), they can speak to school groups and talk to civic organizations. The children's host can make appearances at malls, schools, and nurseries. The fishing expert can do demonstrations at the malls, schools, and civic groups. And of course, you should be ready to plant ideas with the newspaper radio-TV columnists whenever possible. Try to keep in touch with writers from the broadcasting trade newspapers and magazines because it is important that you have a good reputation in the industry. You need to be recognized quickly by potential sponsors when they see your call letters, and a good reputation in the industry will help you hire the best possible employees when positions become available.

Engineering Department

Engineering is headed by a *chief engineer* who is assisted by a *studio supervisor,* a *transmitter supervisor,* and a staff of engineers and technicians who take care of the transmitter, run technical equipment in the studios and control rooms, prepare films and tape for airing, control the satellite receivers, and repair and maintain the equipment. The chief engineer is a key member of management and should be consulted any time another department's activities involve facilities. The chief engineer will play a key role in selecting new equipment and is responsible for strict compliance with all *FCC Rules and Regulations* pertaining to operations and engineering. He or she will maintain liaison with consulting engineers and the station's FCC attorneys on matters relating to changes or additions to facilities.

The chief engineer needs to be a proven professional and should be authorized to hire the best available technical employees. Some of the control room and maintenance technician positions can be filled by recent graduates of college or technical school programs. There must, however, be a core group of experienced technicians to train and supervise the less experienced employees. Some operational positions might be filled by telecommunication program graduates from community colleges or universities. They will need some additional training before they are given many responsibilities.

Technical staff members who sign FCC documents including transmitter logs must have the appropriate licenses. This also applies to maintenance technicians.

This example about the buying and running of a television station has been used to demonstrate that managing a TV station means running a big business, much in the same manner as running a major department store, a factory, or for that matter, a university or college.

Figure 5–3
A UHF TV transmitter. Courtesy of Varian TVT, Ltd.

PUBLIC TELEVISION

Its Beginnings

Public TV is an amazing story. Today the United States has a large network of public TV stations,

supported by a combination of government funds and contributions from businesses and individuals. It wasn't always this way.

Public TV started as educational TV. In many cases the first stations were put on the air in conjunction with universities or statewide education systems. The pioneers in educational TV saw it as a medium to be used to extend access to courses to people outside the university campus.

In a limited number of cases, public TV stations were formed as community ventures or as cooperative projects among several universities. No matter where you looked, money to run these stations was a severe problem.

The first *non*commercial TV station was KUHT in Houston, Texas, which went on the air in 1953. By 1962 there were 75 noncommercial TV stations. In 1967 Congress passed the *Public Broadcasting Act of 1967,* using as a basis the findings of the private *Carnegie Commission on Educational Television,* which issued its report the same year.

The 1967 Act created the *Corporation for Public Broadcasting,* which became the buffer between the stations and federal agencies to protect programming from government influence.

The Corporation for Public Broadcasting is the pass-through agency to direct federal funds to the public TV and radio networks. These funds underwrite central staffs and the production of some programming as well as providing methods of distribution. At first, programs were distributed by airfreight. Later, network lines leased from AT&T were used. The big breakthrough for public TV came when it gained access to domestic satellites, making nationwide distribution of programs possible at a fraction of the cost of wired networking.

The Public Broadcasting Service (PBS) was founded in 1969. PBS started network programming in 1970 with 128 members and a $7 million budget.

Today it has over 300 member stations, which transmit programs to a weekly audience estimated at over 103 million people.

Money

Raising money is a constant problem for noncommercial TV stations. As a result, the public stations have been seeking more liberal government rules regarding the announcements, which indicate who has underwritten their programming. There has even been an experiment in broadcasting that might be called institutional or image commercials in order to raise more money. Originally, all a public station could say was that its programming was supported by an organization that it could mention by name.

The main sources for funds for PBS stations have been government and private grants, state and local public budgets, and donations by the public. However, the frequent "pitching" for public donations, which marks so much of public broadcasting, has built up resistance from some members of the public, who are bombarded for considerable amounts of money by dozens of charities.

PBS gets most of its operating budget from its member stations, supplemented by money it earns for program services it sells. About 2.3 percent of its budget comes from CPB grants. CPB makes direct grants to public stations, which buy programs from PBS, so in reality there is a great deal more CPB (read government) money in PBS's budget than is apparent. PBS is owned and controlled by its member stations.

Channel Swap Proposal

A long-standing battle by commercial (especially UHF) broadcasters to obtain VHF channels took a new turn in November 1984. WTOG-TV, an independent commercial station on channel 44 in St. Petersburg, Florida, offered approximately $25 million to swap channel assignments with WEDU-TV, channel 3, the PBS affiliate in Tampa–St. Petersburg. The deal was later sweetened as other independents, and the ABC-TV affiliate, WTSP-TV, channel 10, began to suggest that the PBS station's board of directors should seek other offers.

This proposed commercial–public TV swap ran into a great deal of criticism because Congress became concerned over the long-term effect of letting VHF public stations exchange their valuable channels, which members of Congress had fought so hard to reserve in the 1940s and 1950s. Most PBS stations that have discussed swaps said they would invest the money they received and use the interest for yearly operating expenses. The issue became further complicated when a court threw out the must-carry rule, which would have assured the public stations a position on cable systems. Some of the public VHF stations had rationalized that swapping their VHF channels for UHF channels would lose little audience because the availability of cable carriage would overcome the disadvantage of lost signal coverage. The must-carry decision threw out cable as a factor in accepting a technically inferior chan-

nel in return for a major infusion of money. The outcry generated by the proposed swaps attracted the attention of Congress and stalled any efforts to make the exchanges.

An interesting historical footnote to this debate is that six VHF stations in the New York metropolitan market banded together many years ago to buy the seventh "V" in the market and convert it to a public station, thus effectively eliminating some of their competition.

Programming the Public Station

In the earlier years PBS relied heavily on programs produced by Britain's government broadcasting service, the British Broadcasting Corporation (BBC) and its commercial counterpart, Independent TV (ITV). The programs were exported to the United States where the able spokesman for British culture, Alistair Cooke, added opening and closing remarks to make the programs more understandable to American audiences. In recent years PBS has responded to criticism that it was not promoting American production by purchasing less overseas programming and concentrating more on domestic production.

Public Station Construction

A major force in the growth of public TV has been the *National Telecommunications and Information Administration* (NTIA), an agency of the administrative branch of government, which funded construction of public TV stations. Huge grants from NTIA helped add public TV stations in areas that had not previously been served.

How PBS Rates

Public broadcasting in the United States has become so significant that it draws regular attention from critics, audiences, and other broadcast organizations. One example is the "MacNeil/Lehrer NewsHour," a PBS news broadcast, which provided a sharp contrast to network newscasts by concentrating on one major topic or a set of related topics per program. It tried to develop the day's major news story more fully than the commercial networks. This approach was so successful ABC adopted a similar approach when it added "Nightline," a late night news program, to its schedule to provide fuller coverage of one major news story of the day.

Children's Programming

Children's programming developed for public broadcasting produced a generation of people who grew up on the antics of *"Sesame Street's"* muppets or the enlightening thoughts of "Mr. Rogers." The muppets became a commercial success; muppet dolls were sold in toy stores and the commercial networks ran muppet specials. Two muppets acted as presenters during the 1986 Academy Awards.

Organizations such as *Action for Children's Television* have been strong supporters of PBS efforts to program for children. The PBS children's programs were seen as a healthy contrast to Saturday morning network cartoon shows and some highly commercialized children's programs shown on local TV stations.

State and Regional Networks for Noncommercial Stations

Some states established statewide public broadcasting networks. South Carolina built a reputation for fine programming on its South Carolina Educational Network.

There are also regional public TV networks. As an example, the association of stations serving the southeast is called the Southern Educational Communications Association (SECA). It serves 118 television and 36 radio stations in 16 southeastern states and the U.S. Virgin Islands. The SECA Center for Instructional Communications serves 51 educational organizations in 22 states, encompassing 15,500,000 students and 840,000 classroom teachers.

In New England the Eastern Educational Network distributes programs areawide, and sells some of its unused satellite time to commercial stations.

Public broadcasting has become a strong force in the mix of TV signals available. The coming of cable has enhanced the coverage of some of the smaller public stations so that it's unusual to visit an area of the country without being able to view at least one public TV station.

Other Nonprofit Broadcasters

Nonprofit organizations have found television a way to reach people. Several religious organizations produce and distribute TV programs. Some own stations, others simply own production facilities. Some of the better known religious

broadcasting organizations included the TV facilities associated with the ministry of Oral Roberts and the Christian Broadcasting Network in Virginia Beach, Virginia, a cable network service.

CBN (the Christian Broadcasting Network) began with a strong emphasis on religion in its programming but moderated its religious emphasis in favor of wholesome "family" entertainment.

STRUCTURE OF THE COMMERCIAL NETWORKS

The commercial networks play a major role in the fabric of the U.S. television system. Now that we know something about how individual stations are structured, we should look at the networks.

The three major commercial TV networks are Capital Cities/ABC, CBS and NBC. The three major networks are important because they provide the greatest part of what Americans watch on TV. Their wealth and programming capability backed up by affiliates in almost every market in the country make them a major force.

Capital Cities/ABC is owned by Capital Cities, a multimedia company with interests in broadcasting and print. CBS is owned by a broadcasting company, CBS Inc. which in the mid-1980s divested itself of other interests, such as a record company, and a musical instrument manufacturer. NBC is a subsidiary of RCA, which is a subsidiary of the General Electric Company, a major financial services, industrial, and commercial electronics firm.

What Do Networks Do?

What does a network do? It sells airtime to companies that wish to have their products advertised on a national or regional basis. It collects, produces, and distributes its own news and public affairs programming and buys a significant amount of entertainment programming. The networks are prohibited by law from producing the greater portion of their own programs (because of FCC concern over possible monopoly situations and fears of television production companies that they would be swallowed up by the networks). The networks closely supervise the creation of the programs and scripts they do buy.

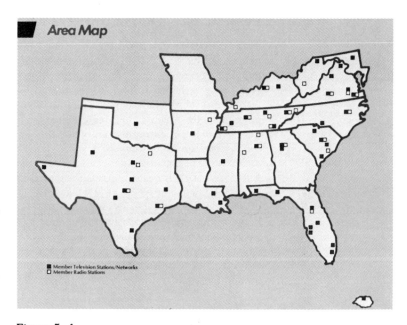

Area Map

■ Member Television Stations/Networks
□ Member Radio Stations

Figure 5–4
A map showing the radio and TV members of the Southern Educational Communications Association (SECA). Courtesy of SECA.

National Advertising

The networks receive a great part of the available national advertising revenue. They exist because they offer advertisers a way to get maximum exposure by showing their commercials to huge audiences. It is also easier to deliver a few copies of a commercial to one, two, or three networks in New York than it would be to negotiate for commercial time with 600 TV stations nationwide, and then ship them the right commercials and make certain the commercials were aired properly.

The network keeps most of the income from these commercials, but a portion is given to the affiliates in exchange for the use of their facilities. Although the revenue from network spots is less than what the stations get for local commercials, they wouldn't be able to get high prices for station break commercials if they didn't have the large audiences created by the network programs.

Because the networks are a unique business, they do their own selling. There are network sales offices in all the major advertising centers in the United States. Network account executives deal directly with both advertising agency time buyers and sponsors.

Seasons

Network time takes on greater value at certain periods of the year when audiences are largest and the sales people often refer to different parts of the year as selling *seasons*. There is always a big push to sell the fall "new season" usually at premium rates because the greatest number of people watch TV during the fall when the new shows come on. Sponsors also know there is a major rating period in mid-fall, and the networks will bring out their best programs for the rating season. Later in the year the TV audience diminishes as the reruns begin. Programs are rerun because they are so expensive to produce they have to be run more than once if they are to pay for themselves. Summer is always slow because people are on vacation or doing something outside the home.

Viewing Pattern Change

Viewing patterns changed a great deal in the 1980s due to the rapid growth of VCR ownership, which led to different viewing patterns than those that the networks had been used to imposing. The term *time-shifting* is used to describe what happens when viewers record their favorite shows on a VCR and play them back later. Time-shifting has made it increasingly difficult to accurately measure network audiences for specific programs at their scheduled times. Cable and independent TV stations also diluted network audiences.

Checks and Balances

Although networks appear to occupy a powerful position in American broadcasting, they are held in check by several forces. Most of all, they have to answer to their affiliates.

Each network maintains a quality control department, often referred to as *program and continuity acceptance*. The departments are known not too fondly as "the censors" by other network people, but they do enforce standards of taste and decency set by the network management.

The big three networks own TV stations and therefore come under the regulations of the FCC in certain areas of their activity.

The networks are also regulated by the Federal Trade Commission, mainly in relation to ads they air, and the Securities and Exchange Commission, which oversees any stock-related business transactions. The Justice Department also keeps a sharp eye on the networks for possible antitrust violations.

Most important, the viewers themselves influence the networks. If they don't like what they see, they dial out, and the networks fear this potent weapon. They live and die by ratings, which are in a sense, votes by members of the public.

Network Programming

A TV producer hungers to have a network buy her or his program. The process usually starts with a written proposal. An extremely small number out of a large number of written proposals make it through the network screening process. If a proposal looks particularly good, the network may decide to spend enough money to make a *pilot* or sample program. The network doesn't stand to lose too much in the deal because pilots can be used as fill-in programs during the summer months when the networks don't air new episodes in their regular series. The high cost of producing TV series has caused the networks to only buy enough episodes each season to run 26 or fewer weeks. The rest of the season, which can be up to 39 weeks, is filled by rerunning some episodes or by preempting the program for specials.

Pilots

The pilot or test show is assessed by showing it to sample audiences, and if it tests well and meets with the approval of network officials in Hollywood and New York, the network will order a number of episodes. Sometimes another step is inserted by running the pilot on the network as a one-time replacement to test the reaction of critics and viewers.

Occasionally, the network works a deal that involves a feature-length presentation, called a *made for TV* movie. If the movie length show goes well, it is *spun off* into a series. This is why you sometimes see different actors on the series than appeared in the pilot. Either some members of the original cast didn't work out well, or they were not available for a long-term commitment, so other stars were found for the series.

Long-Running Series

If a program is a hit, the network will order enough episodes to finish out the year. What the producer hopes is the show will be successful enough to run on the network for at least four

years. This length of run assures that the cost of starting up the program will be covered and it is viable as a syndicated program. After a network run of several years it can either be aired once a week or as a "strip" (at the same time five days a week).

You may have noticed that particularly long running shows sometimes end up having episodes from their early years *stripped* (scheduled at the same time, Monday through Friday) on the network during daytime. Others go into syndication and are distributed, at healthy prices, to local stations to play while the series continues to run in evening prime time on the network. While the networks do not produce the majority of their prime entertainment programs, they are closely involved in every stage of the production, and each program is carefully checked to make sure it meets rigid network quality and taste standards before it is aired.

Careful and Meticulous

It is this meticulous process that makes the networks so successful. Organizations without the years of experience and millions of dollars of financial strength could not afford to do what the networks accomplish routinely. The networks also get producer cooperation because they control affiliate lineups and are the highest-paying national outlets for programs. In recent years the networks have sought and gained greater and greater daytime audiences. Their success is why every broadcast company, which has the opportunity, seeks to gain a network affiliation. Affiliation automatically guarantees an audience, and makes the local spots the affiliates sell far more valuable than if they tried to buy and air their own choice of programs.

Daytime Programs

The networks started TV programming by concentrating on nighttime viewing because they knew from their experience with radio that their biggest audiences would accumulate in the evening.

By the mid-1950s the networks were moving into daytime, following the tried and true formula of radio. Daytime TV became home of the low-cost but tremendously successful soap operas and quiz programs, many of which were adapted directly from successful radio programs. Later reruns of successful nighttime series were added to expand the daytime schedules. Today daytime TV is the second largest money-earner, after prime time, for network television.

Morning Television

The networks have enjoyed considerable success moving into other time periods. The first venture outside the safe evening prime time block was the "Today Show," launched by NBC in 1952. Later CBS attempted to counterprogram with a morning program that was more of a hard news program than the feature-oriented "Today Show." Finally, ABC entered the morning slot with "Good Morning America," which started slowly but eventually overtook the "Today Show" for a period of time. The CBS morning program ran for only one hour to make way for the eternally popular "Captain Kangaroo," until the "Captain" was finally dropped to allow the morning show to expand into the second morning hour so it could compete with "Today" and "Good Morning America." The CBS ratings went up for a while, then settled back. Most observers say early morning TV viewers seem less interested in a heavy news program, which had been the CBS approach, than one that mixes features, interviews, news, sports, and weather as did ABC and NBC.

Late Night Network

The first move into nontraditional time periods by the networks was to provide programming after the late news on local stations (11:30 P.M. Eastern, Mountain, and Pacific and 10:30 P.M. Central). NBC aired the popular "Tonight" program with Johnny Carson while CBS countered with movies and reruns of popular prime time series. ABC tried a new idea during the time Americans were held hostage in the U.S. Embassy in Tehran, Iran. The network ran a single-topic show every night at 11:30 P.M. to discuss the latest developments in the long hostage incident. After the hostages were freed ABC continued the program in a shortened form. It became the successful "Nightline," which was skillfully presided over by Ted Koppel and focused on one news story or issue.

The next move was to run news all night and then to introduce a pre-7 A.M. early morning news show. CBS in particular enjoyed some success with its overnight news program, even though it underwent a number of format changes and some budget cutting.

Weekends

Having moved into segments throughout the weekday 24-hour clock, and having a full assortment of programs on Saturday, starting with

morning children's programs and moving into afternoon sports and evening entertainment, the networks began to wonder what they could do on Sunday morning, which was the only unused local period. For years all three networks had presented excellent but somber public affairs interview programs at about noon on Sunday. CBS tried a variation by starting earlier in the morning with a news and features program, "Sunday Morning," presided over by Charles Kuralt, which enjoyed success. Eventually, the old standby public affairs programs "Face the Nation," "ABC Issues and Answers," and "Meet the Press" underwent format changes to make them livelier and more interesting. ABC designed a long-form morning program around former NBC correspondent David Brinkley, replacing its stuffy "Issues and Answers." In the late 1980s NBC entered the Sunday morning market with a Sunday version of the "Today Show" known as "Sunday Today."

Sunday afternoon had long been occupied by sports, and Sunday evenings were strong network entertainment slots especially since the networks were allowed to start prime time an hour early on Sundays. NBC enjoyed years of early Sunday evening success with programs prepared by Walt Disney Productions, and CBS eventually dominated the 7 to 8 P.M. hour with its documentary magazine show, "60 Minutes."

How Affiliates Reacted

In a few years the networks went from programming daytime and evenings to offering programs in all dayparts. The affiliates did not all receive these incursions into their time with shouts of joy. Many CBS affiliates preempted the morning news program for years, figuring correctly that they could do a local show and earn local revenue with about as much success as they could carry the poorly rated network news show. Not all ABC affiliates were thrilled to have the news block extended beyond 11:30 or 10:30 in the evening, and there were some preemptions. The stations that successfully programmed overnight movies were less than thrilled with CBS's overnight news, but some stations found it a welcome revenue and audience booster because they had been signing off during the early morning hours.

Even the Sunday morning programming did not meet with universal approval since a number of stations had traditionally carried paid or nonpaid religious programs during Sunday morning. Paid religious programming had proven to be a steady revenue source and they weren't pleased with the idea of losing local revenue.

Network News

One area outside of entertainment programming the networks successfully developed as a revenue source was news. Although many of today's affiliated TV stations do have the ability to cover national and some international news, none have found it economically viable to imitate the newspaper industry where a number of large metropolitan papers maintain overseas bureaus.

The networks had been the prime source of world and national news for TV because they had highly sophisticated, technologically excellent, professional newsgathering staffs. However, changes in the corporate ownership of the networks in the 1980s affected the networks' ability to cover news. News departments, once the favored children with unlimited allowances, had severe limitations imposed on them suffering staff and budget cutbacks.

In the three years from 1985 to 1988 the news departments of the big three networks underwent transitions from being the career dream of every young broadcast newsperson, and the arrogant "better half" of the network-affiliate relationship, to being virtual "whipped puppies."

The causes of this shift were complicated. At the heart of the process was the corporate restructuring, which hit ABC, CBS, and NBC and resulted in demands from the new owners for drastically lower costs and higher profits. A small media concern, Capital Cities, took over ABC. A giant corporation, General Electric, took over RCA and NBC, and control of CBS Inc. was wrested from William Paley by the Tisch family media interests.

Concurrently, availability of a new satellite technology made it possible for local stations to create relationships with distant stations, without having to beg the network for support. The technology was the placing of *Ku-Band* satellites in orbit. Unlike the older *C-band*, the Ku-satellite band was highly accessible and soon became the favorite of manufacturers of mobile satellite uplinks, called *Satellite News Vehicles.* As more and more local stations bought these trucks, which permitted them to transmit news items anywhere they wished, and as more stations bought Ku-Band receivers (downlinks), informal relationships grew rapidly among stations to swap news stories.

Soon the networks, which had grudgingly sold a few leftover news items to affiliates, found they had to organize sophisticated news item exchanges or suffer dire consequences, such as losing access to breaking stories. For the first time, affiliates were telling the network news departments what they wanted done, and the networks, for the most part, were complying.

Other developments in domestic and international video transmission opened the way for local stations to cover distant news stories. Other countries, particularly in Europe, liberalized rules governing satellite transmissions and made more facilities available. Prices for transmissions also fell. Some U.S. stations took advantage of the new vistas opened by technology, others did not.

The short-range future holds the possibility of even more significant improvements in the ease and portability of video transmission, using digital equipment and fiber optic transmission cable or alternative satellite systems.

While local stations have not preempted the networks in the international and national news arena, they are chipping away at network dominance of nonlocal news. Much of this dominance was really made possible by the networks' control of scarce video transmission facilities. Once alternatives became available, local broadcasters did not have to beg the network news department for transmission facilities when they wished to cover a distant story.

CBS News: How a Network News Organization Works

Let's take a look at CBS News. CBS News is a separate company of the bigger corporation, CBS Incorporated. CBS News was not set up to be a money-making venture. Ironically, it became a source of a great deal of revenue through the sale of availabilities in CBS News broadcasts and other news division programs (such as "60 Minutes") by the sales staff of CBS Television.

CBS News is structurally independent of the entertainment and network staffs of CBS. It is headed by a president, who is aided by department heads. They supervise the people who cover the daily breaking, *"hard"* news and the people who do documentaries, special events, elections, and other scheduled news coverage.

The central newsroom is in New York. It dispatches reporters and technicians worldwide and it also maintains exchange agreements (through the Foreign Desk) with a number of reputable news organizations around the world such as the

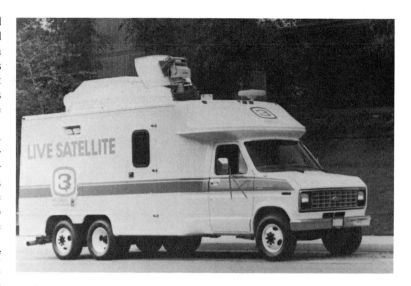

Figure 5–5
A satellite newsgathering vehicle (SNV) used by KCRA-TV in Sacramento, California. It includes two extendable masts for microwave coverage as well as a Ku-Band satellite dish. Even though the truck does not appear to be large, it contains on-board videotape editing equipment allowing reporters and producers to feed finished news stories from the field. Courtesy of Centro Corp.

Figure 5–6
A transportable Ku-Band satellite uplink/downlink. This vehicle can be used for either satellite newsgathering or for special event programming, such as live sports coverage. Courtesy of Microdyne Corp.

CBC (Canadian Broadcasting Corporation), BBC (British Broadcasting Corporation), the EBU (European Broadcasting Union), and broadcast news organizations in Japan. Due to satellite technology it is possible for the CBS bureaus around the world in Tokyo, Hong Kong, Johannesburg, Cairo, Tel Aviv, Moscow, Rome, Paris, and London to videotape news stories from other national and regional news organizations and then beam them to New York via satellite.

Satellites and News

Satellite technology has become so economical that even if the local broadcast organization doesn't have an uplink, a CBS news crew can usually find a satellite uplink facility within a reasonable distance from the place where they are covering the news. For instance, India has a poorly developed national television system with little news coverage beyond the activities of the government, but India does have some satellite transmission facilities, which Western correspondents can use to beam the stories they shoot in India back home. The networks also use portable uplinks for news coverage.

The major networks can even get video from behind the so-called Iron Curtain (the psychological barrier erected by the Soviet Union) because Western Europe's broadcasters monitor and tape the news shown on the Eastern Bloc nations' TV networks. While all these picture sources are available to New York, the editors at the CBS Broadcast Center on 57th Street are reading the newswires from the Associated Press, United Press International, and Reuters.

Correspondents

In addition to permanent news bureaus, the networks will station *correspondents* in key spots for as long as the editors and the financial people feel that the news warrants. For instance, CBS News had resident correspondents in Poland during a long period of labor union strife and in Central America, which had been in turmoil for several years.

Correspondents travel to places where the news is happening. The bureaus are strategically located in cities that have major airports, so that correspondents, producers, and technical crews can be quickly dispatched to news stories.

The typical correspondent is apt to be from 30 to 55 years old. Generally, the networks hire people who have had several years of experience and who are already recognized as being superior

reporters. Network correspondents generally come to the network in three ways: (1) they have already achieved success in large market affiliated TV stations in the United States or Canada, (2) they have proven to be good foreign reporters by their work overseas and are hired for a post in that part of the world, or (3) they are hired from other media (newspapers primarily) or because they have special expertise.

Generally, a successful reporter at a major market affiliated TV station in the United States gets recognition in two ways. He or she frequently feeds stories to the network, which are good enough to be used on the net's newscasts (as opposed to their being sent out on the private feed to affiliated stations for use in local markets). Or, he or she is spotted by a network executive or professional talent scout *(head hunter)* and after intense scrutiny is hired. You notice that we keep referring to a *reporter*. The networks seldom hire anchorpeople to be network reporters, preferring people with strong daily reporting experience.

The reporter then spends a period of apprenticeship in New York, Washington, D.C., or a major bureau, working as a *reporter*. This generally means the new reporter gets all the dirty jobs, such as standing outside a famous person's house all night waiting for something to happen. If the new reporter continues to show talent and initiative, he or she is usually given a more challenging assignment, which if well carried out may result in the person being named a correspondent. Correspondents usually work on contracts and can be terminated at the end of a contract if they have begun to slip or aren't meeting the organization's expectations.

Occasionally, a domestic (U.S.) correspondent will be assigned overseas. Previous experience and the ability to speak one or more foreign languages can help, but willingness to work extremely hard and accept an unglamorous post play a significant role in getting an overseas assignment.

A significant number of foreign correspondents join networks because they are already working for a news organization overseas or have proven themselves by working as *stringers* or *free-lancers* (part-time reporters paid per story used on the air). For instance, at least two correspondents for American networks once worked for the Canadian Broadcasting System. A correspondent for the Cable News Network started fresh out of college, with a degree in Asian studies and a knowledge of Chinese, free-lancing for CBS News in Hong Kong. Later he did re-

A portable prompting system, which allows network correspondents, program hosts, and commercial announcers to work from script while videotaping in the field. Courtesy of Compu-Prompt Corp.

porting for NBC. Then he moved to CNN where he achieved correspondent status. Another correspondent started her career fresh from a Big-10 university journalism school by going to South Africa where she contributed articles to newspapers and reported for CBS News (radio). Later CBS News hired her to work in the Johannesburg bureau and eventually she became a correspondent covering Africa and Europe. ABC later lured her away from CBS and assigned her to Rome. Another foreign correspondent who covers the world's *"hot-spots"* (read that wars) earned his stripes covering the Vietnam war and went on to cover Southeast Asia and later Central America.

Well-known correspondents *Dan Rather* and *Ed Bradley* enhanced their reputations by covering the fighting in Vietnam.

Reporters and correspondents hired from newspapers usually have a needed specialty or have achieved prominence. CBS News business correspondent *Ray Brady* edited a business magazine. Former Supreme Court correspondent and attorney *Fred Graham* had already achieved prominence with the *New York Times* before CBS hired him.

At one time many correspondents came out of the ranks of network news department writers, producers, and editors, but that is no longer true. One reason is the networks' reluctance to train reporters. They prefer to hire proven air talent. Limitations created by union agreements also make it difficult to change from a behind-the-scenes position to being in front of the camera.

In addition to their own staff people around the world, the networks employ *nationals* (people who are citizens of the country) as *stringers* in many other key locations to help when stories break. They are further backed up by the even larger lists of stringers who serve the network news departments' radio organizations.

Bureaus

In the U.S., CBS and the other network news organizations maintain large bureaus in Washington, D.C., because it is the capital, and smaller bureaus in major cities such as Boston, Chicago, Atlanta, Dallas, Miami, Los Angeles, and San Francisco. These bureaus are augmented by the news staffs of the network owned and operated stations in major cities, and by news departments of their affiliates in other cities around the country.

Public Affairs—Part of the News Department

The network news departments are primarily responsible for producing and staffing their companies' heavy schedule of hard news programs but are also responsible for other types of programming. The success of "60 Minutes" is legendary, ABC's "20/20" did very well. Sponsors eagerly buy availabilities in these programs, so the news divisions have become major revenue producers for their companies, although that wasn't the primary idea when they were founded.

The network news departments also produce the news specials, which are detailed coverage of a major news event. These can be immediate happenings such as the explosion of the Challenger Space Shuttle or they could be documen-

Figure 5–7
NBC-TV News anchor studio at the 1984 Democratic National Convention in San Francisco. Courtesy of Basys, Inc.

tary in nature such as a study of the homeless in America's cities.

Election Coverage

Another strength of the networks is their ability to cover national elections. Capital Cities/ABC, CBS, NBC, and CNN maintain election staffs even when there are no major elections pending. They concentrate on strategic planning, research, and preparation of background materials. Once a national election year starts, the nets gear up for massive coverage of the election, starting with the primaries and running until election day in November. They are backed up by the *National Election Service* (NES), to which the networks and wire services contribute, which compiles data and election results.

Network Sports

The networks also have a degree of dominance in national sports coverage. For a long time they were the only organizations big enough to put together the expensive packages which permit nationwide coverage of college and professional football, basketball, and (professional) baseball. In recent years the networks have picked up competition from the Entertainment and Sports Programming (cable) Network (ESPN), the WTBS, WGN, and WOR superstations on cable, and the USA cable network. Although many

regional networks have appeared in recent years, no one has had the wealth to bid for the major league national coverage except the big three networks. ABC, as part owner of ESPN, has helped the cable sports network obtain rights to more top-level sports than it had before ABC increased its holdings in ESPN.

The networks maintain large staffs of sports reporters, sportscasters, producers, and technicians who travel to major league cities to air the network games. Perhaps the ultimate example of the strength of a network as a sports programmer comes every four years when one of the American networks spends millions of dollars for the right to broadcast the Olympics to the United States and the world.

The networks have been responsible for developing a great deal of coverage of specialty sports such as skiing, water sports, horse racing, and track and field through the sports magazine shows, which they run on weekend afternoons.

The relatively low cost of domestic satellite time has encouraged the growth of regional broadcast and cable sports networks. All of the major league football and baseball teams have TV network arrangements which carry their games over large geographic areas. Some, such as the Atlanta Braves and the Chicago White Sox, have been seen across the nation because their games were broadcast over the "superstations." Major college football teams are seen on regional networks even on Saturdays when their games aren't being picked up by a network. Some schools have been able to have almost all of their away games relayed back to their home cities because satellite time can be rented at economic rates. For instance, Florida State University, in one season, may be seen on a network national broadcast, and a couple of network regional telecasts, and any away games not carried by a network are broadcast by local stations, which get their feeds by satellite from the away-game site. Usually equipment and crews are hired at the away game site by the university, a program packaging firm or the hometown TV station. College football telecasts are such big business one TV station in Tallahassee, Florida, home of Florida State University and Florida A&M University spent over $1 million to equip a semi-trailer truck for remote broadcasting.

There are a variety of other sports that are broadcast regionally. Basketball (professional and college) gets extensive coverage as does college and professional hockey. Another "sport" that has enjoyed a revival is professional wrestling. Syndicators take advantage of low-cost satellite

transmission time to place wrestling shows on stations throughout a region. Auto racing also gets some regional TV coverage in the southern U.S.

ISSUES IN TELEVISION

Deregulation

The government's efforts to deregulate the broadcast industry progressed more slowly for television than for radio. TV, because of its perceived power and money image, gets close scrutiny whenever a change in broadcasting regulations is proposed. Some reporting and record keeping obligations have been eased, and some engineering rules have been changed, but TV has not seen the number of changes that have taken place as a result of radio deregulation.

Diversification

On-air broadcasters are concerned that the addition of many TV channels to the viewers' sets will break their stronghold on the commercial TV business. The on-the-air broadcasters first feared competition from cable, then from other technologies such as subscription TV, teletext, direct broadcasting, and multipoint distribution. Finally, they feared competition from new stations being put on the air on less desirable channels.

So far the major audience competition has come from cable and new independent stations, not from the other technologies. The audiences of networks and network-affiliated stations have been dropping as people are offered more choices. TV broadcasters have responded by diversifying their activities.

7-7-7 Rule Change

A proceeding started by the FCC in 1984 aimed at permitting broadcasters to own more stations was seen as one way for commercial broadcasters to combat the competition from other media. In 1984 the FCC moved to do away with the old 7-7-7 rule, which said broadcasters could hold no more than seven AM, seven FM, and seven TV stations (no more than five TV stations being VHF facilities). A change was made allowing multiple owners to own up to twelve facilities in

each category of radio station. A proposal to raise TV station ownership to twelve hit opposition from the motion picture industry and other organizations who feared a concentration of media influence. The FCC ended up approving expanded group ownership of TV stations after devising a formula that limits ownership according to the available audience of the stations. No group owner can own a multiple of stations which serve more than 25 percent of the U.S. TV audience. In figuring these percentages group owners only have to count 50 percent of the TV households reached by UHF stations, which are considered to be at a disadvantage when competing with VHF stations in the same market. There is, however, a bonus provision which permits a slightly larger percentage if the group owner agrees to be a minor partner in ownership of one or two stations with a major partner controlled by minorities.

The large group owners and the networks saw the increase in the limit on ownership as a good way to reinforce their economic position in the face of increased competition. The network owners figured if their network revenue should level out or diminish, they could make up the difference by owning more stations that sold local advertising.

Mergers

Mergers and group expansion have been important strategies for growth in the broadcast industry. What has happened in the broadcast industry is an application of the old adage, "if you can't beat them, join them." Capital Cities/ABC is an owner of ESPN, the Entertainment and Sports Programming Network which provides nearly round-the-clock sports programming to cable viewers. Many group broadcasters own cable systems. Examples include Viacom International, Landmark Communications, and Cox. A major TV station owner, Hubbard, invested heavily in direct broadcasting by satellite. Other broadcast companies have used cable to extend the reach of their broadcast properties. WGN Continental turned WGN television in Chicago into a *superstation* seen all over the country on cable systems. The idea originated with Turner Broadcasting and WTBS-TV in Atlanta. Supported by WTBS superstation revenues, Turner subsequently became a major force in cable programming by creating the Cable News Network in 1980 and Turner Network Television (TNT) in 1989.

This automated camera will move according to cues imbedded in a script. Automation is increasingly being used to cut personnel costs in technical areas. Courtesy of Vinten Equipment, Inc.

Efficiency resulting from automation will help reduce production costs. One technician can control several automated cameras from this console. Courtesy of Vinten Equipment, Inc.

Syndicated Programming

Major broadcast companies have tried syndication as part of an effort to diversify. Westinghouse is an important producer of syndicated programming. The popular "PM Magazine" feature seen in many local markets was syndicated by Group W, the broadcast arm of Westinghouse. The Tribune Company is another major group that produces syndicated programs.

Extra Services—Are There Buyers?

The challenging aspect to technological innovation is finding someone who has a need for the service. *Teletext,* a service which can deliver written information to a regular TV screen, as an example, has moved slowly because not enough viewers seem to feel they need the additional information they could get if they spent several hundred dollars for an attachment to their TV set to decode the teletext signal.

OUTLOOK FOR THE FUTURE

What does the future hold for the TV industry? The networks will continue to have diminished audiences as more homes are connected to satellite receivers and cable systems. The rapid introduction of *cable-ready* TV sets, which adapt to the many choices offered by cable or satellite receivers, has led viewers to sample a wider variety of offerings. The growth of independent stations has provided viewing alternatives, especially when the networks are running programs for their second or third time.

Don't expect the networks to roll over and die. They are strong financially, expert at producing and distributing entertainment, and they will continue to do those things, even if it is in a different form. In 1988 NBC followed ABC's example, and began investing in cable. NBC also told cable industry leaders it hoped to produce programming for exclusive use on cable.

Local TV affiliates are finding that their audiences are slipping, too. Many local TV owners have begun developing other profit centers or ways to make money from their businesses. One on the West Coast purchased a TV production house, which makes commercials and opens and closes for TV news programs. Some broadcasters are looking at the possibility of providing programming to cable systems, as was done by

WAGA-TV in Atlanta. A Florida TV station bought a local LPTV station and programmed both from one studio location while a single sales staff sold time on both facilities.

A few broadcasters produce programs that are good enough to be sold regionally or nationally. In general, progressive broadcasters realize they have a certain resource, people who know how to create programs, and they are looking for opportunities to use that ability in new ways to keep their profits up. The networks and local stations will be affected but not ruined by competition, and eventually because they already know how to produce programs, most of these organizations will survive the business shake-out of the late 20th Century.

The important technological development which appears to have the ability to have a major effect on the TV industry is *High Definition Television* (HDTV), which will deliver a much sharper and potentially larger and wider TV picture to home antennas, satellite dishes, and cable connections. Combined with stereo sound for television, which has already been introduced, a whole new generation of TV receivers and transmission equipment will have to be developed and purchased by consumers and broadcasters. This will provide a tremendous economic stimulus. HDTV will also impact on the production industry because film and video techniques will change to take advantage of the sharper picture and larger screens that will come into use.

Screen for one type of camera automation controller. The operator selects framing and sequences by touching the monitor screen where words or numbers appear. This is a "user friendly" application of computer technology to TV studio automation. Courtesy of Total Spectrum Manufacturing, Inc.

SUMMARY

Television has become the major communication medium in the United States in the three decades since the FCC lifted its freeze on new TV licenses in 1952. TV now serves all but a miniscule portion of American homes. Millions of people watch TV for a considerable number of hours daily. Many people get the greater part of their daily news from TV.

TV has changed from a rather straightforward array of VHF stations carrying network programming to a complex mix of VHF, UHF, and LPTV stations, many of which are not affiliated with a network. The competitive nature of television has changed. In decades past TV stations and networks competed against each other for advertising revenue and audiences. Today independent TV stations, regional and specialized networks, cable, and satellite TV are all trying to cut into the historic audience and revenue dominance of the networks and their TV affiliates. A full-time fourth TV network continues to grow while satellite networking to cable systems spreads rapidly. Personal videocassette usage is growing at a tremendous rate, further diversifying the viewing audience.

Broadcast TV has made a lot of money and will make a lot more, but not in as large hunks because America's love affair with video is cutting the audience and revenue pie into many more pieces.

GLOSSARY

Account executive The person who sells time for a media outlet. The person in charge of a specific account at an advertising agency. A salesperson for a representative firm.

Action for Children's Television (ACT) An organization that seeks to improve the quality

of children's TV programs and the advertisements within these programs.

Anchorperson News presenter.

Assignment Editor Person responsible for coverage of news stories, assigns reporters and requests crews, and plans, researches, and develops news stories.

Availabilities (Avails) Time positions reserved in programming for insertion of commercials. When commercial schedules are being planned for sponsors, sales operations specialists look for open (unsold) positions, called "avails." Positions can be used for promotional or public service announcements if not sold.

Barter An exchange of time and goods without money. Often used when one media outlet wants to promote itself by using another media outlet. Syndicators provide programming to stations in trade for holding back some spots for national advertisers. In this way the station gets the program, the syndicator gets national commercial inserts, and no money changes hands.

Bicycling Shipping a program from station to station in film or videotape form by bus, train, or express service.

Break Short for station break. A time period between programs, which usually incorporates a station identification (ID) and various announcements.

Business manager Person in charge of all business and accounting functions, including general ledger, profit and loss, personnel, and investments.

C-band Portion of frequency spectrum reserved for microwave and satellite transmissions.

Carnegie Commission on Educational Television 1967 study group, which proposed the basis of first public broadcasting legislation by Congress.

Chief engineer Person in charge of all technical operations and equipment.

Clear Agreement by affiliate to carry specific network program. Network department keeping these records is the clearance department.

Client list The clients considered "active" even if they are not advertising at the moment.

Cooperative advertising specialist Person who assists dealers in securing shared advertising funds from manufacturers and distributors.

Corporation for Public Broadcasting Quasi-government organization that filters federal funds to producers of noncommercial programs, the PBS, and NPR.

Correspondent A senior reporter with better assignments, pay, and exposure.

Counterprogramming A technique where one network or station plans a contrasting type of programming for the specific purpose of stealing audience from another network or station. Originally used by ABC to boost its audience, now a normal programming ploy.

Daypart Literally, part of the day. In radio usually broken into 6–9 A.M., 9 A.M.–noon, noon–4 P.M., 4 P.M.–7 P.M., and 7 P.M.–midnight; in television, usually morning, daytime, prime time, or overnight.

Dealer tag Short announcement giving dealer address and phone number at end of commercial prepared by a manufacturer, distributor, or wholesaler.

Executive producer Head of news producers and frequently number two or number three administrator in news department.

First run First showing of a program; can apply to network or syndicated programs if the syndicated program is being shown for first time ever.

Format An outline of a program or, in radio, the type of music played and the style of the presentation.

Fourth network Long-time desire among independent station owners to have a fourth network, over and above ABC, CBS, and NBC, to provide high quality programs and lower per unit cost. The Fox Broadcasting Company created the first viable Fourth Network.

General Manager Customary title for chief executive of a broadcast station or cable system.

General Sales Manager The head of all sales activity for the station.

Head Hunter A special kind of employment agency or employment specialist; finds management and specialized or talent people for TV stations or networks.

Independent Term used to describe a broadcast facility not affiliated with a network.

Ku-Band A portion of the frequency spectrum assigned to transmissions to and from satellites; used extensively for mobile and stationary newsgathering equipment.

Local sales manager Person in charge of sales to advertisers in service area of station.

Logo Graphic *trademark* used by telecommunicators.

Low power TV Also called *Community TV*. VHF TV stations transmitting with no more than 10 watts and UHF TV stations transmit-

ting with no more than 1,000 watts, designed to serve small areas. This class of stations is less heavily regulated than full-power stations.

Marketing manager Specialist in assisting advertisers with promotional and point-of-sale projects; often helps advertisers place their products in stores or develop distributorships.

Meteorologist Person who compiles and airs weather forecast. Term is usually applied to a person who has professional certification and/or professional degree or course work at the university level.

Must-carry Under old FCC rules cable systems were required to carry signals of TV stations within certain distances of their franchise city.

Nationals Residents of a foreign country hired to work for a network news bureau in that country.

National Election Service (NES) Nonprofit election data-compiling service financed jointly by several media organizations.

National Telecommunication and Information Administration (NTIA) Funded construction of public TV stations. Huge grants from NTIA helped add public TV stations in areas that had not previously been served. NTIA is also the communications policy and technology research arm of the White House.

Network An interconnected service with the majority of its programming originating from one location which provides programming at precise times to a number of stations, called "affiliates." The affiliates may be paid in cash or with programming provided at no cost by the network. Syndicated networks charge the affiliates for their service.

News Director Administrative head of news department.

Noncommercial TV See *Public TV.*

Operations manager Person in charge of program traffic.

Operations supervisor News department supervisor responsible for technical personnel and equipment.

Per Inquiry (PI) Term used to describe a commercial announcement when a station is paid based on the number of responses, telephone or written, generated by that commercial; similar to getting a small commission on each item sold as a result of an ad on the station.

Pilot Sample TV program, usually for a series.

Preempt To override, substitute, or replace as in replacing a network program with a local special.

Prime time That time designated by the networks as the highest viewer time period. Generally 8 P.M. to 11 P.M. in the East and West and 7 P.M. to 10 P.M. in the Midwest.

Production director Person in charge of live and recorded production of local programs, commercials, public affairs spots, and promotional spots.

Program and continuity acceptance Department in a network organization, which checks programs and commercials to make certain they meet network taste and ethical guidelines.

Program Manager Person who creates the station's regular program schedule, plans special programs, and buys or contracts for programs. It is a strategic planning position. The program manager also has important responsibilities in assuring compliance with a long list of FCC regulations, such as the political programming rules.

Promotion/promotion manager The department and person that "sells" the station to the community. The objective of promotion is to increase a station's audience.

Public Broadcasting Act of 1967 Federal legislation that established mechanism for federal government support of noncommercial, public TV and radio in the United States.

Public Broadcasting Service Network that contracts for and distributes programming to noncommercial TV stations via a satellite network.

Public file FCC-required file kept in every broadcast station for public inspection during business hours.

Public TV/Educational TV Noncommercial television, usually supported by contributions from public, business, and government.

Regional sales manager Person who heads effort to secure contracts from advertisers outside the immediate service area whose distribution is limited to a region as opposed to the majority of the United States. Milk companies are frequently regional advertisers, as are food companies that make regional foods such as grits.

Reporter Person who covers news; also one who goes to an event, or is present as history unfolds and then tells or shows it to the broadcast audience.

Rep/representative organization Hired by stations, these representatives, operating at national and regional levels, get advertisers to place their commercials at advantageous times and places on the schedule. The rep gets a

percentage of the advertising billing for commission.

Research specialist Person trained in sales, program, and market research who helps develop creative ways to sell time, based on analysis of a station's ratings and other factors.

Rotation A plan describing the times of day and number of plays each song on a radio station's playlist gets during the day; also refers to the way commercials are scheduled and when they play; can also refer to rotating dealer tags to give schedule and adjacency variety and equal distribution to all participants.

Sales traffic The person or persons who keep track of sales commitments, available time slots, rates in relation to length and time, and the rotation for each client.

Satellite News Vehicles (SNV) Trucks or semi-trailers with Ku-Band satellite uplink dishes mounted on them; used for remote news, sports, and program transmission via Ku-Band satellites.

Seasons Refers to the prime buying times on the networks.

Spin-off A program that is derived from within the plot and characterization of another program, an imitator.

Sportscaster Talent professional who describes live play-by-play sports, assists in live coverage, or does sports news for telecommunication outlet.

Spot inventory The total number of commercial announcement positions available. Some references are to remaining unsold spots.

Station manager Usually the next person in rank below the general manager. Frequently, a person who devotes a great deal of time to internal, operational management.

Stringer Reporter paid per story used. Sometimes called free-lancer.

Strip Scheduling a program at the same time of day, Monday through Friday; used most frequently with older syndicated shows or series.

Studio supervisor Engineer in charge of all in-station technical equipment and personnel.

Subscription TV Scrambled TV signal available only to subscribing viewers who have special descrambling device attached to TV set. Pay television.

Syndication Program sold individually to a number of outlets, broadcast and cable. Often used to refer to present or former network series (off-network) available for sale to other parties; can also refer to special "made-for-syndication" programming.

Tags Short dealer identifications at the end of commercials for a regional or national company.

Talent On-air personnel.

Technician Person with technical training who operates and/or maintains technical equipment.

Teletext Method for transmitting alphanumeric (written) material within an existing television signal. Textual information encoded in broadcast TV signal (and some cable signals) which, once decoded, can be read as "pages" of text on TV screen.

Time buyer Person employed by an advertising agency who buys time for commercials using reps or dealing with individual TV stations.

Trade deal An exchange of advertising time for goods or advertising time for advertising time on another medium.

Traffic Generic term that applies to keeping track of sales contracts; commercial, public service, and promotional spots; all materials for use on the air; and the creation of the documents (logs) and reports related to these activities.

Transmitter supervisor Engineer in charge of transmission equipment and transmission engineering staff.

VHF drop-ins A tactic whereby the FCC created more station space on the spectrum by shortening the mileage separations between stations on the same or adjacent frequencies.

Videographer/editor Person who shoots and edits (selects and puts together scenes) videotape. Sometimes these are separate jobs.

CABLE AND OTHER MEDIA

6

In this chapter we will look at the "new" or "alternative" technologies of telecommunication. Some of these technologies are reshaping the telecommunication industry, others have proven to be dreams or ways to dispose of large amounts of money. *Cable, Multipoint Distribution Systems, Direct Broadcasting Satellites, High Definition Television,* and *Teletext* are part of what is called the "new technologies." By new, we mean new compared to broadcast radio and television. The technologies themselves are not the major point. It is the effect they have on each other, the uses the individual and combined technologies have been put to, and the changes they have wrought in our media consumption habits that are important.

In its early days cable's strength consisted of providing clear signals of local TV stations and importing clear signals of popular metropolitan TV stations.

Now cable systems provide more signals from *satellite networks* designed for cable systems than they do from on-air TV stations. You can watch sports, news headlines, long-form news, written form news, weather, old movies, new movies, blue movies, children's shows, cultural events, music videos, health programs, helpful programs, and religious programs; the list gets longer every month. This diversity of programming has made cable a force in the telecommunication world. Cable, if wired for large capacity, can overwhelm a viewer. A viewer could have over 100 channel choices if he subscribed to one of the newly constructed systems. This diversity of choices has TV station owners worried. Despite the large number of choices, many viewers continue to gravitate to the familiar and successful programs offered by affiliates of the major New York networks.

The 1980s became the decade of video choice and cable became a major force. The growth was not without pain, as the industry struggled to sell advertising, battled with home satellite dish owners over *scrambled signals,* and retrenched after cost overruns incurred in building some urban systems. *Pay-per-view cable* became

a trend and *satellite master antenna companies* (SMATV) brought new competition into urban high-rise buildings, thought to be the domain of urban cable.

Multipoint multichannel distribution systems tried to use *microwave* to fulfill cable's function without expensive wiring. Direct broadcast satellites went up, and then sat above the earth, relatively unused. At first DBS was a technology without a market, but it found a new home in Europe and began to attract attention.

Megacompanies consumed other megacompanies and friendly little home-built cable systems disappeared into corporate boardrooms. The same corporate boardrooms kept direct broadcasting by satellite at arm's length and shelved *teletext* and its cable equivalent, *videotex.*

CABLE

Cable started in the hills of Pennsylvania as a way to sell TV sets or so the legend goes. A wise appliance store owner in the mountains of Pennsylvania realized he wasn't selling many sets because the mountains interfered with receiving the available TV signals. Reportedly, he ran a wire from his tall store antenna to other households, and pretty soon he was selling both an antenna service and TV sets. Similar tales are told in other mountainous regions of the country.

CATV—Cable with Another Name

In the late 1940s Cable was called *Community Antenna Television* because the community antenna television company would put up a big tower with several high-power antennas to catch TV signals and then feed by wire (cable) whatever signals it received to its customers. What subscribers got depended on what could be received on the well-placed large antennas. This still limited the choice of signals to transmissions from TV stations that were 25 to 75 miles away.

Figure 6–1
A Ku-Band satellite in space. This satellite is used to distribute the NBC-TV network signal. Courtesy of RCA American Communications, Inc.

Soon cable companies began bringing in distant signals via *microwave*. Microwave operates on line-of-sight just like TV, so there has to be a relay station every 25 to 40 miles between the source and the cable system. Some of these relay networks were privately owned; others were part of the AT&T system. Occasionally, the cable company would pay for the relays, but usually they preferred to lease microwave service from a company specializing in microwave networks. Even with microwave signals cable was a small business, limited to areas where people could not get good TV signals even with the use of rooftop antennas. Large cities with tall buildings which inhibited television signals were the next area to be broached by the cable deliverers. They envisaged a huge lucrative market, but were slowed down by the practical difficulties of laying cable in city environments.

Satellite Cable

The next step in the growth of the cable business had to wait until domestic satellite service be-

came available. *Westar I* was launched in April, 1974. Other satellites were used much earlier but were not available for domestic program transmission until 1974. Westar I was launched by the Western Union Company.

One of the pioneers in the use of satellite transmission for cable was *Ted Turner,* who arranged to feed the signal of his UHF independent TV station, WTBS-TV, Atlanta, to cable systems across the country. Soon program suppliers went one step further when they discovered they could set up a *network* by feeding programs by satellite to cable systems, just like the New York networks fed programming to their affiliates.

Some of the early cable networks were essentially movie theaters in the home. Based on the success of recent release movies on the networks, companies such as *Home Box Office* began to offer (for an additional fee) recent release movies for cable subscribers. The trend caught on and soon there were a number of movie channels. Then cable program companies began to branch out. The *Entertainment and Sports Programming Network* (ESPN) was created, offering almost round-the-clock sports programming. Ted Turner introduced the *Cable News Network.* Various specialty networks carrying business news, health information, and religious programming sprang up.

Cable Today

The Cabletelevision Advertising Bureau, in its 1988 *Cable TV Facts,* said 45 million U.S. homes subscribed to cable. Their investment to receive cable programming amounted to 13 billion dollars. Industry sources estimated in 1988 that cable passed 80 percent of U.S. homes, and was installed in 52 percent of the homes passed. The Television Information Office, in 1988 figures, said 98 percent (88.6 million) of American homes had TV sets, 51 percent had basic cable, 27 percent had one or more pay-cable services, and 53 percent had at least one VCR.

The mechanics of setting up a cable network are fairly simple. All you need is a *master control center,* which looks pretty much like master control in any TV station, with film and slide projectors, videotape machines, graphics devices, and a switcher. The programming is fed to an *uplink* (a big dish that transmits the signal up to a satellite). The problem for the cable program company is not technology—it's *software,* the material sent out in the form of programs. Set-

Figure 6–2
Cable News Network (CNN) assignment editor uses computer to plan all-news network's coverage. Courtesy of Basys, Inc.

ting up a movie channel can be expensive because you have to pay license fees to rent the movies you show. Live sports or news coverage is also costly; supplying 12 or 18 or 24 hours a day of health, finance, or religious programming takes a great deal of effort and personnel, which translates to expense.

Once the cable program company has made arrangements to program its channel, has installed the technical facilities and uplink (if the uplink isn't leased), and has secured space on a satellite, the company then must go out and convince cable systems to carry the programming. The program service can be offered free, the program company can pay the cable company to carry its feed, or, most often, the program company charges the cable system a perconnection fee for the service, and the cable company turns around and tacks on an additional fee for subscribing to a package of extra-fee service. HBO is the classic example of an added-fee service for which the subscriber and the cable company pay extra.

Figures compiled by *Channels* magazine in 1988 listed over 43 million subscribers for WTBS-TV, the superstation; over 44 million for the Cable News Network; 2.5 million for the Nostalgia Channel; over 46 million for ESPN; almost 20 million for two Home Shopping Networks; 31 million for the Weather Channel; nearly 16 million for Home Box Office; and 5.7 million for Showtime.

In 1987 the three New York networks combined had about 20 million viewers on an average prime time evening out of 88.5 million TV households. While you can't compare viewers and subscribers, because they're not the same, it is easy to see that the cable networks have accumulated large potential audiences. In early 1988 the leading cable network series program was Award Theatre on WTBS, which got an average of just over two million viewers on a Sunday morning. WTBS's Prime Movie I at 8:05 P.M. was garnering just under 1.5 million viewers.

Franchising

As cable systems moved into more built-up communities they were faced with having to run their cables along public roads or rights-of-way. Cities and counties rented this land or use of the poles which stood on it by charging fees, called *franchise fees*. The process of drawing up a contract to charge the cable company a *franchise fee* also put the municipality or county in the position of deciding who would and who would not get the franchise. Cable companies then began to bid against one another to gain these franchises. The process became competitive and was one of the factors which led to the *Cable Communications Policy Act of 1984.*

Access

During the 1970s when cable system were becoming more than repeaters for distant TV signals, they also came under fire from franchising bodies (cities, towns, and counties), which sought to have new outlets for local programming, both governmental and private. As a result, cable systems began to originate a little programming locally and assign some of their channels to schools, local governments, and *access* for free use by local citizens.

Cable Grows Complex

Today's cable system is a complex operation, receiving perhaps a dozen off-air signals, plus two or three dozen satellite TV signals and a handful of radio signals and retransmitting these to thousands of homes via a cable, which has amplifiers placed along it at strategic points. The

cable system is likely to be doing some of its own programming and may have dedicated one or more channels for use by the municipal government and the school board as well as setting one channel aside as an *access channel* or *local access channel* for use by the public.

How a Cable System Works

A typical cable system consists of a *head end* where the TV signals are received and then fed into the system. This is a complex operation, housed in a building packed with electronic equipment.

Outside TV signals arrive on special antennas attached to a tall tower, which also supports microwave receiver *dishes.* Programming from area TV stations is received on the antennas. Programs from more distant cities come in on the microwave circuit and are received on the dishes attached to the tower.

Nearby, you would see several satellite dishes, *Television Receive-Only antennas* (TVROs). These are aimed at satellites that relay programming to cable systems. The original transmissions can originate almost anywhere; for instance, the

Figure 6–3
TV receive only (TVRO) dish used by cable systems to receive programming from satellite cable networks. Courtesy of Comtech Systems.

programming of ESPN comes from Bristol, Connecticut. HBO has a transmission facility on Long Island, New York. The programming of Superstation WTBS is transmitted by a private company from a site just outside Atlanta, Georgia.

These signals are received on the cable company's TVROs at the *head* end. There may be other signal sources. For instance, a signal might come in on a telephone company video cable or the cable company might have a wired *interconnect* with a cable company in an adjacent city.

All of the signals are monitored in the cable system's master control room to make sure they are as clear as possible. The signals are then sent out on cables (which are made up of many strands of wire protected by weather-resistant outside sheathing). Amplifiers are placed in the circuit at intervals to bring the signals back up to satisfactory quality. (It's just like running water through a 50 foot hose or 300 feet of hose. Friction generally reduces the water pressure at the end of the 300 foot hose when compared to the pressure at the end of the 50 foot hose.)

The cable spreads out throughout the city. It can be buried in the ground, threaded through conduits in the city utility system, or hung on utility or telephone poles. (If telephone poles are used, the telephone company collects rent on the use of each pole.) Smaller cables lead into outlets in each residence and another cable leads from the outlet to the back of each set which is linked to the cable system.

All this sounds pretty simple, but it isn't. One of the great risks in the cable business is the loss of signal through distance, the failure of an amplifier, storm damage, or damage to the cable. Cable companies constantly maintain their cables and invest large amounts of money in upgrading the equipment as better cable and amplifiers are brought out by manufacturers.

The control center can be a complex place. Some cable systems have two-way capability. Others insert commercials in different cable programs, so they rely on computers and automated videotape machines to perform the commercial insertions at the right time on each commercial program service.

Many cable systems have some sort of studio facilities, either for the production of their own commercials or programming, or to be available for access programming done by community organizations. In addition, some systems have remote trucks used for taping commercials on location or transmitting programming (such as sports or the city council meeting) from distant locations.

The "Must-Carry" Rule

In July 1985 the Federal Court of Appeals in Washington, D.C., stunned the broadcasting industry by striking down the "must-carry" rule.

The court said the *must-carry* rule was at odds with the First Amendment. The *must-carry* rule was devised by the FCC to force cable systems to carry the signals of certain broadcast stations. Under the rule system operators had to carry all TV signals originating within 35 miles of the cable system, and some systems had to carry signals that came from stations as much as 100 miles away.

A three-judge panel of the U.S. Court of Appeals in Washington, D.C., invalidated the FCC's must-carry rules in December 1987. This was the second time the court had thrown out *must-carry,* which had been restored by the FCC using more liberal standards after the 1985 decision. The Court said the FCC had failed to show a "compelling need" for the rules, which protected broadcasters.

The decision opened the way for local cable operators to drop any local signals they desire, replacing them with satellite or other services. Or, they could carry programming only from stations that paid them to transmit the programming. The independent, religious, public, and minority or second-language stations appeared to be most in danger of being dropped. Cable systems with a small number of channels would be tempted to seek out the most popular satellite services rather than carry all the local TV signals. Actually, there was relatively little dropping of on-air signals by cable systems in the year immediately after the court's must-carry decision.

Syndex

In 1988 the FCC reinstated "syndicated exclusivity," a protection it had given local broadcasters until the rule was repealed in 1980. Under syndicated exclusivity, local broadcasters could force local cable companies to block any showing on any channel they carried of a syndicated program being shown on the local broadcast station. The original rule was deleted in 1980, and after years of lobbying by broadcasters, it reappeared as what the trade magazines called *Syndex II.* The rules under Syndex II:

- Stations may enforce their exclusive right to syndicated programming against cable systems that attempted to import duplicative programming on distant signals.

RCA American Communications

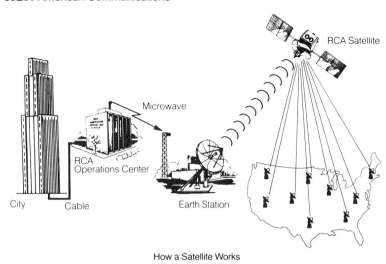

How a Satellite Works

Figure 6–4
How a satellite system works: the example of RCA/NBC. The TV picture or radio audio travels from the RCA/NBC building in New York City's Rockefeller Center by cable to the RCA Operations Center. From there it is sent by microwave to a satellite earth station in New Jersey. The signal is received by the RCA satellite, which then redirects it via transponders to downlinks across the U.S. Courtesy of RCA American Communications, Inc.

- Syndicators also could enforce exclusivity for one year after their first sale to a TV station.
- Stations that sign exclusive contracts must notify affected cable systems within 60 days and allow 60 days for compliance after they assert exclusivity.
- Once exclusivity is asserted, the cable system is in violation of FCC rules and federal copyright law if it permits transmission of the program, unless an agreement is reached with the station or syndication firm.
- The FCC specified the language that must be included in programming contracts to make exclusivity enforceable.
- Superstations can negotiate national exclusive rights to syndicated programming.
- The rules would not go into effect until December 31, 1989.
- Exemptions: cable systems with fewer than 1,000 subscribers or programs on stations generally available off the air, such as stations in nearby cities.

Two-Way Communication

A cable system may carry data. A few have experimented with *two-way communication,* the

best known being the *Warner-Amex QUBE experiment in Columbus, OH,* in which subscribers were given remote control devices, which permitted them to respond "yes" or "no" to questions asked of them by the program hosts. The responses were tallied by a computer and appeared on the screen. Viewer participation was poor and the experiment was abandoned, although the QUBE technology permitted the cable company to provide recently released movies on a pay-per-view basis because the QUBE technology allowed the subscriber to designate specifically what he or she wanted to watch, and pay for.

A cable system in Fairfield County, Connecticut, wired its routes so that the system's new production trucks could "plug in" and send material back to the newsroom on a dedicated cable channel.

Franchises

One of the major problems facing the cable industry is franchise fees. A cable system must have somewhere to string its cable. The two most frequent choices are on poles owned by the telephone company or along right-of-way (borders of roads) owned by local government. Some cable systems pay the telephone company for space on its poles, but this proved to be too expensive for many cable operators. The other choice was to obtain a *franchise* (permission to use government land) from the local governmental body. Traditionally, these bodies have charged for the right to run wires or pipes along public land, and the battle to obtain this permission and settle on equitable fees has been of foremost concern to cable operators for years. The battles to obtain franchises became extremely competitive in some cities, with various cable companies offering more and better features to win the right to install a cable system. You might wonder why a city didn't just go ahead and tell four or five cable companies they could lease the land along the right-of-way. The reason is that it wouldn't be profitable to have more than one cable company serving most areas. A 1985 court case did question whether local governments can grant an *exclusive* franchise to one cable company for a whole city or county.

Big City Franchises

In the late 1970s cable had progressed to the point where it appeared economical to wire some big cities. At this point there were enough major cable companies nationwide to set off bidding wars for franchises in New York City, Dallas, Chicago, and other major cities. Some cable companies seemingly lost sight of their objective and promised the city fathers practically anything to get the right to cable the city. Many companies offered to put in systems with more than 100 channels and to make many channels available to local government. The bidding was so brisk some cable companies promised technology that had not been tested yet. Others accepted limits on the fees they could charge customers.

By 1982 a number of cable companies found themselves in financial difficulties. They had expanded too fast and obligated themselves to spend too much money on construction of systems without providing for income to pay the expenses. Several large companies such as Storer and Warner-Amex had to sell systems and negotiate with cities for rate increases to keep from going under. These problems were eased in October 1984 when Congress passed a cable deregulation bill (the *Cable Communications Policy Act),* which was to take away the rights of cities to set subscriber rates, effective in 1986, and provide for rate increases of up to five percent per year to adjust for inflation without local government approval.

State and local governments challenged an FCC rule limiting regulation of rates for basic cable service. In 1988 the U.S. Supreme Court refused to hear the state and local governments' challenge. This meant that a federal appeals court decision that upheld an FCC rule remained in effect. The 1984 cable law said states and localities could regulate rates only where "effective competition" did not exist. In 1985 the FCC passed a rule saying effective competition exists when a region has three or more over-the-air broadcast signals.

In figures published by the Cabletelevision Advertising Bureau, cable penetration in New York City (where cable had been delayed by construction and political problems) had reached 41.7 percent by July 1987. At the same time, Los Angeles reported 40.2 percent penetration, Chicago had 34.6 percent penetration, and San Francisco–Oakland had 54.1 percent penetration.

By comparison, smaller cities such as New Orleans reported 55.4 percent penetration, San Antonio had 63.3 percent penetration, and Wilkes Barre–Scranton, Pennsylvania, reported 68.9 percent penetration.

One of the key provisions of the cable dereg-

ulation bill, other than weakening cities' power over fees, is a section that prohibits *redlining*. Redlining is a practice in the cable industry in which cable systems do not extend their lines into certain low income neighborhoods.

Modifications of Franchises Under the Deregulation Act

A cable company that can prove in court that its existing franchise requirements are impractical can get modifications of the requirements. The law has built into it terms protecting a cable company which has provided reasonable service from being denied renewal of its franchise. Local franchising authorities can establish requirements for designating public, educational, and governmental access channels.

Leasing Channels

The law requires cable companies to offer a certain number of channels for commercial use. In the past television stations have attempted to lease channels to transmit their own selection of programs, and in many cases cable companies have refused to lease the channels. Under the Cable Act, TV stations could lease channels, although there has been no indication of a rush to do so.

One of the key provisions of the Cable Communication Policy Act calls for both civil and criminal penalties of up to six months in jail and a $1,000 fine for anyone convicted of stealing cable services.

Who Can Own a Cable System?

Although the FCC is involved in regulating the cable industry, there is no federal licensing of cable systems. Therefore, anyone who has the business expertise and money can bid for a cable franchise.

Cross-ownership of cable systems by local TV stations is prohibited, but local newspapers can own a cable system in the same city. *Telephone companies may only own cable systems in certain underserved rural areas.*

Privacy

The Cable Communications Policy Act of 1984 created a national standard to protect the privacy of subscribers from the collection, use, and disclosure of private information by cable companies.

Cable Satellite Feed Reception

As home reception of satellite signals became more popular, the cable programming services became more and more concerned about preventing what they considered "piracy" of their signals by individuals who received satellite signals on backyard dishes, which fed into individual households or by businesses such as bars and motels.

The Cable Communications Policy Act of 1984 legalized home pickup of unscrambled satellite signals. The law complicates things by creating a mechanism by which satellite programmers may negotiate paid licensing agreements with backyard dish owners, manufacturers, and dealers.

After the act became law, some cable satellite programmers ran rather threatening announcements encouraging satellite dish owners to pay a license fee, which included renting a descrambler.

Most major satellite programmers, led by HBO, have scrambled their signals. In 1985 HBO began offering descrambling equipment for backyard dishes for a fee. Other companies followed suit, proposing that home dish owners pay $300 or more for a decoder and then pay a monthly fee, as do cable customers, to receive the scrambled signal. This approach to home reception was complicated by the fact that several different program sources, including the networks, were undertaking scrambling, which would have meant that backyard dish owners would have to have more than one decoder and pay more than one reception fee. The backyard dish owners, led by their lobbying organization, SPACE, put on a strong campaign to get Congress to intervene and either outlaw scrambling or modify the fee structure for receiving scrambled signals. By 1988 industry estimates indicated that about 300,000 of approximately two million backyard dish owners had purchased descramblers. A small number of companies came on the scene, offering combinations of scrambled services for a flat monthly fee.

Another problem facing people who wanted to install backyard dishes was local zoning ordinances. In 1986 the FCC adopted a rule that preempted some of the rights of municipalities and counties to block installation of satellite receive dishes.

Some people who live in rural areas do not

Figure 6–5
Staff member of a Jones Intercable, Inc., cable TV system works on production of an interview program. Locally originated programming tailored to the interests of small communities is one of the unique attributes of cable television. Courtesy of Jones Intercable, Inc.

have access to cable or good signals unless they use a satellite dish pickup. Generally, cable companies will not lay their cable in an area unless it is densely populated. This has led to an adjunct industry of electronic producers who develop and sell decoding chips to satellite owners. The irony of the descrambling issue is that cable companies are the sales agents for backyard dish descramblers because descrambler use is tied to a monthly programming charge. Backyard satellite owners have generally spent between $1,000 and $5,000 for the satellite dishes and controlling electronics, and they think that the cable companies are trying to charge for a service they would not originally provide and do not now provide. The cable companies, satellite program producers, and satellite dish owners continue in a gridlock that may end up being settled by congressional action.

Copyright and Cable

Another battleground for cable systems has been the copyright laws. The copyright laws were written to protect people who create materials, such as books or TV programs, from having their materials or ideas stolen. You are supposed to pay a copyright fee if you reuse someone's creation. There have been long and heated battles over who gets paid for creating programs that end up

on cable. Take for instance, the writer who gets a royalty for creating a film script for a movie. He or she gets paid for the film's use in movie theaters. What if a cable film network then shows the program, or if WTBS-TV in Atlanta plays it and pays only the local fee rather than a network fee? What if the movie company sells the film to a cable network? Writers, performers, musicians, and others who get part of their income from the number of times a program is shown have been concerned. The cable systems insisted they could not afford to pay copyright fees for all of the material that was coming to them on cable networks. Most of these problems were worked out, the Hollywood unions have rewritten their contracts to include fee payments for use of their work on cable and in the VCR market, and cable systems do pay modest copyright fees on some material through a fee "pool" system overseen by the Copyright Tribunal in Washington, D.C.

Cable and LPTV

A new wrinkle arose. Suppose that you get the clever idea to build a tiny LPTV station one mile away from a cable company's *head end* or receiving station in a high cable penetration market. Naturally, it can pick up your signal, so you sign a contract with the cable company that says you will be on its system. Now if the cable company carries your signal—because it's another local signal, you are essentially equal to the costly VHF and UHF full power stations as far as cable viewers are concerned. The cable company doesn't really care as long as people watch and it doesn't have to pay a distant signal copyright fee, but that's the wrinkle. The copyright law doesn't cover LPTV stations, nor did the *must-carry* rules of the FCC, which guaranteed that local and nearby TV stations will be seen on the cable system.

Now you sue the cable company for breach of contract. A federal judge rules that because you were wise enough to contract with the cable company to carry your signal, it is an enforceable contract. The cable company proposes that the copyright law still demands it pay royalties on all the programs it rebroadcasts from your station. So the cable company appeals, and the whole mess gets bogged down in a long legal hassle. (And that's exactly what did happen to one station, which ended up being added to the cable system when the Copyright Tribunal interceded and said if the cable system would cer-

tify that the LPTV station was carrying only locally originated programs the cable system did not have to pay a copyright fee.)

This illustrates the complexity of the copyright law. There is historical precedent for the idea of putting an LPTV station on the air just to get on cable. It was done successfully over a decade ago in Toronto, Canada. Without must-carry rules, however, it is less likely many LPTV stations will be carried on cable systems because the cable systems can now charge the LPTV system for carrying its signal, and it is unlikely most LPTV stations will be able to afford to lease a cable channel.

Fees

Another problem faced by the cable industry has been the fees charged by the cable networks that feed cable systems. The networks, which have highly desirable programming, charge the cable operator on the basis of the number of subscribers the system has. That's fine until the cable operator decides to put in a system carrying 54 channels. Suddenly, the program fees amount to a whole lot of dollars.

Many new cable networks have had to forego fees to get cable systems to sign up and carry their services. The fees have been a constant topic of controversy between the programmers and the cable systems. The programmers have generally not been able to get along on the advertising they sell (if they have any).

The fee problem has raised the cost of starting up cable networks, and as a result, these services have tended to be the ventures of very well capitalized firms, rather than the creation of local middle income programming geniuses.

Pay-Per-View Cable

One of the major trends in satellite-based cable programming is *pay-per-view cable.* The cable subscriber is given a special device, which records his *purchase* of specific programs from the cable service in addition to the basic subscription fee.

In 1987 the A.C. Nielsen Company reported that pay cable was installed in 27.4 percent of all TV homes. Usually, the customer pays a monthly fee for regular service, say $10, plus additional fees for added *tiers* of service, such as HBO. These might cost an extra $8 or $10 per tier per month. With pay-per-view you might

pay $2 for each movie you watch. Pay-per-view is seen as a way to lure people back to cable special services who are currently renting movies to play on their VCRs.

An earlier example of pay-per-view were the televised fights, which were shown in theaters and civic arenas to people who paid admission to watch the fight on large-screen TV. Another example is *pay TV* or *subscription TV,* which sends out a scrambled signal until you indicate you want to view the program by punching information into a special device attached to your TV set. You will also find pay-per-view cable in some hotel rooms. The billing is done by punching selection buttons on a "keypad" attached to the room TV set. (Not all hotel pay-per-view systems rely on cable. They could be received on a TVRO dish at the hotel site or the programming could be played from videotape recorders housed in the hotel building.)

A Typical Cable System

Let's say we're visiting the CrystiallView Cable Company in East Podunk. The system was recently installed, so it is technically sophisticated. The residents of East Podunk had been wanting cable service for some time; so when the city commissioners requested bids for the franchise, they got applications from 14 companies. It took the city commission six years to sort out the applications, develop a clearer set of specifications, and finally agree to give the franchise to CrystiallView Cable, which agreed to install a 54-channel system, with five channels set aside for municipal use and one for access. The cable company was so eager to win the franchise fight it agreed to hook up all the schools on one channel and provide cameras and allied equipment so the school board meetings and other school board projects could be cablecast. A similar arrangement was made with the commission, and the cable company promised to cablecast each commission meeting over one of the reserved channels.

The winning bid cost CrystiallView an extra 0.5 percent on the franchise fee, which is 5.5 percent of the company's gross revenue.

After all the wheeling and dealing CrystiallView is left with 47 channels it can use any way it wants to earn money. The cable company started out by deciding what to carry on the *first tier,* or basic level of service all customers get when they subscribe. The lineup looks like this. The channel numbers are the channel

numbers subscribers tune on their receivers. Because the cable company uses a special *black box* for tuning, the channel numbers don't stop at 13, as they do on the VHF tuner on a TV set. The cable service can be connected directly to TV sets that are marked "cable ready" by the manufacturer.

Tier #1 basic service

Channel 1	Cable News Network
Channel 2	KMGP-TV (local CBS affiliate)
Channel 3	CNN Headline News
Channel 4	KPUB-TV (local public TV station)
Channel 5	KFVE-TV (local NBC affiliate)
Channel 6	KSTX-TV (a distant CBS affiliate)
Channel 7	KFLM-TV (local independent)
Channel 8	KTAB-TV (local ABC affiliate)
Channel 9	KTID-TV (local independent)
Channel 10	KPOD-TV (distant ABC affiliate)
Channel 11	WGN-TV (superstation)
Channel 12	CBN Cable Network
Channel 13	USA Network
Channel 14	Superstation WTBS
Channel 15	Arts & Entertainment
Channel 16	Home Shopping Network
Channel 17	Home Shopping Network 2
Channel 18	Superstation WPIX-TV
Channel 20	Music Television (MTV)
Channel 21	Country Music Television
Channel 22	The Learning Channel
Channel 23	The Travel Channel
Channel 24	Lifetime
Channel 25	C-Span
Channel 26	Nick at Night
Channel 27	Financial News Network
Channel 28	Hit Video USA
Channel 29	Discovery Channel
Channel 30	ESPN
Channel 31	Video Shopping Mall
Channel 32	The Weather Channel
Channel 33	Movietime
Channel 34	The Nashville Network
Channel 35	Nickelodeon
Channel 36	Black Entertainment Network
Channel 37	GalaVision

Tier # 2 extra fee

Channel 38	The Movie Channel
Channel 39	The Disney Channel
Channel 40	Bravo
Channel 41	Home Box Office
Channel 42	American Exxxtasy

Tier # 3 extra fee

Channel 43	Showtime
Channel 44	Festival
Channel 45	American Movie Classics
Channel 46	Cinemax
Channel 47	The Playboy Channel

Plus channels reserved for public use

The basic monthly fee for service is $11.66. Each additional tier costs $10.30 per month, so a customer who orders everything visual CrystiallView offers could be spending $32 a month (basic service plus two pay tiers).

CrystiallView also offers five channels of stereo audio for an extra $10 per month.

The next expansion planned by CrystiallView cable is addition of pay-per-view channels, which require new equipment. These channels are billed per use, so they would earn additional revenue for the cable system.

CrystiallView also sells local commercials in CNN Headline News, the Cable News Network, and ESPN transmissions, which brings in additional revenue. There have been discussions with one of the local TV stations about leasing channels. The station wants to have an additional outlet for some of its programming and wants to better utilize its large local sales staff by selling commercials to be played on the cable channel.

Currently, CrystiallView passes 65 percent of the homes in East Podunk with its cables. It will never reach 100 percent passed because some areas of town are so sparsely settled it isn't financially feasible for the cable to be run in the area. Ideally, CrystiallView likes to have a saturation of 50 houses per mile before it lays cable. Despite the fairly high level of homes passed, CrystiallView currently has only 39% of the homes passed as subscribers, so one of the major efforts by the company is an aggressive campaign

to expand the subscriber base. The company uses broadcast and newspaper ads, telephone sales specialists, and three direct salespersons to contact individual home occupiers and owners of apartment houses. One difficulty the company faces is its high rate of *churn*. East Podunk is home to East Podunk Central University, so the cable company experiences a large number of sign-ups in September, and then a large number of disconnects in May at the end of the school year. This significantly affects the company's operating budget because it must put on a big sales effort in the fall and then employ extra technicians to handle the connects and disconnects.

In fact, CrystiallView is just barely returning a profit at the moment, due to the high franchise fee it pays, the high rate of churn, and the enormous expense of building the sophisticated 54-channel system. CrystiallView's owners aren't that concerned because they don't expect to get their money out of the venture in day-to-day profits. They know that the selling price of cable systems is soaring. Selling prices have doubled in the six years that CrystiallView has been operating, so the owners anticipate selling out in the next two years. In 1988 the per-subscriber price used as a yardstick in evaluating cable system sales reached $2,000.

Programming

A cable system is a strange hybrid with at least five kinds of programming. Cable still serves its historic purpose, by relaying TV signals from both local and distant TV stations; it also relays programming from special networks set up to feed cable systems such as CNN, Showtime, and ESPN; it originates its own programming on its own local commercial channels and on leased channels; it relays programming for government agencies such as school boards; and it may offer members of the public free use of channels designated *access* channels.

Programming on cable satellite networks on which cable systems today depend for much of their programming breaks down into three categories: (1) free, (2) low cost with sponsor availabilities, and (3) high cost designed for add-on subscription charges, such as HBO. When we say low cost and high cost, we mean the per-connection fee the cable system pays the program supplier. This cost gets passed along, if allowed, in the basic monthly rate the subscriber pays the cable company. In the case of services such as HBO and Showtime, the cable system

levies an extra charge on the viewer. A "video catalog sales" channel, such as the Home Shopping Network, which tries to get viewers to phone in orders might provide its service at no charge to the cable system and then pay the system a small commission for each sale called in from its area.

Access and Local Origination

Many cable systems had to guarantee local programming to get their franchises and others decided to do local programming as another way to use their cable channels. In the cable trade local programming is known as *Local Origination* (LO). Many cable systems found they had been overambitious in trying to do local programming. They mistakenly thought they could purchase less sophisticated equipment, build less substantial studios, and use less well trained personnel than competitive TV stations. It didn't work because viewers are so accustomed to the quality of network and local TV production, they paid little attention to poorly produced cable programming. Not all cable systems fell into this trap, but enough did to cause some serious rethinking of local origination.

There are cable systems successfully selling and producing local programs. One system in

Figure 6–6
Cameras used in cable production don't appear to be very different from broadcast cameras. Lack of FCC regulations on picture quality permits use of less expensive but still high-quality equipment like this CCD camera. Courtesy of Panasonic Industrial Co.

Figure 6–7
Broadcast teletext decoder and keypad. Courtesy of Panasonic Industrial Co.

New Jersey did local sports and enjoyed quite a bit of success. Some of the most promising cable programming ventures have originated from experienced communication companies. TV station WAGA in Atlanta, Georgia, fed programming to leased cable channels several nights a week. The programming included both repeats of major public affairs shows and made-for-cable shows on sports and other topics. One of the most popular shows was a local music TV program hosted by a popular Atlanta DJ.

Also in Atlanta, Cox Communications did local programming on its cable system. Cox owns the *Atlanta Journal and Constitution*. The Cox Communications management had radio and TV experience as owners of a chain of broadcast stations, and Cox imported TV people to run and staff its Atlanta cable channel. These two examples tend to indicate that the cable business is one in which major broadcasting companies and networks have the expertise and money to succeed.

Local Government as Originator

Many cable systems gave up some of their channel capacity to local governments when they signed franchise contracts. That's why you can dial through some of the larger systems and see live coverage of the school board meeting or a lecture on flower arranging from the local junior college. Some schools and colleges have used the access channel as an outlet for some of their student productions.

Interconnection

Cable systems have responded to some of the expense of doing business by creating *interconnects*. An interconnect joins two or more adjacent cable systems so they can share the cost of buying and supplying programming and share the cost of selling ads plus offer bigger audiences to advertisers. The CAB's *Cable TV Facts—1988* listed 86 different interconnects.

Cable systems can and do carry advertising just like TV stations. It has taken quite a while for local cable advertising to establish itself because many of the cable operators came from technical backgrounds or simply were unfamiliar with selling broadcast advertising time. In recent years local cable advertising has increased, and some cable systems have two sales staffs. One solicits subscribers and the other solicits national, regional, and local advertising. One of the skills cable systems operators have had to learn is producing TV commercials because many of the local clients do not have agencies to produce their spots.

Figures supplied by the Cabletelevision Advertising Bureau estimated the cable industry would sell 1.41 billion dollars in network advertising and 571 billion dollars in local advertising, for a total of 1.98 billion dollars in 1990.

Cable systems can insert spots in their LO programming and in some programming they get from cable networks.

The *Cable TV Facts—1988* listed the following advertiser-supported national cable services:

ACTS (American Christian Television System)

Arts & Entertainment Cable Network

BET (Black Entertainment Television)

CBN Cable Network

Cable News Network

Country Music Television

The Discovery Channel

ESPN (Entertainment & Sports Programming Net)

Financial News Network

Headline News (CNN)

The Learning Channel

Lifetime

Movietime

MTV: Music Television

The Nashville Network

National College Television

Nickelodeon

SuperStation TBS (WTBS)

TEMPO Television

The Travel Channel

Univision

USA Network

VH-1: (Video Hits One)

The Weather Channel

In addition to national cable channels that are advertiser-supported, the CAB listed several regional advertising-supported channels:

Home Team Sports (Metro Washington, DC)

Madison Square Garden Network (New York metro)

News 12 Long Island

Prime Ticket Network (Southern California)

Pro-Am Sports System (Michigan, Ohio, Indiana)

Prism (Philadelphia, 125 mile radius)

SportsChannel (New York & New England)

SportsVision (Midwest)

(These change from time to time, but they serve to illustrate the variety of programming available to cable systems.)

Audience

Measuring the audience for cable service is somewhat more difficult than it is for broadcast television. First, you have to measure randomly the homes having cable, whereas broadcast homes base their surveys on random selections of TV homes, which is almost all residences. Second, you have to sort out the wide variety of choices coming into some homes to make certain you are getting accurate descriptions of the program sources viewed. Third, there is no consistency from one cable system to another as to what each one carries, so a high rating for Country Music Television in one city cannot be projected to another city because the cable system there might not carry Country Music Television.

Despite all the difficulties, rating and audience measurement systems have been developed for cable, which allow cable's story to be told to national advertisers, who are used to the Nielsen and Arbitron rating measurements of national broadcast network programs.

Other concerns in the cable industry which relate to potential advertising sales have to do with getting and keeping subscribers.

Churn and Penetration

A figure the cable industry watches, besides penetration, is *churn*. Churn is the turnover of new subscribers signing up and current subscribers dropping the service. Too high a churn rate means significantly increased costs for a cable company as it has to do more hookups and disconnections.

The cable industry is concerned about its historical average of about 55 percent penetration. The reason for the concern is as follows: Say a community has 100,000 households. The cable system passes just over two-thirds, or 68,000. Of these, optimally 55 percent will subscribe to cable. That means only 37,400 homes subscribe. It becomes difficult for a cable system to approach an advertiser and offer a mass audience when only about 37 percent of the homes in the community even subscribe to cable. And the 37 percent figure isn't very effective because the cable subscribers may be watching any one of two or three dozen channels. In contrast, the three TV stations in the town of 100,000 can say they as a group can reach over 99 percent of the community (homes having TV) and can show ratings to indicate they reach sizable chunks of the local audience (including cable subscribers who are watching the broadcast stations).

Another Way to Tell the Cable Advertising Story

The spot availabilities in some cable network feeds can be attractive. For instance, a local sporting goods company would find ESPN desirable, not because so many thousand people would view but because the people viewing are apt to be customers for a sporting goods store.

Satellite Master Antenna Television

A thorn in the side of the cable operators has been *Satellite Master Antenna Television* (SMATV). The cable operators were upset

enough by the number of personal satellite receivers that were being installed, grabbing their programming for free, but they became even more agitated at companies that went into apartment houses and put in a master antenna system connected to satellite receivers, duplicating what the cable system does. The SMATV systems found only one disadvantage. They couldn't receive HBO and some other prime services unless they paid a fee. Showtime decided to break a supplier boycott in June 1984, reasoning that it was better to gain viewers than hold out for a little more revenue, and this barrier to prime programming has been dropping.

The 1984 Cable Deregulation Bill prohibits cable companies from making deals with apartment house owners which would shut out SMATV. They will have to coexist, at a considerable loss to cable systems when they finally wire major populated areas.

The Future for Cable

Although some cable systems can handle from 40 to 100 channels of information, there is a definite lag in what is available to fill those channels. For this reason and the concern that they could carry too much entertainment, programming cable operators and other interested parties have looked at a number of options.

One is data transmission for businesses. Some cable companies lease channels for data or even voice trunk service, circumventing one of the traditional services of the telephone company. Under telephone deregulation, the telephone companies lost exclusive hold of these services. As an example, if a big manufacturing company had operations at several sites within the cable service area, the cable system might "trunk" the company's local telephone and computer data traffic between sites at a much lower cost than would be charged by the telephone company.

VIDEOTEX

Videotex is written information appearing on your TV or computer screen. It differs from the news you can read on some cable TV channels because the page does not move or *"scroll."* If you want to read another page, you press a button on a remote control *keypad,* just as you do to change the channel on a remote control TV set. Because the information is presented in screens, videotex

people call the screens *pages*. It is possible to connect a computer with a large page capacity, say 5,000 or 10,000 pages, to a cable channel. What is needed to make the system work is a way to change the page and give the computer instructions. This is accomplished by either feeding the return signal over regular telephone wires or by having a return circuit in the cable system's wiring. Some systems provide a computer terminal or give you software to install in your own personal computer.

Videotex is a potential source for news, sports, weather, airline schedules, recreation schedules, civic announcements, advertisements, movie guides, and a host of other forms of information. In addition it is possible to buy things by videotex, by entering your credit card number. There have even been experiments involving banking by videotex where a viewer can securely call up his or her bank balance on the screen and then carry on some transactions, such as paying bills. It is similar to what happens when you use a bank card at an automated teller machine.

Fairly sophisticated graphics have been developed to make the pictures on the screen interesting. The main problem is that videotex is so far ahead of the general public's demand for information, it is a technology looking for a market. The various computer information services run by modem (telephone line) connection to a main computer database or series of bases have used the concept of videotex but without the picture capability. Two computer data banks, CompuServe and The Source, provide videotex-like services to computer owners who access the data banks over telephone lines via a modem.

The most advanced Videotex operation to date was that of Viewtron in Miami, Florida. Viewtron was a division of the Knight-Ridder newspaper and broadcasting chain. Viewtron was a sophisticated system in which a computer terminal was installed in the viewer's home. It had difficulty in attracting enough customers to make it profitable, partly because its information seemed to exceed many family's needs (and budgets). Knight-Ridder shut down the Viewtron experiment in 1986.

IBM, CBS, and Sears in 1984 announced a joint venture to develop a way to use videotex for selling services and merchandise through a combination of videotex and home computers. AT&T has shown interest in marketing electronic financial services nationally through videotex. RCA and Citicorp have said they are working on a system through which consumers could shop and bank from their home terminals.

Very little happened with these projects because they were not able to gain public acceptance.

TELETEXT

Teletext is a hybrid of television and written communication. In appearance it is similar to videotex. Teletext is a simpler, one-way text system having less capacity to store *pages* of information than does videotex.

Teletext takes advantage of some unused electronic space on the TV signal. That space is called the *vertical blanking interval.* If you were to misadjust the vertical hold control on your TV set, you would see a black line, which is the vertical blanking interval. From 100 to 200 pages of information can be transmitted in that space, using digital data technology.

Teletext requires a different information retrieval system from videotex. In videotex you use a keypad or a home computer to request pages of information. In teletext the pages are moving quickly and continuously, and your teletext remote control device "grabs" or "captures" the page you want to watch. When you select another page the control returns the page you *grabbed* and seizes another page for you. (It would be like rifling quickly through a textbook and having someone suddenly stick their hand in the book and stop the rifling action.)

Teletext is inexpensive to insert into the TV signal. It has been inserted on national network signals and it would be easy for a local station to slip in some local information at a convenient point in the datastream.

Stations KSL-TV in Salt Lake City, Utah; WBTV in Charlotte, North Carolina; and WKRC-TV, Cincinnati, Ohio, experimented with teletext transmissions, and on a nationwide basis, teletext was transmitted in the signal of SuperStation WTBS in Atlanta.

Teletext Problems

Teletext has not been particularly successful. The main reason is the high cost of the decoder that must be added to the TV set to receive teletext. This may involve a $300 investment, which is more than most people want to spend to get an information source they're not sure they need. Some advanced TV sets feature built-in decoders.

Another basic difference between teletext and

Figure 6–8
Control area for a major satellite earth station in Tallahassee, Florida. The earth station handles a heavy schedule of feeds for CBS News, CBS regional affiliates, CNN, Florida station groups, regional and national sports events, music concerts, and primary and election coverage. Courtesy of John H. Phipps, Inc., Satellite and Production Services.

videotex is that it is difficult to charge for the use of teletext, while it is easy to meter and change for videotex use. Both media are designed to make revenue from selling advertising, but teletext is expected to be nearly totally dependent on advertising for income, while videotex can be partially supported through selling subscriptions or charging a user fee. One use of teletext which appeals to broadcasters is that it could give supplemental details that cannot be squeezed into the standard TV commercial, such as prices of a long list of grocery items or addresses and phone numbers of dealers.

Most TV stations have hesitated to install teletext transmission equipment, even when their network fed a signal, because the stations doubted that enough viewers would buy the expensive decoders. The FCC further complicated matters in 1983 when it ruled that a cable system could delete (strip out) the teletext signal when it rebroadcast an on-air TV station, thus killing the value for stations carried on several cable systems.

Teletext Standards

Another problem has to do with the *standard,* which is the electronic system used to transmit

teletext. Two systems have been in use in the United States, and there has been no decision on which to adopt as a national system. One is *World System Teletext (WST),* which is based on a system developed in Great Britain. The other system is called *North American Basic Teletext Specification (NABTS)* and is derived from French and Canadian systems. As long as the companies wishing to provide teletext service squabble over the standard to use, the decoder and TV set manufacturers are not interested in mass producing low-cost decoding equipment.

Teletext is another technology on hold, waiting for the public to catch up with its capabilities. So far it hasn't been demonstrated that enough people are interested in having a data bank to tap. The majority of people seem happy to have radio or TV personalities tell them the information judged to be important.

MULTIPOINT DISTRIBUTION SYSTEM

A *Multipoint Distribution System* (MDS) is similar to cable except that a microwave tower sends

Figure 6–9
Brand new satellite news vehicle parked outside the factory in Texas. This diesel-powered unit weighs approximately 24,000 pounds and carries a 3-meter antenna and a 300-watt amplifier, which makes it a powerful mobile uplink. The customer will have a special paint job, highlighting the station's promotion theme, before the vehicle is put to work. Courtesy of Dalsat, Inc.

out the audio and video channels, rather than a cable. MDS has three disadvantages at present:

1. it is best suited for flat terrain where the microwave signal won't be blocked by hills or tall buildings;
2. it requires that a roof dish receiver be installed on the residence;
3. it has a more limited channel capacity than a modern cable system.

The major advantage is low cost for the company setting up the system. Instead of running miles of cables, the MDS operator installs a transmitter and puts up a tower. One of the headaches for the MDS operator could be the rooftop receivers, which the MDS company is apt to have to install itself. MDS is an adequate substitute for cable in certain situations, but it seems to be headed for limited use, mainly in uncabled urban areas. When the MDS company offers more than one channel, it is called *Multipoint Microwave Distribution System* (MMDS).

DIRECT BROADCAST SATELLITES

Direct Broadcast Satellites (DBS) has been the puzzling medium of the 1980s. DBS cut out the middleman by sending a signal from an uplink to a satellite 22,300 miles above earth and then beaming the signal downward, using high-powered transponders, to small satellite receivers (dishes) mounted on rooftops. The concept eliminates the costly wiring inherent in cable TV systems and the costly repetition of electricity-gobbling TV transmitters needed for on-air TV. It does have the disadvantage of providing only a limited number of channels, far fewer than can be provided by a modern cable system.

Some of the biggest names in communications have invested in DBS, but little has come of the technology to date.

Seven companies were authorized by the FCC to operate DBS facilities in 1982 but by 1984 only four companies remained active in the field. In 1983 the first company, United Satellite Communications Inc., began programming. By the fall of 1984 USCI had only 15,000 subscribers in 26 states. The company underwent several structural changes and had difficulty raising capital in its early months. USCI filed for reorganization under Chapter 11 on April 22, 1985. CBS, RCA, and Western Union, all major communications

companies, announced interest in DBS, and then withdrew or reduced their involvement. One firm with extensive interests in DBS, Hubbard Communications, wrote off some of its DBS expenses by creating a nationwide satellite news exchange service, Conus. It is used extensively by TV news departments which are equipped with Ku-band mobile transmission equipment.

The big question with DBS is who needs it? While DBS companies were overcoming regulatory hurdles and struggling to raise capital to start up, inexpensive satellite receivers began showing up throughout rural and even suburban America. In 1984 the Cable Deregulation Bill finished deregulation started in 1979 making private earth stations legal. Many rural viewers have found it cheaper to pay once to have a satellite dish installed than to pay a monthly fee to a DBS company, which, due to channel width, would have to provide a limited service. Why pay for a few channels of DBS when you can scan the skies and pick off one of a minimum of 50 satellite channels available at no cost?

The situation involving backyard dishes changed radically in the mid-1980s when the cable program companies began to scramble their signals. Although there was no immediate indication that scrambling would help the DBS business, a backyard subscriber might be better off buying one service from a DBS company, which provided several channels of programming, rather than leasing decoders and paying monthly charges to individual cable program companies to unscramble signals from several of their favorite cable (satellite) channels.

The DBS industry continues to work on ways to use direct service, but it increasingly looks as if that way will not be providing home TV service.

Although DBS has not taken off in the United States, it is being used extensively in Europe to provide programming to individual residences as well as to feed cable systems.

SUBSCRIPTION TELEVISION

Subscription TV is similar to HBO. During the time the TV station is operating as a subscription channel it sends out a scrambled signal, which has to be unscrambled by a decoder attached to the receiving TV set. If you select a movie being shown on the STV channel, the decoder unscrambles the picture and you are billed for what you view.

Figure 6–10
Mobile communication equipment for use with satellite news vehicles. The unit works in conjunction with the GEOSTAR Satellite Service and the federal govenment's Loran-C navigation network to provide positioning information and message traffic to moving SNV anywhere in the United States. Thus, an assignment desk can locate a vehicle using this device. Courtesy of Sony Corp.

The government could not figure what to do about subscription TV, also known as pay TV. In conjunction with RKO General and Zenith, the Federal Communications Commission permitted a 10-year experiment with pay-TV transmitted from WHCT, Channel 18, in Hartford, Connecticut. The experiment finally ended in 1968 and the station went into on-air broadcasting. Eventually, the Commission decided to permit stations to broadcast scrambled programming and a number of subscription TV stations went on in Los Angeles, Dallas, Tulsa, Oklahoma, Milwaukee, Wisconsin, Ft. Lauderdale, Florida, and the New York metropolitan market.

The downfall of STV came when cable became a major force in urban areas, competing directly with STV. Cable offered more channels, including more pay channels, and due to the strength

Figure 6–11
A prototype high definition television (HDTV) receiver. Notice that the screen is wider than usual (like a movie screen) and that a provision is made for stereo speakers on each side of the screen. Courtesy of Thomson Consumer Electronics, Inc.

of national companies like HBO (owned by Time-Life), offered better features than the STV stations.

STV began to fade in 1982, and by 1984 15 subscription stations had either gone dark or converted to on-air programming. Cable could offer more than subscription TV and therefore won in the contest of technologies. Ironically, some of the former STV stations went on to be financially viable as independent on-air TV stations.

VIDEOCASSETTE RECORDERS

It probably seems strange to discuss *videocassette recorders* (VCRs) as part of the world of telecommunication, but they have become a force.

Originally, VCRs were devised to permit people to videotape programs from the signal their TV sets were receiving, watch prepared tapes, and make their own home movies on tape.

Most people in the telecommunication field did not think this electro/mechanical device introduced in 1975 would carve a niche for itself, but it did.

Prices fell so low that the number of VCRs sold for home use rose in proportion. There are now about 40 brands of VCRs for sale in the United States. It is estimated 13.4 million VCRs were sold in the United States in 1987 alone. Industry experts estimated in 1987 that VCR penetration of U.S. TV homes was approaching 50 percent.

What has been the impact of the VCR? It has made *time shifting* a common practice. You "time shift" when you record a program at one time and play it back at another. This practice is disturbing to networks, which used to be able to guarantee advertisers that a certain number of people were watching a program at a specific time. This usually meant that you couldn't view an opposition program. With today's VCRs you can record a program from ABC while you're watching a show on CBS. And when you play back the ABC show, you may preempt another program.

For a while it looked as if the copyright law might be used to stop people from time shifting. A suit, known as the "Betamax suit" was filed to try to make copyright laws apply to time shifting, but the U.S. Supreme Court ruled in January 1984 that time shifting does not violate the copyright law.

Commercial "Zapping"

Another broadcast industry concern is the tendency of VCR users to skip over or "zap" commercials.

Video Rentals

Even worse from the view of TV broadcasters was the booming market in tape rentals. People drove through at tape rental stores, and for a dollar or two took home movies to show on their TV sets. It is a whole lot cheaper than taking the whole family out to a movie, and it represents another alternative to broadcast television.

Dubbing Video

The TV industry is not the only one concerned about the recent developments in the VCR mar-

ket; the American movie industry has been up in arms over an innovation in VCR technology, which permits a viewer to duplicate prerecorded movie cassettes at home. This could seriously impact the VCR rental business, which is already suffering from overextension.

By combining a satellite dish and a VCR, a person could alter common patterns of TV viewing. The growth of satellite dishes and VCRs has been hard to measure so that experts could not say just what people were watching. Therefore, it becomes hard to cite the impact of VCRs and satellite receivers to sell advertising when you can't come up with audience figures.

STEREO TELEVISION

Stereo Sound

One of the exciting technological developments to affect TV is stereo sound. The FCC authorized the *stereo transmission of TV audio* in 1984. The audio for television is FM (remember: FM radio falls between channels 6 and 7). Station owners see stereo as a way to enhance the value of their signal to viewers. Some set manufacturers offer receivers with stereo speakers in the cabinets. Many more offer sets that can be plugged into a hi-fi, so that you listen to the TV audio through your stereo receiver. Stereo sound could be particularly attractive to the small number of stations doing a great deal of music TV programming.

The conversion of broadcast TV stations to stereo sound is relatively simple. Many TV stations saw stereo coming and bought equipment which either had stereo capability or could be easily upgraded. The only thing holding TV stereo back is network and syndicated programs recorded with stereo sound. Many new shows are being recorded in stereo and many motion pictures already have stereo soundtracks. The big problem is that older TV shows and movies have to have their sound tracks "reprocessed" to create a stereo effect, and enough stereo-compatible TV sets have to be sold to encourage the conversion of programs to stereo sound. The conversion of TV transmitters is relatively inexpensive compared to some of the other technological changes TV stations have had to make in the last decade. Cable system owners have been less pleased with stereo sound, saying it would cause them to have to spend a great deal of money to equip their system channels with stereo audio.

The conversion of consumer TV sets, however, promises to be a major source of income for set manufacturers and a major expense if viewers decide they want stereo audio in their receivers.

HIGH DEFINITION TELEVISION

One of the most exciting of the new technologies is *high definition television* (HDTV).

What do we mean by "high definition"? The sharpness or clarity of a television picture is determined by a number of factors, such as the quality of the original material being transmitted, the quality of the transmission equipment, the quality of the receiver (TV set), and certain characteristics of the actual television picture. A critical issue in describing the quality of a television picture is the number of horizontal "lines" of information the receiver picture tube can register. The "line" is caused by the rapid horizontal sweep of an electronic "gun," which paints horizontal lines of miniscule illuminated dots on the phosphorescent coating on the back of the face of the receiver tube. If you sufficiently detune a TV set, these lines become apparent to the human eye. The greater the number of lines projected on the screen in a given time, the sharper the picture. High definition television simply means transmitting (and receiving) a significantly greater number of lines within a given time, for instance, one second.

The U.S. standard is 525 lines, not all of which are visible because some are at the edge of the picture, behind the frame which retains the receiver tube. The U.S. standard is known in engineering circles as NTSC (short for the name of the committee which set the standard). NTSC is used in North America, parts of Central and South America, Japan, and parts of Asia. Other standards in use are PAL (625 lines, used in Britain, much of Europe, and the former Commonwealth nations) and SECAM (625 lines, used in France and the USSR).

In the U.S., doubling the 525 lines we now receive to 1050 lines would significantly improve the TV picture we receive; the same would be true for the other standards. There are other technical factors to consider. The picture could be wider. Also, the cycle-rates of the nation's electrical systems differ.

Why make the picture wider? The current 4 by 5 ratio of our TV picture is an artificial standard. Recall the last time you went to the movies. The screen was wider in relation to its height,

Figure 6–12
A sample of an HDTV picture, seen in standard (NTSC) picture ratio using the over-the-air HDTV system proposed by the David Sarnoff Research Center for NBC. Courtesy of the David Sarnoff Research Center.

Figure 6–13
A computer simulation of what broadcast high definition TV might look like if two transmitters were used instead of one. Notice that the HDTV picture is wider than the standard broadcast picture in Figure 6–12. Also, if you compare the two pictures, you will notice finer detail in Figure 6–13. Courtesy of the David Sarnoff Research Center.

compared to your TV set at home. Film (which is still the source of a great deal of TV programming) historically has had a wider picture than television, so some would argue that it would be desirable to have a TV picture with a similar "aspect ratio" (width to height) as in a movie theater screen. There's nothing wrong with this idea, except that all U.S. TV sets would become obsolete. The objective of those who would switch the world's TV systems to HDTV is to present a TV picture comparable to the best film production quality.

Consumer-Related Issues

The motives of the backers of high definition TV are not altruistic. HDTV was first developed approximately two decades ago in Japan. Since then, Japan has become a major world supplier of telecommunication transmission and studio equipment, as well as consumer electronic equipment. To Japanese manufacturers, HDTV could mean a great deal of money!

All the HDTV systems proposed would require either some kind of electronic decoder ("black box") attached to an existing TV set, or a new receiver. The United States and the countries of the European Common Market see the manufacturing of HDTV receivers and VCRs as a way to invigorate their manufacturing sectors. Therefore, there is a strenuous push by manufacturing interests to get an HDTV standard accepted so everyone will eventually have to buy new TV sets. At the same time, there is a great deal of talk about "trade protectionism," largely aimed at keeping Japanese electronic consumer goods from flooding the market.

HDTV—How Does It Affect Broadcasters?

U.S. terrestrial broadcasters are concerned and confused about the possible effects high definition TV could have on their already-beleaguered business. In order to transmit true HDTV over-the-air, U.S. broadcasters would, at a minimum, need one and one half to two times the 6 mhz bandwidth now allocated to their channels. The FCC would have to allocate extra channels (probably in the UHF band) or create a whole new frequency band for HDTV. Neither is likely to happen, since other interests also want allocations of the same frequency bands.

The main reason U.S. broadcasters are so worried is their biggest competitor, the cable indus-

Single-Channel System

LOCAL BROADCASTER NTSC WIDESCREEN

Figure 6–14
Diagram showing one way a broadcast station could transmit high definition TV. The local broadcaster sends out a regular NTSC signal on a main channel, but two side bands contain information which the "smart" widescreen receiver in the home at right translates into a 1050-line picture, twice as sharp as the NTSC 525-line picture we now receive from TV stations. Courtesy of the David Sarnoff Research Center.

try, could convert to HDTV more easily. HDTV for cable would mean getting fewer channels from each cable which carries the signal, because more bandwidth is used. This presents only a minor problem for large, fairly new systems, which have excess capacity. If DBS were ever to become popular in the U.S., it could transmit HDTV pictures with ease, and the same would be true for MMDS systems.

What's Happening?

By the mid-1980s a number of concerned parties in the U.S. saw that several steps were extremely important if U.S. HDTV were to develop in an orderly manner. Concerned parties sought a decision by the FCC on standards for HDTV. This meant the FCC would decide (1) if HDTV would have to be compatible, so it could be seen on existing NTSC receivers; (2) if broadcasters would be given more of the spectrum to allow for extra bandwidth needed to transmit true HDTV, (3) what system would be used to transmit the HDTV signal—over terrestrial TV, cable TV, MMDS, or DBS.

A complex study of economic, regulatory, and technical issues was begun by a consortium of U.S. industrial concerns, research labs, universities, telecommunication associations, govern-

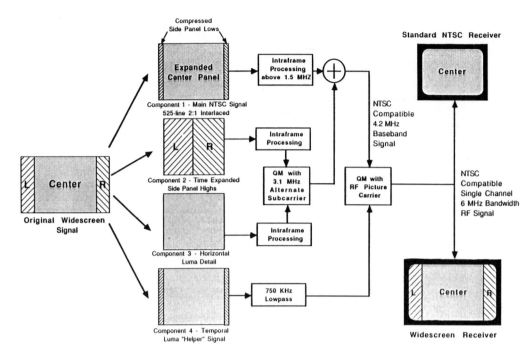

Advanced Compatible Television System

Figure 6–15
Technical diagram of how one over-the-air HDTV system would work. Regular picture would flow from the "Center" signal at left up to the "Expanded Center Panel" at center top, and then to the "Standard NTSC Receiver." All the other data or information would be added to the traditional NTSC signal and would be sorted out and combined by the "smart" TV at bottom right. Courtesy of the David Sarnoff Research Center.

Two-Channel System

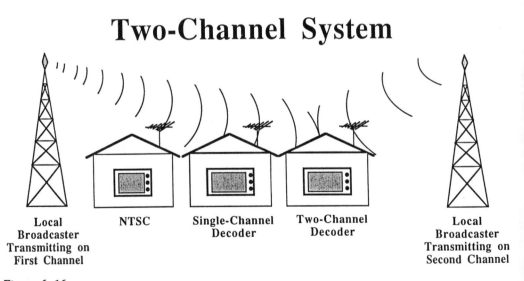

Figure 6–16
One proposal for true high definition broadcast TV, using two transmitters, two towers, and two frequencies. The local broadcaster transmits on two channels, left and right in diagram. The regular NTSC set receives the same picture it has always received. The single-channel decoder gets a much better picture, and the two-channel decoder gets a truly superior picture. Courtesy of the David Sarnoff Research Center.

Advanced Compatible Television II

Figure 6–17
Complex diagram illustrating the technical aspects of the proposal in Figure 6–15. Two transmitters, labeled "Widescreen HDTV Source" and "Transmitter," send out different parts of a high definition signal, which gets delivered in three formats: NTSC, good HDTV, and superior HDTV. Courtesy of the David Sarnoff Research Center.

ment bureaus, and the Federal Communications Commission.

The general direction of these studies was toward development of some sort of Advanced TV System, which would be compatible with current NTSC transmissions, but could be seen on specially-equipped receivers. This might not mean a doubling of the number of lines transmitted so much as an increase in the lines transmitted, and some other improvements in the picture.

It would appear that a full-fledged HDTV system will emerge sometime in the 1990s that will be incompatible with current U.S. terrestrial broadcasting. It is also likely that the new system will take into account terrestrial broadcasting so that full HDTV won't wipe out the U.S. broadcast television business.

HDTV AND THE REST OF THE WORLD

Standards and Competition

There is a strong movement in international circles for setting an international standard for

Figure 6–18
A special high definition television video camera which operates more like film cameras. This is for use by Hollywood camera operators to shoot high definition videotape for features and mini-series. Courtesy of NHK, Japan.

HDTV, so that program material doesn't have to be "converted" as is necessary currently for the switch from NTSC to PAL or SECAM. A true worldwide transmission standard would save a great deal of money and wasted effort.

But it is likely that the only standard which might emerge would be a "production standard," meaning that all electronic programs produced for the world market, including TV entertainment programs, news and public affairs, miniseries, and made-for-TV movies, would be produced according to one set of rules, such as 1125 lines and 60 hertz (which is one of the major proposals). It's also the standard backed by Japan and many U.S. firms.

It is unlikely we will see a common standard for HDTV transmission for broadcast, cable, MMDS, and HDTV worldwide. There are too many parochial interests to be served by having standards which exclude outside competition. This is best illustrated by Europe, where the countries of the Common Market want to standardize practically everything (money, telephones, data, banking, etc.) throughout Europe; but they do not wish to invite in Japanese, Korean, or U.S. manufacturers to compete with small but established European manufacturing firms. The simplest way to do this is to create a "European" HDTV standard for broadcasting, cable, MMDS, and DBS. And that is what is happening.

Most of Europe has a 50 cycle electrical generation system, so it is easy to translate this to a 50 cycle HDTV system, with 1250 lines (twice the 625 of PAL or SECAM). European telecommunications interests have come up with what they call the Eureka Project, which has developed equipment which works on a 1250/50 HDTV standard. This would protect European manufacturers for a long time, because it would probably be uneconomical for Japanese or American manufacturers to adapt their production lines to a different standard. Although broadcasting is expanding rapidly under deregulation in Europe, most European experts talk about HDTV in terms of DBS and cable applications, and indeed there have been indications that Europeans might eventually abandon terrestrial TV broadcasting.

THE BIG QUESTION FOR HDTV

After all this talk about standards and international industrial intrigue, the biggest unknown about high definition television is whether consumers will like it and buy HDTV receivers! Initially the receivers will be very expensive. Additionally, HDTV really doesn't reach its full effect until the home screen exceeds 30 inches diagonally.

One factor which could trigger a major consumer desire for HDTV is "flat screen technology." Scientists have been working for years to invent a high-quality, flat TV screen, which could be hung on a wall, like a picture. Today's TV set takes up a lot of space, and sometimes makes decorating the house difficult, because the electronic "gun" which shoots the electrons against the tube's front screen needs to be a certain distance away from the screen. Eliminate the bulky receiver tube, and you have a new era of TV. Some flat screens have been successfully produced for limited use, such as screens for laptop computers and for tiny TV sets. Once a large, relatively inexpensive consumer flat screen is developed for home use, interest in owning an HDTV receiver is apt to pick up considerably.

COMPUTERS

Home computers have to be considered in the modern media mix because they are having a small but direct impact. If Johnny gets a computer game and hooks it up to the TV set to play games, that TV has been taken off-line and is not receiving the on-air, cable, or satellite signal.

The adults' personal computer can be hitched up to a TV set, which cuts out another audience. Personal computers in the home increased from almost none in 1980 to about 14 percent in 1984. The computer companies expected huge sales of personal computers in 1984. However, they didn't provide the one element they had to have to make home computers really successful. They did not create a need. Some people found the computers too hard to understand. Others simply found it easier to do their checkbook balances by hand, rather than learn how to run a personal finance program. The industry overestimated the usefulness of the home computer, and in late 1984 and early 1985 personal computer sales took a big drop once people found out they were a little more complicated to use than originally thought. Computer sales picked up again in the latter 1980s as people began to find uses for them and services such as Compuserve made usage easier for the noncomputer

wizard. The main threat of the personal computer to the broadcast industry is that a potential viewer might spend the evening with the computer rather than watching TV.

CELLULAR TELEPHONE

Cellular telephone is a new technology which helps telecommunicators rather than disrupting their businesses. The cellular concept of mobile telephone divides a metropolitan area into *zones.* If a motorist using a cellular telephone passes from one zone to another, a computer shifts the signal to another transmitter, called a "repeater," so the signal remains clear. Cellular telephone has far more capacity than the earlier form of mobile telephone.

The cellular telephone is so good many radio stations are giving up their expensive two-way radio systems and switching to cellular. One TV expert predicts that once digital technology becomes further developed, a TV crew will be able to dial up the station on a cellular telephone and send their sound and pictures back digitally. (*Digital technology* involves breaking down a picture or sound into data *bits,* which are reconstructed by a computer at the receiver into sound or a picture.)

SUMMARY

The 1940s saw the start of CATV, the 1950s and 1960s were the growth era of broadcast TV, and cable took off in the 1970s. What we are finding in the 1980s and 1990s is a proliferation of ways to receive a radio or TV signal, plus more and more ways for individuals to manipulate telecommunication to suit their personal needs.

Trends noted in the mid 1980s by *Electronic Media* magazine included increased popularity of wrestling matches, pay cable services running more off-network series, such as "The Honeymooners" and "Ozzie and Harriet," some dramatic series being produced solely for cable, and continued interest in the music video channels.

As so often happens in the telecommunication business, successful formats are copied, no matter where they originate. Once music TV had proven successful on cable, several LPTV operators and some independent TV stations switched to the format, hoping to carve their

niche in the market. Other LPTV stations adapted the home shopping format from cable. Some on-air TV stations arranged to carry portions of the 24-hour news programming of Cable News Network or CNN Headline News. Later, CNN decided to create a radio network based on the audio of CNN Headline News.

Cable is still trying to complete the wiring of America's large cities. Some cable systems have been wrestling with debt burdens created by rash promises and difficulty in installing their circuits in cities.

Cable advertising revenue continues to rise, as does cable penetration, but penetration has slowed as more and more of the areas which are prime markets for cabling are wired.

Cable program services proliferated, offering advertiser-supported programming, subscriber-supplemented programming (HBO), and pay-per-view programming.

Videotex had been seen as a possible expansion route for cable, but it did poorly in consumer tests. Equally, broadcast teletext received little viewer interest.

Direct broadcasting by satellite started out with great enthusiasm, then cooled when markets couldn't be found. Multipoint Multichannel Distribution Services were authorized in the mid-1980s but had not significantly impacted on cable or broadcast TV.

The videotape recorder impacted on both broadcast TV and cable, mainly by *time shifting* by viewers, but increasingly viewers were substituting rented or purchased tape viewing for cable or off-air viewing.

The personal computer allows an individual to entertain herself or himself on a video screen by playing a game or working out a problem. Personal computers can be joined together via telephone modems, which turn the everyday telephone into a way to link data bases.

The extent of the telecommunication revolution is so great that business experts are beginning to talk about thousands of people staying home to work, using computer terminals and telephone communication, rather than crowding the freeways. Most of these visionary predictions have been dampened by the cold realities of the marketplace, which seems to prefer convenience and entertainment to information technology.

The next potentially important "new technology" may be High Definition Television, which has the potential to make obsolete much of terrestrial broadcasting and portions of the cable industry, as well as creating an enormous market for replacement TV receivers.

GLOSSARY

Access channel Local access channel; cable channel set aside by cable franchisee for free public use.

Black box An external device attached to TV set to expand its reception capability or to decode a scrambled TV signal.

Cable Originally and more correctly known as community antenna television (CATV). The signal is picked up out of the air through the use of antennas or satellite dishes and is then sent to subscriber TV sets by a cable into their homes.

Cable Communications Policy Act of 1984 This act authorized local government to regulate cable systems, established federal standards for franchises, prohibited cable companies from omitting service to low income areas, and required cable operators to sell or lease lockboxes to prevent unauthorized viewing. Law also weakened power of local government to control cable subscription rates.

Cablecast Cable equivalent of telecast.

CATV (Community Antenna Television) Early name for what we now call "cable."

Cellular telephone Mobile telephone system using computer-controlled array of transmitters to assure good signal over a wide area.

Churn Rate of subscriber turnover, how many subscribers disconnect from cable system.

DBS (Direct Broadcast by Satellite) A satellite suspended 22,300 miles in space retransmits a signal to earth for reception directly by the consumer.

Digital technology Breaks down pictures or audio into data bits, which can be sent in a stream and are then recombined by a computer at the receiver into sound or picture.

Franchise Exclusive right to install cable facilities on municipal or county right-of-way granted by municipality or county to cable company. It has the effect of licensing one cable company per city or county.

High Definition Television (HDTV) A much clearer TV picture transmission based on having receiver take in and reproduce more lines of video information.

Head end The reception point for a cable system.

Interconnect Two or more cable systems connected by wire or microwave to share programming and/or commercials.

Local Origination (LO) Cable company originates programming from its own studios.

Master control center The major control room of a cable system, much like the major control of a TV station in that it contains the engineering and monitoring equipment to control receiving and sending signals.

Multipoint Distribution System (MDS) One or more channels of TV distributed by microwave equipment. Usually a substitute for cable. Also called multipoint multichannel distribution system (MMDS) when it carries several signals simultaneously.

Microwave A short electromagnetic wave used to transmit data, audio, and video.

Multiplexing Combining two distinct signals on one channel or frequency.

Must-carry FCC rule that required cable systems to carry signal of certain area TV broadcast outlets.

Pay-per-view Cable programming for which subscriber pays individually for each program watched.

Penetration The word used to describe the percentage of hookups in the homes passed by the cable.

Redlining Practice by cable companies of not installing cable in certain high churn, high collection-cost areas.

Satellite networks A business venture whereby programming for sale is packaged at one point and transmitted to cable company subscribers via scrambled uplinked and downlinked satellite signal transmissions.

Scrambled signals Satellite signals that are electronically manipulated to keep viewers who have not paid for decoders from seeing the signal.

Satellite Master Antenna Television (SMATV) One downlink is used to feed satellite programming to a whole hotel, motel, or apartment building. Often run as a business, functioning as a mini-cable company.

Software That which is sent out in the way of programs when one is talking about cable systems.

Standard The commonly agreed upon electronic system used to transmit teletext or HDTV.

Stereo audio New sound system for TV transmission; requires new sets to be thoroughly enjoyed.

Subscription TV Scrambled TV signal available only to subscribing viewers who have special descrambling device attached to TV set. Pay television.

Teletext Method for transmitting alphanumeric (written) material within an existing television

signal. Textual information encoded in broadcast TV signal (and some cable signals) which once decoded can be read as "pages" of text on TV screen.

Time shifting VCR owner records network program and plays it back at time other than when it was scheduled to run.

Television Receive Only (TVRO) Antenna for receiving signals from satellite transponders.

Uplink The satellite dish that has electronics in its center capable of sending a video and audio signal to a particular satellite 22,300 miles above the earth.

Videocassette recorder (VCR) Usually a consumer-level videotape record/playback unit.

Videotex Text service, usually two-way, fed by cable. It has greater flexibility and capacity than broadcast teletext.

Zap, zapping Tactic of VCR, cable, and satellite users to skip over or punch out of commercials.

PROGRAMMING

Programming is the material that is chosen to be sent out via telecommunication channels. It is the reason that telecommunication exists. If there were nothing to communicate, there would be no need for telecommunication. Programming is the result of conscious decisions as to what should be sent out to people who receive the telecommunication messages. In radio these messages consist of words, sounds, and tone that create a message. In television, cable, and DBS we add pictures and color.

Some modernists use the term *software* instead of programming, meaning the nonmechanical, nonelectronic part of telecommunication, but the term may not be descriptive enough. Programming is what we send out; it is our signature, our style. It is the content of the transmission.

The U.S. commercial system of the telecommunication is based on competition for audience, therefore programming is what is responsible for attracting audience. Even noncommercial broadcast stations have to be concerned about audience because they cannot justify their efforts over a long period if no one is listening or watching.

The U.S. system of broadcasting calls for private enterprise to pay most of the cost of building, maintaining, and staffing our telecommunication system. In turn, private enterprise has the opportunity to earn money through the sale of advertising, collection of subscription fees, or rental of facilities. As a result, the major portion of programming in the United States consists of entertainment rather than information. Our telecommunication media have become media for relaxation as well as sources of information such as news, weather, and sports.

The U.S. government recognizes the finite number of channels available within the telecommunication forms such as TV, AM, and FM, which use the electronic spectrum. The government's responsibility, as carried out by the FCC, is to assure that these limited resources are used to the best advantage of the public, without imposing government orders or doctrine on the public through control of the content of programming (censorship).

American telecommunication programming is driven by two forces: (1) the kind of programming that will return the level of profit that the owners seek, and (2) the tempering effect of having to provide the public with information that is needed and perceived as wanted in the areas covered by the telecommunication facility. This second part of the programming is because franchises for frequencies are considered to be held for the benefit of the public as well as for its entertainment.

RADIO PROGRAMMING

Radio is mainly a local, personal medium. Every person listening to radio is listening as an individual. The portability of the radio receiver has directed its appeal toward being an individual medium. Radio is also a background medium. Listening to radio is most frequently done while a person is doing something else. Radio is a companion, and sometimes a source of noise when we cannot stand solitude.

Because radio is a personal medium, it has room for many different programming approaches, called *formats,* which allow stations to appeal to different people. If you were to conduct a survey of ten joggers at a nearby park, you would find they were listening to five or six different radio stations. To some extent their personal preferences would be influenced by their age, gender, and education, but in many cases it would simply be a matter of the type of accompaniment the jogger liked to have while exercising. It might be that the jogger never listened to a particular station, except while jogging.

Appealing to Status

Radio has become a status symbol. The upwardly mobile middle class, dubbed the "Yup-

pies" during the 1984 presidential campaign, saw the sophisticated stereo hi–fi AM-FM entertainment center as one of its status symbols. A sub-symbol for this group were stereo earphones. Youths on the streets of big cities adopted the large portable stereo receiver, sometimes nick-named the *boom box,* which was stylishly carried on one shoulder by its owner. Auto and truck owners have AM-FM cassette audio tape units with graphic equalizers and powerful amplifiers to achieve status. The beltclip receiver with light-weight earphones is a status symbol for serious bicyclists.

Music Programming

The first radio stations used live studio orches-tras or convinced local musicians to come in and play for free. Live performances on radio were limited when the American Federation of Mu-sicians said musicians who performed on radio must be paid union scale.

Records

In the earliest days of radio all that was available for recording musical selections were scratchy, tinny sounding 78 RPM records. This is one reason that recorded music did not make up a large part of the program schedule in the early days of radio. Later a better recording medium, soft disks, called electrical transcriptions (ETs), was used, but largely to record live programs for replay. ETs had better quality, but they did not last long in use because the turntable styli wore out their groves.

Although the medium on which music was recorded had been improved, the real break-through came in 1948 when RCA introduced its extended play record and the seven-inch 45 RPM disk. Columbia Records came out with the 33 ⅓ RPM long-playing record during the same year.

Disk Jockeys

Some radio stations which were not affiliated with networks developed a format involving a host who introduced records. Later this announ-cer became known as a *disk jockey.* The early disk jockeys (DJs) used to be quite talkative. They would introduce the record, mentioning the artist, the band, the name of the selection, some information about when or why the song was written and talk about the performer. Some-

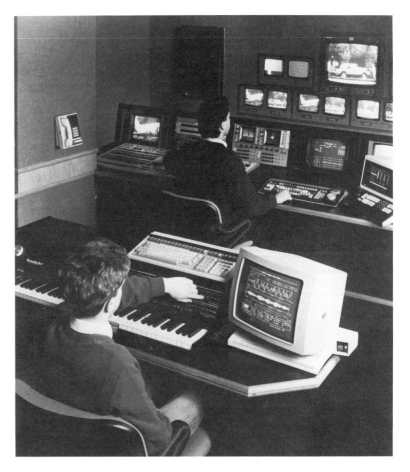

Figure 7–1
In the foreground, a Synclavier digital audio system is being used in a video post production suite. The digital audio system permits a single operator to compose, produce, and edit music recordings, sound effects, and dialogue for movies, commercials, and TV programs. Courtesy of New England Digital Corporation.

times they took requests from listeners and did dedications.

At times this style was carried to extremes as in the case of a 1950s radio DJ in New Haven, Connecticut who played the same selection over and over again for an hour until both the lis-teners and his manager became disgusted. DJs became celebrities. Young listeners particularly, had their favorite presenters, and while the mu-sic they played was important, one significant factor in the post-World War II success of the disk jockey format was the "empathy" which some of the "jocks" built with their listeners.

As the DJ format evolved, some stations ex-perimented with cutting talent costs by limiting the "jock" to very little talk. This style is prev-

Figure 7–2
A morning personality for a Cleveland FM station working from a standing position. Courtesy of Malrite Creative Services.

alent today among "more music" radio stations, which promise minimal interruptions. The changes in style or format by the management made DJs begin to lose their individual personalities and become mechanical voices, which could be (and were) easily replaced at lowest cost.

Automation

Programming is what sells a radio station, while producing programming cheaply is what generates the greatest amount of revenue. The next step in the evolution of the DJ format was to lower the cost of programming a radio station by using automation.

Program automation has been around for years. It was invented in 1956 by *Paul Schafer,* founder of Schafer Electronics, at the request of the owner of a small radio station in Bakersfield, California. One of the authors saw Schafer's early automation system in use in 1958 in a Salem, Massachusetts, radio station. It consisted of several reel tape recorders and a box that looked like the interior of a juke box, which played 45 RPM records in a selected order. The disk jockey announcements were on one of the reel tape machines, as were the weather, news,

and commercials. The system had many mechanical bugs and seldom kept to the time allotted.

Today's radio automation systems employ computers that control any number of playback devices, such as reel tape machines, cartridge players, cassette players, compact disc players, or R-Dat tape players. Modern systems can even switch in and out network feeds on time or can turn on microphones for live inserts by station personnel.

The main value to automation is that you do not have to pay someone to be in the control room at all times. One or two announcers can record all the spoken inserts normally done by four or five DJs, and during times when it is difficult to hire someone to DJ (overnights or weekends), automation equipment can actually program the station with no one present.

The fault of this approach is that it sounds too slick. Too often you can ride through a rural area listening to the radio and hear a musical selection introduced by a professional announcer with a "big voice," only to be followed by a part-time announcer reading the current weather report with an inexperienced "little voice." The main aim of this kind of programming is saving money in the form of salaries for skilled announcers. When considering automation the station manager or owner must decide at which point the savings from curtailment of staff begins to affect revenue because of a drop-off of listeners.

Tape Service Programming

An approach which has gained some popularity is to have a music tape prepared by a firm specializing in syndicated programming. These syndication firms devise formats for all kinds of stations—country music, easy listening, contemporary—and then carefully blend the selections according to a pattern they devise based on listener research. This means blending a number of male vocals, female vocals, and instrumentals according to a predetermined and tested formula. The station rotates the syndication company's music reels according to a prearranged plan, inserting a local live or taped announcer. This gives the radio station control over the music and still provides a familiar local voice suitable to the size and nature of the station.

Syndication tape services will provide tapes with the announcer's voice on the reel if the station owner wants a highly professional delivery and is not concerned about the blandly generic nature of what the announcer says.

Satellite-Fed Automation

Syndication firms also offer live DJ shows via satellite. The program is a highly skilled production version of a local record show, except that the host and the music are coming out of a distant city like Chicago or Dallas. The syndicator sends silent tone cues, which trigger local inserts at predetermined points in the program. The receiving station has its weather, news, and announcements prerecorded and ready to play when the satellite service trips the station's automation computer.

One trend in the 1980s was for radio stations to air hit tune countdown programs on the weekend. The top hits of any type were introduced by a highly skilled DJ who worked in Los Angeles or New York, and who also provided each subscribing station with some drop-in material, which was supposed to be tailored to local needs such as local station identification announcements and promotional announcements.

The main advantage of the satellite-fed service over tape syndication is that it can insert some topical, "fresh" material to make its programming seem as if it were originating from the subscribing station. Some satellite services provide hourly newscasts to further enhance the feeling that you are listening to a *live* program.

Satellite reception of these programs guarantees high quality from a technical standpoint while significantly lowering the cost of running a station since no one needs to be present in the local radio station's control room.

While satellite syndication significantly lowered expenses for some radio stations, many radio owners found they needed to have a local identity, which was best created by using local program hosts.

Music Format

The choice of music has become critical since each community has a selection of radio signals. The majority of radio formats revolve around the type and style of music played. (There are approximately 10,000 commercial radio stations in the United States.) The fact that most radio markets today have from several to dozens of radio stations causes competition to be fierce. Program directors survey record stores to see what is selling, they talk to the public, they hold *focus sessions,* and they check to see what songs are requested. Everyone involved with radio music reads magazines such as *Billboard, Cashbox, Radio & Records,* or *Variety,* which report on the music industry. Scientific surveys are used to

determine music preferences and to determine what songs are foremost in listeners' minds.

Once station management has a clear idea what type of music it would like to present, the program director and general manager have to decide whether to program locally played records or compact discs with live announcers; buy a music tapes service and use a local live announcer; buy a totally packaged tape service; or subscribe to a satellite programming source.

Here are some of the names given to radio music formats:

Contemporary Hit Radio (CHR)

Album Oriented Rock (AOR)

Urban Contemporary

Rock

Power

Country

Jazz

Soul

Black

Business

News/Talk

Full Service AM

New Age

Nostalgia

Hispanic

Classical

Gospel

Religious

Easy Listening

Middle of the Road (MOR)

Adult Contemporary (AC)

Soft Adult Contemporary

Hot Hits

Golden Oldies

Classic Rock

The list by no means includes every type of music format. Programmers are always inventing new combinations and new names.

When music formats are this specific, the process of choosing music becomes extremely important. Program directors use computers to analyze information they gather about the popularity of certain songs and artists, charts from trade magazines, surveys, and any other device they can, to try to figure out what kind of music

Figure 7–3

Once management chooses a radio format, promotion materials must support the concept to ease public recognition. Courtesy of WRTN, New Rochelle, New York.

appeals to a station's desired audience. "Desired audience" refers to the age group, gender, economic level, and style of life of the people and radio station management wants to attract.

There is a great deal of similarity in radio music formats from city to city due to the use of the same sources to determine the music being played in key markets and the common use of syndicated music services.

Once the music list has been selected, the program director must determine the *rotation* for the music *playlist*. This means the number of times each song will be played during any 24 hours and in what periods. Most music or pro-

gram directors assign somewhat different types of music to different *dayparts*. You may not want to hear a slow ballad when you're getting up in the morning, and conversely, you may prefer not to listen to a female stylist belt out a song, accompanied by her amplified rock backup ensemble at midnight. In addition to considering what people are likely to be doing during different parts of the day, the music programmer has to look at the gender and activities of the audience. If the statistics show that a station is strong on young working females, it needs to play music which could be listened to in a work situation and during the commuting hour.

News Programming

Although all radio stations do not present news, it is widely held that local news is an important ingredient in providing the localism needed by modern radio stations. The thinking is that local news is one element a radio station broadcasts which isn't the same as what is being programmed on stations in other cities.

In the 1980s fewer radio stations presented local news because of deregulation, which removed government recommendations for percentages of programming. Specific stations or specific network affiliates are known as the place to listen for news, while others focus mainly on music programming. Despite the decrease in local news the number of news networks has grown, increasing the availability of professionally prepared and presented national and world news programming.

What Is Radio News?

First of all, most news on radio is a summary of what's going on locally, in the United States, and around the world. There is a tradition of presenting brief news stories on radio. This goes back to World War II when people wanted short, frequent summaries of what was happening on the war front. Because radio now tends to be portable and a background medium, the custom of presenting brief news summaries continues.

News on radio requires listener imagination. Someone is describing an event, and you create your own picture of the event in your head. To help listeners visualize, many radio news departments and most networks rely on sound—*actualities,* the voices of newsmakers, the ambient sound of the location where the news story occurs, and the voices of on-scene reporters.

Music and News

Typically, a radio station programming a music format will prefer to present short newscasts. Depending on the balance between news and music, the news may or may not contain tape inserts. Frequently, the style of presentation differs depending on the music format. Some music stations want their news anchors to fit the way the music is presented. So, if the station has a calm, rather *laid back* style of music announcing and music, you frequently find the news anchors also adopt a less forceful, more conversational style of presentation. However, if the station

Figure 7–4
Associated Press Radio Network journalist editing an interview to pull out newsmaker comments, called "actualities." Courtesy of Associated Press Broadcast Services.

management likes a high energy level, the news may sound almost frantic.

Many music stations like the DJ and the news anchor to talk back and forth so that the news is an integrated part of the format, rather than a separate entity.

For a long time the national news networks would not affiliate with FM stations considering their music formats "unworthy" of the seriousness of news broadcasts. ABC broke this tradition when it introduced its four-network service designed to complement different types of programming. Since then many FM stations have signed up with networks such as ABC's network aimed at FM stations, CBS's youth-oriented "Radio Radio" network, Mutual's "Lifestyle," and NBC's "The Source." RKO introduced two networks specifically aimed at younger demographics. (Entertainer Dick Clark and his associates bought the RKO Networks in 1985 and renamed them the United Stations Networks.) Some FM stations have signed up with the more traditional news networks like NBC and CBS.

All-News Radio as a Format

All-news radio came about as a way to counter the growing number of music stations in certain metropolitan areas. The first all-news radio stations were founded on the west coast. There are frequent disputes as to which came first, but there was an all-news station on the air briefly in California in the early 1960s. Radio programming giant Gordon McLendon was known to lay claim to starting the first all-news radio station when he converted XTRA in Tijuana, Mexico to an all-news format in 1961. The station was powerful and easily covered San Diego and Southern California as far north as Los Angeles.

There was nothing particularly inspiring about the McLendon format. Announcers took news copy from the wire service teletypes and read for 15 minutes. The voices changed every 15 minutes, but there was little relief from the monotony of straight reading. One did not hear the voices of newsmakers or reports by correspondents. However, the format worked well enough that McLendon later used it in Chicago.

All-News WINS

In April 1965 the Westinghouse Broadcasting Company decided to switch its long-popular WINS, New York, to an all-news format. The station had been a giant in industry as a music

Figure 7–5
A billboard in Southern California promoting Gordon McLendon's new format, all-news radio. The station was X-TRA, at 690 khz, in Tijuana, Mexico. Courtesy of the Southwest Collection, Texas Tech University.

station for a number of years, but it had lost some listeners to competitors and to the early stages of FM growth.

The Westinghouse approach was innovative; listeners heard a variety of voices, newsmakers, reporters, weather forecasters, and sportscasters. The repetitions of the basic news items were less frequent, so WINS had an entirely different personality from XTRA. Westinghouse later adopted the all-news format at some of its other AM stations.

CBS All-News

CBS followed suit in 1967, converting its flagship clear-channel WCBS, New York to all-news. The CBS format incorporated programming from the CBS Radio Network and used a variety of voices and specialists. Sometimes two people would anchor, chatting with each other and sharing both the news reading and commercial delivery load. It made for a more listenable format for people who wished to stay tuned for longer periods.

NBC News and Information Service

In June 1975 NBC launched an expensive venture in all-news radio in the form of the NBC News and Information Service, an all-news network. NBC utilized unused time on the NBC Radio Network to program up to 40 minutes an hour of all-news and information. The idea was to have local stations insert local news, weather, and sports during the rest of the hour. NBC suggested to AM stations having difficulty surviving as music stations that they could keep their personnel budget about the same, by dropping DJs in favor of the same number of news people because the news staff would only have to fill 10 to 20 minutes per hour while the network would do the rest. Stations that already had news departments ended up with fewer employees and smaller payrolls. The idea sounded good and it caused a number of stations in cities long considered marginal to adopt the all-news format. Until the advent of the NBC News and Information Service, most experts doubted there would be many successful all-news stations outside the top 10 markets. The reasoning was that no one listens to all-news radio for long periods. You have to be in an area where there are so many people that even if the listeners don't tune in for long, there will be a large number of people listening over the course of the day, creating a significant cumulative audience.

NBC's venture failed for several reasons. People seemed to be less interested in world and national news than in local happenings, and NBC had too much content which was not of local interest. NBC never converted its powerful, urban, owned and operated radio stations to all-news. Instead, it mixed some of its AMs and some weak company-owned FMs, thus losing the strong audience and advertising base it needed in the most populous areas of the country. NBC was never able to overcome strong competition from Westinghouse and CBS in markets like New York, Chicago, Los Angeles, and San Francisco. Without big audiences in these cities, the network had no audience base from which to sell national advertising. In 1977 after two years and reportedly spending 10 million dollars, NBC quit the all-news business, leaving the affiliates to figure out what to do next.

One beneficial side effect of NBC's failed all-news network was that some stations in those so-called marginal markets continued to do all-news, and were successful. The format, while not a major one in number of stations, continued to play an influential role in many cities around the country.

Almost a decade later Turner Broadcasting started the CNN Radio Network, at first providing audio from CNN Headline News, and later originating some of its own news programming, while still lifting audio from CNN's two cable TV networks. Some all-news and news/talk stations subscribed to CNN in an effort to relieve pressure and costs on fringe periods.

Other All-News Formats

After the demise of NBC's all-news network, a few all-news stations had been created in markets where the format had not been expected to succeed. For example, an all-news station continued to operate in metropolitan Hartford, Connecticut, an area once thought too small to support an all-news format. The format does better in populous urban areas. Its primary problem is its high cost. At one point WCBS NewsRadio in New York City employed over 100 people. This compares to perhaps 40 employees for a typical New York music station.

A number of all-news stations continue to exist, but the big swing has been to some combination of news and some other type of programming. Even some of the best known all-news stations mix news with live play-by-play sports coverage during evenings and weekends when their all-news listenership drops off.

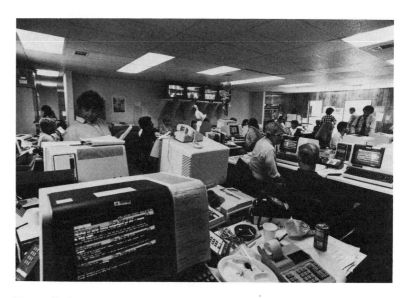

Figure 7–6
Nary a typewriter in sight. Computer terminals dominate the NBC News temporary newsroom at the 1984 Democratic National Convention in San Francisco. Courtesy of Basys, Inc.

Talk and News

Some former NBC all-news affiliates decided to keep some of the news format and mix it with talk programming consisting of interview programs and listener call-in shows. This sort of format was developed by a station in Sarasota, Florida, when NBC's News and Information Network closed down, and it was used successfully for several years.

The most popular form of the all-news format is to program all-news in the morning and afternoon *drive periods*. These drive periods are considered to be the hours from 6 to 9 A.M. and 4 to 7 P.M. Generally, this is when people are commuting to work or school and when they are returning home. The radio audience is largest at these hours, and all-news formats do well in drive time because people think they need information such as the weather, traffic conditions, business news, general news, and sports happenings.

The all-news audience drops off sharply in midday and in the evening. To combat the midday drop, many stations change their programming to talk. This may consist of a studio discussion or someone taking calls from listeners, or some combination of studio and call in. This format has worked well for many urban stations, and requires fewer personnel, so a smaller news staff can still efficiently cover local news.

Many stations have tried some variation of sports in the evening, hoping to capture working and commuting males. Some stations use sports call-in programs during this period, sometimes tied to live play-by-play coverage of seasonal professional or college teams.

All-Talk Radio

Radio stations have found *talk radio* (call-in programs, studio interviews) to be a viable format, especially when mixed with regular local and network newscasts. The talk format grew to the degree that ABC, NBC, Mutual, and the United Stations made major commitments to supplying network talk programming to affiliates. The Sun Radio network was devised specifically to provide talk radio to subscribing stations.

AM Versus FM Programming Decisions

All-news, news/talk, and all-talk radio have become important formats for AM radio stations struggling to keep their audiences against competition from FM music-programmed stations. Some programmers see AM Radio as primarily an information medium with FM being the music medium. Two variables which could change this prediction are AM stereo which might bring music listeners back to AM and increased competition among FM stations, which might encourage more FM stations to do more news and information programming to stand out from the competition.

Sports Programming

Sports has been a major part of radio programming from the early days of the medium. You might wonder why TV hasn't obliterated radio sports programming. The main reasons seem to be that sports lends itself to verbal description and thus makes interesting programming for people who aren't able to watch TV while the game is on.

From an economic standpoint, it is possible to provide live coverage of local public school games, small college games, and minor league pro games on radio at a reasonable cost, while it would be prohibitively expensive and difficult to do the same sort of coverage on TV.

Many local radio stations make a healthy portion of their income from covering local school athletics. If you go into the high school gyms of small towns, you will find two-person crews from local radio stations broadcasting the games.

Regional Sports Programming

A big source of sports revenue in radio is the games of the regional professional baseball, basketball, hockey, and football teams and their college counterparts. Most professional teams and many colleges have set up radio networks. The network sells the commercials and each station is paid a fee to carry the game. In addition, the station gets to sell the adjacent commercial positions, which usually command a premium price.

Since these games occur during low-audience periods when radio stations have plenty of unsold time, i.e., evenings and weekends, they become a good source of income for the stations. The cost is minimal because all the radio station has to do is have one announcer on duty to do station breaks, play commercials, and stand by in case of a technical failure or a rained out game.

If a radio station becomes the base station for a network, it can make a considerable amount of money. Many of the regional sports networks are set up by stations, which work out the schedule and format, hire the sportscasters, sell the spots, line up the affiliates, and produce the broadcasts. The availability of satellites for use by regional networks has cut out one of the major expenses involved in doing sports, which was renting broadcast lines from the telephone company.

How a Radio Sports Broadcast Is Created

Broadcasting the game is not expensive. Sturdy, good-quality *remote* broadcasting equipment can be purchased at reasonable prices. If a station does not have union employees, the engineering can be done by one of the sportscasters or by a person who functions as a producer, although many stations prefer to send a technical person to cope with emergencies. The sportscasters are frequently station employees, who hire spotters for each team to help with recognizing players. A team of four or five people can do a highly professional radio sports broadcast, but it can be done by as few as two people who know the teams and run their own equipment. The basic equipment for a live sports broadcast on radio consists of a remote *mixer* and two or three

microphones or microphone/headset combinations. The remote unit is either attached to a line ordered from the telephone company, or it feeds a *microwave unit* owned by the station.

Sports play-by-play and *color* (description) is extremely challenging, and the practitioners of the art must be thoroughly familiar with the sport, know the rules, understand coaches' strategies, recognize common plays, and must be able to recall statistics, history, and current sports news relating to the game. Successful sportscasters usually develop their own record keeping systems so that they can deal with the all-important statistics, as well as the players' names and biographies.

Sportscasts

The *sportscast* (or *sports newscast)* is a known audience builder. Sportscasts tend to run in drive time when the potential for male listeners is high. One theory in radio programming is to present news in sort of a sandwich format in which the bread is the news stories and the filling is the features, like sportscasts, which attract the attention of particular groups of listeners.

Sports Talk

Sports talk and call-in shows have become standard fare on talk and news/talk radio stations. The targeted audience is male, 18 to 49 years old, although the ratings services are reporting more women listeners in recent years. The secret, according to experienced programmers, is to have an extremely knowledgeable host, because every listener thinks he or she is an expert.

One network programming expert, Ben Hoberman, formerly of ABC, says a sports talk show doesn't work well for a station unless the station also has a solid sports franchise (meaning that the station broadcasts pro games). The activities of the local team or teams provide a common topic the callers and sports-talk hosts can discuss. Other listeners can call in comments because they are familiar with the local teams' records and personalities. One station arranged to have a call-in show featuring the head football coach and his assistants right after the conclusion of the big-name college games the station carried. Another sports programming idea involved inviting in community and amateur sports experts during the summer when there was less interest in national and college sports. Among the topics discussed were soccer and the summer softball leagues.

As the FM band neared saturation in some markets in the mid-1980s, FM stations began to program sportscasts and even play-by-play of games in an effort to differentiate themselves from other FM stations that concentrate on continuous music. FM programmers believe that because the audience "grew up" on FM as the medium was achieving popularity and market dominance they will want to hear information and sports programming on FM, rather than turning to the AM band.

Specialized Interest Programming

Specialized interest programming involves the use of the total programming day or at least large portions of the broadcast day for programming aimed at segments of the overall audience with specific similarities. Examples include religious programs, foreign language programs, and programs aimed at ethnic groups. Many radio stations program some religion or other specialized programs during parts of certain days, but our concern here is with stations that devote large segments of their programming to specialized interests.

Religion

Religious broadcasting is a little discussed but significant minor segment of the radio world. The success of stations with religion-based formats varies from one part of the country to another. Religious broadcasting thrives in the "bible belt" of the southeast and southwest United States, where fundamentalist religion is practiced.

Most religious stations carry two distinct types of programming. They run hours of programming prepared by preachers or religious groups, and they usually play music associated with religious topics.

The owners of these religious stations frequently enjoy high percentage returns in relation to the cost of running their facilities. Although it is not true of all religious stations, there is a tendency to program the less powerful daytimers and less attractive frequency allocations with religion. These stations are usually bought at low prices, which permits their owners to return a profit on relatively low income.

One way to sell religious radio is to accept programming from radio preachers. These are usually individuals or organizations (local or national) who feature evangelic messages and

sometimes support their broadcasts from listener donations. Frequently, the religious broadcaster collects the time fee before the station puts the program on the air, so it has a guaranteed income, with no costs or problems associated with billing or collections.

A religious station doesn't need a large staff of salespeople because the number of firms wanting to advertise on a station with this type of specialized format is small enough to be handled by one or two people. Staff costs are low because you are not paying for personalities or news reporters. Hourly wage announcers are fine for this sort of format. Experienced broadcasters say a religious format will make money for an investor if done well in a receptive market even if the station does not show up in the ratings. The secret to success is a low operating budget, good contacts in the religious community, and a solid cash-at-the-point-of-sale attitude.

Foreign Language

Foreign language broadcasting is widespread in the United States. It would really be more accurate to refer to the programming as non-English programming.

There are big variations in the nature and quality of non-English language stations. In some cases stations that were doing poorly would sell blocks of time to people who would then create the program and sell the commercials within it. This is a hazardous operation because the FCC requires the station management to know what is going on the air, which if you follow the spirit of the law, requires the station to employ people who speak the appropriate languages to monitor the broadcasts.

Around the country you hear many tongues spoken on radio. In the west and southwest you hear Spanish and the languages of the American Indian. In Alaska you can hear Eskimo and Indian. In New England you will hear French-Canadian and Portuguese. In the urban areas you will hear Italian, German, Polish, Russian, and many other tongues of Europe. In South Florida you will hear Cuban Spanish and in New York you will listen to Cuban and Puerto Rican Spanish.

Many of the non-English stations operate exactly the same as English-language stations with highly paid personality DJs and complete news departments.

Spanish-language broadcasting has become particularly important due to the large number of Spanish-speaking people who live in the United States, particularly in areas like New York, Northern New Jersey, Los Angeles, Miami, and parts of Texas, Arizona, and New Mexico. Perhaps symbolic of the importance of Hispanic radio is the fact that many professional baseball games are broadcast simultaneously on radio in Spanish and English.

Black Programming

Programming aimed specifically at a black audience has become a major money earner. These formats vary widely due to local tastes; what works in Philadelphia would not work in Charleston, South Carolina.

A count of black format stations listed in the December 28, 1984 issue of *Black Radio Exclusive* turned up approximately 146 radio stations featuring substantial black-oriented programming.

One format which has developed out of black-oriented radio is called urban contemporary, and it has attracted thousands of black and non-black listeners in urban areas. Most black format stations favor music performed by black artists. Relatively few stations that program to blacks are owned by blacks. Most were established by white broadcasters who thought they had found a good way to make money.

There have been stations which supposedly aimed at black audiences and ended up winning major shares of the local ratings. These are sometimes referred to as *crossover* stations or formats. To get major shares of local ratings, stations must have a majority of listeners, not just listeners from one segment of the audience. This has been true of WBLS-FM in New York City, WBLX (FM) in Mobile, Alabama, WAAA-FM in Winston-Salem, North Carolina, and WANM in Tallahassee, Florida.

Two separate black-owned and black-oriented news networks have evolved. One started as the Mutual Black Network, a division of the Mutual Broadcasting System and later became the Sheridan Broadcasting Company when Mutual sold the network. The other network is the National Black Network. One area in which black format stations have done a great service has been the broadcasting of athletic events from historically black colleges and universities, particularly in the South.

Other Specialties

Station owners are always trying to find new angles, new approaches. All-women radio, chil-

dren's radio, and humor radio have been attempted at various times with only limited success. Periodically, a station owner will decide to staff a station with only women air personalities and news anchors. In 1984 a San Francisco radio station introduced programming aimed at children. In 1979 the Children's Radio Network was founded, and in 1986 it listed five affiliates: Phoenix, Arizona; Jacksonville, Florida; Oklahoma City, Oklahoma; Indianapolis, Indiana; and Little Rock, Arkansas. Stations in Waterbury, Vermont, and Woodstock, New York, set aside special segments just for children. ABC Talkradio in 1986 listed 34 affiliates as carrying programming for children under the name "Kids America." One station owner introduced all-humor radio in Washington, D.C., and a San Francisco station tried running a block of radio quiz shows.

Program Schedule for a Contemporary Radio Station

12:00 midnight	Tina, female DJ: network headline news on the hour, local and state headlines at :20 and :40 read by DJ using wire and news department copy
6:00 A.M.	"Morning Zoo" with Larry Storm and Bob Barrett: pop music, comedy tapes, impromptu stunts by DJs, weather cut-ins from syndicated weather bureau, traffic cut-ins from syndicated traffic bureau, net news on hour, preceded by one of local headlines at :59, 3 minutes of local news at :30 and :40, 3 minutes of sports at :33
10:00 A.M.	Tom Davis Show: More mellow music, more male vocalists to appeal to female audience. Net news on hour, DJ reads local and state headlines at :20 and :40, two consumer features (2 minutes) per hour, prepared by station staff, local headlines at 11:59 and 3-minute at 12:20 and 12:40 from news department
3:00 P.M.	Judy Martin Drive-Time Show: Same pattern as 6 to 10 A.M. but without comedy, and with more conversation between DJ and news/sports/weather/traffic people than during midday
7:00 P.M.	Live Concert (Network): Contemporary music concert fed by network from California (on tape—performed and taped 3 days earlier)
10:00 P.M.	Martin Spain: DJ show, same format as overnight (on nonconcert nights show goes from 7 P.M. to midnight)

Network Radio Programming

Network radio has come full circle since the time when it was filled day and night with 15, 30, and 60 minute programs, much as TV is today. Network radio withered for a long time after TV took away its programs and reduced it to a news and sports service. In the 1980s network radio regained vitality, returning to long-form programming while the number of networks soared.

It is easy to imagine what network radio sounded like in the 1930s. All you have to do is turn away from the TV set and listen. Network radio in the 1930s and 1940s fulfilled the same function TV does today. It was the major center for daily free entertainment. It consisted of dramas, soap operas (which actually advertised soap), quiz shows, variety shows, comedies, news, sports, and music.

The four major networks stayed in business after TV became the dominant form of network programming, by providing news on the hour, sportscasts, and occasional sports events. ABC, CBS, and NBC decided to keep the radio networks because so much of their product had become an add-on to TV. For instance, the same news correspondents who work for TV provide radio stories for the radio networks. (NBC finally sold its radio network in 1988.)

A market developed in the early 1980s for popular music concerts and other types of programs the networks found they could sell to national advertisers. FM stations were anxious to have the benefit of concerts of leading popular music stars to supplement their DJ shows. They reasoned that if live concerts attracted large crowds, and records of these concerts sold well, then there had to be a market for broadcasting concerts either live or by tape delay. Indeed, there was a market and the concept spread quickly

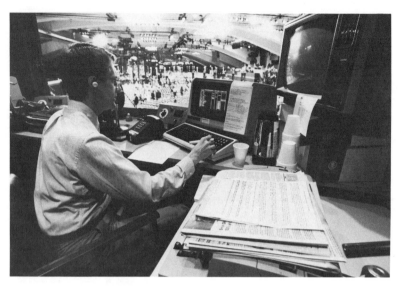

Figure 7–7
A good example of strong network programming. An anchor at work in the NBC Radio booth overlooking the 1984 Democratic National Convention in San Francisco. Courtesy of Basys, Inc.

until several national networks were carrying live pop music concerts. The satellite made possible high fidelity transmission of music at a much lower cost than renting high quality telephone lines.

Call-In Show

Another network service that became popular in the 1980s is the network-originated call-in show. Larry King plowed a lot of the original ground for this form of radio with his all-night national call-in program on the Mutual Radio Network. NBC, RKO (prior to its sale in 1985), and ABC also developed programs which accepted calls from all over the country on toll-free long distance telephone numbers.

NBC enjoyed particular success with its nighttime and weekend talk shows, which affiliates frequently took to supplement their daytime local call-in programs.

ABC went further, offering a full day's programming and a satellite-controlled automation system, which triggered tape recorders at the affiliate. The affiliate could then originate a tape featuring an ABC TalkRadio host giving the local phone number to be used to call the ABC program. The same signaling system could be used to start automation equipment at the affiliate to play local commercials or program inserts such as news headlines and weather forecasts.

This meant the affiliate didn't have to have anyone on duty in the control room during the ABC programming if the station desired to save money on board operators.

Mutual even ventured into presenting an early morning 30-minute news, weather, and sports program, which was the longest network radio newscast at the time, although the segments of CNN Radio overall take up more time. Most network radio newscasts run between 90 seconds and six minutes.

Sports

Sports was the other program form that played a big role in boosting the radio networks. As radio stations became more numerous, there were increased opportunities to air nationally prominent teams. Mutual became the source of a good many national football games, and the other networks offered their share of events, especially playoffs, bowls, and championships.

News

Ever since World War II, hourly news summaries have been a mainstay of the radio networks. It is difficult for a local radio station to do a competent job of reporting world and national news. The networks, however, had the organizations to do a superb job in these areas.

Ironically, the network news departments, which started in the days of radio, quickly became dominated by TV reporters and executives. Network correspondents were instructed to carry audio cassette recorders and to feed both actuality and reports to the radio networks as they covered their television stories. The radio networks made good use of the excellent talent of their owned and operated radio stations (which for CBS was particularly easy because many company-owned stations were all-news operations).

The major networks providing news (particularly ABC, CBS, MBS, NBC, and NPR) developed extensive networks of freelance reporters around the world and got a great deal of help in the United States from reporters at affiliate stations. The networks also made arrangements to get audio feeds from the United Nations, shortwave radio, the White House, the U.S. House of Representatives, and dozens of other places where sound equipment was permanently installed.

The networks also have people who prepare frequent sports reports and various feature pro-

grams, such as the financial advice and news analysis.

Satellites and Growth

Only a few regional or state networks existed prior to the availability of low-cost satellite audio channels. It was simply too costly to maintain network lines in many areas, or even if the lines could be secured, they were often too poor in quality to meet network standards.

The real growth of regional networks came when established organizations were able to shift to satellite transmission, which cost less than telephone lines and permitted them to transmit high quality signals. State news and sports networks sprung up all over the country. The state news networks are particularly significant because they fill a void that existed for many years. Most radio news concentrated either on local happenings, reported by the station, or world and national news, reported by a national network. Little news was available, except from wire service copy, regarding what was going on at the state capital or in other cities around a state. Furthermore, it has been possible to vastly increase the amount of live sports coverage available on a regional basis by using satellite transmission.

Specialized Networks

Just as satellite technology has opened the way to news and sports networks, it has made possible other kinds of information services. For instance, the Dow-Jones Company, which publishes the business-oriented *Wall Street Journal* has a radio network, which provides hourly business reports during the weekday business hours and special features on Saturday. There are a number of agricultural networks relaying farm news and market reports in farming regions. In the South agricultural networks focus on tobacco growing and tobacco prices, hogs, cattle breeding, vegetable crops, corn, soybeans, and peanuts, while midwestern agricultural nets focus on agribusiness, commodities markets, hog and cattle feeding, corn, and wheat. As time goes by, more of these specialized networks will be devised as entrepreneurs find information that people need to have on a daily basis.

One type of specialized network provides audio news stories to radio news departments. Both the AP and UPI do this nationwide, and there are organizations in some states that have this sort of service. AP and UPI also send hourly newscasts, so they are also considered news networks.

Traffic Reports

One recent development in syndication has been traffic report syndication. There are firms in major metropolitan areas which provide traffic reports to several stations. They usually do this by combining information they receive from various police entities with airplane or helicopter observation plus on-scene reports from traffic spotters employed by the service. Maintaining a traffic reporting staff is expensive, especially if a station relies on helicopters. The syndicator spreads the cost normally accrued by one station over several clients, which lowers the per station cost and leaves a profit for the syndicator.

Weather Services

Weather services are another form of syndication. The process of monitoring weather conditions around the country has become so sophisticated that a team of meteorologists located in State College, Pennsylvania, can accurately forecast weather for Baton Rouge, Louisiana, or Casper, Wyoming. There are a number of these weather services available, and they are well accepted in the industry as a reasonable expenditure for quality weather reporting.

Programming Noncommercial Radio

The three most common forms of noncommercial radio are public radio, listener-supported radio, and educational radio.

Public Radio

Public radio in the U.S. has preserved many forms of programming not normally available. In some markets the only classical music to be heard on radio is what is played by a public station. Public radio has promoted radio drama, long analytic news broadcasts (such as "All Things Considered"), opera, jazz in all its forms, and modern music, which has not gained enough popular acceptance to be played on commercial radio.

In general, public radio has been the refuge of programming, which was desired by the public but would not attract broad enough audiences to support a commercial station. Much of this

programming has been so-called "cultural" matter, such as classical music, opera, experimental drama, discussions, documentaries, news, college courses, and news analysis or news interviews.

One program, "The Prairie Home Companion," aired by American Public Radio, attracted so much attention its host, Garrison Keillor, authored a best-selling book based on the show's sketches of a fictitious little Minnesota town, situated on the banks of imaginary Lake Wobegon.

Listener-Supported Radio

A handful are "community stations," which seek program ideas, volunteer staff, and financial support from the community such as the Pacifica stations of Berkeley and Los Angeles, California; Houston, Texas; and New York City. The Pacifica stations are some of the best known listener-supported community stations. They have been a home for *alternative* programming (not popular with a broad range of the public), music, and news and documentaries, usually with a liberal slant.

Figure 7–8
Electronic field production truck which can support five cameras and accommodate an 11-person crew. This vehicle contains 1-inch and 3/4-inch videotape recorders, plus equipment for camera control and monitoring, video graphics, and on-line audio mixing. Trucks like this are used for remote production of commercials and programs, and can increase a station's programming flexibility. Courtesy of Centro Corp.

Educational

There are also university- or college-owned stations that are in the same community or metro area with a public station, which are supported by listener giving and the school budget. Some school districts operate "educational" radio stations.

TELEVISION PROGRAMMING

Until the 1980s networks were the dominant organizations in TV programming, but their dominance of the TV audience has changed as more independent stations have come on the air, cable has grown significantly, and the use of personal VCRs has expanded rapidly. Still, the most desirable position to be in if you own a TV station is to be a network affiliate. Most of your program day is taken up with network-supplied programs, which almost guarantee large audiences and good rates for local commercials. It also means that the programming decisions are made by the network, and it is the network salespeople who must explain to the advertiser when a show does not get viewers or sell products.

Independent stations must buy or barter almost all of their programming, which raises operating expenses. In addition, most of the good syndicated TV shows were once shown on the network, so viewers may have had two to four opportunities to have seen the program. Some programming has been developed specifically for independents and more seems to be on the way as the independent stations get stronger and wealthier.

How Domestic Satellites Have Changed Programming

A satellite is a data retransmitter parked 22,300 miles above the earth. It relays data, audio, and video over long distances, providing a major cost advantage plus higher quality than transmission over AT&T video lines.

The steady multiplication of transponders available for transmitting programs has revolutionized the media in the United States. The number of transponders on one satellite multiplied by the number of hours available to send programming has brought down the cost of transmitting programming. The one part that satel-

lites cannot help with is the content of the programming. Programs still have to be conceived, written, and produced; that takes money.

The networks switched to satellite transmission of most of their programming in 1984. One direct impact of the availability of satellite channel on networks is that their affiliates have many more program sources from which to choose, simply because they must have satellite receiver dishes. They occasionally do preempt a network program in favor of another offering. Independent stations are finding with satellite facilities they can gain access to higher quality, newer programming, which makes them more competitive with affiliated stations.

Occasional Use

One significant change has taken place since satellite video channels became readily accessible for occasional users. Local TV stations are using satellite channels to transmit and swap TV news programming. Local stations first used satellites to cover major stories they thought would capture a local audience. Election programming has benefited from satellite transmission. Now the major networks can link the country in satellite hops and cover primaries in states that are both distant in miles and different in time zones.

News via Satellite

The rather quick growth of interest in swapping stories among stations forced Capital Cities/ABC, CBS, and NBC to take a new look at their affiliate newsfeed services which provide news stories for local use. As a result, the networks began organizing special regional news exchanges to serve clusters of states. They were pushed into offering the new service by their affiliates and the fear that too many state or regional co-ops would crop up crossing affiliate lines, potentially cutting the networks off from sources of local stories and video feeds. The networks eventually went one step further than just offering regional associations. They devised various schemes through which they would help affiliates buy uplink trucks, *satellite newsgathering vehicles,* and act as coordinators for all material being exchanged.

The advantage to having a mobile satellite uplink is that you can cover stories outside the immediate area served by a station. (The station's electronic newsgathering vans have a more limited range.) This flexibility can be particularly valuable to a station that serves a spread-out geographic area. The mobile uplink has increased the flexibility of TV to cover a breaking story. Live coverage is limited only by the time it takes to drive the uplink to the location of the story, plus a brief setup period.

News exchanges among stations equipped with mobile earth stations strengthen their newscasts. During a hurricane, for instance, stations in the affected areas could swap live video, which would normally have been impossible to transport through stormy skies or over littered roads. In the case of a serial killer, stations in affected areas could exchange stories regarding crimes the person was accused of committing.

Television Network Programming

There are three full-time commercial TV networks: Capital Cities/ABC, CBS, and NBC; they are similar in that they supply a variety of entertainment, news, and children's and sports programming.

Most affiliates are paid by the network for carrying commercials the network runs. A few small stations may have to pay the network to receive programming. The secret to the success of the networks is their ability to buy well-produced Hollywood programs.

If you were to ask, "who decides what people will see on the networks?" the nearest answer you could get is the network executive in Hollywood who selects the programs for consideration by the top brass in New York. An article describing one of these executives was headlined: "CBS Program Chief Picks Entertainment for 85 Million Viewers." While the term "Picks Entertainment" may be slightly overstated, it is true that virtually nothing which does not have the approval of the network's West Coast program executive ever gets viewed in New York.

At CBS the executive's title is senior vice president, CBS Entertainment (the division providing entertainment programming to the CBS Television Network). The comparable executives at Capital Cities/ABC and NBC are called division presidents. They have large staffs who help them sort out proposals for eventual production as pilots.

The process of developing a new program can differ, but it usually starts with a detailed proposal, followed by a script, and then, if the idea looks promising, an agreement between the producer and the network over financing a *pilot* or sample show. Sometimes the pilots become episodes (if the show is bought); other times they

are played during the summer to fill open slots in the schedule.

On occasion, a network will make a heavy investment in a new series by financing a made-for-TV movie, which is shown preceding the beginning of the regular series.

Although the networks are kept from owning most of these programs under FCC rules, they play an extremely important part in developing, selecting, and producing the programs. Even though the original programs are offered to the networks by outside producers, the networks become involved by insisting on approval of their scripts, selection of actors, the plots, and clearance for *taste,* a euphemism for legal and moral censorship.

Network Program Choices

The networks try to figure out when a series has peaked, and substitute something new in its time slot before the audience starts turning away to a competitor network. It is much harder to get the audience to return than it is to convince them to watch a replacement. Predicting new trends is tricky. A right choice can mean millions of dollars in increased revenue when a new kind of show takes off. Equally tricky is deciding how to successfully imitate a hit show without creating a copy that *bombs.*

The other major programming decisions originating with the networks are their live coverage of sports and their newscasts.

Sports

The cost of securing broadcast rights for professional sports programming had ballooned; finally the networks started telling professional team owners that when the sponsors decide they can't afford to advertise, it's time to cut the cost of programming.

The promoters of the 1988 Olympics in South Korea originally anticipated a lucrative contract with an American network, but in the wake of poor ratings for the winter Olympics in Yugoslavia and problems with the time difference between the United States and Korea, plus slippage of both sports ratings and overall network audiences, the big bids were not forthcoming. NBC eventually signed a contract, but at a lower price.

Cost Cutting

The networks found that some of their lower cost made-for-TV movies got better ratings than expensive Hollywood films. They tried other approaches such as sharing the cost of production of programs with Canadian broadcasters. Another attempt was to have programming produced in physically cheaper locations, causing a number of series to be cast in cities other than New York and Los Angeles.

Fourth Network Movement

Among the pressures on network profits during the mid-1980s was almost certain competition from strong groups of independent stations, which were created from a series of major mergers and sales. As the independents became stronger due to infusions of capital from large owners, they created a *Fourth Network*. This created turmoil because the one thing that networks have to sell is their program schedule. The major networks do not want competition in programming. Independent stations had for several years created ad hoc networks to carry a limited amount of shared programming and had talked frequently about having regular network service. By the end of the 1980s the Fourth Network was a reality, created by Rupert Murdoch by linking his media acquisitions and using programming they created.

Production by Independents

Some owners of independent stations (and some affiliates) have stepped boldly into national programming by creating and selling their own programs, or by commissioning additional episodes of series, which were cancelled on the U.S. networks after short runs.

The popular "Phil Donahue" program originally started in Dayton, Ohio, later moving to Chicago and then New York. It was developed at a group-owned station and the group provided the financial backing to take the program national. The "Oprah Winfrey" program originated in Chicago and became a nationally and then internationally syndicated program.

Local Television Programming

What do local stations do when they are not receiving a feed from the network? They run programming that they either buy from syndicators or they produce their own programs. The major local programming production activity at network-affiliated stations is the local news. A great deal of money is spent on local news, and in the past 10 years local TV news has become

Figure 7–9
A producer's computer, here showing election results. The computer can assemble, add, calculate percentages, and provide on-screen graphics for election coverage. The producer can choose which screens to show next. Computers are a fundamental part of news and other parts of a station's programming. Courtesy of Dynatech NewStar.

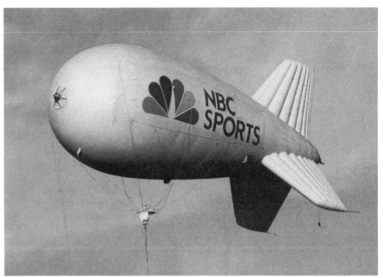

Figure 7–10
A balloon being used as a promotional device by NBC sports. The networks have long dominated major sports coverage, but they are increasingly forced to compete against bids by cable channels when major league contracts are renewed. This balloon floated above a National Association of Broadcasters Convention in Las Vegas. It was there to remind broadcasters that NBC had a strong position in sports coverage. Courtesy of NBC Sports.

the major local profit center at many TV stations.

The amount of local news run by local stations differs widely depending on the station and its owners' viewpoint. There are local stations presenting 30 minutes of news, weather, and sports during the early evening and there are other local stations which air 2.5 hours of news in the early evening.

Access Time

Many local stations fill non-network time with syndicated programs. There is a hot market for syndicators selling programs to go in what is known as *access* time between 7 and 8 P.M.

For the most part, network affiliates carry a high proportion of network programming, do local news, and run old or new syndicated shows, movies, or network repeats during non-network hours.

Some stations have successfully replaced the network morning show and produced their own local morning program. This has been particularly true of the CBS affiliates which opted not to take the CBS Network morning news program.

Old Movies

Old movies are frequent fillers late at night or on Saturday and Sunday afternoons on network affiliates. There are companies in Hollywood that buy up the rights to these films and then sell them to stations in *packages* (groups).

Local Programming Decisions

The decisions a station program director must make are somewhat limited if the station is a network affiliate, but they are extremely critical decisions in terms of the ratings success because these non-network spots in the program schedule contain openings for dozens of commercials, which can be sold at premium rates if the programs get big audiences. The importance of these open times between network blocks is illustrated by the number of syndication firms that exhibit at the annual U.S. National Association of Television Program Executives Convention (NATPE).

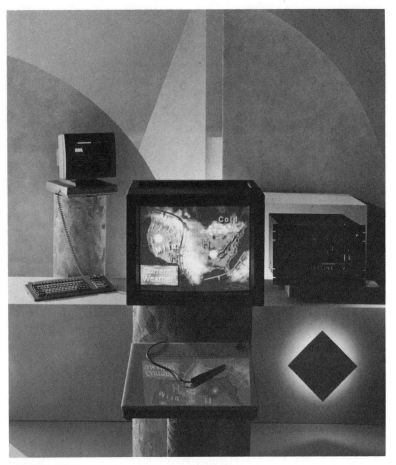

Figure 7–11
Computer system used to generate TV weather graphics. Weathercasters use systems like this, plus data supplied by weather data firms and the National Weather Service, to prepare the weather maps and charts we see on TV. This system can be used for some other graphic applications when it is not being used by the meteorologist. Courtesy of Colorgraphics Systems.

You will find comparative program schedules for a network affiliate and an independent station following the next sections, which deal with independent TV stations.

Independent Television Station Programming

Program directors at independent stations have the opposite problem from program directors at network affiliates. The program director of an independent must fill most of the day with non-network programming. She or he breathes a sigh of relief when a network or external feed becomes available. Some of the larger owners of independent stations do coproduction projects in which the production costs are spread among several independent stations, and then if the program is well received, it is sold to still other independents.

Where Do Independent Stations Get Their Programs?

They buy or barter off-network shows, buy special syndicated programs produced for independent stations, or buy packages of movies of various vintages. The advent of the Fox Network, which offers some original programming, relieves some of the strain on independent station program executives. In 1988 a Florida organization announced it was putting an old-movie network together to provide a full day of satellite programming from which independent stations could select. The network organization said it planned to reserve certain commercial positions for sale to national advertisers.

Satellite News Programming

The development of satellite programming has been a big help to independents. For instance, WPIX, an independent station in New York City was able to develop its own nighttime network newscast under the name Independent Network News (INN). The news network feeds a half-hour newscast at midevening, hoping to catch people who did not get home in time to see the early news on the networks. Although INN does not have the resources of the networks, it was able to develop a credible newscast. Some independents pick up news by satellite from the Cable News Network's short-term service, CNN Headline News.

Sports

Some independent stations have been successful in capturing the rights to regional sports telecasts. This has been particularly true for professional baseball, basketball, and in certain areas, hockey.

Music Television

One variation of independent station programming is music TV. In some cases music videos are introduced by video disk jockeys (VJs). This form of TV enjoyed its first popularity on cable, but it spread and was adopted by independent TV stations, which were seeking a way to coun-

terprogram the affiliates and other established independents.

Foreign Language Television

Another approach is foreign language TV. There are a number of Spanish-language stations, which are now tied together by a Spanish-language TV network, which uses satellites to feed programming. Spanish-language TV has been successful on the West Coast, and in Texas, Miami, and New York City. There are other non-English TV broadcasts, but they usually consist of time purchased on independent TV stations for specific programs. In 1985 New York began selling some of its program time on municipally owned WNYC-TV to companies that planned to air non-English language programming.

Religious Programming

Two organizations which attempted to set up networks of *Christian* TV stations were the PTL Club of Charlotte, North Carolina, and the Christian Broadcasting Network of Virginia Beach, Virginia. Both experienced financial difficulties and by the mid-1980s were divesting themselves of stations in favor of presenting cable programming over their own cable networks. The PTL network experienced legal and financial difficulties in 1988 when its founder, Jim Bakker, was ousted after he was accused of a variety of offenses.

Syndication Is Programming

Syndication is a major force in TV programming. The difference from radio is that syndication is done for individual programs rather than the whole program day.

There are three major types of TV syndication: sale-of-series programs that have already run on a network, movies, and sale-of-programs specifically created for syndication.

Any series that has run on a network is apt to be offered for syndication if it had a long enough *first run* on the network to provide an adequate number of episodes. In some cases syndicators have commissioned additional episodes of a program to bring the number of shows available up to a minimum needed for syndication.

Syndication and the selection of syndicated programs is a tricky business. A program that did very well on the network may die in syndication. Sometimes the subject matter is outdated. For instance, programs on World War II

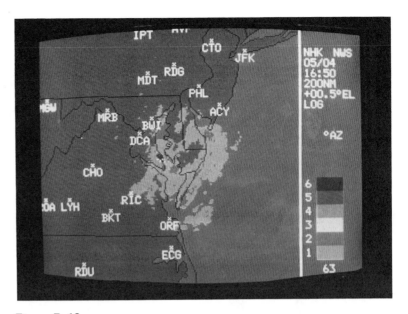

Figure 7–12
National Weather Service radar processed into a color weather visual for television stations' weather forecasts. Courtesy of Alden Electronics, Inc.

Figure 7–13
Production computer systems now make it possible to put the scripts of television shows on screen as closed captions for benefit of the hearing-impaired, who use special decoders to make the writing visible. Since the caption comes directly from scripts prepared by writers, producers, and reporters, these professionals must obviously spell correctly. Courtesy of Dynatech NewStar.

Program Schedule Comparison for an Affiliate and an Independent

For our comparison of weekday schedules we use a fictitious CBS affiliate and a fictitious independent in a top 30 market.

Time	Affiliate Program	Independent Program
12 midnight	Remington Steele (CBS) (in progress)	Off the air until 7 A.M.
12:40 A.M.	CBS Movie	
2:00	CBS Nightwatch	
6:00	CBS News	
7:00	Local Morning Show	CNN Headline News
8:30	Woody Woodpecker (local)	
9:00	Donahue (local synd)	Morning Movie
10:00	$25,000 Pyramid (CBS)	
10:30	Card Sharks (CBS)	Partridge Family
11:00	Price is Right (CBS)	I Dream of Jeannie
11:30	Price is Right (CBS)	Bewitched
12:00 noon	Local News/Interview (preempt network)	Fashion America
12:30 P.M.	The Young and the Restless (CBS) (second feed, net 12 noon program)	Afternoon Double Feature Movie
1:00	The Young and the Restless (CBS)	
1:30	As The World Turns (CBS)	
2:00	As The World Turns (CBS)	Afternoon Double Feature Movie
2:30	Capitol (CBS)	
3:00	Guiding Light (CBS)	
4:00	Jeopardy (local syndication)	Vegas
4:30	$1,000,000 Chance of a Lifetime (local syndication, no net service until 6:30 P.M.)	Vegas
5:00	Divorce Court	Police Woman
5:30	Local News	Police Woman
6:00	Local News	Early Evening Film Feature
6:30	CBS Evening News	
7:00	PM Magazine (local syndication)	
7:30	Entertainment Tonight (syndication)	Live Baseball
8:00	CBS Special	
9:00	CBS Feature Movie	
9:30		Local News
10:00		INN News
11:00	Local News	Horror Movie (until 12:30 sign-off at 12:45 A.M. following devotional program)
11:30	Simon & Simon (CBS)	

ran into trouble once public protest over the war in Vietnam became strong in the late 1960s and early 1970s. Some comedies become outdated due to changes in style or shifts in what the public perceives as humor. However, some shows such as the space adventure "Star Trek" return in syndication and become cult hits to a new generation of televiewers. Occasionally, a very old show will be brought back and will become popular. A sudden interest in westerns could, for instance, stimulate the reissue of dozens of off-network series.

Movies

Hollywood films and made-for-TV movies offer another lucrative market for syndicators. There are thousands of motion pictures available for reuse. Usually the syndicator offers several films as a *package,* which frequently includes a few blockbuster box office hits and a larger selection of not-so-good films. One problem faced in syndicating films is that some films simply don't have a market. Black and white films are less viable, although they are being shown frequently on cable, and late at night on some TV stations. The new technology of *colorization* permits color to be added to black and white films and may result in many more years of syndication for some of the more popular black and white films and TV series.

Hollywood also produced a great many mediocre films, known as "B" or second-feature films, which ran as the second of double-features with better movies. These quickly produced B-grade films are less apt to sell to tough-minded program directors who want to book films people remember and films that will have good reviews in the TV guide magazines.

Some films in other languages and from other countries are offered for syndication, but most have to have their sound redone in understandable English. There is a significant market for Spanish-language films in the United States due to the large number of Hispanics in the population.

Programs Produced for Syndication

The third area of syndication is original programs. As the number of films available has been used up and as off-network programs have become expensive to buy, interest has grown in programs produced specifically for syndication. The development of cost-effective satellite service has pushed this market to high levels. Some of the successful programs have been audience–participation interview shows, and produced-for-syndication quiz programs.

Innovative Programs

Two of the more innovative approaches of recent years include "PM Magazine," which is an access time news feature program produced by Group W (Westinghouse). The program requires the local station to hire two hosts and a small production team. A small number of the program's features are produced locally, and the hosts tie these together with Group W-supplied features done by other stations and by Group W crews. By swapping the segments around, it was possible to do a fairly complicated program nightly at reasonable cost. Other firms have done similar programs using the same technique. Another innovative program has been "Entertainment Tonight," a daily satellite-fed broadcast done in network news style and featuring stories about entertainers and media celebrities.

Specialized Programs

There are also a wide variety of syndicated programs produced for specialized markets, including wrestling, auto racing, fishing, bowling, exercises, and live sports programs. Some major colleges produce a postgame show with the foot-

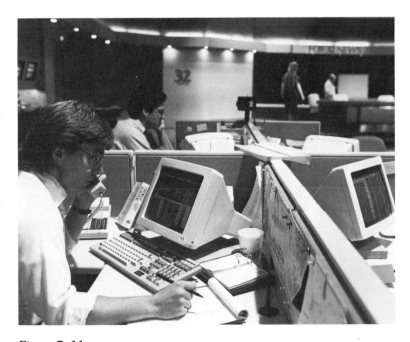

Figure 7–14
Reporter at independent TV station WFLD-TV in Chicago "works the phone" to get additional details on a wire service story taken from the computer screen. Courtesy of Basys, Inc.

The Monitor talks to the President.

Philippine President Corazon Aquino discusses the future of American military bases—July 26/27.

Watch us <u>weekly</u>.

On WQTV, Channel 68, at 7 p.m. Saturday and 12:30 p.m. Sunday

CO-PRODUCED BY THE CHRISTIAN SCIENCE MONITOR, AND INN—THE INDEPENDENT NEWS

Figure 7–15
Satellite technology makes possible live interview programs with the world's newsmakers. In this case, a Boston TV station produced a program which, a few years ago, would only have been done by a network. It was then distributed by INN, a network serving independent TV stations. Courtesy of the Christian Science Monitor, WQTV, Boston.

ball coach (using game film or tape), which is shown regionally.

Programming on Public Broadcasting

Noncommercial TV programming got a big push when Congress was persuaded to fund the Corporation for Public Broadcasting (CPB) and the National Telecommunications and Information Administration (NTIA).

Prior to the allocation of federal funds public noncommercial TV stations were largely supported by state or university funds. The high cost of putting a TV station on the air and maintaining its staff and programming kept all but a few organizations from venturing into the field. Once CPB was created to help fund the production of national programming and the creation of a public network, the building blocks were in place for the creation of a national public broadcasting system, and that's what we have today.

The existence of a public TV network is vital to public TV. It is simply too expensive to do regularly scheduled cultural programming on one station. Spreading the cost among network af-

filiates is the only way to support quality programming.

Station Program Cooperative

The network programs that are shown on PBS are selected through the Station Program Cooperative (SPC), which is a marketing system through which public stations select and finance programs distributed by PBS. SPC was started in 1974, and in 1986 it contributed funding for 874 hours of new programs.

Producers submit proposals to PBS for inclusion in the SPC voting. The proposal amounts to a funding request, which can be for either production or acquisition of programming. Some programs will have received partial funding from other sources. The public TV licensees share the cost of the SPC programs through a complicated formula, which takes into account station size and budget. The proposals are reviewed by an advisory group of station personnel. The review committee, through a voting or bidding process, confirms that sufficient stations will commit to the program to cause its cost to be within reason for the affiliates.

Satellite Service

The PBS network made an early investment in satellite technology, which brought about a significant reduction in its cost of program transmission. PBS and some affiliates earn additional revenue from renting unused transmission time or facilities.

British Productions

CPB and PBS have combined resources to bring to the TV screen some of the finest British drama. The reason a significant amount of British-produced drama ended up on American public TV has to do with the basic differences in the two countries' broadcasting systems. While commercial sponsorship in the United States has underwritten some excellent dramatic programs based on established American dramatists, this sort of programming makes up a small proportion of the total offerings of the U.S. commercial networks. When PBS investigated the cost of producing original drama it found that the time and expense involved would limit production to a relative few hours of dramatic programming per year. British broadcast law mandates that the government networks, the British Broadcasting Corporation (BBC), and the Independent (ITV) networks produce a fairly large

amount of cultural (i.e., drama, music, arts, documentary) programming. The British were anxious to sell these series and found a willing purchaser in PBS, which was able to secure corporate underwriting to pay the cost of importing the British series. One example of the British programming was the popular series about British aristocratic life, "Upstairs, Downstairs."

News Programming

The PBS newscast, the "MacNeil/Lehrer News-Hour" focused mainly on one big story and took advantage of its production facilities in New York and Washington, D.C., to invite important live guests to appear to discuss at some length the issues involved in the day's big story. This was entirely different programming from what the commercial networks and stations offered.

Local PBS Stations

Programming on most public TV stations comes largely from PBS, with local shows and programs produced by regional consortiums making up the balance. Regional and statewide public TV networks have developed to provide relevant programming in a region at reasonable cost. The complexity and costliness of local programming is often determined by funding available and the local station's location. PBS stations in Boston, New York, Philadelphia, and San Francisco have frequently produced programs which were subsequently shown on the public network. This is because the stations were able to raise the funds to construct sophisticated production facilities and then were able to tap local production and talent resources. For instance, WGBH-TV in Boston, Massachusetts, has been the source of many programs involving the Boston Symphony Orchestra and the Boston Pops, simply because these two outstanding musical organizations were available and the community could provide enough money to defray production costs. The same station originated a long-running series based on demonstrating the techniques used in restoring old houses. That program became a PBS feature.

Other PBS stations have leaner budgets and place greater reliance on studio interviews and less elaborate production. The development of lower priced video equipment used to record program material outside the TV studio has made it possible for many smaller PBS stations to produce documentaries and other original outside the studio programming. Frequently, the energy

and inventiveness of the producers and technical crews make up for a lack of funds in public broadcasting.

Television Stations and Narrowcasting

As competition in the telecommunications world becomes more intense, *narrowcasting* becomes more common. Narrowcasting means programming to a narrowly defined specialty audience, as opposed to putting on a program that you hope a great many people from the mass public will watch. For instance, broadcast stations have begun to supply programming to cable systems. They know their audience is more limited due to the smaller number of cable subscribers and the wide variety of programming choices available on some cable systems. But the cablecast permits the broadcaster to resell programming and better utilize his expensive plant and personnel. One broadcaster in Atlanta, Georgia, explained it succinctly when he said his company found that a certain amount of advertising was going to cable, and they wanted to be part of the cable system so they could catch some of that advertising, so they began to produce cable programming.

Cable Programming

Although cable on the local level is primarily a retransmission service, availability of cable channels on local systems and availability of satellite transponders at reasonable prices stimulated a tremendous growth in the cable programming industry. Much of the programming presented on cable channels resembles what a TV network might transmit. For instance, because the broadcast networks have traditionally broken their program continuity on the hour and half hour, you will find that cable services try to start their programming on the hour and half hour. The major difference in some of the cable networks is that they limit themselves to transmission of a specific type of program, such as news, sports, or movies, instead of offering a mixed program schedule similar to a broadcast network. Other cable networks intentionally offer a variety of programming and closely resemble the broadcast networks in their selection of programs and program times.

One reason there are so many cable networks is that it is relatively inexpensive to set up a

cable network. The uplink facility and transponder time can be leased and frequently the local cable system bears the cost of installing a downlink or receiver. The technical equipment can be similar to the control room at a well-equipped local TV station, which when compared to the cost of network transmission facilities, is not expensive. The programming makes up the largest part of the expense and this varies depending on the choice of programs. HBO is a relatively expensive service because it licenses (rents/leases) recent blockbuster movies. However, a channel showing only old movies doesn't have to pay much to rent the films. A specialized channel offering merchandise for sale can operate out of one or two small studios using relatively inexpensive equipment, plus special telephone equipment and a computer order–fulfillment system.

Cable Network Audiences

Cable networks have specific audiences in mind when they plan their programming. For instance, one cable network programs old (as in black and white) movies, which certainly isn't a mass audience approach but is assured of attracting a specific group of viewers. Other examples of narrowcasting on cable include Headline News (CNN), the Christian Broadcasting Network, the Playboy Channel, ESPN, and HBO.

Narrowcasting can be profitable on cable providing you can figure out how to fulfill the simple business formula that revenue must exceed expenses by a decent amount. HBO has done well, while ESPN struggled for years to pass the profitability point because covering live sports, even minor or foreign events, is expensive. The narrowcaster approaches advertisers by demonstrating that he can provide a reasonably large, loyal audience made up of people who are likely to use the sponsor's product or service. In the case of cable, some cable services carry no advertising, relying instead on splitting extra-service fees collected from subscribers with the cable company. Companies that do nothing but run mail order catalog of the air programming are narrow in target but can be lucrative as businesses.

Local Origination

Local origination by cable outlets is a form of narrowcasting because the maximum audience is limited to subscriber homes in the community and the actual audience is limited to people who are attracted to programming run on the local origination channel, such as a high school football game.

PROGRAMMING CONSULTANTS

Both radio and television use firms to help them choose their programming or to advise them on what parts of their programming to change. TV stations are particularly prone to seek advice with their news programs. Three of the best known consulting firms which specialize in TV news are McHugh & Hoffman, Frank Magid, and Al Primo.

One of the most publicized effects arising from a news consultant's work was the famous Christine Craft case. Her TV station had hired a consulting firm to help them with their news show and as a result of the consultant's recommendations Ms. Craft, a news anchorperson, was fired. One of the reasons given for her firing was her "appearance." This decision was fought through the federal courts and ended up costing the broadcaster a sizable amount of money.

SUMMARY

Programming is the essence of telecommunication. You must present something people want to listen to or watch. Despite the rapid growth in number of media outlets, changes in the types of programming available have been slow in coming with most program offerings reusing old programs or program ideas.

The variety of programming channels available has led the telecommunication industry to narrow the focus of some outlets in hopes of attracting audience with very specific demographic characteristics.

Vast technologic changes in the available means of transmission have opened new vistas for distributing programs. In the 1980s satellites took over from telephone company cable as the preferred means of distribution. This significantly reduced the cost of transmission and vastly increased the available channels. The result has been an enormous increase in programming available to cable systems and radio stations. Better transmission facilities have caused the TV networks to face more competition and to be faced with preemptions by their affiliates. These same technological breakthroughs have in-

creased the viability of non-network-affiliated (independent) TV stations.

Specialized satellite transmission technology has widened the scope of local news coverage and redefined the relationships between affiliate and network news departments.

Newer technologies, such as fiber optic cable, KA-band satellite transmission, and V-SAT satellite technology will continue to reduce the cost and increase the flexibility of program distribution systems.

GLOSSARY

Actuality Radio news insert; the voice of a newsmaker.

All-News Radio A radio format that places heavy if not exclusive emphasis on news and news-related material such as sports, weather, and traffic conditions.

Alternative Used in radio to describe programming not usually heard in the mainstream of broadcasting. It is frequently relegated to a small group of listener-supported or public stations.

Alternative music Usually refers to music that is popular with younger listeners and has not yet achieved wide popular acceptance.

Automation Computer-controlled equipment which performs mechanical tasks of technician and/or air personality.

Barter A business arrangement by which syndicator gives station use of program at no charge in return for right to sell a certain number of commercials within program to national or regional sponsors.

Call-in show Program on which calls are accepted and aired from the public.

Cartridge recorder Record/playback machine that plays endless loops of tape contained in plastic cartridge. Tape record/playback unit puts tone on tape and detects it when playing causing tape to move to designated starting point after being played.

Cassette tape Narrow tape encased in plastic container; used in portable record/playback equipment and in some radio stations for recording and playback of program elements; can have cue tones embedded on it similar to a cartridge.

Color Trade term for description of anything relevant to a sports event except the actual plays. The two sports announcing positions essential to most live coverage are play-by-play and color.

Community radio Special low-power radio classification in Britain; proposed to serve ethnic, racial, and social subgroups. A concept in radio in which members of a community collectively program a radio station.

Compact disc Disc-like digital recording medium, which gives high quality reproduction.

Daypart Literally, part of the day. In radio, usually broken into 6–9 A.M., 9 A.M.–noon, noon–4 P.M., 4 P.M.–7 P.M., and 7 P.M.–midnight. In television, usually morning, daytime, prime time, or overnight.

Disk jockey Trade term for recorded music host/announcer. Term originated because records were called "disks."

Drive periods In radio times of day, 6 to 9 A.M. and 4 to 7 P.M. when people are likely to be driving to or from work.

Electrical Transcription (ET) Early recording medium. Live programs were transferred by a cutting stylus onto a coated disk with a soft metal core. The reproductions were of adequate quality, but the disks wore out quickly and were awkward to handle because of their large diameter. ETs were used before audiotape came into being.

Focus sessions Research technique in which selected panel of people are encouraged to talk freely about topics by a skilled group leader while the session is recorded and sometimes observed by trained researchers.

Format An outline of a program or, in radio, the type of music played and the style of the presentation.

Live assist automation A form of automation in which music and some program inserts such as commercials, public service announcements, and weather forecasts are inserted automatically by computer controller while air personality performs announcing duties live.

Log A daily list of a station's program activities, second by second, which shows names, times and lengths of programs, program elements, commercials, and other announcements of broadcast station. Also, a list of transmitter readings or maintenance actions by the engineering staff (at times known as operating log or traffic log).

Long-form programming Term used in network radio indicating a program longer than the customary 5- to 8-minute newscast or feature; specifically applied to popular music concerts carried live or by tape delay.

Microwave unit Many radio stations save money on rental telephone lines at remote sites by employing their own line-of-sight transmission system, using a microwave frequency. This is a compact technology when used in 30- to 40-mile range of station microwave antenna.

Mixer An amplifier with sufficient microphone inputs to mix sound from the remote crew and the crowd.

Narrowcasting In contrast to broadcasting, aiming for a clearly defined audience, usually on the basis of demographic or geographic characteristics.

NATPE National Association of Television Program Executives.

Pilot Sample TV program, usually for a series.

Playlist Songs a radio station plays, usually limited to 40 to 60 current songs for most popular music formats.

Pre-empt To override, substitute, or replace, as in replacing a network program with a local special.

Remote Trade term for an away-from-studio broadcast. Sometimes called "nemo" by old-timers.

Rotation A plan describing the times of day and number of plays each song on a radio station's playlist gets during the day; also refers to the way commercials are scheduled and when they play and can refer to rotating dealer tags to give schedule and adjacency variety and equal distribution to all participants.

Paul Schafer Inventor of radio program automation system in 1956.

Satellite Newsgathering Vehicle (SNV) Truck with Ku-Band up and downlink antenna mounted on it, which can transmit a news story or program from a remote site to a satellite, and then to stations or station designated to receive the signal.

Sportscast (sports newscast) A broadcast devoted to news of sports.

Syndicator Firm selling or leasing programs that have previously aired, movies that have been shown, or programs produced especially for syndication to broadcast stations, cable systems, and cable networks.

Talk radio A format in which the program host interviews guests and takes calls from listeners.

Tape delay Audio or videotaping a program for play at other than the scheduled time; also refers to the recording of a live performance or event for replay later.

Video Jockey (VJ) Video version of a disk jockey; host for a TV format in which station plays videos by recording stars and has a live host to introduce videos and do commercials.

Voice synthesizer Computer-controlled device which can form recognizable words in response to a variety of commands.

THE AUDIENCE AND RESEARCH

How do you measure how many people are watching TV, cable, or VCRs at any particular time? How many are listening to radio? Are they listening to AM or FM? What kind of station, talk or music?

It is important to know the *size* and *nature* of your *audience* because the telecommunication industry sells an *intangible product, influence and impressions,* to unseen consumers. A newspaper can state fairly accurately the number of paid subscriptions it has and where the issues go. It can state less accurately how many other people read the paper at the receiving address and how and if they retain the message in an advertisement.

Audiences must also be measured in terms of (1) *who they are,* (2) *how much they earn,* and (3) *what they are liable to spend.* It would be a waste of time to run a commercial for a rock and roll album or CD store on a music station with an audience made up of people 50 years old or older living on fixed incomes.

Telecommunication *advertising* goes out to an unknown number of people, of unknown *demographic* characteristics, who may or may not be paying attention. The only constants are the *predicted coverage area* of the signal (broadcast, cable, microwave, or satellite) and the *total number of potential consumers* in the *service area.* Therefore, the *telecommunication industry* is particularly dependent on surveys and research to establish meaningful estimates of the size, composition, and attentiveness of the audience. Vast amounts of money are spent each year by telecommunication outlets and advertisers in an effort to pin down the degree to which the dollars spent on advertising yield results.

HOW IS ADVERTISING SOLD?

National, regional, and some local advertising is bought on the basis of *cost per one-thousand impressions* (or viewers). The letters *CPM* are frequently used in the language of telecommuni-

cation sales to mean cost per thousand. This dependence on the cost per thousand yardstick explains why telecommunication outlets have to come up with some means of making accurate estimates of the size and makeup of their audiences.

HOW DO WE FIND OUT WHO IS LISTENING AND WATCHING?

The first step is the famed *"ratings."* These establish the probable size of a station or network's audience in any 15-minute period and indicate something about the type of people who are listening or viewing.

SWEEPS—ANOTHER NAME FOR RATINGS

The *sweeps* is an industry term for the quarterly national television ratings. They are taken by *Nielsen* (a subsidiary of Dun & Bradstreet) and *Arbitron* Ratings Co. (owned by Control Data Corp.) in November, February, May, and July of each year.

The sweeps are taken in 214 local TV markets, which cover most U.S. TV markets. The sweeps estimate station total audience, *program preemptions, cumulative audiences,* and viewing by demographic characteristics. Although the networks refer to the sweeps ratings in their sales presentations, they sell commercials on the basis of *metered overnight ratings* taken in *10 to 12* of the nation's largest cities, which contain over 33 percent of the national TV audience. The same metered systems generate weekly ratings for use by the networks and their advertisers.

The November, February, and May sweeps account for the sudden increase in network *specials* and mini-series during these months. It is important to both the networks and their affiliates to capture the highest audience estimates

Metered Audience Reports For Three Time Periods

Daily Meter Reports

By 6:30AM local market time, the computers have processed and analyzed all the audience data. After the information is verified, the reports are released for client access at 9AM local market time. Daily Meter Reports offer full-day quarter-hour station-by-station ratings and Households Using Television (HUTs).

Weekly Meter Reports

Seven days — Saturday through Friday — of daily viewing data are combined to make up the Weekly Meter Reports. Weekly daypart reporting and program audience averages can be accessed at 9AM each Monday directly by clients via their own computer terminals. Program audience averages and weekly quarter-hour viewing are available in a printed report which is mailed to Arbitron clients the following Tuesday.

Monthly Sweep Reports

Sweep reports integrate data collected electronically by meters with information provided by Arbitron television diary keepers. The monthly reports profile television audiences demographically.

Figure 8–1

Ratings service publicity piece listing available ratings reports based on different time periods. Courtesy of Arbitron Ratings Co.

during the sweep months. The July sweeps are less significant since television viewing traditionally drops off during summer when people are likely to be occupied outdoors or away on vacation.

How the Sweeps Are Done

Here is an example of how the sweeps are done: The Sanderson family of Treeline, Montana, opens their mailbox and among the bills, ads, magazines and a letter from Aunt Tilly, they find a manila envelope from the Nielsen Company. Inside, there's a neatly typed letter and something which looks like a day and date diary. There are also two shiny quarters, wrapped in plastic. The letter tells the Sandersons they have been selected by the Nielsen Company to participate in an audience study of their area television market. The quarters are a small reward for helping out with the survey. The letter goes on to ask the family to keep a record, in the diary, of all their television viewing for a 7-day period. There's another envelope inside with return postage already stamped on it. This is to be used by the Sandersons to mail the diary back to Nielsen.

How did the Sandersons, who own a cattle

ranch in Montana, end up being a diary family for TV ratings? It was simple. They own a telephone. Experts from Nielson had set up a system to pick every 67th telephone number from telephone books serving the *"Designated Market Area"* (DMA) (as Nielson calls it), which is the counties in the area around a cluster of commercial TV stations' signals. In a rural area similar to Treeline, the DMA may include two or three populous communities. Because not all of the television stations are located in one central community, like Denver, Colorado, each television market must be determined by the signal strength of the stations in the area.

The rating services each mail out 200,000 7-day diaries to randomly selected TV households, asking household members to fill in a record of their viewing choices and supply demographic data. The random selection can be done from telephone books, city directories, or any other comprehensive list. It must ensure that each person has an equal chance of being chosen. Most random lists are computer generated. Usually, the rating service includes a small gift with the diary, but the main appeal is to the family's ego, telling them they are performing an important service. The services report they usually get back about 100,000 diaries. That breaks down to

somewhere between 200 and 1,500 diaries being used in any one TV market to rate that area's viewing habits. Industry sources say stations pay from $15,000 to $100,000 yearly for the quarterly ratings.

ARBITRON FOR RADIO

Arbitron Ratings is the major national radio rating service, compiling figures for 259 radio markets. It began measuring radio audiences in 1964 and conducted its first April/May survey of radio listening in 150 markets in 1950.

RADAR

Network radio ratings are compiled twice a year by a service called *RADAR*, a trade name of Statistical Research Inc. of Westfield, New Jersey. The RADAR ratings are compiled by diaries mailed out in the same manner as the TV diaries.

AUDIENCES—WHY SAMPLE THEM?

Audience sampling is based on a simple premise. This premise is that if you are able to obtain a randomly-chosen, adequately sized sample of people, their responses or behavior will mirror the total population, within a certain margin of error. These samples are used as indicators of what people watch and therefore as a potential spot to place advertising. Television research and sampling are not being done to advance research but rather as a better way to find out how to get the attention of the most viewers in order to sell a concept or product, or to prove the value of the thing being viewed.

In a television market, which has a potential of one million viewing homes, only a few hundred will be surveyed. It is hoped that this group will react much in the same way as the total viewing population. It is further hoped that the sample will closely reflect the number of people in different age groups, the audience in terms of gender, and factors such as income, amount of daily viewing, number of adults in the household who work, and other valuable information. Sampling becomes an estimate of a population called *view-*

ers, and the way the figures are used is based on years of previous experience.

Population Figures

Every 10 years the U.S. Census Bureau tries to count the total population of the country and provides vital statistics, which are incorporated into a great deal of telecommunication research. Attempting to visit every household in America is a massive job, which even the Census bureau doesn't accomplish during its once a decade census. Several visits a year to every household in the country to check on radio use or TV viewing would be beyond the financial means of any audience survey organization. Since the ratings companies cannot ask each of more than 240 million Americans about their program preferences, they select a small portion of a larger population at random as a sample.

The Random Sample

To devise a *random sample,* you have to come up with some sort of list. To be random a list is supposed to give everyone an equal chance of being chosen. One common list is the telephone directory. Other popular sources for survey populations include U.S. census maps and city directories. As you might suspect, researchers have to go to considerable lengths to overcome some of the problems involved in using these lists. Telephone directories are out of date by the time they are distributed and don't show anyone with an unlisted number, or anyone who doesn't have a phone. They also list businesses as well as individuals. Audience survey organizations known to broadcasters as rating companies use special updated telephone directories and also make a certain number of telephone calls by just dialing combinations of digits without knowing the name of the person being called.

The Sampling

The ideal way to approach sampling is to change the sample every time you conduct a new survey. This can be done if you do a telephone survey or have respondents write information in a diary, but it is more difficult to change the sample if you have installed an electronic device in the home. The national rating companies solve this problem with their electronic rating *meter* sites by changing about one fifth of the homes where electronic sampling devices are installed every

The Arbitron Television Meter Service Sample of Households

All television households in a market have a chance to be included among the households that actually participate in an Arbitron metered survey. Arbitron follows a strict and complex procedure to ensure that the homes chosen to be metered are representative of the entire market. A complete description of all procedures involved in selecting the meter sample households would fill a volume well over an inch thick.

As many as 10,000 households are identified in each market to determine and reflect the market's demographic and economic character. These households are selected at random based on a comprehensive list of homes and addresses compiled by an independent company and are distributed proportionately throughout the market. These households, called the "Parent Sample," are arranged in subsamples from which the actual meter panel is randomly selected. Ultimately 300 to 500 households are selected to participate in the meter panel. They represent a cross-section of all the households in the TV market. When households agree to participate in the meter panel, Arbitron gives them an intitial monetary premium, a monthly premium to pay for electricity used by the meter equipment and free television repair service during the time the household is in the panel.

Arbitron carefully considers many factors in selecting the meter panel. These include geography, household size, income, education, race, number of children, age of head of household and availability of cable TV.

Arbitron also recognizes that populations change over time; therefore the meter panel must keep pace. A turnover procedure accounts for these changes by gradually changing the Parent Sample and the actual meter panel so that within five years, (six years in start-up markets) a completely new sample has replaced the old one. This process ensures that the homes participating in the meter panel remain representative of the market.

With Arbitron Ratings Meter Service there is a constant, representative measure of television viewing in the market.

Figure 8–2
Ratings service publicity piece describing the service's statistical methods. Courtesy of Arbitron Ratings Co.

year. In five years the complete sample has turned over.

Some of the problems you have to contend with in sampling include failure to agree to participate, failure to do the tasks requested, having multiple radios or TV sets running at the same time with different members of the family watching different programs, and developing definitions of what is *use* of a radio or TV (is it 5 minutes out of 15?).

As a general rule, the larger the sample, the more indicative the data will be of actual audience use. You have to balance this rule against the cost and effort involved in conducting the survey, and come up with a reasonable sample size that will yield acceptably accurate *estimates*. *(Remember, all we are doing is estimating.)*

Sampling Error

One statistical term we need to deal with is *sampling error,* also referred to as the *margin of error.* By error, we do not mean mistakes. We mean that any sampling method has an area of imprecision within it. You frequently hear sampling results described as being such and such, "plus or minus 3 percent." This means if we actually counted all the people who were in our survey population, the real number is likely to be within 3 percentage points in either direction of the survey estimate.

For instance, when polling is done during the national elections and the results come out with the Republican having 44 percent support in a survey and the Democrat having 42 percent (the

remainder would be people who haven't decided or don't care), then the two-point spread would make the results "too close to call" if you were trying to estimate which candidate would win. In this case you would have to wait until the actual voting took place.

Confidence Level

Another statistical term you may encounter is *confidence level*. This means the degree of probability that a sampling error falls within a certain range. What you end up saying is there is a percentage (let's say 95 percent) probability that a specific station has a certain number of households watching or listening, plus or minus the sampling error. Another way of saying it is, from looking at the material we get back from the viewers, we are fairly sure (95 percent) that a certain station, WZXY, has 60 people listening to it at 4:45 A.M.

Ratings can be affected by external factors. If a rating diary lands in the hands of someone employed by, or friendly with an employee of, a radio station and the rating service does not become aware of this, the whole set of ratings for that market might be distorted, just by one carefully filled out diary.

One story we've heard has to do with a station that showed big audience gains. Competitive stations visited the rating company and looked at the diaries. As it turned out, it is said, one person who kept a diary had listed the station in every quarter hour from 6 A.M. to 10 P.M. as the only choice. The problem? The radio station operated only during the daytime hours.

Ratings are what sell commercial schedules, so stations are very interested in knowing if the ratings are compiled honestly and accurately.

RATINGS AND SOME OF THE TERMS

Rating

A rating gives a comparison between the *actual audience* and the *total available audience*. If a program on a certain station got a rating of 40 it would mean that 40 percent of the potential audience watched or listened to that program. Theoretically, the total available audience is 100 percent, but there are many reasons why sets might be out of use. (Someone's asleep, a burglar is stealing the set, it's broken, etc.) We get

a rating by dividing the number of estimated television households in a defined area by the number we estimate to be turned on, based on our sample. If you look at the "Big" prime time network ratings, you'll discover numbers between 10 and the low 20's are common. Of course, if one network gets a 17, and another a 15 and another a 12, then an estimated 44 percent of the available households are watching network television programming.

Now we need to learn some of the terms used in talking about ratings.

Households

Television viewing is well adapted to study by households because TV is a family activity. A household can be a single room, an apartment, or a house. Households tend to be more stable or consistent than individual people. However, one of the problems with studying households is the rapid saturation of households with multiple receivers. In the 1940s, 1950s, and 1960s, it was common for a whole family (and sometimes the neighbors) to gather in the living room and watch one TV set. By 1989 in the U.S. a black and white TV receiver could be purchased for $45 and a color receiver for $180, making it possible for a great many households to have more than one receiver. The different receivers could easily be tuned to different channels by various family members. The concept of households is no longer a good predictor of viewing patterns. The other disadvantage to measuring viewership by households is that it leaves out college dormitories, fraternity houses, and other viewing locations, such as the friendly local pub. The rating services try to overcome these problems by assigning a diary to each TV set.

Share

To calculate one station's share of the viewers in a market at any one time, you have to first estimate the *Households Using Television* (HUT) and then divide by the station's viewing audience. If the total HUT one evening is 60—60 percent of the households having television in the market—and a station gets a 20 rating, the share is 33 (20 divided into 60 = ⅓ or 33.3 percent). The share figure looks better on sales presentations and gives a clearer picture of the station's position in the market. A rise or fall in

the share number is important because HUT figures remain fairly constant unless there is some extraordinary event, which causes people to tune in at other than their normal viewing times.

Cume

Cume is an abbreviation for *cumulative audience.* It is useful in radio because the large number of radio station signals heard in most markets causes the ratings or shares to be small. If the ratings numbers are small, the next thing to do is figure out how many people the station reaches over several hours or days. This cumulative figure can be quite large, as people dial in and out of radio signals far more frequently than they do TV signals. Specialized radio stations, such as all-news stations, find the cume an excellent figure to use when making sales presentations because their audience turnover tends to keep the rating or share down, but the *dial-in, dial-out* effect can yield excellent cumes.

Demographics

Demographics is a catch-all word meaning *major characteristics of the audience,* such as age, gender, race, and income level. The major areas advertisers consider are gender and age, and they frequently request advertising availabilities based on rating points and desired demographics, such as women, 18 to 24 years of age.

The most popular demographic group for most advertisers and broadcasters is the 25 to 54-year-old age group.

Changing Demographics

Research by the National Association of Broadcasters has revealed that the proportion of elderly people compared to the rest of the population was increasing by 20 percent during the 1980s. By the year 2000, the NAB says, this will be America's fastest growing age segment, with 13.1 percent of all Americans being age 65 or older.

The NAB data indicate the 55+ age group is the heaviest consumer of television, watching nearly 35 hours per week (based on 1983 Nielsen data). The report says the 65+ segment has a $60 billion purchasing power, and twice the discretionary buying power of people under 35. *Discretionary* purchases make up a large part of the items advertised on the broadcast media. This refers to the fact that consumers in the

United States often can make choices concerning the nature of the products they purchase and where they buy them. (You could wash yourself with yellow laundry soap, but you don't, do you!)

Diaries

Diaries are notebooks that viewers who are selected to participate in the rating process fill out. Most of the Nielsen and Arbitron TV ratings and the Arbitron radio ratings are gathered by using diaries, which are mailed to selected households. Small additional samples are gathered by interview (telephone or personal) methods to lessen statistical errors caused by lower response to diaries in low-income and minority neighborhoods.

Meters

Meter is the term used by researchers to describe electronic devices installed in a few homes to record set use. The A.C. Nielsen Company had been the major user of this technique. The national network ratings are obtained in about 22 markets using a combination of a meter attached to each TV set in the home and a small computer that collected the data. This information was transmitted by telephone line to Nielsen's main computer, which calculated the ratings. The meters could not record whether anyone was watching or who was watching, so the rating company also supplied diaries to metered homes to gather demographic data. The same system provided overnight ratings for stations in the major cities where the network ratings are gathered. The other major TV rating service, Arbitron, does some data collection using meters.

New to radio is the *Arbitrends* service, a product of Arbitron. The Arbitrends are monthly ratings, which can be fed into a radio station's computer. They were planned to cover the top 23 markets. The *monthly ratings* were designed to show variables such as *continued growth of audience* and *seasonal changes in audience.* Most radio stations in large markets rely on Arbitron ratings taken three or four times a year. The Arbitrends ratings were designed to be more responsive to change. They also cost more.

People Meters

The latest innovation in audience research is *people meters.* These are measurement devices

How Arbitron Meters Collect Viewing Information

Q. What are the benefits of Arbitron's metering system?
A. A meter system offers:
• Information on *all* telecasts
• Minute-by-minute data
• Weekly cume and other analysis capabilities
• Faster reporting

Q. What can the current meter determine?
A. It reports:
• When a television set is on
• To what channel the set is tuned
• How long the set is tuned to a specific channel

Q. How does the system work?
A. There are three basic elements to the meter system:
• Television meter
• Household collector
• Data retrieval system

Q. What is the meter?
A. It is an unobtrusive electronic device encased and attached under or behind a television set.

Q. What is the household collector?
A. The collector stores the information from the television meter.
Tuning choices from up to four meters can be retrieved and stored each day in a suitcase-sized microprocessor.
To protect the data from possible interruption of electricity, the household collector is backed by a reserve battery power source.

Q. How is audience information retrieved by Arbitron's computers?
A. Sometime between 2:30 and 4AM local market time, Arbitron Ratings' central computers in Beltsville, Md. use telephone lines to contact each household collector and retrieve all the information stored in the collector.

Figure 8–3
Ratings service publicity piece describing the use of audience meters. Courtesy of Arbitron Ratings Co.

which electronically record what time a television set is turned on and the channel to which it is tuned. The people meter also requires each member of the household to indicate when he or she is watching by pressing a designated button. The information stored in the people meter is retrieved over telephone lines. The rating service stores demographic data on each respondent. The data are automatically matched by a computer with the information fed to the meter by the viewer.

The obvious problem that this creates is with the person who puts on a set to have noise in the house but does not watch, who is then superseded by another who comes in and changes the channel but does not push the recognition button. This can create the following scenario. A 44-year-old female executive is listed as watching three games shows, then a basketball game, followed by two cartoons. What really happened was she came home and wanted some background sound, meant to switch to CNN for news but hit the wrong channel and ended up in the den at the other end of the house on a business call. Junior came home and changed to the sports channel but didn't punch in the ID information, and then got bored and wandered out to the kitchen to get a snack. Six-year-old Jennifer came in and put on the cartoons. The ratings that this scenario produced would be quite intriguing especially when one thinks of the demographics involved and the fact that one sample would be

The Arbitron Ratings Meter Service System In Action

Tuning decisions are monitored by the meter. Each household collector can store 256 different decisions lasting sixteen seconds or more from up to four television sets. Early each morning, between 2:30 A.M. and 4:00 A.M., Arbitron's central computer in Beltsville, Md. uses telephone lines to access the tuning information from the household collector. This data is converted into Arbitron Metered Audience Reports and made available to Arbitron clients by 9:00 that morning.

Figure 8–4
Ratings service publicity piece describing the operation of a meter-based audience survey system. Courtesy of Arbitron Ratings Co.

projected to yield a population of probably 134 upscale adults who like to watch sports and cartoons in the afternoon. This points up that one of the most important attributes of a researcher doing sample, survey, and predicting work is the ability to look at the material and see if it makes sense.

The idea of a people meter is to combine the advantages of a diary, which gives the rating service information about the people who are watching, with a meter which gives the fastest return of data. One system employs a bar-code reader pen to measure household purchases during the rating period.

Early experience with people meters produced a drop in network shares and childrens' program

ratings, and improvements in syndication and cable numbers. The initial samples consisted of approximately 4,000 households for Nielsen, and several hundred for ScanAmerica (Arbitron), 5,000 for AEG, a British ratings company, which entered the U.S. market briefly when people meters began to be used in 1987. The parent company of ScanAmerica, Arbitron, targeted its people meter program to survey the top 20 local markets by the end of 1995. At least 600 homes are surveyed in each ScanAmerica survey market. Eventually recorders will be placed in 18,000 households.

One reason given for the drop in ratings for childrens' programs was that the children were having trouble learning how to use the people meter controls. Psyhcologists were recruited to develop easier controls and the ratings services started to offer toys as incentives to children to enter their viewing into the meters.

Cable systems operators expressed some concern because the people meter samples used were much smaller than those used for cable. This is a problem because there are so many different choices on the typical cable system that you need a larger sample to accurately estimate the audience for a cable service.

The people meter also circumvents literacy problems and gives accurate station data because the computer already knows the station call letters which correspond with a channel setting on the respondent's TV set.

There are drawbacks to people meters. Conventional meters often sit in a household for 5 years. Will the members of a household conscientiously punch their buttons on the people meter for 5 years? Will the aging of household members during the time the meter is in the home be offset by replacement installations?

One of the big problems experienced with diaries is that viewers and listeners do not understand how stations are identified. They will report Z-103 instead of WOOF radio or say they are watching channel 6, except that they are watching cable and channel 6 on the cable system happens to be the channel 13 on-air station! Viewers and listeners are confused partially because the stations develop logos or ways to be identified that are not tied to either their legal ID or the frequency or channel on which they actually broadcast.

Telephone Surveys

There are two popular forms of telephone survey.

Figure 8–5
One type of audience meter. The viewer is required to "check in" with the system when the prompt appears on the TV screen. This meter system tracks who is in the audience and what channel is being watched. Courtesy of ScanAmerica.

Figure 8–6
A "people meter" in use. TV viewers use a remote control keypad to register their personal ID code or name with the people meter. The on-screen prompt and remote check-in make it easy to track viewing by individual family members. Courtesy of ScanAmerica.

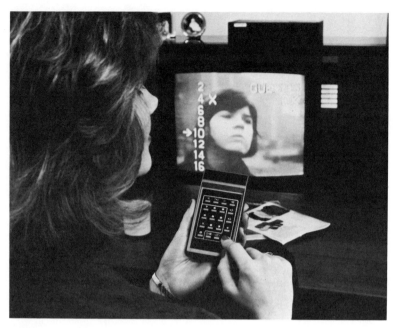

Figure 8–7
A participant in the "people meter" system illustrated above. The participant registers her viewing choices using a remote-access keypad. On-screen confirmation is generated instantly when viewers push pre-coded buttons. Courtesy of ScanAmerica.

The Telephone Recall

Individuals are called randomly and asked to recall what they saw or listened to over the past 24 hours. Usually the same person is called for several consecutive days. The obvious disadvantage to this method is the likelihood people will not remember exactly what they were viewing/hearing at certain times. The other problem is that only people with telephones can be surveyed. People must be willing to spend the time and effort to give the information and must have access to radio or television.

The Telephone Coincidental

The person who answers is asked what is being seen or heard at the moment of the call. Then a few demographic questions are asked to fill out the picture of the audience. It is necessary to make a large number of calls, some in each rated quarter hour. As you might expect, it is difficult, if not impossible, to use this method overnight. The telephone coincidental is used for local surveys but is not used nationally. It has been used by public stations, which usually do not subscribe to rating services.

Focus Groups

A focus group is a method used to gain in-depth insight into audience behavior by conducting a directed discussion with a group of selected respondents. The discussion is recorded and sometimes it is observed through a one-way mirror. This technique is used largely to gather qualitative information about programming or products. It is a supplement to ratings.

Personal Interviews

Personal interviews are an expensive and less efficient method which works best to gather certain types of background information. It is used for some university research. Sometimes limited studies are done in major public areas, such as shopping centers. These types of surveys are usually limited to seeking specific types of information needed by local broadcasters, cable firms, or advertisers.

The Special Survey

Specialized surveys have become popular in radio. In days past, radio program directors used to rely on sales of records at record stores, requests, and lists which were published in the leading music industry trade magazines to prepare their music *play lists*. While all of these continue to be important, an increasing number of radio stations conduct their own surveys to obtain program information. Some of these surveys are conducted on the telephone, others rely on focus groups.

Specialized surveys are frequently needed by specialty programmers and advertisers. Radio stations with black or Hispanic formats need to know the buying habits as well as the music tastes of their audiences. Once a specialty radio station knows what products its audience buys, it can approach advertisers who sell these products. Advertising agencies have done a great deal of work on the product preferences of minority groups so that both marketing and advertising campaigns could be tailored to the tastes of the audience.

Sometimes it is necessary to look at a particular demographic group. For a long time, programmers at all-news radio stations struggled to win more female listeners. Their surveys indicated that upscale males favored all-news programming while all-news was less favored by upscale females. Surveys have been conducted

in an effort to find out why the format does not have more female listeners.

Classical music stations know they have a small, specialized audience. It is important that the program director of a classical music station know who is listening and what the listeners prefer to hear. You may notice that many classical music stations program the more familiar selections, while educational or public stations tend to experiment with new or lesser-known composers and orchestras.

RATING PLOYS

There is a tendency for broadcast outlets in markets facing a *rating period* to put greater effort into their programming and to promote themselves extensively, often using extravagant contests. The major rating services have rules regarding these promotions and they will, if the acts of the station are flagrant enough, "delist" a station, that is, remove it from the next rating period's listing.

Advertisers may benefit from buying commercial schedules during rating periods because they are more likely to get both good audiences and good programming as a setting for their announcements.

ELECTRONIC MEDIA RATING COUNCIL

The broadcast industry created its own organization, the *Electronic Media Rating Council* (EMRC), to address manipulation or distortion of audience measurements. It was founded under another name in 1964. EMRC issues guidelines, which include prohibitions on (1) conducting special research studies which obligate respondents to listen to or watch a specific station or program, (2) contests which run only during the rating period and award larger prizes than given away during nonrating period promotions, and (3) special features or segments which emphasize ratings panels, with the idea of attracting people who are currently keeping diaries or submitting data to meters.

PAYING FOR RATINGS

Who pays for the ratings? Generally, commercial broadcast stations subscribe to one or more national rating service. The radio and TV networks also subscribe, as do advertising agencies and representative organizations. Increasingly, cable services and syndicators buy survey data to prove their value to clients. The charges can vary from several hundred dollars to several thousand, depending on the size of the subscriber and the sophistication and frequency of the data purchased. Some networks, cable companies, and broadcast companies have their own research departments who undertake specific missions which go beyond the gross audience figures developed by the rating services. Most consulting firms include surveys in their services to telecommunication clients.

MARKET RESEARCH

Market research refers to finding out what people buy and why. It is important for advertisers and programmers to understand to whom they are selling or programming. Sometimes surveys fail simply because the beginning premise is faulty. In the mid-1970s most surveys still expected women 24 to 40 years of age to be in the home and surveyed for products and programming aimed at a homemaker market. During the same period there was a tremendous surge of women 24 to 40 years of age choosing to either remain in or reenter the job market.

Market research can involve a wide variety of concerns. A food manufacturer needs to know (1) if anyone thinks they need the product, (2) what special benefit the product offers to the consumer, (3) how the product has to look, feel, smell, and taste to appeal to customers, (4) how the product should be packaged, (5) how the product should be displayed and advertised, and (6) what price can be charged for the product.

Who Listens/Watches and Why

Commercials, programs, and talent are frequently the qualitative and quantitative objects of research. The commercials are tested to see if they convey the message intended. Programs are tested to see if they get a positive reaction from the desired audience. Sometimes stations, networks, and producers try out or test the performance of air talent to try to find out who the audience will prefer.

Testing for reactions to personalities caused a controversy when networks and stations began to investigate ways to find out which talent peo-

Figure 8–8
The parts of a unique audience meter system, which registers both TV viewing choices and consumer household purchasing patterns. The data collected from the system can enable researchers to draw conclusions about the success of TV commercials for particular products, a relationship vitally important to broadcasters and advertisers. The system includes the data collection device, the remote access keypad which allows viewers to check in and register viewing choices, and a data wand used by the participant to scan the bar code of household purchases. Courtesy of ScanAmerica.

ple preferred. One test involved gathering a group of people in a theater and showing them tapes of the individuals being tested. Audience members were told to press buttons adjacent to their seats to indicate levels of interest. In another type of testing, the audience was measured for skin reactions such as perspiration. The theory was that the best choice for talent would be the person who got the greatest degree of physiological response from the audience.

The skin test received a great deal of criticism when it was applied to the process of selecting TV news anchorpeople. Critics said there were ingredients other than the ability to cause a physiological reaction that were important in the selection of anchorpeople.

Commercials are sometimes inserted into what the audience is told are new programs. Then the audience fills out questionnaires, which really gather information on the test commercials, not the programs the people thought they were screening.

There are other variations of these common

methods of ascertaining the potential of a program, commercial, or individual.

Test Groups

Many companies start with small *test groups* who are asked to sample a product and discuss it. They resemble focus groups used in program research. If the test groups react positively, then additional testing is done with groups until the packager is sure the product is desirable. At some point the product is *test-marketed*. It is introduced in grocery stores in one or even a few cities to see if it sells. This is usually a test of the product itself, plus its packaging and advertising.

Certain broadcast markets are known as test markets because advertising agencies have found that the consumers in these markets tend to behave much as people do nationwide. That's why you will occasionally see television commercials for a product you haven't seen elsewhere or can't find in a store in another city until perhaps a year later. Sometimes a product needs to have its marketing approach adjusted for cultural differences if it is to be sold in markets where there are significant percentages of minorities. If you buy some products in New England, you will find that they have both English and French information on the container. French is added as a service to a large number of French speakers in northern New England, and may also be there so that the product can be distributed in French-speaking Canada.

All of this is the result of market research in which a manufacturer attempts to predict who will buy the product and adjusts both the product and its environment to maximize its appeal to consumers.

Broadcast Stations and Market Research

Broadcast stations participate in market research for advertisers. Not only will a station carry test market advertising, it may assist with placement of the product in retail outlets, and may keep a record of compliments and complaints from its audience as a way to give feedback to the advertising agency.

A broadcast station or other outlet may do its own market research to more closely define its audience. This has become a necessity in radio because the addition of more stations and the

splitting of AM and FM signals has created more fractionalization in markets. That way a broadcast station sales representative can tell an advertiser he can reach the 15- to 22-year-old age group on the west side of town to whom the advertiser wants to sell taco chicken burgers.

RESEARCH AS PART OF PROGRAMS

Broadcasters apply research techniques within programming. One of the best known examples is the election poll. It is used to predict the popularity of a given candidate or the likely outcome of an election.

The techniques that work so well to predict winners have come under a great deal of criticism. Critics say voters may be voting according to what the polls tell them, rather than what their hearts or minds tell them to do. Even more threatening, in the minds of some critics, is the possibility that predicted outcomes based on eastern and central time zone votes might keep voters away from the polls on the west coast or cause them to change their minds.

Polling

There are a number of nationwide polls, frequently jointly sponsored by broadcasters and newspapers. The networks are all involved in *polling*. It is used not only during election season, but also as a way to measure such things as the relative popularity of the president or public reaction to government policy. To broadcasters, polls can be a worthwhile expense because they generate news stories. Many of the polls rely on telephone or door-to-door surveying.

Local stations also commission polls. They frequently rely heavily on university faculty and students to conduct surveys. Some telecommunication outlets have expanded their polling efforts because there are other topics of public interest that can be surveyed, and the results lead to interesting news stories.

There are also simple counting procedures which are used to test response to an idea. A variety of telephone counters can be used to add up the number of "yes" or "no" votes on an issue or question. This has been further facilitated by the creation of the "900" telephone number in the U.S., which, for a small flat fee, permits a respondent to dial up either the "yes" or "no" phone number and vote on the proposition being discussed. You don't need a special 900 telephone number; this type of poll done within a local calling area needs only two different telephone numbers, one for "yes" and the other for "no" votes, and some sort of device to count the number of telephone connections that are made in a certain period.

As you might expect, there is no statistical validity to this method, although it can yield interesting results. It doesn't hold up statistically because it is simply a poll of people who were listening who were motivated enough to go to the telephone and dial a number.

RESEARCH AS A TOOL OF GOVERNMENT POLICY

The U.S. government, through the NTIA and other branches, conducts research on telecommunication topics. One of the key problems the NTIA has had to address in the past few years is analyzing the impact and importance of the new technologies. The first question that needs to be answered is, should the U.S. government allocate (and reserve) spectrum space for a new technology? Next, the government has to look at international implications. One of the debates of the mid-1980s centered on whether or not to permit competition in the international communications satellite field. Until then *Comsat,* the Communications Satellite Corporation, had dominated international satellite traffic. Another problem the U.S. government wrestled with had to do with putting existing domestic satellites closer together so that more satellites can be put into orbit.

NTIA also had to look at direct broadcasting by satellite (DBS) in terms of its uses and practical applications versus the amount of spectrum space it might consume. More recently, NTIA has studied transmission standards for HDTV.

The FCC has worked closely with professional engineering societies and manufacturers to deal with equipment quality standards and to develop new technology for improving the broadcast signal.

In the late 1980s the FCC was involved in policy research, attempting to determine whether or not to make provisions for transmission of High Definition TV by existing television stations. Some of the choices involved issues such as: (1) should there be a compatible system to permit all TV set owners to receive a signal while

owners of special HDTV sets would receive high-quality wide-screen pictures; (2) should the government allocate part of the UHF spectrum to provide an extra channel to each terrestrial TV station for use in HDTV transmission; and (3) should the whole TV spectrum be moved to a higher frequency, making obsolete the existing terrestrial TV system?

LISTENING AND VIEWING HABITS

Over the years the location and attention level of listening and viewing has changed, and has had significant impact on the media.

For instance, as David Sarnoff suggested, the radio became a major piece of living room furniture for Americans in the 1930s, 1940s, and early 1950s. The tendency was to own one major radio console (which in later years was combined with a record player) and everyone gathered in the living room after dinner to stare at the radio and listen. Most of the programs in those days sounded like the audio of today's prime time TV programs, with sound effects to help convey the image.

A combination of greater discretionary income and new technology gradually caused radios to be smaller and more portable, and people began to buy them for other rooms in the house, and for the office. Radio was beginning to become a medium that talked to you while you did something else.

When transistors were developed and radios became much smaller, and could be powered by batteries, the radio became a carry-along companion. No longer did listeners want to be wrapped up in a drama; they wanted music. And that was fine because TV had come on the scene in the 1950s, and everyone was back to spending the evening in the living room, watching the TV console!

Technology didn't stand still, and by the 1970s TV sets had become highly portable, and by the 1980s, cheap. Carry-along battery TV receivers, and even color pocket receivers, using some of the first color LCD screens, had become common. TV viewing still required one to look at the set every so often, but family viewing moved from a group activity to an individual activity, with several family members watching their own favorite programs on their personal receivers.

Each change in life-style has created new sur-vey and research challenges for media outlets, programmers, and advertisers.

QUALITATIVE RESEARCH

The need for specific information to use in selling more *segmented audiences* has drawn attention to *qualitative research*. Most rating information is quantitative. It tells us how many people are listening. It gives us only very general qualitative information, in the form of age, sex, and perhaps income breakdowns.

Experts tell us that spot buying has become more marketing oriented. They say media planners are interested in attitudes and lifestyles.

Three approaches to qualitative research include geodemographic, attitudinal, and behavioral studies.

Geodemographics and Qualitative Research

Geodemographics adds categories such as income, geography, occupation, presence of children in the household, home ownership, product usage, and marital status to the usual demographics of age and sex. By using sophisticated computer programs, researchers have done such things as define 47 distinct lifestyle clusters. In the instance of the lifestyle clusters, each residential zip code in a community is given a cluster label, like top income, well educated, professionals, or prestige homes. Although this approach improves the qualitative marketing information we have about a community, you can probably foresee one problem. A typical zip code area in a smaller community might include many subclusters of housing from the very poor to the very rich.

Attitudinal Reactions

One approach looks at subjective audience reactions to broadcast programming, while another technique looks at *psychographics* or a combination of lifestyle and values. One company says it can define "outer-directed" people, who it describes as belongers and heavy TV viewers, while "inner-directed" people are those who generally watch more public TV.

Behavioral Research

Behavioral research relates to product usage. A beer distributor wants to match up the people who drink beer with media that these people listen to or view.

An approach to behavioral research developed late in the 1980s is called *Single-Source Research*. This technique calls for tracking exactly what advertisements people see and how what they see affects what they buy. The researchers recruit a test panel of households. Each home's TV sets are attached to meters, and researchers periodically ask family members what they read. Family grocery purchases are tracked using a hand-held scanning device, which a family members runs over each grocery item's universal product code (bar code).

Can Television Affect the Audience?

The effect of TV on viewers is the subject of a great deal of communication research. However, we have examples of events, which when televised, had tangible effects on large numbers of people.

Edward R. Murrow

World War II was the first major war for the broadcast medium. In a five-year span broadcast news grew from near nonexistence, to a sophisticated system which provided news-on-the-hour from points around the nation and world. Edward R. Murrow, the man William Paley sent to Europe to head CBS Radio's overseas programming, became the voice of Britain's agony and heroism when he took his microphone and cable and went out on the roofs and streets of London to describe to Americans—*live,* with bombs, sirens, and human cries in the background—the extent of the terror and destruction Germany was hurling at London and Britain. Even today, when one hears those imperfect audio transmissions, it's hard not to come away with a lump in your throat.

JFK

Television quickly developed its share of audience impact events. One was the assassination of President John F. Kennedy. This event, covered and reported by TV was so visual and so overwhelming, the nation virtually came to a halt for three days in November 1963. Network television schedules were tossed out in favor of three days of nearly continuous coverage of the assassination, aftermath, funeral, and the swearing in of Lyndon Johnson.

The Vietnam War

In the early days of the Vietnam War, President Lyndon Johnson was able to rally tremendous support for a war which placed thousands of Americans in a foreign land, fighting to preserve a foreign government, and against an enemy who had not attacked the United States or a major American ally.

The American broadcast audience had never before *seen* a war the way Vietnam came into U.S. homes. The Korean War occurred before TV news and TV technology matured, and before TV was a common household appliance.

Vietnam became a television war. Correspondents and photographers were able to get to or near the front, and fairly quickly transmit their stories to network news centers for projection on the evening news. Americans actually saw their sons and daughters dying in the jungles of Vietnam.

Then famed CBS News Correspondent and Anchorman Walter Cronkite went to Vietnam to see the war for himself. Cronkite broadcast a series of dramatic reports, and then as his final touch, did a dramatic commentary on the war, one that condemned the military and national policy. President Lyndon Johnson later blamed Cronkite for single-handedly turning American public opinion against U.S. participation in the war. Soon there were protests on the streets and on the campus quadrangles, and the United States began a long, painful disengagement from the televised Vietnam conflict.

SUMMARY

Radio, TV, and cable are the most consumed media in the history of mankind. The enormous number of people who listen and view has created a multibillion dollar web of enterprises, which we lump under the title telecommunication.

And just because that audience is so large, telecommunicators seek to find out who consumes what, where, when, why, and how. The process of measuring the audience, and then

disassembling it to find out what makes media consumers tick, has triggered millions of dollars of investment in ratings systems and audience research.

Lest we think that the sole purpose of this passion for audience analysis is to find out why people use a gold bar of soap in preference to a pink bar, history reminds us how audience reaction to the media's images has changed U.S. foreign and domestic policy.

GLOSSARY

Advertising Commercial messages that appear on or in the telecommunication medium to sell a product or idea.

Audience People who consume media. There is a component that is measured and therefore is known audience, and another which is unknown and/or potential audience.

Coincidental telephone interview Random telephone numbers being called by rating services; the people who answer being asked what they are watching or listening to.

Confidence level This is the degree of probability that a sampling error falls within a certain range.

Cost per one-thousand impressions (CPM) The basis upon which advertising is sold in TV and radio.

Cumulative audiences (Cume) The figure that represents the best guess at how many people a radio station reaches over several hours or several days.

Demographic The description of the audience using commonly acceptable and understood terms.

Dial-in, dial-out The phenomenon of people listening for a while and then tuning to another station or turning off the set.

Designated Market Area (DMA) The cluster of counties and/or cities that make up the signal area of a number of potentially viewable stations.

Diaries A book designed to have audience entries made every 15 minutes for the whole of 7 days.

Discretionary Consumer money available for spending after the necessities have been taken care of; this is the money that the advertisers are seeking.

Estimates The prediction of what the population (all potential viewers) is doing by looking at the responses of the sample.

Focus groups, focus sessions Research technique in which a selected panel of people are encouraged to talk freely about topics by a skilled group leader while the session is recorded and sometimes observed by trained researchers.

Geodemographics The income, location, occupation, family size, marital status, home ownership, and apartment living factors added to the usual demographics of age and sex to give a fuller picture of media consumers who would be influenced by the programming and the commercials.

Households A term used in TV rating to designate one sampled viewing audience. This term had more relevance in the days before multiple TV ownership. When there was one TV set to a home, you could look at the average family and multiply that number by the number of households and get a fair estimate of the number of viewers.

Households Using Television (HUT) The way that the number of people viewing TV is estimated.

Margin of error The percentage amount that indicates the possibility of the estimate not being meaningful. If there is a 3 percent margin of error and the results say that program one is getting 49 percent of the audience and program two is getting 47 percent of the audience, it means that the programs are 2 percent apart, and so, predictions cannot be made without a good chance of being wrong.

Market research Finding out what people buy and why.

Metered "overnight" ratings Meters that automatically record program choice; they are only used in about a dozen large cities. They are a sample of one-third of the potential audience.

Meters Electronic devices installed in households in a few very large cities to record set use.

Monthly ratings These are designed to show variables such as continued growth of audience as well as to show seasonal changes.

People meters Measurement devices that electronically record when a set is turned on and the channel selected. The people in the household also are supposed to identify themselves to the meter by pushing a button.

Polling, polls A survey process that includes asking people what they have done or will do on a certain issue. The most controversial form is exit polling of elections.

Population The total potential number of viewers.

Program preemptions Programs that are not taken by an affiliate of a network.

Psychographics A technique in qualitative analysis, which looks at lifestyles and values, then attempts to develop images of consumers.

Qualitative research A form of audience research that includes geodemographic, attitudinal, and behavioral studies.

RADAR Name given to rating service which estimates network radio audiences.

Random selection In statistical terms this means that everyone who consumes the media should have an equal chance of getting a diary.

Random sample A sample that is thought to be representative of the whole population and is picked in such a way that each person in that population has an equal chance of being chosen.

Rating period A designated period of time during which the rating companies sample the audience. The problem is the rating periods are well publicized, so it is easy to put on special programs and promotions to inflate audience for the particular rating period. Most advertisers are well aware of this inflation.

Ratings Determination of the statistically probable audience based on a small sample.

Sampling error The imprecision that occurs when a sample is used to predict the behavior or attributes of a whole group.

Segmented audience The programming at most radio stations and some TV stations is aimed at a certain part of the potential audience.

Service area The area that the signal reaches.

Share The estimate of the households watching TV divided by the station's viewing audience.

Sweeps An industry term for the quarterly national TV ratings. They are taken by Nielsen (a subsidiary of Dun & Bradstreet) and Arbitron Ratings Co. (owned by Control Data Corp.) in November, February, May, and July of each year.

Telecommunication industry For the purpose of this book, broadcast and cable television, satellite programming, microwave programming, VCR sales and rental, teletext, videotex, AM radio, and FM radio.

Telephone surveys People are called randomly and asked questions about the kind of programming they consume. There are two kinds, recall and coincidental.

Test groups People who sample a new product and discuss it.

Test market A single market or selected markets where a new product is sold and its desirability is assessed.

Use TV or radio consumption for the purpose of sampling audience.

ADVERTISING: THE ART OF MAKING MONEY

The majority of the telecommunication media in the United States are supported by the sale of *advertising*. Next in order of importance is revenue received from *subscriptions* or *subscriber-based fees*. A minority of the media are supported by *direct sales* and *user contributions*.

It is important for anyone preparing for a career in the telecommunication media to realize that they are entering a business environment in which people who are willing to take risks expect to make a profit. This means that the key to success is a combination of paying attention to how much we spend getting the job done, producing the best product possible with the budget available, and aggressively selling the product. The bottom line in American commercial telecommunication is to make money.

This formula applies at all levels. The traffic manager in a TV station works to prevent *missed commercial plays*. A cable system sales manager thinks creatively to find ways to attract advertisers to local cable programming.

Capitalistic Approach

The U.S. media is financed primarily by private business and therefore can avoid government dominance, which has always been a major concern to Americans. In many other countries the broadcast telecommunication system is run by the government. In the United States it is only regulated by the government. There is a big difference.

Essentially, our system allows for using as many telecommunication channels as can be allocated by either the federal government or local franchise units. The two important factors here are (1) use of the channel for the good of the public because there is a *fiduciary responsibility* in holding an FCC license or local cable franchise, which calls for responsible and public-spirited use of the common property of the people; and (2) making a profit to support the cost of running the facility as well as return a respectable profit on the operating company's investment. The broadcast frequencies are supposed to be used for the benefit of the people, so there are certain ethical business considerations that come into play, which do not concern magazine or newspaper advertising.

The United States has its nonprofit public telecommunication media, but the significant difference is that these media are buffered from direct government interference and get some support from private funds. They are the Public Broadcasting Service (PBS) and National Public Radio, and their affiliated stations. Another major funding source for these publicly supported stations is the business community. Large business firms such as the Mobil Oil Company frequently underwrite the production costs of NPR and PBS program series. Some of these series are later syndicated to other broadcasters (especially in the international market) providing a source of additional revenue for the public broadcasting system.

There is a small fraction of U.S. telecommunication media, which is supported by direct public contributions.

ADVERTISING AND BROADCASTING

Advertising supports most broadcasting in the United States. In addition to financing what is known as *commercial broadcasting,* a limited form of advertising is permitted for firms that underwrite programs broadcast on public stations.

Advertising has made broadcasting a profitable business for companies which are successful in getting enough people to listen to or watch their outlets.

According to figures compiled by *Broadcasting* magazine, the top 100 electronic communication companies reported combined net income of $11.2 billion in 1986. As an example of the proportions of the advertiser-supported communication business in the United States, here is a list of five of the top electronic communication

companies involved in broadcasting or cable in the United States and their 1986 gross revenue, as reported by *Broadcasting* magazine:

General Electric, $36,725,000,000;

Allied-Signal, $11,794,000,000;

Eastman Kodak, $11,550,000,000;

Westinghouse, $10,731,000,000;

Coca-Cola, $8,668,000,000.

Of course, you recognize that not all of this profit came from the broadcast/cable activities of these companies, but a great deal of it did.

How the Telecommunication Media Support Themselves

U.S. telecommunication media (radio stations, TV stations, cable systems, cable program services, and microwave services) get a large portion of their support through the sale of *time.* Notice that we said time. The media company makes available stated periods of time for purchase by advertisers who then insert their messages. The media company generally does not interfere with the content of the message unless it violates company policy, state or federal regulations or law, or commonly accepted industry standards of conduct.

What Is Advertising?

Advertising on the telecommunication media consists of everything from straightforward appeals to purchase a product or service to sophisticated minidramas designed to build goodwill or sell a concept. Typically, the message appears in 10-, 15-, 20-, 30-, or 60-second announcements inserted either in programs or between programs. *Time,* containing a message, is sold in an attempt to influence the behavior of consumers. Advertisers can be any group or business that wishes to sell merchandise, to sell a service, or to influence members of the public (for instance, a politician running for office), providing the product or service meets ethical or legal standards.

Advertising can consist of words spoken over a static visual on TV or just the spoken word on radio. Advertising can also consist of elaborately constructed visual and aural productions. Both have the same aim—to sell something to someone.

Advertising Production Costs

A great deal of local radio advertising is produced at radio stations, frequently at no additional cost to the advertiser. Most TV stations and other video-oriented outlets charge for production services. Thousands of dollars can be spent on the production of a national TV commercial even before time is purchased for its transmission by the media. Commercials intended for use by major local, regional, and national advertisers are usually produced under the direction of an advertising agency working for the company that buys the time. The advertising agency contracts for production services with specialized production companies.

Radio Advertising

Radio stations rely primarily on local advertising sales for their income. The greater number of *sponsors* who advertise on radio stations are located in the same or nearby communities, so radio stations have to offer a variety of services to the advertiser. These include writing advertising *copy,* producing the *commercial,* helping plan the overall advertising campaign, and finding *cooperative advertising funds* to stretch the client's advertising dollars. This is called the *consultant sell,* in which the radio station *account executive* provides a certain amount of free advice, similar to the services offered by *advertising agencies* to larger clients.

Local radio advertising is more likely than regional or national advertising to consist of a spoken message with very little production. Regional or national sponsors usually rely on agencies and have much slicker presentations with music, sound effects, or famous voices to get their point across.

Television Advertising

TV ad sales frequently require putting on sophisticated presentations involving statistics, graphs, and other visuals before clients or their agencies. The focus is frequently on working with both the client and the ad agency to provide the sort of advertising schedule the client desires within the budget the client has set up. Both approaches to TV spot sales require good presentation skills, an ability to deal with numbers creatively, and today, the ability to utilize com-

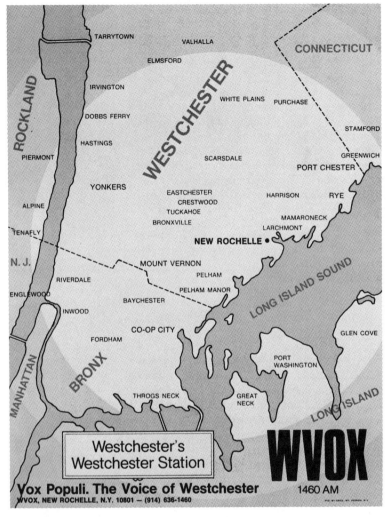

Figure 9–1
Example of a "coverage map" used by a radio salesperson to show area and communities covered by a station. Courtesy of WVOX, New Rochelle, New York.

Cable advertising is growing at a moderate pace on the national level. Some of the most popular among the satellite-delivered services include the Cable News Network (CNN), the Entertainment and Sports Programming Network (ESPN), Christian Broadcasting Network (CBN), USA Network, WTBS-TV (Atlanta superstation), and Music Television (MTV). They are popular because they can deliver large numbers of subscribers as well as targeted audiences.

Local cable advertising, in most cases, is not yet a significant factor in system income.

The top five cable television advertisers for 1987, as reported by Arbitron's Broadcast Advertisers Reports were:

Proctor & Gamble, $23,713,000;

Anheuser-Busch, $22,943,000;

Philip Morris, $20,581,000;

General Mills, $18,580,000;

Time, $16,411,000.

DBS and MMDS

The firms that offer or plan to offer direct broadcast services by satellite plan to charge subscriber fees. Most likely they will have advertising time available on some channels, depending on the final choice of programming.

Multipoint Distribution Systems closely parallel cable and usually charge a subscription fee. They, too, could insert commercials in some programming.

puter software to develop *sales presentations* and *schedules*.

Cable and Advertising

Cable systems earn their base income through fees charged to subscribers. Many cable systems are now selling *commercial availabilities* in local and satellite-supplied programs to supplement their income. Some adjacent cable systems have created interconnections so they can run commercials or even programs from a central control room while offering a much larger subscriber base without duplicating facilities.

ADVERTISING—HOW IT IS DONE IN THE COMMERCIAL MEDIA

The style and placement of advertising differs greatly from country to country. In the United States we frequently use expensive, highly persuasive commercials, which interrupt the continuity of the show we are watching.

Many other countries that permit advertising place rigid restrictions on the content, nature of product advertised, and placement of commercials. If you go to the United Kingdom you will see commercials clustered at clearly designated points within or between programs. In countries where advertising is permitted, one of the frequent topics of discussion is the appropriateness of the commercials that appear on the media.

Ethics and Advertising

Self regulation has always played a major role in American broadcast advertising. Several organizations are involved in this watchdog or gatekeeper function. The major organizations are the *American Association of Advertising Agencies* (4-As), the *Radio Advertising Bureau* (RAB), the *Cable Advertising Bureau* (CAB), the *Television Bureau of Advertising* (TVB), and the *National Association of Broadcasters* (NAB).

SELF-REGULATION—THE NAB'S ROLE

The U.S. broadcasting industry developed a system of self-regulation—setting limits on the length and quantity of commercials broadcast as well as prohibiting advertising of some products and services. These self-regulatory rules were laid out in the Radio and Television Codes of the National Association of Broadcasters. However, these codes were thrown out in a federal court decision in 1983; the court declared the codes to be a monopolistic practice by one industry. The only guidelines in force now in the U.S. are rules established by government regulatory agencies, marketplace forces, and the internal policy books of some broadcast companies. The internal policy books set commercial standards to be followed by the sales, production, and traffic staffs.

In the U.S. cigarettes may not be advertised on the broadcast media, under federal law. There have been efforts to ban alcoholic beverage advertising, but the U.S. broadcasting industry has fought off legislation relating to alcohol ads by modifying ads which emphasize the glamour angle of the products. Many broadcast stations and media groups regulate themselves, essentially using the guidelines of the former NAB Code, which did not permit "hard liquor" ads. You will notice that most network programs portray drinking as only a fringe activity, relating to characterization and location. They do not praise drinking alcoholic beverages, or make drinking look glamorous. This is no coincidence; it is an intentional form of self-censorship.

Throughout the history of commercial broadcasting in the U.S., the Federal Communications Commission attempted to suggest limitations on the total amount of time which could be devoted to commercial announcements within a specified time period. The FCC generally accepted the restraints outlined in the NAB Codes, but in 1981 the FCC dropped time restraints for radio commercial time as part of its movement toward deregulation. The Commission discussed various aspects of TV deregulation, but decided to deal with radio deregulation first, letting TV operate under the existing Rules and Regulations.

Internal Control—How the Big Companies Handle It

The networks, major group broadcasters, and most individual broadcast stations have internal mechanisms to assure that the ads they air are tasteful and not in violation of laws. The rules applied by these organizations may differ, but basically are drawn from a study of court cases, FCC, FTC, FDA, and Justice Department rulings, and the media company's own conclusions as to what its public will think is tasteful.

Various Bureaus and Their Functions

The Radio Advertising Bureau (RAB), is headquartered in New York City. Its purpose is to promote advertising on radio by gathering statistics and case studies which prove the value of advertising on radio. The RAB runs a series of sales seminars to help train local radio sales personnel. It also supplies members with ideas on how to expand their advertising sales base.

The Cable Advertising Bureau (CAB), acts as a statistical center, keeping tabs on cable advertising and working to promote more use of cable by advertisers.

The Television Bureau of Advertising is the TV equivalent of the Radio Advertising Bureau. It is a leading source of statistics on television advertising.

WHY ADVERTISE?

Why is there so much advertising on U.S. media outlets? Fundamentally, it is because the U.S. economy is strong enough that most Americans have *discretionary income*. This means that we can choose between buying a block of tan laundry soap or a scented, deodorant bar to put in the shower. We can use a detergent with additives, rather than a harsh laundry soap and a scrub board. As soon as a country develops an economy in which people can make choices about the character or qualities of the products they

buy and have choices where they obtain the products, an opportunity to advertise exists.

Advertising flourishes when merchants compete against one another. After all someone has to tell the potential buyers where to buy the products and what the prices are. Some small town radio stations have failed simply because there wasn't enough competition to create a need for one merchant to compare his products and services with another retailer's by using advertising.

MEDIA MIXES

Where do advertisers go when they want to put their messages in front of the public? The fact is the local newspaper still gets a significant slice of the advertising pie because of tradition and the newspaper's ability to list a large number of products or services in a small area.

Most advertisers find that they need a *media mix* in which ads are run on a variety of media to catch people who don't use some of the media. For instance, it has been demonstrated that college age people pay less attention to newspapers than they do to radio. This is one reason for the success of radio stations which aim at the 13- to 34-year-old age groups when selecting their music mix. TV is a highly successful medium for some types of ads because the content can be highly persuasive. It can demonstrate a product while the commercial catches the viewer in a relaxed, yet attentive frame of mind.

In today's sophisticated advertising environment advertisers frequently mix the media. For example, a supermarket chain buys big ads in the Thursday newspaper because it can list all of its specials. Then the chain will buy some radio spots to catch people who are driving around, or making up a grocery list. Usually, the radio commercial will focus on only a few specials. The chain's TV spots may be brief, showing one or two specials using products that look good on television. The effort is aimed at changing buying habits by encouraging the viewer to shop one chain rather than another.

SELLING ADVERTISING

Telecommunication firms, radio, TV, and cable, sell *time*. Historically, the time available for sponsorship by businesses was divided into two categories: programs and spots.

Programs

In the early days of radio, sponsors would not only buy whole programs, they would produce the programs. A number of programs carried the sponsor's name in the title, such as "Chase & Sanborn's Eddie Cantor" (Chase & Sanborn made coffee); and the Kraft Music Hall (Kraft cheese products). Pepsodent tooth paste sponsored "Amos 'n Andy" and G. Washington's Coffee sponsored "Sherlock Holmes."

When the choices of networks were limited it was advantageous for an advertiser to have a program named after one company or product. Some firms purchase programs so that their name, product, or service can be associated with a particular type of programming.

The Texaco Company, which distributes petroleum products, sponsored or underwrote the radio broadcasts of the Metropolitan Opera for many years. Prior to government deregulation of telephone service, AT&T or its manufacturing division, Western Electric, sponsored certain special programs, which were likely to garner good-sized audiences plus complementary critical reviews.

Once radio station owners began to realize that they could make more money by selling short spots of time rather than chunks of time, they started to wrest control away from the advertisers.

Barter

Program sponsorships frequently result from the *barter* process. In barter advertising the station receives a program free of cost in exchange for running a stated number of commercials in the program or in some other programs. The station can then sell the remaining advertising time. It's not unusual for a sponsor to pay the cost of producing a barter program, then insert one or two commercials, and attempt to place it on radio or TV stations. Usually, the company sells a product or provides a service that has something to do with the subject of the program.

In recent years magazines have taken to producing short feature programs for radio, using material they have gathered as a resource for the script, and inserting *billboards* (opening and closing announcements which mention the product or sponsor) and commercials. News and information radio stations will play the free programs when they contain information of interest to the stations' audiences.

Some companies sponsor radio or TV features

or programs because the content of the programming complements their product. A company that makes fishing tackle has sponsored a series of miniprograms on radio designed to appeal to people who fish as a sport.

Spot Announcements

As the listener (and later, viewer) had more choices of programs or radio stations playing music, sponsors found they were better off to spread their advertising around in smaller segments to hit as many potential customers as possible.

In the early years the commercial messages tended to be either long (60 seconds) or short (10 or 20 seconds), depending on the sponsor's budget and the time slot available for the commercial. Commercials are sometimes called "spots," for spot announcements. Sponsors frequently prefer to have their messages heard or seen by a wide variety of people over a wide span of time, so they buy spot announcements. These are the 10-, 15-, 20-, 30-, and 60-second commercials which we see within or between programs. The 60-second spot was favored for a long time because it gave the sponsor ample opportunity to deliver the message. In recent years there has been a movement in the advertising community toward shorter commercials. Advertising agencies discovered that listeners and viewers retained nearly as much information from a 30-second commercial as they did from a 60-second spot. Thus, it became more economical to buy shorter spots.

Radio Spots

Radio stations liked the trend toward shorter spots because they did not cut the cost of 30-second spots to half that of 60-second spots. The spots sold for about three-fourths of what a minute sold for, so stations had more time to sell and made more money. Today, the majority of radio commercials are 30 seconds long.

Television Commercials

TV has to program commercials according to the amount of time available within programs and during station breaks between programs. The trend in TV has been for a national advertiser to book a 60-second commercial, and then send a *piggyback commercial* devoting 30 seconds to each of two of the company's products. Piggy-

backing used to be frowned on in TV because it created *commercial clutter* during the two-minute commercial holes in programs. A later controversy arose over whether an advertiser could split a 60-second announcement into three 20-second messages or even into units of 15 seconds. Fifteen second spots tied to others from the same sponsor began showing up on the networks in the mid-1980s.

Fifteen-second commercials accounted for 29 percent of network TV ads in the first nine months of 1987, according to the Television Bureau of Advertising. In the same period in 1986, 15-second commercials accounted for 20 percent of all TV network commercials.

Advertising Budgets

Who spends the most money on advertising? According to figures compiled by the TVB for 1983, which combine local, national, spot, and network ads, here are the top ten categories:

1. Food and food products
2. Automotive
3. Confectionery and soft drinks
4. Toiletries and toilet goods
5. Beer and wine
6. Soaps, cleaners, and polishers
7. Consumer services
8. Household equipment and supplies
9. Travel, hotels, and resorts
10. Proprietary medicines

How Broadcast Advertising Is Sold

Broadcast advertising is sold in a number of ways. If a sponsor pays a premium, the sponsor's spot or spots can be placed in precise locations during the broadcast day. Another technique is to buy a package of so many announcements for so many dollars. This is common in radio because it permits the station to shift some of its commercial load out of the popular early morning hours into other dayparts. Under this sort of plan the sponsor gets X number of spots: so many placed in morning drive time, so many at midday, so many in afternoon drive, and so many during the evening or on weekends.

Selling Time

There are a number of different ways to sell advertising time. A sales representative from the

broadcast firm (frequently called an account executive) can visit the sponsor's place of business and sell directly to the advertiser.

Frequently, the account executive either works through or in conjunction with the sponsor's advertising agency. (An advertising agency is a company which designs a company's advertising strategy, supervises production of the advertising, and buys the space or time for the ads.)

Buying According to the Ratings

Many advertisers, especially those who buy TV, use a more sophisticated approach to purchasing advertising time. The sponsor will demand that the station produce so many accumulated rating points for so many dollars spent, which yields a *cost-per-thousand* (listener/viewer impressions) (CPM). Another term used is *cost-per-point* (CPP), meaning cost per *rating point* delivered based on the latest ratings in the station's market. Usually, the station's sales department has to look for *open spots* on the *operating log* (daily schedule) and match up audience estimates (from the rating book) until a package is derived which delivers the cost-per-thousand or cost-per-point desired points and the number of viewers/listeners desired while giving the sponsor the minimum number of spots. (A station wants to limit the number of commercial announcements needed to fill each order so it can have as many *availabilities* [open commercial positions] as possible to sell to other sponsors.)

Regional and National Selling

There is less personal contact when selling advertising time to regional and national sponsors. They are almost always represented by advertising agencies. Much of the selling effort concentrates on putting together *schedules* to meet the price and audience requirements of the sponsor. A good part of this work is done on the telephone or through computer or teletype circuits linking the station with key business centers around the country. The larger broadcast organizations (especially TV stations) employ specialists who make calls on regional and national advertisers and their ad agencies for the station. The focal point of their effort frequently is to make certain the station will be asked to submit a *schedule* when the sponsor plans a major advertising *flight* (campaign).

Representative Firms

Radio stations, TV stations and cable companies also employ *representative* firms known as *reps* to help them sell regional and national advertising. The *reps* usually *represent* a number of stations or all of the stations of one broadcasting group. They are based in the advertising centers, such as New York, Detroit, Chicago, and Los Angeles. The reps know which firms are shopping for time and the agencies that represent these sponsors. The reps solicit schedules by teletype and computer from the stations they represent in an attempt to secure ad placements from agencies. A great number of these transactions are handled by computer data banks. Work is underway to achieve uniformity of computer software in the industry.

A *buyer* for an advertising agency contacts a number of reps and solicits proposed *schedules* from stations in the target markets. Generally, the advertising goes to the station able to come back with the best overall offer, which may or may not be the lowest price, depending on the sponsor's objectives.

A significant part of the national advertising, heard or seen on local stations (and on some cable systems), has been booked by reps. They have the contacts to deal with the national accounts, thus freeing the media outlet to concentrate on local and regional sales, which make up a large part of media income in all but the largest markets.

The Percentages

The unique factors about these selling relationships is the method of payment. If an advertising agency places $10,000 worth of advertising with a station, it gets $10,000 from the sponsor, deducts a percentage (usually 15 percent), and sends the net to the station. A similar system is used by representative firms. Some ad agencies have more sophisticated agreements with their sponsor companies, which may involve a base fee plus commission. Ad agencies generally make additional income by preparing and supervising the production and distribution of the commercials played on the air.

CREATING ADS

Advertisements or commercials are created in three ways. First, the advertiser may create the

commercial. Second, the station may create the ad for the client. Third, the commercial may be created by an advertising agency.

Sponsor-Created

Sponsor-created ads are more common when the advertising runs in only one market. It is also more common in radio than in TV to have the advertiser write and produce the spot. The best examples are people who are natural salespeople. You've probably seen an auto dealer doing his own commercial on TV or heard a local merchant pitch his service on radio.

On the East Coast, Frank Perdue gained notoriety as spokesman for his brand, Perdue chickens (although an ad agency produced the spots). Among the best example of a sponsor appearing in his own commercial were the campaigns for the Chrysler Corporation, which featured Chrysler Chairman Lee Iaccoca. Iaccoca had a natural stage presence and he conveyed the idea that the top man was vitally involved in assuring the quality of Chrysler products. This strategy worked well for the automaker in the years after it nearly went bankrupt.

Sometimes having the sponsor do his or her own commercial is a problem because many sponsors are not expert at creating advertising or appearing as talent. One of the difficult problems faced by a station account executive is telling a sponsor who wants to appear in a commercial that he or she might be hurting the business and really should leave advertising production to experts.

Station-Created

The station account executive frequently advises the client regarding copy and production, or prepares the actual commercial copy. This is most common in radio where the people who sell the spots often create them. One reason the TV account executive has less need to create a sponsor's commercial is the availability of specialized writers and producers within the station. Another reason is the high cost of TV advertising, which causes the sponsor to want to make certain the commercials have the maximum impact. The sponsor realizes money must be spent on producing commercials if they are to be effective.

Many broadcast stations employ production directors and copywriters who spend the bulk of their time creating commercials for clients. A truly creative production director or copywriter is an invaluable asset to a radio or TV station.

In general, radio stations do not charge for production services, saying creation of the commercial is part of the price of the advertising. Most TV stations levy additional charges if they create and produce the sponsor's commercials. Producing commercials has become a major revenue source for some TV stations.

Many broadcasters rely on generic advertising materials, which can be adapted to local situations. For instance, a radio station can buy sound effects and jingles that can be inserted into commercial copy to make a local ad have more produced sound. Similar aids can be obtained for TV use.

Agency-Created

A significant portion of the advertising we hear and see is created by advertising agencies. Agencies can be found in most urban markets where they create local and regional commercials. The majority of national commercials originate from

Figure 9-2

Artist using a three-dimensional graphics animation system. Pictures are not really three-dimensional, but they give this effect. System shown is used for animation and graphics for advertising, lead-ins to programs, sports, and news. Courtesy of Cubicomp Corp.

agencies in the top 10 markets (the largest cities in the United States).

Creation of commercials by ad agencies has spawned a whole industry based on support services. Most agencies are staffed to write commercials and prepare audio or video outlines or sketches, but they usually call on specialized production houses for the actual making of the spots. There are some companies that specialize in production, others that handle *post production* (final editing and adding enhancements), and others that take care of delivering (distributing) the finished commercials to the networks and stations which are scheduled to air them. Most of the distribution of commercials has been by mail, air freight, or courier, but it is possible to distribute commercials by satellite if the stations carrying the spots have a downlink or are within convenient distance of a downlink for quick reshipment by bus.

A TV COMMERCIAL CREATED

The Consolidated Breakfast Foods company has approved a campaign to introduce "Runchies," a crunchy breakfast cereal flavored with dehydrated red raspberries. The campaign will run on local TV stations in the top 50 markets.

The marketing and packaging strategies have been settled; so it is now the problem of the ad agency to take the product marketing plan and apply it to the advertising plan.

The agency account executive who handles the Runchies account meets with the senior copywriter and the *creative director* to devise a creative approach to selling Runchies. The product has health food qualities, contains no sugar, but is aimed at consumption by children, rather than adults.

The agency people decide there are two target audiences: children who will get their parents to buy the product and mothers who will pick the product off the supermarket shelves because it is "healthy." The agency's question is: how is this product going to be made to register in the mothers' and children's minds during the commercials so it will stand out among all the other cereals displayed when it comes time to shop?

The sponsor provided the solution when its package design consultant suggested using a cartoon rabbit named "Runchy Rabbit" as the focal point on the cereal box. The agency decides to produce animated cartoon commercials, even

though they are more expensive to create. Runchie Rabbit will demonstrate how much he benefits from eating Runchies, by winning races, jumping higher than the other rabbits, even defeating the evil groundhog robot Varghog in a martial arts duel, all because he eats Runchies. (And besides, they taste good!)

The rabbit character makes possible marketing and promotion tie-ins. Gifts can be packed in the cereal box, or obtained by sending in product identifications off the empty carton. Perhaps a toy or novelty manufacturer will like Runchie Rabbit well enough to market him as a stuffed toy.

The animated commercials will be prepared for both target audiences. A pure cartoon minidrama (60 seconds) will be used within local children's shows or cartoon features. A separate 30-second spot, which features a mother wondering what to feed her kids who are bored with their breakfast cereal, will be produced using the cartoon rabbit as an overlay over a realistic kitchen scene. The latter spots will be positioned in local cut-ins of network morning shows and on station breaks from 9 A.M. to 12 noon weekdays.

The strategy has been decided; now production begins. The copywriters begin to prepare scripts while the creative director puts an artist to work sketching the desired scenes in both the cartoon and "live appearing" commercials. These drawings become *storyboards* to guide the production of the spots.

As soon as the cartoon commercials are approved by the sponsor, their storyboards are sent to an animation house in Hollywood. Part of the drawing is done in Hollywood and part is done in Japan where the cost of cartoon illustrators is less. Once the drawings are done, they are turned over to a production house, which uses a variety of electronic computer-driven graphic devices to insert backgrounds behind the rabbit and create motion. After the video is complete, the audio track is prepared, with experienced animation announcers providing the voices of the rabbit and the other cartoon characters. The two tracks are then shipped to a post production house for the final *mix* to combine video and audio. After that is done and the client approves the completed commercial, a master copy is sent to a tape reproduction firm, which makes ample copies to be shipped to the TV stations.

A similar pattern is followed with the commercial aimed at mothers, except that the production house and the agency are more involved

in the final product because actors have to be hired and a set built to create the kitchen scene on which the rabbit character is superimposed.

Shipping is handled by a specialist firm, which is given the play schedules of each spot and is responsible to have the spots in the hands of each station's traffic department five days before the first time they air.

The advertising agency takes responsibility for developing a creative approach to apply the cereal firm's marketing plan, but it turns the actual production and shipment of the commercials over to other companies. At each step final approval for the work must be given by the agency and the sponsor.

The commercial schedule is booked by the agency's timebuyers, who work with rep firms and station groups to get the least expensive schedules which meet the sponsor's and agencies specifications for number of impressions on children and mothers.

The reps require the stations to provide *proof-of-performance* affidavits stating that the commercials actually ran as scheduled. These proofs must be received before the rep processes its invoice to the agency to secure the station's payment for the airtime. All through the period when the commercials are running there is a constant give and take among the stations, reps, and the agency to *make-good* spots, which are missed due to clerical or operator errors, lost due to technical problems, or *preempted*.

After the campaign is over, the agency and the sponsor will analyze the sales of the product and perhaps conduct further market research to see if they can strengthen its sales and image.

Testing Advertising—A Form of Market Research

Few regional or national commercials are aired without some form of testing. The process may be as simple as playing or showing the spots to members of the agency staff, or it may involve juries of people who are paid a small fee to test commercials. In some cases, the spots are played in so-called "test markets" to measure their effect, either by conducting a survey or by checking sales at stores carrying the test product.

The testing of commercials for effectiveness has been the subject of some very sophisticated research. One way to test a commercial is to take a psychological approach and interview individuals or a group to study reactions to the

Figure 9–3
Post production, adding character generator titles and other enhancements, is a major factor in the final "quality look" of a television commercial. This ALEX unit can perform virtually unlimited manipulation and animation of characters and symbols. Courtesy of AMPEX Corp.

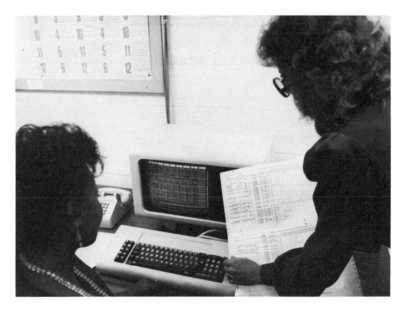

Figure 9–4
Television traffic specialists checking a computer print-out against what is shown on the computer screen. Such computerized record keeping is vital to scheduling, tracking, billing, and other aspects of a station's advertising. Courtesy of John H. Phipps, Inc., WCTV, Thomasvilllle, LA–Tallahassee, FL.

commercial's message and presentation as well as observing reactions to the product itself.

Another approach is to see if the product sells, and more important, resells after ads are played or shown.

Ratings

The key to selling broadcast advertising is being able to tell a sponsor approximately how many people are listening or viewing at any one time. Sometimes this information has to be broken down into elaborate subcategories according to "demographics," which are subgroups defined by age, gender, income, marital status, and education.

A sponsor wants to be sure the produce or service message is reaching someone and frequently the sponsor has research available which indicates the typical characteristics of the people the company wishes to reach. For instance, a company which sells an acne relief cream is interested only in men and women who have this type of skin problem and who probably are in their teens or early 20s. The acne cream company will accept fewer total listeners or viewers if it can be sure it is making its message available to people who are likely to go to the drug store and buy the cream—such as the viewers of music videos.

Rating Services

The two names which are most familiar are Arbitron and Nielsen. Arbitron rates both radio and TV markets while A.C. Nielsen rates only TV markets. Both companies have established definitions of markets and assign market size designations to various geographic areas. The most important to national advertisers are the top ten markets; next in importance are the top 50 TV markets. Many national advertisers feel they have covered the bulk of the nation's population if they can place advertising schedules in the top 50 markets.

Arbitron, in its *Revised ADI Market Ratings, 1987–1988,* lists the top ten U.S. markets as New York, Los Angeles, Chicago, Philadelphia, San Francisco, Boston, Detroit, Dallas–Ft. Worth, Washington D.C., and Houston.

Some of these market areas are quite huge. For instance, the Philadelphia listing includes Allentown and Reading, Pennsylvania; Vineland and Wildwood, New Jersey; and Wilmington, Delaware.

By comparison, Denver is number 19, Albuquerque, New Mexico, is number 56, and Dothan, Alabama, is number 157. Obviously a station in the twentieth market can get much more money for its commercials than one in the 180th market.

Research on Advertising Techniques

Research plays an important role in advertising. Most advertisers conduct research that leads to the development of the product. Then they study how to market the product, and finally the advertiser tries to figure out the best way to spend his advertising budget to sell the greatest amount of his product. The agency does research on how people react to different types of advertising appeals and how different types of spot schedules affect the sale of products. For instance, if it is assumed that to sell a product or service to women, you have to advertise during the daytime when many women watch TV, this ignores the fact that a large percentage of women are employed.

The basic principle to market or advertising research is to try an idea out in a limited area, which is typical of the population to whom you wish to sell your product or service. You've probably received samples of products in the mail. Sometimes you will get a telephone call a few days after the product arrives to see if you received the sample and to ask how you liked or used it. On other occasions the sample includes a contest blank or a cents-off coupon. All of these devices provide measures of product acceptance.

Presentation

Another area of an advertising agency's research is how to present a product. Certain types of commercials are effective for one type of product but not for another. You may find those "typical housewife and husband at the washing machine" commercials obnoxious, but they sell soap. After all, the advertiser wants you to recognize the soap box or container when you go to the store, not love the characters in the commercial.

Who Pays for Research?

Advertising agencies underwrite extensive research on who buys what for what purpose. They have to be able to advise their clients on the best

1988 Arbitron ADIs

Figure 9–5
Map displaying geographic market regions, as defined by the ratings service Arbitron. Courtesy of Arbitron Ratings Co.

media to use to influence potential users. The agencies also study the efficiency of various media in terms of dollars spent per impression and per product sale.

Research by Media

Media outlets such as radio stations, TV stations, and cable companies also do research. They need to know the demographics of their community, the amount of discretionary income available, the buying preferences of the community, and the best way to display a product. They also study their audience in an attempt to define the preferences of viewers and listeners. In today's environment of narrower audiences, a media outlet must know who views or listens, and something about the consumers' buying patterns.

NETWORKS—HOW THEY SELL ADVERTISING

Networks sell advertising time in much the same manner as stations. Their sales representatives make personal calls on major clients and advertising agencies. Usually, the network sales department performs functions similar to those done by reps, thus eliminating one middleman.

The networks are particularly dependent on ratings to sell their advertising. If a network's performance has risen significantly during the previous season, you can be certain it will go into the next season (roughly late September to April) with a higher *rate schedule (rate card),* that is, the price asked for time sold.

Thus, certain programs demand much higher rates than others. For example, the Super Bowl makes a large amount of money for the network that airs it because this football classic almost always dominates the ratings when it is played. The key to the success of a network is having a strong lineup of owned and operated stations plus a selection of highly rated affiliates. The big three TV networks all own major stations in some of the top 10 markets. They also have affiliates that garner large segments of the viewing audience in their cities.

Affiliation

The problem of having a good affiliate lineup shows up in markets where there aren't enough VHF channels to go around or the originating cities of the market are quite distant. An example would be Ft. Myers–Naples, Florida, with one VHF and one UHF in the key city, and a third UHF some distance away. If by any chance the VHF station, now a CBS affiliate, went shopping for a new affiliation, you could be guaranteed there would be a knock-down, drag-out fight between ABC and NBC for the affiliation agreement. This actually happened in Miami, Florida, when NBC bought the CBS-TV affiliate.

The problem of affiliate lineups is critical in radio, where there are nearly two dozen networks competing for strong outlets in the populous markets.

COMPETITORS ALL

Broadcasters and other telecommunication outlets compete against themselves. In today's typical urban market radio stations compete against themselves and TV. TV stations compete against radio and cable. Everyone competes against nonviewers and users of videotape recorders.

More important though is competition from the print media. Newspapers remain major competitors for local retail dollars because they are well established and offer the additional attractions of listing items and reader pass-along. Once a broadcast commercial has been aired it is gone, while you can go back and reread the paper.

Other sources of competition include weekly newspapers, free newspapers (frequently called shoppers), billboards, magazines, and direct mail.

As the telecommunication industry expands, other media such as DBS, MMDS, teletext, and videotex could be competing for advertising dollars.

PUBLIC SERVICE ADVERTISING

One of the historical obligations broadcasters have had under the Communications Act of 1934 is a responsibility to run free advertising for nonprofit organizations. The FCC does not dictate which organizations will receive the free advertising, but broadcasters are expected to air a reasonable amount of *public service advertising.* The term most frequently used to describe these announcements is *public service announcement* (PSA). Frequently, these announcements are just as well made as commercials.

Who Gets Free Time?

One way the broadcasting industry has overcome the problem of selecting organizations to receive PSAs is through cooperation with the Advertising Council. The Council selects organizations it deems appropriate for national exposure, and through the voluntary efforts of advertising agencies produces highly professional spot announcements on behalf of these organizations. Some of the larger charitable organizations produce their own spots. Religious organizations are particularly noted for producing their own spots. Schools and universities often do their own work.

Federal and state agencies may produce their own announcements, with or without the help of outside agencies. The military has even purchased commercial time, wishing to assure that its messages reached the target audience.

Where Do PSAs Run?

Any organization that produces PSAs and asks for free time runs the risk its announcements will be aired in low-audience, unsaleable, or *fringe* time periods. Most stations try to present a minimum number of PSAs per week, so certain periods are reserved for them. However, these frequently turn out to be adjacent to the National Anthem at sign-off or in similar spots.

You will see an occasional public service announcement in prime time. The networks use them to cover unsold time not utilized for promotional announcements, and stations and cable systems fill unsold slots with PSAs. The bottom line is that the time you get for nothing is apt not to be among the choice inventory of spot times.

SUMMARY

Most advertising on our telecommunication media consists of announcements or spots, which may be created by the sponsor, the agency, or the station. Local advertising sales is highly personal and frequently demands versatility on the part of the media account executive. On a regional and national basis, most advertising falls into more structured relationships involving the sponsor, the ad agency, reps, and media outlets.

Advertising finances the greater part of American broadcasting. We must look at broadcasting in the United States as a commercially funded,

Figure 9–6
A key ingredient in a station's success is self-promotion. In this picture, women pretend to "picket" KABL, a beautiful music station in San Francisco. Their signs say: "KABL Music is unfair to other San Francisco radio stations because it sounds so beautiful." This was just one of hundreds of clever promotions thought up by 1960's radio impresario Gordon McLendon. On another occasion, he had a station he had just purchased play the same record for one solid day. After the stunt got everyone's attention, he introduced a new music format the next day. Courtesy of the Southwest Collection, Texas Tech University.

entertainment-based business. The secret to the success of broadcasting in the United States is that it offers what appears to be "free" entertainment to the greater part of the public. Of course, it is not free because the listener or viewer has to purchase a receiver and the cost of advertising is included in the selling price of an advertised item.

Nevertheless, our commercial, entertainment-based broadcast industry is large, varied, and available to almost everyone because advertising foots the bill. When we look at the U.S. system and see that it is for the most part free of government intervention, then we can understand why advertising is so important to broadcasting. Advertising keeps broadcasters independent from government financing and, as a result, free of government censorship. The U.S. system also calls on advertisers and the advertising industry to be responsible and tasteful citizens. Groups within the industry as well as citizens' organizations work to promote responsibility and prevent the necessity of government regulation or intervention.

GLOSSARY

Account executive The person who sells time for a media outlet. The person in charge of a specific account at an advertising agency. A salesperson for a representative firm.

Advertising The business of selling an image, concept, or product by styling it in such a way that people want it. For broadcasting that consists of buying and selling time on the medium in question, creating commercials for what is being sold, and ascertaining the impact of the broadcast commercial.

Advertising agency The middleman between the sponsor and the telecommunication outlet. The agency usually prepares the commercials and plans the kind of time buy that is best for the sponsor. The ad agency makes money from keeping a percentage of advertising billed, fees for service, and fees for commercial production.

Availabilities Time positions reserved in programming for insertion of commercials. When commercial schedules are being planned for sponsors, sales operations specialists look for open (unsold) positions, called "avails." Positions can be used for promotional or public service announcements if not sold.

Barter An exchange of time and goods without money. Often used when one media outlet wants to promote itself by way of another media outlet. Syndicators often barter programming with stations in trade for holding back some spots for national advertisers.

Billboards Short identifying opening and closing announcements to identify a sponsor.

Commercial The material/message that goes into the time that is bought.

Commercial availabilities Another way to describe the time segments that are bought in broadcast/cable advertising.

Commercial clutter Occurs when piggybacking results in a number of usually disparate messages clustered at the station break or between shows. This happens more in TV than radio, but format radio is beginning to cause this kind of pileup.

Consultant sell The radio station account executive provides free advice similar to what advertising agencies do for large clients.

Cooperative advertising funds Manufacturers or distributors and local merchants share the cost of buying commercial time. Typically, the dealer gets a tag, which is an identification of name, address, and telephone number.

Copy The word used to describe the written part of the message that is in the commercial.

Cost-per-Thousand Viewer/Impressions (CPM) A figure derived from rating points which gives a theoretical cost of the advertising schedule in relation to each thousand listeners or viewers. This figure is frequently surprisingly low.

Cost-per-Point (CPP) Cost per rating point delivered based in the latest ratings in the station's market.

Creative director The person who is responsible for the overall production of the commercial once it is decided on. In big agencies this person is responsible for approving all the ideas that get made into commercials.

Direct sales In this instance, it applies to TV stations, which are programmed to be video catalogues where viewers phone in to purchase merchandise displayed on cable channel or station. Home Shopping Network and HSN stations are examples.

Discretionary, discretionary income The money available for spending after the necessities have been taken care of. This is the money that the advertisers are all trying for.

Fiduciary responsibility The legal and ethical responsibility of a broadcast licensee or cable franchisee because either is using a portion of the public spectrum, the public trust.

Flight Advertising campaign planned by a sponsor or more usually by an advertising agency for a sponsor.

Make goods Spots that are replacements for those that didn't run or had some kind of glitch in them when they ran.

Missed commercial plays When an advertisement paid for by a sponsor is not run for any reason. Most of the time the station is expected to make up the missed play, often with a penalty of extra time or better placement. The make-up spot is a *make good*.

Open spots Available time that can be bought.

Operating log The schedule that a broadcast station uses to list everything that is broadcast. The operating log was once required by the FCC, but now its greatest use is to keep programs and commercial scheduling straight.

Piggyback commercial A sponsor using a spot to run two or more commercials for various products.

Post production The final editing and enhancements to make a commercial really effective include monitoring the audio levels.

Pre-empt To override, substitute, or replace, as in replacing a network program with a local special.

Proof of performance Affidavits the stations give to the reps as proof that the commercials ran as bought or indicating whatever anomalies occurred.

Public Service Announcement (PSA) Free commercial for nonprofit institution or cause run at no cost to sponsor.

Rating point Audience expressed as a percentage of the population measured.

Rep, representative organization Hired by stations, these representatives, operating at national and regional levels, get advertisers to place their commercials at advantageous times and places on the schedule. The reps gets a percentage of the advertising billing as commission.

Sales presentation The formal sales pitch, accompanied by audio/visual aides, charts, graphs, etc.

Schedule Formal list of commercial running times and lengths presented to and agreed upon with sponsor or sponsor's agency.

Schedules A run of commercials matched to a sponsor's needs and pocketbook.

Sponsors The people who pay for the advertising on broadcast facilities.

Spots Another term for broadcasting/cable commercials.

Storyboards Sketches that describe, frame by frame, the scenes in a TV commercial. A storyboard resembles a comic strip.

Subscription, subscriber-based fees Similar to magazine subscription, in that a fee is paid for certain time periods of consumption and extras are offered at additional fees.

Time The commodity that is for sale in the media. It is what advertising sells, periods of time with messages superimposed on them.

User contribution supported Many public stations and some community, educational, and religious stations derive part of their funding by solicited contributions from their viewers and listeners.

TELECOMMUNICATION AROUND THE WORLD

There are international agreements that regulate broadcasting, because radio and TV signals cross national boundaries. As you circle the globe you will find that broadcasting is subject to some form of government control everywhere you go.

A world traveler would find three primary broadcast systems: (1) a regulated, but free enterprise system such as we have in the United States; (2) a mixed system which involves some government ownership of broadcasting mixed with some private business ownership, but all of it being tightly controlled by government; and (3) a government owned and operated system that is the voice of the government in power.

In countries with a mixed system there is usually a strong cultural policy, which says the government should provide at least part of the broadcasting service, but there is at the same time little government fear of private enterprise competition.

BROADCASTING, CULTURE, AND POLITICS

Broadcasting frequently mirrors the culture and political system of the country it serves. In this chapter we will look at several countries in an effort to understand their approach to broadcasting. We will also look at how some countries are reacting to the newer technologies, such as cable, DBS, teletext and videotex, and videocassette recorders.

Reasons for Different Systems

There are a number of reasons why countries choose to have different systems for regulating their telecommunication media. Among the forces that affect these choices are the literacy level, the economy, the available technology, and the political philosophy of the government.

The Literacy Level

The United States is a country with a high *literacy* level. Some countries have lower literacy levels and use the radio and television media as tools to raise the literacy level as well as to transmit messages the government wants presented. In these countries, radio and to a lesser degree, TV, are important means to spread information about health, sanitation, birth control, farming techniques, and flood control.

In Turkey radio and TV are used not to directly overcome illiteracy, but to improve the level of training of public school teachers, who are given much less formal training than U.S. teachers.

Technology

The quantity and quality of technology available in a country also affects the way the telecommunication media are managed. Radio reaches the masses inexpensively, and so governments of poor nations tend to want to control the radio stations to preach the message of improvement and development. Expensive high technology equipment may be capable of sending a color TV signal, but if the populace can only afford black and white receivers, color TV would be wasted technology. The application of technology is tied directly to the economy.

Political Philosophy

Political leaders see broadcasting as a powerful force and want to control or manipulate it to varying degrees. Frequently leaders suppress dissent or conceal failures by controlling the media so that the populace does not see what the leaders do not wish to have seen.

Throughout the nonaligned or developing nations, broadcasting is seen as a means to *develop* the country's cohesiveness. Many of the *developing nations* were created by arbitrary political

decisions, and now their leaders are trying to create a sense of *nationhood* among the people within their boundaries. The countries of Jordan and Israel in the mid-East, or India, Pakistan, and Bangladesh in South Asia were created for purely political reasons and are populated by people who immigrated from elsewhere as well as people who have historically lived in that region. The leaders of these countries use the telecommunication media to spread use of a common language, to support a feeling of national identity, and create support for the central government.

HOW THE WORLD SYSTEMS ARE TIED TOGETHER

Broadcasting around the world is coordinated by global, hemispheric, and regional organizations, which from time to time call together diplomats and telecommunication experts from the countries in their jurisdictions to work out mutually agreeable ways to share and utilize frequencies.

The two major global organizations that oversee telecommunication are the *International Telecommunication Union (ITU)* and the *International Telecommunications Satellite Organization (ITSO)*—now known as *INTELSAT*.

ITU

The ITU is part of the United Nations. It was created in 1938 from the Radio-Telegraph Union and the Berne bureau. The *Berne bureau* was originally known as the International Bureau of Telegraphy when it was formed in 1868 to coordinate international telegraph service. Later the organization became involved in international telephone communication. ITU has nearly 150 members. Its headquarters is in Geneva, Switzerland. The ITU is important because it assigns spectrum space among members and registers their use of frequencies. It works to avoid interference and assists countries in establishing rates for international telecommunication service.

The ITU sponsors periodic *World Administrative Radio Conferences* (WARCs). These meetings are used to work out international agreements regarding allocation of frequencies and spectrum use. Several of these meetings were scheduled during the 1980s. Expansion of the AM radio band was just one of the topics scheduled for discussion.

INTELSAT

The *International Telecommunications Satellite Organization, INTELSAT*, is a consortium. It was established in August 1964 when 14 countries signed an interim agreement. INTELSAT now links 171 countries and territories. The system uses 15 satellites, poised over three major oceans and South America. INTELSAT satellites provide video, voice, telephone, and data service around the world.

Other International Telecommunication Organizations

There are several international organizations which speak for interests of specific parts of the world. They include the *Arab States Broadcasting Union (ASBU)* in Cairo; the *Asia-Pacific Broadcasting Union (ABU)* in Tokyo; the *Asociacion Interamericana de Radiodifusion (AIR)* in Montevideo, Uruguay; the *Caribbean Broadcasting Union (CBU)* in Christ Church, Barbados; the *Commonwealth Broadcasting Association* in London; the *European Broadcasting Union (EBU)* in Geneva; the *International Institute of Communications* in London; the *International Mass Media Institute* in Norway; the *International Radio and Television Organization (OIRT)* in Prague, Czechoslovakia; the *Islamic States Broadcasting Services Organization* in Jeddah, Saudi Arabia; the *National Association of Broadcasters (NAB)* in Washington, D.C.; the *North American National Broadcasters Association (NANBA)* in Ontario, Canada; the *United Nations Educational, Scientific and Cultural Organization (UNESCO)* in Paris; and the *Union of National Radio and Television Organizations of Africa (URTNA)* in Dakar, Senegal.

EBU

The European Broadcasting Union (EBU) serves 30 European countries. It is involved in research and exchange of information and helps with program exchanges and cooperative production programs. In the United States it is best known for the news and information feeds that are picked up by the broadcast news divisions of the networks. EBU is important as an exchange agency

Figure 10–1
A studio with a sound control panel and broadcasting room at Radio Saarland in West Germany. Courtesy of the Federal Republic of Germany.

for European news stories. The EBU maintains a technical switching center for program exchanges in Brussels, Belgium. The American networks generally have arrangements to take the EBU feed through their London bureaus, where EBU material can be relayed by satellite to New York. In turn EBU has access to video from the cooperating American networks.

Nordvision

Nordvision, another cooperative, serves five Scandinavian countries with TV news and programming.

OIRT

The Communist nations of East Europe have the OIRT, International Radio and Television Organization. It has its base in Prague, Czechoslovakia and serves 25 countries worldwide, including some non-Communist nations. On occasion, OIRT exchanges programs with EBU.

Use of Satellites in Information Exchange

The growth of satellite technology has promoted an increased interest in regional cooperation,

program and technical exchanges, news exchanges, and regional training sessions. The Asia-Pacific Institute for Broadcasting Development in Kuala Lumpur, Malaysia conducts seminars in Asia, South Asia, and the Pacific Islands for its member countries on the better use of satellites. The Asian Mass Communication Research and Information Center in Singapore also conducts training programs.

Asiavision

Asian and South Asian nations are exchanging news items on a daily basis through Asiavision. Each country supplies stories to a central control point, such as Kuala Lumpur, Malaysia. The stories are then retransmitted, without editing, for reception by all the member nations.

The FCC in International Communication

While international telecommunication agreements are not specifically within the areas of responsibility of the FCC, the Commission provides advice and delegates to the major international meetings. *Section 303 of the Communications Act makes the FCC responsible for carrying out international agreements.* These agreements are treaties and must have the endorsement of the U.S. Senate.

The FCC has been particularly active in recent years in obtaining modifications of broadcast treaties with Mexico and Canada, which have resulted in removal of some restrictions formerly imposed on U.S. AM stations close to the borders of those countries.

Examples of Types of Systems

Next, we'll look at a selection of broadcasting systems to see what similarities and differences we find around the world. Our first stop will be in the United Kingdom, or more specifically, Britain.

BROADCASTING IN BRITAIN

The British system of broadcasting is important not only as a type but also because it was the prototype for broadcasting in many countries. As you travel through the countries Britain ruled

Figure 10–2
Transmitting mast (antenna) used by BBC External Services, the medium- and short-wave external radio service of the British Government. Courtesy of BBC External Services.

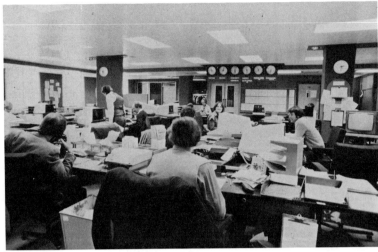

Figure 10–3
The newsroom at Bush House in London, headquarters of the BBC's external services. More than 250 news programs are prepared here every day by an editorial staff of more than 100 journalists. Courtesy of BBC External Services.

and the nations of the British Commonwealth, you find the imprint of the British Broadcasting Corporation (BBC). This is particularly true among what are now known as the Third World countries. Many of the systems were started as British systems, others were started by Brits serving as consultants.

Regularly scheduled programming was begun in Britain in 1922 by the *British Broadcasting Company*. By 1925 a national network existed. In 1927 the name changed to the *British Broadcasting Corporation,* which is run by 12 governors appointed by the Queen on the recommendation of the Prime Minister. The chief executive of the BBC is called the Director-General.

The television side of the BBC was started in 1936 but didn't become a major source of programming until after 1946. Britain's early involvement in World War II caused the curtailment of TV just as World War I curtailed the development of radio in the United States.

Overseas Service

The overseas service of BBC radio began in 1932 and reached great prominence during World War II. It is financed from government funds allocated to the Foreign Office. It broadcasts on both medium wave (AM) and shortwave. The BBC overseas service was begun and is still run as a way to provide unbiased or as close to unbiased information to British subjects and other interested listeners all over the world.

Domestic Broadcasting in Britain

The British system is made up of two parts: (1) a government-owned corporation and (2) a private enterprise system. To understand British broadcasting, we will look at the government-owned system and the private enterprise system separately.

British Regulations

All broadcasting in Britain comes under the *Wireless and Telegraphy Acts of 1949 and 1967.* Essentially, these acts say you must have a li-

cense to send or *receive* wireless communications. Pay particular attention to the word *receive* because this is a major difference between the U.S. system of broadcasting and the British concept. In Britain set owners pay an *annual license* fee on TV sets only. Radio sets used to be licensed, but the growth of small portable radios made enforcement difficult, so the impact of the license fee was switched to TV sets. The domestic radio and TV services of the BBC get their primary support from the license income. The Post Office collects the fee and detects fee evaders in behalf of the Home Office, which is the government department that oversees broadcasting. The BBC does not accept advertising.

There are currently about 18.5 million TV licenses in Britain, of which about 15 million are for color sets. Not all the people who own sets pay the license, and detecting evaders is an ongoing activity. The BBC also earns income from selling its programs overseas, rental of equipment and services to visiting broadcasters, and sale of books and program guides.

In the mid-1980s there was Parliamentary discussion of accepting some advertising on BBC television. The discussion was triggered by word that the license fees on TV sets might have to be raised. TV license fees were raised in 1989. Prime Minister Margaret Thatcher was one of the advocates of accepting ads on the government-owned system. The commercial (or private) broadcasters were fearful that there wouldn't be enough advertising money in such a small country to support two commercial TV systems.

A committee was appointed to study the issue of commercializing the BBC and in 1986 the Peacock Committee recommended against accepting advertising on BBC television and two of the four radio networks, but the committee did suggest that the remaining two radio networks accept advertising.

Semi-independent

The structure of the BBC, with its system of advisory councils and its financial support coming primarily from license fees is designed to keep the organization clear of parliamentary meddling. It is for this reason that the news on the BBC differs radically from news on most state-owned broadcasting systems. Its news staff is relatively free from government interference in the choice and content of the news.

A measure of the independence of British broadcasting is the fact that there has been radio coverage of Parliament since 1978, and in 1985 the upper house (The House of Lords) conducted an experiment allowing its debates to be televised. In 1988 the lower house (Parliament) was preparing to allow live broadcasting of its deliberations.

Four Radio Networks Make up BBC Radio

BBC radio provides four national networks plus national regional services and local radio.

The four national radio networks are:

Radio 1, rock and pop music;

Radio 2, popular music, comedy shows, panel and quiz programs, news and a heavy schedule of sports;

Radio 3, serious music, fine arts, science, political analysis; and

Radio 4, speech channel, news, talk programs, drama, comedy, game shows, and consumer affairs.

The regional networks include BBC Radio Scotland, BBC Radio Wales, BBC Radio Cymru (Welsh language), and BBC Radio Ulster (Northern Ireland). The networks operate independently but do share some programming and have an interconnected news system. The BBC operates 30 local radio stations and planned to add more in the late 1980s and early 1990s.

BBC TV Networks

The BBC operates two TV networks, BBC-1 and BBC-2. Although it is difficult to put a label on each TV network service, BBC-1 tends to carry more entertainment and frequently has the popular programs with the highest ratings. BBC-2 has more cultural content and functions as a supplemental service to BBC-1 in sports events. It is also the network which tends to be assigned new and untried programs.

All of the BBC networks include a heavy dose of *educational* programming in their schedules. The BBC was set up to operate with commitment to educational and cultural programming in its charter.

The domestic part of the BBC uses 1200 transmitters. (These numbers account for both radio and TV.) The BBC domestic service employs 100 studios nationwide. An additional 52 studios

are assigned to the external service, which is headquartered in London's Bush House. In this description of facilities it is obvious the system works differently than the U.S. system in which each station has its own transmitters and studios.

Pirates

Of particular concern to the BBC are the so called *pirate radio stations,* which operate from ships anchored in the North Sea and the English Channel and from locations in some of the major cities. The pirate radio stations located on ships play the latest British and European popular music using contemporary American disk jockey formats. The pirates accept advertising and some have been successful in getting large audiences in Britain and on the Continent. They have been less successful in attracting advertisers. The urban pirates often represent "communities" of people who feel they are underserved by both the BBC and independent radio. In London, Caribbean blacks and Greeks have been actively involved in running pirate radio stations for years. One impact the pirates have had on British radio is that several of the leading pirate DJs eventually ended up working for the BBC, and gradually the BBC altered its music programming to respond to demands for reggae, jazz, and other forms of music it had not been playing.

Community Radio

In 1985 the government responded to the pirate radio movement, which it had not been able to quash, by saying it would license a few low power radio stations, using a liberal set of rules regarding advertising, programming, and technical standards. The announcement by the government set off a flood of applications by pirate broadcasters, community groups, and business people. The government moved slowly in actually setting up the community radio system and no licensed community radio stations were on the air by mid-1988, although some were promised for 1989.

Independent Broadcasting Authority

Britain has a second broadcasting system. It is a for-profit, private enterprise venture. The body set up to govern commercial broadcasting was called the *Independent Television Authority.* It

was replaced by the *Independent Broadcasting Authority in 1973.* IBA was the governing authority over commercial broadcasting. It built and operated the transmitting facilities that were "rented" by the companies the IBA approved. The rental paid the cost of running the IBA. IBA was extremely powerful because it selected the broadcasting companies which rented the transmission facilities and then it supervised the companies, their programming, and advertising. The IBA's role was due to be changed radically under a government plan proposed in 1988.

ITV

In British literature you will encounter the letters *ITV,* meaning *Independent Television.* This is the term for the system governed by the IBA. It is also used to designate one of the two commercial networks. The other commercial network is Channel 4.

So specific is the power of the IBA that when it became obvious Britain needed morning television, IBA selected the company it wanted to program the morning program nationally. The company selected is separate from firms that use the same transmitters later in the day. (It would be as if the "Today Show" were sent out over leased facilities by the Today Show Company, rather than as part of the day's programming of NBC.) TV-am debuted in 1983 and was an instant success with the British population, which generally doesn't start its business day until 9 or 10 A.M. Later the BBC began its own "breakfast program." Still later, both systems decided to run regular (noneducational) programming during daytime.

The independent TV companies pay a tax to the government, based on their profits. They must also rent their transmission facilities from the IBA.

Franchises

The IBA franchises were given for a stated number of years, and there was no guarantee a franchise would be renewed. In 1980 the Authority dropped two operating companies and gave the franchise to competing firms. The operating companies had to consult with the IBA in regard to the programs they ran. There were limits on imported programming and the number of feature films that could be shown. There were also specific directives on the amount of news, public

affairs, and local programming which had to be done. The operating companies sell advertising to pay their expenses and hopefully return a profit.

ITV

Britain's third TV network is ITV, Independent Television. Many programs originate at studios in London, although programming can originate from other points in the country, and there are a total of 17 TV studios dedicated to ITV.

Channel 4

The IBA oversaw the fourth television channel, which was mandated by the Broadcasting Act of 1980. Rather than parcel out Channel 4 local franchises, the Channel 4 network is funded by a percentage of the revenues of the 15 independent operating companies, which also sell Channel 4's advertising. Instead of building competitive TV stations in each city to carry Channel 4, transmitters were added, frequently on the same sites as existing TV transmitters, and the network programming was routed from London. The idea was to provide programming, which was different from the fare on the BBC and the independent TV stations. The IBA encouraged Channel 4 to buy more programming from independent producers not presently supplying the BBC and independent TV stations.

Contracts

The actual TV programs people see are provided by 16 TV program companies which hold contracts to serve the 14 independent television regions. (Yes, there is a discrepancy in the numbers. Two companies serve the London district. One programs on weekdays and the other programs weekends.) The sixteenth is TV-am.

In radio 26 companies hold contracts for 25 regions, with more stations likely to be added as the government revises its policy on broadcasting. (Here again, London is served by two companies.)

Commercial "Network" TV

The member stations set up and financed the central national news organization called Inde-

pendent Television News (ITN). In addition to supplying news to the ITV contractors, ITN will sell newscasts to anyone who wishes to purchase them. ITN also operates several for-profit ventures. The regional companies maintain their own newsrooms in the major cities in their regions and broadcast regional news.

Radio Networking

Most commercial radio stations produce their own programming, unlike the BBC stations, which are heavily dependent on network programming from the four BBC networks. The major interconnection for commercial radio is IRN, the news network, which operates out of the studios of London Broadcasting Company (LBC), a news/talk station in London.

An American in London

If you were in London in the mid-1980s and turned on your TV set, you would have had a choice of only four different signals: BBC-I, BBC-II, ITV, and Channel 4. In some rural areas fewer signals are received because the transmitters don't cover all of the United Kingdom. Cable is just beginning to develop in Britain, and the government only authorized ownership of backyard TVROs in the late 1980s. Owners of TVRO dishes have to pay an added tax.

The successful launch of the European Astra satellite aboard an Ariane rocket in December 1988 opened a new era in British and European television. Individual dish owners can receive DBS signals from Astra in Britain and most of Europe. Some cable systems also pick up programming from Astra.

Media mogul Rupert Murdoch leased six transponders on Astra and moved his Sky Channel to Astra, expanding it from one to six separate services, including Sky Channel (general entertainment), Classic Films and Arts, Eurosport, Sky Movies, the Disney Channel, and Sky News. Another English company, British Satellite Broadcasting, planned a late 1989 launch of its own satellite providing DBS services.

The future of DBS service in Britain looked brighter than in the U.S., because the home receiving antennas needed in Britain were far less expensive than TVROs sold in the U.S. In England, a dish could be purchased for around $360.

Reserve Powers

In theory, the British government could exert a great deal of influence over broadcasting if it chose to use its reserve powers. The government can require ministerial announcements and other emergency statements to be broadcast. It can veto a broadcast or class of broadcast. It sets financial terms for both the BBC and the IBA. The government determines what frequencies will be used and how. The members of the authorities that supervise broadcasting are appointed by the government.

Actual Power

In fact, the government of Britain exerts little direct control over broadcasting, leaving the carrying out of government policy to the broadcasting authorities, which are aware of the government's view that broadcasting is a public service, which should have balance in its programming and news content; be accurate and impartial; should not be offensive to common decency; should not promote crime or disorder; and which should disseminate information and education as well as entertainment. The Home Secretary is designated to assign frequencies and control the use of bands as well as negotiate international agreements regarding broadcasting.

Deregulation

Beginning in 1985, the government began a process intended to expand the number of commercial radio and television stations in Britain. The proposed changes involved "reregulation," or redrawing the broadcasting laws, rather than the "deregulation" done in the U.S. The intended result was to liberalize broadcast regulation by applying a "lighter touch" to government interference in the profit-making sectors of broadcasting, cable, and DBS.

The process in Britain to accomplish a major change in government policy is frequently a long and deliberate one. In February 1987 the government issued a document, called a Green Paper, suggesting changes in the structure of radio. It was called, "Radio: Choices and Opportunities."

The Green Paper was followed in November 1988 by a more comprehensive document, a White Paper, entitled, "Broadcasting in the 90s:

Figure 10–4
Journalists at work in the London newsroom of Sky News, a satellite news channel which serves Europe and the British Isles. Courtesy of Sky Television, London.

Competition, Choice and Quality, The Government's Plan for Broadcasting Regulation."

The proposals outlined in the White Paper included the following:

1. Creation of a fifth national television network, with different companies providing service at different times of day.
2. If technical studies justified the move, creation of a sixth television network.
3. Changes to the structure and method of determining who gets franchises on the present ITV network, plus liberalization of rules on what programs could be run.
4. Continuation, with revisions, of commercial Channel 4 and the special Welsh service in Wales.
5. Development of local services through cable and microwave (MMDS) services.
6. Addition of more DBS channels.
7. Arrangements made to assure that viewers could receive other satellite services. The government was also debating how to regulate the content of programming on DBS channels which originated in other countries.
8. Encouragement of "subscription TV" as another means of financing some commer-

cial stations and much of the BBC's operations. The BBC would be encouraged to move away from supporting itself from the tax on TV receivers.

9. A weaker Independent Television Commission (ITC) to take over some of the tasks of the Independent Television Authority, which would be dissolved.

10. Programs to increase production by independent producers.

11. Independent (commercial) radio would be expanded under the guidance of a Radio Authority.

12. A Broadcasting Standards Council established to "reinforce standards of taste and decency and the portrayal of sex and violence." Broadcasting's exemption from obscenity legislation would be removed.

Most of the proposed changes would occur in 1992, to coincide roughly with a major restructuring of the European Economic Community also set for that year.

The government solicited comments on the White Paper from all interested parties, and then took the proposals, in the form of legislation, to Parliament for consideration.

BROADCASTING IN THE THIRD WORLD

Broadcasting is an extremely important element in the political and social fabric of the *developing* or *Third World* nations. In general, these are the world's poorer, economically less developed nations. There are exceptions to this description, of course. Saudi Arabia and Qatar among the Arabic nations are far from poor and yet often get lumped in the designation Third World.

Development

When you talk with broadcasters from the Third World nations you soon come across the terms *development broadcasting* or *development journalism*. These terms mean the use of broadcasting as a means to promote forward movement in education, health, agriculture, and other target areas set by the government. Many of the leaders of these nations think that the government must exert rigid control over broadcasting. Their reasons are at least fourfold: (1) *broadcasting can be used as a way to ensure government stability;* (2) *broadcasting can be used to create*

cohesion in nations that have strong tribal, territorial, or religious divisions; (3) broadcasting can be used to promote modernization of sectors of the society; and (4) broadcasting should be controlled to prevent cultural or moral intrusions, which are inimical to the country's prevailing standards.

We are going to present an overview of several broadcasting systems. India is a large diverse nation with a predominantly Hindu culture and religion with large minorities of Moslems, Sikhs, and Christians as well as tribal groups. It has one third the land area of the U.S. with three times the population. Pakistan, a separate country, is part of the Indian subcontinent, but its government and culture are largely Moslem. Jordan is an Arabic Moslem nation between Syria and Israel, which is rapidly becoming a cosmopolitan international crossroads of the Mideast. Nigeria in Africa has sharp tribal divisions and a volatile economy. In each of these countries, broadcasting plays a major role.

India

India is a socialist democracy, which means that there are several political parties with members of parliament elected in free elections. The economy and much of the society is socialist in makeup, such as government ownership of manufacturing plants and an extensive system of low-cost social services.

The Prime Minister is the leader of whichever political party gains control of Parliament in democratic elections. Elections can be tumultuous, with a combination of vigorous campaigning, large rallies, outbreaks of violence between warring factions, and instances of election irregularities.

Some agriculture, a great deal of industry, most of the country's transportation system, and a portion of the hotel industry is nationalized. By nationalized we mean the way the Postal Service or the Federal Prison system are run in the United States.

Despite the democratic structure of India's government, broadcasting is controlled by and conducted only by the government.

Ministry of Information and Broadcasting

The broadcast system itself is directly inherited from the British who sent out BBC experts to start up India's first radio broadcasting stations.

The radio system is called All India Radio. Television is operated by another entity, Doordarshan. Both are controlled by the Ministry of Information and Broadcasting.

India's form of broadcasting fits the definition of *Development Broadcasting*. The late Indira Gandhi's personal advisor on information told one of the authors that broadcasting was seen by the government as part of the glue, which held together what is in reality a loose confederation of widely divergent states, cultures, and religions.

Broadcasting is used as a means to disseminate the government's messages, to create a feeling that India is indeed a single country, and as a way to teach Indians the two national languages, Hindi and English. Broadcasting to promote development is considered a strong means to move the country ahead on the path of modernization.

All India Radio

The first radio stations in India were put on the air in Bombay and Calcutta in 1927. The stations were privately owned. In 1930 the Indian Broadcasting Service was created by the British and the private stations were taken over. In 1936 the name became All India Radio (AIR).

AIR (now also called Akashvani) had only six stations when India became an independent nation in 1947. By 1983 the government listed 86 broadcasting centers, with 126 medium wave transmitters (U.S. AM), 33 shortwave transmitters, and three FM transmitters. FM radio was new and was being tried in the urban centers.

In 1989 India's Minister of State for Information and Broadcasting said that 90 additional radio stations would be set up in the following 12 months, with an objective of providing 24-hour a day radio service to the country's entire population. The Minister said that although television reaches 70 percent of India's population, only 10 percent of Indians can see TV because there are only 12 million receivers in the country.

Despite being government owned and run, many of the broadcasting centers carry some commercials. The primary source of revenue continues to be license fees for radio receivers and government budget allocations.

Commercial Broadcasting

Commercial broadcasting by the government media began in 1967 and has expanded to help the tremendous economic burden of extending AIR coverage to all of India. This means not only improving transmission equipment; it means putting radio stations in communities that do not currently have them. While this expansion is underway, AIR is sorely pressed to rebuild its antiquated studios and transmission facilities.

Radio Receivers

A few years ago the government lightened the tax on radio receivers and made liberal provision for the ownership of transistor radios. Now, there are an estimated 21 million radio receivers for 700 million people.

One factor which has held back both the development of AIR and of consumer radio receivers is an Indian government policy, demanding that most products be manufactured within the country. This is done to curtail India's critical balance-of-payments deficit. India has to develop the techniques and manufacturing facilities already in place in industrialized countries. This has taken time and contributed to the shortage of broadcast equipment and radio receivers.

Central News Division

A Central News Division networks news around the country and overseas. News can be heard at various times from 6 A.M. to 12 midnight. There are 250 national news broadcasts daily in 37 languages. India has 27 legally recognized languages. Despite the heavy schedule of news, the content differs radically from what Americans or British are accustomed to hearing. The news staff is paid from government funds and responds slavishly to both real and perceived direction from government officials.

Doordarshan

Doordarshan is India's national TV system. Television was introduced in New Delhi in 1959, but expansion of Indian TV did not start until 1972. India did not have color TV transmissions until December 1982. India has a major task ahead if TV is to be made available to the majority of the population. The government is working to add transmitters and stations. Many areas and a great deal of India's population are not served by television primarily due to the tremendous cost of building the system.

The high cost of developing Indian television is further complicated by the government's decision to place major reliance on Indian-produced programs, which serve the audience better but increase operating expenses.

Satellite Transmission

The launching of India's domestic satellites opened many new avenues for relaying programming. Earlier the government had experimented with placing low-power transmitters in remote areas and feeding them by satellite. This experiment, *SITE,* had mixed results partly because there was a lack of software or programs to feed to the SITE receivers. Many receivers were placed in villages. The idea was to have the villagers come to the village meeting hall in the evening and watch the news and a selection of informational programs.

Three problems arose: (1) *many villagers preferred to watch only when Doordarshan showed entertainment films;* (2) *if the chief left the village, the receiver remained locked up and unusable;* and (3) *it was difficult to locate technicians to repair the village receivers.*

The principle of using satellite dishes and low-power transmitters to bring TV to more remote areas at low cost makes sense, and is the subject of research in both South Asia and Asia.

Programming

A problem that troubles Indian government officials is the popularity of the occasional feature films shown on Doordarshan. Many of India's films are what we would call "low budget." They repeat themes, plots, and cinematographic technique according to a successful formula. (They are much like fairy tales in this respect.)

Indians who can afford TV sets like to sit home and watch movies. This is troubling to the government because TV is seen as an instrument of social change rather than an entertainment medium. The government would prefer that the majority of people watch the news, informational, and cultural programs. Indians who can afford VCRs also use them to consume entertainment.

News

Well-educated Indians tend to pay little attention to the news on TV because they know Doordarshan promotes the ideas of the government in power. Doordarshan News has little news-collecting ability; so the national news seldom provides timely coverage of anything that is not local in New Delhi. Disasters and civil disorder are deleted or deemphasized in favor of endless minutes of video showing officials sitting in chairs or exchanging greetings prior to going into private meetings.

Shortwave

India's shortwave service is operated by AIR. The country is heavily involved in shortwave both as an inheritance from the British system and as a way to stay culturally in touch with the millions of Indian expatriots who are living and working in other countries.

Pakistan

There are similarities between broadcasting in Pakistan and India, as you would expect from neighboring nations on the same subcontinent. Equally, there are stark contrasts.

The Pakistan broadcasting system is quite up to date from a technical viewpoint. TV is transmitted in color and radio utilizes new or nearly-new equipment. Indians who live along the Pakistan border frequently aim their TV antennas to receive Pakistani programming, rather than the output of India's Doordarshan. Pakistan provides more color TV and more popular entertainment.

Receivers

In 1984 Pakistan had one million TV receivers, of which 100,000 were color. The Pakistan government was using 16 transmitters to cover the country. There were 1.5 million radio receivers. The government operates 23 medium wave and 15 shortwave stations, covering approximately 95 percent of the population. Since the broadcasting systems in Pakistan and India were both products of British rule, Pakistan, like India, has a strong central management, and a central news

Figure 10–5
Pakistani broadcaster leaving Pakistan Broadcasting Academy in Islamabad, where news, production, and engineering specialists are trained.

and production organization, augmented by local production and news staffs in the regional radio and TV stations.

Shortwave

Pakistan invested heavily in shortwave radio because so many Pakistanis moved to other countries, especially the Gulf nations, in search of better jobs. One of the primary missions of government shortwave radio in South Asia is to keep in touch with expatriots. Shortwave also helps to fill in poor reception areas not covered by government medium wave (AM) radio stations. The propaganda aspect of shortwave broadcasting, which is important to the Soviet Union, Britain, and the United States, is not the highest priority of shortwave transmissions in Pakistan and India.

Some of the languages used in the Pakistani external service include Dari, Bangla, Burmese, Iranian (Pharse), Arabic, Hindi, Tamil, Turkish, Turki, Hazargi, Indonesian, French, Swahili, Gujarati, and Sylheti.

Government Control

There is no private broadcasting in Pakistan. However, the government partially finances broadcasting through the sale of commercial sponsorships.

The Pakistanis take a radically different view from India about importing goods. You see many types of imported autos on the roads and a good selection of imported radio and TV receivers. The Pakistanis do have a balance of payments problem, and Pakistan Broadcasting is addressing the problem by manufacturing selected equipment within the country, particularly audio consoles, turntables, and master control audio switching devices. In turn, these products, made by PBC (Pakistan Broadcasting Corporation), are sold to other countries. The broadcasting corporations in the Arab states have been some of Pakistan's best customers.

Programming

Program categories published in 1982 by the Pakistan Broadcasting Corporation (radio) list the following: news, drama, and features, 50 percent; news and current affairs, 14 percent; religious broadcasts, 11 percent; talks, discussions, symposia, 9 percent; rural broadcasts, 7 percent; science and technology, 2 percent; women's programs, 1 percent; youth forum, 1 percent; students' programs, 1 percent; sports, 1 percent;

forces (armed forces) programs, 2 percent; and children's programs, 1 percent.

News broadcasts on Pakistan TV more closely resemble Western TV as far as their appearance, but they circumspectly avoid covering stories offensive to the ruling power.

Pakistan maintains a broadcasting academy in Islamabad where the government trains new employees and runs courses for middle-level personnel. In contrast to India, which has its own government broadcasting academies, Pakistan eagerly solicits the assistance of Western nations to provide experts to teach at the academy.

Jordan

Jordan is an Arabic nation, but it is not an oil-rich country. It has an agriculture-, trading-, and technology-based economy. Historically, Jordan sat atop the trade routes to the East and part of the country encompasses the Holy Land. Broadcasting is government controlled, but allows some other viewpoints.

Physically, Jordan is small and its citizens can easily listen to and view broadcasts from Syria, Iraq, Lebanon, Israel, and Egypt. Thus, the government broadcasting company has to take into account two factors: (1) it is competing with media from other sources, and (2) its media can be seen and heard in nearby countries.

Facilities

Jordan Television Corporation has 12 transmitters and 11 low power repeaters, which can be viewed on 200,000 receivers, of which 20,000 are color. The Hashemite Kingdom Broadcasting Service operates three medium wave, three shortwave, and two FM transmitters. There are approximately 540,000 radio receivers in Jordan.

Signals from Neighboring Countries

Jordanians love TV. The terrain in Amman is hilly and some of the wealthier residents of the city have small towers, which resemble oil-rig towers, on top of their flat-roofed houses. A rotary TV antenna is mounted on top of the tower so the owner can turn the antenna to get the best possible reception from neighboring countries. Set owners who can receive Egyptian broadcasts are particularly enthusiastic because Egypt is the major producer of films and entertainment programs in the Mideast.

Programming

Jordan's radio and TV broadcast facilities are adequate, although they lack the frills associated with some of the Arab systems on the Saudi peninsula. In an effort to stimulate more Arabic programming and fund a more vital TV system, the government of Jordan has worked to increase production of both TV shows and films in Jordanian studios. In recent decades Jordanians have traveled widely in the Arab world, providing professionals and skilled technicians to other nations.

The Jordanians are pragmatists. Because their TV signals cross borders, they broadcast news on TV in several languages. Jordan TV does one newscast in Hebrew for Israeli viewers. (The Israelis do a newscast in Arabic.) The French government buys time from Jordan TV and provides a 15-minute newscast in French for French speakers throughout the area. Why? Remember that France once had a great deal of military influence in the Mideast and there are still thousands of French-speaking people living in the region.

Jordan TV also broadcasts news in English (which is a result of the influence of the British presence between the World Wars), as well as in Arabic. The rationale for using English is the same as it is for broadcasting in French. English is the international language, and there are thousands of English speakers who watch the English news.

Jordanian news producers have access to overseas feeds via satellite, and although their resources are too limited to have many correspondents, Jordanian producers have audio and video reports and wire service news to draw from. They steer clear of criticizing the government, but Jordanians do get a wide-ranging and relatively uncensored view of the news of the world.

Nigeria

Nigeria, like India, inherited its broadcasting system as a legacy of British colonialism. However, while India's broadcasting system is highly centralized, Nigeria developed a two-level system giving the federal and state governments controlling roles in broadcasting.

This decision, incorporated in Nigeria's constitution in 1954, helped to politicize the country's broadcasting system. Nigerian broadcasting promotes development, but it also plays an important *political* function. The struggle for power between the states and the federal government is played out as indicated by the structure of Nigerian television.

The Nigerian Television Authority (NTA) broadcasts exclusively on the VHF band, while the state government stations are assigned to the UHF band. This gives the central government stations better coverage and picture quality as they try to serve the nation's 80 million people. International broadcasting expert Sydney Head reported that in 1983 Nigeria had 32 TV stations, which was more than the rest of tropical Africa combined.

There is no such technical division in radio, where over 80 medium wave (AM) and a handful of VHF (FM) radio stations are spread around the country. Nigerian radio operates on a three-tier system. The Federal Radio Corporation of Nigeria (FRCN) operates national stations in each region that must carry the national news. In addition, FRCN operates regional transmitters that program to tribal and language groups. The 19 state governments also operate "grassroots" stations serving local interests. The federal government operates a shortwave service, which, by law, has its programming tied to Nigerian foreign policy.

The federal government has tried to gain control of the country's broadcasting system, but state politicians, loyal to their own tribal, religious, and political interests, have blocked centralization. Frequently, these state leaders belong to opposition political parties.

The principal languages used for Nigerian broadcasting are English, Yoruba, Hausa, Edo, Efik, Fulfulde, Igala, Izon, Kanuri, Nupe, Tiv, Urhobo, and Igbo, plus 12 local languages. There are also 25 additional local languages that are used for selected broadcasts.

Africa's first TV station was built in Nigeria, and its founders said the station was constructed to support the government's educational programs. Today the programming of the national stations of the NTA and FRCN includes programs for children, women, and the family; school broadcasts; sports and recreation; drama and light entertainment; arts and culture; government; news and current affairs; economic and industrial development information; and programs about religion, philosophy, and ethics.

Broadcasting is a public service, supported by government funds. In the 1970s grants and expert assistance from Germany and the United States permitted an expansion of broadcast facilities, particularly TV. The slump in interna-

tional oil prices through much of the decade of the 1980s tightened budgets and limited the growth of broadcasting.

Too rapid expansion has been a significant problem in Nigeria. So, too, has the nation's economy, which includes many people too poor to buy radio or TV sets. High customs duties and excise taxes, put in place to protect Nigerian manufacturers, have tended to keep the price of receivers beyond the reach of many Nigerians.

THE SOVIET UNION

Broadcasting in the Soviet Union is government-controlled. Communist governments are acutely aware of the role of the media in spreading and sustaining their doctrine, and broadcasting is held under very tight control.

Facilities

There are an estimated 75 million TV receivers in the USSR, of which about 2 million are believed to be color. The TV system uses 659 transmitters plus 1,500 relay stations. There are 136 million radio receivers serviced by 61 long wave, 300 medium wave, and 93 shortwave stations.

If you have a shortwave receiver you will find it is not difficult to listen to the English language service of Radio Moscow. You will find the English very understandable.

Policy

Broadcasting policy is set by the Union Republic Committee of the USSR Council of Ministers.

There are four TV networks. Just as in Britain, the various channels carry different types of programming. They do not compete for audiences by offering variations on the same type of program, as do the major networks in the United States. Residents of Moscow can see up to four channels.

Programming

Channel One is designed to serve the entire country, which covers a land area two and one-third times greater than the United States. Soviet broadcasters also have to contend with 11 time zones and at least 100 nationalities, each speak-

Figure 10–6
Temporary TV news editing facility set up in Moscow by the CBS News crew during President Ford's visit. This is minute compared to the tons of equipment taken to Moscow in 1988 when President Reagan attended a summit conference.

ing a distinct language. Channel One's programming is of general interest, including news, talk shows, movies, concerts, and general-interest programming.

Channel Two begins its broadcast day at 8 A.M. with an exercise program and follows with educational courses for home study. Much of the rest of the channel's program schedule is made up by educational programs and sports. Channel Two is also regarded as a national channel, although its programming is replaced in some remote areas with locally oriented programs in the local language.

Channel Three is a local station in Moscow and it begins its day at 7 P.M. It features local news and other programming of interest to Muscovites. Channel Four is also a local station in Moscow and carries primarily educational programming.

Americans who have lived in the Soviet Union report that there is a minimum of Western-style entertainment programming. Native folk dancing and programs extolling economic or agricultural accomplishments are more common.

Radio programs four networks, with the fourth providing FM service, some of which is transmitted in stereo.

You might ask why are there so many networks? One reason is that both radio and TV

have to take into account the vast size of the USSR and the number of languages spoken by its people. Soviet TV broadcasts in 60 languages.

External

The USSR is extremely active in external broadcasting, beaming its shortwave signals to most of the world. Since the Soviet influence has spread into Asia, South Asia, Africa, the Mideast, South America, and Central America, the Soviets are desirous of having their ideology explained to as many people as possible. That is why you can hear Radio Moscow almost anywhere in the world.

AMERICAN PROGRAMMING AROUND THE WORLD

The United States, like many countries, maintains a heavy schedule of government-financed broadcasts aimed at influencing people in other countries. The United States is slightly different from other countries in that our government permits shortwave (overseas) broadcasts by nongovernment groups. There are commercial shortwave stations and there are also religious broadcasts on shortwave from private facilities within the United States and U.S.-governed territories. Among these are WYFR, Okeechobee, Florida; KFBS, Saipan, Northern Mariana Islands; KGEI, San Francisco; WRNO, New Orleans; KTWR, Agana, Guam; WINB, Red Lion, Pennsylvania; KUSW, Salt Lake City, Utah; and KNLS, Anchor Point, Alaska. All but WRNO and KUSW transmit mainly religious programs. WRNO is a commercial top 40 popular music station. KUSW broadcasts contemporary American music, news, and worldwide weather. The religious stations attempt to perform a missionary function by broadcasting Christian messages to Christians and non-Christians. The FCC by 1986 had authorized at least 15 more private shortwave stations.

Voice of America

The Voice of America (VOA) is owned and run by the U.S. government as a *propaganda* outlet. Propaganda is essentially public relations, putting your best foot forward. The question with propaganda is how you put your best foot forward. Do you emphasize the good and positive

and play down the negative? Are you totally truthful or do you change everything you say to meet some master plan? Many nations broadcast to the world, trying to spread their culture and ideology. There are some fundamental differences between VOA and some of the other overseas services. First, VOA doesn't need to concentrate on overseas Americans, although it has heavy listenership among Americans who are overseas for lengthy periods. Many countries use shortwave radio and focus their attention on their own citizens living or working out of the country, trying to hold their ties to the mother land.

VOA has a reputation for journalistic integrity, which is paralleled only by the BBC's Overseas Service. It is this integrity and honesty that accounts for the popularity of both VOA and BBC among people in other countries. VOA services provide programming in a wide selection of languages.

VOA Facilities

To accomplish its massive task VOA uses a network of transmitters, 31 in the United States and 80 overseas. The U.S. transmitters are located at Greenville, North Carolina; Bethany, Ohio; Marathon, Florida; Delano and Dixon, California. The largest U.S. installation is the one at Greenville, North Carolina, which uses 12 transmitter and 66 directional antennas.

VOA's overseas facilities are located in Munich, Germany; Kavala and Rhodes in Greece; Monrovia, Liberia; Tangier, Morocco; Colombo, Sri Lanka; Bangkok, Thailand; Tinang and Poro in the Philippines; Judge Bay, Antigua; Selebi-Phikwe, Botswana; Quesada, Costa Rica; Punta Gorda, Belize; and Wooferton, England. This worldwide complex of transmitters is fed by 18 satellite circuits.

History

The Voice of America began during World War II using shortwave facilities leased from private concerns and news and production talent from CBS and NBC. President Franklin Roosevelt had created the Office of War Information (OWI) and he appointed a well-known broadcaster, Elmer Davis, to head the information agency; the VOA was one of the major projects of the OWI. VOA began broadcasting in 1942.

During World War II VOA maintained a pol-

Figure 10–7
Voice of America Polish Service broadcaster. The Polish Service transmits seven hours daily, and it is estimated that 45 percent of adults in Poland listen to the Voice of America regularly. Courtesy of the Voice of America.

icy of telling the truth, good or bad, about America and the war. Generally, the policy was followed except for information limited by security concerns. After the war VOA was nearly eliminated, only to be saved by the "cold war" with the Soviets. In 1950 during the Korean War, Congress appropriated over $62 million to expand VOA's worldwide network. The suggestion for the expansion of VOA came from RCA Board Chairman David Sarnoff who received the wholehearted support of President Harry Truman. During this period, propaganda became an important element in international diplomacy, and VOA was put under the direction of the U.S. Information Agency, which is a division of the State Department.

In 1985 the VOA resumed its broadcasts to Western Europe, which had been discontinued in 1955 due to budgetary reasons. VOA received another major infusion of funds during the mid-

1980s when President Ronald Reagan backed a plan to update VOA's transmission facilities.

VOA Policy

One notable policy rule which applies to VOA is that it may not broadcast to U.S. citizens on the mainland. (Of course, you can hear VOA if you have a shortwave receiver, but you will note that the programming is not aimed at your interests.)

Target Audiences

VOA does not program to mass audiences. Its aim is to reach people who are curious about the American viewpoint on certain issues. This sort of person frequently tunes to the VOA, the BBC, and Radio Moscow to attempt a comparison. While VOA broadcasts in at least 41 languages, English is still a major language in its programming.

Special broadcasts are prepared, which are designed to make it easier for English learners to understand the announcers. The rate of delivery is slowed down and the vocabulary is restricted so that an English learner will be better able to comprehend the language.

VOA Independence

So far VOA has managed to keep most of its independence. Its correspondents travel on the same credentials used by most foreign correspondents representing Western news organizations. The quality of VOA's overseas staff is demonstrated by the fact that some VOA correspondents have gone on to join the foreign staffs of the major American networks.

Some of VOA's programming is rebroadcast by broadcasting services of other countries, and tapes of VOA programming are provided to foreign broadcasters who request them.

Radio Marti

Under 1983 instructions from Congress, the VOA began building what is known as Radio Marti. Cuban-Americans in South Florida pressured Congress to expand the VOA's effort to counter the large amount of programming Fidel Castro was aiming toward the Cuban-American population in the United States. As a result, the

government assigned a powerful 50,000 watt medium wave radio station in the Florida Keys to beam Spanish language broadcasts to Cuba on a frequency of 1180 khz which could be received by any radio in Cuba.

Bureaucratic delays, slow security clearances, and personality and policy conflicts kept the project off the air for months after it was authorized. In the meantime the government faced the probability of making payments to Florida stations which lost part of their signal to jamming and interference from powerful stations in Cuba. Other Florida stations were given temporary authority to raise their power to compensate for interference from the Cuban broadcasts.

On May 20, 1985 Radio Marti began broadcasting. Ironically, there was little immediate retaliation from Cuba. Many commercial radio operators had anticipated that the Cubans would try to *jam* the Radio Marti broadcasts by sending out interfering signals from their transmitters.

Since Radio Marti was so successful, TV Marti was proposed in 1988.

USIA Satellite Transmissions

In recent years the U.S. Information Agency (USIA) has developed TV programming which it feeds by satellite for use by any broadcast system that cares to pick up the signal. The service is called *Worldnet.* One of its services is to transmit live news conferences between government officials in Washington, D.C., and foreign reporters overseas. The agency solicits features from domestic TV stations and has its own staff produce additional newscasts, features, and programming. USIA plans call for a 12-hour per day program schedule, reaching the whole world. USIA budgeted $1.7 million in start-up funds in 1984 and by 1987 Worldnet was costing about $19 million a year. In January 1988 Worldnet was reaching 3.4 million subscribers on 110 cable systems in 10 countries; nearly 50,000 subscribers on five closed circuit (hotel) systems serving 15 countries; and over 20 million households on 21 broadcast stations in six countries.

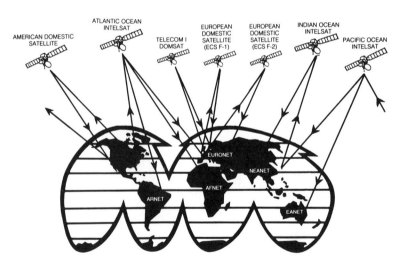

WORLDNET, the U.S. Information Agency's global satellite network, reaches mass audiences worldwide with three international, two regional, and two domestic satellites. A network manager or other available system is established for each international region to bring down the signal and retransmit it to regional satellites.

In Europe, the French Telecommunications Administration serves as the network manager receiving the WORLDNET daily European feed from the Intelsat Atlantic Ocean Spare Satellite, sending it across France via the Telecom I Domestic Satellite to the transmit earth station for the regional satellites. Here the signal is converted to PAL for Western European television standards and SECAM for Eastern Europe before the signal is sent back up to the satellites. Televisions receive only (TVRO) dishes at the U.S. embassies and cable companies throughout Europe then receive the signal from Europe's ECSF-1 & F-2 satellites.

The coverage or "footprint" of a satellite is limited. The WORLDNET signal for broadcasts to the Far East and the Pacific must travel from Washington by the American Domestic Satellite to the West Coast before it is transmitted to the Pacific Ocean Satellite and its final destination. The Intelsat Indian Ocean Satellite is used for parts of East and Near East Asia, receiving the feed from the Atlantic Ocean Satellite.

Figure 10–8
Illustration and information on WORLDNET. Courtesy of WORLDNET, U.S. Information Agency.

Radio Free Europe and Radio Liberty

Both *Radio Free Europe* (RFE) and *Radio Liberty* date back to the "cold war" days of the 1950s. The VOA had not been fully developed, and it was believed there needed to be a way to broadcast news about America to the Soviet Union and the countries of East Europe. With that purpose in mind, RFE was designated to broadcast to five East European countries (Poland, Hungary, Rumania, Czechoslovakia, and Bulgaria), and Radio Liberty was put on the air to broadcast to the Soviet Union. At the time it was thought that these two services were financed by concerned private citizens.

Many of the announcers and writers were anti-Communist expatriates from Eastern Europe. The American public was told that both services had been established by a private organization. Later, public solicitations of funds were carried out to help support RFE and Radio Liberty. In 1972 it was revealed that the U.S. Central In-

DAILY FEED

CET	MONDAY	TUESDAY	WEDNESDAY	THURSDAY	FRIDAY
0700 0900	AMERICA TODAY (120:00)				
HOUR USA 1400	NEWS (5:00) ENGLISH I (15:00)	NEWS (5:00) INNOVATION** (30:00) SCIENCE WORLD I & II*** (30:00)	NEWS (5:00) ENGLISH I (15:00)	NEWS (5:00) IT'S YOUR BUSINESS* (28:00) NEWS LEADERS** (28:00) MODERN MATURITY*** (28:00)	NEWS (5:00) PRIDE OF PLACE * (24:00) ANIMAL WORLD** (22:50)* AMERICA'S MUSIC*** (60:00)
HOUR USA 1415 1430	HOLLYWOOD CLOSE-UP (15:00) GEORGE MICHAEL'S SPORTS MACHINE (24:00)	PROFILES IN AMERICAN ART (30:00)	BUSINESS ENGLISH (15:00) ACTION SPORTS COLLECTION (22:50)	SCENIC AMERICA* (27:00) ESSENCE** (24:45) LIFE IN THE UNIVERSE*** (29:00)	NASHVILLE** SKYLINE (29:00)
1500 1559	DIALOGUE (59:00)	DIALOGUE (59:00)	DIALOGUE (59:00)	DIALOGUE (59:00)	DIALOGUE (59:00)
1600	NETWORK SIGNOFF			TOMORROW ON WORLDNET	

*Week one **Week two ***Week three

Figure 10–9
Sample WORLDNET transmission schedule. Courtesy of WORLDNET, U.S. Information Agency.

telligence Agency was the primary source of funds for both organizations. The CIA stopped funding the services, and in 1973 they were put under the supervision of the Board for International Broadcasting, which is appointed by the President and operates RFE and Radio Liberty using budgeted federal government funds.

The two European services maintain large staffs in Munich, Germany plus supplemental groups in Portugal, Washington, D.C., and New York City. They are less constrained by the government policy, which dictates that the VOA must be even-handed in its news presentation. RFE and Radio Liberty are regarded as sources of reliable news, but there is some flexibility in their programming which is not permitted by VOA policy.

American Forces Radio and Television Service

This branch of the U.S. overseas effort was designed to serve American military personnel and their families on overseas assignments. However, the American-style programming has attracted large audiences from the areas in which AFRTS broadcasts. *There are over 800 AFRTS radio and TV outlets in 50 countries.* Some of the stations are on ships, some are located at remote posts on American-supervised territory, and others are located in foreign countries. The AFRTS stations are organized into regional networks and they have access to "real-time" satellite programming from the United States, primarily through a program center in Los Angeles.

Figure 10–10
Television and newspaper reporters in the press gallery of the German Bundestage (parliament) in Bonn, West Germany. Courtesy of the Federal Republic of Germany.

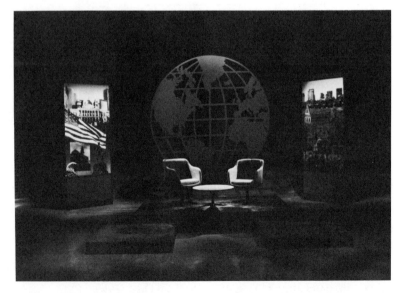

Figure 10–11
International videoconference set used by Christian Science Monitor Television when it interviews world leaders. Courtesy of the Christian Science Monitor.

Is Everybody Listening?

A measure of the potential impact these American overseas broadcasts could have is the amount of effort and money the Soviets expended on jamming RFE, Radio Liberty, and the VOA. The jamming started in the 1950s and continued until the late 1980s. Powerful transmitters send out buzzing signals, which are intended to prevent clear reception of U.S. broadcasts in Soviet Bloc countries. The United States is not the only nation whose programs are jammed. The Soviets also jam broadcasts from China, Israel, Britain, and West Germany, nations that take frequent exception to Soviet policy.

TECHNOLOGY AROUND THE WORLD

Americans have a tendency to think we have an exclusive grip on technology. Our telecommunication system is sophisticated and offers a great deal of variety. Yet some of the early developments in teletext came from Britain and France, where the government planned to supply a teletext unit to every telephone subscriber. The European standard for TV pictures is superior to ours. The European standard for TV transmission is 625 lines and the U.S. standard is 525; the more lines, the clearer the picture. Japan has provided us with many of the sophisticated tools we use in today's communication facilities and has been a prime mover in the effort to build a worldwide High Definition TV system. Taiwan, Hong Kong, and Korea have been the source of inexpensive radio and TV receivers used worldwide.

Sophisticated technology has made it possible for some countries to make vast leaps forward. India would be unable to hook together its TV and radio stations if it were not for satellite technology. The Indian telephone system simply could not accommodate the video cables and microwave relays needed for terrestrial distribution of TV, or radio, for that matter.

Cable

The British and the Europeans studied the growth of cable in the United States and decided they wanted to jump in with the latest in technology, using fiber-optic cables, providing large-capacity wiring in new cable franchises, installing two-

way cable, and developing international interconnects throughout Europe. The cost and the sophistication of these efforts have brought on business failures and a much slowed rate of growth for cable.

In 1983 Britain awarded 11 multichannel cable franchises. Two years later little had been done to develop the franchises in the face of slow-paced implementation of the government cable authority and lukewarm reception from potential investors. Cable system building picked up in 1985 and has continued at a moderate pace since then, stimulated, in some cases, by American investment.

Cable had not developed as fast as the French government had planned either, and while cable was being installed in Germany, it was at a slower than anticipated pace. Some of the complications in wiring the cities of Britain and Europe include government regulation, government ownership of the telecommunication system that would need to cooperate in some areas to provide right-of-way for the cable, difficulties in wiring the old cities of Europe, potential displacement of cable by DBS, lack of subscriber interest in paying for cable service when several channels were already available, and investor hesitancy due to the high cost of installing cable systems.

Cable companies in Britain and Europe have explored the possibility of running advertising. For many years the European countries either strictly regulated or prohibited advertising on their broadcast media, but in the mid-1980s some policies were liberalized to permit additional broadcast networks and stations supported by advertising. There is still a question about the amount of advertising the European governments will permit to be aired on cable. And if advertising is allowed, the next question is, will advertisers buy cable? Some observers believe that there is a backlog of advertiser demand in Europe, but it is unclear in what direction the advertisers will go in selecting media. Most likely, they will concentrate much of their spending on broadcast stations in the initial years of Europe's liberalization simply because these stations provide the greatest coverage.

The European Broadcasting Union in 1985 authorized a daily satellite feed to four nations: The Netherlands, Germany, Italy, and Ireland. In addition, Portugal, Spain, Greece, Belgium, and Switzerland were considering the EBU project. In the meantime, newspaper tycoon Rupert Murdoch had been feeding cable programming on his *Sky Channel*. Religious programming was originating from the *New World Channel*, lo-

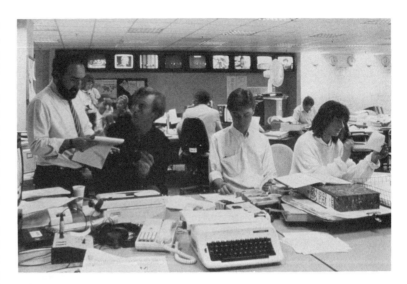

Figure 10–12
Journalists working in the London newsroom of Visnews, the worldwide television news agency. Correspondents and videographers from Visnews cover areas of the world not staffed by journalists from the American networks. Courtesy of Visnews, Ltd.

cated in Oslo, Norway. Other satellite services available to European cable companies include the French *Channel Five* and the *German 3-SAT*. Channel Five is available across Europe, while 3-SAT serves Germany, Austria, and Switzerland.

Mexico's first cable system was introduced in 1954, at Nogales, which was near enough to the border to pick up an assortment of U.S. stations. By 1984 there were 74 cable systems operating in Mexico serving about 320,000 subscribers. Twenty-seven more systems were under construction according to statistics compiled in 1984.

Elsewhere in Central and South America cable is not a major telecommunication medium. Huge foreign debt and poor economies have kept most of the Latin American countries from keeping up with the United States. Chile authorized the building of cable facilities in 1984. There are small cable installations in Peru and Argentina.

Japan reported four million cable subscribers in 1985. Fifteen of Japan's systems formed a consortium in 1984 to produce programming specifically for cable.

Pay-TV and Pay-Cable

Various forms of pay television, on-air and cable, are under discussion around the world. Canada approved a second tier of pay-cable in the

Figure 10–13
International broadcast center at Televisa's San Angel production center, which handled television for the World Cup in Mexico. The inset picture shows videotape recorders used to record incoming games for distribution to broadcasters worldwide. Courtesy of Ampex Corp.

spring of 1984. The Canadian Radio-Television and Telecommunications Commission gave the go-ahead for a rock music channel and an all-sports network. Permission was also granted for the insertion of advertising into the programming by the program owners but not the cable systems. The decision was important in Canada, where cable penetration has reached 80 percent. Cable companies were having trouble increasing income since they had accomplished most of the new hookups that would be available. In 1984 pay cable was reaching less than one percent of Canadian cable subscribers. Some observers blame poor programming by the pay-cable channels, others say Canada simply does not have the population to support a specialized TV service.

France tried subscription TV. The first pay-TV station was called *Canal Plus*. The management of the subscription TV company indicated they would be looking for ads such as cigarettes and hard liquor, which were banned from French TV. There were some problems involved in the system. A Frenchman who desired to subscribe to *Canal Plus* had to have a TV set manufactured after 1981 because a special connection was needed. Then he paid the equivalent of U.S. $60

for a special antenna and a deposit of the equivalent of U.S. $60 on the decoder.

Pay-TV projects were announced in 1984 for Switzerland, West Germany, and Austria. Mexico has pay-cable and plans were announced for addition of a pay multipoint distribution service.

Direct Broadcast Satellites

Some countries around the world are looking at direct broadcast satellites (DBS) as an economical means to open up vast areas to TV reception. In 1984 the governments of France and Luxembourg signed an agreement on DBS. The plan was to create four new TV channels, at least two of which would be advertiser-supported. French government TV would run the two noncommercial channels and private firms in Luxembourg would run the two commercial channels. In July 1985 the French and German governments agreed to introduce a new and common standard for TV transmissions. This would open the way to watching satellite transmissions from other countries, as well as creating business for European set manufacturers. Europeans have begun to buy satellite receive dishes to watch the satellites which are feeding cable systems such as Germany's SAT 1.

Interest in providing satellite programming to cable systems and/or DBS service to European customers brought some of the world's major media tycoons into competition in Europe. They included Rupert Murdoch from the United States (and Australia), Robert Maxwell from Britain, Ted Turner from the United States, and Silvio Berlusconi from Italy. Brazil planned to launch its own satellite. Individuals were to be allowed to own receive dishes. This is seen as a viable solution to providing TV service over the vast underpopulated areas that make up parts of Brazil.

India has studied DBS as a means of getting programming into remote areas, where it might be repeated by low-power unattended transmitters.

Advertiser-Supported Television

Europe has been moving in the direction of advertiser-supported TV. Private TV has created an intensely competitive situation in Italy with more than 500 private TV stations (many owned by Silvio Berlusconi) crushing the competition from Italy's three government-run channels, RAI-

1, 2, and 3. Some of the government-run TV in Spain accepts ads. The Norwegians, who had been hold-outs, have experimented with a light schedule of commercials on government TV. In Britain there was a big debate over commercializing the government (BBC) channels. France opened up its broadcasting to commercial operators in 1985 and the quantity of TV service multiplied quickly. Quite a bit of advertising is shown on Australian TV.

Although there is much debate in nations outside the United States about the role of advertising in broadcasting, the trend has been in the direction of adding commercial broadcast time to defray the costs of broadcasting.

Another concern among overseas broadcasters is how to fill the new airtime, which is being made available by the addition of stations, installation of cable, and implementation of direct broadcasting. The United States is by far the world's largest source of TV programming, and many countries don't want too many shows from America because the government doesn't want its citizens making comparisons with the way Americans live. (Or the way they are portrayed to live.)

Inversely, the tightening of TV competition in the United States caused the American networks to consider importing some European programs, especially for use during the summer rather than suffering major rating drops because they were showing reruns.

Satellites

Earlier we mentioned the key role INTELSAT plays in international communications. Another aspect of satellite technology is the use of satellites by countries to relay signals within their own boundaries. India has paid particular attention to this aspect of communication technology because it has such a vast area to cover. Indian engineers designed the satellites in use by their own country. They were manufactured and launched in the United States.

One problem which has arisen for India and other latecomers to the satellite age is the unavailability of space to "park" satellites in the proper location above the earth to serve the desired area. One solution being used is to reduce the distance between satellites parked in outer space. This maneuver has worked, but it has also required installation of more precise receiving equipment on earth.

Canada has been particularly active in using satellite technology. The Canadians launched their first satellite, Alouette I, in 1962. It was used as a scientific instrument to study outer space. Further studies were carried out, in partnership with the United States, by launching ISIS I and ISIS II. ISIS stands for International Satellites for Ionospheric Studies.

If you read a satellite magazine that lists programming you can receive on your backyard dish, you will see references to ANIK, Canada's communication satellites. Some of the services available to Canadians include tele-education, telehealth, DBS, telephone, data, broadcasting, and facsimile. Tele-education provides educational programs and materials to remote areas and telehealth links doctors in remote hospitals with specialists in Canada's major medical centers.

ISDN

A telecommunication concept which has received much attention in Europe, Japan, and the United States is ISDN. The letters stand for Integrated Services Digital Network. The concept calls for running a wire or fiber optic cable to each residence and business structure as a replacement for the traditional telephone cable. The single wire or cable can simultaneously carry

Figure 10–14
A current affairs interview being recorded at the Visnews studios in London. The interview can be relayed by satellite to a subscribing TV or cable network, or can be transmitted to European viewers by DBS. Courtesy of Visnews, Ltd.

telephone, facsimile, telex, videotex, cable TV, computer data, and audio and video signals, replacing the two or more wires which now must be run to a house to provide telephone and information services. In Switzerland, the government telephone system has already begun installation of combined data, audio, and video lines, and several European governments are studying a continent-wide common ISDN system.

For the consumer, the major convenience would be the existence of only one type of information wiring in the home, rather than having to deal with telephone wires, cable connections, computer modems, etc. The more significant impact of the ISDN concept is the *centralization of information movement in telephone authorities and telephone companies!* This would radically change the traditional pattern in most Western countries, which segregates telephone, broadcasting and cable, and data systems into separate, sometimes competitive economic units.

The New World Information Order

The United Nations Educational, Scientific, and Cultural Organization (UNESCO) has invested a great deal of money in supporting improvement of telecommunication in the developing nations. One idea which came out of UNESCO's efforts was a call for a "New World Information Order." One of the basic premises was to give the developing nations more control over the gathering and transmission of news. UNESCO has supported formation of regional wire services and regional news exchanges, via satellite. As a consequence, the Arab nations planned to exchange materials on ArabSat, and the Asian nations banded together to swap news stories on Asiavision. A pan-African wire service was also created.

There have been many problems in these exchanges. The quality of news provided differed greatly from country to country depending on the training of reporters and editors and the nature of the equipment used. Most of the material provided was biased strongly in favor of the government in power in the contributing nation.

Progress has been made in freeing the nonaligned nations of their heavy dependence on Western sources for world news. Much more needs to be done to promote a uniformity of equipment and technical standards and an equivalent uniformity and quality for the news items

exchanged. The United States became exasperated with UNESCO when some of its meetings became forums for nations which disliked the United States, and the Reagan administration withdrew the United States from participation in or funding of UNESCO. Britain also withdrew from UNESCO.

SUMMARY

For many decades the United States stood virtually alone among the nations of the world by having an advertiser supported, free-enterprise regulated broadcasting system. In recent years some of the ideas incorporated in the American system of broadcasting have been adopted in Britain, Europe, and Japan. Government control of the telecommunication media is strong, with some exceptions, such as Japan, Brazil, Mexico, and the British Commonwealth nations.

The development of satellite technology and cable TV has opened up new opportunities to bring more programs to some nations, particularly in Europe and for other countries to share information as is done in Asia.

Control of the telecommunication media is a major topic of international and national concern, and disputes over the role the media should take in the developing nations contributed to the United States and Britain leaving UNESCO, a United Nations agency that has worked extensively to improve the telecommunication facilities in developing nations.

GLOSSARY

Annual license The fee assessed by the British government on each TV set that is owned; similar to auto registration fees in the United States.

Berne Bureau Originally known as the International Bureau of Telegraphy, formed in 1868 to coordinate international telegraph service.

Community Radio Special low-power radio classification in Britain; proposed to serve ethnic, racial, and social subgroups. A concept in radio in which members of a "community" collectively program a radio station.

Develop To improve the quality of life for the people of a country.

Developing nations Usually refers to countries with large populations, a low literacy rate, and little industrialization.

Development broadcasting Broadcasting designated to be good for the populace it is aimed at. The government in power determines the "good."

Development journalism A kind of journalism practiced with the express purpose of delivering a particular point of view and to teach and uplift.

Economy The state of the fiscal health of the people of a country and its government.

Integrated Services Digital Network (ISDN) Use of a common wire or cable to carry a combination of information signals, including telephone, facsimile, telex, videotex, cable, computer data, audio, and video.

Literacy Being able to read, write, and understand the printed matter in daily life at a level that does not impair functioning. In some countries this could be a sixth grade reading level and in others it could be eleventh.

Nationhood The creation of patriotism in countries with people of diverse backgrounds.

Nonaligned nations Technically, the term refers to the nations that are not aligned to one of the major superpowers; in usage it is generally understood to be a synonym for Developing or Third World. There is a formal international organization of nonaligned countries.

Pirate radio These are unlicensed radio (or TV) stations, which operate illegally for profit. Some operate from ships anchored in international waters, others are land-based pirates who operate from and with moveable facilities.

Political philosophy The way the people in power think about the way a country should be run and how the people are treated.

Position papers Formal statements by the government, through the Home Office, setting British broadcasting policy.

Propaganda Using a public relations approach to a subject; putting the best face on whatever is being discussed or touted.

SITE An Indian experiment in satellite transmission of TV signals to remote villages.

Technology Term referring to the use of electronic equipment needed to broadcast and receive electronic communication signals. It also refers to the newest and best of the various software and hardware improvements.

Third World Also known as the Developing Countries, generally former colonies of the traditional great western powers, who have achieved independence since World War II. The term also includes countries that are perceived as being nonindustrialized.

TELECOMMUNICATION AND SOCIETY

Until now we have been looking at the telecommunication media from a relatively single-minded viewpoint, meaning your relationship to the media as a potential media practitioner. Now we need to look at the media in terms of how media actions, interactions, and reactions affect consumers of the media. We need to look at how various educational, business, and government actions affect others and how compounding media impressions impact. Society as a whole is both a media audience and a media participant, the roles intersect, overlap, and parallel at various times.

childless couples, gangs, nuclear radiation, and terrorism.

Veterans of major social movements, the civil rights, the feminist movement, abortion rights, and antiapartheid groups will tell you that their causes moved forward more rapidly once they forced themselves onto the *agendas* of the major telecommunication media. They were aware that not only does the media act as a gatekeeper, it tends to be imitative. If network A has a major story on its evening news on female astronauts, then network B will shortly have a major feature on the same topic in its weekly magazine show.

TELECOMMUNICATION—THE GATEKEEPER

The *telecommunication* media become *gatekeepers*, selecting what issues will be discussed and what issues are either unacceptable, irrelevant, or simply too ordinary. If you compare various media, you will notice that they do not all assign the same priorities to issues. The print media frequently assign a higher priority to politics and political issues because these issues tend to be best explained in writing. Politicians are acutely aware that being seen and heard frequently on TV and radio can have more impact on reelection than endorsements on the editorial pages of newspapers.

Thus, the telecommunication media play an important role in *agenda setting*, determining what issues are important at the moment. If you compare the topics discussed on talk shows and in docudramas and news features this year with a year ago, you will detect differences. A topic tends to become a *"hot topic"* for a while, and once it has been aired extensively, the gatekeepers begin to look for something new and different.

Some hot topics during recent years include street people, husband abuse, single never-married parents, fertilization techniques for

ENTERTAINMENT

In the United States the telecommunication media are used as sources of entertainment and information, with the greater portion of their time being devoted to entertainment. A long-standing criticism of the telecommunication media in the United States has been the *sameness* of the entertainment offerings. The sameness is caused by (1) most of the programming production being done in either Hollywood or New York City, and (2) the number of program formats (concepts) that will deliver large audiences is limited. Part of the sameness is caused by the same group of people applying techniques which have proven successful in the past to today's product.

Another factor is the necessity or desire to produce programs or movies appealing to large, broad-spectrum audiences. The producers have to take into account the level of artistic and literary complexity a mass audience will accept. They have to choose language and speech patterns which the largest number of people can understand. A British TV show designed for mass enjoyment by people with ten years of schooling will fail in the United States because the accents are difficult to understand, the humorous references are meaningless, and the cul-

tural cues are different. The producers who wish to satisfy a large mass audience have to leave out regional or ethnic context, which would limited or bias circulation.

When you analyze the films and TV shows that attain popularity, you find that there are not a wide variety of situations or themes which gain acceptance at any one time. If a drama about rich and powerful families gains audience acceptance, pretty soon it will be imitated. The TV program "Dallas" spawned "Knot's Landing" in which one of the leading characters (Gary Ewing) was a brother of the main characters in "Dallas" (Bobby and J.R. Ewing). Another popular show about an oil-rich family, "Dynasty," spawned a *spin-off*, "The Colbys," which involved some of the original characters in "Dynasty."

Success breeds imitation. In addition, there are only a limited number of formulas that seem to work for mass audiences at any period in history. The social comedy initiated in the 1970s by Norman Lear's success with a series about Archie Bunker, a Queens, New York, tavern owner who was the stereotype of prejudice, led to a new era in which social issues were the major theme of entertainment programs. Bringing social issues onto TV screens also contributed to breaking down barriers which had kept women, minorities, and handicapped people from starring roles in TV programs.

The entertainment programs on prime time television in the 1980s took a turn toward *soap opera* serial dramas (such as "Dallas"), miniepisodes within a framework ("Hotel" and "Loveboat"), and situation comedies ("Cheers" and "Who's the Boss?").

NEW CHANNELS—NEW PROGRAMMING NEEDED

In the early 1980s many more channels for programming became available with the growth of cable and satellite technology. Media managers found they did not have enough material available, and a quest for new software or program ideas began. One solution was to produce programs addressed to special interests on topics such as health, hobbies, sports, or personal problems. The experiments with specialization revealed that if the programming is of interest to a sufficient number of people and advertisers, it can stand on its own feet. Thus, cable channels

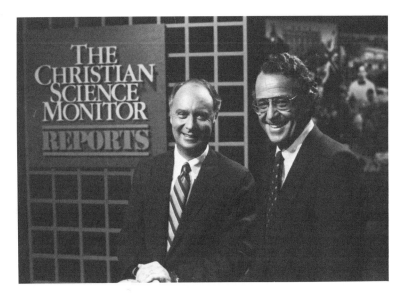

Figure 11–1
Journalists of Christian Science Monitor Television and some other television news programs attempt to treat current affairs issues in depth, an approach which appeals to viewers who say major networks don't allow enough time to properly discuss the news. Courtesy of the Christian Science Monitor.

Figure 11–2
Three satellite news vehicles lined up next to the capitol in Tallahassee, Florida, for coverage of the legislature.

featuring sports, religion, and health survived while other specialized or narrow formats did not. Home catalogue shopping via cable or broadcast TV is another trend. This unique use of the video media underwent early shakeouts as imitators dropped by the wayside, but the market niche remained, despite skepticism by many as to the format's staying power.

A huge success in the area of specialized programming was sports. ESPN took several years to establish itself, but with financial backing from Capital Cities/ABC, ESPN became very successful, and soon spawned regional imitators.

Golf lessons on tape, exercise instruction, and cultural programs have been successfully marketed by companies specializing in medium and low-cost consumer videotapes. This causes us to wonder if the VCR is replacing reading since much of this specialized information has traditionally been found in books. Yet the continued parallel success of how-to books brings up the probability that either more people are consuming specialized information and/or people who read special interest books are supplementing their reading with viewing. Video forms are increasingly being used as information sources; therefore, there is concurrent responsibility for telecommunication professionals to be certain the information is accurate and that it can be safely applied by consumers.

Figure 11–3
Color TV camera in use at Belmont Stakes horse race in New York City. Courtesy of Norelco/Philips Broadcast Equipment Corp.

MEDIA CRITICISM

Sociologists and other critics fear the copying of successful formats in both radio and TV programming is leading our society toward some great homogenization in which we will share the same ideas, wear the same style clothing, vote for the same photogenic candidates, act in the same violent manner, speak the same, and write the same words.

While the worst fears of social and media critics have not been realized, there is a detectable sameness in aspects of American life. For instance, the advertising reach of broadcasting and cable has made possible the repetition of successful fast food restaurant formulas and other chain marketers across the nation. The telecommunication age consumer knows what to expect from a McDonald's restaurant or a Holiday Inn. There is a comfort in knowing exactly what is ahead, but a certain element of adventure is lost in the process.

Slang expressions can spread quickly. If a popular TV comedian uses an expression or a recording artist uses a phrase, it will soon turn up in the vocabulary of people all over the country. The phrase "make my day," taken from a Clint Eastwood movie and later used in a song about a modern-day gunslinger, became so popular the president of the United States used it in a public appearance.

However, speech dialects have become more pronounced in the generation from the 1960s to the 1980s. Maybe we are seeking individuality among the sameness. To some degree this individuality may have been promoted by the mass media. Popular TV programs dealing with specific cultural groups, such as "Dukes of Hazard," which was set in the rural South, popularized expressions and dialect, which we have been told were dying as more people consumed the media, attended larger schools, and moved from rural areas to the city. Country music has undoubtedly had its impact on the nation's speech.

Clothing fads, trends in consumer purchases, and games all are marketed through the mass media, causing consumer trends to be similar across the country. This has some benefits in that if we travel we can go into a drug store in Maine or Utah and expect to find a trusted brand of shampoo.

Is consumer conformity intrinsically bad? An argument can be made that you really cannot suppress individualism and that the person who has a tendency to swim against the current will

do so, no matter what the pressures from society may be.

DANGER SIGNALS IN MEDIA IMAGES

Stereotyping

Entertainment programming can stereotype. After all, aren't all detectives glamorous? Or at least seedy and offbeat? Everyone in the oil business leads lives of scandal while eating caviar and drinking bourbon. Hospitals are places of glamour and excitement, without bedpans to empty or beds to change. In real life these situations are often the opposite. Detectives do a great deal of routine and boring work, chasing after what most would consider meaningless paper. Some oil barons lead quiet, nonpublic lives. And hospitals are frustrating, boring, tedious, and messy places to work. Ask any hospital laundry worker, housekeeper, or even the nurse leaving the double shift on a ward full of patients with dysentery.

Stereotyping, or assigning a standardized mental picture to a person or group, can be dangerous. Only a small percentage of people of Italian-American heritage are involved in organized crime. The percentage is probably similar to people from other groups who are also involved in organized crime, yet Italian-Americans as a group must defend themselves against slurs and jokes implying that all Italians participate in organized crime. Stereotypes about laziness and a lack of promptness continue to hound black Americans. The Polish labor under stereotypes of being stupid but strong. It goes on and anytime the media perpetuates these stereotypes it contributes to creation of misimpressions that could hurt. The video and audio media are powerful and their practitioners must be aware that with power comes responsibility.

One way to help an audience understand humor or drama quickly is to rely on easily recognizable characterizations. This device is also used effectively in advertising to save time when you have only a few seconds in which to establish a situation and deliver a message. This is why "mom" is always pictured in a *daytime scene,* standing by the washing machine, when she beats back the scourge of child-borne grease stains. In fact, the number of mothers who work in the U.S. is large, and many have to do laundry in the evening and on weekends. It is even likely that those demons who got the grease stains on their shirts are already tucked in bed when "mom" or maybe "dad" starts the wash. While setting up a standard characterization makes the point quickly, it can also backfire.

Civil rights groups, feminists, gays, and others have fought to convince producers and scriptwriters not to assign stereotyped sets of behavior to characters falling within these groups. For instance, blacks and Hispanics objected to their constant portrayal as laborers and household workers, which happened in early films and TV programs. Women raised a hue and cry when advertisers portrayed women to be weak, home-centered individuals who need advice from a male to select a brand of laundry detergent.

Gender Typing

In many ways the telecommunication media in the U.S. have been slower to respond to social change having to do with gender topics. Long hard battles have been fought and continue to be fought to reflect the nature of American society more accurately, especially on TV. While the number of minorities and women seen on the screen and heard on radio has increased, their roles and variance from stereotypes have not changed as quickly. There are still few women sportscasters and play-by-play announcers. Most car dealers still aim their commercials at men, although huge numbers of women drive, select, and purchase their own cars.

Even though current U.S. programming is handled with sensitivity to issues of stereotyping, a great deal of the fare seen on TV or heard on radio comes from a different era and cannot be changed to meet more up-to-date attitudes. This can have important negative effects when these programs are sold abroad.

Language and Its Effect

In an attempt to add more realism to recordings, movies and TV programs, writers have used slang, "street talk," and conversational language. This has aroused concern over both the *cleanliness* of media language in terms of profanity and *correct* usage and a perceived lowering of the general standard of conversational English. For instance, it is a common technique in media writing to use short, familiar words rather than multisyllabic words, which might be more precise but which

require the media consumer to leave the set and look the word up in the dictionary.

One result of the mass media's concern for language is a commonly accepted standard in broadcast journalism which calls for on-air personnel to speak in a *middle American dialect*. It is believed by many in the industry that the accents of Iowa or Kansas residents are best copied for nationwide comprehension. This is why you seldom detect noticeable accents in the speech of network correspondents or major market newscasters.

Success and Its Measures

How do we measure success? Certainly one set of standards is acquired from our families when we are told what family members regard as symbols of success. Another source is school and a third is the media. We are told by the media that certain characteristics such as appearance, speech pattern, and the consumer products we own are desirable. TV programs tell us what sort of cars are best to own. They suggest that we should *fly* to destinations, rather than take the bus. In other words, TV and film characters become subtle role models for us to follow. Success could be heading a major corporation, or having a successful singing career, but it could also mean winning the Nobel Prize in Physics or saving starving children in Ethiopia. Success could be, depending on the programs you watch, becoming a leader of a major crime syndicate or an NFL running back.

Social Conduct

The media project an image of how we should lead our social lives. Some observers say that the media reinforces consumption of alcohol, extramarital sex, and drug use. Other observers say, no, these are simply the realities of modern life which we see every day anyway.

These issues have become of sufficient concern to have led to formation of national groups, which attempt to influence the programming of telecommunication companies through attacks on their pocketbooks. We have seen some responses, such as the intentional omission of smoking as an incidental activity of characters in TV programs as a result of pressure from anti-smoking groups.

Cigarette advertising was ordered off the air

in 1971. The action came as a result of a Surgeon General's report, which found smoking to be harmful to people's health.

The ban on cigarette ads had a significant impact on national advertising receipts for broadcast stations for a year or so, but the industry soon recovered by developing other sponsors. In 1986 Congress added commercials for snuff and chewing tobacco to the list of prohibited tobacco products.

In 1985 concern over teenage abuse of alcohol and drugs brought to the fore another in a long series of attacks on beer and wine ads. Hard liquor had been kept off the majority of stations by voluntary adherence to the NAB Radio and TV Codes, and when those codes were eliminated, most stations continued to ban liquor ads.

Efforts were made to get Congress to pass legislation banning alcoholic beverage advertising from broadcast stations. The issue evolved into a major battle, with intense lobbying by a number of involved parties, but no legislation was passed. The National Association of Broadcasters set up its own committee to work with organizations such as Mothers Against Drunk Driving (MADD) and Students Against Driving Drunk (SADD). The NAB encouraged its member stations to vigorously promote safe use of alcoholic beverages.

The issue of drug use focused more on encouraging telecommunication companies to air programs, features, and public service announcements, which carried an anti-drug use message.

Drama writers are faced with a "Catch-22" situation when it comes to scripting scenes involving alcohol and drugs. If you are going to write about life as it actually occurs, then an argument can be made that alcohol and drugs are important topics for drama and serious discussion. However, critics say a TV program set in Miami ("Miami Vice"), which dealt with narcotics-based crime, sent a message to young impressionable viewers that people involved in the drug business wear the best, trendiest clothes, live in fabulous high-rise apartments, and drive luxury cars.

How is the writer going to deliver the message that using or dealing in drugs can and usually does end up in addiction, illness, death, violence, poverty, and jail? It takes courage to write a program for the popular media, which are, after all, means to escape from reality, and still deliver the reality of drugs, crime, or war to the consumer.

THE MEDIA AND PUBLIC TASTE

In many countries the government would intervene in programming which discussed issues such as narcotics or crime. The *First Amendment* to the United States Constitution clearly prohibits the FCC or any other arm of government from censoring broadcast programming. Thus, the final resolution of the argument over taste becomes the product of viewer ballots (the ratings), self-restraint by producers and programmers, and pressure from interested groups.

Telecommunication company executives are constantly faced with questions regarding taste. What one person or several regard as within the bounds of taste may not be seen in the same light by other individuals or groups. The FCC clearly puts the responsibility for making this sort of decision on the licensee of the broadcast station. That's why you will occasionally see an article in a trade magazine indicating that a TV station has declined to carry a program (usually from a network) because it would offend a significant number of viewers in the station's service area.

The issue of responsibility is far less clear for cable firms, which argue that cable only retransmits programming and the decision regarding taste must be taken by the viewer who has the option of turning off the set or changing channels. However, the cable company that chooses to retransmit every "blue" signal available but does not offer Disney or CNN is making a programming statement which it must then be responsible for. Public pressure in several communities has forced cable systems to modify their offerings.

Television Programming Decisions

Programming decisions faced by TV program executives are complex, but there are certain built-in filters in the system. The program director at a network-affiliated station knows that any program transmitted by the network has been scrutinized by several network executives and the network's *clearance department* before it is scheduled. This gives it at least one level of filtering before the local program director has to judge how a program will be received in the local market. Programs which are perceived by network executives to be sensitive are frequently transmitted to affiliates in advance so that they may be reviewed at the local station. This is in

recognition that there can be wide differences in what would be judged acceptable taste by reviewers in Hollywood and New York and what might be acceptable in the affiliate's community. A number of sensitive programs have been preempted in local markets because affiliate management thought they would not be appropriate. Topics that at various times have caused programs to be subjected to close review by affiliates include race relations, interracial marriages, homosexuality, incest, rape, the Vietnam war, drug abuse, and the U.S. Civil War (also known as the War Between the States.)

Films

A local station program director can make an initial review of a film from one of the station's film packages by consulting reference books which give detailed plots of many of the thousands of films produced by United States and some foreign filmmakers. Films are one of the more common sources of taste complaints; so it is important that the program director review the plot and check for indications of what he or she regards as inappropriate content before scheduling a film. Even after reference books have been consulted, it is often necessary to view a film before making a decision whether or not to schedule it.

Syndicated Shows

All syndicated programming should be reviewed by the local management. Programs that formerly ran on a network are relatively safe, but the passage of time and local conditions can affect their airability. Many of the early network TV programs contained characterizations and references, which are no longer considered acceptable. Syndicated programming produced solely for use by stations needs careful scrutiny. This includes syndicated programming for radio. What the producer of the program regards as good taste, or ad lib remarks by a host on a syndicated radio show, could be out of context for a specific community. Program executives in small, nonurban markets face problems in the content of syndicated programs, considered perfectly acceptable in big cities but which would scandalize some elements in their community.

Cable

Generally, cable systems do not review content of programming coming in from satellite cable

channels on the premise that viewers can change channels or shut the set off if they are not happy with what they see. Cable is not under the direct control of the FCC, so it can have this attitude. In the minds of some members of society, this attitude is expressing a lack of responsibility. The cable industry believes it is a by-choice medium. If the cable passes your residence, you choose or don't choose to subscribe, then you can view or not view.

The channels showing so called "blue" movies have been a source of great concern to the cable industry. In some communities these channels have proven to be major revenue sources for cable systems, so the owners of the cable companies know the blue channels are being watched. The very existence of these channels has put cable companies on the defensive in many areas, and a couple of systems have responded by dropping channels with "suggestive" or "explicit" content. In Norfolk, Virginia, protests to elected officials resulted in the cable system dropping channels that carried sexually oriented programming. For the most part, the cable industry responds by saying viewers have and use these channels by choice.

Radio

Questions of taste on radio tend to revolve around two types of programming. One is the playing of records with lyrics which either glorify drug and alcohol use or are sexually explicit. The other is the content of talk or call-in programs.

From time to time a public outcry arises over the wording of the lyrics of popular songs. Some radio broadcasters demand that record companies provide them with transcripts of the lyrics to all songs they play. Most broadcasters listen to or "audition" records before they are put in the *playlist*. The conflict sometimes becomes one of a "generation gap." The program director, who may be in the same age group with the target audience (let's say 27 years old) says the lyrics are acceptable according to current society's standards. The general manager of the station may disagree based on his or her perception of what is appropriate language or content for records the station plays. The issue becomes sensitive for management when the target age is teenagers because the station gets most of its criticism from the teens' parents and from organizations of adults who find fault with this sort of music.

Hidden Messages in Music

There have been people who claimed some popular records contained hidden messages when played backwards. There hasn't proven to be any substance to these claims, but broadcasters have had to check records to determine there were no messages.

The large chain broadcasting companies and other firms frequently develop codes of conduct for the internal guidance of their programmers. Most of these codes demand that records be previewed for taste and questionable lyrics. These codes call for review by higher management at the general manager or group level, or deleting music with questionable lyrics.

Deciding on the acceptability of song lyrics can be difficult because most guidelines or standards are vague. It is fairly easy to decide whether or not a profane word would be omitted or the song deleted, but what sort of reference to alcohol or drug use constitutes a threat to the community's standards of taste? The decision is further complicated by our divergent attitudes about alcoholic beverages versus drugs. Our society is frequently only mildly critical of drunks (unless they drive), but a reference to the use of a small amount of a controlled substance could be regarded as unacceptable. In a society that prohibited consumption of alcoholic beverages for religious reasons, any mention of alcoholic beverages would be offensive.

Talk Shows

Talk shows are potentially hazardous for three reasons: the callers, the guests, and the host. Any one of the three can say something that will be at the least offensive to community *taste* and at the most could subject the station to a defamation suit or threat of an obscenity prosecution.

After liability insurance has been purchased, most stations with talk shows take two defensive steps: (1) install a 24-hour-a-day slow speed tape recorder which records everything transmitted by the station, and (2) install a tape delay machine which delays incoming on-air phone calls for an interval (usually about 7 seconds) to allow the caller to be cut off if necessary.

Callers

The problems with callers using obscenities or making statements the station management might regard as offensive to the community standard

can be dealt with by having a producer assigned to the program to screen callers and act as a backup to the air talent in monitoring conversations. Most important, though, is a clear understanding with the talent as to what types of conversation are acceptable, what are not, and therefore must be cut off the air. This sort of understanding is needed because there are instances where the more controversial the content of the talk show, the greater audience it gathers. If this were true in a specific market, the air talent might let his or her judgment slip in an effort to allow more titillating callers on the air.

Monitoring

This is precisely why call-in and talk programming requires regular monitoring and air checks by responsible members of management. Management also must constantly be involved with the community to be able to *know* what is acceptable and liked. Just because someone doesn't like the host does not mean that the program is unacceptable, but if the host has a voice or style that causes a number of listeners to dial away, that is as important for management to deal with as the airing of profanity.

Talent

Some of the most successful and most imitated talk show hosts have made their reputations by being acerbic, aggressive, or hostile. This type of program host must be closely monitored by management to prevent either the host or callers from stepping over whatever boundaries of taste the station management sets. Hosts who stir the emotions of listeners are apt to get emotional responses from listeners. This can make for stimulating and controversial radio, but it also opens the door to legal and taste problems.

A talk show host was killed in Denver, Colorado, apparently when members of a conservative sect took exception to the host's outspoken opinions. Although this sort of incident is an isolated occurrence, it tends to have a chilling effect on talk show hosts and thus it tends to chill one of broadcasting's designated obligations: the airing of controversial issues in the community.

Guests

In-studio guests also present problems, and the program host is at a disadvantage if the delay mechanism does not operate in the studio envi-

ronment because it is difficult to react quickly enough to cut off a tasteless remark. It takes a skilled host to preside over a program, which invites controversial guests who may have little regard for the conventions of taste accepted by most broadcasters and by the community that is listening or watching. A video talk show host has to be even more careful because a guest can add gesture, facial expressions, and other expressive techniques that might be offensive, as opposed to creating, say, a mild shock.

VIOLENCE

One of the most controversial subjects when TV programming is discussed is violence. Critics say violence incorporated into TV programs including childrens' cartoons is a stimulant to violent, antisocial behavior.

This concern takes us to the "lowest common denominator" theory which says that the way to produce a successful TV program is to present material that can be easily understood by the greatest number of people. This is interpreted to mean the writing and dialogue is cast in simple, direct language and the visual continuity incorporates easily understood action. Violence is seen as action with universal appeal. The actors can do violent things you might consider doing but probably wouldn't because you know the penalties you would pay. One viewpoint is that violence on the screen is a substitute for our own violent behavior; thus, we use the TV violence to disperse our violent tendencies. Another view is that violence on the screen is an incentive and instructor to someone with uncontrolled violent tendencies.

We come to a difficult question. How much violence is too much violence? There is no measure. Some aspects of life are violent, so it could be argued that police work might lead to a high-speed car chase and a subsequent shootout between the bad guys and the police. Critics would then say look at the statistics. We see more high-speed chases on prime time TV than all the police departments in the United States conduct in a year. Does TV drama emphasize one aspect of a police officer's duties out of proprotion for the sake of dramatic license or to enhance the size of the audience in order to gain ratings? Another criticism of crime stories is that they give criminals and potential criminals a diagram to commit more crimes. Some police officials say

police shows give away police tactics, making them virtually useless when the police are confronted with a situation such as a hostage taking.

Some law enforcement experts express the fear that TV violence and crime is a particular problem when viewed by impressionable preteens and teens. There have been cases of copycat crimes in which the offenders got the scenario for their crime from viewing a TV program. Of course, no one has been able to prove that they would not have committed the crime or a crime, had they not seen the crime illustrated on TV.

CHILDREN'S PROGRAMMING AND VIOLENCE

Critics of children's programming also express concern over violence. They wonder if the cartoon characters really need to be subjected to the wide assortment of mayhem which is typically inflicted upon them. The theory is that we are teaching children to be violent, rather than defusing their violent tendencies. Programmers respond by saying that it would be too expensive to replace all of the cartoons now in their inventories with new, milder plots. Cartoons are a highly recycleable product because children rapidly grow out of the the prime age-group for watching cartoons and the same cartoons can rather quickly be recycled for another group of youngsters. Some industry leaders say dumping all the old, violence-filled cartoons would be impractical. There is another argument which says that fairy tales are violent, and they are hundreds of years old.

Industry advocates again respond by saying that parents should maintain closer control over what their children watch on TV. They point out that the television station is assigned the role of baby-sitter in some households, where noisy or bothersome children are sent to "go watch TV" so they will stay out of trouble or at least out from underfoot.

Does Viewing Stimulate Violence?

Researchers have tried to quantify whether viewing violence on TV gives a person violent tendencies. For the most part the results have been inconclusive. One of the first questions which has to be asked when someone suggests that viewing TV made a person violent, is to try to determine the person's level of mental balance.

In other words, there appear to be violence-prone people in the world and it may be that violence seen on TV somehow reinforces their violent tendencies or gives them ideas how to express their violence.

A particularly interesting court case involving TV violence was the Ronnie Zamora case, which was tried in Miami, Florida. Zamora was accused of beating and killing an elderly woman. His attorney took an unusual approach, blaming Zamora's extensive viewing of violence on TV for his antisocial conduct. The case made its way to the U.S. Supreme Court, which rejected the premise that TV viewing was sufficiently influential to prevent Zamora from knowing the consequences of his actions.

Critics of television violence fear that viewing a large dose of mayhem and murder will lead young people to either imitate the violence they view or it will cause them to consider violence acceptable social behavior. A great deal of research has been done in an effort to determine if watching programming containing violence leads to overt violent acts by viewers. The U.S. Surgeon General released a report in 1972 which found a relationship between violence on TV and aggressive behavior in children. Attorneys periodically have tried to convince courts that excessive viewing of violent acts on TV has led to the violent criminal acts ascribed to their clients. The courts have not been forgiving, and no clear precedent has grown out of these legal contests.

The bottom line seems to be that not enough evidence of cause and effect has been developed to trigger enforceable restrictions against violent acts by actors in TV dramas and comedies. Studies by communication researcher George Gerbner over a number of years have shown that the level of violent acts on TV has not decreased appreciably since he began his studies in 1967, despite efforts by various groups to persuade the networks to air less violent shows.

General Children's Programming

Many groups actively monitor and vociferously protest both programming and commercials aimed at children. Since radio no longer carries many dramatic or children's programs it gets nowhere near the attention that is directed toward TV.

Vigorous lobbying by Action for Children's Television (ACT) and other organizations has brought about some modification of the char-

acterizations in network children's programs. In 1970 ACT petitioned the FCC seeking a ban on all advertising in children's programs and increased variety in children's programming. This action caused the FCC in 1971 to begin a major inquiry into children's programming. By 1972 both the networks and local stations were revising their Saturday morning children's program schedules, and some new production was started to replace some of the syndicated cartoon fare. By 1973 the Federal Trade Commission had issued a suggestion that each TV network should have one hour free of commercials during children's viewing time on Saturday mornings. ACT was still pushing for a total ban on commercials in children's programs. The hearings before various federal agencies went on for years until the FTC officially dropped its inquiry into commercials in children's shows in 1981. ACT did not win the victory it sought, but the organization did have considerable influence on the character of network children's shows and on newer syndicated programming for children.

Advertising in children's shows nearly came under a full-fledged attack from the FTC following a 1978 staff report, which could have led to banning some product advertising in children's shows. The broadcast industry convinced Congress to curb the FTC's activities and no official action was taken.

In 1988 Congress debated a bill that would limit the amount of commercial time permitted during children's TV programs; it would also require the FCC to consider a licensee's commitment to children's programming and compliance to advertising requirements at license renewal time.

A focal point of the children's advertising controversy in the United States has been the amount of sugar used in products advertised in children's shows. The dental profession regards sugar as harmful to the proper development of children's teeth. Other critics questioned the nutritional value of sugared food products, fearing that children would fill up on sugared items and therefore skip more nutritious foods.

ACT and other groups have been far less successful in eliminating material they regard as inappropriate for children in non-network programs because many independent stations and some affiliates run syndicated cartoons that were produced many years ago before anyone objected publicly about the conduct of cartoon characters.

Studies have been conducted to try to determine the effects of violence and other factors on viewers of children's TV. These studies have been less conclusive than the opposition would have liked. The FCC did order a study under the direction of its Children's Television Task Force. It focused on advertising and reported increased compliance with industry moves to limit product commercials by children's hosts and limitations on the frequency and number of commercials in children's programs.

After finding they couldn't censor programming, the concerned groups have devoted a great deal of energy to attacking sponsors of products advertised in children's programs through public statements and constant prodding of the FTC. The deregulatory movement in the FCC has given these groups a smaller voice in altering programming.

Public Television

Public TV has become a significant source of alternative programming for children through its instructional/entertaining programs such as "Mr. Rogers" and "Sesame Street." Both programs were designed to teach children basic concepts including language and math. The "muppet" puppets used in "Sesame Street" became so much a part of the TV culture that the program company which produced "Sesame Street" set up a separate commercial division to market the muppets. The muppets eventually appeared in network prime time cartoon specials.

Local public TV stations in some areas developed their own children's programming, and one commercial firm syndicated a somewhat educational childrn's format called "Romper Room," which was carried by many commercial TV stations.

Family Viewing

Th other area of concern was the amount of violence and sex children might see during early evening viewing on the family TV set. In response to criticism, the networks in 1975 (with some encouragement from FCC Chairman Richard E. Wiley) convinced the National Association of Broadcasters to include the "family viewing period" in its Television Code. The Code called for the exclusion of all programs "inappropriate for viewing by a family audience" during the 7 to 9 P.M. period (6 to 8 P.M. Central Time). A federal court ruled in 1976 that the provision violated the First Amendment, so fam-

ily viewing was not enforced but was voluntarily applied by the networks to their 8 to 9 P.M. (7 to 8 P.M. Central) hour for several years. Studies indicate that in recent years the number of households in which there is more than one TV set has risen to 55 percent, and therefore children and teenagers are frequently found to be watching different programs from those being watched by their parents. This change in viewing habits has caused the "family hour" to be deemphasized by the networks, which now place more violent, more active programming in the 8 to 9 P.M. hour than they did when "family viewing" was their policy.

One of the questions which has been brought up in regard to children's programming, family viewing time, and related debates is, when does a child stop being a child? Some concerned parties talk about TV affecting teenagers, in terms of the teens being "children." However, in some states a 16-year-old female could be married, a mother, and co-head of her own household.

SEX

Social scientists study the effects of TV portrayals of sex roles and sexual acts on the actual behavior of viewers. The questions are (1) how are women and men portrayed on TV and (2) how is sexual behavior portrayed?

Of course, you immediately get into a discussion of definitions. Explicit sex acts and nudity are infrequently shown on commercial TV, but they can be found easily on cable channels. Implicit sexual acts and partial nudity or revealing dress are more commonly seen today than they would have been in the 1960s. Sexual innuendo and humor based on sex has been common to some TV programming (especially the late night shows) for years and is more commonly seen in prime time today than it was 10 or 20 years ago.

Perhaps the significant change in TV programming over the past three decades is in the frankness with which topics that were once unacceptable for public airing are handled. Rape, incest, premarital sex, and homosexuality are common topics and sometimes themes of daytime soap operas, interview shows, and prime time dramas and comedies. However, you will find that the same topics are discussed in popular magazines and daily newspapers; so there is no indication that network TV is out in front of public taste.

SOCIAL PROBLEMS IN THE OPEN—THE DOCUDRAMA

In a sense, network TV has made a major contribution to better understanding of some social problems through *docudramas*, which are dramatic programs based on real events and real people, with certain artistic license. TV docudramas have aroused interest in spouse abuse, child abuse, rape and incest, abortion, euthanasia, mental and physical handicaps, and dozens of other social issues.

An outstanding example of the docudrama approach which succeeded was a television movie entitled, "Bill," which starred Mickey Rooney as a retarded adult. The movie made two points: (1) some retarded people are aware of their retardation and are fighting hard for recognition of the abilities they have, and (2) a retarded person can, given the right circumstances, live semi-independently outside an institution. In this dramatic social statement, a couple "adopted" Bill and gave him the support he needed to be more independent. It was a touching, honest, sometimes harsh film, which at one time would not have been shown on TV. It has become a benchmark in the long effort to attain better understanding for the retarded.

There are groups that disapprove of showing programs on TV that deal with one or more of the topics we have listed, and they are vociferous in their criticism of TV programming. These groups keep almost constant pressure on the networks and government regulators in an effort to eliminate references or topics they find objectionable. They are frequently reminded by the FCC that the Commission has no authority over the programming of networks and no authority to censor.

The battle then becomes one of gaining sufficient public concern via media appearances and enlistment of people who share similar values. Groups such as the Moral Majority, the Coalition for Better Television, and the National Council of Churches place a great deal of pressure on programmers in an effort to mold programming to their view of decency.

POWER OF THE MEDIA

Earlier we said that the media sets the agenda for our society. This represents both great power and great responsibility.

The power comes from the fact that you are making decisions as to what is or is not important. This occurs every day. If you are arranging guests for a radio talk show, you are helping to determine who gets on the air and who doesn't; therefore you are helping to determine which issues get discussed. If you are a news videographer, you can choose which picture to shoot or not shoot, which means you are acting as a gatekeeper. If you are an account executive, you can push to get a client on the air even though you know the product or the service is less than what the advertiser claims, or you can work with the advertiser to upgrade the product or service or decline to sign an advertising contract with the potential sponsor.

These are not easy decisions, and sometimes they get clouded by other factors, such as a program host's need for ratings (therefore we put on a guest who represents an insignificant radical group), or the sales manager is below quota for the month, so there is pressure on the account executive to sign up an advertiser who doesn't always meet obligations to customers.

There is no magic formula in dealing with these conflicts except an effort to remind fellow communicators of the dangers in making short-sighted decisions in terms of the long-term responsibility and economic health of the industry.

One of the reasons you are studying the telecommunication media in a college or university is so that you will go out into society with a wider, longer-term understanding of the role of the mass media and with the hope that you will exercise your power as gatekeeper and agenda-maker with care, honesty, and judgment.

SUMMARY

Everywhere you turn there are individuals and groups that want something discussed on, or banned from, the telecommunication media. They apply constant pressure, sometimes winning, sometimes losing. The FCC deflects a great deal of the pressure by responding to most inquiries saying it cannot censor. However, when the Commission sends out a simple letter, or issues a public notice of inquiry, broadcasters will stampede to comply with the perceived desire of the Commission. Cablecasters are less affected by this process, but they, too, are sensitive to social issues and will react if they foresee a threat to their franchises.

Telecommunicators need to develop a sense of what issues are important enough to warrant public discussion. They have to positively pursue opportunities to have this discussion. They must also develop a sense of public taste in their marketplace, and monitor their programming so as not to exceed the bounds of acceptable taste in their locality.

Broadcasters in particular find themselves in the difficult position of defending their right to carry advertising under the First Amendment, while trying to find ways to placate groups that want certain products removed from sight or sound.

The mass media practitioner must be aware that he or she has power: *power to influence, power to set the agenda,* and *power to popularize.* This power has to be exercised with care and judgment while meeting the economic needs of the commercial media and defending the media's First Amendment rights.

GLOSSARY

Ad lib To speak extemporaneously, without a script.

Agenda That which is in the plan for exposure.

Agenda setting Setting a trend as to what is news or important today, a function frequently filled by news media.

Aircheck A tape recording of a program, usually done for quality control or for job application purposes.

Audition An in-person or taped performance during which a performer attempts to demonstrate his/her qualifications for a part or position.

Clearance department A department at the major networks, which makes decisions about the acceptability of programming from a moral, legal, and ethical point of view.

Community Usually defined in terms of the area covered by the facility's primary signal or cable circuits.

Docudrama A drama based on fact done in documentary style with some artistic license applied to the facts, locations, characterizations, and time.

First Amendment The First Amendment to the U.S. Constitution or Article One of the Bill of Rights, which grants freedom of speech and of the press among other freedoms.

Gatekeeper The media's role of allowing and

excluding information and ideas, and selecting programs and topics for mass audience.

Hot topic, hot issue A subject that has the interest of the public because it is current in the media, which in turn makes it cause the media to be more interested and creates more exposure.

Mass audience Thought of as a very large audience, but it can be the greatest part of any available audience of reasonably large size.

Middle American dialect A flat relatively unaccented dialect of American speech that has become the standard for American broadcasting. It has its parallel in standard British speech, which is in truth only standard by birth in a small geographic and economic area.

Monitoring Listening to as a function of quality or content control, as in monitoring live phone conversations to cut them off the air if improper language is used.

Spin-off A program that is derived from within the plot and characterization of another program; an imitator.

Taste Within the accepted bounds of public morality or custom in the context of the community and audience.

Telecommunication In this context, it is the broadcast media of radio and TV, as well as the cable, microwave, and satellite media which bring in audio and video signals. This definition excludes telephone, telegraph, and data transfer.

CAREERS IN TELECOMMUNICATION 12

You are graduating and the whole business is out there waiting to hire you to be a hot shot DJ, a foreign correspondent, a talk show anchor, or maybe even the top salesperson. WRONG! Why? Because all the people out there in the business now got where they now are by putting in time at lesser jobs getting experience, and learning learning, learning. Oprah Winfrey was not an overnight success; she started at a local station at the age of 19. Walter Cronkite worked for newspapers, the United Press wire service during and after world War II and midwestern radio stations for several years before CBS hired him; and then he worked for them for years before he made anchor in 1962. There is a great deal of competition, much of it from people who have great dreams, but little realistic understanding of the hard work which has brought success to the people they admire. The first thing you must do in your job search is to sit down and realistically assess your skills. Be honest, do not try to make yourself feel good. If you are not honest with yourself about your skills, ability, and willingness to work, you may be in for a rude shock. Your first task is to make certain you understand the business and have a clear idea of where you want to start.

THE BUSINESS AND GETTING A JOB IN IT

What Is "the Business"?

Just that, a business. Most broadcast stations, cable systems, and similar facilities are owned by people who have invested money in a business and who expect a decent return on their investment.

The majority of telecommunication businesses are built around entertainment. A radio or TV station usually provides a heavy dose of entertainment and a smaller dose of news and infor-

mation. This means that we are dealing with an audience that wants to be entertained. This fact alone sets a broadcast station apart from a newspaper, which trades more heavily in news and information than it does in entertainment.

One outgrowth of the business aspect of telecommunication is that you are expected to be perfect. Mistakes can be costly, and if not costly, detrimental to the image of a telecommunication facility. You won't achieve perfection, but you need to be aware that this is EXPECTED. *Don't expect anyone to praise you for doing a routine job in an average way.* Don't expect employers to train you in the basics. The units in the telecommunication industry are usually small.

A radio station can have from five to 50 employees, while a TV station may have 50 to 300 employees. People are hired to fill specific jobs, and there is little slack to allow for training new employees. What this means to you is that you must acquire the highest level of skill possible in the areas which apply to your part of the business *before* you go out looking for your first job.

How Is This Done?

The key words are *practice* and *volunteering*. Practice and Volunteer, PRACTICE AND VOLUNTEER!!! Practice SPEAKING *broadcast style*. Practice *writing* scripts. Practice writing in all forms. The more you write and have your writing critiqued, the better you will become. Practice delivering a commercial.

Develop your voice and your writing skills. Work on your *presentation*. Presentation means appearance, voice quality, language usage, appearing or sounding comfortable, and not irritating people as you perform. If you have a speech pattern problem, work on it. If you know you carry around 20 pounds too much or too little, NOW is the time, not tomorrow, to start to correct it. If you've been used to startling everyone with the lastest in trendy clothes and

Figure 12–1
Sometimes "starting at the top" simply means climbing up to the lighting grid with wrench in hand.

Figure 12–2
Computer skills are practically essential for anyone intending to enter the broadcast industry. This picture shows how neat and organized (an unusual quality in most broadcast newsrooms) a computerized newsroom can be. Courtesy of Dynatech NewStar.

hair (green hair and purple clothes), this is the time to reassess.

Keep up with current events: know the latest hijacking, war, disaster, and the names of leading businesspeople and politicians. Learn every skill that you can; they may save your job one day or even your life. Learn audio, lighting, camera angles, and camera shots. Know how to take videotape, learn how to edit. If someone is willing to show you how a character generator works, watch and listen. Bluntly, take advantage of every opportunity to learn.

Volunteer for anything that will allow you to apply your skills. Work on the university radio station, volunteer at the media center, volunteer at the public radio or TV station. Public broadcasters almost always need help in their studios and during their periodic fund-raising campaigns. Volunteer to work with some aspect of a commercial station's operations, such as helping with a TV station's annual health fair. You need to acquire *hands-on* experience plus the skills and presence of mind that comes with having to actually *do something*.

There Must Be an Easier Way

There must be an easier way to make a good living than going into a business that demands a great deal of individuals, and operates seven days a week, 24 hours a day. Maybe. We think you will find out there are fewer differences from one business to another than you may think. All employers like to hire graduates with high levels of skill, even if they offer training. A major conglomerate may say it will give you 6 months of intensive training, but hold in mind two factors. First, you have to have a high level of qualifications to be accepted into the training program, and you have to make some commitment to stay with the firm for several years. No company wants to train you and then have you quit after 18 months.

Also, talk to people who graduated before you. You will find they work a lot more than 8 hours a day if they plan to get ahead in their business. There are long hours, breakfast meetings, work taken home on nights and weekends, required membership in civic and social organizations, and arduous travel.

In the final analysis, success in any profession is likely to take a great deal of your time and energy.

There is one truth in the telecommunication business. Unless you are willing to put a great

deal of yourself into learning the business and establishing your credentials as a professional, there is very little likelihood you will even get your first job and less likelihood you will have a successful career.

On the other hand, if you are willing to do the things we have suggested, you will *enjoy* your career, and a lot of your old classmates will look up to you in envy and awe.

Where Are the Jobs?

One irony of the telecommunication business is that while anywhere from dozens to hundreds of people apply for certain jobs, others go begging.

One reason is that applicants don't know about some types of positions that are available. Another is the unwillingness of many applicants to sacrifice in terms of taking a job that's not precisely what they had in mind or is in a location that does not meet their expectations.

Telecommunication executives will tell you they have considerable difficulty finding good *traffic/ operations* people, sales representatives, and writers. Some of these jobs don't sound appealing to a graduating student.

To illustrate why you need to study your options: the traffic/operations employees in a telecommunication facility get to know something about every department in the operation. They are in daily contact with sales, promotion, business, production, and engineering personnel. The job offers high visibility; so management is more apt to promote a traffic/operations person. It is a good area for someone who is undecided about what area to select for a career objective. You get a chance to shop around while gaining experience.

Selling is a bit scary for a recent graduate. Yet sales offers a wonderful opportunity for high income and has long been a major *track* for people who want to become top level managers. It has also been the key step on the path to station ownership for many people. Selling involves risk. The returns are low and slow until you establish a good client list and begin to bring in the billings (revenue). A salesperson must accept rejection and be willing to go back to a stubborn prospect and convince that person he or she needs to buy advertising.

Oddly enough, we all engage in selling. A promotion person sells the station's image; production person helps sell both the station's image and the sponsors' products. A traffic/operations person works with time that has been sold and helps to promote the station. Frequently, this involves client service. News staffers sell the image of their news product even as they gather the day's stories. A reporter is useless unless he or she has contacts (selling one's self) who willingly share information which makes the station's news presentation successful against competitive news departments.

If you have writing skills, you can find work as a continuity writer, promotion writer, presentation writer, or news writer. Frequently, these jobs lead to being a supervisor, a promotion director, or a producer. Writing skills can also lead to reporter or producer jobs in the news and public affairs area. Good writing skills can lead to an excellent advertising position.

JOB CATEGORIES

What follows is descriptive of *categories* of jobs. Specific information related to job titles is contained in the glossary at the end of this chapter.

Performers: The People and the Jobs

The single largest user of on-air performers is the radio industry. Radio needs disk jockeys, announcers, talk show hosts/hostesses, news anchors, news reporters, weather reporters, sports reporters, and sports anchors.

When you think of on-air jobs in radio, don't forget to include the rapidly growing number of state news networks; specialized sports, business, and agriculture networks; program syndicators; the expanding national radio networks; public radio; production companies; and public relations organizations.

All of these employers need people with an interesting voice, good diction, and a superior ability to communicate without the benefit of pictures.

While there has been some reduction of on-air opportunities in stations that have adopted automation or are taking syndicated programming by tape or satellite, the organizations which provide this programming have had to add personnel.

The demand today is for *communicators*, people who can use their voices to communicate with listeners. There is less and less demand for the deep-voiced announcers who made up the early legion of staff announcers. Women find

they are received with the same interest as men when they apply to today's radio related employers.

Today's radio air person has to have many of the qualities of the staff announcers of the 1930s and 1940s, minus the sonorous tones and the stuffy presentation. Today's broadcaster wants you to *talk* to the audience, get their attention, and hold their interest. However, there are better opportunities for people who can handle tasks more challenging than the seemingly mindless tight DJ record introductions. Many program hosts have to be able to do live remotes, interview guests, fill in as news anchors or reporters, and host talk programs. One must be knowledgeable and able to discuss current affairs in a cogent manner.

There is also a great need for skilled audio salespersons, people who can create and voice audio commercials. With the number of audio outlets continuing to increase, the need for people who can provide sponsors with ear-catching commercials has to increase, too. There is relatively little room for major expansion in national and regional sales, but every local broadcaster or cable outlet has dozens if not tens of dozens of potential advertisers who are not using audio media.

The video media need on-air performers. The hot area continues to be news, information, and public affairs, where there is a need for reporters, weather, sports and news presenters, program hosts/hostesses, and interviewers.

The only area that offers decreasing opportunities is the traditional TV station staff announcer. Most TV stations have overcome union blocks and now use recorded announcements for routine station breaks. The focus in TV has moved toward program hosts.

In addition to news for on-air stations, there is always the possibility to do additional live programming on cable outlets and LPTV stations.

There are opportunities in cable for network program hosts, sports announcers and play-by-play experts, weather presenters, all kinds of news people, interviewers, and commercial announcers.

Concurrent with the growth of the audio/video media are opportunities for creative on-air salespeople to put across the commercial messages which pay for all this programming.

Production

Unless you are in the business, it's easy to lose sight of the many people who work behind the scenes, getting each production on and off the air. It takes directors, producers, writers, editors, researchers, makeup people, technicians, and all kinds of assistants.

Directors in the video media are responsible for the creative execution of the program as it goes live or is recorded. The director determines the sequence of camera shots, and "sets up" insertion of all sorts of video effects while keeping a close eye on the timing of the show. Directors also turn commercial and promotional scripts into finished products.

Producers coordinate and create programs prior to their going on the air. The best on-air opportunities for producers today are in news, where they select the stories that will appear on the evening news and guide the reporters and writers in the preparation of each story, while keeping careful track of the timing of the newscast.

Figure 12–3
TV anchor reading script from a prompter. The anchor is looking at the blind side of a one-way mirror, which is reflecting the images from the TV monitor mounted below. The camera shoots through the mirror. This is also a reminder that what we see on the air is only a small part of the work that takes place in order to produce a broadcast. Courtesy of Dynatech NewStar.

Generally producers take a program up to the moment of airing, where they hand their responsibility off to a director, although you will run across director/producers who do everything.

There are few directors left in radio, due to the industry's restructuring over the past 20 years. You will find there are producers: news producers at all-news radio stations, music producers at syndication companies, producers who are responsible for live concerts, public broadcasting program producers, and commercial producers.

Writers are essential to the telecommunication business. Writers prepare commercials, promotional announcements, newscasts, news stories, public affairs programs, documentaries, religious programs, sportscasts, wire service broadcast copy, music scripts, quiz show questions, prime time movie scripts, and thousands of other scripts that eventually become programs and features.

Editors, as we are using the term here, are people who edit, correct, and modify copy. There are also editors who perform technical functions. News departments, especially at the network level, use editors. Anytime a script is created, there is a possibility it will be edited by someone who has a good knowledge of spelling, English, and the technical details involved in the script.

Researchers, librarians, and records-keepers are essential in a business which has to keep legal and government records and search for volumes of background information. Researchers work on movie and program scripts, dig out background for documentaries, answer technical questions for news correspondents, and do sophisticated economic and statistical analyses for sales departments, program departments, rating services, advertising agencies, and a variety of other units that need statistical data. Other researchers run focus sessions, conduct surveys, and delve into the reasons people make certain product choices or watch a particular TV show.

We mention makeup technicians just to point out that there are numerous behind-the-scenes jobs that involve the artistic part of a program. These include makeup, scene design and construction, lighting, commercial art, commercial photography and videography, costumes, stunts, location seeking, talent booking, and many others.

Many of the skills we have mentioned offer ground-floor opportunities for newcomers who work as assistants. Production assistants help with the details of getting a show or commercial ready, promotion assistants coordinate details in promotion departments, desk assistants help editors and producers in newsrooms, and research as-

Figure 12–4
The use of sophisticated electronic computer graphics in video production has created opportunities for artistically inclined people to work in broadcast/cable facilities and production houses.

sistants take care of the less sophisticated research tasks.

Technical

There has been some reshuffling of technical positions in the telecommunication industry over the past few years. The FCC eliminated its stringent licensing requirements for many of the engineering duties involved in operating radio and TV stations. This has resulted in some positions being eliminated and a great many being reclassified into lower skill and pay categories. Automation of radio and even TV transmission equipment, plus a loosening of FCC regulations, has lessened the demand for licensed engineers to supervise transmitters.

On the positive side, the increased use of computers and sophisticated technical equipment has created jobs, as has the overall expansion of the types of telecommunication media.

Basically, technical positions break down to two categories: operational and technical.

Operational jobs include the people who edit videotape, program character generators and graphics devices, run master control, supervise the playback and recording of videotapes, run the film chain, run studio cameras, run audio boards, act as technical directors on programs, mix and edit audio and video productions, over-

see transmission and reception of satellite signals, run audio in production facilities, shoot videotape for news, programs and commercials, staff microwave and satellite newsgathering vans, edit and record audio tape in some radio operations, and supervise radio, TV, cable, and satellite network transmissions.

Technical positions include people who maintain and repair all types of equipment, some television transmitter engineers, engineering supervisors who must be able to make or direct repairs, computer system technicians (as opposed to people who work solely with computer programming), engineering consultants, design and construction engineers, and anyone with a detailed knowledge of electronics or computers to carry out his or her job.

There are a number of entry-level categories in the technical fields. Usually, the simpler operational jobs are open to beginners. Many graduates start as studio camera operators, videotape operators, editors, and character-generator technicians. There are fewer entry-level operational

jobs in radio, where the necessity of economizing has eliminated many operational people unless union agreements protect the positions.

If a student wishes to concentrate in the technical side of the business, he or she would be well advised to plan to attend some type of technical school or institute to obtain the necessary electronics training. You might consider qualifying for an FCC general license, which opens the door to more advanced engineering positions.

Many areas of the broadcast industry are unionized, and this is particularly true on the technical side. A student considering a career on the technical side of the business should become aware of the functions of a union and how *unionized shops* work. In general, technical departments with union agreements may pay better than nonunion shops, but an applicant needs to look at the way advancement to more sophisticated positions is attained before stepping into a union shop.

Sales

One of the most important areas of the business is sales, and yet employers report they have difficulty attracting college graduates to sales-related jobs.

One reason is that although sales is highly rewarding (much more so than many other options), the salesperson's earnings are determined by her or his tenacity, personality, and persuasiveness. Income fluctuates according to the number of active accounts a person has, and a salesperson must be able to stand rejection (people saying "no") as he or she solicits advertisers.

Generally, salespeople receive a relatively low base salary or *guarantee* and then are paid commissions of 10 to 20 percent on billed and paid up sales contracts. Many employers recapture some of the guarantee from commissions before paying the balance of commission money to the salesperson. A sales representative's normal business expenses, auto, business lunches, etc., are usually paid by the employer.

There are a variety of jobs in the sales field. Radio, television, cable, and some other media sell advertising directly to businesses. Cable firms also sell the cable service to increase their subscriber base. Representative firms solicit regional and national advertising in behalf of stations. Networks and station groups maintain large sales staffs. Salespeople sell syndicated programming to radio and TV stations, while other

Figure 12–5
TV and cable studio camera operators frequently come from the ranks of college telecommunications students and recent graduates. Courtesy of Philips/ Norelco.

salespeople sell technical equipment to broadcasters.

There are support jobs that are related to sales. Many stations, groups, and networks maintain marketing departments to help sponsors get the most mileage out of their advertising. They develop store placements, assist with certain tie-in advertising, organize groups of dealers to share the advertising expenditure, conduct research on the market and product spending patterns, and assist in preparing presentations for potential clients.

The sales traffic staff keeps track of all the commercials to make certain that they are run as ordered, and affidavits are prepared to verify that the spots ran. They usually track materials needed for airing the spots, such as the videotape reels with the commercials on them. The sales traffic staff is also responsible for keeping records on dealer tags and other operational variations that accompany commercial schedules.

Promotion

The word promotion is frequently used to describe the process of advertising a station, but the function is really a public relations one that promotes the image of the station and its staff.

A typical promotion department is responsible for on-air promotion; outside advertising in print media; outside advertising in other telecommunication media; outside advertising on alternative media such as billboards, subway, or bus cards; promotions involving people and events; promotions using give-away items such as T shirts; press relations; civic participation; charitable activities; and a variety of special activities.

The promotion department works with the art department and outside agencies to develop an advertising "image" or "look" so that all the printed and broadcast promotions of the telecommunication firm present a consistent theme and appearance. The logos that people identify with certain radio or TV stations are creations of the promotion department or someone they hired.

Promotion can be detailed. CBS Inc. has had a consistent color, paper, and type style for all of its correspondence and business cards for years. All of this projects an image of consistency, fiscal solidity, and importance.

On inside promotions the promotion department works closely with program sources, such as companies that sell movie packages, syndicators, and networks. Slides, print artwork, and

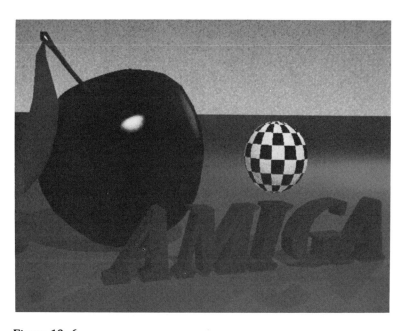

Figure 12–6
The sophisticated graphics capabilities of modern personal computers are allowing even low-budget telecommunications operations to create striking promotional images. Courtesy of Commodore Business Machines, Inc.

film or videotape *clips* from programs must be on hand for on-air promotions. A general rule of thumb is that unsold time goes to either public service spots or promotions. In addition, programs frequently have teasers (telling you to stay tuned) and trailers (telling you to tune in again). Separate voice-over promotions have to be planned for the end of TV programs. In other words, on-air promotion takes a great deal of planning and calls for detailed follow-up so that all available unsold time is used to promote and so that the promotions will be compelling and timely. Telecommunicators believe in promoting themselves. Not only are there jobs in the radio, TV, and cable business in promotion, there are also all the suppliers of material to the radio, TV, and cable companies.

Sometimes media firms swap promotions. The advertising is booked just like a commercial account, but it amounts to a reciprocal agreement that so much of my air time is worth so much of your space or air time. TV stations often swap ads with weekly newspapers and radio stations. Occasionally, radio stations swap ads with the print media. The time is booked as advertising time, but no money changes hands.

Another major duty of the promotion department is to make sure all program guide listings are accurate.

Recently, news departments have gotten so large they have started employing specialists in news promotion who work solely on internal and external promotions for the news department. This is a little tricky because generally the news people do not go out on commercial promotion events, but the good promotion assistant knows that a news personality would make a good speaker at the local Civitan club. People who work in promotion must be creative and not afraid to sell the image of the station.

Promotion is an integral part of the business at all levels. Networks have large promotion staffs.

Production companies need promotion experts to prepare trade advertising to help sell their programs, and once the programs are sold, the production company assists the media outlet with its promotions.

Telecommunication companies that sell their service to subscribers have a lot to do because they must advertise for subscribers and then turn around and attract subscribers to specific programs they offer.

Promotion offers entry-level possibilities because there are positions for clerical assitants, copywriters, and promotion assistants. Skills in writing, print layout, commercial art, and still photography all help when you are looking for a job.

The Business Office

The business office seldom gets much public attention, but it is the heart of any business. The business office keeps track of the company's income and spending, and it tells management whether or not the company is performing up to the stockholders' or owners' expectations.

Payroll, billing, financial analysis, record keeping, compliance with local, state, and federal laws, paying taxes, personnel relations, insurance control, stockholder information, purchasing, subscriber billing, and management information systems (computers)—these and many other functions are performed by the business office.

There is always a need for business office specialists in broadcasting. It is a great way for someone who is not inclined toward performance, production, sales, or engineering to be a part of an exciting business.

There are a number of entry-level possibilities available in business offices. Specific business training in personnel, computers, finance, or business administration is helpful. A candidate's resume is enhanced by evidence of some broadcast experience in college or in the industry.

Business management has been another good track to top management and media ownership.

Public Affairs, Sports, News

We did not list news separately because the skills involved are aspects of production. Today at the broadcast station and network level, separate news departments are more the rule than the exception. Specialized training in journalism is not mandatory, but it certainly is a big help in landing a first or second job. Job openings in news and public affairs attract a lot of applicants, so a student looking for a first position needs to be well prepared and ready to step right in and do a good job. Some stations and networks maintain separate departments that produce the public affairs programming. This can include editorials, documentaries, and newsmaker programs. Sports is another area that calls for skills similar to those used in the production department, but it often operates nearly autonomously from other station activities.

Larger media outlets maintain community affairs or audience relations departments. They respond to audience requests for information or tours. They maintain liaison with community groups. Community affairs departments frequently originate programming. They also work with civic groups to train their officers and members to use media time effectively. The community affairs department in some organizations keep track of employee participation in civic activities and encourages all employees to be good community members after work hours.

Management

Management employees usually come from one of the areas we have discussed, so don't expect to find an entry-level position in management unless the rich uncle who struck gold owns the station.

Program management is an important aspect of the telecommunication business. A program manager determines (in conjunction with other top managers) what a station or cable channel will program. In radio the program manager helps devise the format, guides selection of the music, hires and fires the air personalities, plans the promotions, and takes responsibility for the

station's "sound." Even all-talk stations need someone in charge of programming.

In TV millions of dollars in revenue can depend on the advice of the program manager, who plays a key role in the selection of syndicated programs and the development of local programming.

Networks and similar organizations such as HBO succeed or fail based on their programming. This means their program managers can earn significant sums if they are right, and can be searching for employment if they are wrong. The gross income from just one network commercial could pay several salaries.

Historically, broadcast station program managers have risen through the ranks. In radio on-air talent and music directors tend to become program managers. In larger radio operations a rising employee may become the production manager before being promoted to program manager.

TV program managers often come from the ranks of directors, stopping off to serve as production managers along the way up the career ladder.

Network program executives can come from a number of directions. Some people start out in stations and then move to the network, while a significant number of network program executives work their way up from entry-level programming department jobs to supervisory and management responsibilities, which usually include management of a segment of programming before they reach the top.

Program managers in the distribution companies (HBO, The Disney Channel) frequently move over from networks or film studios.

Sales managers usually rise through the ranks from direct sales, stopping off along the way to perform supervisory jobs as local, regional, or national sales managers. Some station sales executives plan to spend a couple of years during their career selling for a representative organization, and it is not at all unusual to meet a sales executive for a representative firm who has worked in station sales.

Many entry-level sales people start out in some other part of the business, particularly as on-air talent, and gradually shift emphasis to sales. This is particularly true in radio where it is not unusual for an on-air person to split duties, announcing part of the time and selling during the remaining hours. Many TV salespeople gained their initial experience in radio sales.

Business managers usually combine good academic credits, such as an M.B.A. degree, or certification as a CPA, with several years of gradually increased responsibility in the business office. It takes time to learn the systems and the business and regulatory environment of the telecommunication business. Entry is usually made at a level similar to a junior accountant.

Some large organizations split off management information, thus providing a different career path for people trained in computer utilization for business. Large group broadcasters, networks, and program suppliers have need of extensive computer expertise. Entry-level jobs can usually be found by persistent, computer-literate people who (in most cases) have relevant degrees.

Another branch can be personnel management. This is a specialized function dealing with employee benefits, hiring and firing, contract negotiations, payroll, and training. Increasingly, this function is left to professionally trained personnel people, who have college degrees appropriate to either business or personnel. There are entry-level positions in personnel, which can lead to becoming a personnel manager once sufficient experience is acquired.

Engineering managers come from the supervisory ranks of the engineering staff and usually, but not always, from the ranks of the most technically trained staff. An engineering degree or two plus plenty of experience and proven supervisory expertise are the normal prerequisites for top management. The entry-level path usually starts in the sophisticated technical functions of the engineering department and increasingly calls for an engineering degree.

General Managers

General manager is a term frequently used in the telecommunication field to describe the top person in an organization. Ten years ago you could safely assume that most general managers came from a sales background; this has changed. In radio and TV some program managers and news directors have moved up to the top slot. One reason is that there is an increasing emphasis on the total organization of a broadcast property, with a big emphasis on community relations. Some companies found sales executives to be too narrow for their liking, and began experimenting with promoting program and news managers to the top slots because their backgrounds called for superior "people" skills, an ability to create a team effort for the company.

In cable TV many of the early leaders were engineers. They have increasingly been replaced

by people with either a sales or general business background as cable operations become larger and more program- and business-oriented. In one instance a public TV station program manager switched to a management position in a local cable company, and a few months later, when the general manager left became general manager of the cable system.

To some degree the person who is destined to lead often rises to the top, regardless of his or her background. It is just that the process usually flows more smoothly for people who recognize the career path and move along it. It can be safely said that good skills in dealing with people, an ability to sell the total product of the company, skill in keeping costs down and profits up, and an ability to create visibility within the company are attributes shared by most top-level managers.

HOW MUCH WILL I BE PAID?

It would do little to quote salaries in a book because the figures change with the changing nature of the business, and in conjunction with factors such as inflation and the general health of the economy. The National Association of Broadcasters publishes industry average figures and the Radio-Television News Directors Association publishes a whole series of surveys on salary-related matters annually.

Expect to start fairly low, and increase your pay fairly sharply as you acquire more skills and experience.

VOCATIONAL PREPARATION VS. EDUCATIONAL PREPARATION

Is there one best way to prepare oneself for a career in telecommunication?

No. The people you admire in the business have come from a wide variety of backgrounds. Walter Cronkite, the "dean" of network anchorpeople, did not complete college.

Well-known news correspondent Ed Bradley once taught school.

Many famous broadcast journalists worked for newspapers. Fred Graham of CBS News was an attorney and newspaperman.

Former top CBS and NBC news executive Richard Salant was an attorney. Famed CBS president Frank Stanton trained in research.

There are some guidelines: as any industry grows older and more organized, it tends to hire trained people. To us this means that having a college degree is a virtual necessity for long-term career growth. And while many people still enter the industry from disciplines other than broadcasting or journalism, the greater number appear to be professionally trained. The person who tries to enter broadcasting without professional training finds his or her job difficult because employers generally want a trained and, hopefully, experienced entry-level employee.

Even people who have gone on to get law degrees find they have difficulty getting jobs as broadcast reporters because they have no training in converting their knowledge to presentations the public will understand and appreciate.

How about a broadcasting trade school? This can be an appropriate route for someone with a nonbroadcast degree. People who opt to take only trade school training instead of going to college sometimes find themselves held back when it comes time for promotion to higher level positions. If you are planning to enter one of the technical fields and your degree is in broadcasting, for instance, you would be well advised to go to a technical school and obtain an FCC license.

Of course, people seek to enter specialized areas such as personnel, management information systems (MIS), or business may find their specialized training suits them fine, although any employer feels happier to hire someone who has had at least modest experience or coursework related to telecommunication.

MARKETING YOURSELF

Getting a job in a telecommunication field is similar to marketing a new brand of soap. You have to prepare a marketing plan, then get your materials together, and begin your assault on the marketplace.

The better your plan, the more likely you are to succeed. There are a few things you must consider:

1. What do you like to do best?
2. What do you know how to do right now? It will do no good to go looking for a job for which you have no skills at this time.
3. Where will you be willing to go for the job? Don't say "anywhere" because when the time

comes to make a decision, you will find there are some places you won't go.

4. What aspect of the business do you like best? This not only means radio, TV, or cable; it also means production, sales, and adjunct media.

5. Can you afford to move a long distance? Although it may disturb you to read this, your best chance at getting a first job may be right in your home or school community where your familiarity with the town will be regarded as a plus by many employers. The cost of relocation is high. You have to plan on moving, paying a deposit on the phone, lights and your apartment, and buying some necessities, which may include new clothes.

Once you have answered these questions you can begin to make a plan. Pick a geographic area, list all the media outlets of the type you're interested in, and begin to contact them. You can get the names, addresses, and phone numbers of media outlets from *Broadcasting/Cablecasting Yearbook* and similar media guides.

Try to get the name of the current supervisor in the area you choose and use the current title. News directors run news departments. Sales managers run sales departments but traffic co-ordinators run traffic departments. Know the title and the person. People change jobs frequently and rapidly in broadcasting, and the program director listed in a yearbook may no longer be there. Your professors may have more up-to-date directories, which are put out by their professional organizations. Another strategy is to call the switchboard at the media outlet and ask who is in charge of programming, sales, news, or whatever department you are interested in.

Expect to run up a phone bill. You will have to follow up on leads and you may have to call some outlets and remind them to return your audition materials.

Once you have determined your targets, consult with a knowledgeable faculty member to get additional information regarding who to talk to, graduates who may be working at the places you have selected, or employers you should avoid.

Be realistic. If you are hoping to start as a TV production assistant, you can try for any size market. However, if you want to be a TV news reporter, you might as well skip the big markets in your target area and go for the small stations that have to employ entry level newspeople. News reporters need a certain amount of on-the-job experience before they are ready to move up to larger, more demanding markets. This is generally true of any performing job.

There are certain requirements of the job hunt. You must have a resume. If you are seeking a job where you have to demonstrate skill during the initial contact, you must have an audition tape or portfolio. This holds true equally for on-air performers and people who produce or shoot videotape. You will need a portfolio if you are demonstrating writing or artistic skills.

In addition, you should prepare a model cover letter, which is retyped as an original each time you mail out your resume. You can make modest changes in the letters to fit situations, but it is a good idea to have a basic letter to follow.

YOUR RESUME

What follows is a model resume. It may or may not suit your purposes, but it has proven to work well for a number of students. You will notice the resume is two pages long. Some people insist that a resume be no longer than one page. Our contention is that a resume is a sales document and if it isn't readily apparent why we should hire a person, then the resume has to be long enough to sell the jobseeker without exhausting the reader. Two pages will do it. After you acquire some stature in the business you can reduce the length of your resume, because people in the business know what the abbreviated information means.

For instance, if your name were Ted Turner and you owned the Turner Braodcasting Company and the Cable News Network, you wouldn't need a long resume.

Let's discuss some of the highlights of the model resume. You will want to put your name in a prominent place right at the top center. Be sure to provide both school and home addresses and telephone numbers because you cannot be certain where you will be when *the call* comes from a potential employer.

If you have a daytime phone number, such as the one at your part-time job, or at the college radio station, list it if you can rely on people to take messages. Make sure you tell the people at that phone number that you might get messages. It is frustrating for a potential employer to call a number and have the person answering act like they don't know you or won't take a message. If you don't brief people at your message number, it could mean you don't get the message *or the job*.

```
                            RESUME

                 A. TELECOMMUNICATIONS STUDENT

School Address:                          Home Address:

    Arbor Apartments #136               1245 Delta Avenue
    4000 Hayden Road                    Ocala, Florida   33908
    Tallahassee, Florida 32304
    (904) 222-1070                      (904) 678-9065

Born:    Lakeland, Florida October 16, 1961
         Single

Job Objective:   I am seeking a position as a radio news
                 reporter.

Education:
            Florida A&M University, Tallahassee, Florida 32307
            Graduation Date:  June, 1982
               Major:  Broadcast Journalism
               Minor:  Political Science

            Central Community College, Ocala, Florida 33907
            Graduated:  A.A. June, 1980
               Elected to Who's Who in American Community
               Colleges, 1980
               Editor - The Rapper (school paper)
               Treasurer - Delta Delta Social Organization

            Southwest High School, Ocala, Florida   33906
               Diploma:  June, 1978
                  Class Salutatorian

Awards and Honors:

            President, Journalism Club, Florida A&M, 1980-81
            Heath Memorial Scholarship, 1981
            Secretary, Phi Beta Nu Social Organization, 1981

Professional Courses:

               Mass Media Methods          Broadcast Newswriting
               Newswriting & Reporting      & Reporting
               Communications Law          TV News
               Voice & Diction             Oral Interpretation
               Radio Practicum             Theatre Performance
```

Figure 12–7
A model resume for a student seeking employment in telecommunications.

Vital Statistics

You do not, legally, have to list your sex, age, race, or health. We suggest to most students that they go ahead and list a birth date and place, unless the student is a mature returning student who might be subject to age discrimination. One benefit of listing your birthplace is that it may trigger a conversation during interviews, especially if you were born in the same state or city as the interviewer. (Or if you came from a town with an interesting name such as Two Egg, Florida.)

Job Objective

You don't need to, but you can list an objective. Be specific. If you are seeking an internship, say that you are seeking a position as an intern in a radio news department. If you are job hunting, describe the job you really want. Employers are turned off by people who list occupations other than the one they are applying for or who say they will "do anything." You will be hired to do something specific. If you find a need to change this objective to match jobs, you may want to

```
A. Telecommunications Student - 2

Work Experience:

9/81-Present   Intern (paid) - WCTV, Box 666, Tallahassee,
               Florida 32303
                 Intern in news department.  Wrote, researched, and
                 presented news stories as field reporter.

                 Supervisor:  Dan King, News Director
                              (904) 893-6666

1/81-9/81      Media Center, Florida A&M University, Tallahassee,
               Florida 32307
                 Production Assistant - Assisted in production of
                 university public affairs programs as camera
                 operator and video switcher.

                 Supervisor:  Cyrus Brown, Director
                              (904) 599-3456

9/80-1/81      Burger King, 333 Baldwin Boulevard, Tallahassee,
               Florida 32305
                 Relief Assistant Manager

                 Supervisor:  Paula Brewer, Manager
                              (904) 564-8905

Other Interests:  Archery, Tennis, Computer Games

References:
               Dr. Leader A. Person
               Assistant Professor, Journalism
               Florida A&M University
               Tallahassee, Florida  32307
               (904) 555-3102

               Professor Olde R. Stuffe
               History Department
               Florida A&M University
               Tallahassee, Florida  32307
               (904) 555-4567

               Rev. Stancil Goodwright
               Palms Baptist Church
               346 Main Street
               Ocala, Florida  33908
               (904) 678-4578
```

eliminate the line from your resume and include it in your cover letter.

Education

List your current college or university, with its full address plus your graduation year and month and your major and minor. Your letter could end up on the desk of an alumna of the school who would not take kindly to having the school shortchanged on a resume.

Academic Honors

List academic honors next. List any other colleges attended and the dates as well as the name of your high school and the date graduated, but leave out any other information about high school unless you received a very significant academic or athletic honor.

Why high school? Again, it just might turn out to be a topic that would start a conversation with the interviewer. If you have received awards or honors during college, list them. Think, we

often forget things about ourselves that others deem important. Maybe you won the French prize during your sophomore year. Scholarships are honors. So is a trip to a national convention if you are selected over other applicants. The awards and honors do not all have to be related to college.

Activities

Really work on this. If you find you are short on activities, think seriously about investing some initiation and dues money and joining Alpha Epsilon Rho, the Society of Professional Journalists, the Radio-Television News Directors As-

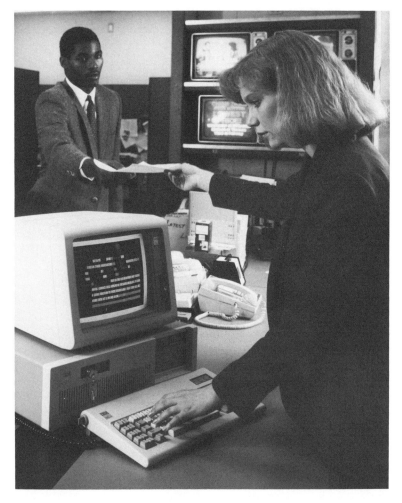

Figure 12–8
An internship can put you in a working environment, where you can polish your skills without enduring the pressure of being a brand new, full-time employee. Courtesy of Data Communications Corp.

sociation, Women in Communications, the Public Relations Student Society of America, or similar organizations. The people who will be interviewing you probably belong to these organizations.

Most employers prefer candidates who are "well-rounded," so membership in a social organization, a civic group, a religious group, the marching band, and participation in intramural athletics all help.

This is where you list your volunteer activities on the school radio station, in the media center, on the school paper, or the literary magazine. Also list nonpaid internships here. (Paid internships can be listed as jobs.)

Professional Courses

This is an optional entry, but if you have little experience, you can enhance your chances of getting a job by listing courses which address specific requirements of the job you are seeking. As an example, a future radio reporter would list Introduction to Broadcasting, Radio Studio Skills, Radio Newswriting, and Radio Reporting.

Employment

List all jobs you have had since graduating from high school. Do not be concerned that the jobs do not relate to your chosen field. Employers are much more secure about hiring people who have worked anywhere and who understand the rules of the workplace, such as showing up on time and getting along with other employees. List the correct name of the business, the full address, and a supervisor's name and complete phone number. Do not worry that the supervisor has left the company; go ahead and list the person you reported to at the time.

Do the employment list in reverse chronological order starting with your latest position and be sure to list any paid internships or work study assignments. If you were a paid program director for the college radio station, list it as a job.

References

Be sure to list references. Someone started a custom of putting "references on request" on resumes. This is foolish. Employers in the telecommunication industry are used to having to work fast, finding replacements for workers who have given as little as 2 weeks notice. They use

the telephone to check references and many employers simply are not going to spend the extra time to call you and request a list of references. It is equally bad form to include a letter of reference in your application because most employers regard letters that begin 'To Whom It May Concern'' as worthless because it is unlikely you would include an unfavorable letter. Be certain to spell correctly and give detailed, accurate information on employers and references.

We recommend that most students ignore pleas to have their resumes printed. For one thing too many things change and you will want to constantly revise your resume. The best strategy is to type a draft, have it checked by your advisor or another faculty member, then enter it on a computer or type it very carefully on a good electric typewriter with a business typeface. If you have access to a computer, you can print a fresh resume whenever you need one. If your access is only occasional, print a copy of your resume to use as a master and have copies made on quality paper at a good copy center. You can take the typewritten master to a copy store and get as many copies run off as you need for little money. Do remember that your cover letter and resume must be neat.

AUDITION MATERIAL

You will greatly enhance your chances of getting a job if you can bring (or mail) examples of your work to a potential employer. For some jobs, such as a TV or radio reporter, many employers will not consider an applicant unless the cover letter and resume is accompanied by an audition tape.

An audition tape consists of a few of the best examples of your work; whether it is as a producer or director, as an anchorperson, as an announcer, as a reporter, or as a disk jockey. If you don't think your day-to-day work is good enough, prepare a special audition tape. Don't be afraid to get faculty or graduate student help when preparing an audition tape because the tape is essential to your success in job hunting. You should plan your job-seeking budget so that you have enough money to buy audio cassettes or video cassettes and mail them. (Sometimes you can obtain almost new audio cassettes from a campus radio station or a public radio station. Some public service announcements arrive on these tapes and are dubbed to others for air use.

Be sure to *erase* the old material, and neatly cover the old label.) Put return addresses on everything, the reel, the case, and your letter, or you stand a chance of not getting your tape back.

A tape should run about 10 minutes and should feature your very best work at the top. Sometimes a potential employer eliminates an applicant from competition in the first 2 minutes of listening or viewing, so you want to come on strong. DJ applicants should "telescope" their tapes, which means to dub the tape and eliminate all but the beginning and ending of the recordings because the employer has heard the music. He or she is interested in how you sound and how you sell, not in listening to music.

Always lead your tape with the activity for which you are applying. For example, many students who want to be radio or TV reporters lead their audition tape with an example of their anchor work. Employers seldom hire entry-level recent graduates as anchors, so they aren't interested right now in your anchor work.

Make sure your tape has ONLY program material on it. It should not have unerased material formerly on the tape, countdowns, or color bars. Leader on audio tape reels should be spliced directly against the audition.

If you go on an internship, try to arrange to make a tape, even if you did not actually work on the air at the station. The experience will be good for you, and the fact that you have an audition tape with call letters indicated in your audition will impress employers. If you work

Figure 12–9
Students with experience in videography should make dubs (copies) of their best stories. You have to be able to show potential employers a tape of your best creative work. Courtesy of RCA Corp.

part-time in a broadcast or cable facility, dub off some of your actual work for the audition tape.

People applying for jobs that involve promotion or art will want to present examples of ads or commercial art in place of or in addition to tape. Whenever possible bring examples of what you would be asked to do in a job. If you sold ads for the school newspaper and the yearbook, bring examples of your ads when you apply for that cable sales job. After all, the cable company sales manager will be impressed that you sold the local mortuary an ad schedule for the football highlights.

COVER LETTERS FOR APPLICATIONS

Each application you send out should be accompanied by an original cover letter, addressed to a specific person. As we said earlier, try to find out the name of the head of the department you would like to work in. Do not send your materials to a personnel department unless there is absolutely no other choice.

A cover letter is a selling document. Here's an example of how a student seeking a position as a radio reporter might do a letter.

Apartment 31-C
Gulf Breeze Suites
111 Main Street
College Town, Idaho 23143

Ms. Ima Newshound
News Director
KWEP Radio
P.O. Box 1
Avalanche, Colorado 41657

Dear Ms. Newshound:

I am responding to your listing in the Radio-Television News Directors Association Job Bulletin. You indicated a need for a hard-digging street reporter.

I have just returned from the RTNDA International Conference where I was given an award for investigative reporting. The five-part series was an investigation of the deficiencies of student off-campus housing. My series, which aired over WTYP, the CBS affiliate in College Town, also won in the investigative category in the Idaho UPI Broadcasters contest.

I have been on the news staff of our 5,000 watt college FM station for four years and I have also been working as a part-time news reporter for WTYP for the past nine months. Last summer I was an intern in the news department of WPUP in my hometown of Warm Glacier Springs.

My resume, an audition cassette, and a cassette of the investigative series are enclosed. I can be contacted at (907) 567-1234 during afternoons and (907) 566-4321 evenings.

Very truly yours,

Eager I. Reporter

Although you can send essentially the same letter to each prospective employer, each letter should be an original. You should include a copy of your resume and any tapes or documentation of your ability.

The cover letter should: (1) show that you have the qualities put forth in an ad or can do what's normally expected for the job you are seeking; (2) highlight your outstanding accomplishments, even though they are included in the

resume; and (3) make it easy for the potential employer to locate you by telephone.

If you were writing to a station in your hometown, for instance, you would be certain to point out that you grew up in that town, knowing that some employers like to hire people from the local area.

PREPARING YOURSELF FOR THE INTERVIEW

Job interviews are hard work. You must dress well, as if you were going to work in someone's office. If you are going to an unfamiliar town, allow extra time and scout out the employer's location. Arrive slightly early for your appointment. Allow enough time that you don't show up perspiring and out of breath.

Stay cool and try to fight nervousness. Don't talk too much, but don't be afraid to ask intelligent questions about the job or the place of business. You should, of course, have learned everything you can about the employer before you go to the interview. Look up the company in trade yearbooks or other volumes. The business librarian at your school can point out some reference books that give backgrounds on companies.

Know what the company owns and what it does. (We hope you have made a habit of reading the trade magazines so you are up on what's going on in the business.) It's a good idea to read the newspaper in the town before you go to an interview in case a reference is made to some item in the local news that would refer to either the type of position you are applying for or to something that could come up in the interview. If you are going for a news position, be sure you are up to date on all the latest news worldwide.

If you are invited out to lunch or dinner, display your best manners. When in doubt, watch your host for cues. One safe rule: if you find a lot of spoons or forks next to your plate, start from the outside of each side of the plate and work toward the plate for each course. Don't drink excessively; your host or hostess will be looking for bad habits. You should probably refrain from smoking or drinking if your host does not smoke or drink.

It is not a bad idea to drop a thank you note to your interviewer right after you return home. Polite follow-up calls are acceptable and expected if you do not hear any news within the time you were told you should expect a decision.

SOME EARLY CAREER CONSIDERATIONS

Employment Agencies

Bluntly, too many of the employment agencies that advertise positions for entry-level employees are simply compiling lists of jobs that were open when they typed their bulletin. You have to do all the follow up and you are barely better off than if you read the want ads in *Broadcasting* magazine and worked from your own list of potential employers. Consult with experienced people, such as faculty advisors, before subscribing to any job leads service.

If your career begins to move along and you are involved in talent or certain areas of production, a placement agency may contact you. Usually, these agencies charge the employer if they find a new employee and they are generally reputable. However, many initial contacts are made only to enlarge the agency's file of potential employees, so don't get too excited until the talk turns to discussion of a specific job at a specific station.

Your best employment agency may turn out to be knowledgeable members of your faculty, who have contacts and who can introduce you to specific employers who are known to hire graduating students.

Unions

Unions serve a necessary place in the industry. They have raised wages, shortened work hours, and improved work conditions for many broadcast employees.

If you join a union station in a non-right-to-work law state, there are a couple of considerations. You will have to raise enough money to pay the union's *initiation fee* for new members. Sometimes union membership limits the flexibility and mobility of young employees, a point you must consider if you start in a job which you expect to use to get a different type of assignment. For instance, you might start as a videographer in a newsroom with the intention of eventually becoming an assistant producer. In a nonunion station there is some potential to do this. A union station may have rather strict job categories, and you may find it difficult to move ahead due to the seniority of other workers or a management tendency to think all people in one category should stay in that category.

In certain situations a union can assist you in

Figure 12–10
Stations pay engineers who operate satellite news-gathering trucks very well. The major disadvantage of this position is that it can require the engineer to spend quite a bit of time away from home.

getting a job. This is particularly true if you already have your membership and move to a new city. Sometimes you can get part-time work through the union and thus meet potential full-time employers.

Contracts

Some stations require on-air talent to sign contracts. The cardinal rule is, never sign a contract without legal advice. The purpose of the contract is usually to assure that if you are doing a good

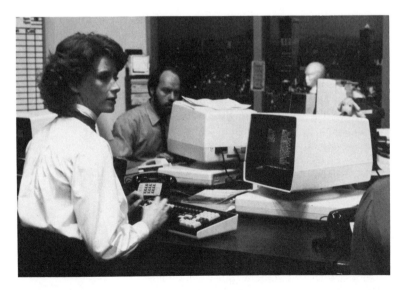

Figure 12–11
The telecommunications industry is an equal opportunity employer. Courtesy of Dynatech NewStar.

job, you will feel obligated to stay in the company's employ for a stated period of time. Often these contracts do not reciprocate by giving the employee much protection if the employer wishes to terminate him or her. Another type of talent contract is called a "non-compete" contract. In it the employee agrees not to go to work for another related employer within so many miles from the current employer. This is designed to prevent the station across town from raiding its competition's staff.

It is true that the highly paid talent employees you hear about and some behind-the-scenes people have contracts. These are usually worked out with full legal and talent management advice, and are at least equal in favorability to the employer and employee and sometimes lean in favor of the employee if the person is that valuable to the organization.

Market Size

The size market a person works in is sometimes taken as a measure of success in the telecommunication world; it shouldn't be. A person could be a desk assistant in New York and be less well off than a comparable person who is a Promotion Manager in Iowa.

The small or large market route is largely a personal choice. We have observed that if you study network news employees who entered the network at the earliest possible date and people who arrived after years of local market experience, it is not unusual to find that both categories arrive at a certain high level of responsibility at about the same time. If you are going to go the big city route, you have to be tough just to get your foot in the door, and then you have to be willing to be a loyal company employee for several years before you begin to acquire some responsibility. You can rise to a high level doing this. The biggest drawback is that you won't have any outside experience to help you along.

Other people feel much more comfortable starting in a small or medium-sized market where they can learn to do everything. There is no specific answer to the question of where to start, as long as your choice works for you.

ORGANIZATIONS THAT CAN HELP YOU

There are a number of organizations that centralize job information. The Radio-Television

News Directors Association has a job service for members. Most state broadcasters associations publish information on jobs and people seeking jobs. There are job banks as well. These tend to come and go, but you can usually get information on job banks from faculty members at your school. Some schools publish and circulate lists of graduating seniors.

Organizations such as Women in Communications, the National Association of Broadcasters (particularly its Clearinghouse for Minorities), the Society of Professional Journalists/Signma Delta Chi, and the National Association of Black Journalists can help.

There are also special job fairs for minorities. One of the best known is held at Howard University in Washington, D.C.

It is a good idea to attend meetings of professional associations if you can. The Radio-TV News Directors Association and the state wire service broadcasters frequently meet together. If you go to one of these meetings, dress to impress and take along resumes and audition or portfolio materials. Your reason for going to the meeting is to make job contacts. Sometimes state broadcasters' associations set aside one yearly meeting for students.

When you come down to it though, the only sure way to get a job is to make a reasonable job-seeking plan and then stick to it until you make a contact that *clicks*.

GLOSSARY

Audition A live or recorded demonstration of practical performance skills. An in-person or taped performance during which a performer attempts to demonstrate his/her qualifications for a part or position.

Audition tape Audio or videotape containing audition; sample of on-air performance or production.

Cover letter Letter introducing applicant that goes with resume or job application form.

Director Person who coordinates live production or live to tape production of a TV (or radio) program.

Editor Person in the newsroom who has control over quality of written content and corrects mistakes; also a technician who edits audio or videotape by combining selected audio and videotapes or tape excerpts into finished product.

General Manager Customary title for chief executive of a broadcast station or cable system.

Graphic artist Artist who works with computer-driven electronic devices that "draw" pictures electronically on a TV screen.

Graphic technician Person who operates a graphic device, frequently a machine, which superimposes titles and lettering on screen.

Intern Student getting on-location training at job site for college credit and/or remuneration.

Internship A stated experience period (quarter or semester) spent at a job site by a student.

Marketing Enhancing marketability (saleability) of a product or service through a combination of promotion, public relations, and advertising.

Meteorologist Person who compiles and airs weather forecast. Term is usually applied to a person who has professional certification and/or professional degree or coursework at the university level.

News director Administrator of a news department at a broadcast station, network, or cable system. Sometimes called News Manager, News Supervisor, Director of News.

News reporter On-air talent trained or experienced in journalism who covers news events, seeks news stories, and/or conducts investigative activities to generate news stories.

Portfolio Presentation folder containing examples of work, used mainly for art, graphics, writing, or creative product.

Production assistant Person who does anything needed to make sure a production goes smoothly. This can include timing, script supervision, clerical tasks, contacting guests and sources, dressing the set, hosting guests, and even getting coffee (This is where the term "Gofer" came from.)

Production manager Executive in charge of facilities and staff used in the preparation of programs and announcements.

Promotion, promotion manager The department and person that *sells* the station to the community. The objective of promotion is to increase a station's audience through public relations and advertising techniques, which enhance image.

Resume Outline of a person's education, employment, and civic qualifications for a job.

Right to work A state law that forbids "closed shops." The "closed shop" means an employee in a job covered by a union agreement must belong to that union or not work.

Sales Manager Administrator in charge of sales department for a telecommunication outlet.

Sales person Sometimes called an account executive. A person who sells media time, services, or equipment.

Satellite coordinator Typically, a person who contacts owners or leasors of communications satellites to arrange short-term rental of transponder (channel) time; acts as a go-between from source in field to satellite company operations center.

Satellite technician Technical operator who works with satellite reception and transmission equipment or operates a mobile uplink or satellite newsgathering vehicle.

Sportscaster Talent professional who describes live play-by-play sports, assists in live coverage, or does sports news for telecommunication outlet.

Station manager Next in responsibility to general manager of a broadcast station, frequently responsible for inside, operational aspects, while general manager focuses on policy, community activities, and sales.

Traffic and continuity coordinator Supervisor of department which compiles and publishes daily operational log, prepares commercial, promotional, and public service copy, and maintains copy control, and enforces company quality/taste standards.

Traffic/Operations Department or position responsible for preparing the operation's daily operations schedule and making sure that all the needed materials are in place.

Union shop Place of employment where wages and employment conditions of some or all of employees are governed by union agreements with management. Union membership is usually mandatory for covered employees.

Videographer Technician who operates field videotape camera and associated equipment.

Voice-over Narration over video.

APPENDIX A

AMENDMENT OF COMMUNICATIONS ACT OF 1934

SEC. 2. The Communications Act of 1934 is amended by inserting after title V the following new title:

"TITLE VI—CABLE COMMUNICATIONS

"PART I—GENERAL PROVISIONS

"PURPOSES

"SEC. 601. The purposes of this title are to—

"(1) establish a national policy concerning cable communications;

"(2) establish franchise procedures and standards which encourage the growth and development of cable systems and which assure that cable systems are responsive to the needs and interests of the local community;

"(3) establish guidelines for the exercise of Federal, State, and local authority with respect to the regulation of cable systems;

"(4) assure that cable communications provide and are encouraged to provide the widest possible diversity of information sources and services to the public;

"(5) establish an orderly process for franchise renewal which protects cable operators against unfair denials of renewal where the operator's past performance and proposal for future performance meet the standards established by this title; and

"(6) promote competition in cable communications and minimize unnecessary regulation that would impose an undue economic burden on cable systems.

"PART II—USE OF CABLE CHANNELS AND CABLE OWNERSHIP RESTRICTIONS

"CABLE CHANNELS FOR PUBLIC, EDUCATIONAL, OR GOVERNMENTAL USE

"SEC. 611. (a) A franchising authority may establish requirements in a franchise with respect to the designation or use of channel capacity for public, educational, or governmental use only to the extent provided in this section.

"(b) A franchising authority may in its request for proposals require as part of a franchise, and may require as part of a cable operator's proposal for a franchise renewal, subject to section 626, that channel capacity be designated for public, educational, or governmental use, and channel capacity on institutional networks be designated for educational or governmental use, and may require

rules and procedures for the use of the channel capacity designated pursuant to this section.

"(c) A franchising authority may enforce any requirement in any franchise regarding the providing or use of such channel capacity. Such enforcement authority includes the authority to enforce any provisions of the franchise for services, facilities, or equipment proposed by the cable operator which relate to public, educational, or governmental use of channel capacity, whether or not required by the franchising authority pursuant to subsection (b).

"(d) In the case of any franchise under which channel capacity is designated under subsection (b), the franchising authority shall prescribe—

"(1) rules and procedures under which the cable operator is permitted to use such channel capacity for the provision of other services if such channel capacity is not being used for the purposes designated, and

"(2) rules and procedures under which such permitted use shall cease.

"(e) Subject to section 624(d), a cable operator shall not exercise any editorial control over any public, educational, or governmental use of channel capacity provided pursuant to this section.

"(f) For purposes of this section, the term 'institutional network' means a communication network which is constructed or operated by the cable operator and which is generally available only to subscribers who are not residential subscribers.

"CABLE CHANNELS FOR COMMERCIAL USE

"SEC. 612. (a) The purpose of this section is to assure that the widest possible diversity of information sources are made available to the public from cable systems in a manner consistent with growth and development of cable systems.

"(b)(1) A cable operator shall designate channel capacity for commercial use by persons unaffiliated with the operator in accordance with the following requirements:

"(A) An operator of any cable system with 36 or more (but not more than 54) activated channels shall designate 10 percent of such channels which are not otherwise required for use (or the use of which is not prohibited) by Federal law or regulation.

"(B) An operator of any cable system with 55 or more (but not more than 100) activated channels shall designate 15 percent of such channels which are not otherwise required for use (or the use of which is not prohibited) by Federal law or regulation.

"(C) An operator of any cable system with more than 100 activated channels shall designate 15 percent of all such channels.

"(D) An operator of any cable system with fewer than 36 activated channels shall not be required to designate channel capacity for commercial use by persons unaffiliated with the operator, unless the cable system is required to provide such channel capacity under the terms of a franchise in effect on the date of the enactment of this title.

"(E) An operator of any cable system in operation on the date of the enactment of this title shall not be required to remove any service actually being provided on July 1, 1984, in order to comply with this section, but shall make channel capacity available for commercial use as such capacity becomes available until such time as the cable operator is in full compliance with this section.

"(2) Any Federal agency, State, or franchising authority may not require any cable system to designate channel capacity for commercial use by unaffiliated persons in excess of the capacity specified in paragraph (1), except as otherwise provided in this section.

"(3) A cable operator may not be required, as part of a request for proposals or as part of a proposal for renewal, subject to section 626, to designate channel capacity for any use (other than commercial use by unaffiliated persons under this section) except as provided in sections 611 and 637, but a cable operator may offer in a franchise, or proposal for renewal thereof, to provide, consistent with applicable law, such capacity for other than commercial use by such persons.

"(4) A cable operator may use any unused channel capacity designated pursuant to this section until the use of such channel capacity is obtained, pursuant to a written agreement, by a person unaffiliated with the operator.

"(5) For the purposes of this section—

"(A) the term 'activated channels' means those channels engineered at the headend of the cable system for the provision of services generally available to residential subscribers of the cable system, regardless of whether such services actually are provided, including any channel designated for public, educational, or governmental use; and

"(B) the term 'commercial use' means the provision of video programming, whether or not for profit.

"(6) Any channel capacity which has been designated for public, educational, or governmental use may not be considered as designated under this section for commercial use for purpose of this section.

"(c)(1) If a person unaffiliated with the cable operator seeks to use channel capacity designated pursuant to subsection (b) for commercial use, the cable operator shall establish, consistent with the purpose of this section, the price, terms, and conditions of such use which are at least sufficient to assure that such use will not adversely affect the operation, financial condition, or market development of the cable system.

"(2) A cable operator shall not exercise any editorial control over any video programming provided pursuant to this section, or in any other way consider the content of such programming, except that an operator may consider such content to the minimum extent necessary to establish a reasonable price for the commercial use of designated channel capacity by an unaffiliated person.

"(3) Any cable system channel designated in accordance with this section shall not be used to provide a cable service that is being provided over such system on the date of the enactment of this title, if the provision of such programming is intended to avoid the purpose of this section.

"(d) Any person aggrieved by the failure or refusal of a cable operator to make channel capacity available for use pursuant to this section may bring an action in the district court of the United States for the judicial district in which the cable system is located to compel that such capacity be made available. If the court finds that the channel capacity sought by such person has not been made available in accordance with this section, or finds that the price, terms, or conditions established by the cable operator are unreasonable, the court may order such system to make available to such person the channel capacity sought, and further determine the appropriate price, terms, or conditions for such use consistent with subsection (c), and may award actual damages if it deems such relief appropriate. In any such action, the court shall not consider any

price, term, or condition established between an operator and an affiliate for comparable services.

"(e)(1) Any person aggrieved by the failure or refusal of a cable operator to make channel capacity available pursuant to this section may petition the Commission for relief under this subsection upon a showing of prior adjudicated violations of this section. Records of previous adjudications resulting in a court determination that the operator has violated this section shall be considered as sufficient for the showing necessary under this subsection. If the Commission finds that the channel capacity sought by such person has not been made available in accordance with this section, or that the price, terms, or conditions established by such system are unreasonable under subsection (c), the Commission shall, by rule or order, require such operator to make available such channel capacity under price, terms, and conditions consistent with subsection (c).

"(2) In any case in which the Commission finds that the prior adjudicated violations of this section constitute a pattern or practice of violations by an operator, the Commission may also establish any further rule or order necessary to assure that the operator provides the diversity of information sources required by this section.

"(3) In any case in which the Commission finds that the prior adjudicated violations of this section constitute a pattern or practice of violations by any person who is an operator of more than one cable system, the Commission may also establish any further rule or order necessary to assure that such person provides the diversity of information sources required by this section.

"(f) In any action brought under this section in any Federal district court or before the Commission, there shall be a presumption that the price, terms, and conditions for use of channel capacity designated pursuant to subsection (b) are reasonable and in good faith unless shown by clear and convincing evidence to the contrary.

"(g) Notwithstanding sections 621(c) and 623(a), at such time as cable systems with 36 or more activated channels are available to 70 percent of households within the United States and are subscribed to by 70 percent of the households to which such systems are available, the Commission may promulgate any additional rules necessary to provide diversity of information sources. Any rules promulgated by the Commission pursuant to this subsection shall not preempt authority expressly granted to franchising authorities under this title.

"(h) Any cable service offered pursuant to this section shall not be provided, or shall be provided subject to conditions, if such cable service in the judgment of the franchising authority is obscene, or is in conflict with community standards in that it is lewd, lascivious, filthy, or indecent or is otherwise unprotected by the Constitution of the United States.

"OWNERSHIP RESTRICTIONS

"SEC. 613. (a) It shall be unlawful for any person to be a cable operator if such person, directly or through 1 or more affiliates, owns or controls, the licensee of a television broadcast station and the predicted grade B contour of such station covers any portion of the community served by such operator's cable system.

"(b)(1) It shall be unlawful for any common carrier, subject in whole or in part to title II of this Act, to provide video programming directly to subscribers in its telephone service area, either directly or indirectly through an affiliate owned by, operated by, controlled by, or under common control with the common carrier.

"(2) It shall be unlawful for any common carrier, subject in whole or in part to title II of this Act, to provide channels of communica-

tions or pole line conduit space, or other rental arrangements, to any entity which is directly or indirectly owned by, operated by, controlled by, or under common control with such common carrier, if such facilities or arrangements are to be used for, or in connection with, the provision of video programming directly to subscribers in the telephone service area of the common carrier.

"(3) This subsection shall not apply to any common carrier to the extent such carrier provides telephone exchange service in any rural area (as defined by the Commission).

"(4) In those areas where the provision of video programming directly to subscribers through a cable system demonstrably could not exist except through a cable system owned by, operated by, controlled by, or affiliated with the common carrier involved, or upon other showing of good cause, the Commission may, on petition for waiver, waive the applicability of paragraphs (1) and (2) of this subsection. Any such waiver shall be made in accordance with section 63.56 of title 47, Code of Federal Regulations (as in effect September 20, 1984) and shall be granted by the Commission upon a finding that the issuance of such waiver is justified by the particular circumstances demonstrated by the petitioner, taking into account the policy of this subsection.

"(c) The Commission may prescribe rules with respect to the ownership or control of cable systems by persons who own or control other media of mass communications which serve the same community served by a cable system.

"(d) Any State or franchising authority may not prohibit the ownership or control of a cable system by any person because of such person's ownership or control of any media of mass communications or other media interests.

"(e)(1) Subject to paragraph (2), a State or franchising authority may hold any ownership interest in any cable system.

"(2) Any State or franchising authority shall not exercise any editorial control regarding the content of any cable service on a cable system in which such governmental entity holds ownership interest (other than programming on any channel designated for educational or governmental use), unless such control is exercised through an entity separate from the franchising authority.

"(f) This section shall not apply to prohibit any combination of any interests held by any person on July 1, 1984, to the extent of the interests so held as of such date, if the holding of such interests was not inconsistent with any applicable Federal or State law or regulations in effect on that date.

"Part III—Franchising and Regulation

"general franchise requirements

"Sec. 621. (a)(1) A franchising authority may award, in accordance with the provisions of this title, 1 or more franchises within its jurisdiction.

"(2) Any franchise shall be construed to authorize the construction of a cable system over public rights-of-way, and through easements, which is within the area to be served by the cable system and which have been dedicated for compatible uses, except that in using such easements the cable operator shall ensure—

"(A) that the safety, functioning, and appearance of the property and the convenience and safety of other persons not be adversely affected by the installation or construction of facilities necessary for a cable system;

"(B) that the cost of the installation, construction, operation,

or removal of such facilities be borne by the cable operator or subscriber, or a combination of both; and

"(C) that the owner of the property be justly compensated by the cable operator for any damages caused by the installation, construction, operation, or removal of such facilities by the cable operator.

"(3) In awarding a franchise or franchises, a franchising authority shall assure that access to cable service is not denied to any group of potential residential cable subscribers because of the income of the residents of the local area in which such group resides.

"(b)(1) Except to the extent provided in paragraph (2), a cable operator may not provide cable service without a franchise.

"(2) Paragraph (1) shall not require any person lawfully providing cable service without a franchise on July 1, 1984, to obtain a franchise unless the franchising authority so requires.

"(c) Any cable system shall not be subject to regulation as a common carrier or utility by reason of providing any cable service.

"(d)(1) A State or the Commission may require the filing of informational tariffs for any intrastate communications service provided by a cable system, other than cable service, that would be subject to regulation by the Commission or any State if offered by a common carrier subject, in whole or in part, to title II of this Act. Such informational tariffs shall specify the rates, terms, and conditions for the provision of such service, including whether it is made available to all subscribers generally, and shall take effect on the date specified therein.

"(2) Nothing in this title shall be construed to affect the authority of any State to regulate any cable operator to the extent that such operator provides any communication service other than cable service, whether offered on a common carrier or private contract basis.

"(3) For purposes of this subsection, the term 'State' has the meaning given it in section 3(v).

"(e) Nothing in this title shall be construed to affect the authority of any State to license or otherwise regulate any facility or combination of facilities which serves only subscribers in one or more multiple unit dwellings under common ownership, control, or management and which does not use any public right-of-way.

"FRANCHISE FEES

"SEC. 622. (a) Subject to the limitation of subsection (b), any cable operator may be required under the terms of any franchise to pay a franchise fee.

"(b) For any twelve-month period, the franchise fees paid by a cable operator with respect to any cable system shall not exceed 5 percent of such cable operator's gross revenues derived in such period from the operation of the cable system. For purposes of this section, the 12-month period shall be the 12-month period applicable under the franchise for accounting purposes. Nothing in this subsection shall prohibit a franchising authority and a cable operator from agreeing that franchise fees which lawfully could be collected for any such 12-month period shall be paid on a prepaid or deferred basis; except that the sum of the fees paid during the term of the franchise may not exceed the amount, including the time value of money, which would have lawfully been collected if such fees had been paid per annum.

"(c) A cable operator may pass through to subscribers the amount of any increase in a franchise fee, unless the franchising authority demonstrates that the rate structure specified in the franchise

reflects all costs of franchise fees and so notifies the cable operator in writing.

"(d) In any court action under subsection (c), the franchising authority shall demonstrate that the rate structure reflects all costs of the franchise fees.

"(e) Any cable operator shall pass through to subscribers the amount of any decrease in a franchise fee.

"(f) A cable operator may designate that portion of a subscriber's bill attributable to the franchise fee as a separate item on the bill.

"(g) For the purposes of this section—

"(1) the term 'franchise fee' includes any tax, fee, or assessment of any kind imposed by a franchising authority or other governmental entity on a cable operator or cable subscriber, or both, solely because of their status as such;

"(2) the term 'franchise fee' does not include—

"(A) any tax, fee, or assessment of general applicability (including any such tax, fee, or assessment imposed on both utilities and cable operators or their services but not including a tax, fee, or assessment which is unduly discriminatory against cable operators or cable subscribers);

"(B) in the case of any franchise in effect on the date of the enactment of this title, payments which are required by the franchise to be made by the cable operator during the term of such franchise for, or in support of the use of, public, educational, or governmental access facilities;

"(C) in the case of any franchise granted after such date of enactment, capital costs which are required by the franchise to be incurred by the cable operator for public, educational, or governmental access facilities;

"(D) requirements or charges incidental to the awarding or enforcing of the franchise, including payments for bonds, security funds, letters of credit, insurance, indemnification, penalties, or liquidated damages; or

"(E) any fee imposed under title 17, United States Code.

"(h)(1) Nothing in this Act shall be construed to limit any authority of a franchising authority to impose a tax, fee, or other assessment of any kind on any person (other than a cable operator) with respect to cable service or other communications service provided by such person over a cable system for which charges are assessed to subscribers but not received by the cable operator.

"(2) For any 12-month period, the fees paid by such person with respect to any such cable service or other communications service shall not exceed 5 percent of such person's gross revenues derived in such period from the provision of such service over the cable system.

"(i) Any Federal agency may not regulate the amount of the franchise fees paid by a cable operator, or regulate the use of funds derived from such fees, except as provided in this section.

"REGULATION OF RATES

"Sec. 623. (a) Any Federal agency or State may not regulate the rates for the provision of cable service except to the extent provided under this section. Any franchising authority may regulate the rates for the provision of cable service, or any other communications service provided over a cable system to cable subscribers, but only to the extent provided under this section.

"(b)(1) Within 180 days after the date of the enactment of this title, the Commission shall prescribe and make effective regulations

which authorize a franchising authority to regulate rates for the provision of basic cable service in circumstances in which a cable system is not subject to effective competition. Such regulations may apply to any franchise granted after the effective date of such regulations. Such regulations shall not apply to any rate while such rate is subject to the provisions of subsection (c).

"(2) For purposes of rate regulation under this subsection, such regulations shall—

"(A) define the circumstances in which a cable system is not subject to effective competition; and

"(B) establish standards for such rate regulation.

"(3) The Commission shall periodically review such regulations, taking into account developments in technology, and may amend such regulations, consistent with paragraphs (1) and (2), to the extent the Commission determines necessary.

"(c) In the case of any cable system for which a franchise has been granted on or before the effective date of this title, until the end of the 2-year period beginning on such effective date, the franchising authority may, to the extent provided in a franchise—

"(1) regulate the rates for the provision of basic cable service, including multiple tiers of basic cable service;

"(2) require the provision of any service tier provided without charge (disregarding any installation or rental charge for equipment necessary for receipt of such tier); or

"(3) regulate rates for the initial installation or the rental of 1 set of the minimum equipment which is necessary for the subscriber's receipt of basic cable service.

"(d) Any request for an increase in any rate regulated pursuant to subsection (b) or (c) for which final action is not taken within 180 days after receipt of such request by the franchising authority shall be deemed to be granted, unless the 180-day period is extended by mutual agreement of the cable operator and the franchising authority.

"(e)(1) In addition to any other rate increase which is subject to the approval of a franchising authority, any rate subject to regulation pursuant to this section may be increased after the effective date of this title at the discretion of the cable operator by an amount not to exceed 5 percent per year if the franchise (as in effect on the effective date of this title) does not specify a fixed rate or rates for basic cable service for a specified period or periods which would be exceeded if such increase took effect.

"(2) Nothing in this section shall be construed to limit provisions of a franchise which permits a cable operator to increase any rate at the operator's discretion; however, the aggregate increases per year allowed under paragraph (1) shall be reduced by the amount of any increase taken such year under such franchise provisions.

"(f) Nothing in this title shall be construed as prohibiting any Federal agency, State, or a franchising authority, from—

"(1) prohibiting discrimination among customers of basic cable service, or

"(2) requiring and regulating the installation or rental of equipment which facilitates the reception of basic cable service by hearing impaired individuals.

"(g) Any State law in existence on the effective date of this title which provides for any limitation or preemption of regulation by any franchising authority (or the State or any political subdivision or agency thereof) of rates for cable service shall remain in effect during the 2-year period beginning on such effective date, to the

extent such law provides for such limitation or preemption. As used in this section, the term 'State' has the meaning given it in section 3(v).

"(h) Not later than 6 years after the date of the enactment of this title, the Commission shall prepare and submit to the Congress a report regarding rate regulation of cable services, including such legislative recommendations as the Commission considers appropriate. Such report and recommendations shall be based on a study of such regulation which the Commission shall conduct regarding the effect of competition in the marketplace.

"REGULATION OF SERVICES, FACILITIES, AND EQUIPMENT

"SEC. 624. (a) Any franchising authority may not regulate the services, facilities, and equipment provided by a cable operator except to the extent consistent with this title.

"(b) In the case of any franchise granted after the effective date of this title, the franchising authority, to the extent related to the establishment or operation of a cable system—

"(1) in its request for proposals for a franchise (including requests for renewal proposals, subject to section 626), may establish requirements for facilities and equipment, but may not establish requirements for video programming or other information services; and

"(2) subject to section 625, may enforce any requirements contained within the franchise—

"(A) for facilities and equipment; and

"(B) for broad categories of video programming or other services.

"(c) In the case of any franchise in effect on the effective date of this title, the franchising authority may, subject to section 625, enforce requirements contained within the franchise for the provision of services, facilities, and equipment, whether or not related to the establishment or operation of a cable system.

"(d)(1) Nothing in this title shall be construed as prohibiting a franchising authority and a cable operator from specifying, in a franchise or renewal thereof, that certain cable services shall not be provided or shall be provided subject to conditions, if such cable services are obscene or are otherwise unprotected by the Constitution of the United States.

"(2)(A) In order to restrict the viewing of programming which is obscene or indecent, upon the request of a subscriber, a cable operator shall provide (by sale or lease) a device by which the subscriber can prohibit viewing of a particular cable service during periods selected by that subscriber.

"(B) Subparagraph (A) shall take effect 180 days after the effective date of this title.

"(e) The Commission may establish technical standards relating to the facilities and equipment of cable systems which a franchising authority may require in the franchise.

"(f)(1) Any Federal agency, State, or franchising authority may not impose requirements regarding the provision or content of cable services, except as expressly provided in this title.

"(2) Paragraph (1) shall not apply to—

"(A) any rule, regulation, or order issued under any Federal law, as such rule, regulation, or order (i) was in effect on September 21, 1983, or (ii) may be amended after such date if the rule, regulation, or order as amended is not inconsistent with the express provisions of this title; and

"(B) any rule, regulation, or order under title 17, United States Code.

"MODIFICATION OF FRANCHISE OBLIGATIONS

"SEC. 625. (a)(1) During the period a franchise is in effect, the cable operator may obtain from the franchising authority modifications of the requirements in such franchise—

"(A) in the case of any such requirement for facilities or equipment, including public, educational, or governmental access facilities or equipment, if the cable operator demonstrates that (i) it is commercially impracticable for the operator to comply with such requirement, and (ii) the proposal by the cable operator for modification of such requirement is appropriate because of commercial impracticability; or

"(B) in the case of any such requirement for services, if the cable operator demonstrates that the mix, quality, and level of services required by the franchise at the time it was granted will be maintained after such modification.

"(2) Any final decision by a franchising authority under this subsection shall be made in a public proceeding. Such decision shall be made within 120 days after receipt of such request by the franchising authority, unless such 120 day period is extended by mutual agreement of the cable operator and the franchising authority.

"(b)(1) Any cable operator whose request for modification under subsection (a) has been denied by a final decision of a franchising authority may obtain modification of such franchise requirements pursuant to the provisions of section 635.

"(2) In the case of any proposed modification of a requirement for facilities or equipment, the court shall grant such modification only if the cable operator demonstrates to the court that—

"(A) it is commercially impracticable for the operator to comply with such requirement; and

"(B) the terms of the modification requested are appropriate because of commercial impracticability.

"(3) In the case of any proposed modification of a requirement for services, the court shall grant such modification only if the cable operator demonstrates to the court that the mix, quality, and level of services required by the franchise at the time it was granted will be maintained after such modification.

"(c) Notwithstanding subsections (a) and (b), a cable operator may, upon 30 days' advance notice to the franchising authority, rearrange, replace, or remove a particular cable service required by the franchise if—

"(1) such service is no longer available to the operator; or

"(2) such service is available to the operator only upon the payment of a royalty required under section 801(b)(2) of title 17, United States Code, which the cable operator can document—

"(A) is substantially in excess of the amount of such payment required on the date of the operator's offer to provide such service, and

"(B) has not been specifically compensated for through a rate increase or other adjustment.

"(d) Notwithstanding subsections (a) and (b), a cable operator may take such actions to rearrange a particular service from one service tier to another, or otherwise offer the service, if the rates for all of the service tiers involved in such actions are not subject to regulation under section 623.

"(e) A cable operator may not obtain modification under this section of any requirement for services relating to public, educational, or governmental access.

"(f) For purposes of this section, the term 'commercially impracticable' means, with respect to any requirement applicable to a cable operator, that it is commercially impracticable for the operator to comply with such requirement as a result of a change in conditions which is beyond the control of the operator and the nonoccurrence of which was a basic assumption on which the requirement was based.

"RENEWAL

"Sec. 626. (a) During the 6-month period which begins with the 36th month before the franchise expiration, the franchising authority may on its own initiative, and shall at the request of the cable operator, commence proceedings which afford the public in the franchise area appropriate notice and participation for the purpose of—

"(1) identifying the future cable-related community needs and interests; and

"(2) reviewing the performance of the cable operator under the franchise during the then current franchise term.

"(b)(1) Upon completion of a proceeding under subsection (a), a cable operator seeking renewal of a franchise may, on its own initiative or at the request of a franchising authority, submit a proposal for renewal.

"(2) Subject to section 624, any such proposal shall contain such material as the franchising authority may require, including proposals for an upgrade of the cable system.

"(3) The franchising authority may establish a date by which such proposal shall be submitted.

"(c)(1) Upon submittal by a cable operator of a proposal to the franchising authority for the renewal of a franchise, the franchising authority shall provide prompt public notice of such proposal and, during the 4-month period which begins on the completion of any proceedings under subsection (a), renew the franchise or, issue a preliminary assessment that the franchise should not be renewed and, at the request of the operator or on its own initiative, commence an administrative proceeding, after providing prompt public notice of such proceeding, in accordance with paragraph (2) to consider whether—

"(A) the cable operator has substantially complied with the material terms of the existing franchise and with applicable law;

"(B) the quality of the operator's service, including signal quality, response to consumer complaints, and billing practices, but without regard to the mix, quality, or level of cable services or other services provided over the system, has been reasonable in light of community needs;

"(C) the operator has the financial, legal, and technical ability to provide the services, facilities, and equipment as set forth in the operator's proposal; and

"(D) the operator's proposal is reasonable to meet the future cable-related community needs and interests, taking into account the cost of meeting such needs and interests.

"(2) In any proceeding under paragraph (1), the cable operator shall be afforded adequate notice and the cable operator and the franchise authority, or its designee, shall be afforded fair opportunity for full participation, including the right to introduce evidence

(including evidence related to issues raised in the proceeding under subsection (a)), to require the production of evidence, and to question witnesses. A transcript shall be made of any such proceeding.

"(3) At the completion of a proceeding under this subsection, the franchising authority shall issue a written decision granting or denying the proposal for renewal based upon the record of such proceeding, and transmit a copy of such decision to the cable operator. Such decision shall state the reasons therefor.

"(d) Any denial of a proposal for renewal shall be based on one or more adverse findings made with respect to the factors described in subparagraphs (A) through (D) of subsection (c)(1), pursuant to the record of the proceeding under subsection (c). A franchising authority may not base a denial of renewal on a failure to substantially comply with the material terms of the franchise under subsection (c)(1)(A) or on events considered under subsection (c)(1)(B) in any case in which a violation of the franchise or the events considered under subsection (c)(1)(B) occur after the effective date of this title unless the franchising authority has provided the operator with notice and the opportunity to cure, or in any case in which it is documented that the franchising authority has waived its right to object, or has effectively acquiesced.

"(e)(1) Any cable operator whose proposal for renewal has been denied by a final decision of a franchising authority made pursuant to this section, or has been adversely affected by a failure of the franchising authority to act in accordance with the procedural requirements of this section, may appeal such final decision or failure pursuant to the provisions of section 635.

"(2) The court shall grant appropriate relief if the court finds that—

"(A) any action of the franchising authority is not in compliance with the procedural requirements of this section; or

"(B) in the event of a final decision of the franchising authority denying the renewal proposal, the operator has demonstrated that the adverse finding of the franchising authority with respect to each of the factors described in subparagraphs (A) through (D) of subsection (c)(1) on which the denial is based is not supported by a preponderance of the evidence, based on the record of the proceeding conducted under subsection (c).

"(f) Any decision of a franchising authority on a proposal for renewal shall not be considered final unless all administrative review by the State has occurred or the opportunity therefor has lapsed.

"(g) For purposes of this section, the term 'franchise expiration' means the date of the expiration of the term of the franchise, as provided under the franchise, as it was in effect on the date of the enactment of this title.

"(h) Notwithstanding the provisions of subsections (a) through (g) of this section, a cable operator may submit a proposal for the renewal of a franchise pursuant to this subsection at any time, and a franchising authority may, after affording the public adequate notice and opportunity for comment, grant or deny such proposal at any time (including after proceedings pursuant to this section have commenced). The provisions of subsections (a) through (g) of this section shall not apply to a decision to grant or deny a proposal under this subsection. The denial of a renewal pursuant to this subsection shall not affect action on a renewal proposal that is submitted in accordance with subsections (a) through (g).

"CONDITIONS OF SALE

"SEC. 627. (a) If a renewal of a franchise held by a cable operator is denied and the franchising authority acquires ownership of the cable system or effects a transfer of ownership of the system to another person, any such acquisition or transfer shall be—

"(1) at fair market value, determined on the basis of the cable system valued as a going concern but with no value allocated to the franchise itself, or

"(2) in the case of any franchise existing on the effective date of this title, at a price determined in accordance with the franchise if such franchise contains provisions applicable to such an acquisition or transfer.

"(b) If a franchise held by a cable operator is revoked for cause and the franchising authority acquires ownership of the cable system or effects a transfer of ownership of the system to another person, any such acquisition or transfer shall be—

"(1) at an equitable price, or

"(2) in the case of any franchise existing on the effective date of this title, at a price determined in accordance with the franchise if such franchise contains provisions applicable to such an acquisition or transfer.

"PART IV—MISCELLANEOUS PROVISIONS

"PROTECTION OF SUBSCRIBER PRIVACY

"SEC. 631. (a)(1) At the time of entering into an agreement to provide any cable service or other service to a subscriber and at least once a year thereafter, a cable operator shall provide notice in the form of a separate, written statement to such subscriber which clearly and conspicuously informs the subscriber of—

"(A) the nature of personally identifiable information collected or to be collected with respect to the subscriber and the nature of the use of such information;

"(B) the nature, frequency, and purpose of any disclosure which may be made of such information, including an identification of the types of persons to whom the disclosure may be made;

"(C) the period during which such information will be maintained by the cable operator;

"(D) the times and place at which the subscriber may have access to such information in accordance with subsection (d); and

"(E) the limitations provided by this section with respect to the collection and disclosure of information by a cable operator and the right of the subscriber under subsections (f) and (h) to enforce such limitations.

In the case of subscribers who have entered into such an agreement before the effective date of this section, such notice shall be provided within 180 days of such date and at least once a year thereafter.

"(2) For purposes of this section, the term 'personally identifiable information' does not include any record of aggregate data which does not identify particular persons.

"(b)(1) Except as provided in paragraph (2), a cable operator shall not use the cable system to collect personally identifiable information concerning any subscriber without the prior written or electronic consent of the subscriber concerned.

"(2) A cable operator may use the cable system to collect such information in order to—

"(A) obtain information necessary to render a cable service or other service provided by the cable operator to the subscriber; or

"(B) detect unauthorized reception of cable communications.

"(c)(1) Except as provided in paragraph (2), a cable operator shall not disclose personally identifiable information concerning any subscriber without the prior written or electronic consent of the subscriber concerned.

"(2) A cable operator may disclose such information if the disclosure is—

"(A) necessary to render, or conduct a legitimate business activity related to, a cable service or other service provided by the cable operator to the subscriber;

"(B) subject to subsection (h), made pursuant to a court order authorizing such disclosure, if the subscriber is notified of such order by the person to whom the order is directed; or

"(C) a disclosure of the names and addresses of subscribers to any cable service or other service, if—

"(i) the cable operator has provided the subscriber the opportunity to prohibit or limit such disclosure, and

"(ii) the disclosure does not reveal, directly or indirectly, the—

"(I) extent of any viewing or other use by the subscriber of a cable service or other service provided by the cable operator, or

"(II) the nature of any transaction made by the subscriber over the cable system of the cable operator.

"(d) A cable subscriber shall be provided access to all personally identifiable information regarding that subscriber which is collected and maintained by a cable operator. Such information shall be made available to the subscriber at reasonable times and at a convenient place designated by such cable operator. A cable subscriber shall be provided reasonable opportunity to correct any error in such information.

"(e) A cable operator shall destroy personally identifiable information if the information is no longer necessary for the purpose for which it was collected and there are no pending requests or orders for access to such information under subsection (d) or pursuant to a court order.

"(f)(1) Any person aggrieved by any act of a cable operator in violation of this section may bring a civil action in a United States district court.

"(2) The court may award—

"(A) actual damages but not less than liquidated damages computed at the rate of $100 a day for each day of violation or $1,000, whichever is higher;

"(B) punitive damages; and

"(C) reasonable attorneys' fees and other litigation costs reasonably incurred.

"(3) The remedy provided by this section shall be in addition to any other lawful remedy available to a cable subscriber.

"(g) Nothing in this title shall be construed to prohibit any State or any franchising authority from enacting or enforcing laws consistent with this section for the protection of subscriber privacy.

"(h) A governmental entity may obtain personally identifiable

information concerning a cable subscriber pursuant to a court order only if, in the court proceeding relevant to such court order—

"(1) such entity offers clear and convincing evidence that the subject of the information is reasonably suspected of engaging in criminal activity and that the information sought would be material evidence in the case; and

"(2) the subject of the information is afforded the opportunity to appear and contest such entity's claim.

"CONSUMER PROTECTION

"SEC. 632. (a) A franchising authority may require, as part of a franchise (including a franchise renewal, subject to section 626), provisions for enforcement of—

"(1) customer service requirements of the cable operator; and

"(2) construction schedules and other construction-related requirements of the cable operator.

"(b) A franchising authority may enforce any provision, contained in any franchise, relating to requirements described in paragraph (1) or (2) of subsection (a), to the extent not inconsistent with this title.

"(c) Nothing in this title shall be construed to prohibit any State or any franchising authority from enacting or enforcing any consumer protection law, to the extent not inconsistent with this title.

"UNAUTHORIZED RECEPTION OF CABLE SERVICE

"SEC. 633. (a)(1) No person shall intercept or receive or assist in intercepting or receiving any communications service offered over a cable system, unless specifically authorized to do so by a cable operator or as may otherwise be specifically authorized by law.

"(2) For the purpose of this section, the term 'assist in intercepting or receiving' shall include the manufacture or distribution of equipment intended by the manufacturer or distributor (as the case may be) for unauthorized reception of any communications service offered over a cable system in violation of subparagraph (1).

"(b)(1) Any person who willfully violates subsection (a)(1) shall be fined not more than $1,000 or imprisoned for not more than 6 months, or both.

"(2) Any person who violates subsection (a)(1) willfully and for purposes of commercial advantage or private financial gain shall be fined not more than $25,000 or imprisoned for not more than 1 year, or both, for the first such offense and shall be fined not more than $50,000 or imprisoned for not more than 2 years, or both, for any subsequent offense.

"(c)(1) Any person aggrieved by any violation of subsection (a)(1) may bring a civil action in a United States district court or in any other court of competent jurisdiction.

"(2) The court may—

"(A) grant temporary and final injunctions on such terms as it may deem reasonable to prevent or restrain violations of subsection (a)(1);

"(B) award damages as described in paragraph (3); and

"(C) direct the recovery of full costs, including awarding reasonable attorneys' fees to an aggrieved party who prevails.

"(3)(A) Damages awarded by any court under this section shall be computed in accordance with either of the following clauses:

"(i) the party aggrieved may recover the actual damages suffered by him as a result of the violation and any profits of

the violator that are attributable to the violation which are not taken into account in computing the actual damages; in determining the violator's profits, the party aggrieved shall be required to prove only the violator's gross revenue, and the violator shall be required to prove his deductible expenses and the elements of profit attributable to factors other than the violation; or

"(ii) the party aggrieved may recover an award of statutory damages for all violations involved in the action, in a sum of not less than $250 or more than $10,000 as the court considers just.

"(B) In any case in which the court finds that the violation was committed willfully and for purposes of commercial advantage or private financial gain, the court in its discretion may increase the award of damages, whether actual or statutory under subparagraph (A), by an amount of not more than $50,000.

"(C) In any case where the court finds that the violator was not aware and had no reason to believe that his acts constituted a violation of this section, the court in its discretion may reduce the award of damages to a sum of not less than $100.

"(D) Nothing in this title shall prevent any State or franchising authority from enacting or enforcing laws, consistent with this section, regarding the unauthorized interception or reception of any cable service or other communications service.

"EXISTING FRANCHISES

"SEC. 637. (a) The provisions of—

"(1) any franchise in effect on the effective date of this title, including any such provisions which relate to the designation, use, or support for the use of channel capacity for public, educational, or governmental use, and

"(2) any law of any State (as defined in section 3(v)) in effect on the date of the enactment of this section, or any regulation promulgated pursuant to such law, which relates to such designation, use or support of such channel capacity,

shall remain in effect, subject to the express provisions of this title, and for not longer than the then current remaining term of the franchise as such franchise existed on such effective date.

"(b) For purposes of subsection (a) and other provisions of this title, a franchise shall be considered in effect on the effective date of this title if such franchise was granted on or before such effective date.

"CRIMINAL AND CIVIL LIABILITY

"SEC. 638. Nothing in this title shall be deemed to affect the criminal or civil liability of cable programmers or cable operators pursuant to the Federal, State, or local law of libel, slander, obscenity, incitement, invasions of privacy, false or misleading advertising, or other similar laws, except that cable operators shall not incur any such liability for any program carried on any channel designated for public, educational, governmental use or on any other channel obtained under section 612 or under similar arrangements.

"OBSCENE PROGRAMMING

"SEC. 639. Whoever transmits over any cable system any matter which is obscene or otherwise unprotected by the Constitution of the United States shall be fined not more than $10,000 or imprisoned not more than 2 years, or both."

UNAUTHORIZED RECEPTION OF CERTAIN COMMUNICATIONS

SEC. 5. (a) Section 705 of the Communications Act of 1934 (as redesignated by section 6) is amended by inserting "(a)" after the section designation and by adding at the end thereof the following new subsections:

"(b) The provisions of subsection (a) shall not apply to the interception or receipt by any individual, or the assisting (including the manufacture or sale) of such interception or receipt, of any satellite cable programming for private viewing if—

"(1) the programming involved is not encrypted; and

"(2)(A) a marketing system is not established under which—

"(i) an agent or agents have been lawfully designated for the purpose of authorizing private viewing by individuals, and

"(ii) such authorization is available to the individual involved from the appropriate agent or agents; or

"(B) a marketing system described in subparagraph (A) is established and the individuals receiving such programming has obtained authorization for private viewing under that system.

"(c) For purposes of this section—

"(1) the term 'satellite cable programming' means video programming which is transmitted via satellite and which is primarily intended for the direct receipt by cable operators for their retransmission to cable subscribers;

"(2) the term 'agent', with respect to any person, includes an employee of such person;

"(3) the term 'encrypt', when used with respect to satellite cable programming, means to transmit such programming in a form whereby the aural and visual characteristics (or both) are modified or altered for the purpose of preventing the unauthorized receipt of such programming by persons without authorized equipment which is designed to eliminate the effects of such modification or alteration;

"(4) the term 'private viewing' means the viewing for private use in an individual's dwelling unit by means of equipment, owned or operated by such individual, capable of receiving satellite cable programming directly from a satellite; and

"(5) the term 'private financial gain' shall not include the gain resulting to any individual for the private use in such individual's dwelling unit of any programming for which the individual has not obtained authorization for that use.

"(d)(1) Any person who willfully violates subsection (a) shall be fined not more than $1,000 or imprisoned for not more than 6 months, or both.

"(2) Any person who violates subsection (a) willfully and for purposes of direct or indirect commercial advantage or private financial gain shall be fined not more than $25,000 or imprisoned for not more than 1 year, or both, for the first such conviction and shall be fined not more than $50,000 or imprisoned for not more than 2 years, or both, for any subsequent conviction.

"(3)(A) Any person aggrieved by any violation of subsection (a) may bring a civil action in a United States district court or in any other court of competent jurisdiction.

"(B) The court may—

"(i) grant temporary and final injunctions on such terms as it

may deem reasonable to prevent or restrain violations of subsection (a);

"(ii) award damages as described in subparagraph (C); and

"(iii) direct the recovery of full costs, including awarding reasonable attorneys' fees to an aggrieved party who prevails.

"(C)(i) Damages awarded by any court under this section shall be computed, at the election of the aggrieved party, in accordance with either of the following subclauses;

"(I) the party aggrieved may recover the actual damages suffered by him as a result of the violation and any profits of the violator that are attributable to the violation which are not taken into account in computing the actual damages; in determining the violator's profits, the party aggrieved shall be required to prove only the violator's gross revenue, and the violator shall be required to prove his deductible expenses and the elements of profit attributable to factors other than the violation; or

"(II) the party aggrieved may recover an award of statutory damages for each violation involved in the action in a sum of not less than $250 or more than $10,000, as the court considers just.

"(ii) In any case in which the court finds that the violation was committed willfully and for purposes of direct or indirect commercial advantage or private financial gain, the court in its discretion may increase the award of damages, whether actual or statutory, by an amount of not more than $50,000.

"(iii) In any case where the court finds that the violator was not aware and had no reason to believe that his acts constituted a violation of this section, the court in its discretion may reduce the award of damages to a sum of not less than $100.

"(4) The importation, manufacture, sale, or distribution of equipment by any person with the intent of its use to assist in any activity prohibited by subsection (a) shall be subject to penalties and remedies under this subsection to the same extent and in the same manner as a person who has engaged in such prohibited activity.

"(5) The penalties under this subsection shall be in addition to those prescribed under any other provision of this title.

"(6) Nothing in this subsection shall prevent any State, or political subdivision thereof, from enacting or enforcing any laws with respect to the importation, sale, manufacture, or distribution of equipment by any person with the intent of its use to assist in the interception or receipt of radio communications prohibited by subsection (a).

"(e) Nothing in this section shall affect any right, obligation, or liability under title 17, United States Code, any rule, regulation, or order thereunder, or any other applicable Federal, State, or local law.".

(b) The amendments made by subsection (a) shall take effect on the effective date of this Act.

APPENDIX B

Radio-Television News Directors Association
Code of Broadcast News Ethics

The responsibility of radio and television journalists is to gather and report information of importance and interest to the public accurately, honestly and impartially.

The members of the Radio-Television News Directors Association accept these standards and will:

1. *Strive to present the source or nature of broadcast news material in a way that is balanced, accurate and fair.*

 A. *They will evaluate information solely on its merits as news, rejecting sensationalism or misleading emphasis in any form.*
 B. *They will guard against using audio or video material in a way that deceives the audience.*
 C. *They will not mislead the public by presenting as spontaneous news any material which is staged or rehearsed.*
 D. *They will identify people by race, creed, nationality or prior status only when it is relevant.*
 E. *They will clearly label opinion and commentary.*
 F. *They will promptly acknowledge and correct errors.*

2. *Strive to conduct themselves in a manner that protects them from conflicts of interest, real or perceived. They will decline gifts or favors which would influence or appear to influence their judgments.*

3. *Respect the dignity, privacy and well-being of people with whom they deal.*

4. *Recognize the need to protect confidential sources. They will promise confidentiality only with the intention of keeping that promise.*

5. *Respect everyone's right to a fair trial.*

6. *Broadcast the private transmissions of other broadcasters only with permission.*

7. *Actively encourage observance of this Code by all journalists, whether members of the Radio-Television News Directors Association or not.*

APPENDIX C

The Society of Professional Journalists,
Sigma Delta Chi

Code of Ethics

The SOCIETY of Professional Journalists, Sigma Delta Chi believes the duty of journalists is to serve the truth.

We BELIEVE the agencies of mass communication are carriers of public discussion and information, acting on their Constitutional mandate and freedom to learn and report the facts.

We BELIEVE in public enlightenment as the forerunner of justice, and in our Constitutional role to seek the truth as part of the public's right to know the truth.

We BELIEVE those responsibilities carry obligations that require journalists to perform with intelligence, objectivity, accuracy, and fairness.

To these ends, we declare acceptance of the standards of practice here set forth:

I. RESPONSIBILITY:

The public's right to know of events of public importance and interest is the overriding mission of the mass media. The purpose of distributing news and enlightened opinion is to serve the general welfare. Journalists who use their professional status as representatives of the public for selfish or other unworthy motives violate a high trust.

II. FREEDOM OF THE PRESS:

Freedom of the press is to be guarded as an inalienable right of people in a free society. It carries with it the freedom and the responsibility to discuss, question, and challenge actions and utterances of our government and of our public and private institutions. Journalists uphold the right to speak unpopular opinions and the privilege to agree with the majority.

III. ETHICS:

Journalists must be free of obligation to any interest other than the public's right to know the truth.

1. Gifts, favors, free travel, special treatment or privileges can compromise the integrity of journalists and their employers. Nothing of value should be accepted.

2. Secondary employment, political involvement, holding public office, and service in community organizations should be avoided if it compromises the integrity of journalists and their employers. Journalists and their employers should conduct their personal lives in a manner that protects them from conflict of interest, real or apparent. Their responsibilities to the public are paramount. That is the nature of their profession.

3. So-called news communications from private sources should not be published or broadcast without substantiation of their claims to news values.

4. Journalists will seek news that serves the public interest, despite the obstacles. They will make constant efforts to assure that the public's business is conducted in public and that public records are open to public inspection.

5. Journalists acknowledge the newsman's ethic of protecting confidential sources of information.

6. Plagiarism is dishonest and unacceptable.

IV. ACCURACY AND OBJECTIVITY:

Good faith with the public is the foundation of all worthy journalism.

1. Truth is our ultimate goal.

2. Objectivity in reporting the news is another goal that serves as the mark of an experienced professional. It is a standard of performance toward which we strive. We honor those who achieve it.

3. There is no excuse for inaccuracies or lack of thoroughness.

4. Newspaper headlines should be fully warranted by the contents of the articles they accompany. Photographs and telecasts should give an accurate picture of an event and not highlight an incident out of context.

5. Sound practice makes clear distinction between news reports and expressions of opinion. News reports should be free of opinion or bias and represent all sides of an issue.

6. Partisanship in editorial comment that knowingly departs from the truth violates the spirit of American journalism.

7. Journalists recognize their responsibility for offering informed analysis, comment, and editorial opinion on public events and issues. They accept the obligation to present such material by individuals whose competence, experience, and judgment qualify them for it.

8. Special articles or presentations devoted to advocacy or the writer's own conclusions and interpretations should be labeled as such.

V. FAIR PLAY:

Journalists at all times will show respect for the dignity, privacy, rights, and well-being of people encountered in the course of gathering and presenting the news.

1. The news media should not communicate unofficial charges affecting reputation or moral character without giving the accused a chance to reply.

2. The news media must guard against invading a person's right to privacy.

3. The media should not pander to morbid curiosity about details of vice and crime.

4. It is the duty of news media to make prompt and complete correction of their errors.

5. Journalists should be accountable to the public for their reports and the public should be encouraged to voice its grievances against the media. Open dialogue with our readers, viewers, and listeners should be fostered.

VI. PLEDGE:

Adherence to this code is intended to preserve and strengthen the bond of mutual trust and respect between American journalists and the American people.

The Society shall--by programs of education and other means--encourage individual journalists to adhere to these tenets, and shall encourage journalistic publications and broadcasters to recognize their responsibility to frame codes of ethics in concert with their employees to serve as guidelines in furthering these goals.

CODE OF ETHICS
(Adopted 1926; revised 1973, 1984, 1987)

BIBLIOGRAPHY AND REFERENCE LIST

"ABC Radio networks reach more than ninety one million listeners according to latest RADAR and Arbitron surveys." 1985. *ABC Radio Networks* (March 1).

"ABC's choice to rebuild fall TV lineup may affect network's standing for years." 1984. *The Wall Street Journal* 37: (December 18): 44.

"Affordable consumer receiving equipment is key to teletext in U.S." 1984. New York: Ameritext News Release (April 29).

"Answers to your Questions About the NRSC Voluntary Standard." 1987. *Radioactive.* Washington, D.C.: National Association of Broadcasters (April).

"Broadcast Regulation '87, A Mid-Year Report." 1987. Washington, D.C.: National Association of Broadcasters.

"Cable Audio: where and why it might fly." 1985. *National Association of Broadcasters Broadcast Marketing and Technology News* 5: (March).

"Cable Stats." 1988. *Cablevision* (March 28): 64.

"Cable television development." 1986. Washington: National Cable Television Association.

"CBS program chief picks entertainment for 85 million viewers." 1984. *The Wall Street Journal* 1: (September 28): 17.

"Communities and frequencies for new FM stations authorized under FCC docket 80–90." 1984. *NAB HIGHLIGHTS* (December 24).

"Early calls of election results and exit polls: pros, cons, and constitutional considerations." 1985. *Public Opinion Quarterly* (Spring).

"FCC authorizes AM stereo: declines to select a single system." 1982. *Federal Communications Commission News Release* (March 5).

"In More than Half Our Homes. . .2 TVs, a VCR, Basic Cable." 1988. *Today.* Washington, D.C.: National Association of Broadcasters (February).

"Interim rules adopted for licensing and operation of direct broadcast satellites." 1982. Washington: FCC News Release (June 23).

"Maintaining rating confidence and credibility." 1983. *Pamphlet of Electronic Media Rating Council, Inc.* New York: (June).

"Minimum standards for electronic media rating research." 1983. *Pamphlet of Electronic Media Rating Council, Inc.* New York: (December).

"Must carry struck down by Court: NAB to appeal." 1985. *NAB Radio/TV Highlights* 1 (July 22).

"Panasonic industrial company brings videotex technology to the American market." 1984. Secaucus, N.J.: Panasonic news release (April 29).

"Senate closes out year by saying yes to satellite viewing rights act bill." 1984. *Satellite TV WEEK* (October 28).

1983 Calendar and Sourcebook. 1983. Islamabad, Pakistan: Pakistan Broadcasting Corporation.

1986 Annual Report, Corporation for Public Broadcasting. 1986. Washington, D.C.

Abrams, Bill. 1985. "Cost of TV sports commercials prompts cutbacks by advertisers." *The Wall Street Journal* 37 (January 15).

Adams, Bill. 1985. "TV Sweeps May Not Say Much, But for Now That's All There Is." *The Wall Street Journal* 31 (February 28).

Adams, David L. 1987. "High School Court Cases Outcome Could Affect Roles of all Advisors, Editors." *CMA Newsletter* (March): 4.

Adams, William C. 1985. "Early TV calls in 1984: how western voters deplored but ignored them." Paper presented at annual conference of the Association for Education in Journalism and Mass Communication, Memphis, August 4.

Agee, Warren K., Phillip H. Ault, and Edwin Emery. 1982. *Introduction to Mass Communication.* 7th ed. New York: Harper & Row.

Alsop, Ronald. 1985. "Some Public TV stations let sponsors pitch their products." *The Wall Street Journal* 33 (January 24).

Archer, Gleason L. 1971. *History of Radio to 1926.* New York: Arno Press and *The New York Times.*

Audet, J. Paul. 1983. "Owning a broadcast station: how to begin." *National Association of Broadcasters Research* (April).

Barnouw, Erik. 1966. *A Tower in Babel.* Vol. 1

of *A History of Broadcasting in the United States*. New York: Oxford University Press.

Barnouw, Erik. 1968. *The Golden Web*. Vol. 2 of *A History of Broadcasting in the United States*. New York: Oxford University Press.

Barnouw, Erik. 1970. *The Image Empire*. Vol. 3 of *A History of Broadcasting in the United States*. New York: Oxford Universtiy Press.

Bentley, J. Geoffrey. 1985. "Buying and selling broadcast properties; working with brokers, lawyers and consultants." Paper presented at National Association of Broadcasters Convention, Las Vegas, April.

Broadcast. 1986–1988. London: International Thomson Publishing Ltd.

Broadcast Engineering. 1981–1988. Overland Park, Kan: Intertec Publishing Corp.

Broadcast Management/Engineering. 1979–1988. New York: NBB Acquisitions Inc.

Broadcast Week. 1983–1988.

Broadcasting. 1978–1988. Washington, D.C.: Broadcasting Publications.

Broadcasting/Telecasting Yearbook. 1984–1987. Washington D.C.: Broadcasting Publications Inc.

Cable Television. 1985. Washington, D.C,: FCC Information Bulletin (August).

Cable TV Facts—1986. 1986. New York: Cable Television Advertising Bureau (January): 31–33.

Cable TV Facts. 1988. New York: Cable Television Advertising Bureau.

Channels. 1980–1988. New York: C.C. Publishing Inc.

Christensen, Bruce L. 1984. "Public service: the real purpose of public television." Speech to the Seventh Annual Program Fair, PBS, Seattle, October 29.

Code of Federal Regulations, 47, Parts 0–19. 1987. Washington, D.C.: Office of the Federal Register.

Code of Federal Regulations, 47, Parts 70–79. 1987. Washington, D.C.: Office of the Federal Register.

Curran, James, Michael Gurevitch, and Janet Woollacott, eds. 1983. *Mass Communication and Society*. London: Edward Arnold/Open University Press.

Davies, Eryl. 1983. *Telecommunications*. London: Her Majesty's Stationery Office.

Davis, Bob. 1987. "Court Throws Out FCC's Requirement that Cable-TV Carry Broadcast Outlets." *The Wall Street Journal* 11 (December 14).

The Decline and Fall of the Fairness Doctrine.

1987. Washington, D.C.: Broadcasting Publications.

Diamond, Edwin. 1982. *Sign Off: The Last Days of Television*. Cambridge, Mass.: MIT Press.

Dickerson, Donna Lee. 1982. *Florida Media Law*. Tampa: University Presses of Florida.

Dimling, John A. 1985. "Local Television Audience Trend Analysis." *National Association of Broadcasters Research and Planning Information for Management* (March).

Directory of International Broadcasting. 1985. London: IBSO Publications Ltd.

Directory of International Broadcasting. 1986. London: BSO Publications Ltd.

Ducey, Richard V. 1985. "On the Value of being old. . .50+." *National Association of Broadcasters Research and Planning Information for Management* (March).

Duch, Raymond, and Peter A. Frank. 1985. "Recent Trends in FM stations sales prices." *National Association of Broadcasters Planning and Research Information for Management* (February).

Electronic Media. 1981–1988. Chicago: Crain Communications Inc.

Federal Communications Commission. 1978. *How To Apply For A Broadcast Station*. Washington, D.C.: FCC Handout, November.

Federal Communications Commission. 1983. *The Communications Act of 1934, as amended*. Washington, D.C.: Federal Communications Commission.

The First 50 Years of Broadcasting. 1982. Washington: Broadcasting Publications Inc.

Flournoy, Don M. 1985. "Asiavision: A Satellite News Exchange." Paper presented at the Broadcast Education Association annual convention, Las Vegas, April 12.

Fratrik, Mark R., ed. 1987. *The Small Market Television Manager's Guide*. Washington, D.C.: National Association of Broadcasters.

Friedman, Wayne. 1988. "Metering the TV wars: who's ahead; why?" *Cablevision* (March 28): 37–43.

Gillmor, Donald M., and Jerome A. Barron. 1979. *Mass Communication Law: Cases and Comment*. 3rd ed. St. Paul: West Publishing Co.

Gillmor, Donald M., and Jerome A. Barron. 1984. *Mass Communication Law, Cases & Comment*. St. Paul: West Publishing Co.

Ginsburg, Douglas H. 1979. *Regulation of Broadcasting: Law and Policy towards Radio, Television and Cable Communications*. St. Paul: West Publishing Co.

Ginsburg, Douglas H., and Mark D. Director.

1983. *1983 Supplement to Regulation of Broadcasting, Law and Policy towards Radio, Television and Cable Communications.* St. Paul: West Publishing Co.

Greely, James E. 1979. "Financial qualifications of broadcast applicants." *Broadcast Financial Journal* 8:1 (March): 14–18.

Gross, Lynne Schafer. 1983. *The New Television Technologies.* Dubuque, Iowa: Wm. C. Brown Co. Publishers.

Gurevitch, Michael, Tony Bennett, James Curran, and Janet Woollacott, eds. 1982. *Culture, Society and the Media.* London: Methuen & Co.

Hague, Lee. 1978. *Purchasing a Broadcast Station: A Buyer's Guide.* National Association of Broadcasters.

Hargrove, Wade H. 1985. "Synopsis of the FCC's EEO Rules and Broadcast Applications Processing Requirements." 1985 NAB Convention Handout.

Head, Sydney W. 1985. *World Broadcasting Systems.* Belmont, Cal.: Wadsworth.

Hind, John, and Stephen Mosco. 1985. *Rebel Radio.* London: Pluto Press.

India, Government of, Ministry of Information and Broadcasting. 1982. *Mass Media In India 1980–81.* New Delhi: Publications Division.

Info-Pak. 1987. "The Basics of Libel Law." Washington, D.C.: Legal Department, National Association of Broadcasters (December).

International Broadcasting, Systems and Operations. 1985–88. London: BSO Publications Ltd.

Jordan. 1980. Amman: Ministry of Information. (Winter).

Kamen, Ira. 1973. *Questions and Answers about Pay TV.* Indianapolis: Howard W. Sams & Co.

Katz, Elihu, and George Wedell. 1980. *Broadcasting in the Third World.* Cambridge, Mass.: Harvard University Press.

Keirstead, Phillip O. 1979. *Modern Public Affairs Programming.* Blue Ridge Summit, Pa.: TAB Books Inc.

Keirstead, Phillip O. 1980. *All News Radio.* Blue Ridge Summit, Pa.: TAB Books Inc.

Keirstead, Phillip O. 1984. *The Complete Guide to Newsroom Computers.* 2nd ed. Overland Park, Kan.: Globecom Publishing Ltd.

Krasnow, Erwin, and Julian Shepard. 1985. "Buying and selling broadcast stations: a dozen myths and popular misconceptions." Paper presented at National Association of Broadcasters Convention, Las Vegas, April.

Kuhn, Frank Y., ed. 1984. *Documents of American Broadcasting.* 4th ed. Englewood Cliffs, N.J.: Prentice-Hall.

Leibowitz, Mathew, and John Spencer. 1988. "Broadcasting and the Law." Newsletter.

Lent, John A., ed. 1978. *Broadcasting in Asia and the Pacific, A Continental Survey of Radio and Television.* Philadelphia: Temple University Press.

Leroy, David, and Judith Leroy. 1987. "Introduction to TV Rating Concepts." *Current* (January 20): 4.

Lichty, Lawrence, and Malachi Topping, eds. 1976. *American Broadcasting—A Source Book on the History of Radio and Television.* New York: Hastings House Publishers.

Mass Communication Media in Jordan. 1978. Amman: Ministry of Information.

McCavitt, William E. 1981. *Broadcasting Around The World.* Blue Ridge Summit, Pa.: TAB Books Inc.

McPhail, Thomas. 1987. *Electronic Colonialism, The Future of International Broadcasting and Communication.* Newbury Park, Cal.: Sage.

McQuail, Denis, and Karen Siune. 1986. *New Media Politics.* London: Sage.

Middleton, Kent R., and Bill F. Chamberlin. 1988. *The Law of Public Communication.* White Plains, N.Y.: Longman.

Mosco, Vincent. 1979. *Broadcasting in the United States, Innovative Challenge and Organizational Control.* Norwood, N.J.: Ablex Publishing Corp.

Murphy, Brian. 1983. *The World Wired Up.* London: Comedia.

Offer, David, ed. 1984. *What a Free Press Means to America.* Chicago: The Society of Professional Journalists, Sigma Delta Chi.

Palmer, Robert. 1981. *Deep Blues.* New York: Penguin Books.

Paulu, Burton. 1981. *Television and Radio in the United Kingdom.* Minneapolis: University of Minnesota Press.

Pember, Don R. 1984. *Mass Media Law.* 3rd ed. Dubuque, Iowa: Wm. C. Brown Co. Publishers.

Pember, Don R. 1987. *Mass Media Law.* 4th ed. Dubuque, Iowa: Wm. C. Brown Co. Publishers.

Pottle, Jack T., Dean C. Coddington, and Ford Frick. 1984. "Impact of mobile communications in business." *National Association of Broadcasters Research and Planning Information for Management* (August).

Prentiss, Stan. 1987. *Satellite Communications.* 2nd ed. Blue Ridge Summit, Pa.: TAB Books Inc.

Public Broadcasting Service. 1986. *Station Program Cooperative.* Washington, D.C. (February 8).

Qatar Yearbook 1980–81. 1982. Doha: Press and Publications Department, Ministry of Information, State of Qatar.

Radio–Television News Directors Association Communicator. 1984–1988. Washington, D.C.: Radio–Television News Directors Association.

Rampeal, Kuldip R. 1984. "Adversary vs. development journalism: Indian mass media at the crossroads." Paper presented at the Association for Education in Journalism annual convention, Gainesville, Florida, August.

Saleem, Mohammad. 1985. Letter to authors from Second Secretary, Embassy of Pakistan. Washington, D.C. (March 19).

Sanford, Bruce W. 1981. *Synopsis Of The Law Of Libel And The Right Of Privacy.* Cincinnati: Scripps-Howard Newspapers.

Schultz, Ernie. 1987. Speech to Kentucky Broadcaster's Association. Lexington, Kentucky, October 1.

Seigerman, Catherine. 1986. "Rediscovering children's radio." *Radioactive* (March): 6–9.

Shane, Ed. 1984. *Programming Dynamics, Radio's Management Guide.* Overland Park, Kan.: Globecom Publishing Ltd.

Shook, Frederick. 1982. *The Process of Electronic News Gathering.* Englewood, Col.: Morton Publishing Co.

Shosteck, Herschel. 1983. "Cellular Radio: its economic feasibility for smaller markets." *National Association of Broadcasters Com/Tech Update.* Washington, D.C. (September).

Shute, Bill. 1987. "The FCC's New Indecency Standard: Recognizing the New Pig in the Parlor." Counsel Memo from the Legal Department, National Association of Broadcasters, Info-Pak (July–August).

Simmons, Steven J. 1978. *The Fairness Doctrine and the Media.* Berkeley: University of California Press.

Smith, Jim, and Jerry Del Colliano. 1984. "What you should know about Arbitrends." *Radio Only* (April): 19–27.

Sparkes, Vernone M. 1985. "The half wired nation: cable television's fifty-five percent penetration barrier." *National Association of Broadcasters Research and Planning Information for Management* (February).

Television/Broadcast (formerly *Broadcast Communications*). 1980–88. New York: PSN Publications.

Tellis, Jeff. 1987. "FCC Clarifies Rules on Indecent Programming." *Intercollegiate Broadcasting System Special Report* (November 27).

Trager, Robert, and Donna L. Dickerson. 1979. *College Student Press Law.* Athens, Ohio: National Council of College Publication Advisers.

Tunstall, Jeremy. 1984. *The Media in Britain.* London: Constable.

TV Technology. 1986–1988. Falls Church, Va.: Industrial Marketing Advisory Services Inc.

Tyrie, Carl, and Charles Cliff III. 1984. "Broadcast Public Files: FCC Requirements, Station Performance and Public Use." *Journal Of Broadcasting* 28, no.3 (Summer): 305–315.

U.S. Congress. Cable Communications Policy Act of 1984. 98th Congress. S.66,: 27pp.

Unger, Zave M. 1985. "Buying and selling stations, structuring the transaction: the buyer's point of view." Paper presented at National Association of Broadcasters Convention, Las Vegas, April.

The Wall Street Journal.

Ward, Bernie. 1984. "An eye on the sky." *SKY* 13:9 (September): 76–84.

Webster, James G. 1984. "People Meters." *National Association of Broadcasters Research and Planning Information for Management* (April).

Wilson, Joslyn, ed. 1982. *Florida Open Government Law Manual.* Tallahassee: Florida Press Association.

Yoakam, Richard D. 1981. *ENG: Electronic News Gathering in Local Television Stations.* Bloomington: Indiana University, School of Journalism, Center for New Communication.

Zeigler, Sherilyn K., and Herbert H. Howard. 1978. *Broadcast Advertising.* Columbus, Ohio: Grid.

INDEX

ABC
 formation of, 30
 four radio networks of, 81–82
 merger with Capital Cities Communications, 39
 merger with United Paramount Theaters, 30
Academic honors, on resume, 269–270
Access, cable television and, 135
Access channels, cable television and, 136, 143
Access time, local television programming and, 177
Account executives, 205
 of television station, 108
Action for Children's Television (ACT), 8, 118
Activities, on resume, 270
Administrative law, FCC and, 49
Administrative law judges, 49
Advertisements, 210–212
 agency-created, 211–212
 sponsor-created, 211
 station-created, 211
 for television, creating, 212–216
 testing, 213–214
Advertising, 204–217. See also Radio advertising; Sponsors; Television advertising
 barter and, 208–209
 budget for, 209
 cable and, 206
 cable television and, 145
 capitalistic approach to, 204
 of cigarettes, 36
 competition and, 216
 DBS and MMDS and, 206
 definition of, 205
 ethics and, 207
 fees for, 210
 international, 240–241
 media mixes and, 208

network sales of, 216
news coverage and, 67
production costs of, 205
programs and, 208
public service, 216–217
ratings and, 210, 214
reasons for, 207–208
regional and national, 210
representative firms and, 210
research on techniques and, 214, 216
sales of, 89–90, 187, 205, 208–210
self-regulation and, 207
selling time for, 209–210
spot announcements and, 209
Advertising agencies, 205
 advertisements created by, 211–212
Advertising flight, 210
Advertising time, selling, 209–210
Agenda setting, 244
Alexanderson, Ernst F.W., 16
All India Radio (AIR), 229
All-news format, for radio, 166–167
All-talk radio, 168
AM (amplitude modulation), 1
AM radio, 3, 9, 74–77
 four classes of stations and, 74–76
 operating hours and, 76–77
 ownership of FM stations and, 33
 programming for, 168
 stereo, 77
 wattage and direction and, 76
American Federation of Musicians, 20
American Forces Radio and Television Service (AFRTS), 237
American Marconi, 18
Amplitude modulation. See AM; AM radio
Anchorpeople, of television station, 114
Applications, competing, 87
Appropriate coverage, news coverage and, 66

Appropriation, 64
Arab States Broadcasting Union (ASBU), 221
Arbitrends service, 192
Arbitron Ratings Co., 187, 189
Armstrong, Edwin H., 9, 25–26
Ascertainment, 58
Asia-Pacific Broadcasting Union (ABU), 221
Asiavision, 222
Asociacion Interamericana de Radiodifusion (AIR), 221
Assignment editor, of television station, 114
Attitudinal reactions, market research and, 200
Audience
 of cable television, 145, 184
 cumulative, 192
 effect on television, 201
 sampling, 189–191
 segmenting, 73, 200
 of Voice of America, 235
Audition material, for telecommunications jobs, 271–272
Automated programming, 80
 radio music programming and, 162, 163
 satellite-fed, 163

Baird, John, 26
Banzhaf, John, III, 52
Barter
 program sponsorship and, 208–209
 of television programming, 112
Behavioral research, 201
Bell, Alexander Graham, 14
Berlusconi, Silvio, 240
Berne bureau, 221
Billboards, 208
Black box, cable television and, 142
Black programming, on radio, 170
"Blacklists," McCarthyism and, 29

Bona fides, political candidates and, 54

Boom box, 161

Bradley, Ed, 125

Brady, Ray, 125

Breaks, between network programs, 108

Bribes, 67

Brinkley, David, 122

Brinkley, John, 45

Britain, 222–228
 Channel 4 in, 226
 commercial "network" television in, 226
 community radio in, 225
 contracts in, 226
 deregulation in, 227–228
 domestic broadcasting in, 223
 franchises in, 225–226
 government powers in, 227
 Independent Broadcasting Authority in, 225
 independent television in, 225, 226
 pirates and, 225
 radio networking in, 226
 regulations in, 223–224
 semi-independence of broadcasting in, 224

British Broadcasting Corporation (BBC), 223
 beginnings of television broadcasting by, 26
 overseas service of, 223
 radio networks of, 224
 semi-independence of, 224
 television networks of, 224–225

Broadcast properties, sale of, 56

Broadcasting, 9–12
 radio and, 9–10
 television and, 10–12

Brokers, purchasing radio stations and, 93

Budget, for advertising, 209

Bureaus, television network news and, 125

Business department
 careers in, 264
 of television station, 111–112

Business environment, of radio stations, 85

Business manager, 111

Business plan, for radio stations, 84–85, 93–94

C-band satellites, 122

Cable, 4
 coaxial, 30–31
 fiber optic, 5
 international telecommunication and, 238–239
 obscenity and, 62
 programming decisions and, 249–250
 regulation of, 60–62
 satellite, 134

Cable Communication Policy Act of 1984, 61, 135, 138

Cable News Network (CNN), 38–39, 134

Cable radio, 83–84

Cable television, 1, 35–36, 133–146
 access and, 135, 143–144
 advertising and, 145, 206
 audience of, 145
 CATV and, 133–134
 churn and penetration and, 145
 competition from, 7
 complexity of, 135–136
 copyright and, 140
 fees charged by, 141
 franchising and, 135, 138–139
 functioning of, 136
 future for, 146
 interconnection and, 144–145
 leasing channels and, 139
 local government as originator on, 144
 local origination and, 143–144
 LPTV and, 140–141
 "must-carry" rule and, 102, 137
 pay-per-view, 133, 141
 present status of, 134–136
 privacy and, 139
 satellites and, 134, 139–140, 145–146
 shopping channels on, 2
 station ownership and, 139
 Syndex and, 137
 two-way communication and, 137–138
 typical system and, 141–143

Cable television programming, 143, 183–184
 audience and, 184
 local origination and, 184

Cable-ready TV sets, 128

Call-in show, on radio, 172

Callers, talk shows and, 250–251

Cameras, in courtroom, 66

Canal Plus, 240

Car radios, FM stations and, 34

Caribbean Broadcasting Union (CBU), 221

Carrier, 9

CBS News, 123–124

Cease and desist order, FCC and, 50

Cellular telephone, 157

Censorship, prohibition of, 47

Central News Division, in India, 229

Channel(s), FM, 77–78

Channel Five, 239

Channel swap proposal, public television and, 117–118

Chief engineer, of television station, 116

Children's programming, 8
 on public television, 118
 violence and, 252–254

Churn, cable television and, 143, 145

Cigarette advertising, on television, 36

Clear channels, 74–75

Clearance department, 249

Client list, of television station, 110

Coaxial cable, 30–31

Collingwood, Charles, 27

Color, sports broadcast and, 169

Colorization, of old movies, 181

Columbia News Service, formation of, 24

Columbia Broadcasting System (CBS)
 all-news radio format of, 166
 color television and, 28
 formation of, 23
 during television channel allocation freeze, 29

Commentators, early, on radio, 21

Commercial(s)
 missed plays of, 204
 political, 55

Commercial availabilities, 108–109, 206, 210

Commercial broadcasting, 204

Commercial clutter, 209

Common Carrier Bureau, of FCC, 48

Commonwealth Broadcasting Association, 221

Communications Act of 1934, 24, 42, 46–52
 amendment of, 277–294
 criminal law implications of, 51–52
 FCC and, 47–51
 politics and, 53–55
 powers under, 46–47
 provisions of, 47
 rationale for, 46

substance of, 46
today, 59
Communicators, careers as, 259–260
Communists, McCarthyism and, 29
Community Antenna Television
 (CATV), 133–134
Community radio, British, 225
Community TV. *See* Low-Power TV
Competition, 7
 advertising and, 216
 HDTV and, 155–156
 of radio, 96
 response to, 7
 during television channel allocation
 freeze, 29
Computers, 156–157
Confidence level, ratings and, 191
Confidential sources, 65
Conrad, Frank, 18
Conservative pressure, 8
Constitution, communication law and,
 42
Construction permit, for radio station,
 87–88
Consultant sell, 205
Contracts
 British, 226
 for telecommunications jobs, 274
Coolidge, Calvin, 27
Cooperative advertising specialist,
 108, 110
Copyright, 62
 cable television and, 140
Copyright Act of 1976, 62
Corporation for Public Broadcasting,
 35, 117
Correspondents, television network
 news and, 124–125
Cost cutting, television network pro-
 gramming and, 176
Cost-per-point (CPP), 210
Cost-per-thousand (CPM), 187, 210
Counterprogramming, 31, 106–107
Courtroom, cameras in, 66
Cover letters, for job applications,
 272–273
Creative director, 212
Cronkite, Walter, 27
Crystal sets, 17
Cume, ratings and, 192
Cumulative audience, 192

Daylighters, 76
Dayparts, radio music programming
 and, 164
Daytime television programming, 121

Daytimers, 76
de Forest, Lee, 16
Defamation, 63–64
Deintermixture, UHF television and,
 28–29
Demographics, ratings and, 192
Department of Justice, regulation by,
 62
Department of Labor, regulation by,
 63
Deregulation, 8–9, 59–60
 in Britain, 227–228
 television and, 127
"Designated Market Area" (DMA),
 188
Developing nations. *See* Third World
Development broadcasting, 228, 229
Dial-in, dial-out effect, 192
Diaries, ratings and, 192
Digital technology, cellular telephone
 and, 157
Direct broadcasting by satellite
 (DBS), 1, 4, 148–149
 advertising and, 206
 international, 240
Direct sales, 204
Directional signals, 76
Discretionary income, advertising and,
 207–208
Dishes, cable television and, 136
Disk jockeys, 80, 161–162
Diversification, television and, 127
Docudrama, 254
Dolbear, Amos, 15
Don Lee Network, 24
Doordarshan, 229
Double-billing, criminal law and, 51
Drive periods, radio programming
 during, 167
Dubbing, VCRs and, 150–151
Dumont Company, 30

Editing, ethics and, 67
Education
 on resume, 269, 270
 for telecommunications careers, 266
Educational radio. *See also* National
 Public Radio; Public radio
 programming for, 174
Edwards, Douglas, 31
Election coverage
 Press–Radio War and, 24
 television network news and, 126
Electromagnetism, 15
Electronic Media Rating Council
 (EMRC), 197

Electronic newsgathering (ENG), 37–
 38
Employment, on resume, 270
Employment agencies, for telecom-
 munications jobs, 273
Engineering consultant, 86–87
Engineering department, 116
Entertainment and Sports Program-
 ming Network (ESPN), 39, 134
Environmental Protection Agency
 (EPA), regulation by, 62
Equal Employment Opportunities
 Commission (EEOC), regulation
 by, 59, 63
Ethics, 42, 66–67
 advertising and, 207
 codes of, 67, 295–296
 management and, 67
 news and public affairs and, 66–67
European Broadcasting Union
 (EBU), 221–222
Eveready Hour, 20
Executive producer, 114
Exit polling, regulation and, 59

Fairness Doctrine, 52–53
False light, 64
Family viewing, violence and, 253–254
Farmsworth, Philo, 26
Federal Aviation Administration
 (FAA), regulation by, 62
Federal Communications Commission
 (FCC), 3–6, 47–51
 administrative law and, 49
 bureaus of, 48
 creation of, 24
 deregulation and, 8–9
 functions of, 49
 international telecommunication
 and, 222
 membership of, 47–48
 offices of, 48–49
 penalties imposed by, 49–51
 powers of, 46–47
 rules for radio stations, 91
 Sixth Report and Order of, 30–31
 television channel allocation freeze
 and, 28–30
Federal Radio Commission (FRC),
 creation of, 23, 44
Federal Trade Commission (FTC),
 regulation by, 62
Fees
 license, British, 224
 cable television and, 135, 141
Fessenden, Reginald A., 15–16

Fiber optic cable, 5
Fidelity, of AM radio, 9
Fiduciary responsibility, 204
Field Operations Bureau, of FCC, 48
Films. *See* Movies
Fines, imposed by FCC, 50
Fireside chats, of Roosevelt, 27
First tier, cable television and, 141
FM (frequency modulation), 1
FM radio, 3, 9, 25–26, 77–79
 advantages of, 79
 AM drop-ins and, 33
 broadcast channels for, 77–78
 car radios and, 34
 commercial, 26
 development of, 25–26
 dual ownership and, 33
 growth during 1950s, 32–34
 power levels and, 78–79
 programming for, 168
 stereo, 33–34
 switch to, 32–33
Focus groups, ratings and, 196
Focus sessions, 163
Foreign language programming
 on radio, 170
 on television, 179
Format. *See also specific formats*
 diversification of, 79–80
 for radio programming, 160, 163–
 164
Format changes, regulations and, 57
Fowler, Mark, 60
Franchise(s)
 British, 225–226
 cable television and, 135, 138–139
Franchise fees, cable television and,
 135, 141
Free-lancers, television network news
 and, 124
Free materials, ethics and, 66–67
Frequency, 15
 application for, 84
 choosing for radio station, 19
Frequency modulation. *See* FM; FM
 radio
Frequency spectrum, 9
Frey, Lou, 60
Friendly, Fred, "See It Now" docu-
 mentaries of, 29
"Fringe" time periods, 217
Fundraising, by public television,
 117

Gag order, 65
Gender typing, 247

General manager
 position of, 265–266
 of television station, 107
General sales manager, 108, 109
Geodemographics, 200
Gifts, 67
Government
 British, 227
 as originator on cable television, 144
 in Pakistan, 231
Government policy
 market research and, 199–200
 Soviet, 233
Graham, Fred, 125
Grossman, Lawrence, 66
Ground wave, 76
Guests, talk shows and, 251

Hands-on experience, getting telecom-
 munications jobs and, 258
Head end, cable television and, 136
Head hunter, 124
Herrold, Charles D. "Doc," 17
Hertz, 9, 15
Hertz, Heinrich, 15
High Definition Television (HDTV),
 129, 151, 153, 155–156
 consumer-related issues and, 153
 developments in, 153, 155
 effect on broadcasters, 153
 standards and competition and,
 155–156
Hoberman, Ben, 169
Home Box Office (HBO), 2, 134
Hoover, Herbert, 19, 20
"Hot topics," 244
"Hot-spots," television network news
 and, 125
Hottelet, Richard C., 27
Households, ratings and, 191
Households Using Television (HUT),
 191

Indecency, FCC penalties for, 50–51
Independent(s), Press–Radio War
 and, 24
Independent Broadcasting Authority,
 225
Independent Television (ITV), Brit-
 ish, 225, 226
Independent television stations, 102–
 103
 programming by, 176, 178–179
India, 228–230
 All India Radio in, 229
 Central News Division in, 229

commercial broadcasting in, 229
Doordarshan in, 229
Ministry of Information and Broad-
 casting in, 228–229
programming in, 230
radio receivers in, 229
satellite transmission in, 230
shortwave in, 230
Initiation fee, of union, 273
Integrated Services Digital Network
 (ISDN), 241–242
Interconnection, cable television and,
 136, 144–145
International Institute of Communica-
 tions, 221
International Mass Media Institute,
 221
International News Service (INS),
 Press–Radio War and, 24–25
International Radio and Television
 Organization (OIRT), 221, 222
International telecommunication, 220–
 242
 American, 234–238
 in Britain, 222–228
 integration of, 221–222
 literacy level and, 220
 political philosophy and, 220–221
 reasons for different systems and,
 220
 in Soviet Union, 233–234
 technology and, 220, 238–242
 in Third World, 228–233
International Telecommunication
 Union (ITU), 221
International Telecommunications
 Satellite Organization (ITSO;
 INTELSAT), 221
Interviews
 pay for, 67
 for telecommunications jobs, pre-
 paring for, 273
Intrusion, 64
Islamic States Broadcasting Services
 Organization, 221

Jamming, of Radio Marti, 236
Jenkins, C.F., 26
Job(s). *See* Telecommunication ca-
 reers
Job applications, cover letters for,
 272–273
Job objective, on resume, 268–269
Johnson, Lyndon, 35
Jordan, 231–232
 facilities in, 231

programming in, 232
signals from neighboring countries and, 231

Kaltenborn, H.V., 21
KDKA radio station, 18–19
Kennedy, John F., assassination of, 201
Koppel, Ted, 121
Krasnow, Erwin, 95
Ku-Band satellites, 122
Kuralt, Charles, 122

Language, effects of, 247–248
Late night television programming, 121
Legal environment, 5–6, 42. *See also specific laws*
broadcast regulations and, 6
FCC and, 5–6
source of communication laws and, 42–44
in United States, 5
Letter of reprimand, from FCC, 50
License
FCC and granting of, 55–57
renewal of, 49–50, 56–57
revocation or nonrenewal of, 49
License fees, British, 224
Linking. *See also* Networks; Radio networks; Television networks
of radio stations, 21
Listener-supported radio, programming for, 174
Literacy level, international telecommunication and, 220
Local access channel, cable television and, 136
Local Origination (LO), cable television and, 143–144
Local sales manager, 108, 109
Local television stations, programming by, 176–178
Location, of radio station, 88
Loomis, Mahlon, 15
Lotteries, criminal law and, 51
Low-Power TV (LPTV), 11–12, 39, 103–104
cable television and, 140–141
Lowest unit charge, political candidates and, 55

McCarthy, Joseph, 29
McLendon, Gordon, 32
Make-good spots, 213

Management. *See also specific types of managers*
careers in, 264–266
ethics and, 67
Marconi, Guglielmo, 15, 16
Margin of error, ratings and, 190–191
Market research, 197–201
on advertising techniques, 214
broadcast stations and, 198–199
as government policy tool, 199–200
listening and viewing habits and, 200
by media, 216
payment for, 214, 216
polling and, 199
qualitative, 200–201
test groups and, 198
testing advertising and, 213–214
Market size, telecommunications jobs and, 274
Marketing, of oneself, 266–267
Marketing department, 109–110
Marketing manager, 108, 109–110, 111
Mass media
criticisms of, 246–247
definition of, 1–2
power of, 254–255
specialized, 2
Mass Media Bureau, of FCC, 48
Master control center, 134
Maxwell, James Clerk, 15
Media mixes, advertising and, 208
Mergers, television and, 127
Meteorologist, of television station, 114
Meter(s), 189, 192
Metered overnight ratings, 187
Microwave, 1, 134. *See also* Multipoint distribution system; Multipoint Microwave Distribution System
sports broadcast and, 169
Ministry of Information and Broadcasting, Indian, 228–229
Minow, Newton, 34–35
Missed commercial plays, 204
Mix, television advertising and, 212
Modulation, 9
Morning television programming, 121
Morse, Samuel F.B., 14
Movies
local television programming and, 177
programming decisions and, 249
on television, 181

Multipoint Distribution System (MDS), 1, 4, 148
Multipoint Microwave Distribution System (MMDS), 148, 206
Murdoch, Rupert, 176, 226, 239, 240
Murrow, Edward R., 24, 27, 29, 201
Music and news programming, for radio, 165
Music programming, 161–164
automation and, 162
disk jockeys and, 161–162
format and, 163–164
records and, 161
satellite-fed automation and, 163
tape services and, 162
on television, 178–179
"Must-carry" rule, cable television and, 102, 137
Mutual Broadcasting System, formation of, 23–24

Narrowcasting, television and, 183
National(s), television network news and, 125
National Association of Broadcasters (NAB), 221
National Broadcasting Company (NBC)
creation of, 22
radio broadcasting inaugurated by, 23
during television channel allocation freeze, 29
television network of, 3
National Public Radio (NPR), 95–96
National Radio Systems Committee (NRSC), AM stereo standards of, 77
National representatives, in television, 109
Nationhood, telecommunication and, 221
NBC News and Information Service, 166–167
Nelson Brothers case, 45
Networks. *See also* Radio networks; Television networks; *specific networks*
monopolies among, 24
satellite, 133
New World Channel, 239
New World Information Order, 242
News department, 114–115
News director, 114
News programming
careers in, 264

early, on radio, 20–21
election, 24, 126
ethics and, 66–67
Indian, 230
for radio, 165
radio networks and, 80–81, 172–173
on television, 175
television networks and, 122–126
Newsfilm, 31
Newspapers, competition with, 7, 24–25
Nielsen ratings, 187
Nigeria, 232–233
Nipkow, Paul, 26
Nixon, Richard, 67
Nordvision, 222
North American Basic Teletext Specification (NABTS), 148
North American National Broadcasters Association (NANBA), 221

Obscenity
cable and, 62
definition of, 50
FCC penalties for, 50
Occupational Health and Safety Administration (OSHA), regulation by, 63
Open records laws, 65
Open spots, 210
Operating hours, of radio stations, 76–77
Operating log, 210
Operations manager, 112–113
Operations supervisor, 114

Packages, of old movies, 177, 181
Pakistan, 230–231
government control in, 231
programming in, 231
receivers in, 230–231
shortwave in, 231
Paley, William S., 23, 25, 29
Patrick, Dennis, 60
Pay, for interviews, 67
Pay-cable, international, 239–240
Pay-per-view cable, 133, 141
Pay TV, 141
international, 239–240
Payola, criminal law and, 51
Penetration, cable television and, 145
People meters, ratings and, 192–195
Per inquiry (PI) spot, 109
Performer, careers as, 259–260

Permits, for radio station, 91
Personal attack rule, 57–58
Personal interviews, ratings and, 196
Pilot programs, on television, 120
Playlist, 164, 196, 250
Political philosophy, international telecommunication and, 220–221
Political pressure, 8
Politics, Communications Act of 1934 and, 53–55
Polling, market research and, 199
Popov, Alexander, 15
Portable communication, 6
Post production, 212
Power levels, of FM stations, 78–79
Practice, getting telecommunications jobs and, 257
Predicted coverage area, 187
Preemption
of commercials, 213
of television network programs, 108
Presentation, getting telecommunications jobs and, 257–258
Press. *See also* Newspapers
freedom of, fair trials and, 65
Press–Radio War, 24
Pressure groups, 7–8
Price, of radio stations, 94
Prime time access, 36–37
Privacy, 64
cable television and, 139
Privacy Protection Act of 1980, 65–66
Private facts, 64
Private Radio Bureau, of FCC, 48
Production, careers in, 260–261
Production costs, of advertising, 205
Production director, 112
Professional courses, on resume, 270
Program and continuity acceptance, 120
Program manager, 112
Programming, 160–185. *See also specific types of programming*
automated, 80
cable television and, 143
foreign language, 170, 179
Indian, 230
Jordanian, 232
new, need for, 245–246
Pakistani, 231
Soviet, 233–234
sponsor-produced, 208
Programming consultants, 184
Programming decisions, radio stations and, 86

Programming department, 112–113
Programming survey, of radio stations, 85
Promotion
careers in, 263–264
by radio station, 90–91
Promotion department, 115–116
Promotion manager, 107, 115
Proof-of-performance affidavits, 213
Propaganda, Voice of America and, 234
Psychographics, 200
Public affairs
careers in, 264
ethics and, 66–67
television network news and, 125–126
Public Broadcasting Act of 1967, 35, 117
Public file, 58–59, 91, 108
Public radio, 95–96. *See also* National Public Radio
programming for, 173–174
ten-watt stations and, 96
Public service announcements, 216–217
Public taste, 249–251
Public television, 116–119
beginnings of, 116–117
channel swap proposal and, 117–118
construction of stations and, 118
fundraising by, 117
ratings and, 118
state and regional networks for, 118
Public television networks, 118
Public television programming, 118, 182–183
British productions and, 182–183
for children, 118, 253
local stations and, 183
news programming and, 183
satellite service and, 182
station program cooperative and, 182
Purchase, of radio station, 93–95

RADAR, 189
Radio, 3–4, 72–97. *See also* AM radio; FM radio
Arbitron ratings for, 189
automation of, 73
big business and, 17–22
cable, 83–84
competition of, 96
competition with newspapers, 24–25

current status of, 72–74
early advertising on, 19–20
income sources in, 96
listener-supported, programming for, 174
as local medium, 74
1950s change in, 31–34
public. *See* Educational radio; National Public Radio; Public radio
short-wave, 9–10, 230, 231
spot announcements on, 209
World War II and, 26–27
Radio Act of 1912, 19, 43
Radio Act of 1927, 20, 22–23, 44–45
key ideas in, 44–45
Radio advertising, 89–90, 205, 209
early, 19–20, 22
growth in importance, 23
rate cards for, 89–90
Radio Free Europe, 236–237
Radio Liberty, 236–237
Radio Marti, 235–236
Radio networks. *See also specific networks*
British, 226
growth of, 23–24
money and, 83
multiple, 81–82
for news, 80–81, 172–173
programming and, 171–173
satellite transmission and, 82–83
specialized, 173
specialty, 83, 173
as syndicators, 80
Radio programming, 79–83, 160–174, 250
ABC's four networks and, 81–82
all-news, 166–167
all-talk, 168
AM versus FM and, 168
appealing to status and, 160–161
early, 20–21
foreign language, 170
format diversification and, 79–80
multiple networks and, 81–82
music, 161–164
music and news, 165
network, 171–173
networks and money and, 83
networks as syndicators and, 80
networks for news and, 80–81
news, 165
for noncommercial radio, 173–174
religious, 169–170
satellite network radio and, 82–83
segmenting and, 80

specialized interest, 169–171
specialty networks and, 83
sports, 168–169
syndicators and, 80
talk and news, 167–168
Radio receivers
in India, 229
in Pakistan, 230
Radio stations, 19, 84–92
application for frequency and, 84
business environment and, 85
business plan and, 84–85, 93–94
buying, 93–95
competing applications and, 87
construction permit and, 87–88
engineering consultants and, 86–87
FCC rules and, 91
going on air and, 92
internal organization of, 90
location of, 88
permits and, 91
pirate, 225
programming decisions and, 86
programming survey and, 85
promotion and, 90–91
ratings and, 85–86
selling advertising and, 89–90
size and character of, 73–74
staffing of, 88–89
ten-watt, 96
Radio-Television News Directors Association, code of ethics of, 295
Random sample, 189
Rate cards, 89–90, 216
Rather, Dan, 125
Rating period, 197
Ratings, 187–197
advertising and, 214
Arbitron and, 189
buying advertising according to, 210
cume and, 192
definition of, 191
demographics and, 192
diaries and, 192
Electronic Media Rating Council and, 197
focus groups and, 196
households and, 191
meters and, 192
paying for, 197
people meters and, 192–195
personal interviews and, 196
of public television, 118
RADAR and, 189
radio stations and, 85–86
rating ploys and, 197

sampling audiences and, 189–191
share and, 191–192
special surveys and, 196–197
sweeps and, 187–189
telephone surveys and, 195–196
Reagan, Ronald, 27, 53
Record(s), radio programming and, 161
Record keeping, regulations and, 57
Redlining, 139
References, on resume, 270–271
Regional sales manager, of television station, 108
Regulation, 6, 52–62. *See also* Deregulation
ascertainment and, 58
of cable, 60–62
cameras in courtroom and, 66
confidential sources and, 65
copyright and, 62
defamation and, 63–64
exit polling and, 59
Fairness Doctrine and, 52–53
format changes and, 57
free press versus fair trial and, 65
gag orders and, 65
government agencies and, 62–63
identification and, 57
licenses and, 55–57
obscenity and, 62
open records laws and, 65
personal attack rule and, 57–58
of political broadcasting, 53–55
privacy and, 64
Privacy Protection Act and, 65–66
public file and, 58–59
record keeping and, 57
right to cover trials and, 65
secrecy stamps and, 66
technical standards and, 57
Religious pressure, 8
Religious programming, on radio, 169–170
Remote broadcasts
radio, 20
sports and, 168–169
Reporters
for television network news, 124
of television station, 114
Reporting
on-scene, 27
portable, 27
Representative firms, advertising and, 210
Research. *See* Market research
Research specialist, 108, 110

Resume, for telecommunications jobs, 267–271
Roosevelt, Franklin D., fireside chats of, 27
Rotations, 110, 164
Rules, 42

Salaries, in telecommunications, 266
Sales, careers in, 262–263
Sales department, 108–109
Sales presentations, 206
Sales schedules, 206
Sales staff, hiring, 110–111
Sales traffic specialists, 110–111
Sameness, 244, 246
Sampling, 189–191
 confidence level and, 191
 population figures and, 189
 random sample and, 189
 sampling error and, 190–191
Sarnoff, David, 17, 22, 23, 26, 235
Satellite(s), 1, 4–5
 cable television and, 139–140
 competition and, 7
 early, 35
 Indian, 230
 international telecommunication and, 222, 241
 radio networks and, 82–83, 173
 television network news and, 124
 television programming and, 174–175, 178
Satellite cable, 134
Satellite-fed automation, for radio music programming, 163
Satellite Master Antenna Television (SMATV), 133, 145–146
Satellite networks, 133
Satellite newsgathering vehicles, 122, 175
Schafer, Paul, 162
Schuler, Bob, 45
Scrambled signals, 133
Scripps, William E., 18
Seasons, television networks and, 120
Secrecy stamps, 66
Securities and Exchange Commission (SEC), regulation by, 63
Segmenting, 80, 200
Self-regulation, advertising and, 207
7-7-7 rule, 60, 127
Sex, on television, 254
Share, ratings and, 191–192
Shepard, Julian, 95
Short-wave radio, 9–10
 Indian, 230

Pakistani, 231
Sigma Delta Chi, code of ethics of, 296
Single-Source Research, 201
Sixth Report and Order, 30–31
Skips, 76
Sky Channel, 239
Skywave, 76
Slaby, Adolphus, 15
Soap operas, 245
Social conduct, 248
Societal issues
 children's programming and, 252–254
 docudrama and, 254
 language and, 247–248
 measuring success and, 248
 media criticism and, 246–247
 media gender typing and, 247
 media power and, 254–255
 media stereotyping and, 247
 need for new channels and programs and, 245–246
 public taste and, 249–251
 sex and, 254
 social conduct and, 248
 telecommunication as gatekeeper and, 244
 violence and, 251–254
Software. *See* Programming
Soviet Union, 233–234
 external broadcasting of, 234
 facilities in, 233
 policy in, 233
 programming in, 233–234
Spin-offs, 245
Sponsors, 205
 advertisements created by, 211
 early, on radio, 20
Sports, careers in, 264
Sports programming
 creating broadcast and, 168–169
 early, on radio, 21
 for radio, 168–169
 radio networks and, 172
 regional, 168
 sports talk and, 169
 sportscasts and, 169
 on television, 176, 178
 television networks and, 126–127
Sportscaster, of television station, 114
Spot announcements, 209
Spot inventory, 109
Staffing, of radio station, 88–89
Staging, news coverage and, 66
Standards
 for AM stereo, 77

HDTV and, 155–156
technical, regulations and, 57
for teletext, 147–148
Station identification, regulations and, 57
Station manager, of television station, 107–108
Status, radio programming and, 160–161
Stereo
 AM, 77
 FM stations and, 33–34
 television and, 151
Stereotyping, 247
Storyboard, 212
Storz, Todd, 32
Stringers, television network news and, 124, 125
Stubblefield, Nathan B., 15
Studio supervisor, of television station, 116
Subscriber-based fees, 204
Subscription(s), 204
Subscription television, 102, 141, 149–150
Success, measures of, 248
Superheterodyne circuit, 18
Superstation, 127
Surveys, ratings and, 195–197
Swayze, John Cameron, 31
Sweeps, 187–189
Syndex II, cable television and, 137
Syndication
 programming decisions and, 249
 television programming and, 128, 179, 181–182
 television programs produced for, 181
Syndicators, 80

Tags, 110
Talent, talk shows and, 251
Talk and news format, for radio, 167–168
Talk shows, 250–251
Tape services, radio music programming and, 162
Technical careers, 261–262
Technical standards, regulations and, 57
Technicians, 114
Technology, 6–7
 international telecommunication and, 220, 238–242
Telecommunication
 definition of, 1–2

forms of, 2–5
as gatekeeper, 244
international. *See* International tele-
 communication
issues facing, 7–9
legal environment of, 5–6
significance and impact in United
 States, 6–7
Telecommunication careers, 257–275
 audition material and, 271–272
 in business office, 264
 "business" and, 257
 contracts and, 274
 cover letters and, 272–273
 employment agencies and, 273
 getting jobs and, 257–259
 helpful organizations and, 274–275
 in management, 264–266
 market size and, 274
 marketing oneself and, 266–267
 performers and, 259–260
 preparing for interviews and, 273
 in production, 260–261
 in promotion, 263–264
 in public affairs, sports, and news,
 264
 resume and, 267–271
 salaries and, 266
 in sales, 262–263
 technical, 261–262
 unions and, 273–274
 vocational versus educational prepa-
 ration for, 266
Telegraph, 14
 wireless, 15
Telephone
 cellular, 157
 development of, 14–17
Telephone lines, leasing, 22
Telephone surveys, ratings and, 195–
 196
Teletext, 128, 133, 147–148
 problems with, 147
 standards for, 147–148
Teletype reports, early radio news
 programming and, 21
Television, 2–3, 100–129. *See also* Ca-
 ble television; Public television;
 UHF television
 advertiser-supported, international,
 240–241
 allocation developments in, 103–104
 allocation of channels and, 28–30
 audience's effect on, 201
 beginning of, 26

cigarette ads on, 36
color, 28, 35
deregulation and, 127
diversification of, 127
educational, beginning of, 35
electronic newsgathering and, 37–38
extra services and, 128
family viewing and, 38
freeze on station allocations and,
 28–30
future of, 128–129
growth during 1946–1948, 27–29
low-power, 11–12, 39, 103–104,
 140–141
mergers and, 127
need for new channels and pro-
 gramming in, 245–246
1980s developments in, 38–39
nonprofit, 116–119
prime time access and, 36–37
satellites and, 35
7-7-7 rule change and, 127
stereo, 151
subscription, 102, 141, 149–150
syndicated programming and, 128
time base corrector and, 37
VHF, 2–3, 10–12
videotape recorders and, 37
Television advertising, 205–206, 209
 commercial creation and, 212–216
 commercials and, 209
 national, 119
Television networks, 3, 100–102, 119–
 127. *See also specific networks*
 checks and balances on, 120
 dependence on, 100–102
 fourth, 103, 176
 functions of, 119
 national advertising and, 119
 news programming and, 122–126
 programming by, 120–127, 175–176
 for public television, 118
 seasons and, 120
 sports programming on, 126–127
 viewership drop and, 102
 viewing pattern changes and, 120
Television news programming, 122–
 126
 bureaus and, 125
 correspondents and, 124–125
 election coverage and, 126
 public affairs and, 125–126
 satellites and, 124
Television programming, 113–114,
 174–184, 249–250. *See also* Cable

television programming; Public
 television programming; Tele-
 vision news programming
affiliates and, 122
careful and meticulous process in-
 volved in, 121
cost of, 105–107
daytime, 121
foreign language, 179
independent stations and, 176, 178–
 179
innovative, 181
late night, 121
local, 176–178
long-running series and, 120–121
morning, 121
narrowcasting and, 183
network, 120–127, 175–176
news, 122–126
noncommercial stations and, 182–
 183
pilots and, 120
satellites and, 174–175
sports, 126–127
syndication and, 128, 179, 181–182
weekend, 121–122
Television Receive-Only antennas
 (TVROs), 136
Television receivers, in Pakistan, 230
Television stations, 104–116
 administration of, 107–108
 advertisements created by, 211
 affiliates, advertising and, 216
 business department of, 111–112
 construction of, 118
 engineering department of, 116
 facility and, 104–105
 hiring sales staff for, 110–111
 independent, 102–103, 176, 178–179
 marketing department of, 109–110
 news department of, 114–115
 organizational structure of, 107
 programming and, 105–107, 113–
 114
 programming department of, 112–
 113
 promotion department of, 115–116
 sales department of, 108–109
Test-marketing, 198
Third World, 228–233
 development in, 228
 political philosophy in, 220–221
3-SAT, 239
Time base corrector, 37
Time shifting

television networks and, 120
VCRs and, 7, 120, 150
Titanic, 17
Toll broadcasting, 20, 21–22
Trade deals, of television station, 115–116
Traffic/operations people, 259
Traffic reports, on radio, 173
Transmitter supervisor, 116
TransRadio Press, 24
Trials
cameras in courtroom and, 66
fair, free press and, 65
right to cover, 65
Truman, Harry, Voice of America and, 235
Turner, Ted, 38–39, 134
12–12–12 rule, 60
Two-way communication, cable television and, 137–138

U.S. Information Agency (USIA), satellite transmissions of, 236
UHF (Ultra High Frequency) television, 2–3, 10–12
during 1946–1948, 28–29
early, 35
reception and, 35
Union(s), 273–274
Union of National Radio and Television Organizations of Africa (URTNA), 221
United Nations Educational, Scientific, and Cultural Organization (UNESCO), 221, 242
United States, 234–238
American Forces Radio and Television Service and, 237

Radio Free Europe and Radio Liberty and, 236–237
Radio Marti and, 235–236
USIA satellite transmissions and, 236
Voice of America and, 234–236
Uplink, 134
User contributions, 204

Van Deerlin, Lionel, 59–60
Vertical blanking interval, 147–148
VHF (Very High Frequency) television, 2–3, 10–12
VHF drop-ins, 103–104
Videocassette recorders (VCRs), 150–151
commercial "zapping" and, 150
dubbing video and, 150–151
time shifting and, 7, 120, 150
video rentals and, 150
Videographer/editors, of television station, 114
Videotape recorder (VTR), 31, 37
Videotext, 133, 146–147
Vietnam War, newscasting and, 201
Violence, 251–254
children's programming and, 252–254
Vital statistics, on resume, 268
Vocational preparation, for telecommunications careers, 266
Voice of America (VOA), 10, 234–236
facilities of, 234
history of, 234–235
independence of, 235
policy for, 235

Radio Marti and, 235–236
target audiences of, 235
Volunteering, getting telecommunications jobs and, 257

Warner-Amex QUBE, 138
Wattage, of radio stations, 76
Weather services, on radio, 173
Weekend television programming, 121–122
Western Union, 17
WINS, all-news format of, 166
Wire services, Press–Radio War and, 24–25
Wireless and Telegraphy Acts of 1949 and 1967, 223–224
Wireless Ship Act of 1910, 42–43
World Administrative Radio Conferences (WARCs), 221
World System Teletext (WST), 148
World War II, 26–27
broadcast news and, 27
on-scene reporting and, 27
portable recording and, 27
Roosevelt's fireside chats and, 27
Worldnet, 236
World's Fair of 1939, television and, 26

Yankee Network, 24
beginnings of, 26
Young, Owen D., 18

Zapple Doctrine, 54
Zenith ruling, 43–44
Zukor, Adolph, 23
Zworykin, Vladimir, 26